For the Love of Beauty

For the Love of Beauty

Art, History, and the Moral Foundations of Aesthetic Judgment

Arthur Pontynen

Transaction Publishers
New Brunswick (U.S.A.) and London (U.K.)

Library of Congress Catalog Number: 2005055936
ISBN: 0-7658-0301-1
Printed in the United States of America

Library of Congress Cataloging-in-Publication Data

Pontynen, Arthur.
 For the love of beauty : art, history, and the moral foundations of aesthetic judgment / Arthur Pontynen.
 p. cm.
 Includes bibliographical references and index.
 ISBN 0-7658-0301-1 (alk. paper)
 1. Aesthetics. 2. Art—Philosophy. I. Title.

N66.P66 2006
701'.17—dc22 2005055936

To my beloved wife Alison, and our children
Alina, Abigail, and Anson

Contents

List of Illustrations

Preface

This book on the history of Western art has an unlikely origin. It stems from a concern that arose in the writing of a dissertation on Chinese Daoism. The nature of that concern and its importance to the study of art history is illustrated by reference to two events. Although anecdotal, those events are more than merely personal. They illustrate the power and influence of a particular contemporary paradigm for scholarship, culture, indeed life, and that paradigm's inadequacy.

While in residence at the Freer Gallery of Art under the auspices of a Smithsonian Fellowship I casually asked a renowned Sinologist a question that was lingering in my mind: *Is Daoism true?* By that was meant, do the ideas and values expressed particularly in the Chinese classic, the *Dao De Jing (The Way and Its Virtue)* provide genuine insight into how the world and life work? Although this question seemed vital (and still does), it was rebuffed as an inappropriate scholarly concern. But Daoist art advocates Daoist belief. The makers or patrons of Daoist art believed (and still do) in the Daoist values depicted via their art; to assume otherwise is to assume massive ignorance or a conspiracy of hypocrisy or malevolence. So to deliberately avoid addressing the validity of those beliefs is to deny the intrinsic meaning of that art. To study Daoist thought and art without evaluating their claims to truth is not then an act of scholarship. Rather, it is an act of violence. By omission or commission it destroys the intrinsic meaning of the work of art and the possible validity of the tradition of which it is a part.

The second event that served in the genesis of this text resulted from my concern that in ignoring the truth claims of Daoism (or those of any work of fine art), contemporary scholarship tacitly substitutes a different cultural perspective to that which is intrinsic to the art being studied. In a critique of the first draft of my dissertation, a respected philosopher and member of the committee wrote:

> It is wrongly supposed that science does not explain anything, presumably because it doesn't arrive at or presuppose cosmic purposes. If a lawful explanation of an occurrence—an eclipse of the moon, for example—isn't an explanation, what is it?

I responded in writing as follows:

...To say an explanation of an occurrence is an explanation seems not to tell us much, and that which is lawful to an empiricist is often distinct from that which is lawful to a metaphysician. But the question is raised: what is it? I would suggest that it is a description given the title of explanation. An eclipse of the moon may be described (or empirically explained) as the result of the earth blocking out the sun, but why do these planets pursue their paths? Metaphysical explanations include God, the Buddha, and the Tao. And those explanations reflect intellectual traditions which from an empirical viewpoint (...doesn't arrive at or presuppose cosmic purposes.) must be viewed as subjective.

... using a methodology which considers descriptions to be explanations, to investigate a system of thought and its art (Taoism) which holds explanations to be beyond the descriptive, results in the tacit denial of the latter's objective validity.

Should this understanding be in error, correction would be most graciously received. However, a persuasive argument addressing this issue has not yet been made available. I accept the authority of the department in determining the philosophical position proper to the pursuit of knowledge. Nevertheless, until this issue is resolved, that authority seems to be based not upon a desire for knowledge, but rather, upon the propagation of dogma.

Years of subsequent research on the methodology of contemporary Art History [1] provides in hindsight an understanding of what was, and still is, at issue: The pursuit of truth, once central to the fine arts and humanities has largely been abandoned. It has been replaced by the pursuit of facts, feelings, and style. With reason no longer seeking knowledge of reality, scientific facts and our emotional manipulation of those facts purportedly provides our lives with meaning. To this view, facts are understood to be objective, but how we put those facts together in understanding reality and life is subjective. In other words, in science, ethics, and art, the pursuit of knowledge is limited to a constructed aesthetic vision. The result is an alleged subjective-objectivity where if truth and reason are acknowledged at all, they are confused with power.

This aesthetic pursuit is commonly viewed as both factually objective and emotionally meaningful. But reflection suggests that it is neither. The assumption that scholarship is dedicated to the pursuit of facts, and those facts are put into constructed narratives, offers us but a superficial intellectual content. It mandates a dogmatic relativism that presupposes and therefore mandates – and teaches—that knowledge beyond the factual is a matter of aesthetic preference or experience, and from an aesthetic perspective reality is meaningless and purposeless. Purposeless, that is, but for existential acts of will. Those acts may result in arbitrarily constructed lifestyles, or lifestyles that are held to be a matter of our empirical identity based on race, gender, or economic class. In either case we pay no heed to the question of whether or not such acts (or works of fine art) are true to a meaningful reality. By its presumption of a purposeless world this existentialist viewpoint reduces life to mere self expression and self realization, and limits thought to mere willful rationalization, or a will to

power. It thus reduces culture to calculations of power and fine art to entertainment, therapy, or propaganda. [2]

The pursuit of truth is the pursuit of knowledge of reality, of *Being*, and that knowledge affects us on personal, social, and most importantly, ontological levels. The last is most important because lacking a ground in meaningful reality, personal and social opinions are functionally the expression of arbitrary power. The pursuit of quality, of wisdom, of knowledge of that which is true and good then makes no sense. But bereft of the possibility of quality, our lives must necessarily be meaningless. Lacking the pursuit of truth, of some degree of knowledge of what is true and good, the fine arts and humanities necessarily lack intellectual and cultural grounding and purpose. Fields of study such as philosophy, music, art, and history are therefore trivialized, and brutalized.

But for art history the denial of purpose and quality is fundamentally destructive; as a matter of historical record, such a mandate contradicts the intrinsic meaning of virtually all of the fine art produced around the world prior to the last two hundred years in the West. In contrast to the Modernism and Postmodernism[3] of that period, the fine art of Daoism and Buddhism, Classicism and Christianity (to cite but a few) all attempt to explain a purposeful world and life. To reduce all such attempts to nostalgic fact and mere personal or cultural opinion is neither inevitably nor necessarily correct. And it certainly is not tolerant.

Aesthetics center on facts, feelings, and style with the practical consequence (after a Kantian interregnum) that culture is a construct based on power. In contrast, beauty is traditionally associated with the attempt to understand a purposeful reality. Beauty is found in or via meaningful *Being*. That attempt is ultimately an intellectual rather than a willful endeavor. It is cognitive rather than coercive.

With the denial of objective truth there has also been a denial of an objective, meaningful reality, or *Being*. Consequently, there is a reduction of goodness and beauty to a matter of identity, of willful aesthetic experience; that reduction denies the possibility of civil and responsible conversation. If our cultural beliefs are a matter of identity, of willful preferences or experiences, then those beliefs are but preferences that can be asserted, or attacked, but never civilly evaluated—for such intellectual evaluation is beyond the purview of the merely willful. As explained later, *being* is transformed into a meaningless and therefore brutal *becoming*.

The reduction of meaning to willful assertion denies the possibility of goodness and beauty, and our ability to search for and discuss such possible knowledge. We are thereby required to perceive the world and life via a willful aesthetic metaphysics. The end result is a focus that is dogmatically existentialist. This existentialist viewpoint occurs in Modernist and concludes in Postmodernist modes.

The tragic irony is that the assumption of a purposeless world is not an avoidance of metaphysics. Both Modernism and Postmodernism presume a metaphysical belief; as a statement of faith they foundationally presume a relativistic denial of any possibility of understanding an objective purpose and quality in life. Be they Modernist or Postmodernist, it is concurred that there is no *being*, no objective transcendent truth of which we can have any precious degree of knowledge. The lack of objectivity results in the dominance of subjectivity, where public culture is the result of the will. Those with a lingering sense of civility cling to the notion that the will must therefore be good. They conclude that culture occurs as the result of a benevolent sociology.

This premise has the appearance of civility, but even if such a (Kantian or Rousseavean) will could be recognized as benevolent, which as we later shall see is at the very least deeply problematical, a culture based upon the benevolent will remains unable to objectively discuss much less discern qualitative distinctions. It hence remains blind to (*being*) goodness —and benevolence— yet is committed to freedom (becoming). But freedom without goodness is meaningless or worse. In willfully advocating a goodness that it cannot understand, a dogmatic relativism remains blind to the possibility of its own banality, malevolence, and decay.

This inability to pursue knowledge of goodness—and beauty—blurs the qualitative distinction between civilization and barbarism, between justice and legality, between fine art and the trivial or malevolent. It conflates truth with power, goodness with sensitivity, and beauty with aesthetics. As such it fails to provide justification for fine art, scholarship, and even civilization. Lacking the ability to perceive quality, fine art and culture descend to the realms of mere material culture, sociological fact, and subjective lifestyles.

This denial of the possibility of knowing anything of objective value, of benevolent being, of goodness and beauty, is seen by the subjectivist as key to freedom from dogma. But it condemns us to the dogma of relativism and to a tyranny of violent banality. Lacking the possibility of even a degree of knowledge of objective goodness and beauty, only the will remains, and in a society of competing wills, violence and coercion replace responsible freedom as the norm. Indeed, the abandonment of the pursuit of Truth is an abandonment of the possibility of meaningful conversation. We cannot conscientiously pursue the good when the good cannot be understood, and therefore there is nothing to discuss, only things to assert. As discussed below, when meaning is equated with mere existence, our beliefs are a matter of identity, of our individual or group experiences which establish what we are. But when belief is defined as identity, then disagreement can only be personally destructive. The inability to evaluate and discuss meaning violates essential and foundational qualities intrinsic to being human.

Around the world, and through history, fine art has perennially been distinguished by its very attempt to transcend entertainment, therapy, or propa-

ganda. It is marked by a serious attempt to discern what purpose the world and our lives enjoy. And particularly in the West it has been dedicated to the realization of responsible freedom, where *being* and *becoming* harmonize. But today ignoring those attempts or assuming their irrelevance or failure is as commonplace as it is tragic.

The writing of this text begins with the question: Why is the pursuit of truth (be it called Dao, Dharma, God, Logos, Ideal, etc) no longer acceptable in academic circles? Examination of this question requires an extensive and critical reconsideration of the intellectual history of Western (and in this text, Eastern) culture. It requires that we attempt to understand—and critique—our current abandonment of the attempt to understand reality and life.[4] As such it is a task that requires that we escape the limitations of the aesthetic mindset. As the following pages attempt to establish, such reconsideration reveals that the shift from the pursuit of truth to the pursuit of facts and feelings is indeed a shift from the pursuit of beauty to that of aesthetics. It is a shift with profound political and social consequences in that it marks a move away from principle to power, from virtue to violence, from responsible freedom to narcissism, coercion, and nihilism. And it is a shift to which there is an alternative.

A number of writers have argued for a progressive resistance to Modernist and Postmodernist dogma. Examples in the field of Asian studies are Ananda Coomaraswamy, Edward Conze, and more recently Jonathan Chaves. In a a Western context, Alasdair McIntyre and Thomas Molnar have similarly resisted such conformity of thought, belief, and scholarly practice. Although they have not framed their efforts as such, they have indeed resisted an aestheticization of culture. In different ways they have remained committed to the pursuit of beauty.

So the requirement that Daoism be studied without concern for the onto-logical validity of Daoism has led to a study of the ontological claims of Modernism and Postmodernism. The conclusion offered is that Western culture and scholarship are now deeply existentialist; mandated is a purposeless aesthetic of life where feeling is confused with thinking and the pursuit of power is dangerously confused with the pursuit of truth and freedom. This aesthetic heavily relies upon the false Kantian assertion that a good will can be discerned even if goodness cannot be understood. It is a Modernist assertion that, as the Postmodernist Nietzsche presciently noted, cannot be defended.

The narrative of this History of Art is not informed by Modernist and Postmodernist relativism. It is limited neither to an aesthetic of alleged toler-ance, nor an aesthetic of identity. As an alternative it initially offers a cosmo-politan pursuit of the true, good, and beautiful. It focuses on an attempt to understand reality (*being*) and time (*becoming*) via the history of art. That attempt is one where there is the recognition that substantively different cul-tural traditions exist, and that the truth claims of those traditions might actu-ally be true in whole or part. It accepts that the Modernist-Postmodernist

worldview might be true, but contrarily, so might be Daoism, or Classicism, or Christianity. As a matter of both theory and practice, it accepts that we can and ought to engage in an important conversation where facts and reasoning permit us to evaluate the various truth-claims that compete for our belief and actions.

But to avoid slipping yet again into the relativism and barbarism of a values-clarification approach, a further step is taken. The narrative of this text will show how the history of art parallels the intellectual history of Western culture, and how those parallels affect both aesthetics and ethics. It will show how an aesthetics of fact, feeling, and power, has gradually superceded intelligible beauty and goodness in the public realm, and how that development is neither inevitable nor morally or culturally beneficial. A solution offered is to engage a viewpoint that *does not privilege* the notion of a purposeless cosmos. We seek to engage in a viewpoint that facilitates a pursuit of knowledge of reality, of beauty, rather than mandates an advocacy of a dogmatically aesthetic worldview.

The aesthetic worldview purports to be diverse, but is uniformly subjectivist. It concludes in but one option: that the will determines meaning, *being* is actually us *becoming*. In contrast, the pursuit of beauty accepts that there are many different traditions which offer very different understandings of reality and life. Not all of those traditions can be true, and it is our task to strive to decide which, in part or whole, is better. So the pursuit of beauty is substantively diverse, whereas the advocacy of aesthetics is not.

Whereas aesthetics denies the possibility of beauty, the pursuit of beauty does not deny the existence of aesthetics, or the importance of facts and feelings. It does, however, recognize that the realm of aesthetics is not as profound, not as meaningful, as beauty. It posits a continuum from the aesthetic to the beautiful, a continuum that is as realistic as it is qualitative. As such it recognizes the influence passion has on reason but accepts that such influence is not necessarily subjectivist or obscurantist. It is a viewpoint that recognizes not only fine art and ethics, but history itself, as more than an aesthetic construct or a narrative of oppression, coercion, and power. That viewpoint is not one facing a choice between the secular and the religious. It is a viewpoint that aspires to understand reality, resulting in responsible freedom, and the possibility of a glimpse of beauty—and wisdom—without insisting upon its way.

Notes

1. That research was introduced in my article, "A Winter Landscape: Reflections on the Theory and Practice of Art History," Art Bulletin, LXVIII, no. 3 (September, 1986): 467-79.
2 For a discussion see: Arthur Pontynen, "Beauty and the Enlightened Beast," American Outlook Magazine (2002), 37-40.

3. The terms Modernist and Postmodernist here refer to the single tradition beginning with Kant and continuing with those who start with a departure from his system: Hegel, Marx, and Nietzsche (and his many contemporary epigones). This is discussed in Arthur Pontynen, "Oedipus Wrecks: PC and Liberalism" Measure 113 (February, 1993): 1-4.

4. Ananda Coomaraswamy, Christian and Oriental Philosophy of Art (New York: Dover Publications, 1956), 30: "The study of art, if it is to have any cultural value, will demand two far more difficult operations than [aesthetic appreciation], in the first place an understanding and acceptance of the whole point of view from which the necessity for the work arose, and in the second place a bringing to life in ourselves of the form in which the artist conceived the work and by which he judged it. The student of art, if he is to do more than accumulate facts, must also sacrifice himself: the wider the scope of his study in time and space, the more must he cease tobe a provincial...He must rather love than be curious about the subject of his study." Coomaraswamy's work will be discussed below.

1

Introduction

The painting *Dante and Virgil in Hell* by Eugène Delacroix was exhibited in the French Salon of 1822. The painting attracted widespread and notorious attention. Some viewed it as a great advance in Western culture, whereas others viewed it as marking an ominous decline. The question of whether it marks an advance or a decline remains significant to the present. It is a question that centers on the issue of beauty.

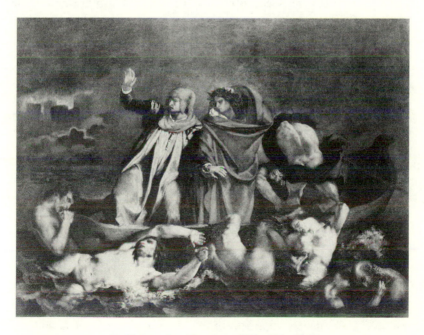

1. Delacroix, *Dante and Virgil in Hell*

The theme of the painting is literary, drawn from Dante's great fourteenth-century masterpiece *The Divine Comedy*. More than literary, it is indeed a metaphysical exposition. It is concerned with presenting an understanding of reality and life. The story begins a week before Easter in the year 1300. Dante is depicted lost in a forest, threatened by a wolf, a lion, and a leopard. The forest represents the tangle of worldly cares, and the animals represent respectively greed, pride, and lust. The ancient Roman poet Virgil appears as a servant of the Blessed Virgin (Divine Mercy), St. Lucy (Grace), and Beatrice. A contemporary of Dante, Beatrice died at the age of twenty-five; it was she whom Dante loved, and it was her untimely death that Dante mourned.

According to the story, Virgil, as the personification of philosophy, has been instructed to guide Dante through Hell and Purgatory in his ascent to the spiritual realm where now dwells Beatrice. It is Beatrice who brings him to the gates of paradise where, having been denied happiness in the world, he seeks unification with the Divine happiness that transcends the world.

The Divine Comedy is widely recognized as a superb literary presentation of the beliefs of traditional Western culture. The conclusion of the book is expressed in its last lines: the realization that it is Divine Love that makes the world go round. The world rightly has meaning; it is informed by both Truth and Love and therefore is beautiful. But the world is also affected by the reality of freedom. Freedom makes possible the pursuit of what is true and good and it is love that inspires us to do so. Therefore, freedom is realized by loving God. But it is misused freedom that results in the pursuit of foolishness —or worse. As Augustine (354-430 AD), a primary influence on Dante, had earlier explained: misused freedom is love misplaced, and when love is misplaced, terrible consequences result.

Dante's book presents an understanding of the world that is hierarchical and qualitative, and of life that is informed by responsible freedom. It is intellectually and culturally associated not only with the Augustinian tradition, but also with Scholasticism. It concludes that we must strive to rise above the folly of this imperfect world to obtain a glimpse of reality in all of its truth and goodness. We strive to obtain a glimpse of beauty; *becoming* seeks *being*. That striving occurs in this world as a matter of time and degree, but the goal remains transcendently constant and divine. It is a beatific vision that is pursued.

Delacroix's painting depicts Dante crossing the river Styx with Virgil, who initially guides him during his ascending journey from Hell to Purgatory, eventually reaching the realm of Truth and Love, of *being*. The boat in which stand Dante and Virgil is surrounded by the damned, by those who are condemned to suffer the consequences of their own misused freedom and misplaced passions. In terrible suffering they surround the boat in their agony.

What then did some of Delacroix's contemporaries find so disturbing about his painting? Those who agree with Dante's explanation of reality and life find

little comfort in Delacroix's work. Delacroix selected a traditional theme with a moral and spiritual content, but then includes discordant notes in it. To the viewer's right in the painting is Phlegyas, the boatman, attempting to steer the craft to the far shore. But to a person familiar with ancient art, his torso is a duplication of the famous sculptural fragment from the Hellenistic period, the *Belvedere Torso*. That torso is not recognizable as having any connection to Dante or Virgil or the pursuit of Truth and Love and Beauty. It was readily recognizable however as part of the collection of the Vatican Museum in Rome. The use of the *Belvedere Torso* in this painting is clearly out of context; it lurches us out of the realm of allegory and metaphysics, into one that is aesthetic and historicist. It is aesthetic in that it appeals merely to the emotions; it is historicist in that it offers no vital and enduring positive ideals.

The *Belvedere Torso* is recognized as an aesthetic object dating to a particular time and place. Its inclusion thereby changes this painting from a metaphysical and moral drama to an artificial aesthetic construct. No longer is the painting a window by which to obtain a glimpse of a timeless moral and spiritual realm. It is a constructed composition of artistic imagery that suits the whims and experiences of the artist, offering its viewers a temporal, nostalgic, aesthetic voyeurism.

To drive home this point, it is significant to note that Delacroix famously altered the painting by applying some dabs of pure color on the torso of one of the damned. The application of primary pigments to the work is significant. It indicates a shift from the idea that a painting or a literary work attempts to explain the purpose of reality and life. The application of primary colors on this canvas emphasizes that this object is just that—an object on which paint is applied. It is not metaphysical, it is physical, its meaning is not perennially valid, but at best temporal; it is not explanatory, it is factual and emotional. It is aesthetic.

Aesthetics emphasizes feelings, as does the nineteenth-century tradition Romanticism. Delacroix was a Romantic—and so too was Dante, of a sort. Instructive is how they differ in their understanding of love, and history. *The Divine Comedy* makes clear that truth and love actually do make the world go round. By that is meant that Love is ontological, and has an intellectual and qualitative as well as emotional content. It offers the belief that eternal Truth, Goodness, and Love can be pursued; as Augustine explained, just as a song is first learned then sung, love is first understood and then lived. In both art and life, purpose is recognized to exist and is then pursued; that pursuit is literally for the love of beauty. It is a pursuit (*becoming*) that cannot merely be temporal and emotional; it must involve ontological truth and love (*being*). It cannot merely be aesthetic and historicist; it involves a temporal manifestation of the eternal, a reconciling of the contingent with the purposeful. When the contingent is dedicated to the trivial or brutal, it is understood to be misplaced love. Indeed, misplaced love evidences our ability to misuse freedom. The result of

such misuse is to live out of sync with a beautiful reality; it is to exist in the realm of the damned.

What then of Delacroix? To the point, Delacroix's painting was condemned by some for its overt emotionalism. As a contemporary of Beethoven,[1] Delacroix contributed to and was influenced by the nineteenth-century artistic phenomenon known as Romanticism. He once declared that color is painting, and emotion rather than intellect is supreme. He departs from the company of Dante by asserting a diminution of intellect, where reason is subservient to or a mask for emotion. Reason is traditionally recognized as a means of attempting to understand reality (*being*) and life (*becoming*); for Dante reason combines with love when we seek contact with a purposeful cosmos. But when reason is reduced to a matter of aesthetics, then it is reduced to mere rationalization—or experience—where we boldly justify what we feel, desire, and will to be good.

This results in multiple problems for Dante, and for us. In declaring reason a mask for emotion or power, we deny Dante's belief that reason and love are real, forming a transcendent unity worth seeking. By reducing reason to emotion, truth becomes a matter of how we feel. We thereby eliminate the space between the subject who attempts to understand, and the object to be understood. When that space between subject and object is denied, then our freedom and ability to seek understanding of reality is denied. When reality cannot be understood, then conversation in the pursuit of meaning is replaced by assertions of opinion—and power.

When the space between subject and object is denied, the notion of culture, ethics, and fine art is also denied. But it makes no sense to say that within culture (and politics) there is no space in the public realm; when knowledge is denied, then the public square is filled by skepticism, irony, and violence. As later discussed in detail, an alleged subjective-objectivity is key to Modern and Postmodern culture. Objective reality is replaced by a subjective-objectivity, in which truth, or objective *being*, or a transcendent God, are progressively replaced by an alleged transcendent self. But it is a chronological (*kronos*) rather than qualitative (*kairos*) progression. It marks an empty passage of time, rather than one filled with meaning.[2] When reality and culture are held to be the temporary products (*kronos*) of competing alleged transcendent selves, competing demi-gods, then public culture is reduced to violence and conflict, and thus denied.[3]

For example, what does Delacroix's painting mean? Beyond the particular facts involved, the painting either means what we feel it means, or it means something as a distinct object of our consciousness. But if it means what we feel it means, if we construct its meaning, then we embrace a self-deification where truth is a matter of how we feel and rationalize. This eliminates the possibility of any degree of objective knowledge of reality since for such knowledge to be obtained, subject and object cannot be identical.[4] If we as-

sume that they are identical, then the object is that which we feel and construct it to be. We thereby abandon the attempt to comprehend Delacroix's painting; beyond its basic facts, its meaning is determined by us.

This results in a type of skepticism, but not one dedicated to humility and a denial of dogma. In contrast to the skepticism of the Socratic (and Confucian) tradition, which produces the humility necessary in the attempt to understand the world and life, we have here a skepticism that denies the value of humility—or of understanding reality. Rather, it presents the dogma that truth cannot be known, only made. We thereby abandon love, which (as explained by Plato) is the desire to embrace beauty—which is the splendor of wisdom. When meaning is reduced to feeling, then a nihilistic skepticism results; love and beauty are reduced to an aesthetic pursuit of the self. As Dante observes, this path leads to the realm of the damned.

Delacroix's approach to history was famously torn between Traditionalism and Modernism, between the pursuit of truth, goodness, and beauty and the aesthetic pursuit of facts and feelings. This conflict is evident in his painting *Dante and Virgil in Hell*. It is traditional in theme but its depiction is decisively Modernist in substance. Delacroix advances what can be termed *empirical scholasticism*: the mass accumulation of descriptive facts and subjective explanations.[5] By pursuing an aesthetic vision of reality and life Delacroix contributes to the ultimate rejection of both Dante's cultural vision and the traditional pursuit of beauty. Rejected as well is the assumption that the world and life are or can be purposeful. Instead is advocated a purposeless, aesthetic temporality where there is no space between subject and object which permits understanding, freedom, and love to occur. Instead, beyond the sphere of fact, the meaning of the painting (and of reality) is reduced to subjective coercive opinion. Knowledge of reality (*being*) is denied, and consequently, so too is responsible freedom (*becoming*). They are replaced by the will to power. Neither the fine arts nor the humanities therefore make much sense.

The central theme of this book on the history of art is that the rejection of beauty requires our embracing a subjective and therefore willful understanding of the universe and life. Either we (or Dante) really have a destination or we do not, and the Nietzschean conclusion of the aesthetic vision is the latter.[6] The aesthetic vision thus requires us to accept the premise that life is purposeless, but for the fact of mere existence. But when existence becomes purpose then culture is indistinguishable from the mundane, the trivial, and the violent.

To accept that studying the history of art is meaningful is to rise above an existentialist aesthetic mindset. It is to accept the possibility that life ultimately is meaningful and makes sense. But it is now often taken for granted that Delacroix's path is right: the pursuit of beauty and wisdom is no longer tenable. Such an assumption not only denies the importance of fine art and art history; it indicates a woeful provincialism by its presumption that the vast

majority of fine art around the world and through time is wrong. An accurate assessment of the history of art reveals that Dante's position is far more typical. Historically, fine art around the world and throughout time is consistently concerned not just with aesthetics, but primarily with beauty. Fine art is historically dedicated to the attempt to understand reality and life. But just as Delacroix critiques the content of *The Divine Comedy*, contemporary art and art history critiques most of the history of art by its rejection of the pursuit of beauty and wisdom. This is disturbing since in denying even the possibility of pursuing truth, goodness, and beauty, it typically denies both the intrinsic meaning of fine art objects, and it denies any significant reason for studying it. Indeed, an aesthetic world lacks objective meaning, and therefore limits belief to and in violence.[7] Beyond a utilitarian or pragmatic need to be co-conspirators to gain ultimately meaningless advantage, there is scant need for culture, scholarship, or beauty, in an aesthetic and violent world. And there is certainly no ground, or space, for responsible conversation.

Should we follow Delacroix or can we emulate Dante in his quest for Beauty? As critical as these questions are to the quality of our lives, they are nonetheless obscured by the prevalence today of aesthetics. From an aesthetic viewpoint, there is no way to judge whether Delacroix or Dante is closer to the truth —because we know *a priori* that truth is a matter of aesthetic taste, and meaning is a matter of opinion or identity. If art is viewed aesthetically, then it is commonly viewed sociologically.[8] If it is viewed only sociologically, then it cannot rise above the realm of willful assertion. Our willful assertions, or those of Delacroix or Dante, are then neither better nor worse.[9] They merely exist, and the questions of right or wrong, truthful or false, beautiful or ugly, make no sense.

As evidenced by Delacroix's painting, and by the cultural and political controversies that surround us today, the conflicts of our age typically pit traditionalism versus progressivism. Indeed, Delacroix's painting is incoherently traditionalist *and* progressive; but neither traditionalism nor progressivism is today commonly dedicated to the pursuit of beauty and wisdom. Neither the conservative traditionalist nor the liberal progressive admit the possibility of obtaining a glimpse of wisdom and beauty. Their common denominator is an aesthetic vision where both tradition and innovation emanate from experience. As such, each is but a distinct type of fetish.

The crux of the matter is the participation by much of the political and cultural Right, and the Left, in the Modernist and Postmodernist antagonism towards beauty as the splendor of wisdom. Both deny the possibility that the world and life have objective purpose which to some precious degree can be understood. As evidenced by Delacroix, even when beauty is approached via traditionalism, it is now often approached aesthetically and sociologically; therefore it cannot offer a true alternative to aesthetics.

So it is inadequate to approach the problem of the abandonment of beauty and purpose as one of Traditionalism versus Progressivism, Conservatism versus Liberalism. Nor is it a conflict between religion and science. Religion is not just the subjective counterpart or antagonist to empirical science; it is the systematic attempt to make sense of our lives, and to comprehend reality. It is not whether we are religious. It is the question: which religion do we embrace?

That is the deeper issue, and it centers on the antagonism between the aesthetic mind, and the mind which seeks beauty and understanding; it is between the mind seeking knowledge of reality, of *being*, and the mind that seeks power. It is as disturbing as it is commonplace that advocacy of the pursuit of truth, goodness, and beauty is today seldom heard of from the political and cultural Left - or Right. [10]

The lack of that advocacy entails much more than just words and fashion. It involves practical consequences that are for better or for worse. The history of art centers on the question of the relationship of aesthetics and beauty in our lives. It centers on our attempt to understand the world and life as they occur in time. As such, that question is central to our cultural, ethical, and religious beliefs.

When the history of art centers on the pursuit of beauty, it is rightly recognized as centering on the pursuit of belief, and therefore centers on intellectual history; the pursuit of beauty and belief center on our continuing attempt to understand the world and life. However, when the history of art centers on aesthetics, then neither art history nor intellectual history can make much sense. They cannot make sense because aesthetics cannot perceive purpose and is thus unintelligible; it can only perceive the realm of fact, feeling, and style. Or to put it differently, for those who assume meaning to be a matter of opinion, it makes no sense to seek more (than) opinions. The difficulty is that it is only via beauty and reason that this can be understood, but today aesthetics convinces us that the pursuit of beauty makes no sense.

To the aesthetic mind the knowledge necessary for beauty is not possible to obtain, and therefore neither its need, nor even an awareness of its absence, is common. Beauty is thus condemned to the realm of aesthetics, even by those who advocate the importance of culture.[11] But to advocate the importance of culture via an aesthetic vision is to deny what is necessary to culture, namely, the possibility of obtaining a glimpse of understanding of a meaningful world and life. And it denies our ability to purposefully discuss and debate that understanding without rancor. It is not that the aesthetic viewpoint should be rejected; rather it should be recognized as insufficient. Aesthetics alone simply fail to do enough. It commits us to a history, an art, and a life, informed not by meaning but by violence.

So why is it that for Delacroix and later Modernists the beatific vision of reality and life as articulated by Dante (and others) has become so suspect? To answer this question is to enter the realm of intellectual history, and thus to

enter that of the history of beauty. [12] It is to engage in an examination of the relationship of beauty and aesthetics spanning millennia. And it is to conclude in an advocacy of the idea that we can today pursue a qualitative continuum rising from the factual and aesthetic to the realm of wisdom and beauty. The choice is not between pursuing aesthetics, or beauty, in our scholarship, our activities, and our lives. We are limited neither to a dogmatic intellectual scholasticism nor a dogmatic empirical scholasticism. Nor are we limited to a choice between Traditionalism versus an allegedly progressive Modernism/ Postmodernism. [13] Rather it is a matter of attempting to rise from an aesthetic of violence, to the love and beauty that permits responsible freedom.

These points warrant clarification and elaboration. However, what should be clear is that the outcome affects more than just the study of the history of art. It affects how we understand reality (*being*) and it affects how we live our lives (*becoming*). It is imperative to reestablish then the possibility of responsible freedom and thus our ability to escape the false conflicts today assumed to exist between aesthetics and beauty, tolerance and belief, action and ideal, the temporal and the enduring. It is essential that we reestablish the lofty pursuit of beauty.

Notes

1. Aldous Huxley says that it was Beethoven "who first devised really effective musical methods for the direct expression of emotion…he made possible the weakest sentimentalities of Schumann, the baroque grandiosities of Wagner, the hysterics of Scriabin; he made possible the waltzes of all the Strausses.… And he made possible, at a still further remove, such masterpieces of popular art as 'You Made Me Love You.'" See: Robert S. Baker and James Sexton, *The Complete Essays of Aldous Huxley* (Chicago: Ivan Dee Publishers, 2002), Volume IV, 1936-38.
2. Andrew Benjamin and Peter Osborne, *Walter Benjamin's Philosophy. Destruction and Experience* (London: Routledge, 1994), 10: "It is the distinction between fulfillment *in* historical time and the fulfillment *of* historical time which marks the difference between Heidegger and Benjamin. Benjamin identifies Heidegger's understanding of historical time as tragic…"
3. Nietzsche argues in *The Birth of Tragedy* (1872), that culture is realized by the denial of purposeful knowledge. Apollo (reason) is judged but a mask for Dionysius (pleasure). In contrast, Dante recognizes the mystic realm where human intellect cannot comprehend Divine Truth, but in which case reason accepts the need for humility rather than asserting that reason is a tool of human will.
4. This idea is discussed in Thomas Molnar, *God and the Knowledge of Reality* (New Brunswick, NJ: Transaction Publishers, 1993), 74.
5. This term is coined and discussed in my article, "A Winter Landscape: Reflections on the Theory and Practice of Art History," *Art Bulletin*, LXVIII, no. 3 (September, 1986): 467-79.
6. As evidenced, for example, by Samuel Beckett's play, *Waiting for Godot*.
7. The assumption of a metaphysics of violence in Modernist-Postmodernist culture is explained in John Milbank, *Theology and Social Theory. Beyond Secular Reason* (Oxford: Blackwell Publishers, 1995), 278ff.

8. Sociology can be pursued in either an aesthetic fashion or as a pursuit of beauty.

9. The Modernist claim that genius grants special authority, and the Postmodernist claim that power grants either the powerful—or the weak—special recompense, will be discussed later. The conclusion offered is that Nietzsche's analysis in *Beyond Good and Evil* is accurate: claims of genius needlessly attempt to sanitize bald assertions of the will to power. But that analysis is also provincial by its assumption that Kantian Modernism is the necessary ground line for serious cultural scholarship.

10. As discussed below, both Burke and Kant are deeply aesthetic. For example, the influence of traditionalism is championed by Samuel P. Huntington (*The Clash of Civilizations* [1996]); the inevitability of modernism is advocated by Francis Fukuyama (*The End of History and the Last Man* (1992)). That both are today considered to be to some degree conservative (Stanley Kurtz, "The Future of History," *Policy Review*, no.113 [June-July 2002]: 44), would be incomprehensible to Dante—or Confucius. We will return to a discussion of their ideas in later chapters.

11. Arthur Pontynen, "Art, Science, and Postmodern Culture," *American Outlook* (November/December, 2000), 37: "The dilemma is that the Postmodernist habit of thinking trivializes the reasoning process by confusing thinking with feelings or power...Thus it blinds us to our own decline, and the nation becomes increasingly deaf to concepts such as beauty and justice." The Victorians spoke much of beauty, but understood it aesthetically. For example, John Ruskin considered beautiful the material object which gives pleasure without intellect.

12. Aesthetic oriented intellectual histories are common. But they are fundamentally incoherent since aesthetics denies the possibility that the world has discernible objective purpose. See for example, Harry Elmer Barnes, *An Intellectual and Cultural History of the Western World* (New York: Dover Publications, 1967). The differences between the various available intellectual and cultural histories center on the fundamental choice of whether such a history aims at beauty or aesthetics. However, those few that in effect advocate beauty often do so by assuming the authority of religious doctrine (See: Hugh Black, *Culture and Restraint* (New York: Fleming H. Revell Company, 1901), Frederick Heer, *An Intellectual History of Europe* (Cleveland, OH: The World Publishing Company, 1953)) a precondition that is paradoxically aesthetic since it is grounded in the will. As discussed below, the association of faith with the will blossoms in the Baroque and flourishes in Postmodernity. For arguments lauding this development see Wilfred Cantwell Smith, *Faith and Belief: the Difference between Them* (Oxford: One World, 1979).

13. It is problematic to consider Modernist/Postmodernist aestheticism progressive since as an active tradition it now has dominated the course of several centuries, and as a cultural viewpoint it shares a common worldview with those whom Plato combated in the fifth century BC. For a discussion of early manifestations of aesthetic relativism see: Frederick Artz, *The Mind of the Middle Ages* (Chicago: University of Chicago Press, 1980).

2

Art History and the Cultural Amnesia of Modernism and Postmodernism

In the midst of the multiple attractions and distractions of daily life, it is reasonable to wonder if a book on the history of art can warrant our attention. At first glance the history of art may not appear to be particularly vital to the needs and aspirations of most readers. Few aspire to a career in the fine arts; fewer yet aspire to becoming art historians. A vague notion that an appreciation of the arts is important might linger but without clarity or compelling justification. Despite these circumstances and obstacles, if done right, the study of art history is indeed both practical and inspirational. It can result in tangible good for those who choose to study it.

To state that art history is both practical and inspirational—if done right—is an invitation and a challenge. It offers that the study of art history can result in tangible good—if it is properly pursued. But the suggestion that art history should properly be pursued will elicit an indignant response by those who currently assume that it already is, or by those who assert that no objective standards can or ought to exist.

It is now worth noting that the discipline of art history currently alternates between two subjective standards; that is to say, it uniformly rejects the possibility of any objective standards. A subjective-objectivity now prevails, in which *the selection of certain objects as works of art is viewed as an aesthetic matter.* It relies upon assertions of taste, be they trivialized, or seen as a mark of genius or of identity. So the assumption that there are no objective standards does not deny that within the public realm some standards occur. What is problematic, however, is that if those public standards are subjective, then those standards are not really standards at all.

This denial of the possibility of objective standards necessitates standards that are subjective, but the idea of subjective standards makes little sense. So the suggestion that art history is both practical and inspirational if done right— is necessary for such a thing as art history to exist, and for that thing to be

practical and inspirational. But within the context of contemporary culture such a suggestion is offensive. It is offensive because it contradicts that standard which today is so normative as to be largely unquestioned.

That standard which today is so normative as to be largely unquestioned is aesthetic. It is a standard that centers on facts, feelings, and power, and it is a standard that concludes in *existentialism*. It maintains that we are free to make choices, but there are no rational criteria for those choices since we live in a purposeless world. A consequence of this assumption of a purposeless world is the tacit denial of all traditions that hold otherwise. The assumption that there is no objective truth that we can rationally pursue prevents us from considering the possibility that we can pursue a truth that might be found. But when objective truth cannot be pursued, much less even dimly perceived, then public choices necessarily become a matter of coercive power alone. Consequently, the traditional notion of responsible freedom, of hoping to freely do the right or better thing, is replaced by a subjective-objectivity where we simply try to do our thing, or that required by others. Neither life nor art history are seen as pursuing an ideal which permits true standards to exist.

That aesthetic paradigm is clearly and forcefully advocated by the primary and seminal advocate of Modernism, Immanuel Kant; it concludes (via Hegel and Marx) in the Postmodern[1] work of Friedrich Nietzsche and his many epigones, particularly Heidegger. The philosophical position of Kant is as influential as it is complex. His essential ideas are embraced by many even though few have read much less critiqued his writings. Kant's approach to understanding science, ethics, and art will be discussed repeatedly through out this text. Initially, Kant's position may be summarized by his twofold claim: there is the Categorical Imperative from which a rational yet willful morality stems, and the Hypothetical Imperative whereby we construct our own vision of reality and life. Correspondingly, Kant holds that morality ultimately stems from good will and tolerance, whereas science aims to offer individual facts that are to be put into constructed explanatory narratives. Consequently, *scientism* and *emotivism* are the Modernist paradigms of life and thought; culture and the humanities are thus trivialized.

Scientism presumes that only empirical scientific facts provide us with actual knowledge of reality and life. But since scientific facts are descriptive, then science can only perceive the universe descriptively. Consequently, the universe can only be understood aesthetically, as a matter of *what* rather than *why*. So it is not that scientism avoids metaphysics, that it avoids the question *Why?* Rather, scientism offers a metaphysical view of reality that is limited to the vision possible to physics. Metaphysics is thus reduced to aesthetics, and so too is knowledge. Since empirical science can only perceive a world without *why*, a world driven by random or willful chance, or by a presumed mechanical or biological necessity, it is methodologically blind to the pursuit of truth, wisdom, and beauty.

One consequence of this ideological view is that all attempts to use descriptive facts as part of an explanatory and purposeful narrative of reality and life are seen as mere constructions of the mind of an individual or group. So facts are objective (or at least are descriptions with a high degree of probability), but the meaning of reality and life is, or rather are, subjective. A subjective-objectivity thus prevails—even in science. The once common notion of science seeking objective facts is now given a twist: science seeks objective facts via an authoritative methodology, whereas culture centers on subjective, emotive experience. But since both citizen and scientist exist culturally, the pursuit of knowledge by natural science is subject to presumably different individual or cultural perspectives of reality and life.[2] So too with the recognition of fine art.

So whereas beauty assumes a variety of substantively different attempts to comprehend the world, the aesthetic notion is that all attempts to comprehend the world are a matter of fact and opinion. Within this subjective-objectivity there is no knowledge beyond meaningless fact, chance, or mechanical or biological necessity. This constitutes a shift from beauty to aesthetics, but it is important to recognize that this is also a significant step on the path towards folly—and tragedy. By reducing the pursuit of knowledge to the pursuit of individual facts and subjective experience, all attempts to comprehend the meaning of reality and life are condemned to be a matter of meaningless fact and meaningless subjective experience. And when knowledge is reduced to meaningless experience, or to a subjective-objectivity, then reality, life, and art are reduced to expressions of power and violence.

Power and violence have indeed been advocated by various Postmodernist factions who assume that in a meaningless world, self-realization and self-expression offer meaning and lead to an earthly paradise. But if culture is but a matter of power, then culture is reduced to a narcissistic violence, a realm where we are condemned to contend with competing appetites, all equally valid and therefore all equally unimportant. A realm where there can be no transcendent qualitative values, no ethics, and therefore no love, justice, or beauty. Culture serves then as a narcissistic mirror reflecting a subjective-objectivity; for those seeking beauty, that reflection provides a glimpse of the folly of purposeless desire—which by definition is incapable of obtaining contentment. The self-conscious gaze of the subjective-objective mind can only perceive an aesthetic self—and therefore becomes unconscious of reality. As Dante would observe, it thereby fails to escape the folly of competing desires because its aesthetic vision cannot obtain a glimpse of beauty.

As discussed in detail below, contrary to the position of Dante, Nietzsche argues for just such self-expression and self-realization as remedies to the malaise of meaninglessness. He declares that Apollo (reason) is Dionysius (pleasure) in disguise, that attempts to understand reality are but masks for power. But a different analysis is offered by Classical mythology: should

Apollo (reason) and Aphrodite (beauty) be denied, then the Giants (chaos) prevail—and both the cosmos and culture die. Both Dante and traditional Classicists clearly differ from the Postmodernist Classicism of Nietzsche. Either culture is based on wisdom or it is indistinct from arbitrary power. But if the latter is correct, then the necessary and anti-intellectual result is that our lives center on a meaningless pursuit of pleasure and power, while culture, fine art, and the humanities matter little—if at all.

In contrast to the tradition stemming from Kant and leading to Nietzsche (via Hegel, Kierkegaard, and Marx), a primary and clear justification for studying art history is that as self-conscious beings we have the duty and responsibility of freely attempting to understand the world and our role in the world. As self-conscious beings we cannot avoid making conscious choices, for better or for worse, and those choices profoundly affect our lives. That it is part of the human condition to freely attempt to accurately comprehend the world and live accordingly is central to a wide variety of cultural traditions, even, idiosyncratically, to Modernism and Postmodernism. What is peculiar is the Modernist and Postmodernist trivialization of this aspect of the human condition. For Kant and Nietzsche the attempt to obtain some degree of knowledge of a purposeful reality and life is reduced to a subjective-objectivity. We will see that this results in knowledge being aestheticized, and a purposeless self-expression, self-realization, and self-destruction, reigns.

Those dedicated to the pursuit of beauty maintain that we ought not to engage in the folly and hubris of attempting to make the objective world an extension of the self. Rather, we should freely seek knowledge of reality. Since we cannot help but draw upon our thoughts when faced with making decisions and choices, our understanding of the world affects the decisions we make in our daily lives. Such ethical decision-making is at the core of the notion of responsible freedom, and this practical pursuit of wisdom is central to most traditions around the world. Based upon their understanding of how the world works, Buddhists, Classicists, Confucians, and Christians (to name but a few), will respond differently to social and cultural issues. It should be obvious that those differences in behavior are influenced by differences in belief. Yet the notion that responsible freedom and belief are at the foundation of that which we call culture is now contested. Scientism and emotivism reduce culture to fact and feeling, in which an alleged Kantian tolerance vies with Postmodernist notions of authenticity. Their shared presumption is that knowledge of reality and life is really a matter of aesthetic taste, be it indifferent, or central to one's identity. But this is incoherent since tolerance and identity are incompatible, and both reject all traditions that believe in beauty.

Those who deny that conscious choices and responsible freedom are important variously maintain that what we do is determined by (1) nature or nurture, or (2) consists of unfettered acts of the will, or (3) that human rationality provides us with an ethic of tolerance in a world that cannot be understood,

or (4) that a hedonistic calculus is sufficient. All of these responses are essentially aesthetic, in that they minimize the notion of wisdom, of any degree of knowledge of what is true and good in reality. As such all deny the possibility of responsible freedom and beauty. They do so by reducing culture to random or willful chance, mechanical or biological necessity, or calculations of pleasure and power. Consequently they wreak havoc on the very existence of culture and assault the fundamental human characteristic of striving towards responsible freedom. As we shall see, they deny the possibility of beauty, love, and justice for a narcissistic emptiness.

This is particularly unfortunate since art history focuses on the study of fine art, and historically works of fine art are recognized by their attempt to present an understanding of the world and life. To deny this is not only to deny the clear historical evidence, but also to deny the very distinction of fine art as such. If fine art does not attempt to present an understanding of a purposeful reality and life, then it has no objective meaning or justification of consequence. The seemingly odd simultaneity of fact and feeling, of scientism and emotivism, leads to the conclusion of an oxymoronic *material-culture*—and power. If that Nietzschean conclusion[3] were universally accepted, then we would also be coerced by an oxymoronic *willful norm,* a *Dionysian wisdom*, which in its affect is culturally banal and violent in art, thought, and life.

So fine art is recognizable as such by its attempt to explain the nature of reality, and how we ought to act. Postmodernists find such definitions to be arbitrary results of power. The irony of that position is that it is by the attempt of fine art to explain the world that it is recognized as such, and can be distinguished from the trivial, mundane, and the violent. To (re)define it is to deconstruct fine art to entertainment, therapy, or propaganda. So the study of art history centers then on our attempt to understand the world via a contemplation of fine art, in the hope that we can escape from the violence of arbitrary meaning and power. The underlying principle is that how we understand reality affects how we treat our neighbors, and how we understand reality and how we treat our neighbors is manifested in fine art. There is a direct correlation between fine art and ethics. [4]

So seeking knowledge of reality and life inescapably involves seeking virtue, and we can either beautifully contribute to or aesthetically debase the importance of that search. [5] At stake is not just the premise that how we understand the world affects how we treat our neighbors; it has long been a foundational aspect of Western culture that such understanding aspires to knowledge of what is true and good in reality rather than merely opinion. It is this optimistic and normative principle that is now particularly contested—by the competing normative principle which incoherently denies that normative principles exist. The optimistic pursuit of truth and goodness is now contested by those

who pessimistically hold that in a purposeless world we are limited to an aesthetic pursuit of facts, feelings, and power.

To the aesthetic mind the notion that truth will set one free makes no sense. The vision offered by its subjective-objectivity leads to the conclusions that there is no truth, there is no possible knowledge of a meaningful reality, and there are no objective ethics. They hold that the pursuit of knowledge of a meaningful reality cannot free us from ignorance and injustice; in history and in daily life, it is just such assertions of knowledge that oppress. So to the aesthetic mind Keats's invitation to the pursuit of and truth beauty, as expressed in his *Ode on a Grecian Urn*, would better advise: beauty is power, power beauty, —that is all ye know on earth, and all ye need to know.

The underlying principle of this position is fascinating to consider. The notion is that a subjectification of truth results in freedom and fulfillment. It is a principle that makes no sense, since as Dante makes clear, such competing desires cannot publicly be resolved. As previously mentioned, the aesthetic vision results in a Kantian tolerance, or a Marxist or Nietzschean (or other) authenticity. But all conclude that morality is an expression of power, where goodness is recognized as self-expression and self-realization. The solipsistic assumption that a good will thus defined makes sense is highly questionable to many traditions that historically, and currently, seek beauty.

For example, those who assume that morality is the expression of the will posit that the will of the individual, or a group, will lead to bliss. But they will find no succor with Plato. As he noted long ago, willfulness results in brutality precisely because it lacks principle. The assumption that power can work for the good if tempered by the assumedly benevolent will of humanity, is deeply problematical. A culture based upon the benevolent will is unable to objectively discern qualitative distinctions. It thereby remains blind to goodness yet committed to action. It is blind to the possibility of its own banality, malevolence, and decay, but acts in the assumption of its own self-righteousness.

In contrast to the vision of the aesthetic mind, the pursuit of truth and goodness via beauty aims to escape the imposition of arbitrary assertions or dogmatic restrictions. It means that as conscious beings we enjoy an individual right to freely pursue what is true and good in reality, and a social responsibility to rise above mere willful assertion. The self-conscious subject seeks knowledge of objective reality because to resist reality is to commit folly and eventually experience tragedy. To put it in traditional terms, we face the privilege and necessity of seeking the truth because the truth will set us free. It will free us from our own ignorance, and the ignorance or willful coercion others might wish to impose upon us.

For example, in legal circles the beautiful idea of Justice (as discussed, for example, by Plato) largely has been replaced by the aesthetic notion of legality. Justice makes truth claims on our conscience whereas legality simply

demands compliance. But the aestheticized truth—claim of legality is that of coercive power and obedience; it centers on a subjective-objectivity in the realm of law. Since an aestheticized vision of law, comprised of legal facts and authoritative power offers no objective ideals to freely aspire to, legality results in a denial of the possibility of responsible freedom. Lacking principle, we can no longer act according to notions of Justice and conscience, but rather are condemned to follow the dictates of our appetites or those appetites foisted upon us by the power of others. Even if one mistakenly accepts that a subjective-objectivity can offer a reasonable way of living within a mysterious universe,[6] it can provide no objective moral principles by which to live, and offers no way of knowing what a good life is. To reduce the pursuit of truth (or justice) to fact and feeling, is to aestheticize scholarship and art (and law), which is to deny the possibility of seeking a glimpse of objective meaning.[7] The subject seeking knowledge of reality, beauty, and justice is transformed by a subjective-objectivity where the world becomes a matter of fact, of meaningless opinion—and power. Those in positions of power enjoy their game, whereas those out of power do not. It is a brutal and dismal charade.

So aesthetics claims to be tolerant and liberating, and yet is intolerant of belief and freedom—except for a required belief in relativism. But to deny the propriety of seeking a glimpse of meaning is to demand that we obediently embrace meaninglessness—in life and in art. It is to deny that as conscious beings we have both a right and a duty to freely attempt to comprehend the world, and that the rational choices we make can be for better or for worse.

This aestheticization of culture and scholarship commonly substitutes the pursuit of truth and goodness with *scientism* and *emotivism,* and fine art with *material-culture.* As introduced earlier, scientism reduces truth to descriptive fact and emotivism reduces goodness to subjective preference. The result is that facts are objective, but how we choose to put those facts together into an explanatory narrative of reality and life is deemed subjective. This reduction of reality and life to a matter of fact and feeling corrosively aestheticizes scholarship and culture, and they deny the core value of Western tradition: the pursuit of responsible freedom. The pursuit of knowledge of reality, of objective truth and goodness, is reduced to the level of aesthetics, to a matter of meaningless fact and subjective feeling. In such a world neither ethics nor culture can make much sense.

But is the notion of responsible freedom, a core value of the Western tradition, merely habitual to that tradition, or is it objectively valid and universal? Is it a mask for power or is it true in reality? To believe in the objectivity of responsible freedom as a core cultural value one can be neither a determinist nor a nihilist. There are various advocates of determinism, some religious, others secular; there are certainly those relativists and others who would reject entirely the possibility of universal insight concerning reality and life.

It is curious that to declare that human life is *determined* by a historical dialectic, or by nature and nurture—is viewed as liberating; it is curious that the provincial declaration that the world has no meaning is viewed as both liberating and tolerant. It is curious to encounter the view that all narratives (or meta-narratives) are masks for power—except aesthetic narratives. But for the fine arts and the humanities to make sense, not only must reality and life make sense, but to some precious degree we must be able to attempt to comprehend reality as well. Otherwise, we are left with purposeless fiction—an existential void, a mystery in which power is the only certainty.

The attempt to comprehend reality and life is identical to the pursuit of beauty. So to pursue beauty some degree of success is necessary in escaping a willful or deterministic aestheticism. As discussed further in the concluding chapter, Augustine, Descartes, and Nietzsche make the point that none can doubt their own existence. None can doubt that they think and live. To this extent they are all existential. Given that we think and live, that we are conscious and even self-conscious beings, then it is impossible for humans to avoid the freedom and necessity of making conscious choices. To be denied that ability is to be deprived of our freedom to do so; to assume our inability to do so is folly. The foundational principle that we as conscious beings have a right and a duty to make conscious choices takes for granted that to do so is intrinsic to being human. Since we are conscious rather than merely sentient beings, we enjoy then both the necessity and the freedom to attempt to come to terms with the world and life.

But that which is permitted can still be trivialized, ignored, or brutalized. To reduce human action to nature or nurture is to trivialize the importance of conscious choice. If, as does Nietzsche, we limit our conscious choices to mere willful experience, then the world and life cannot be objectively purposeful. They are, then, brutalized. The freedom to make choices in a meaningless world is by current definition *existentialist*. But in so doing, we deny that freedom matters or that conscious choice can be qualitatively distinct; we trivialize conscious choice. The pursuit of the good life is then reduced to the pursuit of mere lifestyle; the question of which lifestyle is better becomes irrelevant—or a matter of brutal preference. This marks not so much an abandonment of a conscious pursuit of truth as its being brutalized. It is brutalized by the influence of aesthetics.

The term *existentialism* now conveys the meaning that the world is meaningless. But it is a term whose meaning has changed in time. The Buddhist (in a unique way) and Daoist, the Classicist and Christian all acknowledge the importance of existence, of *Being*. But they perceive it differently than do Kant, Nietzsche and their epigones such as Heidegger and Sartre. For example, as a matter of human experience, Augustine holds that the context of human consciousness is found in life. This is philosophically articulated in Augustine's foundational principle: *si fallor sum*, which establishes that none can doubt

that we think and live—and err. The search for truth is then associated with freedom to pursue the good within the context of human experience. But it is not simply our feelings and conscious desires that warrant action. Nor can it be difference or indifference. Key is the reconciliation of freedom of individual conscience in the context of a meaningful world. To put it differently, when the self-conscious subject attempting to understand the objective world is replaced by a subjective-objectivity where the world is an aesthetic construct or experience, then the object of our consciousness becomes identical to or the product of our consciousness. The consequence of a subjective-objectivity is that reality and culture are but the expression of our will to power. What Kant cautiously introduces, Heidegger and Sartre trumpet: the goal of identity is to be God.

All cultural traditions accept foundational principles upon which their house of life is built. The assumed first principle of contemporary existentialism is that the meaning of existence is unknowable or nonexistent. In contrast, the first principle of most other traditions is that the universe is meaningful. This position historically finds succor in the notion of beauty: that the universe evidences neither mechanical necessity nor chance, but rather, purpose. And since that context permits us to contemplate the good, the goal of consciousness is to resolutely pursue, and to the best of our ability choose the good and decline the bad.

So both the aesthetically minded and those who seek beauty make choices. The seekers of beauty aspire to wisdom and even the Divine. The seekers of beauty admit that choices might be for better or worse, and consciously aspire to the former. It is this concern for making good choices that informs a responsible humility. In contrast, the aesthetically minded define reality and life by their existence. This results in irony: the aesthetically minded deny beauty as an appeal to divinity, but assume the role of that which they purportedly deny.

Since how we understand reality affects how we treat each other, and both are made manifest in fine art, the influence of fine art can result in great good, whereas that mistaken for fine art can do great harm. Art history can advocate great wisdom or err in promoting sheer foolishness or viciousness. The challenge in both scholarship and life is in distinguishing between the two. The pursuit of the good begins with the personal and manifests itself within a social context. But if limited to that aesthetic context, then good is denied. For good to be socially defined is to make it sociologically determined, and to do so is to reduce it to mere willful assertion. To equate goodness with willful assertion is to confuse truth with power. To do so is to diminish the importance of knowledge and conscious choice by reducing it to an aesthetic triviality.

The term *aesthetics*, coined at the very beginning of the Modernist era, literally refers to that which is sensually experienced, namely, facts and feelings. It is sentient rather than cognitive—although this can be obfuscated when we confuse feeling and rationalization for thinking. That confusion is

inevitable for those who pursue physical facts and subjective emotions, and who construct meaning; both center on that which we can feel. The pursuit of facts, feelings, and rationalistic style has today largely superceded the pursuit of truth and goodness, of that which we understand and value. When facts and feelings replace truth and goodness, aesthetics replace beauty. When that happens, terrible consequences result.

Our understanding of reality and life constitutes a type of knowledge very different from that provided by facts alone. Whereas the pursuit of facts centers on obtaining accurate descriptions of particular things or events, truth attempts to make sense of the whole. Truth differs from facts in that truth attempts to comprehend how particular things and events properly combine in a meaningful way. The question of how those facts are to be combined is the crux of the matter. Are they aesthetically constructed and experienced, or do they refer to an objective meaning; are they aesthetic or do they evidence a purposeful beauty? Do we construct reality, life and art, or do we discover a meaningful cosmos?

The non-authoritarian rationale for studying the history of art is historically grounded in the latter. It does so by centering on the study of objects or events that attempt to offer meaningful explanations of reality and life. Those explanations often differ both in kind and in degree. For example, Buddhism, Augustinianism, and Modernism view the world differently; their art differs accordingly. Each tradition has its fundamental principles about the nature of reality and life. Each differs in its perception of the degree of meaningfulness present in the world. To the Buddhist and Augustinian, Modernism is metaphysically shallow and violent; to the Modernist, the Buddhist and Augustinian are engaged in metaphysical nonsense.

To the point, those traditions devoted to the pursuit of truth and beauty view aesthetics as essentially trivial, whereas aesthetic traditions view the pursuit of truth and beauty with a relentless hostility. Both beauty and aesthetics exist for the Buddhist and Augustinian, but for Modernists there is only aesthetics—even when they gaze upon traditions that believe in beauty.

Therein lies the problem. The notion that fine art is dedicated to the pursuit of truth and beauty is suspect to the Modernist-Postmodernist. It is suspect because the pursuit of truth and beauty has been largely reduced to the Modernist pursuit of aesthetic taste. When aesthetics replaces beauty, sentience supercedes cognition. It is then assumed that truth is best obtained via the seeking of scientific facts, and that beyond the realm of fact is merely that of feelings. For example, we can study Buddhism and Augustinianism (and their art) as systems of facts and never address and evaluate their truth-claims; we can gaze upon them aesthetically but never attempt to comprehend or dispute their beauty and their claims of how the world and life work. This reduces truth to mere fact, culture to sociology, and fine art to aesthetic opinion—even when the subjects studied state otherwise. But worse yet, philosophy, theol-

ogy and the humanities are thus essentially trivialized, and we are denied the attempt to find objective purpose in the world and life. We are denied the possibility of beauty.

This presents particular problems for the history of art. First, the intrinsic purpose of fine art is specifically to convey an objective vision of the world and life; lacking that purpose, fine art and scholarship lack definition, justification or purpose. Historically fine art is dedicated to that task by its pursuit of beauty. Second, there can be no point to the history of art in a purposeless world, and by definition a world that is aesthetic is just that. Finally, aesthetics reduces the very notion of fine art to a matter of entertainment, therapy, or propaganda. Each focuses on feelings rather than understanding, power rather than truth. Since aesthetics dwells in the realm of feeling, power, and ultimately, the will, then lacking coercion, it can have no compelling affect upon our conscience. To pursue an aesthetic vision of reality and life is to deny the need to attempt to even partially understand the world, or to engage in a meaningful conversation about what meaning might exist. Denied such understanding we are denied the possibility of responsible freedom. To accept an aesthetic vision of reality and life is to be condemned to a willful nihilism or totalitarianism, where feelings are either random or made uniform by force.

Art History and the Pursuit of Aesthetics

The study of art history is today unevenly divided into two distinct approaches. Those approaches are respectively dedicated to the pursuit of aesthetics, and the pursuit of beauty. It is the pursuit of aesthetics that is now nearly exclusively commonplace. Aesthetics center on facts and feelings rather than the pursuit of truth, or rather, truth claims are reduced to the realm of a subjective-objectivity. Accordingly, there are works of art, there are facts concerning those works of art, and we experience and construct an emotional response to both. This aesthetic approach to art history centers then on the accumulation of historical facts, and on our emotional response to those facts and to art objects. How we emotionally respond to those facts and objects is judged to be a matter of personal or group perspective. It is seen as a matter of aesthetic taste.

This approach is so commonplace that it now appears to be objective and normative. But it is not by any means a neutral or objective approach. Rather, it is informed by an intellectual and cultural relativism—be it Modernist or Postmodernist. It takes for granted that the meaning of art, and indeed, the meaning of life, centers on the accumulation of facts and an emotional or experiential response to those facts. We select certain facts that interest us, and we respond to the facts of experience as we see fit. In so doing we construct our own understandings of art and life.[8] The dilemma is that in assuming that we construct our own understandings, truth is constructed or made manifest by us. Therefore neither fine art nor the history of art can be particularly interesting

or useful. If we construct our own understanding of reality and life, then objects that purport to inform us of such understanding are trivial, or obnoxious,[9] or both.

To the point, Western culture is historically informed by two primary traditions: Classical and Judeo-Christian. Neither of these traditions is limited to aesthetics. They share a commitment to the pursuit of beauty. But often these two traditions are now aesthetically studied or applied to practical use. Their meaning has been reduced and trivialized to a matter of fact, feeling, and style. It is the aestheticizing of those traditions that constitutes a cultural tragedy in the West, and one that similarly affected or threatens other beauty seeking traditions around the world. It is a tragedy that is masked by a cultural amnesia produced by aesthetics, where all cultural traditions are presumed *a priori* to be subjective social constructs or the expression of subjective experience. By presuming that all claims of beauty are actually aesthetic, all claims of beauty are trivialized in our minds and our lives. We no longer seek beauty because of the prejudicial illusion that beauty cannot really exist. [10]

The assumed constructive or experiential nature of truth is central to the aesthetic worldview of Modernism and Postmodernism. Both take for granted the construction of truth, but do so in different ways. Briefly, the Modernist view assumes that a prime necessity in constructing a worldview or lifestyle is that it be coherent; it posits an aesthetic of tolerance where race, gender, and economic class do not matter. In contrast, the Postmodernist assumes that a worldview must reflect our authentic experiences as individuals, or as members of empirical groups where race, gender, and economic class are centrally important; as such it posits an aesthetic of identity. But an aesthetic of tolerance conflicts with an aesthetics of identity; in either case truth is reduced to aesthetics, to the realm of facts and feelings, of power.

From this point of view the partisan purpose and result of studying art history is to embrace and advocate a relativistic worldview. Some might emphasize establishing the individual facts involved with works of art; others might emphasize our aesthetic and emotional responses. Still others might emphasize using those facts to construct explanatory narratives that suit their fancy or experiences. But the result remains the same: we construct an understanding of facts and art just as we construct our lifestyles and our ethics.

Consequently, we are to study the great works of art of the past to become aware of how those works of art expressed the feelings and experiences of those who made them, or to become aware of those who were excluded from such expressions. We are to experience an emotional response to looking at those works of art, and we are asked to recognize that the makers of those works of art might have felt differently about the world than do we. That recognition requires an incoherent response: the need to embrace either an aesthetic of tolerance and/or an aesthetic of identity. Tolerance and identity are the two sides of the relativist coin, and yet, cannot meaningfully be one.[11]

This important point warrants further discussion. The aesthetic approach is relativistic in that the issue of objective truth is either ignored or reduced to a matter of subjective experience. As an article of faith it takes for granted that beyond singular facts, attempts to understand reality and life are essentially subjective and result in a variety of perspectives. Instead of visiting an art museum to experience objects that embody an explanation of reality and life, the aesthetically minded visit a museum and study works of fine art to engage in the experiencing of what Neo-Kantians call "meaningful fictions," and what Postmodernists would call "expressions of authenticity." Consequently degrees of objective and universal insight about reality and life cannot and should not be sought. The public pursuit of truth, of some degree of knowledge of reality and life, is viewed as obnoxious and even intolerant. It is seen as obnoxious in that it presumes to offer knowledge rather than facts or opinion; it is condemned as intolerant in that it presumes to privilege one perspective over others.

This is disingenuous since relativism privileges its own perspective over others all of the time. The alleged multiculturalism associated with relativism is not multicultural at all. In reducing truth to opinion and power, and transforming the subject seeking knowledge of objective reality, to a subjective-objectivity where truth is constructed, it is dogmatically and uniformly relativistic.[12] This and other contradictions indicate that there is a tragic incoherence to aesthetic relativism; the consequences which result establish that relativism corrodes not only the very notion of civilization, but of freedom and beauty as well. Aesthetic relativism purports to advocate tolerance, but uniformly reduces culture to the level of violence, and the history of art to willful banality.

This is evident in other contradictions intrinsic to aesthetic relativism. Those contradictions reflect the different ways in which the notion of aesthetic taste can be viewed. As the phrase *gustibus non disputandum* makes clear, there is no disputing taste. Matters of taste are subjective and defy objective analysis; taste can be cited as an appeal for tolerance, but it can also be cited as justification that our tastes must prevail. These two approaches to aesthetic taste inform the two major facets of aesthetic relativism: Modernism and Postmodernism.

Modernist relativism advocates coherence and a purported tolerance, that there is a wide variety of differences in how we understand the world and life, and such aesthetic differences should be broadly accommodated. But the benign appearance of that accommodation is deceiving. Its reduction of belief to personal taste is not really tolerant; it trivializes meaning. Upon visiting a museum one is not likely to learn much if the meaning of the fine art in it is considered to be a matter of personal or cultural opinion.

Postmodernism attempts to escape this trivialization of culture (and life); it does so by advocating the importance of subjective taste. That is, whereas the

Modernist is seen as trivializing culture by reducing it to a matter of arbitrary lifestyle, in the name of authenticity the Postmodernist claims that lifestyles are essential to the identity and experience of particular individuals or groups of people and is therefore sacrosanct. For example, as a matter of aesthetic taste, to the Modernist race is irrelevant. But to some Postmodernists it is essential to one's identity. In this self-contradictory aesthetic context, ignoring or focusing on race is both offensive and essential. But this antinomy is left unresolved because as relativists neither has a way to escape their aesthetic conundrum: namely, that taste is simultaneously trivial and essential. Similarly, to give but one other example, the relativistic democracies of Liberal Modernism have long resisted—yet tolerated—the identity-based relativism of Postmodernist Marxism. Such cultural incoherence cannot long endure.

Those conflicts are not a private matter. Rather, it is in the public realm that such problems become manifest. The aesthetic relativism of Modernism permits individuals and groups to believe and value what they wish as long as those beliefs and values are privately celebrated. But if those beliefs and values are denied a public role, then they are limited to being mere personal preferences. Consequently, cultural expressions of positive ideals are denied public importance, even though the public realm is inescapably a major part of our lives. Lacking a positive vision, public culture is thus reduced to the level of entertainment or therapy. [13]

In contrast, the Postmodernist insists upon the public application of specific aesthetic tastes. The Marxist, the gender feminist, the religious fundamentalist, all demand a place in the public square as essential to their authenticity. Each recognizes what the Modernist has forgotten: that in the public realm the cultural, the political, and the legal necessarily interact. But by reducing truth to the public expression of subjective authenticity, the Postmodernist politicizes both culture and law. By denying the possibility of truth, of principle, public ideals are reduced to the realm of willful preference. Whether tolerant or authentic, aesthetics is grounded in facts and feelings, whereas beauty requires understanding. Where the need for understanding is denied, there is no need for discussion or persuasion. The demagogue and propagandist replace responsible citizenship and scholarship. Public art, ethics, and law depend then only upon the will to power. This aestheticization of politics is totalitarian, be it of the Left or the Right.

The history of art is thus trivialized by Modernism, reduced to propaganda and conflict by Postmodernism, and is made incoherent by the concurrent claims of both. Each focuses on a different way of approaching taste, thereby sharing an emphasis on feelings rather than truth, on emotions rather than understanding, on power and contractual arrangements rather than responsible freedom.

So the ostensible purpose of an aesthetic and relativistic study of art history is to become both tolerant and authentic. The difficulty is that tolerance is at

odds with authenticity. Forms of authenticity clash with each other, and the very notion of authenticity cannot be pursued publicly in a tolerant fashion. For example, a Modernist relativist who believes in the necessity of tolerantly entertaining a variety of beliefs cannot publicly be reconciled with a Postmodernist relativist who declares, for example, that the history of humanity is clearly and singularly a matter of class conflict. In either case, tolerance and authenticity are at odds in the museum and in life, leaving the Modernists hapless by their wish to tolerate even the taste of those who insist upon their own.[14]

There are yet other contradictions within aesthetic relativism. One example is found in the relativistic denial of objective truth (that is, of truth not being determined by the perspectives and experiences of people). That denial incoherently requires a public acceptance of the singular and enduring truth of relativity. In this case, one cannot meaningfully study Buddhist or Christian or Daoist art from the past since that art is necessarily limited to the sociological opinions of a distant time or place. As seen in Delacroix's painting, history as the pursuit of enduring wisdom and beauty is replaced by historicism: the temporalization of meaning. Art history thus privileges the notion of *kronos* over *kairos*, and becomes the history of *fashion*. Moreover, those allegedly sociological possibilities only matter to those who emotionally cling to those traditions. The possibility of evaluating the truth claims of any tradition is therefore beside the point; it is what people aesthetically prefer at the moment that matters, not whether what they prefer makes sense in the context of reality and life.

Consequently, aesthetic relativism's posture as the defender of tolerance is really an imposture. Relativism is intolerant of any public expression of belief other than of relativism. A result of this is that the public expression of substantive and positive ideals beyond a willful authenticity is viewed as both impossible and abhorrent. So the millennially great art of Buddhist or Christian or Classical traditions (to name but three) allegedly can have no intrinsic and vital meaning to the viewer's public life today.

Relativism purports to advocate pluralism but singularly mandates that the world cannot have an understandably objective purpose. In the name of pluralism it publicly demands that we accept the singular premise that the world and life are purposeless beyond a solipsistic self-expression and self-realization. Consequently its alleged pluralism is intolerant of all traditions that hold reality to be informed with meaning and purpose. As Nietzsche rightly noted: It requires the public assumption that there is no objective answer to the question: Why? By its assumption of a purposeless world, relativism results in a culture of social manipulation and calculations of power, be they ostensibly benign or blatantly malevolent.

It is a sad irony that the Modernist denial of objective truth was intended to secure for us freedom of conscience from the alleged restraints of dogmatism

and transcendental religion. But by replacing the idea of a self-conscious subject seeking knowledge of an objective reality, with a subjective-objectivity where reality conforms to the subject, the result is a dogmatic metaphysics of purposelessness and a dangerous self-deification.[15] It is dangerous in that a society of petty gods, a constellation of *Übermensch* (to use Nietzsche's terminology) is a society of conflict where no human rights exist. In this view, we visit museums assuming that the artist is a special sort of person who is literally *creative,* just as we assume the right and privilege of creating our own purpose in life. But the difficulty is that in most traditions around the world, the notion of an artist, or politician, as a demigod who creates reality and life is rightly viewed with horror.

Indeed, the relativistic notion that reality conforms to how we think, or rather, feel[16] appears benign but masks an immanentism that is sociopathic in its egoism. If we make the world in our image, then how can we publicly resolve differences concerning how we feel about reality and life? We could incoherently affirm all such worldviews, nihilistically deny them all, or insist upon our own. It is therefore within our will to trivialize, destroy, or impose preferences. But it is not within our ability to love, since love requires more than a solipsistic subject. In contrast to violence, love is fulfilled by embracing an object rather than making it conform to our will. A subjective-objectivity is a world without love, justice, or beauty.

Aesthetics as Existentialism

To the point, if the world has no purpose, then only we can provide what meaning might exist. This ethic of current *existentialism*, where we construct meaning via our acts of will, is then the required worldview—or religion—of aesthetic relativism.[17] But in being the source of such purpose, a self-deification is manifested to varying degrees by a blatant display of the will to power, be it obvious or masked by pragmatic or utilitarian calculation. Existentialism requires that we embrace a self-deification (as freely advocated by Sartre) but that embrace is solipsistic and therefore empty, and even deranged. It marks an expansiveness of ego that is associated with sociopathic violence and self-hatred.[18]

So an aesthetic relativism poorly serves the person who in the pursuit of genuine happiness attempts to learn what it means to be civilized and cultured. Relativism ultimately denies the possibility of publicly expressing belief in a purposeful world and life. It requires that public art be tolerant and authentic, empty yet willful, vacillating between an enervating nihilism and an absolutist immanentism. This stands in marked contrast to the vast majority of the history of art, which is comprised of objects that are dedicated to the exposition of what is cautiously discerned to be objectively true, good, and beautiful. Those works of fine art often differ in what they understand to be true, good, and beautiful, but they are united by the pursuit of objective mean-

ing. To view the history of art relativistically is to deny the intrinsic meaning of all works of fine art—since foundationally even aesthetic relativism presents a type of understanding of reality and life. However, the universality of cultural relativism cannot be absolute without a nihilistic self-contradiction.

Whether we consider individual artists such as Rembrandt, or Jackson Pollock, or Fan Kuan, or the artistic traditions of Classicism or Buddhism, Christianity or Confucianism, in each case the works of art produced were not or are not merely aesthetic. Works of fine art historically and perennially attempt to provide genuine insight concerning the world and life. Therein lay their value and the value of studying them.

To view such works of art aesthetically and relativistically—that is, as only representing particular subjective perspectives of reality and life which occurred at particular moments in time—is to reduce the study of the past—even the immediate past—to a mere nostalgic and voyeuristic dabbling. To view them as empty or as masks for power is to deny their ability to positively contribute to our lives. If none of the historically produced works of art can to some precious degree be true, then the prime purposes of studying them is to voyeuristically gaze upon someone else's self-expression or to expose the oppression of those prevented from so doing. In an aesthetic culture, self-expression and self-realization justify art and art justifies self-expression and self-realization. The result is a mundane and violent circularity.

Nonetheless, for many aesthetic relativism is today culturally normative. The aesthetic and relativistic justification for the study of art history assumes that there is no possibility of obtaining a glimpse of truth. If there is no truth, then (for the Kantian Modernist) tolerance and sensitivity are keys to civilization. But neither tolerance nor sensitivity work very well if we lack goodness. Underlying the pervasive intellectual and cultural influence of aesthetic relativism is the premise that we naturally are, or ought to do, good. But relativism mandates that there is no publicly objective ideal, no transcendental[19] right or wrong. Lacking such a context, then goodness is elusive. It is then impossible to determine if particular acts done in the name of tolerance and sensitivity are morally benevolent or malevolent. To the aesthetically minded, killing Jews, Kulaks, or the handicapped can be either; it's but a matter of taste. To simply assume that an act of tolerance and sensitivity must by definition be benevolent tells us nothing. How then do we obtain a substantive understanding of morality? Aesthetic relativism tells us that we do so aesthetically, by a Kantian association of morality with an assumedly benevolent will of humanity, or by a Nietzschean denial of the very legitimacy of such notions as good and evil.

But this is subject yet again to the charge of being circular: the moral is willful (Kant) and the willful is moral (Nietzsche). If sensitivity provides the key to recognizing morality, tolerance, and the very notion of civilization, then the proponents of aesthetic relativism must escape that circularity. Some attempt to do so by assuming that a benevolent sensitivity is manifested by

the will, and that will is either associated with rational principle, or with the will of the majority, or with the will of the exceptional individual.

These are indeed the positions articulated by Kant, Rousseau, Hegel, and Nietzsche. Immanuel Kant pointed out that goodness can only and must only be found in the human will.[20] He associates that will with duty and duty with the need to follow a purely rational principle: the Categorical Imperative. The Ideal is no longer grounded in God or a purposeful Nature, but rather in human rationality. However, as discussed above, for that human rationality to be deemed normative and compelling, it must assume a brutal self-deification. Rousseau similarly concurs that goodness is found in the human will, but holds that goodness is evidenced neither by association with rational principle nor by the expression of the individual, but rather is seen in the common will of the people. In this instance there is an odd confluence of ideas between the political Left and Right; as expressed by Burke, common tradition is distilled wisdom stemming from experience. Hegel differs from Kant and Rousseau in assuming that truth and the will are one as manifested in the very unfolding of history. However, Hegel's (and Marx's) confusing of truth with power—particularly with the power of the State—requires a troubling advancement of totalitarianism. Finally, Nietzsche's denial of the categories of good and evil requires an existentialism where, as he notes in his closing comment in his book, *The Genealogy of Morals: An Attack* (1887): man would sooner have the void for his purpose than be void of purpose. He marks a distinction, however, which lacks any qualitative difference.

In each case there is a shift to an aesthetic and relativistic position, and a shift of morality from objective Truth to subjective experience. The transcendent purpose, or Ideal, or God is subjectified as the mind and will of Humanity —be it principled or not. This shift necessitates a belief in the natural or willful goodness of humanity since morality is seen as relying upon human will rather than the qualities of objective reality. Indeed aesthetic relativism assumes that reality and the human will are inextricably linked via a subjective-objectivity where the world is a product of our will. As such it marks a vanity without limits, shame, or hope.

The Good Will, Tolerance, and Authenticity

Two principles that inform the aesthetic mind is that human nature is neutral or good, and that reality conforms to our thoughts or experiences. Belief in the natural or willful goodness of humanity[21] is flattering, but it is an assumption that is intellectually suspect and one which is rejected by many cultures around the world. It is not so much that those cultures embrace a negative vision of life. Rather they advocate humility as an antidote to dangerous pride, and knowledge of reality as the attempt to escape a willful and publicly coercive subjectivism. In varying ways they agree that it is truth that sets us free. They commonly view the utopian premise that we are or can be made

good, as delusional, narcissistic, and coercive. They reject the aesthetics of relativism for the pursuit (under many names) of truth, goodness, and beauty.

The assertion that tolerance requires Buddhists and Augustinians (to name just two) to abandon that pursuit is recognized as absurd. To require them, in the name of tolerance, to abandon their belief that egoism is wrong, for a public adoption of egotistical Existentialism, makes no sense.

Art History and the Pursuit of Beauty

The currently neglected alternative to this aesthetic relativism is a history of art dedicated to the pursuit of beauty. That pursuit takes as foundational three principles: (1) that the universe makes sense and is purposeful (2) that truth is ineffable, but (3) some glimpses of qualitative insight are possible. It is then a confident yet humble pursuit of beauty that prompts a desire to know— to some precious degree —that which is true and good. There is confidence that beauty exists, that is, that the world is ultimately purposeful; there is humility in the recognition that such purpose higher than us exists; there is confidence yet again that the pursuit of some qualitative insight is practical. As Socrates maintains, skepticism need not lead to nihilism. And as Plato puts it, there is a continuum rising from ignorance, to informed opinion, to truth. To reach for the Ideal is to escape the trivial, mundane, and violent.

So in place of the arrogant subjective-objectivity of the Modernist-Postmodernist tradition, there is the confident subject recognizing the need to understand a meaningful object. Skepticism leads not to nihilism, but rather to a determined and critical pursuit of beauty and truth. Neither is constructed or deconstructed; they are not the product of our mind but its object. Beauty is the goal of thought, ethics, and art.

In contrast to the aesthetic assumption that all cultural traditions are social constructs and all such attempts at understanding reality just opinion, beauty is associated with the attempt to understand reality and life in an objective and meaningful way. When we visit museums of fine art, aesthetics, tolerance, and identity result in a nihilistic skepticism or an identity-based fanaticism. Each can be avoided by the hope that some glimpse of wisdom might be obtained, particularly when such claims of wisdom are properly tempered by the witness of other works of art offering differing claims.

The pursuit of beauty acknowledges the importance of facts and feelings, but is not limited by them. Beauty affirms that the facts of reality and life aspire to a higher purpose than mere existence. Meaning and understanding are above the realm of descriptive fact, but must not transgress that realm; facts cannot lead to understanding, but attempts at understanding can be disproved by clear and certain violation of fact. So the pursuit of beauty is the pursuit of truth, and any glimpse of beauty and truth is also a glimpse of goodness.

Beauty is associated then with the attempt to obtain knowledge of a purposeful reality. The assumption of a purposeful reality is at the very least as

intellectually plausible as its aesthetic alternative, belief in a purposeless reality. So we can rightly choose to pursue truth rather than assume the truth of the aesthetic premise that the world is meaningless. However difficult it might be to discern, a thing is beautiful, and moral, when it fulfills its purpose within a meaningful universe. It is to some precious degree beautiful and good when it embodies a glimpse of some degree of truth.

For example, Buddhists (such as the Mahayanists), Classicists (such as Plato or Aristotle), and Christians (such as Augustinians) agree that the world is purposeful, that it ultimately makes sense. They agree that fine art aspires to embody or represent an understanding of reality and life. Although they differ greatly in what that understanding consists, they concur that the pursuit of wisdom, of knowledge of what is true and good, is central to the fine arts and to civilization. It is not the construction of the world, or worldview, or a lifestyle that matters. What matters is getting in touch with meaningful reality.

Just as Dante distinguishes the forest of competing desires and sufferings from the realm of divine bliss, beauty assumes that beyond the chaos of daily life the world ultimately makes positive sense. Beauty is an ideal that is transcendental in nature, but it is a vision that does not necessarily deny the immanent. A meaningful cosmology makes possible a purposeful teleology. By teleology is meant the notion that things have an objective purpose and the goodness of a thing is determined by the degree to which that purpose is realized. To gaze upon that which embodies a high degree of that purpose is to gaze upon beauty. By cosmology is meant that the universe is purposeful, is a cosmos rather than a chaos, where all things contribute to the ultimate perfection, which is reality. As later discussed in reference to Raphael's famous painting, *The School of Athens*, an Aristotelian teleology deconstructs when separated from a Platonic cosmology.

So the pursuit of beauty aims at obtaining a glimpse of wisdom rather than the construction of a subjective preference; it privileges optimism over an aesthetic despair and violence, and love over power. In this way beauty is associated with hope. It aims at the free pursuit of wisdom. The pursuit of beauty embraces a sensitivity and tolerance that is markedly superior to that of aesthetic relativism. Aesthetic relativism reduces Buddhism, Classicism, and Christianity to three subjective exercises in world-making, or three constructed lifestyles within an aesthetic and meaningless world. In contrast, the pursuit of beauty accepts the possibility that these traditions, and others, might help us enjoy better lives.

This is where the pursuit of beauty evidences a capability for diversity not possible in aesthetic relativism. In seeking meaning in life the pursuit of beauty permits failure, whereas the pursuit of aesthetics precludes success. The search for beauty might lead to the conclusion that the world indeed makes no sense, but the pursuit of aesthetics cannot come to the conclusion that the world does

make sense. It cannot do so because it cannot reach beyond the limits of its own nature. The aesthetic vision can only see facts and feelings; it remains blind to the realm of understanding beyond facts and feelings. It remains prejudiced to the possibility of any truth other than the reductionistic version of it offered by an aesthetic Existentialism. As Kant claims, the *ding an sich* cannot be known; as Nietzsche claims, our knowledge is limited by the veil of *maya*, of illusion. If the thing in itself cannot to some extent be known, then no degree of truth can be known. Consequently, the Kantian *ding an sich* concludes in a Nietzschean will to power.

As a public practice, the pursuit of beauty is then more diverse than aesthetic relativism, and more hopeful. In advocating the free pursuit of beauty it recognizes that there are other options beside Existentialism. Buddhism, Classicism, Christianity, and Confucianism (to name but four) all pursue truth, but understand truth in fundamentally different ways. Clearly, all cannot be right, indeed all might be wrong, but the possibility exists that some might partially be right, and one might be significantly so. It is in that singular possibility amongst differences that is found true diversity. It rejects a dogmatic relativism for a genuine variety of belief and the hope that some answers might now be found and better understood in the future.

The pursuit of beauty offers as an antidote to aesthetic relativism a pluralistic pursuit of truth. Whereas the pursuit of knowledge of a meaningful world accommodates a wide variety of substantively different attempts to understand the world, the pursuit of aesthetics only permits constructs to exist. It is ironic that the allegedly tolerant diversity of aesthetic relativism does not permit substantive disagreement about the nature of reality and life, whereas the pursuit of beauty requires it. The pursuit of aesthetics appears diverse but is dogmatically relativist; the pursuit of beauty is made manifest via a pluralistic pursuit of what is true and good.

Indeed, the pursuit of truth, goodness, and beauty facilitates a humility and freedom of conscience not possible in a dogmatic relativism. It denies the pride of a subjective-objectivity where truth claims are revealed as an act of will, or even the product of a self-deification. Rather, there is the assumption that the search for truth requires an essential humility. It is the subject which seeks knowledge of a meaningful object, in science, culture, and art. We do not construct truth and reality. Instead, we seek knowledge of them. Claims of truth and beauty require evidence to be persuasive, whereas with a subjective-objectivity assertion alone exists.

In comparing these two viewpoints, aesthetics and beauty, it might appear that they are irreconcilable. Those embracing the aesthetic assumption that civilization is a matter of taste operating in an existential void cannot be expected to view with sympathy appeals to objective principle. For them such claims of truth and knowledge are untenable. But whereas those focused on a subjective-objectivity assume meaning is a matter of opinion or existence,

those engaging in a subjective pursuit of objective meaning seek not opinions or experience, but degrees of insight.

Such insight occurs not just as a matter of fact or fiction, but rather, is nuanced and occurs as a matter of degree over time. In this view, the light of understanding is not subject to, but rather struggles to rise out of confusion and error. One strives to rise from ignorance to tentative knowledge (known as *doxa* and which will be discussed in the next chapter) and perhaps even to genuine wisdom. The present point is that the vagaries of existence can be seen as an influential rather than determining factor in the pursuit of beauty. Aesthetics cannot recognize beauty, but beauty can recognize that aesthetics can function as a moment in the pursuit of beauty. To put it differently, for those who pursue beauty it is not that aesthetics and relativism are wrong. It is that they do not do enough.

For that reason the following text focuses on the writing of a history of art from the historically accurate point of view of fine art seeking truth, goodness, and beauty. It offers an alternative choice to that of a violent aesthetics. That choice is not a trivial one; the cultural consequences that result are enormous. Those consequences go beyond a mere history of art. They go to the very root of our understanding of reality and life. They reflect a fundamental choice: do we pursue a society where the will prevails, or do we pursue a society where love and responsible freedom reign? Until the advent of Modernism and Postmodernism, with its aesthetic relativism, the latter path is that taken by Western civilization. It is a path that remains possible if now neglected; it is a path worth considering anew.

Notes

1. The term *Modernist-Postmodernist tradition* is here used to refer to one tradition that can be recognized as beginning with the work of Kant and concluding with that of Nietzsche and his contemporary epigones. Common today is the Modernist-Postmodernist assumption that an aesthetic pursuit of facts and feelings is value neutral. Science seeks objective facts, and culture centers on subjective experience. For a critique, respectively, of scientism and emotivism see Alasdair McIntyre, *After Virtue*, (Notre Dame, IN: University of Notre Dame Press, 1981) and Pontynen, "Art, Science, and Postmodern Society," *American Outlook Magazine* (2000), 37-39.
2. See Thomas Kuhn, *The Structure of Scientific Revolutions* (Chicago: University of Chicago Press, 1970); as discussed below, Alan Sokol exposes the dangers of a subjective-objectivity in science by writing a brilliant parody.
3. Friedrich Nietzsche finds comfort in power, and concludes in his *Genealogy of Morals: an Attack* (1887): "...man would sooner have the void for his purpose than be void of purpose." Francis Golffing, translator, *Friedrich Nietzsche. The Birth of Tragedy and the Genealogy of Morals* (New York: Doubleday Anchor Book 1956), 299.
4. For a discussion of the ethical standards intrinsic to Modernist pedagogy and art, see: Pontynen, "Beauty vs. Aesthetics: Ethics in the Fine Arts Curriculum," Robert Ashmore, Richard Starr, editors, *Ethics Across the Curriculum* (Milwaukee, WI: Marquette University Press, 1994), 147-162.

5. The association of knowledge with virtue is universal, whether we refer to the D*ao De J'ing* (the primary text for Daoism) whose title literally means *The Way and its Virtue*, or to the works of Marx and Engels where a dialecticism is present in nature, politics, and ethics. See: Pontynen, "Daoism," *A Dictionary of Art* (London: Macmillan Press, 1996).

6. The United States Supreme Court has made into legal principle the notion that knowledge of the world and life is impossible. The practical result is that in the public realm belief in a purposeful world is now denied. The citation for what is now called "the Mystery Decision," is: Planned Parenthood of Southeastern PS v. Casey (1992). As discussed below, the destructive aestheticization of Justice is both Aristotelian and Rawlsian. In contrast is the Platonic-Augustinian tradition which perennially centers on the pursuit of ideal Justice.

7. As noted by Edward Conze, *Buddhist Thought in India* (Ann Arbor: University of Michigan Press, 1973), 24-25, in science all we have is facts and nothing has any meaning. By that he is referring to the triumph of nominalism in Western culture where individual facts are deemed objective, but reality is understood to be subjective – and therefore not understood at all. He viewed an empiricist approach to the study of Buddhism as provincially coercive and dismissive. As an antagonist to the Modernist paradigm that surrounded him, his scholarship was denied the recognition which it deserves.

8. As discussed in Mark Bauerlein, "Social Constructionism: Philosophy for the Academic Workplace," *Partisan Review*, LXVIII, 2 (2001): "Notwithstanding the diversity trumpeted by humanities departments these days, when it comes to conceptions of knowledge, one standpoint reigns supreme: social constructionism. It is a simple belief system, founded upon the basic proposition that knowledge is never true per se, but true relative to a culture, a situation, a language, an ideology, or some other social condition…[In] academic contexts, constructionist ideas are not open for debate. They stand as community wisdom, articles of faith."

9. To be precise, propaganda is not obnoxious to the propagandist, but it is to those manipulated by it.

10. Nietzsche claimed that it is the realm of illusion, of *maya*, that falsifies truth claims; the irony is that today Nietzsche's claim is not the remedy, but the cause of prejudice.

11. For example, Modernism rejects the importance of race in culture, yet Postmodernism cites it as central. The positions of Martin Luther King Jr. and Malcolm X are incompatible. For a discussion, see: Arthur Pontynen, "The Aesthetics of Race, the Beauty of Humanity" *American Outlook Magazine* (2002), 37-40.

12. To the point, cultures brutalized in the nineteenth century by colonialism were not relativist. Consequently, the use today of Postmodern relativism by post-colonial scholarship to counter Western cultural hegemony makes no sense. Postmodernism is today's Western cultural hegemony, and it is one which is nihilistic.

13. Richard John Neuhaus, *The Naked Public Square. Religion and Democracy in America* (Grand Rapids, MI:W.B. Eerdmans Publishing Co. 1984).

14. The Modernist posturing of tolerance towards all views is therefore dedicated to a nihilistic and self-destructive cultural paradigm with dreadful political and practical consequences. This has recently been made large by the murder of two prominent figures in Holland, the politician Pym Fortune and the filmmaker Theo Van Gogh.

15. This will be discussed in detail later. For the moment, note that in his text, *The Groundwork of the Metaphysics of Morals*, Kant states his axiom of morality: Act as if the maxim of your action were to become *through your will* [italics mine] a Universal Law of Nature. In his private notes not published until 1920 Kant states: "God must be represented not as a substance outside me, but as the highest moral

principle in me…The Idea of that which human reason itself makes out of the World-All is the active representation of God. Not as a special personality, substance outside of me, but as a thought in me." For this reference see Thomas Molnar, *God and the Knowledge of Reality* (New Brunswick, NJ: Transaction Publishers, 1993).

16. Immanuel Kant explicitly articulated this idea in his work, *The Critique of Pure Reason* 1781 and it was developed further by such figures as Nelson Goodman, *Ways of Worldmaking* (Indianapolis, IN: Hackett Publishing Company, 1988).

17. For the Kantian sources of existentialism see: Edwin Burtt, *Types of Religious Philosophy* (New York: Harper and Brothers Publishers, 1939), 258ff.

18. As discussed by Janine Chasseguet-Smirgel, *Creativity and Perversion* (New York: W.W. Norton & Company, 1984). This will be examined in detail in a later chapter.

19. In contrast to Kant's redefinition of transcendentalism as referring to a subjective-objectivity, the rational a priori structures of the human mind (*Critique of Pure Reason*), I here refer to the traditional notion of transcendentalism as posited by philosophical Realism: the transcendental are archetypal.

20. Immanuel Kant, *Groundwork of the Metaphysics of Morals* (1785), First Section. Even if one accepts the dubious proposition that duty results in our summoning the will to do good (via the Categorical Imperative), the Kantian vision offers no insight as to what is good, and what is worth doing . This is discussed in later chapters.

21. Whereas Rousseau takes for granted that human nature is naturally good, in *The Critique of Pure Reason*, Kant declines to base morality upon an analysis of human nature choosing instead to base it upon rational principle of which there is a duty to pursue. See: Frederick Copleston, S.J., *A History of Philosophy* (Garden City, NY: Image Books), Book Two, Volume VI, 312. For a critique or rousseau see: Irving Babbitt, *Rousseau and Romanticism* (New Brunswick, NJ: Transaction Publishers, 1991).

3

Classicism: The Nature of Beauty, the Fragility of Goodness

With roots in Greek and Roman antiquity, the Classical tradition has been a perennial part of Western culture. Its foundations were established, interpreted, and then interpreted yet again.[1] Once widely influential, Classicism now displays but a remnant of its former sway. One reason for that decline in influence is found in the type of interpretations it has recently endured. Interpretations of cultural traditions can either be aesthetic, or done in the pursuit of beauty. They can seek to establish the facts about a tradition, inviting us to emotionally respond to those facts. Or they can seek to obtain wisdom via an understanding and application of that tradition's core beliefs. We can voyeuristically accumulate facts about Classicism, or we can attempt to understand the world as Classicists. That is to say, a factual and emotional study of Classical art and culture is radically different from a study of art and culture in a Classical pursuit of truth and wisdom. It is as different as aesthetics is to beauty.

This distinction of an aestheticized Classicism, from one seeking beauty, is obscured by the assumption that the acquiring of a quantity of facts will somehow result in a quality of perception. As a matter of course, some assume that an aesthetic approach to the study of Classicism, and art history, is most appropriate. It is an aesthetic assumption that an accumulating of facts will necessarily lead to an *empathetic understanding* and that an empathetic understanding makes sense. But that assumption is false. Learning a lot of facts about Classicism will not bring us to understand Classicism, or the history of art, or of culture. Nor does the notion of an empathetic understanding make sense. As previously introduced, and developed below, an aesthetic approach to culture results in an allegedly *empathetic understanding*. It results in what Nietzsche calls a *Dionysian wisdom*. But a Dionysian wisdom marks a reduction of truth and culture to arbitrary preference, to a will to power —which is antithetical to Classicism. It reduces Classicism to a Postmodernist version that is not Classical at all.

So the difficulty in studying Classicism via an aesthetic viewpoint is that it denies the possibility of actually understanding Classical culture, at least, that Classicism which is not aesthetic. The term *culture* here centers on belief whereas empiricist sociology centers on mere experience—be it the accumulation of chance events, arbitrary choice, or of biological or cultural necessity. Classical culture seeks to understand reality and life, and thus seeks beauty, whereas an aestheticized, sociologized, Classicism is the aesthetic record of the facts and preferences of a particular group of people.

To learn a wide variety of historical facts about Classicism is not enough; that is to engage in a voyeuristic or willful antiquarianism. The attempt to understand Classicism involves an *evaluating* of the world and life as would a Classicist. It involves then not merely the aesthetic pursuit of facts, but the pursuit of truth.[2] Consequently, it involves the pursuit of beauty. And it takes a deliberate and self-conscious act to proceed accordingly.

This is perhaps a subtle point, but one with enormous consequences. The seemingly objective accumulating of facts is not objective at all, since those facts must be selected and constructed into an explanatory narratives and such constructions are necessarily a matter of perspective and of the will. The pursuit of facts and the construction of narratives is then pedagogically and intellectually relativistic; it is informed by a subjective-objectivity. It teaches the student to think relativistically and therefore—unclassically. For example, aesthetically, Classicism factually refers to a sociological preference from a particular—yet arbitrary—time and place distinct from our own. The term Classical thereby refers to a particular time span, perhaps from the fifth century BC to the third century AD; during that era a particular group of people viewed reality and life in a fashion peculiar to their time and experience. The problem with this view is that it is essentially relativistic, and as such is not how all Classicists view themselves.

Plato's great goal is to escape relativism and skepticism. By seeking knowledge of reality he develops a cultural Classicism dedicated to the pursuit of knowledge of that which is true and good, and therefore, beautiful. That knowledge aspires to being valid for anyone in any society at any moment in time. So on the one hand is aesthetic Classicism, which centers on our experiencing facts and feelings. Consequently, our understanding of reality and life are determined by a subjective-objectivity; (our) reality conforms to (our) experiences. Consequently, Classicism is viewed as a temporal record of aesthetic necessity or taste, of a means by which aesthetic taste has or can be realized. In contrast, the Classical pursuit of beauty recognizes culture as a subjective pursuit of objective knowledge. It centers on the pursuit of objective knowledge of a purposeful reality, of the true, good, and beautiful.

So Classicism is not limited to the aesthetic and sociological view that it refers to the great variety of opinions expressed in the time period commonly yet arbitrarily referred to as the Classical period (ca. fifth century BC—third

century AD). During that particular time period there were persons who advocated beliefs that are distinct from the beliefs of an aestheticized Classicism culture.[3] Indeed, it was the widespread prevalence of skepticism and relativism that prompted the very development of the Classical tradition that perennially seeks beauty. Beauty seeking Classicism is not a ghostlike apparition that conforms to the aesthetic taste of an individual or group. Nor is it identifiable as a particular lifestyle or set of lifestyles, or as a particular power structure. To view Classicism in such a limited fashion is to perceive it via an aesthetic relativism; to view Classicism as an aesthetic and sociological phenomenon is to deny the very substance and character of Classical culture. In contrast to the aestheticized Classicism of Kant and Nietzsche (discussed below), the Socratic/Platonic tradition is central to the pursuit of beauty.

The pursuit of beauty within Classical culture has long played a key role in Western civilization, a role that only recently has been obscured or denied. The present use of the term *Classical* here refers to a cultural way of thinking and living dedicated to the realization of wisdom and beauty. For the Classicist the point is not to embrace a subjective-objectivity in the study of Classical art, where meaning becomes a matter of experience and taste. Rather, it is to cherish the subject seeking knowledge of objective reality (*being*). To Classically study art is to do the same. It invites us to engage in the pursuit of enduring wisdom and beauty, and to apply that understanding to the contingencies of life. It values reason without making reason a fetish. Therefore, in contrast to the aesthetic notion that principles are contingent but our will is absolute, Classical culture maintains that certain rational principles are true in the midst of a life filled with contingencies.[4] Classicism believes that essential principles concerning reality and life can to some precious degree be understood. Consequently, it is not the will that is supreme, but rather, wisdom, permitting responsible freedom.

The aesthetic relativist believes that since facts must be put into explanatory narratives, then meaning is constructed. Since those facts must be constructed, then the Classical pursuit of wisdom and beauty cannot really occur. But this begs a deeper issue: whereas aesthetic relativism takes as foundational that the universe is purposeless, Classicism takes as foundational that the world is purposeful. Significantly, either choice is at the very least intellectually plausible. Therefore, the Classicist's dedication to comprehending a meaningful world, of the subject seeking knowledge of a meaningful object, is no less plausible than is the aesthetic notion of a purposeless subjective-objectivity. Indeed, it is not merely as plausible; the pursuit of beauty is demonstrably better than aesthetic taste.

So it is not that facts are used to construct a Classical conversation; rather, a classical conversation centers on the pursuit of truth, of knowledge of objective and purposeful reality. Consequently, it is a conversation that occurs at a more profound level than that afforded by aesthetics. Fact-based constructs

can provide but a shallow opinion of reality and life for two reasons: (1) because facts center on *what* and explanations address *why,* and (2): a constructed explanation is by definition arbitrary. To confuse what for why, and opinion for knowledge, is to reduce our understanding to an aesthetic superficiality. To reduce understanding to the realm of willfully constructed opinions or experiences is to mandate belief in a shallow and violent understanding of reality and life, offering no meaning, no purpose, and no hope. Socrates and Plato resisted just such a worldview.

So if the choice is to study Classical art and culture aesthetically, then we choose to study that art not from the perspective of Classical culture, but rather from the antagonistic perspective of aesthetics. The injustice is that this privileges the viewpoint of the antagonists of Socrates, Plato, and Aristotle, namely those sophists and nihilists through the ages, and culminating in Nietzsche and his epigones. To study Classical culture from an aesthetic perspective is to deny the pursuit of truth, and to reduce it to a purposeless and willful sociology. It is to proceed via a foreign assumption that Classicism could not be a perennial and vital means by which we attempt to make sense of our lives. It is to deny the core beliefs of Classicism by reducing them to a matter of aesthetic taste and lifestyle. As discussed below, studying Classicism aesthetically results in a desiccated Classicism at best. Little wonder then that the influence of Classical culture has so declined. Its optimistic realism has long been ignored, denied, and subverted via the pursuit of facts, feelings, and style. It has been aestheticized—and—anesthetized.

For some time now aesthetic interpretations of the Classical tradition have commonly and unfortunately prevailed. This is unfortunate because Classical culture is devoted not to aesthetics, but to the pursuit of beauty. To interpret it aesthetically is to attempt to understand it via the perspective of relativism. To do so is to deny the very substance of Classicism. Should that substance be denied? Perhaps the evidence could lead to that conclusion. The conundrum is that the very issue of whether or not Classicism is true makes no sense to those who *a priori* assume that truth cannot make sense. And if we uncritically accept the premise that truth cannot to some precious degree be understood, then neither Classicism nor our lives can have much meaning.

Two examples of an aesthetic interpretation of Classicism are those offered by Modernism and Postmodernism. Philosophically, a Modernist interpretation is represented by proponents of the Enlightenment such as Immanuel Kant, and is evidenced within the history of art by the Neo-Classical movement dating from around the end of the eighteenth century. This is an interpretation of Classicism where reason no longer seeks knowledge of a meaningful reality. A significant Postmodern interpretation of Classicism is offered by Friedrich Nietzsche, as evidenced by his book, *The Birth of Tragedy.* For Nietzsche and a variety of Postmodernists the Classical pursuit of truth is transformed into an existential (Dionysian) will to power. Examples in the fine

arts follow suit. Before addressing the intellectual foundations of Classicism it is useful to see how an aestheticized Classicism is now common and how it interferes with our attempt to understand that tradition on its own terms. We can do so by considering a Classical theme: Venus.

The Venus de Milo and the Reality of Love

In the Louvre Museum in Paris, France, is a marble sculpture depicting Venus. The *Venus de Milo* is approximately 6' 10" tall and dates to the second century AD. A product of the Hellenistic period, it represents the attempt to put the Ideal into physical form. What is that Ideal, and is that Ideal real? The Ideal here represented in material form is Love. As one textbook factually puts it, with the *Venus de Milo*, "the ideal is taken out of the hypersensible world of reasoned proportions and made into an apparition of living flesh."[5]

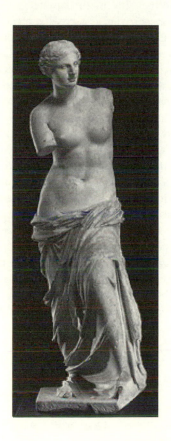

2. *Venus de Milo*

We can look at the *Venus de Milo*, and memorize a multitude of facts about it, but lacking one question, such activity is essentially meaningless. That question is: is the *Venus de Milo* true? By that is meant: does the ideal put into physical form by this work of art exist? Is Love an intelligible reality, or is it merely grounded in nature, nurture, or the will? Is love a vital element within a meaningful reality, or is it limited to being a matter of fact, feeling, and power? Dante would view Venus as a symbolic representation of a driving force of the universe. He sees love, truth, and goodness uniting in a beatific vision. But is Dante right?

That question can be ignored, or pursued vigorously; it is a question that permits two essential possibilities, and the choice between the two is the crux of the matter. The choice is between pursuing facts without concern for whether those facts are meaningful, or pursuing truth. The latter involves a discerning of whether the intrinsic meaning of the object in question is more than a statement of biological or sociological necessity, choice, or power. The task is to determine if its meaning is to a significant degree in touch with purposeful reality. The choice between aesthetics and beauty radically affects the writing of a text on art history. It also fundamentally affects how we understand reality and life. This can be illustrated by showing how two works of fine art interpret Love in essentially different ways.

As just noted, the Classical viewpoint is that Love is an objective Ideal. The *Venus de Milo* aspires to explain to us the nature of Love and its affective role in the world. But what does that mean, and can we take that meaning seriously? This is not a rhetorical question; rather, it is a personal and cultural challenge. If we cannot take the explanation of the meaning of Love as presented by the *Venus de Milo* seriously, then we cannot take the intrinsic meaning of the art object seriously. Nor can we distinguish purposeful love from mere appetite or sheer violence. The now common Modernist and Postmodernist understanding of love as an aesthetic experience, rather than an aspiring to the ideal, stands as an obstacle to the contemporary viewer of the work of art. The ability to get beyond the limitations of aesthetics is central to our ability to understand Classical art and to perhaps live a life informed by Classical belief. To get beyond those limitations requires that we recognize that those limitations exist.

The Aesthetic Venus

Within Classical culture love is associated with the desire to possess beauty, and beauty is recognized as the splendor of that which is true and good within a meaningful universe. From antiquity the association of love and beauty is considered. In the mythological account of the Judgment of Paris, Paris is confronted by three gods: Athena, Hera, and Aphrodite (or Venus). They ask him to decide which is most beautiful. Athena offers victory and glory, Hera offers wealth, but Aphrodite offers Helen as beauty incarnate. Paris chooses the last, and tragedy unfolds.

In the French Salon of 1865, Edouard Manet similarly addresses the issue of love. He exhibited *Olympia*, a work depicting a young girl in a traditional pose long associated with love and marriage.

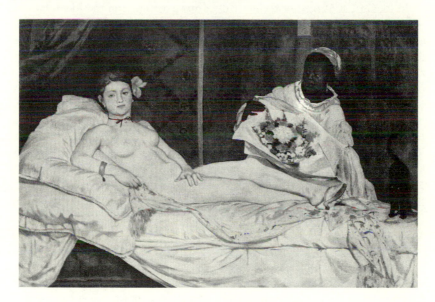

3. Manet, *Olympia*

Reclining, *Olympia* assumes a pose long associated with the depiction of Venus. This pose is also associated with traditional marriage portraits and the traditional association of freedom with love and family.[6] Although the formal aspects of depicting that subject remains, its meaning has now been altered. Here *Olympia* is not associated with transcendental notions of love and marriage. Quite to the contrary, it is an aesthetic statement.

In the exhibition catalogue Manet uses a verse by Zacharie Astruc to refer to his painting:

> When, weary of dreaming, Olympia wakes, Spring enters in the arms of a gentle black messenger; it is the slave, like the amorous night, who comes to make the day bloom, delicious to see: the August young girl in whom the fire burns[7]

In contrast to traditional notions of the nude, where Love is associated with an Ideal personified by Venus, love is here presented as material, sensual, aesthetic. Manet's interest in non-idealistic love was not unique in his time. Contemporary to his painting there was an abundance of literary works concerned with the prostitute (whose profession is intrinsically aesthetic), and with artistic honesty being associated not with ideal truth but with sociologi-

cal fact. For example, the very name "Olympia" had been used by the then contemporary writer Dumas to refer not to transcendent love, but rather to one of the courtesans in *La Dame Aux Camelias*.[8]

In looking at Manet's *Olympia* we are not gazing upon the Ideal, but the materially real. We are glimpsing at aesthetics, not beauty, the naked rather than the nude. Manet's aestheticization of Venus is but a continuation of the demythologizing of ideal love, a process started during the Italian Renaissance. For example, Titian's *Venus of Urbino* (1538),[9] was criticized as subtly pornographic. If aesthetics reduces the nude to the naked by its lack of an objective ideal, and if the naked, the pornographic, is intrinsically exploitative and dehumanizing, then the path from the *Venus de Milo* to Titian to Manet marks a sad decline. Such demythologizing is corrosive of human dignity, if myth refers to an ideal reality and beauty, and is not merely material, emotive and aesthetic. So, is it the myth of Love, as Venus, or the deconstructed myth of love (as Olympia) that we can believe and cherish? The Greeks viewed their myths as embodying truth not fiction, and in their own ways, so did later figures such as Manet, Nietzsche, and Freud. So the question is: are we to take an aesthetic vision of love as being accurate, or can (indeed should) love be beautiful?

Historians have traced at least eighty-seven reviews of the Salon of 1865, and the overwhelming majority of those reviews criticized Manet's art. Many found the work to be obscene, an invitation to sexual relationships with a minor (Manet's supporter, Emile Zola thought the model was sixteen years old and defended it yet).[10] Some celebrated its formalistic qualities, while denying that an advocacy of immoral behavior was depicted.[11] Defense of the work as promoting Love and Beauty as transcendent Ideals is conspicuously lacking.

This is significant given the name of the movement associated with Manet's art. Subsequent to the Romanticism so common to Delacroix's time, was the cultural movement called Realism. Manet's art is associated with Realism, but the realism of his time was deeply associated with materialism and aesthetics. This is in complete contradiction to the traditional Classical meaning of the term *realism*. Just as the notion of aesthetics is now confused with beauty, materialism is now associated with being realistic. A corollary is the implicit assumption that to believe in transcendental Ideals such as Truth, Goodness, and Beauty is to be *unrealistic*.

Traditionally a Realist is someone who believes that transcendental ideals are more objective and real than the constantly changing and flawed physical world in which we live. For example, Plato (and later, Augustine) held that the ideal is more real than the material; Humanity or Justice are objective, whereas in life we experience but flawed manifestations of the genuinely real.

To the Classical realist we ought to enjoy goodness, beauty, and justice, and when deprived of those ideals our lives are less than they ought to be. But to a materialistic realist, that which is real is that which is factually experi-

enced. So the critics of Manet's art, accustomed to the traditional understanding of Realism, see in Manet's art not a nude, associated and elevated by reference to the ideal, but rather, a naked girl. It is not fine art, but pornography. They see not artistic license, but an immoral licentiousness. And whether Manet is mocking tradition, or lamenting its passage, the result remains the same. Love is no longer portrayed as an objective ideal. Jules Claretie in *L'Artiste* offers:

> What is this Odalisque with a yellow stomach, a base model picked up I know not where, who represents Olympia? Olympia? What Olympia? A courtesan no doubt. Manet cannot be accused of idealizing the foolish virgins, he who makes them vulgar virgins.[12]

As Paul de Saint-Victor in *La Presse* put it:

> The mob, as at the Morgue, crowds around the spicy Olympia...by Manet. Art sunk so low doesn't even deserve reproach. Do not speak of them; observe and pass on, Virgil says to Dante while crossing one of the abysses of hell. But Manet's characters belong rather to Scarron's hell than to Dante's.

Those who believe in ideals and beauty rather than mere aesthetic experience, and who elevate culture above sociology, will continue to find Manet's *Olympia* deeply disturbing. It undermines the values and hierarchies found in the Classical understanding of the world and therefore undermines the possibility of responsible freedom. In denying the possibility that reality and life can enjoy lofty purpose, he advances the alternative conclusion: that culture is grounded in facts, feelings, and ultimately power. In so doing, Manet remains offensive to those who believe that responsible freedom is possible, and that culture aspires to ideals that are better and more enduring than the confusion and violence of daily life.

Manet's art lacks beauty; it can even be judged ugly, but only if it is not true. The question facing the viewers of *Olympia* is whether a painting that is aesthetic can offer a meaningful expression of love. Or does this interpretation of a Classical theme actually degrade the way things are in reality? Classicists think so.

The Beautiful Venus

As introduced earlier, in the Louvre Museum in Paris, France is a marble sculpture depicting Venus. A product of the Hellenistic period, it represents the attempt to put the Ideal into physical form. What is that ideal, and is that ideal real? The Ideal represented in material form is Love. The sculpture makes manifest that Love which is a cosmic force to be reckoned with. It is the ontological force that seeks completion within a meaningful world. What that means is that love and truth are closely related; we can know someone both

intellectually and erotically. Conversely, to be confused about truth is to be confused about love.

As discussed in Plato's *Symposium*, both love and truth seek meaningful objects. Both seek completion. Clearly, how we understand Love will affect how we understand this sculpture. But more is at stake than that. How we understand Love will fundamentally affect how we live our lives. To approach Love aesthetically is to approach it in terms of fact or feeling. To understand love as a matter of fact or feeling requires that we approach this work of art in terms of fact and feeling as well. In that case we can cite the facts associated with the object and we can discuss our emotional response to those facts and to the object itself. But the assumption that facts and feelings actually explain this object requires the corollary: that love can only be understood as a matter of fact and feeling and therefore as a matter of biological or emotional appetite, or violence. The dilemma is that the *Venus de Milo* was made to express not facts or feelings, but the Ideal. It was made to express the belief that Love is an Ideal that is true and good in reality (*being*). It involves the belief that love rises above instinct, appetite, and violence; it assumes that love functions as an essential part of a meaningful universe.

Within the Classical tradition love consists of much more than facts and feelings. Love is an Ideal which actually exists, and which is associated with wisdom and beauty. Plato argues that love is the desire to possess beauty, and beauty is the splendor of wisdom. Since beauty is associated with truth and goodness, love is associated not with facts and feelings, but with understanding. Love is associated with the attempt to comprehend a purposeful universe. But since facts and feelings assume no purpose, they cannot assume to provide understanding; by reducing truth to fact and feeling we deny the possibility that this Venus is real. To approach this work accordingly is to deconstruct the very meaning of this work of art. But more than that, to approach both art and life aesthetically is to deny the possibility that we can embrace beauty and wisdom.

So contemplation of the *Venus de Milo*, and of *Olympia*, offers two distinct possibilities. It can prompt an aesthetic concern for descriptive facts and for subjective emotion. In this case love is reduced to biological fact and subjective emotion where as a historical object the Venus is relegated to nostalgic irrelevance. Or it can prompt the pursuit of truth. Truth about what? The very nature of the universe, and the role of love within that universe. In that case, Olympia pales besides the Goddess of Love. If that sounds too grand, consider this: to approach these works of art aesthetically is to accept an aesthetic understanding of reality and life. It is to assume one understanding of the world and life is no grander than another. Therefore neither object really matters much. But if love as an objective and enduring ideal is plausible, then an aesthetic understanding of love is incomplete and superficial. *Olympia* is violently trivial whereas the *Venus de Milo* truly warrants our attention and our devotion.

For the *Venus de Milo* to be real and true, a passionate knowledge awaits the lover. Classical mythology, philosophy, and theology all agree that the world makes sense; chaos is common but occurs within a purposeful cosmos. There is an ideal realm that is real. What is the nature of the Ideal by which the cosmos and our lives are intelligible? In the *Phaedrus* Plato quotes Hesiod to present a foundational premise of Classical culture: "First chaos, then order, then love". The world is rightly a cosmos, and we must constantly struggle to avoid slipping back into chaos. Whether one wishes to quote Hesiod or Homer, reflect on Atlas attempting to push the earthly orb up the hill or Hercules attempting to clean out the Augean stables, the theme is constant. We must perennially struggle against confusion and chaos by striving for the Ideal. The Ideal is most real, and when made manifest it is beautiful; love is then an appetite—but one which can be sated via lofty purpose. That purpose is to unite with beauty, and therefore to become one with truth and goodness.

The Ideal is the reason for how things ought to happen. Classical mythology personalizes the Ideal, that is, the notion of *why*. Those myths attempt to offer insight concerning reality and life. How do they differ and to what degree are they reliable? Certainly they differ in terms of aesthetics vs. beauty. Classical mythology aims at understanding reality and life, but myth can be studied aesthetically, as grounded in obscure superstition, mere tradition, or unverifiable revelation. However, from the point of view of beauty, a myth is valuable only when it embodies a degree of truth, and myths are recognizable as being to some degree truthful only via critical exegesis.

Classical mythology represents the attempt to explain why the world works as it does. In so doing, it presents an Ideal vision of a House of Life, one in which we might live. That mythology presents us with a Pantheon of gods, and their history. There are several accounts of that pantheon, which differ to some degree. One holds that Earth (Gaea) and Sky (Uranus) coexisted, producing numerous children. One of those children, Time (Kronos) overcame Sky (Uranus) and began to devour the divine children. But Kronos' son Zeus managed to conquer Kronos. Zeus conquering Kronos represents Truth prevailing over Time,[13] thus denying that truth is at best but of the moment. When truth prevails over time, meaning prevails over chaos; affirmed is that the universe (and time) is meaningful (*kairos*) rather than empty, chaotic or violent.

Subsequently, the devoured children were restored. The result then is that Zeus conquers Time, and that a family of gods endures. That family represents various forces of the universe, and includes Venus (love), Mercury (transmission of knowledge), Mars (war), Artemis (pursuit), Poseidon (commerce), Athena (glory), Apollo (reason), Demeter (agriculture), and Dionysius (pleasure). It is by the qualities of those family members, and by their interactions, that Classical Mythology attempts to explain the nature of reality and life. They present to us a particular understanding of our House of Life.

Certain universal and perennial themes are evident in Greek myth: the relationship of Venus and Mars, representing the relationship of different types of passion; Athena, representing the importance of maintaining a civil community; Apollo representing light, reason and music. Other myths focus on human activity: Narcissus, who falls in love with his own image; Oedipus, representing possible dynamics within filial and familial relationships, and the tragedy that can result from ignorance or fate. Once again, these myths can be approached aesthetically or in terms of beauty. To name but a few, such themes have been studied in terms of psychology by Aristotle and Sigmund Freud, in terms of philosophy by Augustine and Nietzsche, and by a wide variety of religious traditions around the world.

For example, to a Classicist such as Aristotle (*On the Soul*) psychology is the study of the human soul, a soul that aspires to be in harmony with a purposeful world. Psychology seeks beauty. In contrast, psychology is today commonly an aesthetic field of study, centering on our inclinations and utility, rather than what we substantively ought to do by conscious thought and free responsible choice. It can aid in identifying and resolving certain types of conflicts, but cannot offer purpose (beyond self-expression and self-realization) that can inform or transcend those conflicts.

Aesthetically, the notion that Zeus (truth) permits us to objectively transcend[14] the destruction of *kronos* (time) is nonsense since aesthetically truth cannot transcend the facts of place and time. But if this viewpoint, called historicism, is true (at least for the moment?) then it can only be true for and of the moment—since it too is constantly destroyed by time. The assumption of the momentary nature of truth (or of *being* and *time*) is existentialist,[15] and entails a worshipping of Kronos and his work. In this case Zeus, Apollo, and Venus are dead, and reduced to masks for power, subsumed into the realm of the will.

In contrast, Plato's notion that time is the moving image of eternity offers a liberating possibility in that it permits us to escape from historicism. We are liberated from the historicist requirement that our lives be limited to but a series of ultimately meaningless, existential events. It permits us also to escape the view that the history of art is a record of the passing fashionable or coercive moment and therefore a merely nostalgic dalliance or a reminder of oppression. If history and art do not have an enduring content, then works of fine art are merely matters of past taste be it trivializing or violent. Such objects from the past would then have little real importance to the present or the future. In art and life we would then have no memory, no understanding, and no beauty. There is only the sentient aesthetic moment—and power.[16] The Giants of Greek myth represent such chaos; Classicism holds culture to depend upon their defeat.

What then is the perennial meaning of Love? From a teleological point of view, Aristotle argues that we must be careful of what we love, because some of

us love terrible things. From a cosmological view Plato associates the pursuit of love with the pursuit of Justice and Beauty; he holds that from a universal point of view, refined Love is understood as the desire to possess beauty, with beauty being the splendor of what is true and good. That may sound artificial and abstract, but it is not.

As introduced earlier, the aesthetic mind assumes a subjective-objectivity. The subject constructs the object of knowledge, as a matter of fact and feeling. When applied to love, a subjective-objectivity transforms the object of our desire into a product of our desire. To do so is to assault the object that we purportedly seek. For love to be more than aesthetic, more than the physical or emotional, more than eros or erotica, it has to enjoy a natural purpose (teleological) and an ontological one as well (cosmological). To recognize love is to refer then not to fact, feeling, or power, but to some degree of knowledge of the purpose of reality and life.

To study the goddess of love only from a sociological viewpoint is to reduce her from the ideal to the erotic, from meaningfulness to base sensuality. The object is destructively transformed into a willful aesthetic construct. Those who are accustomed to viewing love aesthetically can neither understand this object of love, nor the object of love. But according to Plato, Love is real. Love marks the desire for and realization of how things ought to be. In attempting to understand the nature of love, the Classicist considers love from a personal, a social *and* a universal point of view.

But what does that mean? Just what is meant by the notion of cosmological love? What is meant by Dante's reference (discussed above) to love as the force that makes the cosmos move? Understanding these ideas is facilitated by a broadening of our understanding of what love means. To understand these notions also requires that we recognize how important such understanding is to our daily lives. If we equate love with physical pleasure, then we will live one way, if we equate love with power we will live in another way. Neither of those ways of living is admirable to the Classicist.

Classical vs. Modernist-Postmodernist Hermeneutics

The Greek god Hermes (Roman: Mercury) is depicted in a sculpture from the fourth century BC made by the Greek artist Praxiteles. Made of marble and reaching a height of eighty-five inches Hermes is depicted with the infant Dionysus. Why is Hermes here associated with Dionysus? According to myth, one role of Hermes was that of taking divine children to safety. Thus he is here shown giving Dionysus to the Nymphs of Nysa.[17] At a minimum this act illustrates the central function of Hermes: to serve as the messenger of Zeus. As the messenger of Zeus, he is thus associated with the conveyance of truth. As the messenger of the gods his name is now eponymous with hermeneutics, the science of interpretation.

The hermeneutics of love center on the variety of attempts to understand love. That variety constitutes what some philosophers now call the circle of hermeneutics. Without doubt, we can understand love via a variety of perspectives. One perspective is that of materialism. An example of a materialistic approach to love is that which associates it with chemicals.[18] Published research argues that love is like a compound chemical that occurs in chocolate. Therefore, when we desire chocolate, we desire love. Practically speaking then, when next we find ourselves lonely, then we ought to snuggle up to a box of chocolates. Other materialistic philosophers, with a more organic orientation, argue that love is glandular, that love is a physical biological act. Yet another position is that love is empirically psychological. According to one such interpreter, love is an admission that we feel inadequate; love indicates a neurosis, an unresolved personal conflict. We fall in love to remedy a bad self-image.

To the point, so far, the importance of understanding the meaning of the *Venus de Milo* has not been established. From a chemical point of view the importance of the statue is trivialized—even if we could buy chocolate replicas of the statue in a gift shop. A physical-biological point of view of love reduces the notion of love to a physical performance, a performance achievable without knowledge or art, as evidenced by the natural ability in such matters by utterly uncultured rabbits. Finally, to reduce love to the level of neurosis is to do little to inspire much interest in the notion of love or in its depiction in art.

It is important to note that all of these attempts to understand the *Venus de Milo* have been aesthetic and sociological. Each has focused on facts and feelings, rather than ideals. For the sympathetic viewer of Manet's *Olympia* this dismal analysis of love is sadly comforting, but for the traditional viewers of the *Venus de Milo*, the net result is both disappointing and falsely prohibitive. It is disappointing in that it makes the object trivial and subjective, at the very least, subject to the violent male gaze. It is falsely prohibitive and disappointing in that the intrinsic meaning of the *Venus de Milo* goes much further than chemistry, biology, and empiricist psychology in its understanding of love. It presents a vision of reality as beautiful.

But if limited to an aesthetic perspective hermeneutics is interpretative and reality is never understood. If that is the case, then Hermes and Venus are reduced to the trivialized level of facts and feelings. Some prefer chocolate, or dopamine, others, biological sensuality and violence, others, a venting of neurosis. Those who seek a more satisfying understanding of love are then imposters who falsely represent the claim that Truth and Love can actually be understood and found to be beautiful. Their assertions of content are thus limited to historicist fact, whose meaning is but fiction or a mask for power. Venus (Apollo, Hermes) sculptures are then objects used in the past to provide a variety of sensual delights and to oppress the viewer by their false truth claims.

This results in a limitation that is not only superficial, but artificial as well. It neglects, for example, the possibility that love is teleological and cosmological. Classical cosmology holds that love is an ontological force that manifests completion; it is the motivating factor that results in things being made somehow right. To paraphrase Dante's later position mentioned above, love not only makes the world go round, it contributes to realizing the purpose and meaning of the world as well.

In contrast to the aesthetic approach to love, where it is reduced to a trivializing or oppressive occurrence, a cultural approach to love is rooted in beauty, in the intellectual and the spiritual. Plato, for one, argues that loftier love is the desire to possess beauty, and beauty is the splendor of wisdom. As an Ideal, Love is grounded in an understanding of how the world works. Love makes clear that the world is purposeful. Spiritual love assumes that the world makes sense, that it is a cosmos, and that since an impersonal world is not one where love can exist, the meaning evidenced in the world must also somehow be personal. So it is intelligible love that reveals a world that ultimately makes sense, and within that world our personal lives can make sense as well. Lacking such intelligible love, the universe of nature and humanity can only be grounded in necessity, chance, or power. In that case, our lives, our ethics, and the history of art, matter little.

The pursuit of beauty offers a perennial alternative to an aesthetic historicism. The study of the *Venus de Milo* involves three concurrent and essential tasks: to establish the facts of belief, to evaluate the merits of those beliefs, and to consider whether those beliefs are true and thus worth living by. Those tasks necessarily must occur within the context of a meaningful universe. That evaluation is motivated by love, by the conscious desire to understand how life makes sense. That desire requires, however, hermeneutics to be more than circular. It involves the attempt to understand reality as more than a matter of opinion or a matter of fact. It requires an evaluation of love from a variety of perspectives, but the existence of hermeneutics—at least to the Classical understanding – does not require a denial of wisdom and beauty. It does not demand that Hermes be lost, going in circles without destination or positive effect. It does not limit us to an aesthetic relativism. Rather it permits us to rise from variety to profundity, from facts to understanding, from aesthetics to beauty. Indeed, by involving a shift from aesthetics to beauty it suggests that the Ideals represented by Venus and Hermes, Athena, Apollo, and Zeus are perennially real.

So the circle of hermeneutics culminates in the realm of the ideal; love can be chemical, biological, psychological, and it can be objectively purposeful. It can be chemical at the lowest level of understanding, biological or psychological at another level, but at its highest and most essential level, it is objectively purposeful. By distinguishing vulgar from divine Love, a qualitative stance is taken. And in so doing, the statue of the *Venus de Milo* becomes more

than an aesthetic object. Instead, it is recognized as the embodiment of a vital and real Ideal. We are then no longer trapped in a relativistic aesthetics.

When hermeneutics are viewed aesthetically, then our vision of reality and life is a subjective-objectivity. It assumes that all attempts to understand the world are a matter of futile opinion; the world lacks purpose and conforms to how we think. It demands that we privilege the single assumption that reality is a matter of perspective; and thus aesthetic and purposeless. Aesthetically, Hermes is constantly in motion without destination or relief. He is permitted neither to rest nor to consummate his journeys. It is not so much that Hermes has nothing to do; it is just that he is a subject without an object. He is not permitted to love.

Beauty differs by rejecting the assumption that the world is merely aesthetic and therefore purposeless. This is not to arbitrarily privilege beauty over aesthetics. It is to deny that a meaningless aesthetics must be privileged over beauty. Lacking beauty, hermeneutics is circular and aesthetic, and the god Hermes (that is, our attempt to understand our lives) makes no sense.

In the pursuit of beauty, facts and feelings play a role, but their role is initial rather than conclusive. Facts and feelings contribute to the attempt to make sense of the world and life when they are incorporated into the pursuit of truth and beauty. In human existence love has material, organic, and psychological aspects; in a world with meaning, these constitute progressive steps towards a qualitative pursuit of beauty. In the context of human life our understanding of love ascends from the most crude, the chemical, to the most lofty and fulfilling, the spiritual. And the spiritual realm is that of responsible freedom.

Plato declines to view love only in terms of aesthetics or sociology. He regards such base notions of love as being insufficient and even beneath our dignity. Not surprisingly, those who hold an aesthetic and sociological worldview find fault with Plato's position on the nature of love.[19] This is as predictable as it is unfortunate. It is predictable because aesthetics reduces love to violence, be it that of unqualified pleasure, utility, or psychological need. It does so because it cannot comprehend that which is beyond its grasp.

As understood by Plato, beauty is associated with Venus, who is associated with the realization, indeed consummation, of personal, social, and cosmic harmony. That harmony is not aesthetic, realized by submission to habit, power, or to the controlled violence of hedonistic and pragmatic calculation, or contractual obligation. Rather it is a harmony that is substantive and realized via responsible freedom. It is to be in harmony with a purposeful reality.

But it is not the authority of Plato that makes such ideas influential; rather, it is the ideas themselves that make Plato worth considering. To do otherwise is to transform Plato (or a variety of other writers) into demigods. For example, Plato notes that according to the poet Hesiod Venus was born from the severed genitals of Uranus, free from the participation of women who are less rational. On the other hand Plato's *Republic* advocates the development of leadership

among both men and women. Certain aspects of Plato's and Aristotle's (and others) reasoning on such matters are complex, problematic, and debatable. The pursuit of beauty is not a simple process.

Plato recognizes that love can be approached in a variety of ways. He clearly distinguishes the sociology of the cult of Venus, some of the practices of which were obscene, from those who approach Venus intelligibly and spiritually. In the *Symposium* (180E) he distinguishes common love (*Pandemos*) from that which is exalted (*Urania*). It is spiritual and divine love that liberates us, by enabling us to embrace, and become one with the true and the good. It is indeed one of the first of the gods. It is in the *Symposium* (178ff) that Plato refers to Parmenides:

> First in the train of gods, he fashioned Love…

and quotes Hesiod as well:

> First Chaos came,
> and then broad bosomed Earth,
> The everlasting seat of all that is,
> and Love.

Plato invites us to consider that love is not just a matter of fact and feeling, but is more significantly a matter of intelligible meaning. There is the love that is common, and the love that is exalted. But he goes on to state that the latter is the better of the two types of love. Common love is typically physical, but exalted love is associated with the soul. It has a noble rather than base purpose. Love then is more than a matter of fact and feeling, of nature and nurture. There is a matter of quality. Love can be merely physical, but better yet is love that is physical and spiritual, and still better yet, is that love that is spiritual alone. That spiritual love drives the world towards a harmonious perfection rather than narcissistic and exploitative discord. Plato thus associates love with genuine justice.

The *Venus de Milo* is correspondingly both physical and intelligible. It is material form, but it also has an ideal content. Concerning this sculpture's physical properties, it follows the Greek Canon.[20] By canon is meant that Classicists believe that in the manufacture of sculpture, painting, music, and architecture, there is a form by which the artist is bound and thus set free from chaos and violence. There is a right way for things to be done, as determined by their nature; that right way for things to be done can to some degree be understood via the intellect and mathematics.

Classicists neither profess that the *Venus de Milo* is merely pretty and aesthetic, nor that it objectifies, for example, the simultaneous exultation and oppression of women via the male gaze. Since both male and female nudes are common to Classical art, if the gaze oppresses, it oppresses us all, which is the logical and dismal conclusion of the Postmodernist view of culture.[21] Classi-

cists profess that the nude is better than the naked in that the nude pursues the ideal whereas the naked dwells in the purposeless and therefore exploitative passions. The nude is linked to the ability of human rationality to discern purpose in art and life; the naked is linked to brute instinct or worse.

We can return to the quote cited earlier: with the *Venus de Milo* "the ideal is taken out of the hypersensible world of reasoned proportions and made into an apparition of living flesh." That phrase is subject to the circle of hermeneutics; how we understand that ideal is subject to a variety of interpretations. Is the "hypersensible world of reasoned proportions" grounded in human rationality alone; is it but a mask for power? Or is it connected with a meaningful reality? Without a thorough discussion, those choices are not recognizable much less meaningful. But as noted above in detail, they are meaningful indeed. For the beauty- seeking Classicist that phrase means that love is a transcendent ideal beyond place and time which is made manifest in temporal and human form via fine art. That is a fact, but it is also more than a fact. It is a fact considered within the context of a meaningful universe. Within this context a work of fine art offers meaning and that contextualization is more than personal or social. It is ontological. It is then possible to seriously consider Venus for what she claims to be: a representation of the driving force in our lives in a meaningful world. And it stretches credibility to assume that the makers of such objects were all naïve or conscious and determined hypocrites who merely pretended that those beliefs were true, good, and beautiful.

The Foundations of Classicism: Mythic and Philosophic

The initial step in escaping an aesthetic misunderstanding of Classicism is to consider myth and philosophy as more than aesthetic fictions —or masks for power. What then are they? They are attempts to comprehend a purposeful cosmos. One foundational principle of Classicism is that reality and life are purposeful; the cosmos and civilization are more real than chaos and barbarism. Some degree of knowledge of that purpose is to be sought. Consequently, another principle is that truth is thought that corresponds with reality and therefore truth and meaning are not constructed, not created, but discovered. The world evidences degrees of perfection, and ultimately that which is more perfect, more ideal, is that which is ultimately more real.

These principles are important to the history of art, since they mandate that art correspond with reality, that fine (or rather, liberal) art aspires to the ideal, and that fine art is found, not made. Combined, these ideas result in the premise that art is concerned with finding and making manifest truth, that it is imitative of reality rather than creative. The free and responsible subject seeks to understand a meaningful object.

In contrast, aesthetic relativism holds that human freedom and dignity are realized via our ability and need to construct our own understanding of reality

and life. Freedom is thus seen to be realized via the creative pursuit of an aesthetic vision. It is no surprise then that to the aesthetic mind the idea of finding truth, and the notion that the goal of art and life is to imitate the real, is seen as a dreadful form of repetitive oppression. We shall see in later chapters that the association of freedom with creativity makes no sense, since creativity in the absence of objective truth is meaningless. To engage in such purposeless freedom is neither free nor creative. It is to be condemned to the prison of pointless banality.

The present point is that since imitation of truth is central to Classical culture, then before we can look at a Classical work of art and actually understand it, the prejudices held by the aesthetic mind against it must be acknowledged and taken into account. To get beyond an aesthetic appreciation of a work of art there is the need to obtain the knowledge that makes possible a glimpse of beauty.

We have discussed how Venus and Hermes are but a part of the pantheon of Greek mythology, and as such are part of the larger family of deities. They are accompanied by Mars, Artemis, Zeus and Poseidon, Athena, Apollo, Demeter, and Dionysius. The presentation of these deities in fine art is an attempt to explain how the world works. So if statues of Apollo, Athena, Venus, or any other Greek god, are viewed aesthetically, as a matter of nostalgic fact to which we can respond emotionally, then we necessarily are looking at public art the meaning of which is fictitious or purely personal. That art might serve in providing emotional pleasure or a private mystical connection with a deity of some sort with whom one emotionally identifies with. It could not serve as a means of rising above the subjective in the pursuit of the ability to freely do what is known to be close to the right and good.

Aesthetically speaking, such works of art are then fictitious, or only ontologically true to subjective and emotional experience. In the former (Kantian) case the intrinsic meaning that what those works of art declare to be true can no longer be taken seriously, in the sense that what they declare could be accepted as a matter of objective understanding. In the latter (Nietzschean) case, we are permitted to respond to these deities only as a matter of personal feeling and identity, via a willful mysticism of a sort. In neither case is Classical art considered on its own merits.

The Aesthetic vs. the Beautiful Apollo

For example, according to the Postmodernist interpretation of Classicism offered by Nietzsche, the famous Apollo Belvedere in the Vatican Museum (figure 4) is disingenuous. It purports to represent Apollo, the god of reason, as distinct from Dionysius, the god of pleasure. But for Nietzsche Apollo is simply Dionysius in disguise, rationality is but a mask for willful preference. Moreover, the work is a Roman copy of a Greek sculpture from the late fourth century. But if it is a copy, it cannot be creative, and since the original is Greek

and the copy is Roman, then it is difficult to maintain that the copy is authentic in meaning or manufacture.

This presents multiple problems for understanding statues of Apollo. If a statue of Apollo is aesthetic, it must be both creative and authentic, but this statue is neither. In either case the personal reigns, and reason is reduced to feeling, Apollo is reduced to Dionysius, who in turn is reduced to a subjective and willful preference. The result of reducing our acceptance of the reality of Apollo to a matter of personal taste and identity is—a rejection of Apollo. He embodies the importance of the rational; to accept his existence on the basis of feeling is to destroy him. Another result of reducing Apollo, or reason, to a matter of personal opinion and identity is the attempt to deny the public sphere of art and culture. Apollo represents the subject attempting to comprehend an object, namely reality and life. But when art and culture are the expression of the personal, then public culture can only be grounded upon power. The public realm becomes the arena of the subjective, where the object dissolves into a Dionysian passion. This rejection of Apollo, of what that noun represents, is a rejection of the objective realm—both of the public square and of a meaningful objective reality. It requires the privileging of an aesthetic of indifference and an aesthetic of identity. But both cannot rationally be privileged at the same time, nor can either recognize an objective realm beyond the subjective, the political, and the willful. A subjective-objectivity reigns.

The *Apollo Belvedere* is now in the collection of the Vatican Museum, Rome. From the perspective of a fact-based aestheticism, this statue of Apollo can only be a physical object made by people at a particular time or place. It is then a kind of nostalgic mask, presenting subjective ideas once held by some but without objective and enduring merit. For the sociologist, it is a fact that Greeks at one time made such statues representing their religious beliefs, but those beliefs are held to be a matter of personal and social convention—where only matters of naturalistic and sociological fact can be confirmed or denied. Within that context, the success or failure of the Apollo Belvedere in attempting to portray an accurate understanding of reality and life is held to be beside the point. Apollo is to be contemplated via an anti-Apollonian viewpoint.

But such objects were commonly made precisely because they were held to represent an aspect of truth, that is, an accurate understanding of reality and life. More than being considered merely a part of Greek mythology (and thus incorrectly understood to be psychological or social fiction), they represent the attempt to obtain a glimpse of wisdom, and to apply that wisdom in the public square. That is why they are beautiful. For example, Plato recognizes that for better or for worse the fine arts influence behavior. He argues that if a product of ignorance, fine art is harmful, and as a product of malicious intent fine art becomes demagogic. In either of these situations it exercises a corrup-

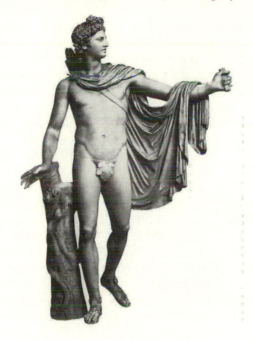

4. *Apollo Belvedere*

tive influence on people and society. Contemporary advertising reaffirms the merit of Plato's concerns. Billions of dollars are spent annually on advertising to influence commercial and political behavior. Current funding for Modernist and Postmodernist art advances a specifically aesthetic vision of life. Such funding influences our political and moral notions as well.[22]

Plato attributes to fine art the ability to influence human behavior. So in the case with Apollo, sculpture can influence behavior by making a truth claim publicly attractive. As Kenneth Clark puts it:

> The Greeks had no doubt that the god Apollo was like a perfectly beautiful man. He was beautiful because his body conformed to certain laws of proportion and so partook of the divine beauty of mathematics...So in the embodiment of Apollo everything must be calm and clear; clear as daylight, for Apollo is the god of light. Since justice can exist only when facts are measured in the light of reason, Apollo is the god of justice; *sol justitiae*.[23]

Apollo is variously perceived to be the God of light, of prophecy, as the mouthpiece of the wisdom of Zeus, and of fine (or rather, liberal) art. Wisdom is knowledge of how the world makes sense, and how we might best pursue happiness. That wisdom is to be grasped by reason, but reason operates in varying ways. Homer (*Odyssey,* viii 488,) perceives a close connection between prophecy and wisdom and the role of Apollo. The oracular form of

wisdom was musical, which contributed to associating Apollo with music, song and dance. The rational is also associated with music, song and dance with Apollo, as opposed to irrational noise, ranting, and childish leaping. In his text, *Laws* (Book 2, 653,654), Plato notes that reason and wisdom produce rhythm and harmony, and since the world is properly a cosmos, then harmony is both intelligible and beautiful. Whereas aesthetics alone results in an unintelligible and therefore ugly cacophony, reason and wisdom refer to what Plato calls the *music of the spheres*.

Plato extensively discusses the meaning of music in his various texts. It is consistent that Plato would agree with the association of Apollo with music and the arts at their finest, because art at its finest is intelligible and beautiful. Apollo is often shown holding a lyre, a musical instrument, whose music is associated with beauty, with intelligible harmony rather than the ecstatic rhythms of the flute and drums that belong to Dionysus and Cybele. Why is intelligible harmony better than ecstatic passion? It is because we can be passionately stupid in our attitudes, our beliefs, and our actions. Since passion alone leads to chaos and unhappiness, music should embody more than just emotion. Beautiful music is the *music of the spheres*; it is the intelligible sound of the cosmos (as opposed to chaos), whereby an understanding of reality and life is obtained.[24]

For Plato, and Apollo, music is ontological; the arrangement of sounds in music properly reveals how the world works; the organizing principle of music imitates the organizing principle of reality and life. By that Plato means that if you like frenzied music, if you mistakenly find it to be beautiful, then for your preference to have standing, reality itself would have to be frenzied. If the world is naturally chaotic, then noise would be music and vice would be virtue. Alternatively, in a cosmos, harmonious music is objectively true, good, and beautiful and worthy of our love.

To a significant degree, Plato makes the point. To argue against Plato is to argue that fine music and the visual arts neither influence our behavior nor mirror our understanding of the world and life. It is to trivialize them or reduce them to a matter of subjective identity. Discussing the meaning of music is then to engage in a non-aesthetic task. It is therefore important to recognize that treating music as a matter of Modernist taste (where the arrangement of sounds is coherent and or emotional but not grounded in a knowledge of reality) or Postmodernist taste (where it is reduced to a matter of willful identity) is to trivialize and brutalize both music and reason.

Without doubt, there is a place (albeit a minor one) for entertainment. But to equate culture with the trivial (or the partisan) is to reduce fine art and culture to narcissistic gratification. And a culture of narcissistic gratification is no culture at all.

Classical Philosophy and the Pursuit of Beauty

For those who confuse thinking with feeling, who see Apollo as Dionysius in disguise, the attempt to understand the world and to grasp a glimpse of love and beauty makes no sense. Nor do the ideas of Socrates, Plato and Aristotle. Those ideas center on the notion that culture ought to aspire to the objective ideal. That ideal is found in the intelligible purpose of the universe. Plato presumes a cosmological source of that purpose, whereas Aristotle pursues a teleological vision. Since a purposeful universe is a beautiful one, Plato and Aristotle must address the nature and relationship of *being* and *becoming*, and also of goodness and evil, of virtue and vice. Beauty is key to this task. Plato and Aristotle agree that beauty lies in perfection, but whereas Plato sees the pursuit of goodness and beauty as one in art and life, Aristotle separates them. He finds ethics to be concerned with goodness and beauty, but art to be aesthetic—a matter of perfection and emotional response.

For Plato, art and ethics aim at that which is both true and good; they aspire to the intelligible rather than material and emotional realm. There are particular instances of beauty and justice, but those rightly aspire to the universal Ideals of Beauty and Justice. Therefore art and ethics qualitatively vary in degree from the mundane and aesthetic to the ideal and beautiful; one climbs a ladder from the material to the ideal, from the merely aesthetic to the splendor of beauty.

For Aristotle, behavior is subject to a moral criterion involving goodness and beauty, but art is to be evaluated in terms of producing something with aesthetic perfection. Whereas for Aristotle, a perfect barn, a perfect bomb, and a perfect cathedral are all equally perfect and thus of equal artistic value, for Plato the intelligible aspects of a perfect cathedral are qualitatively more profound than those of a barn, and therefore the cathedral evidences more beauty than merely an aesthetic barn. This is because its form is a closer approximation of the Ideal, of Beauty, Truth, and Goodness.

The tensions between these two positions are central to the very substance of Western culture, at least until the advocacy of Modernism. As discussed in detail later, it is the Aristotelian tradition that is central to the development of the Modernist-Postmodernist tradition. That tradition places the Classicism of both Aristotle and Plato into a purposeless context, with the result that they and Western culture are trivialized and brutalized.

The identification of Classicism as a set of beliefs is identical to recognizing Classical culture being dedicated to the pursuit of beauty. In Plato's text, *Cratylus* (416), beauty is affirmed to be associated with the mind, not aesthetics, with intelligence rather than sensation and emotional response. It is an intelligence seeking knowledge of a meaningful world. As Socrates puts it:

> Then mind is rightly called beauty because she does the works which we recognize and speak of as the beautiful...

However, Plato and Aristotle differ significantly in their approach to art and life. Greek language distinguishes between *aisthesis* and *kalos*, the former associated with sense perception, the latter with the goodness and excellence of a thing. Both Plato and Aristotle use the terms *aisthesis* and *kalos,* but differently. Plato distinguishes aesthetics from beauty, finding the former to be comparatively trivial. He discusses the differences between aesthetic pleasure, utility, and beauty, in the *Hippias Major* (287e ff), and the *Republic* (Book VI, 505d). Pleasure and utility are shown to be utterly inadequate as determiners of goodness. In the *Symposium* (211b) Plato presents a beatific vision:

> He who...under the influence of true love, begins to perceive that beauty, is not far from the end. And the true order of going, or being led by another, to the things of love, is to begin from the beauties of earth and mount upwards for the sake of that other beauty, using these steps only, and from one going on to two, and from two to all fair forms, and from fair forms to fair practices, and from fair practices to fair notions, until from fair notions he arrives at the notion of absolute beauty, and at last knows what the essence of beauty is.

For Plato, beauty (*kalos*) is superior to *aisthesis* by its intelligible qualities, its association with the true and good, which are transcendental in nature,[25] and enduring rather than just momentary, materially pleasing, or utilitarian. Aristotle reconsiders the transcendentalism of Plato, and therefore must reconsider the relationship of beauty and aesthetics.[26] He does so by using the term beauty in two very different ways. On the one hand beauty refers to moral action, where *becoming* aspires to the good (*being as good*). On the other hand beauty is used in an aesthetic sense, in that it refers to the perfection of a thing (*being as such).* Since Aristotle assumes a purposeful world, he then assumes that *being as such* is an aesthetic perfection. But lacking the assumption that the world is purposeful, then *being as such* has no real significance—in art or in ethics. It is but a formalistic and existentialist construct. As explained below, the consequences of this position affect us to the present.

When Aristotle uses the term *kalos* in his book, *Metaphysics* (1078a), he makes a telling distinction concerning the realm of beauty. He states that "...the good and the beautiful are different (for the former always implies conduct as its subject, while the beautiful is found also in motionless things)."[27] Physical beauty is disassociated from living transcendental goodness because goodness is a matter of conduct whereas beauty is a matter of condition.

In his text, *Rhetoric* (1366a), Aristotle states that the morally beautiful (*kalos),* which is desirable for its own sake, is that good which is pleasant because it is good. It is good because it involves acting truthfully, that is, for a good purpose. But outside of the realm of behavior, beauty is disassociated from goodness. For example, Aristotle states in *Poetics* (1450b) that beauty is found in perfection rather than goodness.

So Aristotle associates beauty with good behavior, but otherwise beauty is associated with formal perfection. Goodness is a matter of becoming, whereas beauty is a matter of being. This distinction between conduct and condition is one that reflects a general philosophical difference between Aristotle and Plato.

Some writers have suggested that there exists confusion in Aristotle's viewpoint concerning beauty and aesthetics. But there is consistency to his approach: in *Rhetoric* (1366a) Aristotle refers to *beauty (kalos)* in terms of goodness, as found in ethical action rather than as an object or thing, whereas in Metaphysics (1078a) he refers to beauty (*kalos*) in an aesthetic fashion: beauty is not associated with goodness, but with the perfection of a thing.

For Aristotle, art is skill, which when applied to things, is aesthetically evaluated. But it is prudence that can to varying degrees aspire to truthful and good action. For Aristotle fine art is not so much an epiphany of the transcendental, as a perfection of a kind. Thus the world is no longer where to varying degrees the transcendental ideal operates. Rather, it is separated into two realms: that which is sensual and aesthetic, and that which is moral and intellectual.

But when aesthetics is separated from the moral and intellectual, beauty is reduced to aesthetics, and the world is no longer beautiful. It becomes a matter of fact, feeling, and perfection.

For example, with Aristotle ethical actions are beautiful when they evidence that which is true and good, but art objects and performances are to be evaluated aesthetically—as a matter of perfection and emotional response. Their goal is to provide aesthetic pleasure. Even in the rare instances where Aristotle uses the term *kalos* in this context, he defines the term aesthetically. Art objects are to be judged in terms of their perfection and our emotional response to them, not by the degree of their claims to wisdom. So for Aristotle a perfect barn (or for that matter, a bomb) may be as perfect as a perfect cathedral, and since both are perfections of a kind, both are equally aesthetic. But for Plato, the intelligible content of a barn (or a bomb) is comparatively base to that of a cathedral; so a perfect barn is not as beautiful as a perfect cathedral because the latter is closer to the Ideal and thus more profound.

For both Plato and Aristotle artistic sin is to fail to make something perfectly. For Aristotle, artistic sin is separate from moral sin; making a perfect barn (or bomb) is one issue, the use of that which is made is yet another. For Plato artistic sin is combined with moral sin (or virtue): the making a perfect barn (or bomb) substantively and comparatively remains base and lacking in the Ideal. To some degree the barn is beautiful, but for Plato it is not nearly as beautiful as beauty can be, because absolute beauty is beyond the merely utilitarian and mundane.

By recognizing a difference between the beauty of moral actions, which admit intelligible ideals, and the aesthetic perfection found in works of fine art, Aristotle rejects the Transcendentalism of Plato and occupies a middle position between Idealism and Naturalism. However, it is a tenuous position.

He still relies upon the assumption that the world is purposeful. But lacking that assumption, both beauty and morality become solely aesthetic and thereby cease to have a meaningful connection with the ideal. Culture then becomes a matter of power, however perfect or imperfect its pursuit might be. Indeed, by distinguishing between a moral beauty of action (*Metaphysics* 1078a), and an aesthetic beauty of things (e.g. *Poetics*, 1450b), Aristotle anticipates and accommodates the later Modernist assumption that beauty is non-cognitive, self-referential, and a perfection of a kind; that aesthetics can make ugly or harmful things seem beautiful.[28] This will be discussed in detail later. For the moment, let it be emphasized that however much Aristotle's aesthetic vision is compatible with that of Modernism-Postmodernism, there remains a significant difference: the Aristotelian tradition disagrees with the Modernist-Postmodernist tradition by denying that reality itself is merely a willful and thus purposeless construct.

So we see that the Greek term *aisthesis*, to perceive through the senses, is in contrast to *kalos,* the beautiful. The foundational principle of *aisthesis* is materialism, whereas the foundational principle of *kalos* is intelligibility. Plato emphasized *kalos*, Aristotle attempted to compartmentalize *kalos* and *aisthesis*, and as we shall later see, Modernism and Postmodernism pursues a type of *aisthesis* alone. The clarity of that singularity of emphasis is found in the coining of a new term in 1750: *Aesthetics*. It is a term of great importance to the Western tradition from Kant to Nietzsche; but it is of tragic importance, in that its rise to importance parallels a general decline in Western civilization.

Working from the traditional Greek term *aesthesis*, the new term *Aesthetics* was coined by Baumgarten in 1750. In his text, *Aesthetics,* Baumgarten blurs the distinction between *aisthesis* and *kalos,* a blurring anticipated in Aristotle, and commented upon by none other than Immanuel Kant.[29] It is a confusion that remains commonplace today, amongst specialists and general readers alike.

This confusing of the terms *beauty* and *aisthetics* has practical consequences in that the pursuit of aesthetics is to privilege one particular metaphysic over the other. It is to view the world materialistically or naturalistically rather than as a source of meaning. It is to demand that reason and the correspondence theory of truth be limited to facts, feelings, and rationalistic perfection. It is to demand a purposeless reality and life. The subsequent confusing of *aisthesis* and *kalos* is necessarily paralleled by a confusing of fact and truth and a blurring of empiricist sociology with culture. Aesthetically, facts and feelings are assumed synonymous with truth and beauty, but an aestheticized beauty and truth cannot help explain the world. Indeed, they are reduced to factually describing parts of it, and accommodating how we feel and rationalize the world to be. And when aesthetics occur in the absence of transcendent or divine good, then barbarism results.

To reduce judgments of value to mere aesthetic preference and rationalization is to reduce them to a matter of subjective preference; this undermines the very notion of culture. Indeed, the philosopher Walter Benjamin stated that the aestheticization of politics is fascism;[30] to reduce politics to a matter of individual or group preference is to reduce culture to a perpetual form of violence, controlled, at best, by calculations of hedonism or legality, to the exclusion of Justice.

The consequences of this Aristotelian distinguishing of beauty from aesthetics can be illustrated as follows: Which is better, vanilla or strawberry ice cream? That question is an aesthetic one, which can only be approached as a matter of personal and subjective taste. Which is better, vanilla or cyanide ice cream? To treat this question as a matter of aesthetic taste is repugnant to basic civility. It is barbaric. It is rightly a question of beauty, not aesthetics. It involves the issue of understanding. Those who understand the enormity of manufacturing and distributing poisonous ice cream rightly understand and see such an act as ugly. But to the aesthetic mind, it is perfection and emotion, not quality, that matters. Indeed, as Plato and even Kant recognize, aesthetics can make ugly things seem beautiful; therein lays the danger of an unintelligible aesthetic world.

The term aesthetics refers literally to that which is sensual and physical; it is central to contemporary thought, and antithetical to the view of most traditions around the world through time. That which is aesthetically pleasing is a matter of taste, a matter of personal or group preference, however simple, fancy, or dangerous it might be. It stands in contrast to the notion of beauty, which is associated with the attractive power of wisdom or perfection. That attractive power of wisdom or perfection is associated with that which is true and good. As just introduced, that association differs somewhat between the Platonic and Aristotelian approaches.

So how would Plato and Aristotle evaluate ice cream? The Platonic tradition is cosmological and transcendent. It agrees that beauty is intelligible, and is characterized by the splendor of wisdom, of making manifest to some degree that which is universally true and good. The Aristotelian tradition is teleological and immanent. Here beauty is also intelligible, but in a limited way: beauty (and goodness) is found in actions rather than objects. It is moralistic rather than physical. For Aristotle both prudence and art are teleological but whereas the former aims at realizing virtue, the latter aims at the perfection of making something. So ice cream is not a matter of taste, but a matter of beauty; ice cream ought to be wholesome. It is the ideal that ought to be realized. About this both Plato and Aristotle would agree. But whereas Plato focuses on our need to love ice cream that is wholesome, Aristotle assumes that ice cream will be wholesome (as all food ought to be), and takes for granted that the person selling the ice cream will be a responsible moral agent (as all persons ought to be). In comprehending the wholesomeness of ice cream, Plato can then admit

to loving it; Aristotle takes for granted that the ice cream made and sold is wholesome, and focuses on the pleasure of eating it. Their approach to fine art follows the same logic.

Within the Classical tradition two important trends coexist: beauty (or ice cream) is directly associated with goodness or it is not. Those like Plato who identify beauty (or ice cream) with goodness, will see beauty when goodness is understood. Those like Aristotle who indirectly associate beauty with goodness assume that the role of art is to provide aesthetic pleasure, separate from ethics and prudence. These positions can be in harmony in the presence of the benevolent Aristotelian assumption that the artist, the maker of a thing, ought to be moral. But in a culture that no longer believes in a purposeful world, or an objective morality beyond calculations of power and advantage, Aristotle's aesthetics are transformed from the perfection of *being* to the application of violence. As we will consider later, lacking the assumption of a purposeful world, Aristotle provides the means by which taste alone prevails. When taste alone prevails, love and beauty and justice no longer exist.

Doxa as the Alternative to Skepticism and Absolutism

Both Plato and Aristotle are committed to the correspondence theory of truth. The correspondence theory of truth takes for granted that the goal of thought is to be in contact with objective reality. As evidenced by Plato's famous example of truth-seekers being like those deep within a cave, who can only obtain a slight glimpse of truth, Classicists acknowledge that there are serious difficulties to be dealt with in pursuing a correspondence theory of truth. But they view those who thus abandon all hope that wisdom is obtainable as disingenuous at best. Those who argue that truth is made, not found, are recognized as constructing a subjective truth by which to live. As such, they do not actually deny a correspondence theory of truth. What they do is transform the correspondence theory of truth from a concern for objective purpose to one of subjective purpose, from that which a scholar seeks, to that which a demigod decrees. A subjective-objectivity results then where the only discernible "good" is found not in reality but in the triumph of the will.

The Classical presumption that the world is purposeful is particularly significant to understanding Classical culture. A purposeful world is one where things have comparative value—those things or events that are objectively purposeful are better than those that are random or mechanical. The idea of value depends on our ability to recognize some things as more important than others. When comparative value exists, hierarchy exists because hierarchy is simply another term for value. A world with purpose is a world with meaning; a purposeless world is devoid of both. However, a hierarchical culture does not require a hereditary hierarchical society; we can advocate an equal freedom to responsibly seek the ideal, which may or may not result in equal results. But to deny hierarchy is to deny value, and to deny value is to abandon any hope of

life being more than mere chance, mechanical or biological necessity, or sheer willfulness. It is to establish a hierarchy based not on virtue, but on violence.

To study Classicism as a matter of fact and feeling is to attempt to understand Classicism from a valueless aesthetic perspective. This results, however, in a censorship of the Classical viewpoint (and of most traditions around the world that are not Modernist-Postmodernist) without it first being understood. But beyond that concern, to assume that all values, and therefore cultures, are equal is to censor ourselves by removing any purpose in studying the history of art.

The irony is that those who deny the correspondence theory of truth cannot help but advance their own beliefs about the nature of reality and life. Whether it is Materialism or Pragmatism, Structuralism or Deconstructionism, those who denounce or transform the correspondence theory of truth inescapably advance their own theory of truth about the nature of reality. According to the relativism of Modernist thought, facts are objective, but reality conforms to how we think. From the Classical point of view truth is thought that corresponds with reality, but reality is not simply a matter of fact or fiction; it neither conforms to how we think, nor to what we experience. The world is not an extension of our narcissism.

To Classical culture the nature of reality is that it is objectively purposeful. And since determining its purpose is a difficult task, knowledge is not simply a matter of fact or fiction, but rather, is mediated by *doxa*. By *doxa*[31] is meant that given the evidence available a certain degree of insight about the nature of reality and life is reasonable. Attempts to understand reality and life are not a matter of dogmatic conviction, nor are they skeptically denied. Rather, they result as a matter of thoughtful discourse. Just as in a court of law, *doxa* requires an evaluation of the evidence resulting in a conclusion based upon that evidence. In his *Republic* (509) Plato gives his famous *Simile of the Line*. He discusses the differences between sheer nonsense, opinion, and true knowledge. He prefers true knowledge to informed opinion, and informed opinion to nonsense, but he significantly notes that understanding can purposefully attempt to rise from nonsense to opinion and perhaps even to knowledge.

It is not disputed that in the future, with more or different evidence, conclusions might need to be reevaluated (which is no different to that which happens with scientific theories), but that does not negate the value of *doxa* as part of the path towards understanding. Indeed, it confirms its importance and value: it affirms the necessity of informed judgments in life, and it confirms the possibility of progress in the realm of knowledge. A constant evaluating and reevaluating of our knowledge of reality and life negates skepticism, fanaticism, and reductionism. We cannot simply embrace a simplistic, nihilistic, or obscure dogmatism. We cannot embrace aesthetics.

So the assumption that thought corresponds with a purposeful reality necessarily requires that truth be found, not made, and that the attempt to under-

stand reality occurs as a matter of degree rather than as a matter of factual particulars or prideful assertions. It requires the free exercise of responsible discourse coupled with a respect for evidence and logic.

This has a practical effect on how we approach works of art. That works of fine art attempt to explain reality and life is self evident to any thoughtful viewer. Even a cursory visit to a major museum will make clear that fine art through the ages and around the world attempts to provide us with a glimpse of reality and life. Moreover, to argue otherwise is to argue that works of art are meaningless and therefore no longer recognizable in any but an arbitrary fashion. If their attempts (and ours) to explain reality and life were limited to facts and feelings, we would learn little that could advance our understanding of the world and life. We would deny the possibility that *doxa* ought to be deliberately pursued and critically analyzed. We would simply embrace the facts and constructions towards which our feelings draw us—engaging in a smugly aesthetic self-indulgence.

But the notion of *doxa* affects more than the notion of knowledge. *doxa* denies the necessity of an approach to culture that vacillates between aesthetic subjectivism and aesthetic authoritarianism. As such it offers a different way of approaching fine art. If we are accustomed to thinking in terms of fact vs. fiction, then it is likely that our approach to art will be one of art vs. non-art. What is neglected is the notion of gradations of art just as the pursuit of *doxa* recognizes that there are gradations in knowledge. This permits that works of art are not a given, grounded in taste, genius, or power, but rather, must somehow be recognized and qualitatively distinguished from other works and amongst themselves. It encourages that a realistic hierarchy of value be determined and justified.

In an aesthetic world, fine art is distinguishable from the mundane by assertions of personal taste, claims of genius, or power. In any case, free and responsible thought on our part is made negligible. We need merely to assert (positively or negatively) or submit. But Classicism does not rely on assertions of taste, genius[32] or power; rather, works of art are to be evaluated and assessed, to determine if they are indeed works of art, and if so, to what degree they are important.

Creativity and Imitation

It is common in Classical art to encounter copies of original works from the past. The Apollo Belvedere is just one example of many. The issue then arises as to the intrinsic value of such a copy. It is not original in any sense of the term, nor can it be viewed as progressive or innovative. The practice of imitating past works is not unique to Classicism; various traditions around the world (such as Confucianism) take it for granted. But Modernism does not.

The question that results is whether imitation should be considered in knowledge and art, and if so, on what grounds. This results in a reexamination

of the notions of reality (*being*), time (*becoming*) and knowledge. It also causes us to reconsider the idea of freedom, since the Classical tradition advocates freedom via imitation whereas Modernism advocates freedom via creativity. So which is it in art and life? Is freedom synonymous with imitation, or creativity? These questions present us with practical issues to contemplate and resolve. A study of Classical art facilitates that task.

A common principle held by both Plato and Aristotle is the idea of the eternity of the universe; the world was not created out of nothing (as maintained by Biblical culture and referred to by the Latin term, *creatio ex nihilio*), nor as a matter of chance. Rather, it is arranged out of what is always there (*being*). They also view time as cyclical rather than linear. The origin of the world and the nature of time may seem obscure to daily life. They may also seem obscure to a history of art. But fine art reveals how a culture views the world and it attempts to affect how its viewers pursue their daily lives. A culture believing the world to be eternal will differ from those believing in linear progress, or of mere random change. Such differences entail enormous political, social, and cultural consequences. Western culture has long believed in progress. That the Classicism of antiquity, the Neo-Classicism of Kant, and the Postmodern Classicism of Nietzsche do not believe in progress is worth addressing since the stakes are so dear.

Aesthetic vs. Beautiful History

The question of whether reality and life are linear or cyclical involves many peripheral issues as well. It touches upon the notion of ethics, of freedom, and of beauty. It certainly affects our understanding of history, and of the history of culture and art.

The complexity of this important issue is easy to establish. As Plato put it, time is the moving image of eternity. To Classical culture, history is the perennial record of humanity striving for the immutable ideal. The Neo-Classicism of Kantian Modernism holds that time is but a category in our minds, hence, so too is history. History is a constructed narrative with no essential beginning and no anticipated destination. History is thus blind to purpose and quality. In contrast, Postmodernists such as Hegel and Marx affirm the linear and objective nature of time, and history, but view it as the unfolding of power. So when Nietzsche reaffirms the Classical idea of eternal recurrence (in his 1881 book, *Thus Spake Zarathustra*), he does so in a way incomprehensible to Kant, Hegel, Marx, —or Plato. Nietzsche associates history with aesthetics rather than beauty, with which Kant would agree, but he also associates history with power and the will. Hegel and Marx would accept the association of history with an aesthetic unfolding of power (while erroneously considering the unfolding of power to be beautiful), but neither could accept Nietzsche's notion of eternal recurrence.

So where then are we? Kant's and Nietzsche's Classicism are both aestheticized, and as such, are subjectified. Neither aims at an understanding of purposeful reality. Rather, they aim at aesthetic taste or identity. Similarly, Hegel, and Marx aestheticize history by associating history with the unfolding of power. The common result is a conceptual morass—but it is only the necessary result of the aesthetic vision. It is a chaos that Plato and many others would reject. For example, is Plato's idea of history being the moving image of eternity, a moving image that operates not within chaos, but a cosmos. This vision associates history with beauty rather than the temporal or perennial pursuit of aesthetic fact or power. For Plato history is the temporal realm in which perennial beauty is sought. The subject seeks knowledge of a purposeful object—reality (or *being)*.

Classicism offers as foundational a number of principles, which provide a means by which we might attempt to understand and find purpose in reality and life. The foundational principle that the universe is eternal has one consequence: it makes impossible the notion that art is creative in the sense that it involves making something substantively and historically new; we cannot willfully remake reality (or *being)*. Even that which seems new to us is not. If there is nothing ontologically new in this eternal universe, then two choices remain: Plato's, where that which we make and do can aspire to an imitating of an objective and enduring ideal, or Nietzsche's, where that which we make and do is that which we repeatedly make and do. Nietzsche's hatred for Socrates and Plato therefore makes perfect sense; his existential interpretation of Classicism (discussed below) is antithetical to all that Plato stood for. It is willful, coercive, arational, and violent. Of the two choices, it is Plato who invites us to imitate a transcendental realm of the ideal. Doing so may initially strike us today as an affected celebration of repetitive boredom: all that we make and do merely being an imitation of that which is staid and established. But consider the Kantian and Nietzschean tradition's notion of creativity from the viewpoint of Classicism. For the Kantian and Nietzschean, both reality and art are constructs, the former ostensibly a rational structure, the later a structure based on authentic experience. In both cases the ultimate conclusion is the will to power. Both are aesthetic responses to the world and life. Creativity is then the process by which we rationalistically and or willfully construct new visions of reality and life; art follows suit. But the Classicist can well ask if such history and such creativity can have any meaning in a world where truth and culture are willfully constructed. Since no construct is necessarily better or more meaningful than any other, then there is no objective value to any constructs at all. In the name of freedom or authenticity creativity thus reduces culture to a meaningless and willful trivialization of reality and life. If all meaning is comprised of willful constructs, then all such constructs are equally a matter of taste. And there is no disputing taste: it is both trivial and dogmatic at the same time. Within the Kantian-Nietzschean

tradition, history is thus trivialized by Kant, and brutalized by Hegel, Marx and Nietzsche.

By equating dignity and freedom with a subjective creativity, we can only be free to do that which is objectively meaningless. This reduces culture to mere rationalization, or a willful assertion of authenticity, where freedom is substantively identified with willful necessity. Once again, a subjective-objectivity prevails, and it permits no space, no air, for freedom or love or beauty. We are thereby condemned to a consistent and violent banality where the subject can no longer freely and responsibly seek a meaningful object.

What then of the Classical notion of imitation? The Modernist-Postmodernist tradition is consistent in its belief that reality and art are experiential constructs, and as such, are essentially aesthetic experiences. It is consistent in its relativistic reduction of culture to mere lifestyle, be it trivialized or viewed as a matter of absolute identity. It is also consistent in its assumption that progress is synonymous with change, rather than with the unfolding of wisdom. In contrast, the Classical notion of progress as a perpetual pursuit of wisdom and beauty centers on the imitation of the ideal; it is what permits progress to be realized: it is the perennial attempt to comprehend that which is ultimately beyond our complete comprehension. The Classical pursuit of the ideal admits that historically the ideal can never be completely or perfectly known or achieved. But precious glimpses of it can be obtained to some degree. It advocates neither an absolutist skepticism nor dogmatism. It is at least doxatic, while striving for more.

So just as friendship progresses in time as the bonds of amity and community are deepened, the Classical notion of imitation recognizes progress in time as a deepening understanding of the enduring ideal. It is not a matter of a new and superficial arrangement of facts and feelings, but rather, a deeper (and hence more profound) understanding of that which is truly important. Art as the imitation of that which is enduringly right facilitates a broad variety of substantive insight rather than a wide and superficial variety of aesthetic responses.

Finally, the idea of an eternally meaningful universe results in a series of consequences that affect not only art but also our daily lives. It permits a limited possibility of responsible freedom rather than an aesthetic monism, where an aesthetic subjectivity uniformly prevails. Instead of a purposeless and thus self-negating creativity, the goal is a free imitation of the enduring ideal, an imitation of which is paramount to the pursuit of genuine happiness.

Is freedom rightly associated with creativity and aesthetics, or is it dependent upon the pursuit and imitation of a purposeful reality (or *being*)? Creativity and aesthetics, which necessarily deny meaningful purpose, cannot offer much. In contrast to the Modernist-Postmodernist notion that creativity is the act of newly constructing the world and our place in it, the Classicist holds that producing such novelties is at best naive, at worst, self-deifying. It is

naive and harmful by its egotism and its denial of meaningful freedom; it reduces our actions to a trivial or dogmatic aestheticism, which denies freedom by confusing it with power. In sum, an aesthetic culture assumes power to be the essence of social life, and its admonition for tolerance can only mask a culture of violence where none truly can be free. It matters not whether the rule of law exists: a codified violence is no solution to ontological violence. Nor does it matter if society is secular or religious: whether it is the will of the people, or the will of God, which prevails, no qualifications can be offered of either. In the name of aesthetic freedom a nihilistic totalitarianism prevails.

In summary, the pursuit of beauty centers on understanding rather than power, and understanding is dependent not upon a willful coercion, but upon a freedom to love beauty and justice. This brings us back to a consideration of the Apollo Belvedere. As noted above, Kenneth Clark says of Apollo (*The Nude. A Study in Ideal Form* (1956)), 55:

> The Greeks had no doubt that the god Apollo was like a perfectly beautiful man. He was beautiful because his body conformed to certain laws of proportion and so partook of the divine beauty of mathematics...in the embodiment of Apollo everything must be calm and clear; clear as daylight, for Apollo is the god of light. Since justice can exist only when facts are measured in the light of reason, Apollo is the god of justice; sol justitiae.

In the *Symposium* (204d) Plato makes clear that beauty and love are counterparts; both are associated with reason and justice. An act of will must occur to believe, but that will can aspire to objectivity, where belief is the result of conscious evaluation, dialogue, and a capacity to embrace the true and good. The Classicist holds that one can no more create reality and ethics than deny the seeking of truth, which is at the root of meaningful freedom. Therefore Aristotle admonishes us to be careful as to what we love—and believe. It is good advice since for better or for worse none of us can avoid believing and loving something.

Plato advocates an enduring vision of Justice and Love as positive cosmic forces. As such, freedom centers not on an aesthetic willfulness, but rather, on free and responsible action. For each generation to commit repeated acts of justice and love is a glorious use of our freedom; for each generation to fail to imitate and realize such enduring principles marks a cultural failure. Repeated realizations of justice and love are intrinsically valuable, and to assume that such repetition lacks value is equivalent to saying that acts of justice and love diminish in value as they become more frequent. To the Classical mind the imitation of the ideal is the goal of the active and free imagination, of those who can glimpse above violence and beyond an immature self-absorption. It involves the vital application of ideals to the endless variety of circumstance.

The Role of Athena

The city of Athens debated which god would best represent the primary ideals informing its society and citizens. That debate eventually centered on a competition between Athena and Poseidon. Poseidon, as the god of the sea, is the god of commerce; one of the roles of Athena, the goddess of wisdom, is to serve as the protectress of cities. She is associated with craft, both material and state. In warfare she expresses rational force rather than the violence of Ares (or Mars). Successfully competing with Poseidon, Athena becomes the patroness of Athens. That contest with Poseidon illustrates an affinity with Aristotle's philosophy, and can be demonstrated by considering that great work of Classical architecture, the Parthenon in Athens.

As a matter of fact, the Parthenon is a fifth-century BC building dedicated to Athena, who embodies the highest ideals of Athenian culture. But what are those ideals, and are they true? At the time of its completion, the western pediment of the Parthenon contained a sculptural program depicting the mythic contest between Athena and Poseidon. To make a long story short, that contest represents an important and enduring social issue: which is more important, wisdom or commerce? That issue was most important in ancient Athens, and it is an issue that remains relevant today. It is a practical question for us all regardless of time or place. Which then is more important to life? Which provides the better motivation for living, or more specifically, for studying art history? Which is more important, reading a book on the stock market, or reading a book on the pursuit of wisdom and beauty?

Given the text of this book, that is perhaps a loaded question. Nonetheless, the question remains; what is most important in our lives is central to a history of art, and it is central to a defense of the fine and liberal arts in general. In defending the liberal arts today it is common to hear utilitarian arguments. The skills in thinking and analysis, and writing, we are told, will be marketable. They will help the student to obtain a good job. No doubt similar arguments were made in ancient Greece (by the Sophists) and throughout the ages. But the sculptural program of the Parthenon argues quite differently: wisdom is valuable in and of itself. It is essential to a genuinely successful society and a noble life. Athena wins the contest with Poseidon, which indicates that within this cultural tradition it is made clear that wisdom is understood as more important than commerce. But is that triumph a mere myth (or fiction as the aesthetic sense of the term denotes), or is it true?

Pericles was central to the construction of the Parthenon, and spoke of culture and principle, but he also transformed Athens into an imperial realm. As a matter of culture, Athens celebrated Athena's triumph over Poseidon; but as a matter of politics, the transformation of the Delian League into an Athenian empire was accompanied by a change of location of the Delian League's treasury from Delos to Athens. So does commerce and empire trump lofty principle? Is Athens' devotion to Athena, to wisdom, a mask for power?

This is an important issue for us to consider since our personal and political existence cannot avoid taking a stand on it; our daily actions embody our understanding of wisdom, material wealth, truth and power. It affects not only our understanding of what society is, but also what it ought to be. To aesthetically approach this issue is not very satisfying. On one hand, Modernists advocating art for art's sake would naturally dispute that wisdom and commerce really matter at all as an artistic issue. It is the aesthetic perfection of expression that is central.[33] On the other hand, those Postmodernists who view culture as based upon economic class would argue that wisdom and material wealth cannot really be separated in politics and culture (i.e. power).[34] Politically, does not material wealth determine cultural truth? From either aesthetic viewpoint, culture is grounded in personal or group expressions of taste—and power. From this perspective "beauty and truth" result from those conflicting tastes. As taste changes, culture and our understanding of beauty and truth change.[35] Or do they?

As a lover of beauty, Plato disputes this vision of the relationship of truth and power, of wisdom and wealth. In the *Republic 2* (369ff), he differentiates between necessities and luxury, observing that given the choice between the two, many will pursue the latter. For Plato this is cause for worry since the pursuit of luxury without bound corrupts society. For this reason Plato is distrustful of democracy and the demagogues who manipulate the many for the purposes of the few.

Aristotle concurs while at the same time approaching the issue via aesthetics, but an aesthetics operating within a teleological scheme where the world (or *being*) is purposeful. He argues (in the *Nichomachean Ethics*) that money is used to obtain things, whereas wisdom determines that which is worth obtaining. Money is a means to an end, and therefore is clearly less important than that which it is used to get. Central to Aristotle's viewpoint is that primary goods are good unto themselves and more important than secondary goods. The primary good that is most valuable is wisdom. According to Aristotle, perfect wisdom and perfect commerce might be equally aesthetic as activities, but wisdom is the knowledge of what is right to seek, and seeking that which is good is essential to obtaining both beauty and happiness. Commerce does not determine culture, nor beauty and truth; it is merely an aesthetic means to an end, not an end unto itself.

To view the western pediment of the Parthenon and its sculptural program depicting the competition between Athena and Poseidon is to be asked to contemplate the important issue of whether wisdom or commerce is more important in life. It is a question with which the Greek ruler at the time, Pericles, struggled as well. Admittedly, both wisdom and commerce are significant parts of life. But whereas the aesthetic mind equates the two, for both Plato and Aristotle, wisdom is recognized as more important. In the Classical sense of the terms, it is a more liberal and practical endeavor.

The Liberal, Servile, Practical, and Productive

The determination of value is then central to the Classical tradition. How can we distinguish the valuable from the trivial, what is fine art and what is not? What is significant and what is mundane? In his text, *Metaphysics*, section VI, Aristotle offers a seemingly simple solution of enormous importance. He observes that much of what we do as human beings can be understood as involving three tasks: knowing, doing, and making. The realm of knowing is that of science (understood broadly as any form of systematic knowledge), the realm of doing is that of ethics, and the realm of making is that of art. So science, ethics, and art refer to: knowing, doing, and making. From a Classical point of view these realms cannot be separate in life. To separate them, as does the Modernist university with its separate departments of science, ethics, and art, makes no sense.[36] So engineers who lack the scientific knowledge to do the task at hand are deficient both scientifically and morally; so too are knowledgeable surgeons who cannot or will not skillfully work to heal.

In either case, Aristotle never completely disassociates scientific and artistic activities from ethics. It is understood that neither engineers nor surgeons can rightly ignore the ethical implications of what they do. What then unites science, ethics, and art? An understanding that reality is intelligible and purposeful, and therefore that which we know, do, and make, ought to make sense and be purposeful as well. So art is skill, and those skills that make things are judged aesthetically. Aristotle observes, however, that art is skill, but not all skills are equally profound. The liberal arts are those arts connected with the mind, the servile arts are those associated with matter, practical arts attempt to conform to nature whereas productive arts work on nature. So ditch digging is to a significant degree servile and productive, whereas surgery is liberal and practical. Both can be aesthetically judged in terms of physical perfection. But ditch digging is a lower art than surgery, at least where medicine maintains a purposeful commitment to health. It is not the degree of intellectual difficulty that makes surgery more important than ditch digging, but rather, its connection with an understanding of biological and teleological nature.

So both the ditch digger and the surgeon have a calling, and the dignity of each hinges on how well that calling is achieved. Indeed, a virtuous ditch digger has greater dignity than a corrupt surgeon. In either case, having a genius for doing something has nothing to do with ego. It is not Social Darwinism at work, neither the sanitized genius of Modernism nor the brutal *Übermensch* of Postmodernism. As we shall see, it is fate and virtue that determines such things.

The result then is a way of understanding reality that privileges the notion that the world makes sense, rather than privileging the notion that the world is absurd, brutal, or indifferent. It also privileges the pursuit of the ideal over a narcissistic self-absorption with its claims of genius or of self-realization and

self-expression. This results in the ability to affirm the dignity of all that is done virtuously, while discerning the comparative importance of all that we do without pride. As Coomaraswamy notes[3]:

> When Plato lays it down that the arts shall care for the bodies and souls of your citizens, and that only things that are sane and free, and not any shameful things unbecoming free men, are to be made, it is as much as to say that the artist in whatever material must be a free man; not meaning thereby an emancipated artist in the vulgar sense of one having no obligation or commitment of any kind, but a man emancipated from the despotism of the salesman...
>
> A system of manufacture, or rather of quantity production dominated by money values, presupposes that there shall be two different kinds of makers, privileged artists who may be inspired, and under-privileged labourers, unimaginative by hypothesis, since they are asked only to make what other men have imagined. As Eric Gill put it, On the one hand we have the artist concerned solely to express himself; on the other is the workman deprived of any self to express. It has often been claimed that the productions of fine art are useless; it would seem to be a mockery to speak of a society as free, where it is only the makers of useless things, and not the makers of utilities, that can be called free, except in the sense that we are all free to work or to starve.

The Mathematics of Cosmic Beauty

Classicism understands that the universe is a cosmos, and that the cosmos is recognizable via mathematics. Vitruvius, a Roman Classicist, discusses the idea that an ideal person could be contained within a circle and a square. Called *Homo Quadratus*, it depicts a person with outstretched arms and legs reaching for the corners of a square that is inside a circle. By referring to Plato's book, *Timaeus* (section 37) (the book he is shown holding in Raphael's painting, *The School of Athens*, discussed below), we are reminded that the square represents the material world; the sphere represents the universe and the perfection of intelligence and knowledge. The universe is the soul that has been made visible; it partakes in reason and harmony. Referred to as a visible body, the world is the image of the eternally ideal. It is the moving image of eternity. Humanity is then shown as a mingling of the ideal and the material, spanning the gap between the two. At one level, are the material and the organic realms, and on a higher level, is the realm of the ideal. That ideal is the intelligible content of reality, which provides purpose to the cosmos, and which can be understood via reason and mathematics. The Classical Canon provides us with the means by which to do so.

The importance of the Classical Canon lies in its attempt to pursue beauty, rather than aesthetics. Its importance lies in its attempt to convey the idea that the world makes sense, that there is a connection between the material and the organic, and between them and the ideal. We live in a House of Life, and that House of life makes clear that there is a place in the universe that we can call home. Our political and organic lives can dwell together harmoniously. These ideas apply not only to sculpture and music, but to architecture as well. Concerning the latter, Vitruvius states:

Since Nature so created the body that its members are proportional to the whole frame, the principle of the ancients was that in buildings also the relationship of the parts should correspond to the whole.[38]

In looking at the Parthenon, we can look intellectually beyond (but physically beneath) the pedimental sculpture program, discussed earlier, and consider the building itself. How does this structure represent a House of Life, and is it solid enough to move into? As just noted, the general proportions of the Parthenon center on symmetry and harmony, which are not an invention of the artist, but rather a property of nature and the ideal. Again, we can refer to Vitruvius:

Composition depends on symmetry, whose laws architects should observe strictly. Symmetry is created through proportions...the proportions of a building we call the calculations relate to its parts as well as to the whole, in accordance with an established module.[39]

That module is found in a type of mathematics evidenced by the *Venus De Milo* and known as the *Golden Section*. Just as Plato famously used the simile of the Line (*Republic*, 509) to explain the differences between the material and the intellectual, confusion and knowledge, the Golden Section uses the principle of dividing a line to explain how the artist is to strive for the Ideal via the material. The principle is to divide a line in whereby the smaller part is to the greater as the greater is to the whole. It found uniformity between human proportions, architectural proportions, and the proportions evidenced by the cosmos. As the ancient historian Galen informs us, this principle of beauty is set forth in the Canon of Polykleitos:

[Beauty resides] in the proportions...of the parts, that is to say, of finger to finger and of all the fingers to the palm and wrist, and of these to the forearm, and of the fore-arm to the upper arm, and of all the parts to each other.[40]

So our House of Life is based on nature, and nature best reflects the ideal where harmony (cosmos) reigns. That harmony is recognized via mathematics, and is realized not only in human physiology, but in architecture and music as well. Not only are we gazing upon Venus; we here obtain a glimpse of Apollo as well. Classical architecture is recognized as harmoniously embodying the very substance of Apollo (reason) and Venus (love). It is beautiful.

When we look at Classical buildings today, whether they are our court buildings, or our libraries, it is all too easy to miss seeing what the architectural canon determines their appearance to mean. Friedrich Nietzsche, a Classicist who reinterpreted that tradition via a Postmodernist perspective, noticed this decline, lamenting that:

Everything in a Greek or Christian building originally meant something and referred to a higher order of things; this feeling of inexhaustible meaning enveloped the edifice

like a mystic veil... What is the beauty of a building now? The same thing as the beautiful face of a stupid woman, a kind of mask.[41]

However offensive parts of that quote may be (and those quotes are mild considering the source), the point is that without belief in, or even knowledge of, the ideas being discussed, the building is reduced to an aesthetic experience rather than a statement of the nature of beauty.

Within the Classical Canon there are various modes, including the Doric, the Ionic, and the Corinthian. Visually, the Doric order is the heaviest of the three orders being considered, the Ionic and Corinthian are associated with grace and freedom. One writer observes that the heavier order displays a more disciplined effect, whereas the Corinthian displays a more relaxed effect.[42] But if left at that, this analysis is essentially aesthetic, emotional, and disputable. How then can we understand the Classical orders? The modes of architecture were much more than arbitrary fashions of design. On one level, they are merely aesthetic, some evoking solidity, others, grace. But on another level they are associated with sociological identity: the Ionic, Doric, and Corinthian referring to specific and different modes of group behavior. But Plato and Aristotle analyze these architectural modes ontologically—as a means of explaining reality.

In various sections of the *Republic*, Plato associates the Doric order not only with architecture, but with forms of music. The Doric order is associated with self-restraint in contrast to the Phrygian order that is associated with freedom or even disorder. Plato observes that the modes of music are never disturbed without unsettling the very foundations of culture,[43] essentially arguing that when music changes, the laws of the state will change. Aristotle comments even more profusely on the meaning of the Classical orders of architecture, music, and politics. In the *Politics* (1276b) Aristotle explains:

> For inasmuch as a state is a kind of partnership, and is in fact a partnership of citizens in a government, when the form of the government has been altered and is different it would appear to follow that the state is no longer the same state, just as we say a chorus which on one occasion acts a comedy and on another a tragedy is a different chorus although it is often composed of the same persons, and similarly with any other common whole or composite structure we say it is different if the form of its structure is different—for instance a musical tune consisting of the same notes we call a different tune if one time it is played in the Dorian mode and at another in the Phrygian.

He continues in the *Politics* (1342b):

> Moreover since we praise and say that we ought to pursue the mean between extremes, and the Dorian mode has this nature in relation to the other harmonies, it is clear that it suits the younger pupils to be educated rather in the Dorian melodies.

What then should one see when looking at the Parthenon in Athens? The physical building is the embodiment of several different strands of thought, all of which converge in the pursuit of wisdom. That wisdom is not aesthetic but a matter of beauty.

The Parthenon is constructed using both the Doric and Ionic orders; the columns are visually Doric, but proportionately Ionic. The temple thus presents us with the attempt to reconcile responsibility with freedom. Pericles was central to the construction of the Parthenon, and he was associated with the then democratic position of the Ionians; his rival, Cimon, favored the Dorian mode of art and politics, which was more aristocratic. The former favored inclusion, the latter favored qualitative distinctions in art and life. This age-old and still current conflict is to a degree resolved in the Parthenon.

The building itself exhibits proportions that denote the idea that the universe is a harmonious perfection. It is constructed according to a system of proportion whereby a basic unit is consistently applied to the entire structure. Vitruvius wrote that the diameter of a column should equal two units; the height of a column including the capital, fourteen units, and the width of the temple itself should be twenty-seven modules. This system of proportion is roughly that of the human figure, with the head being one-seventh of the total height of a figure. As Aristotle mentioned above, within this system of proportion there existed variations: the Doric, Ionic, and Corinthian orders appear either heavier or lighter, and consequently, more or less disciplined. These proportions reflect the influence of geometry, a geometry that is associated with natural proportions; those proportions are found, as illustrated by the *Homo Quadratus*, in both the nature of the universe and the nature of humanity.

Nietzsche admits that Doric art has immortalized "Apollo's majestic rejection of all license,"[44] but in contrast to Classicism, Nietzsche laments its occurrence. He views the Doric and Apollonian as oppressive. But are they? However geometric and mathematical those Doric proportions might be, it is important to note that the Classicist is dedicated to both truth and freedom. Rather than ask how a finality of truth can be reconciled with freedom, it can be asked how the two cannot be. As the Parthenon evidences, freedom without responsibility is anarchy or tyranny. As Aristotle stated above, in Classical architecture, music, and politics, there is much room for variation. But those variations culturally aim not at narcissistic and willful disharmony. Rather, they involve the free application of principles in the attempt to express profound ideas in as many ways as possible. It is Apollonian to conclude that the more manifestations of Venus appear in our House of Life, the more free and beatific it will be. The canon was not proscriptive, but rather prescriptive. It stated the ideal towards which a variety of efforts might be employed. But what of that ideal? We next come to a final consideration of the Classical tradition, at least as it initially manifested itself.

The Classical Archetype: The School of Athens, and the Imitation of Truth

The School of Athens (1508) (figure 5) is a work by the Italian Renaissance artist Raphael (Raffaello Sanzio, 1483-1520). It makes visual the foundational principles of Classicism. Plato (427-347 BC) and Aristotle (384-323 BC) are shown walking through a House of Life not as antagonists, but rather as protagonists. Flanking Plato and Aristotle are depicted a cosmopolitan entourage of luminaries of the Western tradition. Plato is shown pointing to the heavens, to the intelligible realm of divine Beauty, whereas Aristotle gestures towards the earth, where matter and the ideal coexist. Both see art as skill, and beauty as purposeful, but each pursues beauty via different means.

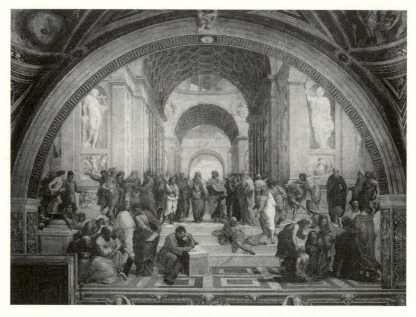

5. Raphael, *School of Athens*

In a limited sense both the Modernist and the Classicist can view this work of art aesthetically, by marveling at the technical proficiency shown by the artist, the ability to render figure and architectural space convincingly. Both can also comprehend the historical and sociological facts and figures depicted in the work. But whereas the Modernist can appreciate its formal and histori-cist qualities, the Classicist can rise also to the higher plane of beauty. To see its beauty, it is necessary to understand its meaning. That requires more than that which is permitted by aesthetics, more than recognition of skill, a summation of its historicist content, or claims of genius or power. It requires a consideration of the foundational beliefs presented by this work of art, and a

consideration of the evidence that supports or disputes those beliefs. By making those facts of belief intelligible, by making them understandable, we shift from the aesthetics of facts and feelings to that of intelligible beauty.

Dating to 1510-1511 AD, the work clearly dates to the Renaissance. Studying a Renaissance painting in the context of Classicism is entirely appropriate since the Classical tradition is one with perennial import—but only if it is understood as a pursuit of beauty. As introduced earlier, Classicism was reinterpreted during the Renaissance, and reinterpreted yet again by Postmodernism. Those interpretations vary in substance and consequence, some affirming the foundational principles of Classicism, others undermining them. This is a salient point since how we view Raphael's painting affects whether or not we can believe that the intrinsic meaning of the painting makes sense.

For example, in his book, *The Classical Tradition* (1978), p. 11ff, Michael Greenhalgh writes that Classicism marks a revival of past art and tradition, that Classicists believed in the ideal rather than the real, clarity was preferred over confusion, imitation of the Antique is central to Classicism, art should express a moral content, that art should be polite and liberal rather than useful, and be produced by persons of genius capable of inspiring sentiment and filling the mind with great and sublime ideas. This summary is concise and accurate. But to avoid misinterpretation by a relativist reader it nonetheless warrants parsing. Otherwise it could invite us to see and misunderstand Classicism as interpreted via a non-Classicist point of view.

Consider each point: It is noted that Classicists believed in the ideal rather than the real. Certainly the changing usage of the term Realist affects our use and understanding of language. As noted above, historically Realists such as Plato are those who believe in the Ideal. Realists are those who find enduring principles to be more permanent, more actual, than the constantly changing world of facts and feelings. Indeed, it was only in the 19th century that the meaning of the term *realism* was aestheticized and made synonymous with material reality. To avoid a misreading of historical Classicism, the term realism (and many other terms) must be accurately rather than colloquially understood.

That clarity was preferred over confusion in Classical art is true. For Plato it was more than an aesthetic preference for a formalistic coherence; it was linked with the conviction that the world (or *being*) reveals itself by degree. It is a qualitative rather than a quantitative or formalistic revelation. Correspondingly, imitation of the Antique might be taken as a nostalgic (historicist) preference for the past, rather than the imitation of perennial wisdom. That art should express a moral content is stated, but without justification of why that might be the case, or what that morality is. The distinction of fine art from the useful might be misconstrued as support of the notion of art for art's sake. As discussed above, neither Plato nor Aristotle agree with that premise. Finally, to the Classicist view, the role of genius is precise: it is not persons of genius, but

rather, persons who use the gift of genius who can do remarkable things.[45] In sum, without a careful explanation of these significant differences of interpretation, one could easily approach Classicism via an aesthetic perspective quite foreign to the Classical view.

Why then study a Renaissance work of art within a consideration of the Classical tradition? Because its subject and its meaning are deeply influenced by perennial Classical themes. It is an imitation not only of Classical art but of Classical belief; it attempts to provide a glimpse of beauty. Consequently, to attempt to understand this work aesthetically is to trivialize it. How then are we to approach this painting in terms of beauty? The painting depicts the two foundational figures in the Classical tradition, Plato and Aristotle. Plato is depicted holding a copy of his book *Timaeus* while pointing to the heavens, indicating his contention that the ideal (*being*) is more significant than that which is just purposelessly material (*becoming* without *being*). For Plato, crime and disease are facts, and we may feel bad when afflicted by either, but justice and health are ideals that are objectively better than that which we experience daily. The pursuit of the ideal might never be complete, but the closer we get to the ideal, the better. Aristotle is shown pointing to the earth, to emphasize his concern for the ideal being manifest on the earth. He is shown holding a copy of his book, The *Nichomachean Ethics*. A central observation of that book is that virtue is that which leads to happiness in daily life. Without objective principles, we are adrift; without practicality, we can be foolishly obstinate or dissolute. As discussed earlier, Aristotle distinguishes between the liberal and the servile, the practical and the productive. The liberal is concerned with the intellect; the servile is concerned with matter, the practical works with nature, and the productive works on nature. That which is liberal and practical is qualitatively superior to that which is servile and productive.

Two facets of the Classical approach to culture are then personified by Plato and Aristotle: aspiring to the transcendent ideal, or making the ideal manifest in our daily lives. They are not necessarily antagonistic. Indeed, within Western culture is the consistent hope that they are ultimately complementary, just as Plato and Aristotle are presented collegially in Raphael's painting.

Both the cosmology of Plato and the ethics of Aristotle are justified by the premise that the universe makes sense and is purposeful. Things are beautiful with reference to some standard and for both Plato and Aristotle, that standard is cosmological and teleological. In reference to Plato's comment in the *Symposium* that "if there is anything worth living for, it is to behold beauty," Tatarkiewicz explains[46]:

[W]hen he praised beauty, Plato was praising something different from what is today understood by the term. Shapes, colours and melodies were, as far as he and the Greeks in general were concerned, only a portion of the full scope of beauty. Within

this term they included not only physical objects, but also psychological and social ones, characters and political systems, virtues and truths. They included not only things which are a joy to behold and hear, but everything which causes admiration, which arouses delight, appreciation and enjoyment.

The notion of beauty is discussed in the *Hippias Major*, and Plato's view is summarized in his *Symposium*, where beauty and goodness are recognized as one. So to seek Beauty, or Justice, is to seek a vision of the Ideal, a vision of the Ideal that is more significant, more reliable, than the experiences we encounter in life on this earth. That vision of the ideal is not aesthetic and sensual, but rather, it is intelligible and beautiful. As stated in Plato's *The Republic*, we need to learn how to obtain a vision of the intelligible sun of Goodness.

In Raphael's painting Plato is depicted pointing to the heavens. That is a fact about what the painting depicts, but what does it mean? It refers to Plato's direct association of beauty with ideal goodness and all with reality or *being*. Plato's gesture, pointing towards the realm of the heavenly and ideal rather than the earthly and material, may seem to make this obvious. But while that gesture can be recognized, it cannot truly be seen until it is understood. Both beauty and goodness are ultimately intelligible rather than material, they refer to the ideal which is more significant and real than the momentary and material. In the *Symposium* Plato advances the idea of a ladder of beauty reaching towards the ideal, and in the book *Phaedrus* Plato clearly states that beauty and goodness are one. For that to be true then reality itself must be beautiful and good; if reality is not beautiful and good, then reality itself must be merely aesthetic. The idea that truth and goodness and beauty are interdependent is clearly one that associates reality with truth and goodness. It requires that we accept optimism rather than indifference or pessimism as natural. Just as the association of the true with the good necessitates that the world be intrinsically beautiful, the disassociation of the true with the good (or its reduction to purposelessness as in the case of Postmodern Existentialism) necessitates that the world be aesthetically indifferent or malevolent.

Instead of viewing science, ethics, and art as aesthetic constructs, beauty views science, ethics, and art as an engagement with meaningful reality. This necessitates that it is more realistic to be an optimist than a pessimist; little wonder then that those who focus on facts and feelings so often manage only unqualified pleasure, pessimism, indifference, and rage.

Plato often refers to our seeking a vision of intelligible beauty,[47] by which is meant that beauty is grounded in those ideals that are objectively true and good. To see an act of justice is to see the beautiful realization of the ideal; to see a crime is to witness ugliness. With caution, Plato admits that access to that intelligible beauty can be facilitated by physical works of art; to varying degrees objects can embody that which is true and good, or rather, can embody wisdom. The degree to which they embody wisdom is the degree to which they approximate ideal beauty, that which is most true and good. Beauty is grounded

in wisdom, in knowledge of a meaningful reality or *being*. We then ascend from sensual approximations of beauty, to beauty of the mind, and eventually to essential beauty itself in its purity and perfection (*Symposium* 211e). We learn to love beauty first in its diluted form, but later we can go to higher and more perfect manifestations of beauty. Just as the most perfect circle can only be intellectual because all physical attempts to make a perfect circle fall short, beauty is the degree of perfection possible but rarely achieved in physical form. At its most perfect and real, beauty is not sensual, but rather it is intelligible. So Plato is pointing towards the realm of the ideal, a realm that is more permanent, more purposeful, more ennobling than found in the confusing and chaotic world in which we live. In practical terms, justice remains an untarnished ideal despite how common the fact of crime is on earth. In a world that has purpose, the ideal of Justice is objectively better than crime; however perfect the crime committed, or however imperfectly justice is applied.

So the *School of Athens* depicts two fundamental and complementary approaches to culture, which have proven both venerable and valuable over time. But neither Plato nor Aristotle matter much in contemporary life if they are viewed via an aesthetic perspective. Plato, with his insistence on pursuing *kalos,* is compatible with a life lived in the confidence that excellence and wisdom matter; it offers us the possibility of there being inspirational ideals to love and aspire to. Aristotle associates *kalos* with moral actions, or on occasion, with perfection, in which case his focus is on that which by any other name is indistinguishable from *aisthesis.* Aristotle accepts that moral ideals can indeed enjoy tangible manifestations, provided that we are wise enough to perceive them in a meaningful context.

Beauty and Civic Responsibility

The pursuit of beauty is coincident to the pursuit of truth and justice. All make possible our pursuit of meaning in life and assume a right and a responsibility for us to do so. The pursuit of such responsible freedom infers the idea that there is a qualitative hierarchy to aspire to. It assumes that within a purposeful world some actions are noble and wonderful whereas others are to varying degree, not. Virtue and vice are therefore a matter of at least doxatic understanding rather than ignorance, be it the result of indifference or willfulness. As such, vice is to varying degrees uncivilized and should be recognized as in violation not only of justice, but of the law as well. Who is to publicly recognize what constitutes virtue and what is vice? Plato argues for the importance of experts in making judgments of quality in art and life, a position quite in tune with the Modernist tradition. In contrast, Aristotle distrusts the notion of such specialists, preferring the judgment of his peers. At first glance this in turn may appear to be close to the Postmodernist notion of (Rousseauean) communities of practice determining value. But for Aristotle, those peers must offer the judgment of a cultivated public. He distinguishes between lofty and

vulgar audiences, music, and pleasure, holding that those pleasures grounded in the liberal are objectively better than those that are not.[48]

But Plato argues that because the ideal can never fully be realized in the physical realm, the artist can never really present something in its absolute purity and perfection. He values scholarship and philosophy above the arts because intellectual pursuits can get closer to the ideal. Since works of art can only make manifest approximations of the ideal, ultimately, for Plato they cannot but be a lie. Plato is also concerned that works of art can be false in a different sense: a willful or ignorant misrepresentation of the ideal to deleterious effect. Plato recognizes that beauty is associated with love, but that human love can be at odds with truth. We can passionately embrace nonsense.

Beauty is the attractive power of perfection, and for Plato it is associated with wisdom, but if falsehood is beguilingly presented, then its influence can be sordid indeed. For example, the influence of the *Venus de Milo* is quite different from the influence of Manet's *Olympia*. Each affects us emotionally, and each presents a different explanation of love. To praise both is to trivialize both and to understand neither.

Plato is concerned with the negative propensity of ill-conceived assertions of beauty influencing our behavior. He is for censorship of that which has a clearly malignant affect, just as a judge censors criminality and a scholar should attempt to censor error. However, the very notion of censorship is today a loaded term; it is loaded because if truth is a matter of taste, then no taste can or ought to be denied. But censorship can also refer to choices or actions that suppress misrepresentation of what is genuinely the case, or suppress demagogic manipulation of others. The rules of evidence in a court of law are censorious in that they intend to do just that: advance knowledge of the issue at hand rather than permit that issue to be obscured. In this sense, censorship is a laudable insistence that the truth should be known.

Those who denounce all censorship (be it on a personal or a public scale) cannot avoid reducing culture to a matter of entertainment, therapy, or propaganda. An absence of any form of censorship involves a trivialization of public art and a trivialization of the results that can stem from lies, indifference, and demagoguery. Alternatively, Plato's notion of censorship strikes the advocates of genius as particularly obnoxious since to them censorship of genius is a censoring of revealed truth. Correspondingly, advocates of an identity-based vision of culture (where fine art becomes a statement of one's existence, or as a member of a race, gender, or economic class), view censorship as prejudice - unless it is inflicted on those who deny their taste. But Plato does not accept that anyone has a license to lie nor to influence others with their lies or their errors. Nor does he agree with the premise that art is separate from ethics.

On this issue Aristotle's position differs. Raphael depicts Aristotle pointing grandly towards the earth. That gesture does not deny the importance of the ideal, but rather presents the position that the ideal coexists with the material.

In philosophical terms Plato is a type of transcendentalist, whereas Aristotle is concerned with immanentism. Aristotle agrees with Plato that beauty is the attractive power of perfection.[49] In contrast to Plato, he holds that qualitative distinctions between perfect *things* make no sense. A perfect cathedral is as beautiful—or rather, as aesthetic—as a perfect barn; it is useless to evaluate that which is perfect, since aesthetic perfection once attained cannot vary in degree.

He states in his text *Physics* that there are four causes or types of explanations for such perfection available: material cause (e.g., the bronze of the statue), the formal cause (the pattern or formula of the essence), the efficient cause (the sculptor and his activity) and the final cause (the end or purpose of a thing). It is the final position that is crucial to understanding beauty and art. It is the *teleos* (as discussed in the *Nichomachean Ethics*) that gives meaningful context to the object (or of life). But if that *teleos* is falsely perceived (or denied purposeful *being*), then the formal cause looses its grounding in meaningful reality. It thereby becomes formalistic, that is, a perfection of a kind, rather than perfection within a meaningful world. As we shall see, this is what happens as the Classicism of Aristotle and Plato is interpreted by some Scholastics, and by Kant, Nietzsche, and Heidegger.

In contrast to Plato's lament that physical representations of the Ideal must always be inadequate, Aristotle places confidence that such imitations of the Ideal can reach admirable degrees of effectiveness and therefore degrees of perfection. Aristotle assumes that like the person making and selling wholesome ice cream, it is the artist's task to make the physical as perfect as possible.[50]

Importantly, in the context of Aristotle's understanding, since the *teleos* of the object and the teleos of the object's maker are necessarily grounded in a meaningful reality, then they cannot be totally distinct. So although Aristotle technically separates the beautiful and the good in art, in practice they are not. That is to say, the ability to make a perfect object does not alone warrant someone being an artist. The artist makes things, but in so doing, the artist is also a citizen who is responsible for that which is made. It is an artistic sin to not seek to realize the purpose of a thing being made; it is a moral sin to produce a perfect work of art that does great harm. Aristotle assumes that the competent architect designs a building so that it will not collapse. If it should collapse then Aristotle would condemn the occurrence of both artistic and moral sin. In contrast, Plato would censor the architect as singularly guilty of moral sin, of a failure to embrace *being*.

To put it differently, Aristotle holds that aesthetics and goodness are substantively but not practically distinct. As art, a perfect crime can be aesthetic, but as a social action, it cannot be good. Since knowing, doing, and making are not separate in a world that makes sense, then science, ethics, and art cannot be separate in the life we live. Since there are material, formal, efficient,

and final causes to all explanations, in Aristotelian Classical culture beauty, aesthetics, and art are understood as occurring in a world and a society that ultimately make sense.

The Fragility of Goodness and Beauty

But there is a crucial challenge facing the Classicist. The challenge before Classicists is not found in their confrontation with nonsense. Nonsense can be understood as grounded in ignorance or maliciousness. It is the issue of the failure of virtue that haunts them. When virtue fails, the notion of responsible freedom, of the pursuit of beauty and truth, become suspect.[51] The challenge is that of tragedy. In a world that makes sense, how and why do tragedies occur?

For Plato art is didactic, and since art teaches it therefore ought to teach what is good. He also accepts that goodness and excellence are transcendental ideals of which we can only obtain but a precious approximation. But how is transcendence to be reconciled with the sordid affairs of the world? Can ethical wisdom effectively resolve the dilemma of tragedy in our lives?

Aristotle associates the fine arts with the pursuit of happiness (eudemonia). That includes the pursuit of pleasure and the pursuit of perfection. Plato fears the influence of seeking pleasure as a seductive means of manipulating others for ignoble purposes; both good and bad art might be pleasurable, and therein lays the problem. Plato saw a susceptibility to malign influence, one that exists in both children and adults; history shows that it is a fear to be taken seriously. But Aristotle differs from Plato in that whereas art should be didactic if it is directed towards children, he believes that adults need no such care. For adults, Aristotle considers the role of the arts to be one of providing pleasure, and that pleasure is taken to be a celebration of perfection within a purposeful world.

As just discussed, for Plato beauty and wisdom are uniformly associated with actions and objects; in reality and life all things and actions are to varying degrees true, good, and beautiful. So for Plato a perfect cathedral is better than a perfect barn, and a ballet is better than a stumble. In contrast, for Aristotle beauty and wisdom are unified in actions but separate in objects. Or rather, for Aristotle, in the case of objects beauty is associated with physical perfection; he associates it with that which by any other name is aesthetic. For Aristotle a perfect cathedral and a perfect barn are both perfect and therefore are both equally aesthetic; a perfect crime is as aesthetic as a perfect act of charity. The comparative morality of a crime and an act of charity is indeed discernible, and the cathedral is intellectually more liberal, more profound than the barn, but the quality of the art object as such has nothing to do with its profundity.

To the point, whereas Plato recognizes the danger tragedy holds for civilization, Aristotle does not. For Aristotle the purpose of art is not to instruct, but rather, to produce emotional delight of an elevated type. Aristotle holds that the emotional effects of music (and by extension, the arts in general) serve a

valuable cathartic purpose for the public. Tragedy contributes to the moral needs of society by emotionally involving the public in moral dilemmas.

Aristotle defined tragedy in *The Poetics* (1449b) as follows:

> A tragedy is the imitation of an action that is serious and also, as having magnitude, complete in itself; in language with pleasurable accessories, each kind brought in separately in the parts of the work; in a dramatic, not in a narrative form; with incidents arousing pity and fear, wherewith to accomplish its catharsis of such emotions.[52]

In his *History of Philosophy* Frederick Copleston presents the two main lines of psychological explanation of Aristotle's theory of catharsis.[53] One view is that of a purification of the emotions of pity and fear, the other is a temporary elimination of those same emotions. He finds the latter to be most compelling in terms of scholarship: that in response to Plato's criticism in the *Republic* that tragedy is harmfully demoralizing, Aristotle makes the case for the presence of such fears on all people, and that it is healthy and beneficial to give release to those anxieties via the pleasure of art. But there is more at stake here than mere empiricist psychological health. From a cultural point of view Aristotle's concern for catharsis indicates an unresolved cultural crisis in Classicism: how to account for tragedy in a world where virtue allegedly makes sense. To put it differently, how can the different and conflicting gods, particularly Apollo and Dionysius, be reconciled? We will return to that question in the last chapter of this book. For the moment consider that Plato rejected catharsis as morbid and harmful; believing in the Transcendental Ideal he was confident that answers to the appearance of tragedy exist; truth cannot ultimately be confused, in conflict, or duplicitous. Consequently, in the *Republic* 398 Plato has Socrates state that the poet Homer erred in writing that Zeus sent a lying dream to Agamemnon. Plato further affirms that poetry and other arts will be admitted to a healthy society only under a clear condition:

> We are ready to acknowledge that Homer is the greatest of poets and first of tragedy writers; but we must recognize that hymns to the gods and praises of the good are the only poetry which ought to be admitted into our State...we shall be delighted to receive her, knowing that we ourselves are very susceptible to her charms; but we may not on that account betray the truth.[54]

As far as can be discerned from existing documents, Aristotle offers a psychological solution to tragedy that is essentially aesthetic. It attempts to make us feel better about things without offering an actual solution to what ails us. As such, it is a failed solution that proved unsatisfactory. Homer's challenge remains. As next discussed, the story of Paris and Helen, and of Laocoön, threatens the notion of culture to its very core.

Notes

1. For example, a partial discussion of this phenomenon is found in Caroline Winterer, *The Culture of Classicism* (Baltimore: John Hopkins Press, 2002).

2. As explained by Ananda Coomaraswamy, *Christian and Oriental Philosophy of Art* (New York: Dover Publications, 1956), 30: "The study of art, if it is to have any cultural value, will demand two far more difficult operations than [an aesthetic appreciation], in the first place an understanding and acceptance of the whole point of view from which the necessity for the work arose, and in the second place a bringing to life in ourselves of the form in which the artist conceived the work by which he judged it. The student of art, if he is to do more than accumulate facts... must rather love than be curious about the subject of his study. It is just because so much is demanded that the study of "art" can have a cultural value, that is to say may become a means of growth. How often our college courses require of the student much less than this!" Coomaraswamy, former curator at the Museum of Fine Arts, Boston, produced a significant body of art historical scholarship. His critique of Modernist and Colonialist culture remains important. His alternative (which he identifies with the philosophia perennis), that all cultural traditions aim at the same spiritual goal, is demonstrably false and indicates the tragic influence of Postmodernist Theosophy which was prevalent during the time of his career and which lingers on to this day in various forms.

3. It was against the prevalent idea of skepticism and its deleterious effects upon culture and life that Socrates, Plato, and Aristotle worked so hard. See: Frederick Copleston, *A History of Philosophy, Vol. 1: Greece and Rome* (Garden City, New York: Image Books, 1962). But to the aesthetically minded, the attempt to escape the willful arbitrariness of skepticism is folly. For example, Harry Elmer Barnes (*An Intellectual and Cultural History of the Western World* (New York: Dover Publications), vol. 1, 134, 262) criticizes Socrates' attempt to realize responsible freedom, justice, and beauty, holding that "When Socrates turned philosophy from fact to truth, as it were, the Greek mind became entranced by its own fanciful creations...The philosophers fled from particulars and took refuge in generalities...Since any such notion as [natural law] has long since been revealed to be palpably untrue [sic], Socrates really placed a nasty stumbling block in the way of those who would seek a sane and accurate guide to moral conduct." Barnes position resonates with that of Nietzsche.

4. It is important to distinguish Classicism and Modernism in this respect. Kant attempts to distinguish a rational and objective morality (the Categorical Imperative) from the contingencies of empiricism (the Hypothetical Imperative). He does so by associating morality with a rational will disconnected from a meaningful world. As discussed in later chapters, this position finds justification via a self-deification that ultimately reduces morality to an amoral will to power. See also "Beauty and the Enlightened Beast" *American Outlook Magazine* (2002), 37-40.

5. Helen Gardner, *A History of Art* (New York: Harcourt Brace Jovanovich, 1975), 176.

6. Gregory R. Beabout, "Liberty is a Lady," *First Things,* number 46 (October, 1994), 18ff.

7. Charles Harrison and Paul Wood, with Jason Gaiger, editors, *Art in Theory 1815-1900. An Anthology of Changing Ideas* (Oxford: Blackwell Publishers, 1998), 514.

8. Linda Nochlin, Realism (1972), 203.

9. Frederick Hartt, Italian Renaissance Art (Englewood Cliffs, New Jersey: Prentice-Hall, 1987), 601.

10. George Heard Hamilton, *Manet and his Critics* (New York: W.W. Norton & Company, 1969), 99.

11. For a discussion see Ibid, 65ff.

12. Charles Harrison and Paul Wood, with Jason Gaiger, editors, *Art in Theory 1815-1900. An Anthology of Changing Ideas* (Oxford: Blackwell Publishers, 1998), 514.

13. The Classical notion of transcendent truth prevailing over Kronos will be discussed later within a Christian context, and in Chapter Nine of this book, "Western Culture at the Crossroads: The History of Art beyond the Postmodern Eschaton. In summary, the Christian view is that linear time, or kronos, is fulfilled and therefore transcended by meaningful time, or kairos (e.g. Mark 1: 14-15). To live in kairos is to be reconciled with a meaningful *being*.

14. According to Classical culture, the transcendent Ideal dwells within the empyrean realm, which is within, not above, the cosmos. This results in a pantheistic worldview, where nature is populated with gods. Via mis idea or the Good Plato struggles to escape pantheism and chronos, and their necessary denial of responsible freedom and meaningful time. It was Christianity that establishes the distinction of the divine and nature, of Becoming (Christ) and Being (God). The world is not an emanation of His being. Hence freedom is real and kairos triumphs over despair.

15. On this point Nietzsche is more aware than either Hegel or Marx; as discussed below, in his book, The Birth of Tragedy, Nietzsche boldly states that "The Apollonian is Dionysius in disguise."

16. The Marxist attempt to have a meaningful historicism relies upon a confusing of power with truth and love, becoming with being. Marx was haunted by the perennial appeal of Classical art nonetheless.

17. Simon Hornblower, Antony Spawforth, *Oxford Classical Dictionary* (Oxford:Oxford University Press, 1996), 690.

18. Helen Fisher, *Why We Love* (New York: Henry Holt Publishers, 2004), argues that love is the result of dopamine.

19. Simon Hornblower, Anthony Spawforth, *The Oxford Classical Dictionary* (Oxford: Oxford University Press, 1996), 120: "Plato was wrong about two types of love..."

20. Polykleitos stated in a treatise on sculpture that in a work of art that perfection depends on many numerical relations, and small variants are decisive. Wladyslaw Tatarkiewicz, *History of Aesthetics* (The Hague: Mouton, 1970), 55.

21. According to Nietzsche, the notion of the spectator was smuggled into aesthetics by Kant. See: Francis Golffing, *Nietzsche, The Birth of Tragedy and the Genealogy of Morals: An Attack* (Garden City, New York: Doubleday and Company, 1956), 238. The smuggling continues with the work of Lacan.

22. The primary justification for the National Endowment of the Arts is the Modernist notion that aesthetics and the selection of art are apolitical and even non-partial. The fallacy of that premise is abundantly clear to Postmodernists and to others. See Arthur Pontynen, *"The National Endowment for the Arts"* in Ready Reference: Censorship (Pasadena: Salem Press Publishers, 1996) , 532-534.

23. Kenneth Clark, *The Nude. A Study in Ideal Form* (Garden City, New York: Doubleday Anchor, 1956), 55.

24. The idea that music has meaning beyond aesthetics is commonly neglected. As discussed below, Schoenberg's atonal music was a deliberate attempt to repudiate the hierarchical musical scale (do, re, mi, fa, so, la, ti, do) formulated during the Medieval period in reference to St. John the Baptist. He thereby produces Socialistic music.

25. As discussed below, in the Classical view of the world, the Ideal lies within the empyrean, the highest region of the cosmos. Thus, it was not transcendent as understood, for example, by Christianity.

26. Some writers have argued that Aristotle's writings on beauty are fundamentally confused. The following discussion argues otherwise: that Aristotle went to great lengths to distinguish aesthetic from beauty, but with tragic results.
27. Frederick Copleston, *A History of Philosophy. Greece and Rome*, Vol.I, Pt.II (Garden City, New York: Image Books, 1962), 100.
28. Immanuel Kant, *The Critique of Aesthetic Judgment*, section 48.
29. Immanuel Kant, *The Critique of Pure Reason*, 1781, Chapter I.
30. Andrew Benjamin, Peter Osborne, editors, *Walter Benjamin's Philosophy. Destruction and Experience* (London: Routledge, 1994), 36ff.
31. A doxatic position is one that aspires to avoid both skepticism and dogmatism. See: Jonathan Kvanvig, *The Intellectual Virtues and the Life of the Mind: the Place of Virtues in Contemporary Espistemology* (Maryland: Savage, 1992). This position is distinct to that of constructivism in that it rejects the notion that reality is non-cognitive and or purposeless. Doxa implicitly accepts the possibility that the world is neither a chaos, nor a subjective arrangement of fact, but rather is a difficult to discern cosmos. Plato preferred knowledge to opinion, but recognized that rising to knowledge involves passing through the realm of doxa.
32. "Where we see a genius as a peculiarly developed personality to be exploited, traditional philosophy sees the immanent Spirit, beside which the individual personality is relatively nil...What Augustine calls ingenium corresponds to Philo's hegemon, the Sanskrit Inner Controller, and to what is called in medieval theology the Synteresis, the immanent Spirit thought of equally as an artistic, moral and speculative conscience...No man...can be a genius: but all men have a genius, to be served or disobeyed at their own peril." Ananda Coomaraswamy, *Christian and Oriental Philosophy of Art* (New York: Dover Publications, 1956), 37ff. The aestheticization of genius by Modernism and Postmodernism is viewed then as arrogantly and dangerously prideful.
33. As discussed below, in *The Critique of Aesthetic Judgment*(1781) Kant defines art as non-cognitive, self-referential, and a perfection of a kind.
34. See: Karl Marx, *The Communist Manifesto* (1848).
35. For a discussion of this perspective, see: Terry Eagleton, *Literary Theory* (Minneapolis: Minnesota University Press, 1996).
36. The postmodern university attempts to solve this fragmentation of the curriculum and our lives by advancing interdisciplinary course work. One cannot *inte*grate knowledge via an *inter*disciplinary approach, just as one cannot integrate different racial groups into one body politic by multiculturalism. Interdisciplinary and multicultural efforts represent an aesthetic attempt to solve substantive intellectual and social problems via a violent methodology. Both reject the notion of a cosmopolitan pursuit of beauty.
37. Ananda Coomaraswamy, *Christian and Oriental Philosophy of Art* (New York: Dover Publications, 1956), 14ff. He was for many years a distinguished curator at the Museum of Fine Arts, Boston.
38. Ibid., 62.
39. Ibid. 49.
40. Wladyslaw Tatarkiewicz, *History of Aesthetics* (The Hague: Mouton, 1970)., Vol. 1, 55. Although this multi-volume work inadequately distinguishes between beauty and aesthetics, it remains a valuable source.
41. Raphael Stern, Esther Robison, editors, Changing Concepts of Art (New York: Haven Publishers, 1983), 281.
42. Wladyslaw Tatarkiewicz, *History of Aesthetics* (The Hague: Mouton, 1970)., Vol. 1, 52.

43. *Republic,* sections424c. In contrast to Plato's and Aristotle's intellectual treatment of the Classical orders, others dwell on the sociological history involved. For example, see Herodotus, *The Histories*, where a consistent association of these modes with specific social groups is maintained.

44. Francis Golffing, *Nietzsche, The Birth of Tragedy and the Genealogy of Morals: An Attack* (Garden City, New York: Doubleday and Company, 1956), 26.

45. See note 70, above.

46. Wladyslaw Tatarkiewicz, *History of Aesthetics* (The Hague: Mouton, 1970), vol. 1, 113ff.

47. For example, *Phaedo* 65, 75d

48. *Politics*, v (viii) 5. 1340

49. The notion of beauty being the attractive power of perfection, which is nevertheless associated with the moral goodness of the artist who makes things, is found not only in the Western Classical tradition, but in the East as well. The ancient text of Confucius, *The Analects*, observes that the war dance is perfectly beautiful, but not good, whereas the succession dance is perfectly beautiful and perfectly good.

50. *Rhetoric*, I,ix,1371b

51. Plato's reliance on the notion of ethical wisdom and transcendence, and his opposition to the position later taken by Aristotle, are discussed in Martha Nussbaum, *The Fragility of Goodness. Luck and ethics in Greek tragedy and philosophy* (Cambridge: Cambridge University Press, 1986), 122ff. That author states (p. 11) that her method is Aristotelian, but in contrast to recent writers such as Rawls (the author of the highly influential Aristotelian-Kantian book, *A Theory of Justice*), will study the Platonic tradition from its own point of view. She also comes to a very Aristotelian-Kantian conclusion (p. 15): that Nietzsche was right that a Western culture in crisis could learn much by returning to the Greeks. However, the conclusion of this book is that the Aristotelian tradition leads to a Kantian and ultimately Nietzschean endgame; that the conclusion of Modernist Liberalism is Postmodernist nihilism. It is a conclusion that is held to be lamentable and unnecessary.

52. Frederick Copleston, *A History of Philosophy* (Garden City, New York: Image Books) , vol. 1, pt.2, 104.

53. Ibid., 107-8.

54. Ibid., 280.

4

The Laocoön: The Challenge of Tragedy and the Metaphysics of Plotinus

The *Laocoön* is a Hellenistic sculpture dating to the late first century BC. It was newly excavated in Rome in the sixteenth century and during the Baroque and the Enlightenment it was recognized to be an important and disputed work of fine art. Depicted is an event from the Trojan War. That war was based not merely on the willful or the economic. According to Homer's account it centered on passion, both human and divine, and on the pursuit of beauty.

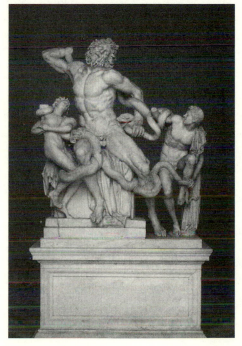

6. *Laocoön*

Those passions were personified by Paris and Helen, and by the gods. As mentioned earlier, Paris is confronted by Hera, Athena, and Aphrodite (also known as Venus). He is asked by them which is the most beautiful of all. Hera offers wealth, Athena offers glory, but Aphrodite offers love, manifested in the earthly realm by the mortal Helen. Paris falls in love with Helen (who under difficult circumstances was married to Menelaus of Sparta) and carries her away to Troy. The high king Agamemnon, older brother of Menelaus, pledges to retrieve her. Agamemnon besieged Troy for ten years.

One (and perhaps the) cause of the Trojan War is the love of beauty. But beauty is understood to involve the intelligible, not merely the physical. On an intellectual level the story of the siege of Troy marks the start of an attempt to reconcile competing gods (or truth-claims). Since virtue depends on knowledge of what is true and good, such knowledge is necessary to make virtue real. But Paris of Troy had to choose between the goddesses Hera, Athena, and Aphrodite; Agamemnon had offended the god Artemis and had even sacrificed his daughter Iphigenia to placate him; Laocoön had offended the gods as well. So both Troy and the House of Atreus (Agamemnon's and Menelaus' father) are thus in the midst of conflict between themselves and the gods (or truth-claims). In particular, Hera and Athena, Apollo, Poseidon, and Zeus join in the melee.

According to the Roman writer Virgil (*Aeneid*, Book 2), Laocoön, a defender of Troy, was selected by lot to conduct a sacrifice at the altar of Poseidon, and as he was doing so, he and his sons were attacked and killed by serpents. The reasons for the attack vary: Virgil states that it resulted from the displeasure of Athena on account of his hostility to the Trojan Horse; Hyginus says that he was punished by Apollo for having married in spite of his priesthood status. In either case, competing truth-claims make virtue impossible for Laocoön to achieve. According to Livy, Laocoön's fate, and the fall of Troy, prompted his countryman Aeneas to flee to Italy, and thus to initiate the founding of Rome. But to the point: contemplation of the sculpture of Laocoön leads to a consideration of whether love is possible or virtue matters. It is a passionate question, and one that goes beyond fact, feeling, or mere intellectual inquiry. It centers on the very possibility of a meaningful life and of our ability to pursue it.

Rather than affording an easy understanding of reality and life, the result of the siege of Troy was a denial of love and a confrontation with tragedy. Troy falls, with Paris, Achilles, Laocoön, and later, Agamemnon dead; oddly, Menelaus returns home with Helen. It is a result that mocks the notion of virtue, wisdom, and indeed of beauty. The esteem of Homer's epic makes clear that the problem of tragedy baffled the Greek mind. As noted above, Aristotle offers no solution to tragedy, and Plato resists tragedy with only partial success. As we will later examine, Nietzsche embraces a pre-Socratic paganism once more by accepting a re-birth of tragedy, and the death of love, truth, and

objective ethics. Indeed, neither the Neo-classicism of Kant nor the Postmodernist-classicism of Nietzsche can offer a solution to tragedy. Nor can they offer an adequate defense of truth, goodness, and beauty. Instead, they revert back to an empty aesthetics devoid of love or virtue.

So events and fine art objects can be evaluated on three levels: the personal, the sociological, [1] and the ontological. On a social level the *Laocoön* is representative of the Hellenistic period in the development of Classical art. On an ontological level it represents a cultural crisis. Gone is the calm repose and harmony characteristic of the Classical art thus far considered. Instead, the sculptural group *Laocoön* shows the failure of virtue and wisdom in the presence of competing gods, where fate and chance deny love and responsible freedom, condemning us to tragedy.

Literary accounts agree that Laocoön objected to the Trojan Horse being drawn within the gate of Troy, and that he and his two sons were subsequently destroyed by serpents sent by the gods. Those accounts vary as to which god sent the serpents and specifically why. In general, however, it can be said that Laocoön's crime was his inability to effectively love the divine. When such love is denied then conflict results; therefore neither love nor claims to truth can find completion. The resulting conflict between gods and our passion denies both reason and virtue. When neither reason nor virtue matter, then folly and tragedy appear real. But there is more to it than that.

If to some precious degree the story of Laocoön is true, then it would be impractical to ignore the warning offered by this work of art, given that it would then represent the way the world actually is. It states that life is existential, that it lacks objective purpose and denies reason and virtue. Whereas the Postmodern existentialist takes comfort in the notion that meaning is obtained by the sheer constructive act of making willful yet arbitrary choices, the *Laocoön* denies that even such constructive acts necessarily matter. It denies that existence can determine essence in a meaningless world because meaningless essence is death.

Taking this work of art seriously is then to be personally terrified. It invites us to believe that belief is empty, and that not even a will to act is enough. So Nietzsche's notion that the will to power provides meaning is meaningless; like Nietzsche's last man who is so despicable that he is no longer able to despise himself, we face the void not with a willful triumphalism but a meaningless self-contempt.

Since Laocoön aspired to being a virtuous man, but came to grief, then do love and virtue really matter? And if they do not matter, then can life have meaning or freedom exist? This is a perennial question of human existence, and it is the central question to an intellectual history of art. Without truth, love, and beauty, a life both cultured and free ceases to exist. Responsible freedom, culture and art are thereby reduced to the banalities of chance, fate, and ultimately an empty violence. Whether Laocoön represents the failure of

virtue in the world, or the incompleteness of Hellenistic Classicism, its conclusion remains dismally the same. This sculpture attempts to explain the meaning of life, and that explanation is dismal: our lives are plagued by tragedies of which there is no understanding, and from which there is no escape or remedy.

Artistically, the Laocoön also raises the question of whether Classicism is still a vital cultural option. Instead of a Platonic representation of a beautiful ideal, this is a sculpture that proclaims the triumph of tragedy. As such Plato would censor it as harmful to society. For Aristotle there is a need to balance ethical rationality with aesthetic passion, where a cathartic and therefore purgative sense of drama relieves pathos, fear and despair. But an emotional catharsis does not cure the malady of a world that appears to make no sense. To be well adjusted in a meaningless world is to make an absurd mockery of being well adjusted. In the *Laocoön* sculpture there is conveyed a pervasive sense of brutal, cruel, arbitrariness. This object embodies the cultural antinomy of Hellenistic culture: on the one hand is the attempt to rationally understand a purposeful reality and life, but on the other hand is the occurrence of the irrational. Nietzsche's analysis of Classical culture as neurotically conflicted between Apollo and Dionysius appears justified.

As noted earlier, a distinction is made by Aristotle between intelligible beauty and physical aesthetics. Aristotle associates beauty with moral good in behavior (*Rhetoric*, 1366a), but approaches works of art aesthetically. Morality is beautiful, whereas objects aim at an aesthetic perfection. Aristotle holds that art, or making, is distinct from ethics, or doing. Art focuses on making things right while ethics focuses on doing that which is right. Persons who make things are artistically responsible to make a work of art as perfect as possible, but also morally responsible for how they should use those things. That which is made ought to be made well, and should be used to serve a good purpose. Art and prudence, aesthetics and ethics, are then understood to be related but separate realms. So in considering the purpose of art there occurs for Aristotle a shift from making to doing, from art to prudence.

In contrast is Plato's unity of the true, good, and beautiful. He does not separate art and prudence as Aristotle does. By not substantively separating art and prudence, he uniformly pursues the true, good, and beautiful. Plato concludes that fine art is properly instructive of morality. All fine art is to varying degrees ugly or beautiful, ignorant or wise, and all fine art is didactic. It teaches us. Therefore, in a civilized community, the violent and irrational cannot be fine art.

So Aristotle maintains that the adult experiencing of art aims not at receiving instruction. Art is not made to convey moral truths. To the contrary, for Aristotle the purpose of art remains aesthetic. The arts in general are valuable because they repair the formal deficiencies in nature, and aesthetic delight is the pleasure of perfection. For Aristotle, the liberal arts provide profound mean-

ing, whereas the art object itself provides emotional pleasure. What then of content? For Aristotle the liberal arts result in fine art that is materially and formally aesthetic, but which can embody profound meaning. In uniting beauty and goodness in ethics but distinguishing them in art Aristotle makes a subtle yet significant shift from the Platonic position, a shift with profound future consequences. The result is that when ethics are depicted via art, they represent not so much a glimpse of numinous wisdom and beauty, as *a concept presented aesthetically.*[2]

So for Aristotle the purpose of art is to pursue perfection and to produce emotional delight, but that delight should be of an elevated type best experienced by a refined audience rather than one debased and vulgar. However, in contrast to Plato, for Aristotle neither delight nor profundity need be substantively optimistic. Aristotle speaks of tragedy being one of the primary and significant modes of art, providing an emotional and spiritual cleansing for the audience.

The *Laocoön* is obviously an emotional piece of fine art. It depicts a piteous agony on the part of Laocoön whose alleged crime was being subject to the conflicting wills of gods, and for pursuing both patriotism and sagacity. He was unable to effectively love conflicting gods. He attempted to remain pious; he fought valiantly for Troy, his community; he wisely counseled that the Trojan Horse should not be permitted to enter the city. However, his wisdom, actions, and piety lead to disaster. The theme of this sculpture is then not only tragic, but irrational as well. For Plato it is harmfully conflicted; to Aristotle it elicits a cathartic emotional response: we all have suffered unjustly, and from the Aristotelian viewpoint the work of art provides a healing experiencing of that suffering.

This work echoes Aristotle's words in the *Poetics* (1453) that refer to theatre but can easily be applied to sculpture:

> The Plot in fact should be so framed that, even without seeing the things take place, he who simply hears the account of them shall be filled with horror and pity at the incidents...
>
> Those, however, who make use of the Spectacle to put before us that which is merely monstrous and not productive of fear, are wholly out of touch with Tragedy...
>
> The tragic pleasure is that of pity and fear, and the poet has to produce it by a work of imitation; it is clear, therefore, that the causes should be included in the incidents of his story. Let us see, then, what kinds of incident strike one as horrible, or rather as piteous.

and also his words in *Rhetoric* (1386f):

> Most piteous of all is it when, in such times of trial, the victims are persons of noble character: whenever they are so, our pity is especially excited, because their innocence, as well as the setting of their misfortunes before our eyes, makes their misfortunes seem close to ourselves.

Plays such as *Oedipus Rex*, where acts done in ignorance reveal assumed virtue as vice, is cathartic but also somewhat understandable; Oedipus did not consciously commit patricide, and so he can be viewed with some sympathy. Consequently, it does not threaten Aristotle's limit on tragedy excluding that which is irrational, or evil. But the story of Laocoön strikes deeper. It presents the specter that rationality as a means to understanding the world and ethics is subject to fault at the hands of irrational or perverse humans or gods. Attempts at responsible freedom may in actuality lead to despair and death.

So this sculpture challenges the Classical notion that evil is the result of ignorance or vice, and that the world ultimately makes sense. It puts into doubt that tragedy as the result of a conflicting pursuit of the good can be resolved or even assuaged via catharsis. And it contests that virtue matters. Laocoön is never accused of being stupid or evil; he pursues a virtuous path. Yet he meets a dreadful fate. Consequently, this object invites us to contemplate the perennial issue of why do bad things happen to virtuous people? As such, it also challenges the notion of transcendental beauty.

As discussed previously, Plato and Aristotle believe the world and culture to make sense, that reason and virtue matter. What then of tragedy? Tragedy denies that condition (*being*) and conduct (*becoming*) are in a causal or exhortative relationship. It thus denies the possibility of beauty. In contrast to Plato, who identifies beauty and goodness with *being*, *aisthesis* is the concept favored by Aristotle. It is significant that when Aristotle does speak of beauty (*kalos*), such as in the *Metaphysics* (1078a), he chooses not to associate it with goodness. He specifically associates it with condition, rather than with conduct. Similarly, when he uses the term in the *Poetics* (1450b), *kalon* is aesthetically defined as that which is orderly arranged and shows magnitude. But to the point: can Laocoön's condition be separated from his conduct? And if so, then how can virtue and beauty be real?

To put it differently, for Plato reality is that in which transcendental ideals such as goodness and beauty are to varying degrees physically objectified and reasonably understood. In fine art Plato combines the material with the ideal in the pursuit of that which is true, good, and beautiful. In contrast, Aristotle asks whether an object represents a perfection of a kind, and how it and its content are emotionally experienced.[3]

How is the *Laocoön* to be emotionally experienced? For Plato that question makes no sense: the object evokes irrational tragedy and as such undermines morality and goodness. It warrants censorship because it declares that the gods and the world make no sense. For Aristotle, the object conveys the concept of tragedy, and does so aesthetically and skillfully. It represents a pathetic story about failed virtue, or fate, and it elicits an emotional response since a rational one cannot suffice. When virtue or fate result in tragedy, Aristotle's offered solution is catharsis. That catharsis necessarily centers on the emotions rather than on the ideal. It alleges that the solution to tragedy is

not found in understanding but in feeling. Consequently, the ideal is reduced to a concept that is aesthetically experienced. The irony, as we shall later see, is that this conceptualization of the ideal is historically tragic.

The *Laocoön* perfectly expresses its concept, but if its concept is true, then virtue does not matter. If it is true that the world makes no sense, then morality in art and life, as a matter of action or condition makes no sense. And if it does not make sense, then our personal and social existence cannot make sense. Existence just is, and is not enough.[4]

In summary, if beauty is intelligible and connected with the way the world and virtue really are, then the abandonment of beauty for an aesthetic of conceptualization and emotion is an abandonment of attempting to make coherent sense of reality and life. On the one hand, Aristotle advocates virtue by positing that moral agents will prevail because rationality will prevail; the pursuit of happiness is both liberal and practical. But on the other hand, he is at the same time aware of tragedy; rationality proved to be of little use to Laocoön. The solution to tragedy offered by Aristotle is that the emotional impact of the aesthetics of this object ought to produce a valuable catharsis on the part of the viewer. But it may instead produce a dreadful realization of utter despair or violence, stemming from the realization that virtue does not matter.

Plato transcendently unifies and transforms morality and aesthetics, aiming for a beatific vision of the Good; he finds the appearance of tragedy to be grounded in a lack of piety, ignorance, or economics. But although he proposes a transcendent solution to tragedy, he offers no compelling means by which to do so. Alternatively, in Aristotelian thought an initial and unfortunate step is taken where moral principle can be viewed as a mental concept rather than as part of reality. Why unfortunate? Because when principle fails in practice, the principle becomes a mere word, a concept—which has failed. In sum, the conflict between rational morality and experience is denied by Plato, turned into a concept and a cathartic experience by Aristotle, and is in either case ultimately unresolved.

The dilemma of why bad things happen to good people is a fundamental challenge not only to the Platonic and Aristotelian understanding of reality and life, but to all of humanity as self-conscious beings. It is a challenge that results in the Classical tradition shifting its focus from the polis to a new metaphysics. We will see in the next chapter that this involves a reconsideration of Plato, and much more. Such periodic reconsiderations of Plato's and Aristotle's ideas characterize an important element in the history of Western culture. It is an element that continues to the present. The history of the reemergence of Classical thought through the centuries will be a major theme in coming chapters; an early example of that periodic reemergence will be considered via the influence of Plotinus and Augustine.

The problems facing the Classical tradition are made dramatically clear by the selection of the story of Laocoön as the subject of fine art during this

historical period. Aristotle's philosophy assumes that happiness can be achieved via virtue, while at the same time it recognizes the existence of tragedy. But how can the two be reconciled? Plato thinks they cannot. In the *Republic* he criticizes the very notion of tragedy, and perhaps he is right. The *Laocoön* tells us that virtue does not necessarily lead to happiness; nor might catharsis lead to a purifying emotional cleansing. It may simply produce first fear then ridicule, and then despair and violence. The message of this work of art is not that fate can lead to tragedy, but rather, that tragedy is our fate.

So a new generation of thinkers attempts to solve these difficult problems. Going beyond the foundational efforts of Plato and Aristotle in seeking the ideal society or happiness, the central cultural question that remains is: How can individuals be virtuous and free when, like Laocoön, virtue and sagacity appear to nonetheless lead to tragedy?[5] It is a question that marks the Classical tradition not so much obsolete, as incomplete. Indeed, the Classical tradition responds by advancing Plato's thought, not one step further, but rather, one step higher. It departs from the aesthetic worldview of Aristotle[6] to the pursuit of beauty once more.

The message afforded by Laocoön is that circumstances result in negative consequences and both may well be beyond our power to change. It is a message that rings true for the present as well as the past; we are indeed buffeted by events and circumstances distant to our control. But this message is unsatisfactory in the attempt to embrace responsible freedom. If fate or chance is supreme then the issue of personal responsibility fades. Alternatively, if there are no consequences to our actions then both freedom and morality wither into mere arbitrariness where reality and life elude comprehension.

While the *Laocoön* is perhaps aesthetically effective, its denial of a rational morality is corruptive to ethics and civilization. Its disconnecting of reason from reality relegates us to believe in the limitation of science to fact, of culture to emotion, and of politics to power. An aesthetic of art and life prevails where reason becomes a mere concept, or a rationalization; what Kant would cherish Jeremy Bentham calls nonsense on stilts. But the denial of reason is indicative of the periodic manifestation of the harmful denial of beauty in Western culture.

The Perennial Significance of the *Laocoön*

The perennial appeal of Classical culture is evidenced by the *Laocoön* sculpture. Through the centuries those who are dedicated to culture and civilization have discussed this image and theme. For example, the Classical *Laocoön* was the subject of much discussion during the so-called Enlightenment of eighteenth-century Europe. What prompted an interest in the *Laocoön* during the eighteenth century? The *Laocoön* sculpture makes manifest the struggle between aesthetics and beauty in the eighteenth century, as it did during the Hellenistic period, and the Baroque.

Proponents of the Enlightenment uniformly reject the notion of transcendent beauty.[7] What is interesting to note is that so does Aristotle. The link between the Enlightenment and Aristotle centers on aesthetics. The central premises of the Enlightenment (as expressed by Kant) are resonant with some of those advocated by Aristotle. As discussed above, Aristotle attributes the formation of matter into things to four causes: material, formal, efficient, and final. For example, in fine art you have a material medium, which is given form when the material makes manifest the idea. This is achieved by our efficient efforts, to explain a meaningful world. So for Aristotle the formal depends ultimately on the final cause, and the final cause is recognized as ontological and metaphysical; it refers to essence not accident, to the objective ideal not the subjective or the physical.

Kant similarly understands art to be a matter of aesthetic perfection. In contrast is how the Enlightenment treats reason, form, and the final cause. The primary difference between Aristotelianism and the Enlightenment is in the latter's denial of a teleological and cosmological context. For Kant there are facts, feelings, and reason, the last being logically coherent and conceptual rather than ontological[8] and numinous. Kant rejects that knowledge of reality is possible, and therefore, declares that final causes are unknowable, and that formal causes are merely rational; for Kant reason is reduced to mere rationalization.[9] The Enlightenment's faith in necessary fact, subjective emotion, and in non-teleological reasoning, requires an aesthetic and merely rationalistic approach to culture and life. As discussed later, the Aristotelian paradigm becomes extraordinarily accommodative of the Modernist substitution of feeling for thought, and aesthetics for beauty when placed within a non-teleological and non-cosmological context. In either case, no solution to tragedy, or foundation of culture, obtains.

The *Laocoön*, Reality, and Biography

This linkage between Aristotelianism and the Enlightenment is evidenced by the latter's continuing interest in the Laocoön story and its representation in art. And it lends credence to the need to discuss the *Laocoön* sculpture and its meaning via a wide variety of historical perspectives. For example, *aesthetics*, the *sublime*, and *eurythmy* center on an absence or rejection of rationality as a means of understanding the world. During the ancient period such terms are discussed variously by Longinus and Vitruvius then reinterpreted in another way in the eighteenth century by Winckelmann and Lessing, Burke and Kant, and in yet another way in the twentieth century by Baumgarten, Lipps, and Worringer. In each case the issue of fate or chance versus virtue and knowledge comes to the fore. That issue is no less than a challenge to the very possibility of culture.

The crux of the matter is that ancient literary accounts of the Laocoön story are intensely emotional; in contrast, the Laocoön sculpture is comparatively

constrained. This difference of interpretation was evident both during the ancient period and by writers during the eighteenth century. That difference of interpretation is not merely one of aesthetics; to put it differently, the deeper question involves determining which of these interpretations is *better*. To determine which answer is better involves the question of which answer is more realistic. That question involves addressing the issue of how in touch with *being* is the *Laocoön*, and our understanding of it.

When asked to be realistic, the aesthetic mind will conclude that our understanding of reality is the result of a subjective-objectivity; to be realistic is to focus on taste, opinion, or power, be they rationalized or not. But to the mind seeking beauty, to be realistic involves behaving in accordance with the way things really are. But what does that mean? Does it mean that we should be pessimistic or optimistic, contentious or considerate, driven by power or by ideals? The term *realism* once referred to the pursuit of objective ideals that are more genuine and more important than the events and experiences that are subjectively experienced. Plato was in this sense a realist. To such a realist, biography and beauty are clearly linked as a record of how close to the universal ideal particular events and experiences are. Biography and beauty are then linked by responsible freedom, where actions aspire to be in touch with a benevolent reality. To varying degrees, and with varying success, those events and experiences are made manifest in time via art.

To Plato and Aristotle, since the world ultimately makes sense, it is more realistic to be an optimist than a pessimist. And it is more objective to link biography and beauty within meaningful time, where history evidences purpose. For biography to be meaningful, it must be grounded in reality; for the idealist, reality is ultimately wonderful. However, if reality is understood aesthetically, that is, as a factual and subjective construct or experience, then not biography, nor time, can have much meaning or offer much hope. If the Homeric tales are generally accurate, as archaeological evidence suggests, then to view the sculpture of Laocoön is also to contemplate biography. But the difficulty is that the historical meaning of the *Laocoön* is that biography and responsible freedom mean nothing. His life was a tragedy despite his attempts at piety and sagacity. In this case, the sculpture can offer mere spectacle, leading at best to an emotional catharsis. If the *Laocoön* is viewed as indicative of a purposeful reality and our place in it, then to echo Kant's terminology, we are confronted by the antinomy of Classical culture: virtuous idealism in the midst of tragedy.

With its confidence in virtue, in responsible freedom, Classical culture cannot intellectually succumb to tragedy; and yet it has no adequate response. With its confidence in intelligible beauty, it struggles to come to terms with passion and evil. Laocoön's tragic biography displays a random or brutal experience that denies the importance of virtue and responsible freedom. It denies the possibility of beauty by declaring that reality and life are indeed

not intelligible. Not biography, nor beauty, nor time can escape meaningless-
ness. The Enlightenment's denial of teleology would then appear to be justi-
fied and so too the Postmodernist assumption that reason is but a mask for
pleasure and power. But are they?

The conflicts inherent to this work of art have prompted significant com-
mentary over the centuries. Johann Winckelmann (1717-68) wrote that the
reason why the *Laocoön* statue refrains from depicting displays of intense
emotion, whereas in Virgil's literary account such restraint is absent, is that the
Greek genius has a superior noble restraint to that of the Latin. The Greek
aspires to the beautiful, whereas the Latin relishes the tragic; for Winckelmann,
this explains and resolves the conflict between beauty and tragedy as evi-
denced by varying presentations of the Laocoön story. However, in response,
Gotthold Lessing wrote in 1766 an essay titled *Laocoön*. He disputes the
contention of Winckelmann. Lessing (Romantically) argues instead that both
Greek and Latin viewed vehement expression of emotion as natural and god-
like. He cites various accounts of Greek gods exhibiting such behavior, and
concludes that sculpture is more conducive to beauty, whereas literature per-
mits more variety in the expression of an idea or event. It is the particulars of
art (making) that determines whether an object is best presented in terms of
beauty—or sublimity.

Note that the attempt by these Enlightenment writers to reconcile beauty
and tragedy are aesthetic: following Aristotle, they seek technical, psycho-
logical, and sociological explanations for an ontological problem. As a matter
of conscious understanding, the conflict between beauty and sublimity, truth
and tragedy, presents an intellectual problem; it raises the question as to whether
or not we can understand the world and life and thus live virtuously. In the
Aristotelian tradition, beauty and tragedy are in conflict not as a matter of
skill, or taste, or psychology, but as a matter of cognition and action, of the
contingencies of fate or the conflict between final, formal, and efficient causes.

Practically speaking, Classicism holds that the world is indeed rational.
But if reality is rational, then why is public life as it is experienced, so often
irrational? If we naturally seek a Platonic or Aristotelian Good, then why are
we surrounded by violence and evil? Only a partial explanation is offered by
the idea that ignorance is the source of conflict; as Laocoön and Greek tragedy
make clear, there is often more to it than that. Hellenistic culture exposes a
contradiction between Classical culture and experienced reality, between bi-
ography as it seeks knowledge, and biography as it is often lived. As noted
above, Plato quotes Hesiod: "First chaos, then order, then love." But if a pri-
mordial chaos should be escaped, then how and why can that escape occur
when tragedy prevails? The conflict between an eternal and chaotic world,
and the truth that gives form to a world that is a cosmos, is left unsolved in
metaphysics and in life. [10]

To the Classical mind, for chaos or tragedy to be averted, violence must be controlled or transcended. To control violence is not to resolve violence; on a metaphysical level it is incoherent to control violence because obtaining such control requires an act of violence. It therefore subverts purposeful time and purposeful history. Time and history are brutalized and aestheticized. Aristotle attempts to transcend the anxiety caused by the gap between experienced chaos, and virtue, with his theory of catharsis. He is successful emotionally and psychologically (in an empiricist sense) but not ontologically. Catharsis cannot suffice for conscious beings attempting to understand the world and life. Plato argues for transcendence, rejecting tragedy as immoral and destructive, but fails to explain tragedy as more than a failure of reasoning and piety.

So Classical culture notwithstanding, the Greeks were well aware that in life virtue not always corresponds with happiness, that chance or fate can be antagonists of responsible freedom. Nonetheless, they clung to the hope for wisdom, freedom, and beauty. Philosophically and theologically they were dedicated to the attempt to make sense of reality and life. To the point: just as within a relativistic culture where truths exist and compete, within a polytheistic culture fate is contingent upon the willful conflicts of the gods - as seen in the case with Laocoön. In the presence of many truths, our fate is to be victims of virtueless chance or fate. Aeschylus, in *Prometheus Bound,* makes clear that lacking omniscience, even the omnipotent Zeus is not the master of his own fate; Plato is aware of these difficulties, and in *The Republic* (398) has Socrates state that Homer erred in writing that Zeus sent a lying dream to Agamemnon. Later, the Roman writer Tacitus declines to choose between the two unsatisfactory alternatives of fate or chance:

> ...most men...cannot part with the belief that each person's future is fixed from his very birth [but] the wisest of the ancients...leave us the capacity of choosing our life...I suspend my judgment whether it is fate and unchangeable necessity or chance which governs the revolutions of human affairs. [11]

Tacitus' ruminations on the meaning and purpose of life have a perennial import. As a historian he raises the question of whether biography and beauty can be linked, or must they be violently torn asunder by Kronos, or by conflicting gods. These issues echo contemporary debates as to whether our lives are primarily influenced by nature or nurture, random chance or fate. What is omitted is the possibility of responsible freedom, where we can make better or worse decisions in time. This denies the possibility that our lives can to some precious degree be beautiful. But if we agree that we can indeed enjoy responsible freedom, and the choices we make can result in a qualitative difference in how we live, then the problem remains: How can the situation of Laocoön be averted?

So as Greek myth asks: can we escape the dreadful prospect of choosing between the Scylla of choice without purpose and the Charybdis of purpose

without choice? Laocoön presents us with an existentialist dilemma that re-
curs over the millennia. It evidences a Nietzschean eternal recurrence—what
beckons is the possibility of a beautiful resolution.

Laocoön as Existential Fact

The existentialist dilemma offered by the *Laocoön* is a perennial one. What
is existentialism? For the moment, it can be noted that following Kant, exis-
tentialists advance the notion of a subjective-objectivity. From an Existential-
ist perspective it is not a question of whether our acts of free will result in good
or bad. What matters is whether free and conscious choices result in our being
authentic. By authenticity is meant that one is true to one's self, to one's
empirical sense of identity. That is, in a meaningless world we obtain meaning
via our mere existence. Existentialists assert that authenticity is a matter of
identity rather than knowledge—or goodness. That identity is based upon an
unfettered individualism, or by our race, gender, or economic class.

This notion of authenticity is commonplace today; how common is the
phrase "we have to be true to ourselves?" This appeal to authenticity affords a
wide variety of superficially distinct points of view. Under the rubric of Exis-
tentialism, there are those who seek authenticity as autonomous individuals,
and those who seek authenticity via race, gender, or economic class; fascist or
communist, religious or secular, all share the same concern for authenticity.
However, authenticity is at its core a singularly aesthetic concern; it centers
not on that which is understood but rather that which is experienced and lived.
It centers on aesthetics while ignoring beauty. It thus provides no actual es-
cape from meaninglessness.

To Tacitus, the plight of Laocoön remains a mystery; to an Existentialist
that mystery is the solution: as long as Laocoön was authentic, then the sculp-
ture evidences the dignity that results from our making choices in a meaning-
less world. But neither can successfully provide an enriching explanation of
reality and life, and neither can accommodate hope or love. In contrast, Exis-
tentialism advocates self-expression and self-realization in a world that is
assumed to have no knowable purpose beyond self-expression and self-real-
ization. And this solipsistic view of culture devolves into a violent narcissism.
It takes for granted that attempts to pursue beauty are foolish attempts to
construct grand comprehensive schemes to spuriously explain reality and life.
There are Nietzschean existentialists who simply advocate an irrational will to
power; there are those Existentialists who embrace a violent dialectic of race,
gender, or economic class. In each case the choice is clear: our lives lack
purpose beyond a willful striving for authenticity, or simply, for autonomous
or group power.

This Existentialist approach to reality—and biography—centers on a sub-
jective-objectivity which ignores the notion that *doxa* can provide an initial
step towards that of obtaining knowledge; that rather than merely differently

constructed stories, or identity based violence, there can be obtained degrees of actual accuracy and insight. Existentialism ignores also the possibility that the world is purposeful and can to some degree be understood. Should we will (which is the only option) that purpose is found in a purposeless subjective-objectivity, in self-expression and self-realization, then our identity is established by a sociopathic vision. The existentialist must contest the power structures that impede that narcissistic goal. This presents a problem that can be made clear by paraphrasing Aeschylus's comments about Zeus: even among those who, like Zeus, construct their own realities or assert their own authenticity, the authors of conflicting visions of reality and identity have no recourse but violence.

The biography of Laocoön presents us then with a realistic problem: if Tacitus and contemporary Existentialists are right in questioning the importance of virtue, wisdom, and beauty, then that which we do is unimportant even if we have chosen to do it as a willful and violent aesthetic act. Alternatively, if beauty is important, then why do bad things happen to those who are to a substantial degree virtuous and wise? If our destiny depends on chance, or violence, then our lives can make no sense. If it depends on our arbitrary choices, then our lives still make no sense. If it depends on power, then our lives make no sense yet, even if we equate violence with truth. In sum, if we are dependent on the idea of conflicting gods (or demi-gods) who construct their own realities,[12] then are we not still pawns to the fate of those conflicting gods (or demi-gods)?

To the point, to take this sculpture seriously, we have to tremble for our future. It presents us with two dreadful options: if responsible freedom is impossible, then human dignity is trivialized; but if responsible freedom leads to terrible consequences, then the price of virtue and human dignity may be too dear. This work of art cannot provide a healthy catharsis as advocated by Aristotle. Aristotle articulated his theory of catharsis with an important clarification: the tragedies afflicting those in the story somehow had to make sense. They were to be based upon error, ignorance, or conflicting necessity rather than the occurrence of rationalized and willful evil in the world. For example, Oedipus is free from moral sin because he did not know that he was attempting to kill his father. Because his tragedy was not the result of intentional malice, the audiences' catharsis could be redemptive. The world still made sense despite the tragedies presented by art and experienced in life. But what if those tragedies were not based on the presumption of ignorance? What of the situation faced by Laocoön? What if tragedy occurs with complete knowledge and in total contradiction to genuine virtue? Then catharsis would have no redemptive effect, and the result is a morbid despair or a sadistic voyeurism.

Enlightenment proponents such as Winckelmann and Lessing attempt to reconcile beauty and tragedy via an aesthetic path; they seek technical, psychological, and sociological explanations for a conflict in belief about the

world. In so doing, they miss the metaphysical point: the problem is whether or not our attempts to make sense of life can be successful, whether or not beauty and responsible freedom are possible.

Nor does an Existentialist explanation offer much hope. Authenticity requires us to believe that existence just is. To assume that authenticity facilitates responsible freedom is to fundamentally err because the proponents of authenticity share a commitment to the notion that truth is power. When truth is power then culture is violence,[13] and a violent culture is no culture at all. It is barbaric.

Intelligible Beauty, Eurythmy, and the Sublime

A rejection of intelligible beauty leads to a search for alternatives. During the Hellenistic period, the Doric order in architecture was increasingly replaced by the Ionic, the Phrygian, and the Corinthian styles. By extension the Doric Orders' ideas about ethics, music, and law decline in influence. This is paralleled by a shift in how beauty is understood, which is so essential to Classical culture. It shifts to that which is known as *eurythmy,* and to the *sublime.* Whereas beauty strives to be in harmony with reality, the latter strive to be effective in affecting or suiting the subjective needs of the viewer.

The first-century AD Roman architect Vitruvius was concerned with both *symmetry* and *eurythmia.* Classical culture maintains that symmetry is associated with ontology, with *being,* with the nature of a harmonious reality. It takes for granted that the world makes sense. In contrast, *eurythmia* is epistemological and experiential. It is concerned with the subjective experiencing of art and life; it is aesthetic rather than intelligible. As explained by Vitruvius:

> Eurythmia depends on the beautiful (venusta) shape (species) of the building and on the proper (commodus) appearance (aspectus) achieved by the arrangement (oppositio) of its individual parts. [14]

Symmetry deals with the objective determination of beauty via intelligible harmony, a harmony that is ontological rather than emotional. It refers to the world being a cosmos rather than a chaos. In contrast, *eurythmia* centers on its experiential aspects. It applies to species rather than essence, the particular within the general. A beautiful species makes little sense to Aristotle.[15] It results in a conceptual confusion where knowledge and feeling are muddled. So the nature of *eurythmia* is different from that to which the Greek term *kalon* refers; the meaning of *venusta species is* closer to *aisthesis*: that which is lovely, comely, charming, pleasing, and graceful. Vitruvius using the terms *venusta species* rather than *kalos* in reference to the idea of beauty indicates a shift from the Platonic *kalos.* But it also indicates a shift from the Aristotelian *aisthesis* where perfection and tragedy are to be experienced in a universe that

ultimately makes sense; where formal and final causes ought to rationally correspond. Instead there is now a tension between an experience that once referred to a world that makes sense, and a subjective eurythmy, which can only be felt.

Aware of these issues, Vitruvius speaks in support of symmetry, arguing that it was proper that given the different qualities of the gods, they ought to be placed within different types of temples. He holds that Athena and Ares should have Doric temples, with Aphrodite and the nymphs housed in Corinthian temples, and Hera and Dionysius in Ionic temples. But in attempting to bridge the gap between truth and passion, the objective ideal and subjective experience, both the *Laocoön*, and Vitruvius, personify the cultural conflicts of the age. Not Laocoön, Agamemnon, or Paris can reconcile competing gods, or reconcile the rational with experience, virtue with freedom. Consequently, there is a shift from knowing to feeling, from understanding to experiencing, and therefore from beauty to an aesthetic *eurythmia*.

Another attempt to transcend the conflict of beauty and tragedy is found in the first-century AD text, *On the Sublime*. Traditionally but doubtfully attributed to Longinus, it is argued that great style goes beyond that of intelligible beauty. It springs from an artists' passion, and that passion stems from a great soul.[16] Longinus maintains that sublimity must descend neither to a superbly crafted artificiality nor to puerility, timidity, affectation, or bad taste. So it must transcend beauty without violating it. It requires that one rise above principle. The resulting dilemma is similar to that faced by the mystic: how can we know that we *have risen above* intellectual principle when only intellectual principle permits such knowledge to be known? The relationship of beauty and the sublime, and of truth and tragedy, here remains subjectified and problematic. It remains problematic to the Modernist-Postmodernist tradition as well.

So the dilemma faced by Laocoön is not so ancient after all; indeed it is one that confronts us today. None of us can rightly be entertained or bored by the work—and *eurythmia* offers no genuine relief. Laocoön's story is more than a matter of opinion; his situation actually provides insight about a crucial dilemma in life faced by us all. His biography is more than aesthetic and emotional, or conceptual and manipulative. But if it aspires to beauty it should make physical a glimpse of the true and the good; if it aspires to the sublime, it should rise beyond beauty and tragedy to the realm of transcendence. For it to pass from the beautiful to the sublime, the Laocoön should evidence not only trial and tribulation, but also the possibility of redemption. We could understand how tragedy can be overcome. But it does not. It offers no hope.

Plotinus and the Metaphysics of Love

The crisis evidenced by Laocoön is a crisis of understanding. The world no longer makes sense. The tie between intellect, virtue, and happiness has be-

come tenuous at best. There were various attempts to make sense of the sense-less, to reconcile reason with an apparently unreasonable world. There were attempts to replace beauty with aesthetics, eurythmy, and the sublime. Sto-icism and Epicureanism are two such examples, respectively offering dignity and pleasure as respites from our dilemma. But as Plato anticipated, neither personal dignity nor pleasure provides sufficient responses. As public responses to evil and suffering they abandon the public realm for the personal and trivial. Existentialism today attempts to do the same in the face of an apparently meaningless world:[17] to make sense of a purposeless life by an advocacy of self-expression and self-realization. But Stoicism, Epicureanism, and much later, Existentialism, fail by their essentially aesthetic narcissism. Even grant-ing a personal appeal, they fail as positive modes of public culture. To deal with the problems of life via a reduction of public needs to the merely per-sonal, be it individualistically, or as a matter of group identity, is to fail both personally and culturally.

Conceptually, existentialism purports to escape an unworldly transcenden-talism by an aesthetic authenticity. But an aesthetic authenticity denies the possibility of a meaningful world beyond a subjective-objectivity. It therefore assumes we are world-makers, and as such assumes a self-deification.[18] Indeed, it is the worldly narcissism of existentialism that stands paradoxically com-mitted to the attempt to find a refuge *from* the world; it attempts to find refuge from a purposeful *being* by willfully assuming that we are that *being*. That self-referential *being* demands that truth and love exist as subjective-objec-tive aesthetic preferences. But that demand destroys that very possibility.

So the bigger problem remains: if responsible freedom makes no sense, then the world cannot be beautiful. If the world is not beautiful, then are we not condemned to a life of banality and violence? Perennially this is a serious issue. It was an issue directly addressed at the close of the third century AD by Plotinus. In his writings Plotinus evidences a fundamental shift in thinking, from the aesthetic to the beautiful once more. His work addresses how beauty and virtue exist in an imperfect world by returning to and advancing the ideas of Plato.

Plotinus was of cosmopolitan background. He may have been born in Egypt, possessed a Roman name, and likely spoke Greek as his native language. It was not until he turned fifty that he began to produce a series of philosophical essays, arranged and published between 300-305 AD. For what purpose did he write? His work constitutes the attempt to understand a seemingly meaning-less world. Every cultural tradition faces a fundamental choice: either we choose to pursue how the world is beautiful and makes sense, or we aestheti-cally choose to assume that it does not. It is a choice that cannot be decided scientifically, and it is a choice that directly affects our vision of politics and of ethics. Plotinus seeks beauty and knowledge by trying to understand just how the world makes sense.

In contrast to Plato's and Aristotle's assumption of a primordial chaos aspiring to the ideal, Plotinus concludes that the purpose of reality and life is found in a transcendent monism. God is the ultimate Principle, and from that Principle emanates both purpose and multiplicity. The first emanation from the One is Thought and that Thought is not merely factual or emotional. It is beautiful. We seek knowledge of and eventually identify with the One from which all descends. The pursuit of this intelligible beauty is driven by love. The love of beauty leads us from the material to the intellectual and from the intellectual to the spiritual. There is a continuum from the mundane to the divine, from random and meaningless aesthetics to the beauty of truth.

Plotinus steps away from the Classical notion that the world begins in a state of chaos that must somehow be controlled and formed into a harmonious cosmos; consequently he rejects the idea that art should be based on symmetry and harmony. He also rejects the Classical idea that fine art resolves tragedy by catharsis. Plotinus advances the Platonic position that there is a continuum from the divine to the mundane, and that culture ought to aspire to the former. He argues that beauty is that which makes meaning evident. Beauty is that which illuminates. Beauty is the emanation of the truth that gives meaning to the world. Consequently, that which we make or do is the realization of the idea in our minds, but the idea in our minds ought to be a reflection of the ideal that is the mind of reality.

Plato emphasized intellectual beauty, leading to the conclusion that material objects were but imperfect physical imitations of what really is. Aristotle advocated aesthetics, which could not answer the challenge of tragedy. Plotinus develops the notion that to varying degrees the material world reveals intellectual beauty, and that the closer one is to intellectual beauty, the more real things are:

> He who looks at physical beauty should not lose himself in it, but should realize that it is only an image, a hint and a shadow, and should flee to that of which it is a reflection. [19]
> This, then, is how the material thing becomes beautiful—by communicating in the thought that flows from the Divine. (First Ennead VI, 2)

Plotinus accepts that both good and bad occur in life; he accepts also that bad things happen to good people. Why is that? Evil is the result of failing to adequately rise to the ideal. The ideal is not coexistent with matter, as with Aristotle, but rather is transcendent. There is a continuum from the material to the ideal, and the ideal is more real than the material. Intelligible beauty is superior to material beauty, or rather, aesthetics.

So Plotinus rejects the aesthetic notion of a subjective-objectivity. He accepts that the subjective mind of humanity needs to love and aspire to the objective mind of reality. It needs to seek the objective ideal. The very mention of such metaphysical ideals within a Modernist-Postmodernist culture is

to invite ridicule.[20] Aesthetic sociology (as opposed to that which accepts the possibility of a meaningful world) cannot fathom metaphysics, even though it advances its own metaphysical vision. As discussed in chapter 1, metaphysics based on facts and feelings pale before idealism. For example, it is a fact that murder occurs, we probably feel badly about it, and civilized societies commonly hold that murder should be against the law. As a matter of aesthetic sociological fact, both as individuals and as groups, humanity is often murderous, and as a matter of fact, respect for the law is based then upon fear or calculation: does the crime warrant risking the time in jail? In contrast, Plotinus (and others) advocates the ideal that promotes an elevated spirituality. We choose to obey the law as a matter of free and responsible choice. We do so not out of fear or calculation, but because we know its right. Culture is not what we so often sadly do, but rather, is that which we ought to do. Culture is to some degree a manifestation of a transcendent ideal.

By that is meant that there is a qualitative difference between *what* and *why*. *What* is the realm of materialism, the realm of facts, whereas *why* exists beyond the what. Not merely beyond the what, but above it. Plotinus argues that in the world good and evil are intermixed, but at the highest levels of reality, the ideal shines forth, giving meaning to a seemingly confused world. As he states in his First Ennead (IV, 14ff):

> If he should meet with pain he will pit against it the powers he hold to meet it; but pleasure and health and ease of life will not mean any increase of happiness to him nor will their contraries destroy or lessen it....The life of true happiness is not a thing of mixture. And Plato rightly taught that he who is to be wise and to possess happiness draws his good from the Supreme, fixing his gaze on That, becoming like to That, living by That.

In contrast to materialist doctrine he holds that matter alone is dull and meaningless; in contrast to subjectivists, he holds that the One of Parmenides, and the Good of Plato's *The Republic* is the objective ground of reality and is the source of all values. [21] Between One and Matter lie descending grades of goodness marked by increasing individuality and a loss of unity. For Plotinus, a factual empiricism is superficial and malevolent, a narcissistic subjectivism marking a tragic failure to understand reality and life.

Plotinus argues that there is a metaphysical ideal that gives meaning to the world and life. In discussing what that ideal is he refers to the association of beauty and love. In his Third Ennead, (V, 1) he explains that:

> It is sound, I think, to find the primal source of Love in a tendency of the Soul towards pure beauty, in a recognition, in a kinship, in an unreasoned consciousness of friendly relation. The vile and ugly is in clash, at once, with Nature and with God: Nature produces by looking to the Good, for it looks towards Order—which has its being in the consistent total of the good, while the unordered is ugly, a member of the system of evil—and besides Nature itself, clearly, springs from the divine realm from Good and Beauty...

He concludes the fifth tractate of the Third Ennead with these words:

Thus Love is at once, in some degree a thing of Matter and at the same time a Celestial, sprung of the Soul; for Love lacks its Good but, from its very birth, strives towards it.

This offers cause to return to our earlier consideration of the *Venus De Milo*, the *Apollo Belvedere* and the *Laocoön*. It has been established that the *Venus De Milo* and the *Apollo Belvedere* can be approached empirically and aesthetically, or intellectually. Intellectually, love is not distinct from Apollo, but rather affects him. Love marks the desire for an intelligible good. It permits us to love others on the basis of character rather than on mere appearance, utility, or power. It permits love to be spiritual rather than merely chemical, biological, or psychological. Plotinus agrees with Plato's analysis of love: that it can be material or celestial, and that celestial love is objectively better. A rejection of Plotinian metaphysics has a practical effect: it requires that Venus and Apollo merely represent material and biological fact, or power. It trivializes love and reason and makes them vulgar by reducing them to fact and feeling, empiricist science and emotion. What then of the *Laocoön*? The tragedy it represents is grounded neither in ignorance, chance, nor fate. Following Plato, he holds tragedy to be an individual and collective will to do as we will, and a failure to love what is good.

We can conclude this review of Plotinus' understanding of beauty and life by a brief reference to his Fifth tractate of the Fifth Ennead, titled, *On Intellectual Beauty*. In that chapter he gives the example of two stone blocks lying side by side. One block, left untouched, remains dull and meaningless. The other block, formed by the artist's hand, enters into the intelligible realm of beauty. He states that all that comes to be, as the work of nature or of craft, entails wisdom, knowledge of that which is true and good. True wisdom has as its source itself: it is the intrinsic meaning of reality and life. He closes the chapter with these words:

Thus beauty is of the Divine and comes Thence only.

At the time of his death, Plotinus' last words are recorded as follows: "I was waiting for you, before that which is divine in me departs to unite itself with the Divine in the universe."[22] The facts of his biography, and of his works, were compiled by his student Porphyry, who was a polemicist against Christianity. Plotinus undoubtedly knew about that faith, but chose not to attack it. Plotinus struggled with Plato's transcendental notion of theism on the one hand, and pantheism and monism on the other. This is to be expected, since for Plotinus philosophy is rightly indistinguishable from theology.

Plotinus is important to the cultural history of art because he introduces a solution to tragedy, and he provides a transition in culture from Classicism to Christianity. He influenced deeply the work of that primary source of cultural

belief in the West, Augustine. Upon understanding the contribution by Plotinus and the conversation between him and Augustine, an intellectual history of art advances. It advances not by rejecting previous fashions, but rather, by addressing serious problems facing us as we attempt to make sense of the world, and our lives.

The *Laocoön* Today: Apollo and Dionysius, Abstraction and Empathy

It was once a commonplace belief that virtue is important. Whether we understand virtue via the Classical perspective of Plato, or the Neo-Classical perspective of Immanuel Kant (as discussed below), there was a recurring confidence that responsible freedom makes sense. Plato recognizes the difficulty in bridging the gap between the Ideal and experience. To resolve the apparent conflict between virtue and tragedy he relies upon the notion of transcendence. He maintains that it is transcendent Truth, Goodness, and Beauty that mark the means by which we can make sense of an often-senseless world. But for Plato tragedy remains problematic. Plato's conclusion is that evil results from a failure to pursue reason and piety. But it is a conclusion that makes every victim or society a partner in crime.

Alternatively, Aristotle favors catharsis as the solution. Catharsis can provide emotional and psychological relief but it can offer no real solution. The challenge of the Laocoön continues to confront us. Indeed, that work of art challenges the possibility of reconciling reason and experience during the first century BC, the sixteenth century, and yet again in the eighteenth century. And it continues in making that challenge even today.

For example, in 1910 Wilhelm Worringer wrote an important text, *Abstraction and Empathy*. In that text he argues that culture consists of the conflict between theory and feeling. It is an argument that is central to Kant and concludes with Nietzsche. Kantian aesthetics posit that there are facts and feelings, and how we arrange those facts into meaningful narratives is a matter of personal or social construction. The world is a hypothetical imperative: it conforms to how we think, *and ultimately feel*. In speaking of rationalization and feeling we can also refer to Apollo and Dionysius. If reason is deontologized then the Apollonian is necessarily reduced to Dionysian feeling. If reason is not linked with reality, then it can only be subject to our own rationalized emotions. When reason is thus confused with rationalized emotion, beauty is replaced by aesthetics. But when the Apollonian is in fact subsumed by the Dionysian, then neither thought nor Hermes is left with any purpose. This results in an aestheticization of truth and love. They are transformed from ontological and personal elements (as Dante understood them to be) to a subjective emotion. Love no longer is a qualitative part of reality; rather it refers to our emotional response to arbitrary stimuli.

The necessary results of this argument are articulated by Friedrich Nietzsche in his book, *The Birth of Tragedy*. As discussed in detail later, Nietzsche de-

clares tragedy to be the key to understanding the fundamental flaw in Classical culture and its lofty aspirations. That culture is one where the rational attempt to understand the world (the Apollonian) and our emotions (the Dionysian) are in continual conflict with each other. The result is that Apollo (theory, reason) is but a mask of Dionysius (empathy, the will to power).

This reduction of truth to theory and love to empathy results in but an aesthetic consideration of theories of art and life, and in an aesthetic experiencing of both. Consequently, we can consider the lifestyle constructed by Laocoön, and the rational structure of thought that provides the arbitrary and theoretical guidelines by which he lived. We might also attempt to empathize with Laocoön's sad plight, to imagine ourselves feeling that which he and his sons felt, to imagine being in their place, suffering as they did. But this empathetic denial of the space between us and Laocoön is a denial of the distinction of subject and object. To embrace this subjective-objectivity is to do yet more violence to Laocoön and to mock the idea of tragedy. Even if we could identify with Laocoön's lifestyle, and actually empathize with his plight, the challenge of the tragic remains: Laocoön is simply lost in a violent confrontation that is ultimately absurd. Aesthetics permits no true recognition of or solution to Laocoön's plight, or our own. An empathetic aesthetics promises an intimate response to tragedy, but simply mocks it; it leads to pretense that transforms tragedy into parody. [23]

Aesthetics permits us to recognize the lifestyle pursued and to emotionally respond to that lifestyle. But those responses are theoretical and empathetic. We are asked to comprehend their rationales and empathize with their experiences. But when reason and love fail to address reality, we engage in a merely *theoretical* consideration of fate and virtue; and it is easy to talk about philosophies or theories of reality, life, and art. We can talk about theories of art, life, and beauty, without ever talking about Art, Life, and Beauty. It is clear that in discussing theories of art, rather than discussing art, we avoid attempting to learn what art (or *being*) is. By not seeking to understand reality, art (and *being*) is consigned to be a matter of personal or group opinion. The initial result is that since no clearly stated personal beliefs are at stake, there are no necessary consequences involved. Theorizing can be pleasant—but it is also useless - because it is theoretical; we can assume that such activity involves no necessary consequences. There are no necessary consequences because by focusing on theory we engage in aesthetics rather than beauty. But beyond this initial response is the specter that there is no room for understanding and belief, and lacking such, there can be neither love nor truth. The paradox then is that a subjective-objectivity results not in a greater intimacy, but rather, in a kind of oppressive voyeurism. So too with empathy.

Theory reduces understanding to a subjective-objectivity where truth can only be opinion. Aesthetically, we look at the *Laocoön* image not with fear and trepidation, but rather find it curious or interesting. We are thus placed in

a voyeuristic relationship, where the meaning of the *Laocoön* is reduced to mere entertainment. By talking about philosophies and theories of art and life, we obtain an excuse for engaging in the vain attempt to avoid reality itself. That vanity extends beyond the intellectual, to the cultural and the personal. Assumedly, since no personal beliefs are clearly advocated, then nor are there any personal consequences. We can remain content with our own prejudices. What are those prejudices? That the meaning of "art," "life," and "beauty" are a matter of personal or sociological aesthetic preference. Such theoretical discussions permit us to appear broad-minded while remaining dogmatically relativist and skeptical.

Empathy reduces understanding to a subjective-objectivity where the object is absorbed by the subject. That can be illustrated both in terms of language and in terms of content. It is significant that as in the case with *aesthetics*, the etymology of the term *empathy* is rather recent. A review of the writings of Aristotle and Plato (and other Classicists before the eighteenth century) reveals that whereas the term for sympathy is extensively used, the term referring to empathy is not. Indeed, the word *empathy* was coined by E.G. Tichener in 1910, to provide an English translation of the German *Einfuhlung*. Einfuhlung literally means "feeling into," whereas the term for sympathy, *Mitfuhlung*, means "feeling with."[24] This coining of the term *empathy* is new and is associated with a development in aesthetics rather than beauty. Rudolph Lotz, Wilhelm Wundt, and later, Theodore Lipps, developed an aesthetic doctrine. That doctrine held that when empathizing with a work of art, viewers imaginatively project themselves into the object. The art historian Wilhelm Worringer mentions Lipps theories in his book, *Abstraction and Empathy* (1910) and comments (4,5):

> Aesthetic enjoyment is objectified self-enjoyment. To enjoy aesthetically means to enjoy myself in a sensuous object diverse from myself, to empathize myself into it. Every sensuous object, in so far as it exists for me, is always the product of two components, of that which is sensuously given and of my apperceptive activity.

Aesthetics requires that we engage in empathy, in the attempt to emotionally feel that which other persons feel, or in the attempt to internalize the feelings experienced via works of art. There are good reasons to be suspicious that those attempts can be effective. It is impossible to know that we have subjectively identified with another's subjective state; we can only guess that we feel what others feel. If two people share a taste for chocolate (or tragedy), then we might be tempted to surmise that their taste is empathetic, that they taste the same thing. This would be a mistake, because two people tasting the same kind of chocolate (or tragedy) might vehemently disagree on whether what they both taste is good, and why. Should they by chance happen to agree, then that agreement still can have no objective basis.

Empathy has consequences concerning the notion of love as well. Empathetic love is narcissistic in its attempt to emotionally become one with the other by denying the other; as such it is both futile and marked by violence. When the subject empathizes with a beloved, the object of love can no longer exist; it is subsumed and consumed by the subject. But lacking the existence of the beloved, love has no object and cannot exist. So the empathetic destruction of the object of love denies the possibility of love.[25] Socially, that violence has consequences. It reflects a malignant narcissism, an extreme form of self-love, indicating a self-hatred. Freud is but one of many to speak of this relationship. In his 1914 article, *On Narcissism: an Introduction*, Freud argues that it is the failure to recognize an objective Ideal that traps one in a debilitating self-absorption, a self-absorption that cannot be real, because a subjective ideal is no ideal at all. Narcissism itself, in Freudian terms, involves a pathological obsession with and hatred of the self to the exclusion of all others, with a malignant gloss in the need to take pleasure in causing pain or destruction to others.

Consequently, as a product of aesthetics, empathy consists of a narcissistic and violent voyeurism. It results in an empathetic subjectivity that produces alienation rather than intimacy; we pretend to experience that which others experience, but since that type of experience is subjective, then such pretense is yet again a vain or coercive sort of voyeurism.[26] In *Creativity and Perversion* (1984), the psychoanalyst Janine Chassguet-Smirgel summarizes the healthy progression out of narcissism:

> Thus narcissism, which is the stage of development in which the Ego furnishes itself with its own ideal, [properly] gives way to the object relation. The Ego is led to break with a part of its narcissism by projecting a gap, a rift between the Ego and its Ideal.

So to escape the nihilistic fantasy of self-perfection, an objective reality is necessary. But from the aesthetic viewpoint, with its subjective-objectivity, neither the objective ideal nor reality exist beyond brute experience, and if they did, they could only remind us of our own imperfection. The world becomes then a fetish, an idol, where everything is equal, and which conforms to our pleasure - and provokes our hate. This marks a hopeless struggle between humanity and reality, resulting in a promoting of a reality marked by violence.[27] It is a demiurgic impulse that marks aestheticism, where demi-gods make a new universe from chaos and mixture, and it is that same impulse that is violent. It is violent by its empathetic assumption that the world and those we purportedly love conform to our will; it is violent by the ego's need to be perfect in a context in which perfection cannot exist. According to Chassguet-Smirgel, it is a Lucifernian assumption, in its denial of objective truth, love, and beauty. It celebrates the ego, but without love granting purpose the ego must hate the other —and itself.

Belief, Sympathy, and Beauty

Both theory and empathy are then linked to a narcissistic rejection of beauty; they stand in contrast to belief and sympathy. To sympathize with others is to accept that a subject seeks a meaningful object. It is to attempt to understand to some degree the other's plight. Sympathy involves some significant degree of understanding of the human condition, and consequently involves some degree of shared universal knowledge. It involves a higher frame of reference than afforded by aesthetics, or by claims of shared authenticity. Since authenticity is subjectively experienced, then claims of individual or group empathy can only be willful and arbitrary. We can empathize with our neighbor's taste for chocolate ice cream, and imagine that they like chocolate as much as we like strawberry. But there can be no reasons for those preferences; they are a matter of empathy, and as such a matter of aesthetic taste. In contrast, we can sympathize with a shared preference for wholesome ice cream because we both know that wholesome ice cream ought to be nourishing and healthful. We can even understand that a preference for particular flavors is subjective, a matter of personal or cultural taste, and that such preferences are ultimately inconsequential. The ego escapes a violent narcissism by seeking knowledge of, not identity with, reality.

Sympathy admits that we ought to have compassion for others, and that emotions are involved, but sympathy respects *the other*, whereas *empathy* does not. Empathy requires that we identify with the feelings and preferences of others, and therefore deny their identity—and our own. The decision to embrace an aesthetic empathy is not merely a personal one. It results in a simultaneous cultural, political, and theological demand for a self- annihilation and a self- divinization, a nihilistic and totalitarian impulse at the same time. In contrast to authoritarianism that holds that we must obey, totalitarianism holds that we must not only obey, but that we must also feel good [sic] about it. The former admits freedom of conscience, but the latter does not. Totalitarianism goes beyond the realm of culture and politics, however, to that of metaphysics. Totalitarianism requires a particular vision of reality to justify its existence. It requires an empty and violent metaphysic of theory and empathy. It is a metaphysic of the aesthetic, and therefore, empty.

As introduced at the close of the previous section, Plotinus addresses the cultural contradictions evident in Classical tradition. In his Fifth tractate of the Fifth Ennead, titled, *On Intellectual Beauty* he gives the example of two stone blocks lying side by side. One block, left untouched, remains dull and meaningless. The other block, formed by the artist's hand, enters into the intelligible realm of beauty. He states that all that comes to be, as the work of nature or of craft, entails wisdom, knowledge of that which is true and good. That wisdom is of the very ground of reality, of *being*, itself. He closes the chapter with these words:

Thus beauty is of the Divine and comes Thence only.

For Plotinus the objective of philosophy is to obtain knowledge of reality; knowledge of reality results from a love of God. He attempts to escape both abstraction and empathy, both a desiccated view of Apollo and a narcissistic one of Dionysius. He attempts to resolve the dilemma of why bad things happen to good people as evidenced by Laocoön. In so doing, Plotinus posits a cultural vision beyond the violence of paganism, the polytheism of Classicism, and yet fails to reach the transcendent monotheism anticipated by Plato and realized by the Judeo-Christian tradition.

According to Aristotle (*Poetics*, 1449), tragedy began in the arts with an improvisation during a play connected with the worship of Dionysius. Aristotle addresses the tragic in cathartic terms, but in the *Republic* Plato criticizes tragedy in art as demoralizing. Plotinus pursues the Platonic vision to come to terms with a better understanding of reality and life. He finds compelling the fundamental principle that the world makes sense. He goes beyond Plato's idea that the Idea and Matter are to be combined by the Demiurge, and beyond Aristotle's aesthetic immanentism as well. He sees reality as a singular totality, a monism in which the ground of *being* is the ideal, and the material marks a decline from that ideal. The first emanation from the ground of being is Thought or Mind, which occurs as both a universal and in particular things. Thought or Mind makes possible Beauty. From the Divine descends Truth and Beauty, from Truth and Beauty descends the material world. Within the material world, evil exists. Therefore, Plotinus urges that we mystically identify with The Good. Plotinus aspires to unite his soul with objective Love and Goodness; that now involves a denial of the material world and all aesthetics, but it also requires empathy.

To reduce Laocoön's predicament to that of an unlucky choice of lifestyle is to trivialize humanity; to pretend to feel the pain of Laocoön's theoretical situation is pretense, and worse, it is useless pretense. It is a useless because it offers no solution, no comprehension of the terror afflicted. It is merely an aesthetic response. The shift from aesthetics and empathy to beauty and sympathy is a shift in which a subjective-objectivity is replaced by a subject seeking unity with a meaningful object. It is a shift that remains clear as long as the differences between feeling and understanding remain clear. This distinction is not merely a theoretical one; it directly impacts our understanding of reality and life. To deny the differences between subject and object, feeling and understanding, is to deny the differences between aesthetics and beauty. To do so is to embrace a nihilistic and totalitarian narcissism where reality becomes subjectified. But to state that feeling and understanding are distinct is not to state that we must choose one over the other. Indeed, it is by success in reconciling aesthetics and beauty, the subject and object, without the destruction of either, that we realize culture and beauty. Plotinus takes an initial step in this direction.

Biography, Beauty, and Aesthetics

Philosophy can be cold and analytic, whereas biography, by its very nature, is concerned with the human condition. Biography is concerned with how the subject encounters reality. It is concerned with how we think, live, and love. Biography can be approached aesthetically or in terms of beauty. It can be viewed as that which is constructed by us, or that which centers on responsible freedom. The story of Laocoön is biographical, and can be approached aesthetically, or as a matter of beauty. Aesthetically, we can attempt to view Laocoön's plight as a matter of fact, and we can respond to it on a theoretical and emotional level. Some might find Laocoön's story to be odd, sad or terrifying, and respond to it with indifference, amazement, pity, or even pleasure. In each case, a subjective story is used to provoke an emotional response. One aspect of this emotional response to the story of Laocoön might involve catharsis, a purging of the emotions, as advocated by Aristotle. But such emotional responses are ultimately ineffective. They are symptomatic rather than healing. Aesthetics reduce biography to entertainment, therapy, or propaganda. We can be entertained by the odd or the quaint, made to feel better or worse by its emotional impact, or be emotionally manipulated, propagandized, to act in a particular way.

The alternative is to approach biography in terms of beauty. Biography is obviously linked to history, and history is traditionally linked to the pursuit of wisdom, to obtaining knowledge of that which is true and good.[28] We study history to better understand and respond to the world. For that pursuit to make sense, the world must ultimately make sense. If the world makes sense, reality must to some degree be both true and good; wisdom is then possible to obtain. The aesthetic vision of reality is limited by the metaphysical presumption that the world is purposeless; therefore our "understanding" of reality is limited to a matter of facts and feelings. The pursuit of wisdom holds that the world is beautiful.[29] So too is the case with biography. The pursuit of wisdom constitutes an optimistic and realistic pursuit of meaning—in history and in life. An intellectual history of art is nothing less than history dedicated to that pursuit of meaning and beauty.

Although Plotinus' system offers much, it remains a metaphysical system, and as such it is only one available possibility out of many. But its relationship with Christianity proved efficacious. It gave system to Christian belief, it gave biographical necessity to Plotinus' speculations, and it advanced a means of understanding how to reconcile aesthetics with beauty. The result was a system of fundamental principles, grounded in history, and made intelligible. Unlike the Laocoön, Christian culture attempts to provide positive answers to the problem of tragedy. Those answers celebrate beauty once again, by reconciling beauty and aesthetics with new insight.

At this point it is clear that Plotinus marks an advance on the developing understanding of beauty. Plotinus points the way to a resolution of the problem: if reality is understood to be, in varying degrees, meaningful and therefore beautiful, then our conscious choices can rightly aspire to beauty. What then of tragedy? It is not due to a conflict of gods or of goods, or a conflict of taste, rather it is due to a failure to love The Good. Plotinus attempts to steer a middle course between subject and object, theism and pantheism; for him there is no tragedy in the sense of it being an irresolvable conflict. Reality issues from God, which is associated with light and understanding; the material world lacks light, and lights' intelligible beauty. Evil and tragedy result as an absence of that divine light. Evil is inherent to the material realm.

In viewing Laocoön Plotinus can offer an explanation of the event that transcends the notion of tragedy: Laocoön's plight is the result of a collective and willful failure to love Divine Good. But his solution requires an abandonment of the material world and aesthetics, for the realm of the divine. As such, it offers an inadequate solution—at least for the living -to the issue of human suffering. If Plotinus' dismissal the world makes sense, then the historical meaning of this sculpture cannot, and nor can our lives.

So the *Laocoön* is not just a Hellenistic sculpture from the first century BC. It is not just an aesthetic object from the past. It centers on a perennial problem in human life: can chance or fate be reconciled with virtue? Aristotle defined virtue as a good habit, a mark of intelligence and character united in the pursuit of genuine happiness. The realm of virtue is then that of responsible freedom. But just as Aristotle failed to come to terms with tragedy, Laocoön's virtue was rewarded with terrible suffering. If virtue does not indeed lead to happiness, then why be virtuous? And lacking virtue, then what does it mean to be cultured and what replaces responsible freedom?

These are obviously not trivial questions. The very substance of our cultural, political, and personal life is at stake. To abandon virtue is to abandon not only responsible freedom, but hope as well. It is to submit to the notion that the world and our lives make no sense. That the stakes are high in a very practical way is evidenced by this problem recurring in history. So the Laocoön sculpture evidences the issue of tragedy resulting from conflict with and amongst the gods, or rather, the issue of conflict with and amongst claims to truth. That issue troubled the Classicists of ancient Greece as well as those embracing Modernist and Postmodernist Classicism. Friedrich Nietzsche can be viewed then as a latter-day Laocoön confronted by the circumstances of his existence. But rather than despair, he celebrates our ability to make choices even if the world is empty of meaning. As discussed below, Nietzsche's hatred of Platonic Classicism and the Judeo-Christian tradition is made clear by a stunning conclusion: we should aspire to become our own gods. Where Plotinus seeks meaning in a pious love of the divine, Nietzsche transforms that love of the divine into a love of self. But such a love lacks a meaningful object – and dissolves into self-hatred.

Classicism is today torn between beauty and aesthetics, between Classicism as understood by Plato, Aristotle, or Plotinus and that understood by Kant, Lessing, or Nietzsche. So too is the case with Christianity. The Christianity of Augustine, Aquinas and Luther are radically different than that of apostates such as Nietzsche (or Heidegger)—or even of Kierkegaard.[30] Those differences center on the problem of evil, and on whether or not the world makes sense. So the choice is not between ideologies, be they Classical or Christian—or Pantheist for that matter. The choice is between what first principles are embraced, and whether or not those principles are pursued aesthetically or can be pursued in terms of beauty.

As introduced in the previous chapter, Plotinus addressed the issue of why bad things happen to good people. He posited that evil was a failure to become one with divine Love. He postulates a supra-rational mysticism where virtue is rewarded not physically, but ideally. It is the soul's union with the divine where virtue is redeemed. But there is another alternative to the idealism of Plotinus. And there is another vision of beauty that admits the physical without denying the spiritual. A vision where responsible freedom is real. That vision is Christian.

Notes

1. The term sociology can be approached aesthetically or in terms of beauty; it can refer to what we do within a purposeless, or a purposeful universe.
2. Introduced here is the notion that the distinction of moral good and aesthetic perfection by Aristotle is foundational to the reduction of reason or logos from *being* (or the mind of God), to the mind of humanity, to the structure of the mind of humanity, and finally to the mere product of the will. This descent begins with Aristotle, is continued by Abelard's conceptualism (in contrast to other Scholastic proponents), and finds its necessary conclusion in the rise of nominalism, the rationalism of Descartes, and in the work of Kant and Nietzsche. This is a trend in which there is a gradual separating of reason from reality and a reduction of truth to power. In contrast stands the Platonic and Augustinian tradition.
3. Aristotle makes possible the initial step that Kant later pursues vigorously: an aesthetic vision of reality and life where fact, feeling, and coherence are primary concerns and where reason becomes conceptualized rather than the light by which degrees of wisdom are obtained.
4. The Postmodern, Heideggerian term for this state of affairs is *dasein*, or being there. This is discussed in the final chapters of this book.
5. The conflict between chaos and order, fate and virtue in Classical culture are mentioned by J.H. Pollitt, *Art and Experience in Classical Greece* (Cambridge: Cambridge University Press, 1972).
6. As Frederick Copleston, *A History of Philosophy* (Garden City, NY: Image Books, 1962) vol. 1, part II, 80 explains: Aristotle's treatment of the virtues betrays the fact that he was under the influence of the predominantly *aesthetic* attitude of the Greek towards human conduct...The notion of a crucified God would have been abhorrent to him: it would most probably have seemed in his eyes at once unaesthetic and irrational.

7. Whether or not Kant's transcendental aesthetic makes any sense will be addressed below.

8. As discussed later, some privilege the notion that a biological/naturalistic structure of the human mind objectifies the thoughts and moral claims of such a mind. But the disassociation of mind with cosmic purpose mandates that the possible structures of any creature's mind do the same. To affirm this is to equate a formalistic subjective-objectivity with reality, and thereby reduces beauty and civilization to an aesthetic violence.

9. As discussed elsewhere, Kant posits a subjective-objectivity where the structure of the mind provides a naturalistic foundation for morality. However, the Categorical Imperative which aims to provide a rational and immanent morality reduces goodness to an act of an assumedly good will, but even a rationalistic morality based on a dutiful goodwill remains substantively empty.

10. The assumption of an eternal and chaotic foundation of the universe is later replaced by the notion of *creatio ex nihilio*, that the world is made in perfection by a God of truth and love, but then due to the misuse of freedom, that perfection is transgressed. This will be discussed in detail in the next chapter within a Christian context, and in the concluding chapters where the Postmodern mind yet again is condemned to a metaphysics of violence.

11. Mortimer Adler, *A Syntopicon of Great Ideas, Fate* (Chicago: Encyclopedia Britannica, Inc., 1978), 515.

12. See: Nelson Goodman, *Ways of Worldmaking* (Indianapolis, IN: Hackett Publishing Company, 1978).

13. As discussed by John Milbank, *Theology and Social Theory. Beyond Secular Reason* (Oxford: Blackwell Publishers, 1995), 278ff.

14. WladyslawTatarkiewicz, *History of Aesthetics* (The Hague: Mouton, 1970), 273.

15. It does for Augustine, but for non-Classical reasons.

16. According to Aristotle (*On the Soul*), psychology is the study of the soul, a study which falls within the science of discerning a purposeful Nature. It is a soul that strives for beauty. It is Kant who denies that nature is purposeful, and who aestheticizes psychology, the soul, and culture.

17. Ernst Cassirer, *An Essay on Man* (New Haven, CT: Yale University Press, 1944), 21ff: "Our modern theory of man lost its intellectual center. We acquired instead a complete anarchy of thought. Theologians, scientists, politicians, sociologists, biologists, psychologists, ethnologists, economists all approached the problem from their own viewpoints. To combine or unify all these particular aspects and perspectives was impossible...That this antagonism of ideas is not merely a grave theoretical problem but an imminent threat to the whole extent of our ethical and cultural life admits of no doubt...our wealth of facts is not necessarily a wealth of thoughts. Unless we succeed in finding a clue of Ariadne to lead us out of this labyrinth, we can have no real insight into the general character of human culture; we shall remain lost in a mass of disconnected and disintegrated data which seem to lack all conceptual unity. "

18. Thomas Molnar, *God and the Knowledge of Reality* (New Brunswick, NJ: Transaction Publishers, 1993), 141.

19. Wladyslaw Tatarkiewicz, *History of Aesthetics* (The Hague: Mouton, 1970),Vol. 1, 323.

20. For example, Harry Elmer Barnes, *An Intellectual and Cultural History of the Western World* (New York: Dover Publishers, 1965), 263, dismisses Plotinus as guilty of intellectual bankruptcy, while failing to consider the possible bankruptcy of scientism.

21. According to Barnes (Ibid, 130) "…Democritus, although he propagated a system of philosophical materialism, was one of the loftiest moralists of the ancient world." Frederick Copleston, *A History of Philosophy* (Garden City, NY: Image Books, 1962), vol. 1, 146 notes that "Democritus' theory of conduct, so far as we can judge from the fragments, did not stand in scientific connection with his atomism." Caution is required in applying the label Materialist and drawing ethical conclusions. For example, as a materialist Democritus believes that both body and soul are comprised of atoms. Therefore neither a transcendent God nor Beauty exists. Nonetheless he declares that the good and the true are the same for all men, but the pleasant is different for different people. The difficulty is in how that can be known. The association of Democritus' moral theory with a non-teleological concern for a materialistic soul warrants critical reflection. Indeed, it is worth noting that followers of Democritus such as Pyrrho lapsed into Skepticism.

22. Frederick Copleston, *A History of Philosophy* (Garden City, NY: Image Books, 1962). 208. Plotinus embraces a self-divinization by seeking an empathetic unity with the Divine.

23. As discussed below, Pop Art mocks the pretensions of Abstract Expressionism.

24. That both terms refer to feeling is indicative of the degree to which feeling and thinking have been confused in the Modernist-Postmodernist era. This will be discussed later.

25. This idea will be expanded upon in our discussion of the Christian rite of Eucharist.

26. Janine Chasseguet-Smirgel, *Creativity and Perversion* (New York: W.W. Norton & Company, 1984), 27.

27. Ibid

28. How we understand history is directly influenced by our metaphysical vision. For example, for Kant history is a construct of our minds; Hegel finds history to be meaningful as the unfolding of power; Augustine understands history as a temporal narrative of the battle between those who seek goodness and those who do not. History as the pursuit of wisdom, of knowledge of that which is true and good, was once a primary concern of history and a motivation for its study. See: Jacob Abbott, *Makers of History* (Philadelphia: John D. Morris and Company), 1904.

29. As to be discussed shortly, in the account of creation according to Genesis, God made the world and it was good. However, the Hebrew term for good (*tov*) involves the notion that the good is beautiful.

30. The notion that changes in some Christian doctrine indicates that it is a sociological and transient ideology is presented by Modernist and Postmodernist scholarship (e.g., Charles Guignebert, *Ancient, Medieval and Modern Christianity. The Evolution of a Religion* (New Hyde Park, NY: University Books, 1961). In contrast, see Jaroslav Pelikan, *Jesus through the Centuries. His Place in the History of Culture* (New York: Harper and Row, 1985). Greek and Russian Orthodoxy stress the perennial aspects yet further.

5

The Judeo-Christian Tradition:
Aesthetics and Beauty Reconciled

To the aesthetically minded, be they skeptical or devout, the Christian tradition is viewed in an aesthetic way. For them Christianity (or for that matter, Buddhism or Classicism, Daoism or Confucianism, to name but a few) is based on facts and feelings. Those facts center on possibly canonical works or biographies, towards which they may feel indifferent, hostile, or devoted. So Christianity is a matter of taste, be it indifferent or absolute. The secular aesthetes are indifferent or absolutely hostile to the intellectual meaning of Christianity. What is curious is that the religious aesthetes are also.

The secularly aesthetic are either indifferent or hostile to non-secular thought. They hold that science and empathy will elevate humanity from a superstitious metaphysics, substituting solid fact for speculations about truth, and a willful empathy for speculations about cosmic love. It is thus assumed by both Modernist and Postmodernist that Christianity is a historical and sociological construction, a subjective-objectivity, expressed via certain texts, and a matter of hero worship. For the secularly aesthetic it is a given that they have no interest in constructing a theological understanding of Scripture, nor in establishing for themselves an empathetic sense of identity with Scripture, or with a person named Jesus Christ.

Alternatively, the religiously aesthetic will attempt to obtain a type of understanding of the faith and its sacred text, the Bible. For the Modernist that understanding is seen as a personal or social construct and therefore is beyond objective rational resolution. The formulation or meaning of dogma and text is deemed then a matter of personal or social interpretation. But the Postmodernist Christian attempts to become one with the faith and its sacred texts as a matter of identity, of empathy; meaning is held dear, but reduced to a realm beyond rational discussion or interpretation. As discussed below, the Modernist reduction of reason to mere rationalization, is developed further by the Postmodernist Christian Soren Kierkegaard, who declares that faith begins where thinking ends. [1]

So there are secular and religious Modernists and Postmodernists. They differ in the objects of their devotion and of what that devotion consists. But they share an aesthetic vision of reality and life. The difficulty is that the Christian tradition is grounded not just in aesthetics, but in beauty as well. Like Classicism, it is grounded in the assumptions that the world makes sense, is purposeful (that love is real), and that there is a rational ideal, difficult to comprehend, towards which we ought to strive. The notion that the world makes sense, and is to some degree understandable, involves more than the idea that the world is comprised of predictable natural laws. It involves the idea that there is a source for and a purpose to those laws; there is a purpose to existence beyond merely existing. It posits that there is more to life than chance, necessity, or the subjective will. It embraces the notion that love is real, and that the object of our love ought to be the truth and goodness that gives meaning and beauty to existence. Truth and love unite in numinous being, and a fullness of purposeful meaning. In contrast, aesthetics reduces fact, feeling, and faith, to a matter of subjective willful taste.

Beauty and the Bible

Any text or work of art can be approached aesthetically or in terms of beauty. Aesthetically, texts or works of art are considered factually, emotionally, and sociologically; they present a theoretical narrative affected by (or via) the subjectivity of its author, its readers, or the historical context in which they occur. From an aesthetic perspective, they are also considered with suspicion if they aspire to an objective glimpse of beauty. They are viewed with suspicion because such aspirations attempt to do more than is possible from an aesthetic point of view. They attempt to provide an understanding of reality and life which is to some precious degree above the factual and subjective. Since beauty is cognitive, then to approach a text for its beauty is to approach a text via its attempt to actually understand the world. A beautiful book is then one that to some precious degree explains reality and life. To the aesthetically minded, this is obnoxious. For them, a book expresses the opinions and feelings of an author, or a reader, which may be viewed and understood as a matter of opinion, or a matter of personal or social identity. But to consider that a particular book might actually be understood as true is incomprehensible to the aesthetic mind. And since meaning is thus restricted to personal or social opinion or experience, what is revealed? A stark antagonism to the possibility of being enlightened. In its place is a aestheticism in contrast to a spiritual pursuit of beauty.

Moreover, the aesthetic mind views with suspicion systematic attempts to understand a religious (or any other) text. Theology represents the attempt to understand the world, and for the aesthetically minded, all theologies are personal or social constructs that have little to do with the way things really are, except (or even) as a matter of personal or group identity.

The result of the aesthetic mindset is that understanding and sympathy are then replaced by theory and an empathetic identity. One can trivially accept a holy text as the expression of theory or opinion, or accept as a matter of identity a holy text on the basis of its authority or our own. In either case, the text is then denied the possibility of being understood, where evidence and persuasion permit us to rise above brute assertion. In the pursuit of beauty, the truth claims of a text or an object might lead to authority, but authority can never lead to truth. This is in contrast to the aesthetically minded believer, who views the Bible as authoritative and therefore true; and it is in contrast to the skeptic for whom the authoritative claims of the Bible are viewed as religious and therefore false. In either case, the notion of responsible freedom in the pursuit of understanding is denied.

In the pursuit of beauty—and meaning—a history of art foundationally holds that the free pursuit of truth is essential. It entertains the possibility that some texts just might, to some precious degree, be beautiful. Culture assumes that responsible freedom is possible, and that responsible freedom relies upon our need to understand reality and life and to make choices that matter. The problem is that when our attempt to understand a text, a work of art, or the world, is approached aesthetically, reason is either subjectified or reduced to theory or empathy. The result is rationalization, indifference, or the willful brutality of the willful true believer or the determined non-believer.

If a book, or a work of art, is approached aesthetically, then we either submit to the authority of the work, or deny it. "Truth" is then determined by our accepting or denying the authority of works of art or Scripture. But if we approach a book or a work of art in terms of beauty, then its beauty depends not on authority, but understanding realized via evidence and purposeful discussion.

In studying the concept of beauty as discussed in the Bible, an aesthetic approach is utterly ineffective, if for no other reason than this: the Bible (like the texts of many other traditions around the world) qualitatively distinguishes beauty from aesthetics. If we approach the Bible (or works of art depicting Biblical truth) aesthetically, then we reduce our ability to understand that text or work of art, and we reduce our ability to think about beauty in life. We therefore tacitly deny the possibility that such texts (or art) can indeed be beautiful. We instead think about facts, feelings, and power, rather than thinking about a meaningful reality; we quarrel over epistemology instead of thinking about ontology. We cease conversing because a willful conflict over taste is all that can be.

We can approach any text or work of art aesthetically, or in the pursuit of beauty; but the former denies the possibility of wisdom, whereas the later permits it. How do we discern those objects that contain wisdom and those that do not? By attempting to gauge how close to a meaningful reality they are. How do we gauge how close to reality a text (or a work of art) is? By a consid-

eration of its first principles, and whether those first principles result in a House of Life whose foundation is sound. The degree of soundness of a belief can be evaluated in terms of factual error, contradiction, and perhaps also logical fallacy.[2] Empirical science cannot explain the world, the factual realm of *what* cannot satisfy the question: *Why*? But it can with some confidence refute attempted explanations that are factually or logically in error. If a belief system is inescapably contradicted by obvious fact or compelling logical fallacy, then the degree of confidence in the tradition is adversely affected.[3]

Obviously, there are many different traditions in the world whose first principles are beyond factual or logical reproach. Those traditions result in the realization of very different, and often conflicting, values and visions of beauty. There results then a situation where a need to consciously prefer one over the other exists, not as a matter of willful opinion or prejudice, but rather as a result of conscious thought; of the attempt to rise from sheer ignorance, to informed judgment (doxa), to perhaps even a glimpse of truth. This is the methodology of an art history dedicated to the pursuit of truth and beauty, and as such it marks a beginning rather than an end of the matter. It invites conversation rather than denies it.

The *Book of Genesis* presents certain foundational principles about beauty and reality. What are those principles, and can they be held with confidence? According to Genesis, chapter 1, verse 31(italics added):

And God saw everything that He had made, and behold, it was very *beautiful*.

It is more common to find the sentence quoted above to read that God found all that He created to have been *good*. But in the original Hebrew, the last word of that sentence is *towb*. That word means not only good, but beautiful as well. The Book of Genesis, foundational to all three of the Abrahamic religions, holds clearly that the universe is purposeful and therefore beautiful. In numerous chapters of that book the point is made: the world is beautiful because like a work of art it is consciously made, is purposeful, and Jewish tradition maintains that purpose can to some precious degree be discerned. The distinction of beauty from aesthetics is one that distinguishes understanding from feeling (but not from Love), for to reduce understanding to feeling is to deny the mind and substance of *being*, or God.

In reference to theological and philosophical texts, both beauty and aesthetics have been referred to by a variety of terms that should be approached with clarity. For example, the Greek translation of the Book of Genesis is known as the Septuagint, and it was written by Jewish scholars of Alexandria in the third century AD. It is important to note that those scholars choose to use the Greek term *kalos* for the term *towb*. They did so for good reason. The Hebrew term *towb* entails the same notions as the term *kalos*.[4] Both associate beauty with goodness and morality. The beauty (kalos) of creation, as pre-

sented in the Book of Genesis, the Book of Wisdom, Ecclesiastes, and the Psalms cannot properly be understood aesthetically. Indeed, to understand aesthetically is oxymoronic, leaving actual understanding adrift.

Nonetheless, some writers have erroneously claimed that the notion of beauty has an aesthetic, sociological, source: that it is distant from the Hebrew of Genesis and other texts, and is a product of Hellenistic society. They suggest that the Hebrews had an indifference to beauty and to the appearance of things.[5] This sociological and aesthetic critique reveals not the indifference of the Hebrews to beauty, but rather the confusing of beauty with aesthetics by Modernist-Postmodernist scholarship. It is not that these texts reveal a Hebrew indifference or hostility to beauty; rather they reveal a keen awareness by the Hebrews that beauty is cognitive and liberating whereas aesthetics is sensual and by itself debilitating and destructive.

For example, when the Holy Bible was translated into Latin by St. Jerome, *kalos* was translated as *bonum* and not *pulchrum*. Indeed, it is instructive to note that when St Jerome uses the term *pulchrum*, he follows Hebrew precedent in using it to refer to that which is dangerous. To equate *pulchrum* or aesthetics with beauty (without reference to the Incarnation, as discussed below) is to be conceptually confused.

In translating the passage in Genesis referring to the Tree of Knowledge, St. Jerome calls that Tree of Knowledge *pulchrum* to the eyes and pleasant to look at; it is not a compliment, but a warning. In the Book of Proverbs (XXXI, 30), the same term, *pulchrum*, is used to establish the vanity of aesthetics. So there is not a Biblical conflict between the notion of beauty as vanity and that of beauty as a manifestation of the divine. Nor is there a conflict between an alleged Hebrew notion of beauty as dangerous and a Greek notion of beauty as wonderful. Rather, there is a conflict between those limited to aesthetics and those who also seek a glimpse of the spiritual and the beautiful. Indeed, in reference to God, the Book of Wisdom states: "Let me see thy countenance...thy countenance is comely." In his commentary Tatarkiewicz recognizes that the assertion that Hebrews distrusted beauty is problematic; if both creation and the transcendent God are beautiful, then how can a faithful Jew be against beauty? He writes:

> This can only be reconciled with the Hebrew view [sic] of beauty if one assumes that the word speciosus, (beautiful), is used here in a different sense, in a sense which could be applied to the deity, beautiful as affording, not sensuous, but purely intellectual pleasure.[6]

A solution to what the Hebrew hopes for, a glimpse of the divine, is denied to the realm of fine art. In Exodus, 20, graven images are condemned. This is not a denial of beauty. Rather, the point is that aesthetics is a form of idolatry, embodying a false or debased vision of Truth. This position resonates with

Plato's position as well as Plotinus'. It does not indicate a conflict between an alleged Hebrew sobriety and a Greek optimism; rather, it refers to the problem of reconciling the divine with the material, the purposeful with the accidental. Lacking a glimpse of reality, of the Kantian *ding an sich*, works of art are necessarily idols, by definition worthless by lack of contact with genuine reality. Idolatry is then an aesthetic phenomenon. It is based on materialism and emotion while lacking genuine meaning. To use modern terminology, idolatry is an aesthetic phenomenon that promotes a type of fetish. Why did the Hebrews avoid associating beauty with the physical? They attempted to avoid the idolatry of materialism and the self-idolatry of narcissism. As later chapters of the Book of Genesis make clear, the avoidance of such idolatry is not an easy thing to achieve. Indeed, the concluding chapter of this book will offer an alternative to the secular form of idolatry offered by Modernist and Postmodernist relativism, an idolatry which is but a fetish celebrating the absence of meaning.Aesthetic discussions of the Book of Genesis are subjective and sociological. For the secular Modernist, the book is to be taken as one of many such creation myths present in the history of human society. As such, it is to be viewed figuratively and sociologically, as the expression of subjective opinion on the part of different traditions. The religious Modernist will take the text to be an imperfect expression of divine truth, the meaning of which is subject to personal and social interpretation. Both will view the literal text to be potentially oppressive.

For the secular Postmodernist, there is no doubt that the text is oppressive, since it is viewed as a falsely normative document which ought not to be forced on others; the religious Postmodernist will likely view the text as the expression of divine truth, which ought to be accepted with little discussion, and obeyed. In either case, the Book of Genesis is considered to be beyond discussion. It is a matter of aesthetic dogma, be it trivialized, vilified, or made absolute.

The result is that for the Modernist the text becomes a reflection of the structure of our mind and our fickle empathy, whereas for the Postmodernist the text becomes a matter of social power structures reflecting an empathetic identity that reveals either an oppressive lie, or a dogmatic truth. To sociologically approach the Book of Genesis, or any other text offering the promise of wisdom and beauty, is to reduce those texts to the level of aesthetics; to reduce them to a matter of aesthetics is to reduce them to the level of material, personal, or social idolatry. It is to promote not enlightenment, but to engage in a fetish of power that simultaneously denies belief while demanding belief.

In terms of beauty, the Book of Genesis contributes to an understanding of reality and life. The Book of Genesis presents certain foundational principles about the nature of reality and life, and upon those foundational principles is built a particular House of Life. Those principles include the following: the universe is created and is beautiful and purposeful, that none can doubt that

they think and live, and as living and self-conscious beings, humans face the necessity of making value judgments, for better or for worse. The necessity of our making value judgments leads paradoxically to the necessity of freedom: we are obligated to the pursuit of responsible freedom, which is a humble yet confident task.

Some of the principles cited in *Genesis* are in conflict with Greek precedents, and some are in conflict with certain contemporary and scientific modes of thinking. In contrast to Greek thought, it is here held that the universe is not eternal, but created. The question of whether the universe is eternal or created cannot be explained by empirical science. Nor can it be explained conclusively on the basis of logic or reason. It might initially seem to be an abstract and even impractical question as well. Nonetheless, the position we take on this issue is of great importance. For example, if the universe is eternal, then nothing can really be new, and if nothing can really be new, then the idea of progress makes little sense. Whether or not progress is desirable is a matter to discuss, but the point is that the question of the origin and nature of the universe affects how we behave on a daily basis. It also affects our notion of personal responsibility. For example, in a world of eternal recurrence, and no beauty, no choices ultimately matter.

In contrast to the Greek view that reality eternally exists in a state of chaos, a chaos that must be controlled and transformed into a cosmos, the Christian tradition holds that creation begins in perfection, but is later marred by the misuse of freedom and a misplacing of our love. The Greek attempts to make chaos into cosmos, a rightful order, whereas the Christian attempts to restore a fallen world to its God-granted natural and original beauty.

So, the universe can be viewed as either aesthetic or beautiful. The Book of Genesis states that to view the universe aesthetically is to view the universe as a meaningless, mysterious, and even evil entity. To view the world aesthetically is to reduce the importance of conscious decision making to mere, or violent, triviality. It is to deny ethics, justice, and beauty. If reality is meaningless or mysterious, then life is correspondingly meaningless and mysterious. In such a universe, we can still be certain that we think and live, but for what purpose? And if our actions are purposeless, then can our lives consist of more than a sentimental and empty hedonism at best?

The Book of Genesis presents certain foundational principles, just as other traditions and their proponents, from Darwin to Marx, Confucius to Sakyamuni, present theirs. As just noted, the principles of the Judeo-Christian tradition include the following: the universe is created and is beautiful, that none can doubt that they think and live, and as living and self-conscious beings, humans face the necessity of making value judgments, for better or for worse. The necessity of our making value judgments leads paradoxically to the necessity of freedom: we are obligated to the pursuit of responsible freedom. It is an obligation not always lived up to, but should be.

Two questions then occur: in a purposeful world, why do bad things happen to good people? And second: in a beautiful world, why are aesthetics, indeed ugliness, so common? These questions return us to the challenge presented by the Laocoön, and invite us to contemplate the response offered by Plotinus. In essence, Plotinus ultimately rejects the notion that those bad things that happen really matter, since what does matter is that which is associated with the Divine One. What happens is trivial compared to what Is. Consequently, that which is material and aesthetic is the furthest emanation of God, and therefore it is the least good.

What then does the Bible say? This problem is addressed in the Book of Genesis and the Book of Job. *Genesis* gives an account of why bad things happen in a universe that makes sense. It is the result of freedom misused, of pride, of a subjective-objectivity. We can suffer from our own acts of pride, and from the arrogant pride of others. Job, like Laocoön, attempts to live wisely; nonetheless he is afflicted by the pride referred to in Genesis and recognized as Satan. Whether we refer to personal, social, or metaphysical pride (as personified by Satan), pride centers on the attempt to ignore reality, and to ignore reality is to invite disaster. So sin results from acts of pride, and pride rests on the attempt to ignore reality. What is reality? An initial response to that question is that it is that which exists outside of our mind.[7] But it is a response that invites a wider conversation. It invites a conversation about the nature of *being*, of God.

It is now a commonplace to distinguish between those who believe in a transcendent ideal or *being*, and those who do not. The latter are often presented as enlightened, dedicated to the pursuit of a naturalistic worldview confirmable by natural science, and often dedicated as well to a rationalistic and humanistic ethics (e.g., the Categorical Imperative). In contrast are those assumedly unscientific persons who make into a fetish a particular religious book, or emotional enthusiasm, and attempt to impose that fetish on others.

This leads to the modernist assumption that the pursuit of truth and beauty is intolerant, whereas the apparent pluralism of aesthetics is tolerant and diverse. But this alleged aesthetic pluralism intolerantly insists that no tradition could be true – except itself. Aesthetics is intolerant of all belief other than those that are aesthetic. And an aesthetic belief is no belief at all. As a matter of taste it can only be a willful assertion. It is not the aesthetic vision that is tolerant, because aesthetics uniformly declares that no other religion or worldview can be true. Consequently, in the name of diversity, the aesthetic vision demands but one view: that in the name of tolerance we all must publicly believe in nothing.

But it is the pursuit of beauty that recognizes a wide variety of attempts to understand reality and life. The pursuit of truth necessarily recognizes a wide range of belief in the cultures attempt to comprehend the world. It is not constricted by dogma that all belief is actually a matter of taste, of opinion and power. Buddhism, Daoism, Christianity, and Classicism are not just subjective

expressions of taste; they are understood as representing substantively different approaches to reality and life. They are not necessarily wrong, and they cannot all be right. It is by that observation that a meaningful discussion begins.

An aesthetic framing of the issue accommodates the worldview and the prejudices of those who are aesthetically minded. It thereby promotes the religion of relativism to the exclusion of all other possibilities. Once again, the terminology used influences the discussions that become possible. Just as the terms *Aesthetics*, and *Empathy*, were coined to replace *Beauty* and *Sympathy*, so too has the term *religion* been redefined. The term *religion* literally refers to the tissue holding things together; it refers to the attempt to comprehend how things fit together and make sense. Charles Jencks, an influential contemporary writer on Postmodern architecture, has commented that relativism is the dominant contemporary religion of the West. Similarly, in the text by Edwin A. Burtt, *Types of Religious Philosophy* (1939) Modernism is cited as a primary religious tradition as well. So it is not so much a dichotomy between the enlightened secularist and the impassioned religious; to frame it in such a way is simply to tacitly accept as a first principle the necessity of aesthetics. More fairly, the issue is a matter of what religious views are possible, and which should we embrace, since as self-conscious agents we cannot do otherwise.

In considering the existence and nature of God, we are really being asked to consider the purpose of reality and life, of *being*. We are asked to consider in what should we place our trust, our faith. From the point of view of beauty, an aesthetic naturalism and humanism is simply a religion of a different kind. Indeed it is viewed not only as different, but as lesser; it is recognized as shallow and violent. Our answer to the question of the substance and nature of *being*, of God, is foundational to our existence. Foundationally, for a materialist, *being* is matter, for a narcissist, *being* is self, for a transcendentalist *being* is the source of a universe that is purposeful and makes sense. To the point, the first two options deny the importance of meaning, reducing them to aesthetic facts and feelings. In contrast, it is the last that leaves much to be discussed concerning the nature of reality, and in what we should place our faith.

Faith, Belief, and Knowledge of the Nature of God

This can be explained by addressing the meaning of faith. To an aesthetic view faith is separate from reason or understanding. The gap between subject and object is denied. But in the pursuit of beauty, faith refers to the fundamental principles we embrace in our attempt to comprehend the world and life. In what do we place our faith, and how do we know that we should? We can place our faith in an aesthetic vision, as do Modernists and Postmodernists. Or we can place our faith in beauty.

The Church of San Vitale, in Ravenna, Italy dates to the mid-sixth century. Its interior is noted for its magnificent mosaics, one of which depicts the story of Abraham and the Sacrifice of Isaac. The mosaic is present to inform those within the church of basic church doctrine. It presents an opportunity to understand the faith.

7. San Vitale, Ravenna

How we understand reality is then a matter of faith. The question central to our lives is: in what do we place our faith? It was the question faced by Abraham on Mount Moriah; it is a question that faces us yet. Indeed, a contemplation of the meaning of the *Akedah*, of the events unfolding in Genesis 22 where Abraham prepares to sacrifice his son Isaac, is revealing—but not just of Abraham's faith. It is revealing of our own faith. How we understand that event reveals the content and perhaps even the failure of our faith.

To pursue this point, which is indeed a defense of both reason and beauty, we can analyze the centrally important story of the *Akedah* and how differently it is understood aesthetically and in terms of beauty. It requires a discussion involving some figures not yet introduced, but who will later be important in this text. We will compare the Modernist Kantian understanding of the Akedah with that of the Postmodernist Soren Kierkegaard. That will be followed by Jewish and Christian writers who advocate the pursuit of beauty.

The *Akedah* is a story that centers on the question of faith, and in a very real sense, Abraham serves as the primary role model for citizen, scholar, and artist alike. For Immanuel Kant, and consequently, for the Modernist Liberal, the story of Abraham and Isaac makes no rational sense. Kant notes:

> We can use, as an example, the myth of the sacrifice that Abraham was going to make by butchering and burning his only son at God's command...Abraham should have replied to this supposedly divine voice: "That I ought not to kill my good son is quite certain. But that you, this apparition, are God—of that I am not certain, and never can be, not even if this voice rings down to me from (visible) heaven." [8]

Kant argues that faith is continuous with the secular and rational, and that when Biblical passages appear irrational, then those passages are false.

So Abraham is prepared to sacrifice his son when he hears God's voice speaking in his head; for Kant the content of Abraham's faith is revealed by his ability to emotionally respond to and obey the divine voices in his head. His willingness to kill in the name of God is judged a testament of his faith—but for Kant this action, this event, this willingness evidences not a successful testing of Abraham's faith, but rather a manifestation of his bad faith. To kill a son by the alleged command of God is viewed as irrational and barbaric.

To understand Abraham's apparent willingness to kill in the name of God as proof of his faith is indeed barbaric. It is barbaric in that both secular and religious terrorists embrace the false notion that ends justify any and all means. It requires a subjective assertion, an alleged subjective-objectivity, to justify killing the other to please the Other. The claim that God wanted Abraham to murder his son is a claim that cannot be rationally authenticated since to kill (non-*being*) in the name of *Being* makes no sense. As discussed below, for the French revolutionist Marat to kill his contemporaries at the command of the Revolution is to make a mockery of liberty, equality and fraternity. For Marat to kill for freedom, and for Abraham to kill his son at the command of God, is for Marat, or Abraham—to be gods, and for God to be a terrorist.

Nonetheless, Soren Kierkegaard, a Lutheran active in the early nineteenth century, rejects Kant's position. As such Kierkegaard is a Postmodernist, and one who has deeply affected our thinking and our understanding of faith. Kierkegaard opposes Kant's attempt to associate faith with human reason; indeed, he goes to the extreme opposite position: that faith and reason are separate. In section 66 of his text, *Provocations*, Kierkegaard states that

> The object of faith is not a doctrine...the object of faith is not a teacher with a doctrine...the object of faith is the reality of the teacher, that the teacher really exists...the object of faith is hence the reality of the God-man in the sense of his existence....God's reality in existence as a particular individual.

Kierkegaard accepts that faith is beyond reason, and the Knight of Faith (as discussed in his 1843 text, *Fear and Trembling*) has a singular duty to God. Faith is relational, and is determined by inner necessity; and that inner necessity demands a teleological suspension of the ethical. That is to say, if there is an apparent conflict between ethics and Divine direction, between human reason and the Divine Will, then the latter must prevail. Kierkegaard accepts that Abraham was unethical, but right. Neither God nor Abraham (nor Marat) is

a terrorist because God (or the Revolution) is beyond the ethical. Or to view it differently, God, Abraham and Marat are terrorists—and to be so is good.

For Kierkegaard, and for Postmodernism, faith centers on a rejection of reason; specifically, it rejects the correspondence theory of truth. Instead, Postmodernist faith becomes relational rather than based on knowledge. The content of faith is not understood, but rather experienced and felt. To use Kierkegaard's phrase, *faith begins where thinking ends* (*Fear and Trembling*, 1843).

So Kant declares that human reason is God, and Kierkegaard declares God to be beyond human reason. One pursues a rational fetish, the other, a fetish of the will. What they share is a subjective-objectivity that leads to a self-deification. Both deny the possibility or importance of any knowledge of the transcendent Logos (i.e., Reason) of John 1—by focusing on the immanent Logos of John 1. Kant pursues a secular rationalism, and Kierkegaard, a religious irrationality. Both deny the Logos, and knowledge of God. But when the transcendent object is denied, and the logos is reduced to the will, then a self-deification results.[9] As Voegelin puts it, when the transcendent is immanentized, the result is terror. In the absence of transcendent being, and reason, a subjective-objectivity denies knowledge, humility, or harmony. It results in an ontological violence.

The positions represented by Kant and Kierkegaard are today common; they represent the liberal Modernist position vs. that of the fundamentalist Postmodernist. Those positions affect not only how we understand faith, but also how we understand the purpose of fine art and education. And neither of these positions suffices.

What then is the alternative to Kant and Kierkegaard? That alternative understands Truth as thought that corresponds with reality, where a thinking subject (logos) seeks knowledge of an object (Logos). The alternative is the pursuit of beauty.

The ideas of Augustine will be discussed in detail shortly. For the moment, however, it is useful to note that his position that faith permits a subject to successfully obtain knowledge of an object. As Augustine puts it, the object of faith is God (or *Being*), and the content of that object is unchangeable wisdom (*On Christian Doctrine*, I. 8). It is wisdom that is not felt, but rather is understood; it is wisdom that reveals reality rather than masks authority. It attempts to obtain a glimpse not of the self, but of the Other. Then how is the gap between faith and reason, subject and object, bridged? In contrast to the Modernist claims of a secular rationality that cannot address *being*, and the Postmodernist claims of an existential and irrational identity with *being* (or the self), is the commitment to seek an understanding of reality and life. It is the pursuit of truth that sets us free.

Augustine does not make a fetish of human reason, nor does he deny the possibility of rational and ethical knowledge in the presence of a transcendent God. He argues instead for the possibility of some degree of understanding as

central to the Christian life. In *The City of God*, section 16, chapter 32, Augustine discusses the *Akedah*, the story of Abraham and Isaac:

> Of course Abraham could never believe that God delighted in human sacrifices; yet when the divine commandment thundered, it was to be obeyed, not disputed. Yet Abraham is worthy of praise, because he all along believed that his son, on being offered up, would rise again; for God had said to him, when he was unwilling to fulfill his wife's pleasure by casting out the bond maid and her son, "In Isaac shall thy seed be called..."
>
> Therefore the father, holding fast from the first the promise which believed to be fulfilled through this son whom God had ordered him to slay, did not doubt that he whom he once thought it hopeless he should ever receive would be restored to him when he had offered him up...
>
> For the Scripture says, "And Abraham stretched forth his hand to take the knife, that he might slay his son. And the Angel of the Lord called unto him from heaven, and said, Abraham. And he said, Here am I. And he said, Lay not thine hand upon the lad, neither do though anything unto him: for now I know that thou fearest God, and has not spared thy beloved son for my sake." It is said, "Now I know", that is, "Now I have made to be known"; for God was not previously ignorant of this.

So God knew the outcome of the *Akedah*, and to a lesser degree so did Abraham. For Kierkegaard, and for terrorists, obedience to God requires a teleological suspension of the ethical; for Augustine, and for the traditional Jew, to be ethical is to be in contact with God. As Rabbi Milton Steinberg puts it (in a fashion echoing Levinas' critique of Kierkegaard):[10]

> What Kierkegaard asserts to be the glory of God is Jewishly regarded as unmitigated sacrilege. Which indeed is the true point of the Akedah, missed so perversely by Kierkegaard. While it was a merit in Abraham to be willing to sacrifice his only son to God, it was God's nature and merit that He would not accept an immoral tribute. And it was His purpose, among other things, to establish that truth.

For Augustine the foundation of faith is not obedience, but rather, understanding, and that understanding is neither subject to the parameters of human reason and emotion (as with Kantian Liberalism), nor beyond the parameters of the rational and ethical (as for the Postmodernist). For Augustine, the Biblical understanding of the substance of God as Truth and Love makes sense, and it is the combination of truth and love that is now so neglected.

Augustine recognizes the central role of love in theology and life, but does not neglect reason at its expense. He rejects the Modernist Liberal position that makes God subservient to human reason, and he rejects the Postmodern position which makes God irrational and thus unethical. In harmony with both experience and Scripture Augustine recognizes that to understand something is to love it – and to understand something about the divine is to be in touch with the ethical. The touchstone of this ethical faith is not subjective faith, but rather, the need to understand and love a purposeful and benevolent reality. It is to embrace benevolent *Being*.

So the consequence of Kant is that the mind of God is subject to human reason; of Kierkegaard the consequence is that the mind of God is subject to the human will; both demand a faith that can only be a fetish. It can only be a fetish in that a fetish by definition is an object that evidences no intrinsic meaning. What is today lacking is the notion that the story of Abraham and Isaac is important in that it establishes not the obedience of Abraham, but the benevolence of God. That benevolence entails both love and truth, and it is that combination which neither Kant nor Kierkegaard understands. The Augustinian position is that faith, hope, and love lead to an understanding of *being* which ameliorates the anxiety of *becoming*. Fear and anxiety are thus replaced by love and beauty.[11]

But there is one final irony to address. The implicit suggestion of this analysis is that to escape the bad faith of Postmodernism a reconsideration of Augustinian reasoning is essential. But even to the Postmodernist Christian, Augustine's Christian rationalism is not the solution but part of the problem; it is understood as a polluting classicizing of Christian faith. The irony is that a primary proponent of Postmodernity today is Jacques Derrida. And it is Derrida who uses the story of Abraham and Isaac to attempt to destroy Christian belief and the tradition that he fears the most: Platonic and Augustinian faith.

Let's be certain that we recognize this irony—or is it a vicious tragedy? The attack upon the Christian rationalism of Augustine is joined not only by Postmodernist Christians, but by the premiere Postmodernist theoretician today: Jacques Derrida. But it is Derrida's contention that Postmodernist thought makes clear the impossibility of Christian theology. He uses the logic of Postmodernist Christianity to deconstruct Christianity. Or to put it differently, Postmodernist Christians are in harmony with those who would destroy their faith; to be a Postmodernist Christian is to be an apostate.

In his 1992 book, *The Gift of Death*, Derrida discusses the nature of Christianity and the meaning of the *Akedah*. In his first chapter, *Secrets of European Responsibility*, he argues that religion is the attempt to be responsible, and responsibility makes possible freedom. Religion is where we explain ourselves to the other—that is, to God. Responsibility and freedom are the results of faith, but for him faith denies the knowledge necessary for responsible freedom to occur. Derrida notes Abraham's secretiveness about the sacrifice to be offered, and takes Abraham's statement from Genesis 22: (God will provide the sacrifice), as being ironic, and therefore intrinsically unethical. The Christian Kierkegaard and the atheist Derrida agree that we stand in fear and trembling before the inaccessible secret of God—or *Being*—who decides for us - although we remain responsible. It is the secret will of God that incoherently demands that we be responsible to God—while denying the knowledge that makes responsibility possible. And since we cannot be responsible to God— only we can be God.

In contrast, a beatific understanding of Abraham and Isaac does not pursue a subjective-objectivity. It is not one which denies, mystifies, or subjectifies the *Other*. It is not just the will of God that is at stake, but rather, the nature of *Being*. A benevolent *Being* is established, one worthy not of fear and trembling, but of love and understanding.

The Augustinian perspective sees no secret, no irony, no deception, in Abraham's comment that God will provide the sacrifice. There is no *other* which is totally ineffable, mysterious, and terrifying; nor is the Divine Other found in our minds. Therefore our reasoning and our actions escape the arrogance and the failures of Postmodernism, and Modernism. In his text, *On Free Will*, Augustine presents that different understanding of the Christian faith. A benevolent God knows what we will do, but does not, indeed cannot, decide for us what we will do. Goodness is a divine gift of Grace, Grace can foolishly be rejected, and a lack of knowledge is central to such foolishness. This permits responsible freedom to be real, and it permits a rational faith to be possible. We are not to live a trivialized Modernist faith, nor live our lives in a Postmodernist fear and trembling. It is not just the will of God, but God's Being that matters. We should live in the knowledge and comfort of what is meant by faith, hope, and love. We should dedicate our lives to the pursuit of beauty.

Christian Culture: From Scripture to Theology

In reaching past the Modernist-Postmodernist aesthetic habit of viewing art and religion as a matter of subjective taste or a matter of identity, we are thus able to seek a glimpse of beauty. A new type of art occurs, different from that of Aristotle's view, and an advance on Plato's and Plotinus' brilliant foundations. It is an art that is dedicated to beauty and to the triumph of love and truth over tragedy and death. Initially the Neo-Platonism of Plotinus faces the Laocoön's challenge and offers some relief. Then Christianity takes the lead. Both recognize that reality is a totality, and that totality descends from the sacred to the mundane. Both recognize that tragedy occurs, but they offer different solutions to show that tragedy does not prevail and that the goal of culture, to obtain some understanding of the meaning of reality and life, is not in vain. It is with some anticipation then, that we encounter a work of art offering that promise of relief.

The church of Sant Apollinaire Nuovo was constructed in the early sixth century. The exterior of the church is of austere brick construction; the interior of the church is of an entirely different case. The rational clarity of the interior, with its majestic columns and arches, is evident; the structure of the building declares that rationality and virtue make sense even in the midst of an often chaotic world. The interior space is also filled with mosaic illuminations.

By *illumination* is meant that the interior is not merely decorated and made aesthetically pleasing; nor is it evocative of a vague or aesthetic mysticism

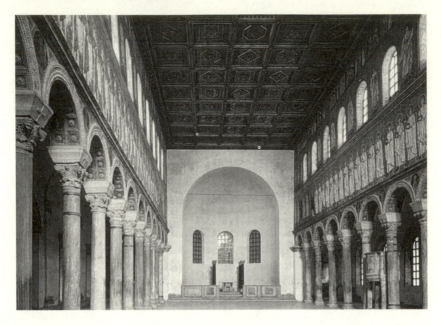

9. Sant Apollinaire Nuovo

more emotional than understood. It illuminates the meaning of the faith and the triumph of love and truth over adversity and death. As such it presents a vision of beauty rather than of aesthetics.

Facing the altar, and above the nave arcade to the left, is depicted a procession of females advancing towards the altar; on the right is a similar group of men. A comparison of their demeanor with that of Laocoön and his sons presents an image that even a cursory glance offers relief. What is presented is not tragedy but triumph, of virtue redeemed rather than mocked. The figures represent the triumph of truth and goodness in a fallen world.

How are these works of art to be understood, and how do they present an advance to that of the Laocoön? They represent a new approach to beauty. That approach is naturally accompanied by developments in theology, philosophy, and social ethics. In sum, as a work of art the church represents a social striving for the ideal, for benevolent and meaningful *being*, that triumphs over the tragic. The mosaics are part of a program which rises from the material to the social, to the spiritual, and finally to the divine. According to early custom, the women of the congregation would gather on one side of the church, the men on the other. There would then be a procession consisting of women and men, carrying bread and wine for consecration at the altar. Above the heads of those people are depicted the martyrs of the faith, those who had been victimized by the tragic circumstances of life. But in contrast to Laocoön, they are not presented as tragedies; rather there is a sense of triumph. Nor are

they depicted in a naturalistic way; the images of the martyrs appear to be shimmering apparitions, material humans ascending into an immaterial realm of *being*. Their images float on a gold surface much as hope can float on the surface of an aesthetic and often terrifying world. They are more than material —they are symbolic. But here the symbol refers not to fiction or willful preference. The symbolic refers us to Truth, Goodness, and Beauty.

So the congregation imitates the martyrs, and the martyrs imitate the Divine. Actions reveal spirit, but are not spirit. One ascends from the chaotic material world to a meaningful spiritual world and from aesthetics to beauty. They march triumphantly towards Mary and Christ, and ultimately, to God. This however is but a superficial presentation of the meaning of this church. To fully understand, and thus to see, this work, the philosophical and theological beliefs must be presented and understood.

The mosaics illuminating its interior assert that despite circumstances within and beyond our control, responsible freedom makes sense. The mosaics are true if the persons depicted were not only right in dying for their beliefs, but actually triumphed over evil. And if they are true and good, then they assert also that the world is ultimately beautiful rather than aesthetic and violent. In contrast to Laocoön, the mosaics of the Church of Sant Apollinaire Nuovo offer the promise of meaningful faith, hope, and love.

It is useful to consider how Plotinus would respond to that contrast. Plotinus would not make much of Laocoön's plight. For Plotinus the world is a continuum from the mundane to the divine, a continuum where evil occurs within the material realm. Surely he would appreciate that from the material we should strive for the spiritual, and that the spiritual should strive towards the One. He would appreciate the notion that the beauty of these martyrs lies in their meaning, not their appearance. He would appreciate that even with the tragedies that occur in life, there is hope, since Love and Truth are more real than evil. But he would be unable to offer tangible comfort for life in this world, or a practical ethics. For that, we turn from Plato and Aristotle to the Christian tradition and its early articulators.

In entering the church we enter much more than a utilitarian structure to protect us from the weather; it also offers much more than an aesthetic and emotional provocation. The church presents a vision of reality and life where just as one's mind is more valuable than the color of one's hair or skin, that which is intelligible is more valuable, more real, than that which is material. Light and truth are seen to be more authentic than darkness and physical matter in the sense that wisdom is more authentic than is ignorance or error. It is more authentic because it is grounded in *being*, in reality, in the objective ideal. Looking at the church's nave arcade we find at lowest level, where the congregation stands, a rather material and dark realm. Above the Congregation are the mosaics of the martyrs, as well as a series of windows that permit light to enter the church. That light, literally from above, is more than physical

light. It is understood to represent the point of transformation where the spiritual light of truth and understanding descends into the material realm of fact and feeling. This descent of *why* into *what* represents a materialization and hence a reduction in the purity of intelligible Truth and Beauty. Moreover, the light of understanding is no longer merely an attribute of one god among many, such as Apollo. It permeates all of reality to varying degrees.

To see the light is to understand, to be in darkness is to remain ignorant. The processions of figures depicted on the nave arcade raise our immediate attention from the material to the spiritual, but does so via a celebration of virtue and hope via Mary and Christ. The women model themselves after Mary, the men after Christ, and Mary and Christ triumph over death and time by a trans-generational bridging of the material to the spiritual.

As recounted above, Plotinus faced a dilemma: remaining straddled between a meaningless materialism on one hand and a Platonic transcendentalism on the other, he attempts to find a solution via monism. Monism posits that but one ultimate substance exists. What then of evil? It is a falling away from that ultimate. So evil is associated with materialism, and salvation is associated with becoming one with the Divine. But if evil is to be escaped by denying the importance of the material then the practical question of evil is merely avoided, not resolved. Furthermore, monism posits that our goal is to become one with the Divine; but even if we accept the premise that making the transcendent immanent in ourselves is possible, one conclusion is inescapable: it demands a self-deification. This is pleasing to the ego, but problematic. To escape the chaos of many gods, or alienation from an immanent god, we posit a self-deification. But that self-deification results in us all becoming world-makers (e.g., Nelson Goodman, *Ways of Worldmaking* [1978]), where wisdom and beauty are no longer found, but made, no longer a matter of sympathy or devotion, but rather of empathy, and the will to power.

Whether we consider this problem in late classical terms, or in those Postmodern, the dilemma persists: when self realization and self expression *become* the ideal, then an empty and violent narcissism is inescapable. However, a different means of answering the question of evil, and the issue of responsible freedom is presented by Judaism and articulated by Christian belief. Transcendent truth and beauty becoming Incarnate on the earth is foreign to Plotinus' thinking but its promise, or fulfillment, is central to the Judeo-Christian tradition. That tradition centers on the reconciliation of biography with history and the triumph of optimism over despair.

Laocoön presents the challenge of reconciling biography with beauty; however, the result of his pursuit of virtue, that is, his life, was indeed ugly. Plotinus recognizes this failure of Classicism and advances the attempt to resolve the problem of tragedy by pursuing Plato's notions of the transcendent. That pursuit recognizes that a transcendent realm of the ideal is necessary to reconcile virtue and tragedy on earth. But while he advances

consideration of the problem, his solution fails to affirm the material while pursuing the transcendent.

That affirmation occurs with the Christian Doctrine of the Incarnation. Evidence suggests that Plotinus knew of Christian belief, and remained ambivalent about it. He and his student Porphyry are likely to have been aware that the doctrine of the Incarnation offers a solution (to be discussed shortly) to the problem of reconciling practical virtue with the existence of evil. But whereas there are no written polemics against that faith by Plotinus' hand, his student Porphyry focused on a rebuttal of the meaning of the Incarnation. In terms of the history of art, Plotinus' caution was prescient; his ideas were used by Augustine in the development of a Classically facilitated Christian understanding of beauty and life. A solution to why tragedy and evil occur in a meaningful world is offered by Augustine, Athanasius, and Basil. They address the central question in the pursuit of beauty: is responsible freedom possible? They affirm that it is, given the reality of beauty—and benevolent *Being*.

We can now return to our discussion of the church of Sant Apollinire Nuovo, built by the emperor Theodoric. One act of infamy by that emperor was the murdering of the author of the famous text, *The Consolations of Philosophy*. Boethius was executed, or rather, murdered, for the alleged crime of defending an unjustly accused friend. But it was more than murder; it was an act of violence to body and soul. He was sentenced to death in a year's time, and told that before his death he would be brutally physically mutilated. So, Boethius' biography makes real the prospect of *becoming* (time) and *being;* for him the association of *being,* with a brutal death, loomed large. In the time he had to contemplate his grim demise he wrote his text, which opens with the famous question:

If there is no God, from where comes Good?
If there is a God, from where comes Evil?

As we have seen, within Classicism and the Judeo-Christian tradition, goodness is historically and philosophically associated with beauty. But given the prevalence of evil, then how can the world again become beautiful? How can beauty re-enter an imperfect world? Biblical prophecy provides an answer: by the arrival of the long-awaited Messiah. To the postmodernist mind this is but a hero-worshiping fetish. But intellectually it represents the solution to how to restore beauty (beatific *being*) in a world where beauty and love are under assault. When the transcendental divine (*being*) becomes incarnate in the created world, the possibility of beauty in a violent and aesthetic world is restored.[12]

The anticipation that truth and beauty would again become real in an imperfect world is central to Christian thought. The belief that this occurred

with the birth of Christ is the foundational principle of Christian belief. But just what does the doctrine of the Incarnation mean? Satisfactory answers to this important cultural question are obtained neither by Modernist nor Postmodernist scholarship.

Just as Modernist and Postmodernist understanding of the *Akedah*, of the Sacrifice of Isaac, differ along aesthetic and beatific lines, so does understanding of the Incarnation. For the secular Modernist, an aesthetic and sociological approach prevails: the alleged dual nature of Christ, as man and divinity makes no sense. Since parallels to Christian belief can be found in a variety of traditions,[13] they conclude that such belief is necessarily a social construct, a meaningful social fiction. Aesthetically, the conclusion then is that the Incarnation is a sociological assertion rather than an ontological occurrence.[14] At best it represents but one opinion among many; at worst it is pure fiction. Alternatively, the religious Modernist considers the meaning of the Incarnation, and of the New Testament, as a matter of personal or social opinion. It is a matter of a personal and subjective opinion—or rather, mere faith.

On the other hand, the Postmodernist adopts an aesthetic of identity. This approach assumes that the issue of the meaning of the Incarnation centers on the question of hero worship, with the skeptical declining, and the faithful exalting. Consequently, the very notion that the meaning of the New Testament of the Christian Bible is understandably true makes no sense since it must *a priori* be viewed either as a matter of willful identity or not. For those who accept Christ as their hero, the goal is to embrace, empathize, and obey rather than understand. For those who feel differently, a passionate contempt obtains.

Christian (or other) belief is seen then as a matter of cultural or personal opinion that can be casual or intense, skeptical or devout, depending on one's degree and object of empathy. But none of these responses provides insight into the meaning of God, or the Incarnation, and how that meaning is literally beautiful. This is because they are aesthetic, dwelling in fact and feeling, relying on empiricism and mysticism, grounded in some degree of empiricist and empathetic identity. Both empiricism and mysticism rely upon feeling rather than reason or understanding. Those who are empiricists are materialistic, maintaining that the universe is naturalistic and comprised of facts; those who are mystic will maintain that knowledge of the universe is unnecessary; how we come to terms with reality or God (*Being*) is a matter of feeling and identity, of power.

In contrast, the traditional meaning of God, the Incarnation, and the Eucharist is radically different to that offered via aesthetics. Each addresses the need to be in touch with reality or *being*. Each embodies a transformation from the realm of aesthetics to that of beauty, from the material to the spiritual, from ignorance to understanding to love. It is a transformation that when considered aesthetically, is either absurd or obscure. To view it in terms of beauty, however, is to obtain a glimpse of wisdom.

Christianity is a tradition historically dedicated to the pursuit of beauty, not by a rejection of aesthetics, but by their subordination. It does not limit its understanding of the world only to aesthetics, nor does it reject the role aesthetics plays. It does not worship power, but rather sees purpose and beauty as well. It does not assume that reality is a construct of our taste or experience; rather, it holds that reality is purposeful and objective and needs to be understood. What then is the nature of the world; what is the nature of *being*, and how is it thus to be understood? Some fundamental principles are (1) that the universe is purposeful; (2) that purpose is ultimately ineffable; but (3) some degree of insight and knowledge is possible. It also addresses the relationship of *being* and *becoming*, of eternity and time, and of truth and love.

So far we have discussed several foundational beliefs of Christianity, none of which are subject to scientific determination or refutation: it is held that the universe is not an accident, nor merely a machine, or an organism, but rather is purposeful. It is held that the universe is not eternal and cyclical, but created as an act of Divine Truth and Love. It does not begin in a state of chaos that must be controlled and given form, but rather was created perfect and then became corrupted. Creation is the result of a conscious act of the eternal Divine that results in the reality of linear time. There is indeed a beginning and an end to the world and the span between the two is temporal. Thus both Truth and Love are associated with rather than defined by power, and are associated with rather than defined by time. Moreover, love is associated with freedom since love cannot insist upon its way. Truth and love within a purposeful universe make real responsible freedom and beauty, and makes possible our ability to rise from the material and temporal to the Divine and eternal. It makes possible our rising from the realm of aesthetics to that of beauty, from facts and feelings to understanding. This results in the cultural principle that responsible freedom is real, that the choices we make have consequences and those consequences can be for better or for worse.

As the Book of Genesis states, the universe was created out of nothing (*creatio ex nihilio*). To the prosaic mind this is but a curious sociological claim. But from the point of view of beauty and understanding it prompts a variety of provocative questions. It invites the question: Why did God create the universe? And it begs the question: Where was God when God made the universe?

So out of the ground of reality, of *Being* (or of *Supra-Being*, as discussed below), springs the world. Why was the universe created? This involves a consideration of the nature of God, or to put it differently, it requires a consideration of the purpose of reality and life. According to Christian belief, God is truth and love, and created the world as an act of love, or of glory. By that is meant that love and glory must have an object, and lacking an object, they descend into a narcissistic and destructive pride. If God is love, then love must have an object to remain love. So the free act of Divine creation was out of the

necessity of Divine love and glory. God created the universe as a result of a free will that is grounded in the necessity of a divine *Being*. That mind is one of truth and love, and the result is a creation both good and beautiful. So the Christian tradition focuses on the relationship of truth, love, and freedom. Therefore, it focuses on the free pursuit of beauty—as do other traditions.

For a history of art dedicated to the pursuit of beauty, the consequences of this viewpoint are several. It argues, for example, that culture is based upon freedom of conscience, and is more than a matter of taste or power. It is based upon an uncoerced love of truth that properly results in goodness. So transcendence makes possible the transformation of the destructive self-love of narcissism and pride into a subject having an object of love and honor. Christians are to love their neighbors as themselves, but not in the sense of the neighbor being an empathetic extension of themselves. By the act of creation God denies the narcissism that destroys love, but for humans to do the same is for us to play God. Humanity cannot make reality—it already exists; to attempt to (re)make reality is to reduce *being* to a *becoming,* subject to our competing wills. But when *being* is *becoming,* then *being* is empty. It is to embrace an empty and violent nihilism where competing wills to power eternally conflict. It is to enter what this tradition calls hell. Indeed the attempt to (re)make reality is a mark of sadistic brutality. It is a Sadean vision that is aesthetic and violent to its core.

The alternative is to not attempt to empathize with God, nor with our neighbors. To do so is to destroy both by demanding that they become us. Rather, we passionately attempt to aspire to the ideal as it unfolds in time. New knowledge can be found, it just cannot be made. So the world has purpose and that purpose is grounded in freedom, truth and love. The world as created is beautiful. Freedom, truth, and love are then metaphysically and culturally necessary companions. Both truth and love reveal *Being*, and lead to beauty–and both require an object. Despite other differences, the cultural goal of Christian tradition is the same as Classicism: the pursuit of the objectively True, Good, and Beautiful.

But as a matter of empirical and sociological fact, there is much apparent randomness and coercion, falsehood and hatred. The biography of Laocoön, of Boethius, and of the martyrs of Sant Apollinaire Nuovo, makes clear that we face a dilemma: if the world makes sense, then why is it that so often our lives do not make sense? If the world is beautiful, then why is there so much ugliness in life, and how might goodness prevail?

The Christian tradition offers a solution beyond that posited by Classicism and the Neo-Platonism of Plotinus. That solution is found in a consideration of the interaction of freedom, truth, and love. In a universe driven by accident or mechanical necessity, there can be no goodness. There can only be the facts of contingency, necessity, or desire. For goodness to exist, the universe must

have purpose, and for that purpose to exist there must be a source or grounding of that purpose. That source can be immanent and pantheistic, or it could be transcendent and theistic. The latter is the Christian position. The rejection of pantheism lies in its denial of the possibility of individual personality and responsible freedom. Pantheism denies the cultural idea of truth, goodness, and beauty and is incompatible with the nature of self-conscious humanity. It therefore appears false in reality and in reference to the theology of Christianity.

The Incarnation, Aesthetics and Beauty

A means of bridging the gap between the practical and the divine, between an often chaotic world and the ideal, is offered by the Incarnation. Above the issue of whether as a matter of historical fact the Incarnation (or at least the birth of Jesus) occurred, which is not really disputed by history, is that of its meaning. The meaning of the Incarnation might be ignored by declaring it as necessarily being a matter of myth, opinion, or subjective identity. But rather than ignore its meaning, perhaps it is more appropriate to attempt to discern it first, particularly since its meaning has been of paramount importance to the development of Western culture through the last two millennia. To ignore the meaning of such a doctrine, particularly as a matter of scholarly inquiry, is indefensible. And yet, its intrinsic meaning is today consistently aestheticized and thereby reduced to entertainment, therapy, and propaganda.

What is the intellectual content of the Incarnation? In summary, it provides a defense of responsible freedom and beauty. It reconciles eternal truth (*Being*) with that temporal (*Becoming*) by putting truth in time. It thereby makes progress possible, since progress without truth is meaningless. It does so without embracing a pantheism or monism that denies the possibility of love and responsible freedom. It reconciles imitation with creativity by associating particular choices with universal good. It reconciles biography with beauty by affirming ideals within an imperfect world. It denies the self-deification resulting from a prideful relativism and constructivism where we make the world conform to how we think, by maintaining the uniqueness of Divinity in the person of Jesus Christ. Indeed, to advocate a meaningless pluralistic relativism is to advocate a meaningless multiple self-deification; it is to engage in a self-destructive polytheism. The necessary result is despair, where the outcome is as tragic as Laocoön, but lacking even a Stoic dignity. It results in Nietzsche's last man who is unable to even despise himself.[15]

With both Laocoön and Christ biography is connected with beauty; the former with the failure of beauty in the world, the latter with its restoration. For beauty to once again become a possibility in an often ugly world, truth must once again be in, but not of, the world.[16] A result is that our lives ought to strive to do what is true and good. Biography must restore the beauty that has been lost in the material world and life. The martyrs of Sant Apollinaire do so on a

cultural level, but for their actions to make sense, then we must transcend tragedy on a universal level. They must be grounded in reality, in *being* or ontology, and ontology thought through is metaphysics. The Old Testament states the need for perfection to restore a fallen world; that perfection must be personal for love to be real and meaningful. Therefore, a Messiah is necessary to renew the possibility of beauty and love in the world. Christians hold that need to have been met, but not merely as a matter of cultural opinion, nor as a matter of puerile hero worship. They advocate the position that when truth reenters the created world, that which was once good and beautiful can then be restored, and fine art can be more than aesthetic, more than a fetish or an idol.

By making the possibility of a benevolent *being* real within a world filled with tragedy (or non-being), the Incarnation provides a means to rise from the material to the divine, from violence to truth and love, from aesthetics to beauty. It embodies the transition from fact to understanding, time (kronos) to purpose (kairos). And the claim of the uniqueness of the Incarnation prevents a society of demigods whose competing claims of truth and love lead to tyranny or chaos.

The Incarnation provides a doctrinal basis not only for a restoration of meaning and purpose in a chaotic world, but also for the importance of the fine and liberal arts. It does so by establishing that degrees of beauty and wisdom are possible. In terms of art and life, it recognizes three levels of beauty: the lowest level is the aesthetic, where meaning is slight, the next higher level is the aesthetic informed and to some degree made beautiful by truth, and the highest level is beauty itself.

It concurs that *doxa* is an alternative to the self-deification which is found in the a esthetics of skepticism, and or identity. Above material fact and pleasure are meaningful facts and pleasure, where truth and matter are recognized as coexisting to some degree. However, divine truth is infused with love. It is neither a matter of fact versus feeling, nor of absolute truth versus fiction. It is a matter of degrees of meaningful passion, of a loving commitment to that which is true and good. The attempt to realize that commitment is central to our personal, intellectual, and cultural existence.

So because of the existence of the divine realm and the realm of creation, transcendence and immanence are reconciled. Truth and love are by degree material and ideal, temporal and eternal, aesthetic and beautiful. In each case is assumed a world that is personal rather than impersonal, meaningful rather than meaningless. Being personal, both truth and love require an object to exist; they are sympathetic[17] rather than merely empathetic. The need to understand how a personalized meaningful love makes sense metaphysically parallels the need to consider if such a personalized meaningful love can make sense culturally and personally. This need is then cognitive and practical, cultural and personal. And it brings us to a consideration of Christian theology, particularly of the Trinity. In attempting to comprehend its meaning we

enjoy the possibility of rising above an aesthetic and therefore superficial understanding. In so doing we rise not only above the secularization of Christ (and a divinization of humanity),[18] but also above an often unacknowledged yet virulent censorship of Christian theology.

For example, in our discussion of Sant Apollinaire Nuovo it has been noted that it is a Christian church, but neglected up to this point is the fact that is was built in the midst of controversies concerning the Incarnation. Arians accepted the divinity of Christ, but rejected the notion of the Trinity, holding instead that Christ and God are two. Soon to follow was the idea of docetism where the human soul of Christ was identified with the Logos. Such matters are inconsequential if viewed aesthetically. But in considering what their meaning is, and the practical consequences that might result, then fresh insight occurs. The issue of the nature of the Incarnation and the Trinity refers to how we are to understand not only the Eucharist, but how we are to understand art and life as well.

The Trinity, Art, and Life

Sant Apollinaire Nuovo accommodates a discussion of a particular understanding of the Incarnation, an understanding later held to be theologically corrupt by all three of the major branches of Christian belief. The Emperor Theodoric was involved in the construction of this great church, and was theologically Arian. The term Arianism comes from Arius, a Bishop of Alexandria in the early fourth century AD. Arius' theological position was condemned at the Council of Nicea in AD 325. Although condemned, the position evidenced continued advocacy nonetheless.

What was that theological position, why was there a controversy about it, and how could it matter today? How Christ is understood indicates an understanding of how reality works. So from the viewpoint of intellectual history, the issue of personal allegiance to Christ is not paramount. What is at issue is the meaning of Christ, the necessary outcomes that result if that meaning is correct, and what practical consequences result in the conduct of life.

Arian Christians hold a different understanding of Christ than does, for example, Augustine, or Basil of Caesarea. On the surface, the issue is the relationship of Christ with God. In contrast to orthodox Christian belief, the Arians held that Christ and God were two persons. This distinction is the source for the once common phrase: how could that matter one *iota*? The *iota* is a Greek letter, and the absence of the *iota* in the word *homoousios* (of the same nature) and its presence in the word *homoiousios* (of a similar nature) was the center of the controversy. Augustine and Chrysotom would never accept the *iota*, Arius insisted upon it.

Aesthetically, it might appear that we are speaking of an inconsequential semantic dispute about a mythic relationship of a God and a Christ. But on one level the issue is how can the world be meaningful, how can an objective truth

and love be one and exist. For science to make sense, science must be in touch with reality. In science truth must be singular or be reduced to utilitarian fiction;[19] it addresses the issue of fact vs. fiction. But for reality and life to make sense, truth cannot be self-referential fact or opinion. They require an object beyond themselves; knowledge requires an object outside of a subject. A meaningful world must have an object, a purpose, and if that object exists, then the world can be understood and beautiful. If that object does not exist, then the world cannot be meaningful and it cannot evidence purpose. In that case, it is merely aesthetic—and at best factual and emotional.[20]

So too is the case with love. Love without an object cannot exist; love without an object is a self-love that implodes into nothingness. As Plato put it, love is the desire to possess beauty, and beauty is the splendor of transcendent benevolent truth. Lacking the transcendent then both love and beauty are limited to the aesthetic. But if they are limited to the aesthetic, then they result in a love-negating and violent narcissism. So as is suggested by Laocoön, if we have more than one God (or Truth) then the universe makes no sense and is reduced to confusion and violence. To escape that confusion and violence, a monotheistic truth and love must be real. But for such love to be real, then God must have an object for that divine love, an object which is equal to rather than subservient since love can only exist between equals.[21]

As discussed previously, how we understand love is of fundamental importance to how we live our lives. The issue of the relationship of God and Christ, and the issue of the meaning of the Trinity address the nature of Love, its reconciliation with Truth, and the nature of our relationships. The New Testament holds that God is Love. If God is love, and God is singular, then love is destroyed by its prideful contradiction, narcissism. A God of Love cannot be empathetic and narcissistic because both reduce love to a self-contradictory violence. Love must have an object as well as a subject, and that object of love must be equal to be equally real.

In holding that God and Christ have two natures, Arianism declares that Christ is in fact a demigod. Intellectually this marks a return to pagan polytheism and its intrinsic problem of irresolvable violence. It denies not only the possibility of reconciling truth and love, it replaces love with violence. Arianism destroys truth and love by its violent denial of Truth, and Love, therefore by assigning to Christ the role of the demigod. Similarly, the contemporary aesthetic mind does the same via abstraction and empathy (as discussed in detail above). The issues surrounding the Arian Controversy continue then to the present, as do their consequences.

The Trinity is necessary to understand the faith, and the faith holds that God and Christ are equal in the sense that they are of the same substance. But what is their relationship? Although equal in substance (empathy), Christ is subordinate to God (sympathy). It is a subordination of Christ to the Father, but at the same time, this subordination is not one of power, but rather of

function. The Trinitarian model disputed by Arianism provides a model not only on the metaphysical level, but on a social level as well. It establishes a model for social and family life. This principle provides a model for social relationships as well: persons united in love are persons liberated from narcissism, ego, and envy. They are equal in importance, but are variously subordinate to others. It provides a means by which freedom and quality can be reconciled with necessity and equality. We are free to pursue our talents, as they vary among us, without descending into envy. Our talents are complimentary rather than divisive; our differences are transcended rather than emphasized or ignored. They produce acts of love rather than violence. In sum, the Trinity reconciles truth which must be singular with a love of the other in society, and in the family as well. Individualism is not denied but put to the service of a transcendent ideal; that ideal is informed by benevolent purpose. Just as God loves Christ, and Christ loves humanity, the martyrs dedicate their lives to the true and good, and so should we. In society and family we are not to play the role of the demigod, but rather, of the responsible and free moral agent.

When the Byzantines took possession of the church of Sant Apollinaire Nuovo in the middle of the sixth century, its Arian mosaic program was altered. The figures of the king Theodoric and his court originally had been depicted as the point of departure for the male martyrs. These figures were removed, and the new leader of the male martyrs was Saint Martin who was a leader in the battle against Arianism in northern Europe. To the point, Theodoric's theology, Arianism, had practical political implications. If Christ had but a similar substance to God's, then Christ is a demigod; and so too could be the ruler who is ordained by God to rule. Since in this case the relationship of Christ to God was understood as a model for imperial power, then when the Trinity is denied, limitations on imperial power are confused. If both emperor and Christ are demigods, then authority is equally vested—yet equally denied. Truth is reduced to aestheticized power, and the link to the transcendent is muddled.

Arianism posits a type of political pluralism, which might appeal to the modern aesthetic mind. But if that pluralism results in the destruction of truth and love, where demigods compete and where each of us decides for ourselves the nature of the universe and the meaning of life, then that pluralism masks a barbaric culture where only the coercive power of legality can now prevent social dissolution.

For the moment it is sufficient to note that Sant Apollinaire was constructed in the midst of these controversies; at first some of its mosaics supported the Arian position, and later they were changed to clearly disassociate the Church from that position. As mentioned previously, Arianism was condemned by the Council of Nicea in 325. The central dogma of the Christian faith, the Incarnation, was held to be absolutely necessary to reconciling divine beauty with an aesthetic world, divine truth with divine love. What was left unresolved for the

moment was an incoherent association of a metaphysic of freedom with a politics of authority.

In the midst of the Arian controversy one unfortunate event occurred. It refers to what is known as the Filioque Clause. Filioque is a Latin term that means "and from the Son." The controversy again centered on the relationship of Christ and God, and therefore involves a model for social relationships as well. At issue is whether the Holy Spirit proceeds from Father, or from the Father and the Son. As discussed in detail below, this dispute, with obvious sociological and political consequences, originated in 589, and came to a climax in 1054 when a split of the Christian Church into Western and Eastern realms occurred.

In summary, the orthodox understanding of the nature of God, and of the doctrines of the Incarnation and Trinity, are intellectually rich and culturally profound. They articulate a sophisticated reply to the crucial question: if the world makes sense, then why do bad things happen to virtuous people? Our response to that question is of fundamental importance to how we live our lives. Christian doctrine also offers an alternative to an empathetic and violent narcissism. Such knowledge enriches our ability to understand and thus see the beauty of Christian art. Should we find that vision compelling, then we are enriched by a benevolent vision of reality itself.

Christian Theology and Beauty

In the historical development of Christian theology a fundamental question is asked: what is the relationship of *what* and *why*? This question is but only initially addressed by what is known to Christians as the Old Testament, and by the New; a deeper understanding of the faith and of our place within reality and life is soon pursued. This pursuit is a theological one, and it centers on our attempt to comprehend the doctrines of the Incarnation, the Trinity, and the Sacramental (especially the Eucharist). It is a quest that is directly connected with the idea of beauty, and its relationship with aesthetics.

Our understanding of the meaning of the Incarnation, the Trinity, and Communion directly correlate with our understanding of fine art and ethics; such understanding can occur either within an existentialist or purposeful context, within secular or sacred worldviews. Choices must be made, and consequences result.

There are numerous stages in the development of Christian doctrine, and variances as well. This prompts some to approach the historical development of the faith aesthetically and sociologically.[22] History is thus viewed as a nostalgic triviality. But to historicize Christian doctrine is to deny its fundamental tenets; it is to view it via a perspective that necessarily denies its validity. In contrast, the historical development of doctrine may be seen as part of a historical process without doctrine being a product of that process. History and doctrine do not have to be historicist.

There are seven primary positions evident in the historical debate concerning Christian doctrine; those positions profoundly affect how the faith is understood. But they also profoundly affect how reality, life, and beauty are to be understood. The following chapters should make clear that Christian doctrine attempts to reconcile what with why. Those attempts center on understanding the Incarnation, the Trinity, and the Eucharist. It will be shown that our understanding of those elements of belief fundamentally affects how we understand beauty and art. Or conversely, how we approach beauty and art indicates our understanding of reality and life.

These positions occur within time (*becoming*), but are also engaged simultaneously in an analysis and debate of that which is real (*being*). This is obscured by the contemporary confusing of thought with feeling, and of history with historicism, with an unfolding of fashion be it aesthetically trivial or absolute. In either case historicism causes conversation to be reduced to mere opinion or identity. Being limited to matters of taste we can no longer analyze and discuss those positions.

But the pursuit of beauty is more than a matter of taste. It accommodates responsible discussion. The following discussion will follow the chronology of the unfolding of this debate, but it should soon become obvious that chronology need not coincide with ultimate validity. There are contemporary proponents of each of those stages up to the present, although those who are Modernist and Postmodernist now dominate the field. That discussion will focus on the Eucharist, how it is understood, and what consequences result.

The Eucharist, Ethics, and Art

Briefly, the development of Christian doctrine concerning the Eucharist begins (1) with that of the Early Church fathers; to the original company of disciples the meaning of the Last Supper was inseparable from that of the presence of Christ. But how is that presence to be understood and made manifest, and what consequences result?

This question is addressed in the remarkable writings of Augustine. He advocates a Symbolic approach to both the Sacramental and art. But the symbol is not understood as empty; rather it is an analogue (lit. *ana—logos*, of the same reason) whereby it is the visible sign of the presence of invisible Grace. An act of charity is a real symbol of the presence of love. In this sense, rather than attempt to establish reality, the symbol is in harmony with reality. The symbol re-presents what is reality. Therefore the Eucharist marks a participation in a saving transaction; it offers the means by which we can participate in rising from the material and tragic to the divine. Each work of fine art is thus understood to attempt to realize the same.

The Symbolic approach was contested by those advocating the idea of Conversion (2). This position became dogmatic within the Eastern Church, as finalized in the eighth century by St John Damascus. It emphasizes that both

Sacrament and the Icon mystically make manifest the spiritual presence of *Being*. It is via Christ, the Sacraments, and the Icon that the Holy Spirit permits us to be in the presence and see the image of the invisible God. The Eucharist is not a symbolic continuation of the Last Supper leading to the Cross. Rather, it is a shifting to the mystical realm where a divine sacrifice occurs.[23] So too is the role of the Icon.

Whereas in the East the conversion doctrine became established, in the West a conflict continued between the symbolic and the conversion theologies. In AD 844 Paschasius Radbertus of Corbie stated in his *On the Body and Blood of the Lord* that the bread and wine are changed by consecration into the body and blood that were born of Mary, but that this change is not apparent to the senses. It is a spiritual occurrence. He argues for a deeper understanding (3) of the symbolic and conversion positions: the aesthetic and material aspects of the bread and wine are transformed by consecration into the body and blood of Christ. The elements of the Sacrament of the Eucharist are then twofold: physically real and spiritually transformed—or to use later terminology, transubstantiated. It is an inward and spiritual change that occurs, not apparent to the senses. As Harnack puts it: "The sensuous appearance of the consecrated elements is the symbol of Christ's body, their essence is the true historical body itself." Consequently, the notion of the Icon is disputed.

In the midst of a debate about the nature of the Eucharist, the Incarnation, and art, Charlemagne sent a response to critique the Byzantine position as he understood it. The text *Libri Carolini* argues that icons should not be destroyed, nor should they be venerated. To the Byzantine view the West was desacralizing communion, art, indeed life. To the view of the West, the Augustinian notion of the symbolic role of art is reasserted, but only for the moment. Later figures such as Ratramnus and Berengar attempted to reestablish Augustine's position, but the conversion theology was soon established as the norm.

It is the Scholastics (4) who pursue the notion of transubstantiation, employing an Aristotelian perspective to understand the Sacraments and Beauty. Just as John of Damascus codified the Eastern position on these matters, the notion of transubstantiation is codified by Thomas Aquinas (1227-74). Although incorporating Augustinian elements, his analysis is markedly Aristotelian. We consequently see an increasingly Aristotelian perspective of Communion and the fine arts.

Concurrent to the Scholastic position, the Augustinian and the Byzantine traditions continue their advocacy. But with the critique of Scholasticism there occurs a reconsideration of Christian doctrine and the notion of beauty yet again. The Lutheran position (5) differs from the Calvinist (6), and both differ from the Christian Existentialism of Kierkegaard (7).[24]

So there is a historical development and a continuing discussion. A variety of traditions which debuted at different times are concurrently practiced to the

present. So that discussion does not require that we abandon hope of obtaining a glimpse of wisdom. It does not require skepticism or indifference. Rather, it is a call to engage in that conversation because the quality of our lives depend on the answers by which we live.

As just noted, over the millennia clear divisions within the Christian faith have developed. Those divisions are: Early Christian/ Augustinian, Eastern (and Russian) Orthodoxy, Scholastic Roman Catholicism, and the broad array of Protestant traditions. The last is often at least partially dedicated to a reinstitution of Early Christian practice and the Platonic/Augustinian approach. From an aesthetic viewpoint, those divisions are based upon differences of textual interpretations and personal commitments. From an aesthetic viewpoint, those divisions are insurmountable; they hinge on a matter of taste or identity, and an aesthetic ecumenicalism is the best that can be hoped for. At best, we can hope for an empathetic inter-denominationalism where differences in theory can be put aside. The problem is that differences in theology (or science) cannot be put aside, without putting understanding and belief aside as well. Should those be put aside, then our attempts to understand the world and life are necessarily reduced to a matter of subjective aesthetics. But then a new belief dominates: the belief in culture as a matter of subjective aesthetics. And when that occurs the adherents of any faith become demigods.

Whether we are speaking of Christianity, or of art history, the point is that an aesthetic approach reduces the content of their subjects to theory and empathy, obscurity and power. The difficulty with an aesthetic history of art is that the vast majority of works of art around the world and through time have been dedicated to the pursuit of beauty. Indeed, those few that do aspire to aesthetics are in fact simply positing a superficiality of belief. From the vantage of beauty, aesthetics is not different, but inadequate. It does not do enough.

What then of the divisions that presently exist within traditions, be they Christian or other? It would be disingenuous to deny their significance in the course of history and life. Obviously, bloody strife has occurred within and between cultures. Nonetheless, we find much common ground among the three primary divisions within the Christian faith. Indeed, during the Early Christian period there were debates but no schism, and those elements that later separated into Orthodox, Roman Catholic, and Protestant traditions later managed a tenuous peace via rather than inspite of understanding. Those foundational beliefs shared by all can be discerned once again via the pursuit of beauty.

An understanding of those foundational ideas was developed both by Late Classical and Early Christian philosophers. Plotinus in the third century AD provides an introduction to a new vision of beauty, a vision that influenced the theological thinking of authors such as Basil of Caesarea and Athanasius. They provided much to the foundation of what is now the Eastern Orthodox tradition. Influenced also was Augustine who provided a foundation of what is

now the Roman Catholic and Protestant traditions. Within the work of these early Christian writers we find also ideas that provide an ecumenical heritage for the development of Christian belief. So we go from the Classical to the Christian and from the realm of tragedy to that of redemption.

Augustine's Illumination Theory of Art and Life

Augustine (354- 430 AD) is a primary source for understanding the Western Church, and for understanding art and culture. Once again biography and culture are intertwined. Raised by a pagan father and a Christian mother, Augustine personified the conflicts of his age, and offered a solution to those conflicts. His life and work are important both for the challenges he faced and for the solutions to those challenges he offered. Those challenges amounted to nothing less than an attempt to make sense of the world, and *being*, in the midst of a metaphysical crisis. The old Classical culture was at that moment contested, and new and various cultural alternatives were vying for prominence. In many ways, his life and times are particularly comparable to the situation in the West at the turn of the twenty-first century.

As a young man, Augustine lived a studious and at the same time dissolute life; his pagan father's delight at the sight of his puberty conflicted with his mother's concern for the quality of his soul. While he sought to satisfy his passions, his intellect focused on an essential question: if the world makes sense and has purpose, then how can the existence of evil and suffering be accounted for? Augustine confesses (using his own terminology) suffering an existential angst; his aesthetically driven desires conflicted with his need for beauty, and he voiced a conscious need to comprehend and love the good in a world where evil is prevalent. For a while he embraced Manicheanism, a theology advocating a universe composed of contradictory forces, where the good is associated with light, and evil is associated with darkness. Evil triumphs when the body triumphs over the soul, which is composed of light; goodness triumphs, at least momentarily, when light and truth prevail. This model provides an explanation for the anxiety Augustine felt, and the dissolute life that he lived. According to Manicheanism, his anxiety resulted not from his personal failures, but rather, due to the pernicious influence of an evil cause outside of himself. He was the pawn of a never ending metaphysical battle between good and evil. It was during this period that influenced by Aristotle he wrote a now lost text on aesthetics, titled *De pulchro et apto*.

Augustine soon came to doubt the success of Manicheanism in making sense of the world. He could not understand why that violent dialectic could be, and could not understand how it could ever be resolved. Whether one speaks of a dialectic of good and evil, of light and darkness, or of race, gender, or economic class, the dilemma is that such conflicts cannot be resolved via a transcendent solution—but only because they do not recognize that as a possibility.

Unsatisfied, he first went to Rome and then Milan, where he became acquainted with the writings of Plotinus, listened to the sermons of St. Ambrose, and recommitted to the Christian faith in 386 AD. His book, *Confessions* (ca.397-400 AD), marks a milestone in the development of Western culture. It introduces a shift from the Classical focus on the exterior world, to that of the interior, and a shift from aesthetics back to beauty. Hailed as perhaps the first work to focus on the personal and the psychological (in a non-Aristotelian or empiricist sense), Augustine's *Confessions* is an autobiographical account of his search to make sense of life.

In that text he laments his early foolishness, stating:

> I loved [aesthetics] (pulchra) of a lower order and descended into the depths, saying to my friends: do we love anything but [aesthetics] (pulchra)?[25]

What is the alternative to a foolish aesthetics (pulchrum)? An aesthetics that rises to become *Bonum*. Recall that Jerome translated *kalos* (the Greek term for beauty) with *bonum* (Latin for goodness), not *pulchrum* (Latin for physical pleasure). Augustine concurs: to his experience and understanding pleasure uninformed by truth is insufficient. Indeed, in the book which many consider his masterpiece, *The City of God*, there are two realms presented: the City of the World, with its foolishness and violence, and the City of God, with its genuine bliss. It is the city of aesthetics vs. the city of goodness (bonum) and beauty (*kalos*). It is a conflict between two worlds,[26] but not between two realities. Goodness is real, and evil marks a deprivation of the real.

The competition between mere *pulchrum* and *bonum* is not viewed by Augustine as a competition between two types of reality (that would be what his Manichean opponents advocated), nor was he a world denying Monist and Idealist as Plotinus was. It is not that he is less theocentric than Plotinus, as some have argued. Instead he represents the importance of the Christian doctrine of the Incarnation to understanding reality and life. The gap between the low, the world where evil lurks (*pulchrum* unformed by truth), and the high, where divine Goodness reigns (*bonum*), is bridged by the Incarnation. *Pulchrum* thus informed by truth bridges the gap between the base and the divine. The realm of beauty is therefore made possible in a fallen world. It makes possible the pursuit of beauty as a realistic and essential task.

Augustine presents a vision of reality and life that is both Biblical and optimistic. He echoes Classical thinking: there is chaos, and order, and love, but he holds that harmony and love are more real than the chaos and hatred we encounter. It is not that chaos must be controlled as the Classicists contend; rather, it is that harmony and goodness need to be realized and thus restored. So harmony and goodness are (super)natural, in the sense that it is how the world ought to be; evil, disease, and violence, are deficiencies in what ought to be.

He follows the Biblical texts explaining that aesthetics are not enough. According to Matthew 13:13:

> This is why I speak to them in parables:
>
> "Though seeing, they do not see; though hearing they do not hear or understand.
>
> In them is fulfilled the prophecy of Isaiah:
>
> "You will be ever hearing but never understanding;
> you will be ever seeing but never perceiving.
> For this people's heart has become calloused; they hardly
> Hear with their ears, and they have closed their eyes.
> Otherwise they might see with their eyes, hear with their ears,
> understand with their hearts and turn,
> And I would heal them.

As Augustine points out, to see beauty we must first understand truth,[27] and for truth to be understandable, the world must make sense. So we need to hope that the world makes sense, in order to justify our attempts at understanding it. We must hope that there is meaning to reality and life before we can seek wisdom, and we must entertain the possibility that these works of art are true to seek a glimpse of their beauty.

In the *De natura boni* (14-17) he says that "No nature has any evil, but a decrease of good (bono) in it." In the *Confessions* (X, 34) Augustine explains the beauty of God being different from aesthetics:

> The eyes love [aesthetic] and diverse shapes and splendid and pleasant colors These things do not hold my mind in their sway; but rather it is held by God, who made them—valuable [bona] indeed, but my good is God.[28]

And in *De vera religion* (XXXI, 57):

> I am delighted by the highest equality, which I apprehend not with the eyes of my body, but with those of my mind. I, therefore, believe that the more what I see with my eyes draws near to what I apprehend with my spirit, the better it is.[29]

So Augustine sees a world informed by truth and love, where evil, disease, and violence marks a deficiency in *being*, in that which is and ought to be. Ugliness is the inverse of beauty, a privation of form (*De Immortalitiate Animae* viii, 13). The aesthetic experience of evil is of the lowest, most deficient type; the aesthetics of harmony and equality have a greater degree of goodness to them, and hence are loftier. This realm is made possible by the Incarnation. Ultimate reality is where the beauty (*bonum*) of *Being*, of God, is realized and experienced completely.

The practical consequences of this vision of beauty and life are as follows: it is realistic to be optimistic; evil has no positive existence, rather, it indicates

the result of a failure to love; pleasure (aesthetics) ought to be qualified; the ability to rise to the divine is made possible by the Incarnation; it links beauty and understanding in reality and life. The key elements in Augustine's theory of beauty and culture are measure, form and order. As Tatarkiewicz (48) offers:

> These three properties determine the value of a thing. Everything which contains measure, form and order is good; the degree to which it contains them makes it more or less good; where they are absent, goodness too is absent. Here, Augustine used the word "good," but [sic] he clearly meant to include beauty.

The source of those qualities is found in the source of purpose in the world, a God of truth and love. As explained above, truth and love make freedom possible. Indeed, Augustine explained the seeming contrast between an all knowing God and human freedom by noting that although God knows what we will do, such fore-knowledge does not result in a denial of personal freedom and responsibility. God knows what we will do, but responsibility for what we do remains with us.[30] Augustine's theory of beauty is identical to his understanding of theology and life. It is an understanding that resonates with Plato's story of the Cave.

Often referred to as Augustine's illumination theory of beauty, truth is associated with understanding, and understanding is associated with light. Light is a symbol of God, with both ignorance and evil evidenced by the absence of light. Ugliness is to beauty as shade is to light: each provides a contrast that facilitates understanding; the former remains but a shadow of reality as it ought to rightly be.

Like many of his contemporaries, Augustine considered intelligible beauty rather than physical aesthetics to be most important. As such, he worried about the negative influence of mere sensationalism (pulchrum) in art and in life. In *De vera religion*, XXVII, 43 he states unequivocally:

> So it is that some perverse people like the verse more than the actual art of writing verse, since they have cultivated their hearing more than their intellect.

And he continues in a letter regarding the Gospel of St. John, making the point that aesthetically admiring the appearance of a text is vastly inferior to reading and understanding it.[31] Although Augustine differs by holding that paintings and sculpture do not need to be similarly read, the same point can indeed be made of visual art:

> But if we were looking somewhere at beautiful [sic] (pulchras) [sensational]letters, it would not be enough for us to praise the skill of the writer for making them equal, symmetrical and ornate, unless we also read what he has expressed for us by means of the letters. Thus, whosoever looks only at the work is pleased by its [aesthetics], for which he admires the artist; but whosoever understands has, as it were, read the book.

So Augustine's spiritual struggle centers on the relationship of aesthetics and beauty, of fact and meaning, of what and why, of the world and God. But for Augustine it is not a choice between the two, for the two are bridged by the Incarnation. There is then a qualitative continuum from the base to the divine.

9. Sant Maria Maggiore, Rome

In a wide variety of works of architecture, such as the church of Santa Maria Maggiore, Rome (depicted here in a print by Piranesi), Augustine's approach to art and life are clearly present. His admonition that we need to read the meaning of art rather than merely respond emotionally to its appearance is all too evident for how could this church be seen, and thus understood, while we are in a state of ignorance? Although rejecting the meaning of Christian architecture, Nietzsche recognizes the point made by Augustine. In his text, *From Human, All Too Human* (section 218) Nietzsche states:

> As a general rule we no longer understand architecture...Everything in a Greek or Christian building originally had a meaning, and referred to a higher order of things; this feeling of inexhaustible meaning enveloped the edifice like a mystic veil. Beauty was only a secondary consideration in the system without in any way materially injuring the fundamental sentiment of the mysteriously exalted, the divinely and magically consecrated; at the most, beauty tempered horror—but this horror was everywhere presupposed. What is the beauty of a building now? The same things as the beautiful face of a stupid woman, a kind of a mask.

As we shall later see, Nietzsche is wrong in his Postmodern interpretation of Christian and Classical culture. What then is the meaning of this church that remains beyond his ken? The church appears to be a Greek temple turned inside out. The exterior is secondary to the interior of the structure, just as Augustine rejects outside forces as central to our destiny, and affirms that personal responsibility is key to happiness. The orderliness of the columns lining the nave of the church bespeak of a universe that is a cosmos not a chaos; the lights entering from above indicate that understanding is more profound than the shadows of ignorance or the blatant insipidness of the merely factual.

Aesthetically, these points will be missed or ironically reduced to emotion or nostalgic sociological fact; they can be recalled but not understood unless the ontological and metaphysical meaning of the Incarnation and the Trinity are understood. In so doing, they offer a means to go from aesthetic illustrations to beautiful illuminations; they offer a numinous understanding of reality and life. Beauty and love are reconciled in art and life, and are realized via the exercising of responsible freedom. There is all that and much more, none of which can be seen aesthetically.

The building is modeled after the Roman basilica, or law building, but here law leads to the altar that is beneath a triumphal arch. The triumph is that of beauty over base aesthetics, and grace and love over violence and despair. The altar marks the role of the Incarnation as making real the pursuit of the ideal within an imperfect world. Communion and art are understood to be physical symbols in the sense that they each indicate the actual presence of the divine. The Incarnation provides an explanation of how we can seek goodness and beauty within an often tragic world.

The mosaics of Sta. Maria Maggiore, Rome, do not attempt to merely depict the past, or illustrate a Scriptural reference, or merely attempt to reproduce a naturalistic vision. Instead, they parallel Augustine's understanding of history and the world: that there is a conflict within temporal time between goodness and evil. History is the narrative of that conflict, and of the means to transform that conflict into love. The mosaic depicting The Parting of Lot and Abraham confirms that understanding in terms of the past, present, and future. We have a choice and a responsibility to seek the true, good, and beautiful.

Similarly, the triumphal arch of the church celebrates Christ as the Incarnate Truth, that to be realistic is to pursue the true, good, and beautiful, even though due to free will the world is filled with foolishness. Mary is presented as the bearer of the Incarnate God, and thus provides a trans-generational model for all families to be grounded in both truth and love.

The Greek Patriarchs

In contrast to many of the churches in Rome, the Church of Holy Wisdom (Hagia Sophia) in Constantinople (now Istanbul) represents a different ap-

proach to the same foundational beliefs. Built on the order of the emperor
Justinian, it represents an approach to art and life that emphasizes the Divine
presence amidst the material. In entering the church, the very floor plan corre-
sponds with an exposition of Biblical truth. The church embodies a narrative
explaining Biblical truth; one walks through the church as one walks through
life with faith. But with the light piercing the church walls from beyond, one is
confronted not so much by a discursive rationality, as by a mysticism, a realm
where the transcendental unity of reason and love becomes ineffable. The
dome hovers above on a seat of divine light, the light that is indicative of
divine wisdom. Justinian, upon entering his new church famously proclaimed:
"Solomon, I have vanquished thee!" Later visitors may consider the words of
the patriarch Photius who said: "The faithful enter a church as though entering
heaven itself."[32] This is not to confuse the church for heaven, or the icon for an
idol. The idol manifests fiction whereas the icon manifests the presence of
divine purpose. That presence is by definition sacramental.

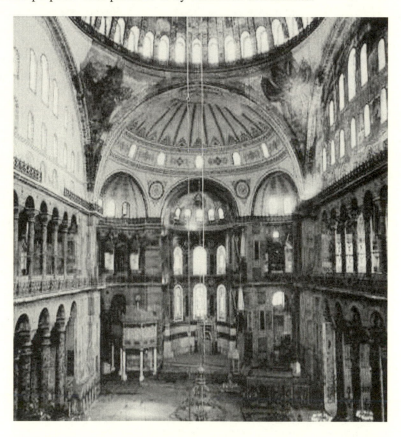

10. Hagia Sophia

The Greek Church fathers addressed the issue of why bad things happen to good people by following the Biblical doctrine that for those who believe in God, all things work ultimately for the good. As Basil of Caesarea (329-379 AD) put it:[33]

> Nothing is without cause; nothing is by chance; everything contains an ineffable wisdom.

And he explains the role of fine art:

> We walk the earth as though visiting a workshop in which the divine sculptor exhibits his wondrous works. The Lord, the creator of these wonders and an artist, calls upon us to contemplate them.[34]

Similar to his contemporary Augustine in the West, Basil of Caesarea accepts that Plato and Neo-Platonism provide a valuable means by which sacred scripture can be understood. Like Augustine, Basil and his colleagues declined to attempt to develop an overall Christian (or other) philosophy.[35] Their speculations were dedicated to an exegesis of Scripture, aided primarily by those Platonic thinkers helpful to those efforts. It is inevitable that those efforts lead to a consideration of beauty.

In contrast to later difficulties that resulted in a splitting of the church into Eastern and Western parts, during this period there was no split in Christendom. Indeed the foundational creeds of the Church were still in development. Nonetheless, the cultural emphasis of Eastern Christianity differs from that of the West. The notion of the world being beautiful (*pankalia*), as introduced in the Book of Genesis, was a shared starting point: the world is beautiful not because it is always pleasing, but because it is the creation of God, showing purpose perfectly achieved with neither excess nor want. As Basil explained in *Homilia in Hexaem*:

> "And God saw that his work was beautiful." This does not mean that the work pleased his sight and that its beauty affected him as it affects us; but that that is beautiful which, in accordance with the principles of art, is completed and serves its purpose well.[36]

Therefore beauty is understood as a physical harmony that is in harmony with divine purpose. That beauty is to be recognized intellectually, and then sensually; from beauty descends a meaningful aesthetics. However, Basil recognizes the frail human propensity to judge beauty in terms of pleasure rather than goodness. He concludes that there is the pursuit of the aesthetic and superficial, and there is the pursuit of beauty that is profound and even mysterious. Whereas aesthetics please and deceive, the intelligible aspects of beauty are divine. The purpose of art, and life, is not to imitate nature, as much of Classicism emphasized, but rather to comprehend that nature is a work of divine art. The practical consequences of this are many.

For example, if beauty is purposeful and divine, then intellectual beauty is superior to aesthetics, and justification for fine art and public culture diminishes. This conclusion recurs within Platonic systems of thought through the ages. As a contemporary of Augustine, St. Jerome, stated:

> I shall not be persuaded to admit into the liberal arts painters as well as sculptors and stone-masons, and other minions of dissoluteness.[37]

Greek fathers such as Clement of Alexandria and Tertullian, make the same point of deprecating the importance of aesthetics. This leads however to a serious difficulty in Christian culture: what is the importance of religious works of art? To deny the importance of physical works of art is to deny the importance of wisdom being associated with objects and actions. But Christ is the Incarnate God, the physical embodiment of the Divine. To deny fine art is, by logical inference, to question the value of the Incarnation and Passion. It is the later Greek writer, John Damascene (700-749 AD) who makes the point:

> The image is a likeness reproducing the prototype, but also differing from the original: because it does not resemble the original in everything. The Son is the living, natural and faithful image of the invisible God…In looking at His physical shape, we also penetrate, within the bounds of possibility, to the glory of His divinity. Because we have a double nature, composed of body and soul, we cannot penetrate to spiritual things without physical things. In this way, through physical contemplation, we arrive at spiritual contemplation.[38]

As John Damascene concludes, Christ is physical, but must be beautiful as well. The Incarnation represents the presence of beauty in a fallen world. It makes realistic the attempt to be idealistic. Consequently, images of the divine represent physical gateways to the spiritual; in art as with the Eucharist there is a conversion that takes place where the material connects us with the spiritual. The material is distinct from the spiritual, but the Incarnation provides a means by which beauty and wisdom can be approached. In an antisritean fashion Theodorus Studites notes:

> He does not err who says that the deity is in an image…even though it is not present in the image through physical union.[39]

So Theodorus Studites and John Damascene defend the fine arts as a physical means by which we might obtain a glimpse of divine truth and goodness, just as creation provides us with a glimpse of the Divine. The shift from fact to understanding is mysterious, but not obscure. The central idea of Eastern thought is that physical objects can lead us to a contemplation and knowledge of the divine and the beautiful, just as the Incarnation made knowledge of beauty and God present in the world—without being identical with the world.

Boethius

After Basil and Augustine, the differences between the Eastern and Western Church gradually became more pronounced. In the West there was the lingering effect of Roman culture within a Christian society. As mentioned earlier, Boethius (c. 480-525 AD) linked the Roman past with the Christian future. Boethius was a philosopher with a biography much akin to that of Laocoön. In his writings and in his life the relationship of biography, virtue, and beauty intertwine.

In the pursuit of wisdom and justice, Boethius suffered tragically and without redemption. He suffered an ugly fate. According to one account, Boethius' friend was unjustly accused of a crime, and Boethius came to the defense of that friend. The result of his responsible bravery was that he later found himself in jail as well. But his punishment was to be more than mere imprisonment. For the so-called crime of defending a friend from false charges, Boethius was condemned by Theodoric, the Arian, first to mutilation and then to death. To make matters worse, if that is imaginable, he was imprisoned for a year to contemplate his terrible fate. Remarkably, those contemplations lead to his writing a classic work, the *Consolation of Philosophy*.

That text begins by raising the perennial question about the human condition:

If there is a God, then from where comes evil.
If there is no God, then from where comes good?

Boethius raises the perennial issue of why do bad things happen to good people, with the added problem of why virtue is so often rewarded by grief. If responsible freedom leads to calamity, then what does it mean and why should we strive to be cultured? But if responsible freedom does not exist, then what happens to human dignity? These questions have an obvious impact on the issue of how we might understand beauty and life.

In his book a character asks: "Think you that this universe is guided only at random and by mere chance? Or think you there is any rule of reason constituted in it?"[40] Boethius admits that the universe makes sense, but that his current travails have interfered with his judgment. Not only tragedy has interfered, however. Aesthetics has as well. At the moment of his doubt he questions not only truth, but even beauty. Boethius chastises the Muses as seductive distracters who never provide any healing remedies in support of those suffering. Instead, they offer poisonous sweets that stifle any fruit-bearing harvest that reason might otherwise provide.

So he is drawn to a formal and quantitative rather than substantive and qualitative notion of beauty, or rather, he is tempted by the reduction of beauty to aesthetics. His influential text on music, *De Institutione musica* presents a

theory of aesthetics that is based in proportion, form, and pleasure. In an Aristotelian mode he celebrates aesthetic perfection: "Aesthetics [pulchritude; physical pleasure] appears to be a certain commensurateness of parts."[41] But in contrast to Aristotle, he holds that aesthetics is a superficial thing, a thing that exists only in the appearance of things, not as part of their teleological nature. Indeed, in art and life the ugliness within the aesthetic vexes him. Given his circumstances, it is not surprising to learn that Boethius finds human nature unattractive. He laments that physically attractive people can by nature be ugly. In his *Consolation of Philosophy* (III,8) he makes the disturbing observation:

> It is not your nature, but the weakness of the eyes of the onlookers that makes you appear aesthetic [pulchritudo].

Boethius can no longer with confidence accept that aesthetics is linked by a teleological vision to perfection, much less virtue, and goodness. Indeed, he links aesthetics (*pulchritudo*) both with physical perfection and the weakness of human character. Why did this devaluation of aesthetics to a superficial realm occur, and what does it mean? It is reasonable to link his aesthetic skepticism concerning mere formalism and outward appearance with a growing lack of confidence in the world making sense and therefore being good.

So beauty remains associated with understanding, but that understanding is now suspicious both of aesthetics and of human nature. As Tatarkiewicz explains it:

> [Boethius] introduced an ambiguity into aesthetics: the word species, which had denoted beauty of form and beautiful composition, now came to signify beautiful appearance [i.e. aesthetics]...If beauty is a value which belongs only to appearance, there must be other values higher than beauty...[42]

He expresses this idea via music. His formulation of music in *De Institutione musica* (I, 2) is both biographically prescient and culturally timely:

> ...For there are three kinds of music. The first is the music of the world, the second is the music of man, and the third kind is based on certain instruments...And the music of the world is best to be discerned in all that is in the sky, or in the arrangements of elements, or in the rotation of the spheres...And human music is understood by anyone w h o descends into the depths of himself.

The ancient assumption that the world is harmonious justifies the idea that we also ought to live and act harmoniously; but here human music is understood not by examining the purposeful architecture of the world (or virtue), but rather by introspection. This flight from benevolent *Being* marks a cultural crisis. Both Plato and Aristotle believed the world to be purposeful. But to contemplate one's own imminent mutilation and murder is to make difficult the perception of such purpose. While Plato is likely to be offended by Boethius'

plight, and Aristotle but offers catharsis, neither offers a solution. For that we must turn to the Christian doctrine of redemption.

In his attempt to understand both beauty and art, Boethius separates ideal beauty and justice from human experience, as well we should. It is a separation that bespeaks of a life lived in turmoil, where evil appears to triumph while the virtuous perish. How then does he and others escape the fate of Laocoön? By the conviction that happiness and fortitude are found via adversity; that suffering for what is good is to transform the world. Another example of this Christian principle is found in the biography of St. Lawrence, whose life and example are evidenced in the Mausoleum of Galla Placidia, Ravenna (425-450 AD). The exterior of the building is of unadorned brick, but upon entering the building one is enveloped by a glimmering display of mosaics. One of those mosaic compositions depicts the martyr St. Lawrence.

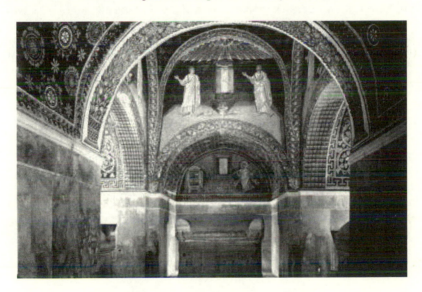

11. Mausoleum of Galla Placidia, Ravenna

Born in Spain in the third century, Lawrence was made archdeacon of the Church by Pope Sixtus II. Sixtus was seized by the prefect of Rome and was sentenced to death for his religious beliefs; he told Lawrence to distribute the wealth of the church to the indigent. This was done. However, Lawrence was then instructed by the prefect to turn over to him the wealth of the church. Lawrence agreed to do so and showed up with the poor and afflicted, declaring that here is the wealth of the Church. Predictably, the prefect was displeased, and ordered Lawrence killed by roasting over a gridiron. History records that in the midst of his agony Lawrence called out defiantly: I am roasted on one side. Now turn me over and eat!

The visitor to this Mausoleum is not expected to appreciate the aesthetic qualities of the mosaic. Nor is it assumed that the circumstances and events involved with the incident are a thing of the distant past. The work illuminates the history of the world as a moral and heroic struggle, and serves to inspire the pursuit of beauty. It is not simply beautiful, but spiritually sublime as well. It marks the reality of terror in a world that nonetheless ultimately realizes the good.

Carolingian Art

The time between Augustine (354-430) and Charlemagne (768-814) is commonly called the Dark Ages. It would be better to call them the Heroic Ages, since during this period of turmoil and difficulty a small group of people managed to maintain a fragile watch over the cultural heritage of the West. That group included religious authorities such as Pope Gregory (6c), the establishment of an extensive monastic system by St. Benedict (480-547), and secular figures such as the already mentioned Boethius (c.480-524), and Cassiodorus (c 490- 585).

At last, during the rise of the Carolingian period, public culture flourished anew. Under the auspices of the emperor Charlemagne and court scholars such as Alcuin (c.735-804) and Erigena (ninth century), a renewal of grammar[43] and beauty occurred. John Scotus Erigena's thought was deeply influenced by the writings of a person now known as the Pseudo-Dionysius Areopagite. In the latter's text, *The Divine Names and Mystical Theology*, a negative rather than positive theology is pursued. By that is meant that rather than proceed from knowledge of God via the Scriptures, the mystic approaches theology from the knowledge of what we cannot know, or what God cannot be. Nonetheless, the world is presented as intrinsically good and beautiful. God may be beyond finite knowledge, but Nature is understood to be a theophany. In advancing Augustine's idea that evil marks a deprivation of reality, of *being*, the Pseudo-Dionysius declares that evil also lies in the failure of a being to exist according to its God-given nature.[44] So too with beauty:

> We contemplate visible forms, whether they be in nature or in the most holy sacraments in accordance with divine scripture, not because they have been created, not because we desire them if they are made known to us; rather, because they are images of invisible beauty [invisibilis pulchritudinis] by means of which divine providence calls the minds of men to the pure and invisible beauty of the truth which we love, and which all that loves moves toward, whether knowingly or unknowingly.[45]

In a beatific passage, Pseudo-Dionysius contemplates the nature of beauty:

> The beautiful and good are the same:
> all beings desire the beautiful and good
> with respect to every cause,
> no being fails to partake
> of the beautiful and good.

(Indeed, we must necessarily dare to say:)
that which is not partakes in the beautiful
 and good; it is itself the good when
 beyond-beingly celebrated in God in the
 denial of all.
The one beautiful and good is the single cause
 of all of the many
 which are beautiful and good.

From out of the beautiful and good:
 the essential constitutions of all beings,
 their unities and their differences,
 their identities and their otherness...

That beyond all rest and motion is
 the rest and motion for all, as
 founding each being in its logos, and
 moving each being according to its proper motion. [46]

The ideas of Augustine and Pseudo-Dionysius the Areopagite contribute to Carolingian and later culture. Although they differ in their approach to *being*, their contributions remain vital to this day. The issue of the nature of *being* remains central to our attempt to understand reality and life; this is evidenced by Martin Heidegger's important Existentialist work of the twentieth century, *Being and Time*. But in contrast to Heidegger, both Augustine and Pseudo-Dionysius the Areopagite privilege meaning instead of despair, fullness over emptiness.

In Charlemagne's court the propriety of sensual pleasure is accepted, but it remains secondary to eternal wisdom, which is the ultimate source of *being*. We should celebrate physical pleasure, but not be satisfied with it since it alone is momentary and passing. It should be a way station as we ascend to the divine beauty of a purposeful God. Once again the doctrine of the Incarnation has an important impact on the thinking of the Carolingians. As John Scotus Erigena puts it:

The sense of sight is an inborn good, and is given by God for the apprehension of physical light, so that, through it and in it, the rational soul might perceive the forms, shapes and proportions of sensual things...[But] the sense of sight is abused by men who approach the [aesthetics] of visible shapes desirously.

God realizes Himself in the creation, manifesting Himself in wondrous and ineffable manner; though invisible, He becomes visible, and though incomprehensible, He becomes comprehensible...He becomes known, and though He is without form and shape, He becomes well-formed and shapely.[47]

And he speaks of Divine Beauty:

He alone is truly worthy of love, because He alone is truly the highest goodness and beauty; and all which is known to be good or beautiful or worthy of love in things created—this is God himself.[48]

The distinction of a base form of aesthetics to that which aspires to the divine (as mediated by the Incarnation) is also discussed by Alcuin:

> What is easier than to love aesthetic [pulchras] shapes, sweet tastes, pleasant sounds, fragrant smells, things nice to the touch, and temporal honour and happiness? It is easy for the soul to love things which disappear like a fleeting shadow, and not to love God, who is eternal fragrance, eternal delight and unceasing happiness...The lower [aesthetics] passes away and vanishes, and either abandons the man who loves it, or is abandoned by him. So let the soul preserve its proper order. What is the order of the soul? That it should choose what is higher, that is, God, and rule what is lower, that is, the body.[49]

The relationship of body and soul, or of media and content, is a perennial one in art, in theology, and in ethics. Each centers on the question of the relationship of action and meaning, of *becoming* and *being*. The Christian tradition historically rejects a direct imitation of the transcendent divine since it negates the importance of humility and prudence (e.g. Plotinus). The goal is the transcendent but the realm in which we seek the transcendent is immanent. Our actions must aim at making physically manifest in the world that which is higher than the world. Our context is sociological, but our goal is cultural. But can or should we love that which is aesthetic and worldly however transcendent and moral its inspiration? Or is such love a step towards an empty idolatry?

During this period, the issue of the appropriateness of making images of the divine sparked what came to be known as the Iconoclastic Controversy. At issue was not whether works of art, including those depicting Christ, ought to be made; it was agreed that they should. At issue was whether those works of art (or acts of prudence) should be venerated – or adored. At issue is the notion of the Sacramental and sacred versus idolatry, of the work of art (or ethics) as a means to beauty and wisdom, or merely a fetish. Complicating matters were problems resulting from the translation of documents from Greek to Latin. The Seventh Ecumenical Council had concluded that the correct attitude towards the icon should be one of honor and veneration, but not of adoration. True adoration befits God alone. However, when translated from the Greek to Latin, and conveyed to Charlemagne, the Greek term for veneration was translated into the Latin *adoratio*.

Idolatry can be in reference to works of art, or in reference to ethics. To worship objects or actions themselves is to worship those who make or do them. To worship either is to engage in an empty self-deification. Charlemagne was outraged by the prospect of such idolatry, and in response to what he thought to be the canons of the council, he sent to the Pope a document called the *Libri Carolini*. In that text Charlemagne disagreed with the Nicene Council (787 AD), and Pope Adrian I, both of whom had condemned the iconoclasts. Charlemagne concurred with the iconoclasts that iconic art was not holy, that

when fine art is adored, it becomes a fetish, an idol, and an abomination. Nonetheless, art is useful as a means of instruction for the viewer. Art is the product of the artist's imagination which serves as valuable reminders of persons and events worthy of our emulation. Art serves ethics as a reminder of what we ought to do.

Although this denial of idolatry was in fact in accord with the Seventh Ecumenical Council, Charlemagne's response to the specter of idolatry was to institutionalize a fundamental change with enormous repercussions. For Augustine and Pseudo-Dionysius Areopagite art makes manifest an understanding of *being,* as does the eastern tradition of the Icon. But now, the centrality of our art and our actions striving to objectify *being*, striving to be in some sense sacramental, to be to some precious degree a glimpse of *being*, is made suspect. The symbol no longer indicates the presence of *being*, of objective purpose, of the Divine. Rather, the symbol, the icon, and the work of art are considered the products of the artist's imagination which serve as a historical reminder of exemplary events and actions. In the proper attempt to avoid the adoration of purposeless things, the possibility of veneration was denied; but when art and the Sacramental are no longer venerated, they and life begin to be trivialized.[50] Sacred art begins on the path towards mere art appreciation; the sacramental begins to descend towards the mere pursuit of lifestyle; beauty begins to decline towards aesthetics.

Where then do we stand? In general, Christian culture naturally corresponds with Christian ethics and theology. Cautious of pride in all of its forms, it is intelligible rather than merely sensual beauty that is found most attractive; the path from the aesthetic to the beautiful is made possible by the Incarnation where the two combine. We rise from the trivial to the venerable to the properly adorable. The world is beautiful as a manifestation of divine beauty (theophany). Basil finds beauty to be a theophany, Augustine finds that to varying degrees the presence of beauty occurs symbolically as a real presence in the physical realm. The Pseudo-Dionysius concurs, but with a difference, that the failure of a *being* to follow its divine purpose results in a loss of both goodness and beauty. So beauty and ethics both refer to *being*—in varying ways. But after the iconoclastic controversy the role of *being* in art and life begins to be distanced. The pursuit of the sacred and sacramental becomes a consideration of the ethical and prudent, and both increasingly become aestheticized and trivialized.

So reality is understood to be a continuum; it rises from the material to the divine, from fact to truth, from the aesthetic to beauty. It is a seamless continuum where all of creation participates in a purposeful universe, a universe informed by truth and love, realized via responsible freedom. Above that seamless continuum lies a transcendent purpose that makes possible our attempt to rise to the higher realm of Truth, Goodness, and Beauty. But love and freedom require the possibility of evil. As Augustine and Pseudo-Dionysius the

Areopagite respectively explains: it requires the possibility of a willful depri-
vation of, or resistance to *being*, to the good. Responsible freedom depends
upon knowledge of what is right to do, and as the *Libri Carolini* concludes: a
purpose of art is to serve as a reminder of what we ought to do.

The idea of nature being a theophany raises a number of issues. As a
theophany, the nature of the world and society has divine foundations. But
what then of politics: is the State part of God's theophany? Should the govern-
ment or the ruler be obeyed, venerated, or adored? Charlemagne embarked on
an extensive program of fine art production. He supported various scriptoria
for the production of Illuminated manuscripts, and the construction of numer-
ous important buildings. His chapel and palace complex in Aachen is one case
in point.

12. Palace Chapel of Chalrmagne, Aachen

The church follows Early Christian and Greek prototypes by its conscious emulation of Justinian's Church of San Vitale, Ravenna. Both are octagonal structures; as such they embody the multiple ideas associated with the *octave*. The *octave* refers to the death and resurrection of Christ, and as such it marks the triumph of love and truth over death and violence. As such, the *octave* demarks a religious celebration lasting eight days. The element of time is present, but the linear and pointless seven days of the week (*Kronos*) escape meaninglessness (historicism) by returning to its source on the eighth day. There is therefore a fullness of time (*Kairos*). The *octave* refers to music as well, where we rise from octave to octave, thereby once again reconciling time (*becoming*) with eternity (*being*).

In the church of San Vitale, Ravenna, a haloed Emperor Justinian and Empress Theodora are depicted in mosaics flanking and above the altar. This presents them as at least semi-divine intermediaries between humanity and God. In contrast, Charlemagne's throne is situated on the second floor of the Palace Chapel at Aachen, but across from the altar rather than above it.

In addition, there is a conspicuous demarcation between the Royal residence and the chapel. They were physically distinct, linked by a causeway. The political insinuations of theophany are here tempered by the Augustinian principle of the City of Man being distinct from the City of God. Just as Scripture informs us to render unto Caesar that which is Caesar's and render unto God that which is God's, we see also in artistic form the idea articulated by Pope Gelasius, that in the West there are two kingdoms, secular and sacred, the former being the sphere of law, the latter the sphere of conscience. In contrast to theophany, this complementary relationship of Church and State resists the abuses resulting from their combination (totalitarianism) and by their total separation in which only the coercion of legality prevents anarchy from ensuing.

That complementarity occurs within a world comprised of things more or less beautiful. Church and state function within different realms, but within the same qualitative context. Human actions and institutions ought to be analogic, ought to strive to embody—but not be—the Divine Mind and *Being*. Plato, Augustine, and Basil see the world as a continuum comprised of those things more or less beautiful and divine. As introduced earlier, the formal Aristotelian separation of aesthetic perfection from moral goodness, of *being* from goodness, permits us to think of the separation of church and state as a matter of type rather than degree and function. As discussed below, this facilitates a shift from beauty to aesthetics which later unfortunately results in a shift from justice to legality. When justice is distinct from legality, then the separation of church and state is understood as demanding that an aesthetic violence replace the pursuit of Justice.

The Gothic House of Life

The gradual shift from a Platonic/Augustinian viewpoint to one informed by Aristotelianism blossomed during the Gothic period. It was during the Carolingian period that Paschasius Radbertus wrote a monograph on the Eucharist. He attempts a synthesis of the symbolic and conversion theologies. He introduces a non-Augustinian concept: that upon consecration the sensuous aspects of the bread and wine are – merely - symbolic of Christ's body, whereas their essence is the true historical body itself. Paschasius introduces an approach that later develops into transubstantiation. To the point, how to understand the Eucharist is more than an obscure theological dispute. The relationship of the material and the essential is fundamental to our attempt to understand reality—and art.

Augustine accepts that there is a continuum ranging from the mundane to the divine. And he accepts that we approach knowledge as a problem of effective rational intuition. To varying degrees, the material is symbolic of the divine, but not merely so. It is analogic. We attempt to comprehend the presence of *why* via a consideration of *what*. The shift advocated by Paschasius Radbertus is towards the Aristotelian mode: there is matter and essence. There are the particular and the universal, the relationship of which must rationally be discerned. It is no longer a matter of obtaining degrees of knowledge and beauty. It is now increasingly a question of the relationship of matter and idea.

The Gothic mind (ca twelfth century) centers on a concern for rationally understanding the Divine; that concern increasingly focuses on the problem of the relationship of the particular and the universal. In secular terms, Universals refer to the notion of a meaningful generalization that permits us to rise above the confusion of particulars. But religiously, Universals aspire to rise from mere words, to truth comprehended by our minds, and to the source of that truth: the mind and substance of God.[51] Consequently, each individual (or work of art) is somehow distinct, and yet all individuals are also somehow referent to Humanity (*being*), Christ (*being, Becoming,* and *Being*) and to God (*Being*). So a shared Humanity transcends all the particular differences that are evidenced amongst individuals. This is not idle intellectual speculation; lacking the notion of Humanity, it is difficult to obtain an objective foundation for ethics and human rights; nor is there an obvious ground for knowledge beyond fact and feeling.[52] The meaningful generalization is essential to knowledge; as Copleston concisely puts it (160):

> [If] the question as to the existence of an extramental foundation of a universal concept is answered in the negative, skepticism would result.

However, the very topic of the Universal makes little sense to the Modernist and Postmodernist mind. While Constructivists aspire to making meaningful narratives, Deconstructionists tear them down. The battle between Kantian

Modernism and Nietzschean Postmodernism (as discussed below) is as fruitless as it is rarefied. It might be recognized that *species* and *genera* are physical references to a conceptual type of universal that is still subject to change, alteration, amendment. But the notion that intelligible universals exist and rise above confusion and change is incomprehensible to a mind that can only perceive individual facts and subjective constructs or experiences. Incomprehensible too is Augustine's association of species with beauty.[53] It is beyond the understanding not only of Modernism and Postmodernism, but of Aristotle as well. Nonetheless, those cultures which accept that Universals of some sort exist are the cosmopolitan and historical norm. Whether known as the Dao, or Dharma, or Logos, around the world and throughout history the attempt to comprehend meaning in a constantly changing world is normative.

The historically unusual rejection of the possibility of Universals brings into question whether or not knowledge is possible. If one accepts that Universals exist, then the question remains of how to understand them and live up to them. As Copleston notes, the universal may be approached ontologically, psychologically, or conceptually. Plato engaged a form of ontologism in which the universal enjoys objective existence; in this view (as evidenced by Plotinus) then lacking the framework of the Trinity, it is hard to avoid monism where each individual person is but an aspect of the Universal. If the transcendent is denied, then as Anselm points out, the notion of cosmic Love and the Trinity dissolve. The object of knowledge becomes subjectified, and as such, a self-deification occurs. The opponents of philosophical realism, of the affirmation of the reality of the universal, argue then that only particulars exist. Hence Roscelin argues that knowledge is limited to fact and feeling. But if only fact and feeling exist, then meaning is reduced to superficiality, even if it conforms to an assumed rational structure of the human mind. Since the universal is then but a mere word, both knowledge and beauty are determined by our word—and therefore our will.

So opponents of ontological realism may either deny the universal or reduce it to a concept, a notion in our minds. The latter is the position of Abelard. He accepts Boethius' Aristotelian definition of a universal and declares that truth can exist in our minds as concepts and exist in the mind of God. But the Aristotelian separation of aesthetic perfection from moral goodness denies the necessity of goodness—and of God. As we shall see, this commitment to Aristotelian logic constitutes a rejection of Augustine. Augustine does not engage in a logical debate in terms of the relationship of the particular with the universal. Rather, knowledge is the result of illumination. His symbolic approach associates knowledge not with logic, but with being in the presence of the Logos—and of Love. As Copleston (p.81) puts it:

> ...Augustine thought it necessary to postulate a special illuminative action of God, beyond His creative and conserving activity, in the mind's realization of eternal and necessary truths, whereas St. Thomas did not."

To this point we will return shortly. For the moment, the nature of Universals is of primary concern to the development of Gothic art. We have seen that two primary positions exist in the Western tradition concerning universals: the Platonic and the Aristotelian. This can be introduced by considering one of the earliest Gothic projects, the partial reconstruction of the Church of St. Denis in France. Romanesque in origin, the current building was extensively altered during the Gothic period. That reconstruction gives evidence of the Gothic mind. It evidences a mind concerned with issues strikingly contemporary to our own time once understood.

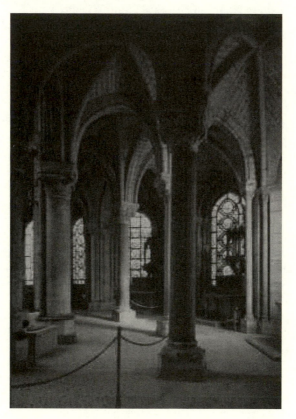

13. Cathedral of St. Denis

The linking of the Gothic Scholastic mind with Gothic architecture has been presented by the art historian Erwin Panofsky. In his book, *Gothic Architecture and Scholasticism*, he cites the primary principles of Scholasticism: clarity and concord. The world and art make sense, and is driven dialectically, but it is a dialecticism that transcends confrontation via love, via a passionate pursuit of purpose. Panofsky cites St. Denis in France as a prime example of the

early realization of those principles. The architecture, mosaics, and objects associated with this church are remarkable. Those architectural plans indicate that both the narthex and the choir were significantly altered between 1135 and 1140 AD. Those alterations were done under the jurisdiction of Abbot Suger. He presents a Neo-Platonic/Augustinian defense of the fine arts and of cathedral architecture, that the prospect of Beauty raises the mind to the spiritual realm.

> I delighted in the beauty of the house of God, and the diverse colour and shapeliness of the gems detached me from my outward cares and, bearing me from the material to the non-material sphere, inclined me to reflect on the diversity of holy virtues; it seemed to me then that I was in some wondrous region placed neither in the mire of this earth nor in the purity of heaven, and that, by the grace of God, I could in like manner be transferred from the lower to the higher world.[54]

It marks both a blossoming example of the Platonic and Augustinian approach to life and art, as well as a precursor to future developments. Why was the choir area rebuilt? To make the Divine more intelligible via the material. Here is Suger's explanation:

> Bright is the noble work; but by being nobly bright, the work should brighten the minds, so that they may travel, through the true lights, to the True Light where Christ is the true door, in what manner it be inherent in this world the golden door defines. The dull mind rises to Truth through that which is material and in seeing this light is resurrected from its former submersion.

The idea that it is through the material that we can rise to the spiritual is a long-standing concept within Christian and Western culture. In his *Theaetetus*, and later, in the *Republic*, Plato articulates why neither sense perception nor lucky claims of true judgment are effective means of understanding the world. He accepts the relativity of sense perception, but declines to accept the notion of a universal relativism. He views those who do as the majority of people who remain all their lives in a state of illusion driven by ignorance and prejudice. Plato speaks of the need to rise above the realm of fact and confusion via his Simile of the Line and his Analogy of the Cave. One rises from ignorance to opinion to knowledge. He points out that true knowledge is knowledge of the universal, and that knowledge of the highest universal is better than knowledge of any particular. It is better because any degree of knowledge of the universal permits us to obtain a glimpse of understanding, and such understanding is crucial in advancing culture and civilization.

Plato's conviction of the need to rise from the confused realm of the particular and material, to the class of intelligible particulars, and then yet higher to the realm of the true universal resonates with Christian belief. But the specter of monism remains lingering. The Neo-Platonic tradition affirms a vision where the divine is present in creation to varying degrees. It offers a unified vision of reality and life, but if there is no distinction between divinity and creation,

then pantheism results wherein we are all part and parcel of God. It denies the possibility of responsible freedom, and devolves into a skeptical narcissism. Augustine addresses this problem by accepting the rational possibility that the world was created, and therefore there can indeed be a distinction between a transcendent God and humanity. His theory of illumination and his treatment of the symbol prevail. But from Boethius on, the relationship of the universal and the particular becomes increasingly paramount.

So the doctrine of *creatio ex nihilio*, and the importance of the Incarnation, as explained both by Augustine and John Damascene, is in their denial of monism and skepticism. It is central not only metaphysically, but scientifically and artistically as well. In art, science, and life, it is the Incarnation of Truth that causes us to seek the Divine via the material. The intelligible particular rises to and partakes of the divine and thereby permits us to obtain a glimpse of Divine *Being*, or the Universal, while still in this imperfect world. It also denies that any of us can lay claim to be divinity. Thus the destructive pride of power and skepticism is thwarted. A free and responsible pursuit of truth is thus intellectually, socially, and politically afforded.

In looking at Suger's church one is invited to obtain a glimpse not merely of the early Gothic mind, but of God's mind as well. From material confusion we can rise to the intelligible particular, and due to the Incarnation the possibility of making the leap to Divine knowledge is limited but made possible. That leap, however, is marked by humility not pride due to the exclusivity of the Incarnation, which prevents a self-deification. From a Divine perspective, the light of God enters the building as Divine wisdom enters the world. Nature and Humanity are to mirror that wisdom as best as they can.

But for the Aristotelian mind the question is framed differently: if wisdom gives form to nature and life, then what is the relationship of that form and wisdom to creation? Gothic art invites us to rise to the presence of the Divine, but what is the nature of the Divine, and what is its relationship to our lives? It is posited that when matter is clearly organized, when it makes sense and is beautiful, it makes manifest the mind of God. Moreover, the often confused particular can then rise to the clear and universal. This is a rationalistic approach to theology, and it is an approach with both Biblical and philosophical merit. But its focus is on how we might best understand the universal and its relationship with the particular.

What then is a Universal? By universal is meant that reality is comprised of more than facts and feelings, more than individual or sociological constructs. There is an intelligible reality that is more constant, more meaningful, than physical reality which is in a state of flux. The universal provides the world with purpose. It means that just as Health exists above illness, and Justice is above legality, so too Beauty can exist above and beyond aesthetics; or it can be said that there are material facts and intelligible meaning, and intelligible meaning reveals a meaningful universe.

So universals such as Humanity, Justice, and Beauty are not fictitious but refer to that *being* which is most real. This is not an idle or obscure issue because if there is no such thing as Humanity, then (Kant notwithstanding) human rights and knowledge have no objective ground. Lacking an objective ground, they cannot exist. If there is no Justice then at best legality or sentiment prevails, and when Justice is replaced by legality or sentiment, then truth is replaced by power. Not even the assumption that such power and sentiment is benevolent helps, since in the context of power and sentiment benevolence cannot be recognized much less established. As the Nominalists declare, they become mere words.

Concurrently, if there is no Beauty, then all we have is aesthetics, where a world of fact, feeling, and power offers no inspiration, no knowledge, no escape from violence, and no basis for responsible freedom. Lacking the objective ideals of Humanity, Justice, and Beauty, then human rights, law, and culture are reduced to a violent narcissism. Indeed, it is arguable that without universals, we cannot comprehend the world; that not only ethics, but natural science as well rely upon the universal, by which reality and life might be comprehended to some precious degree. But what is the relationship of the universal with the particular? That becomes the central question of the period; although seemingly neglected, it remains the central question for us today, be we Modernist Constructivists or Postmodernist Deconstructivists.

It was also the central question inspiring two remarkable contemporaries: Peter Abelard (1079-c.1142), and John of Salisbury (c.1115-1180).[55] These contemporaries mark the struggle against Nominalism on the one hand and Realism on the other; between skepticism and a perceived absolutism. It is a struggle markedly similar to that occurring against Modernist structuralists (who believe that knowledge conforms to how we think) and Postmodernist deconstructivists (who reduce knowledge to aesthetic identity). It is a challenge that has repeatedly occurred within the context of Western culture; it is a challenge that centers on two approaches to aesthetics (taste indifferent or taste absolute), versus the pursuit of beauty.

Platonic Realists such as Bernard of Chartres or St. Anselm of Canterbury recognize Universals to be objectively real and find the physical world but an approximation of the real. In contrast, Nominalists, such as Roscelin and later, William of Occam (1280-1347), maintain that universals are but words; Humanity, Justice, or Beauty exist only in our minds as mere words.[56]

A different option is offered by Peter Abelard. And it is that path which provides for the future development of Scholasticism. The Gothic period centers on the Scholastic attempt to come to terms with understanding Universals, which in turn centers on the possibility of both knowledge and beauty. In that attempt the arguments of Plato and Augustine were initially followed. However, in the thirteenth century a newly rediscovered Aristotelianism entered into the fray. In contrast to Realists such as Anselm, Abelard denied the notion

that universals exist as non-physical parts of the world. In Aristotelian fashion, he is a conceptualist. Art, Beauty, and Justice are not things in the sense that they independently exist. The question then is: if universals are not real, then how can knowledge, justice, and beauty *be*, and what of God and Christ? Via an Aristotelian logic he posits a possible reconciliation of the transcendental and immanent God of Christianity: Universals exist in the mind of God, but it is as mere words that they refer to species, genera, and principle. But this puts both Christ and knowledge in doubt.

The reduction of logic to abstract reasoning denies that type of reasoning which hopes to obtain knowledge of what are true and good in life. By so doing Abelard slights the possibility of logic seeking knowledge of reality, and begins the long decline of grammar[57] and beauty to mere rationalization. The reduction of a philosophical problem (the seeking of wisdom) to a rationalistic program (assumed formal laws of logic) denies us the ability to comprehend the world—the first step towards a Kantian formalism is now taken. And it is a step towards an ethical and intellectual nominalism (as advocated by William Quine and Richard Rorty) that concludes in the triumph of the will.

Abelard's contemporary, John of Salisbury, was concerned about such an outcome. He offers that there are at least the following solutions to the important question about the nature of universals: that they exist only in material things; that they are mathematical; that they are words or nouns; that they are concepts. He neglects the rational philosophy of Augustine's approach, in which degrees of truth exist in things, but that truth, however illuminating, is but an approximation of the transcendent. But John follows yet the church father by abandoning extravagant attempts to understand the nature of universals, to produce a systematic and all-inclusive explanation of the world and life. He questions the lifeless and barren quality of pure logic divorced from actual philosophy. Instead he advocates a humanistic sensitivity not at odds with faith. Indeed, he holds that knowledge is derived from three different sources: the senses, reason, and faith. By faith is meant the acceptance of a particular set of foundational principles. John of Salisbury would surely find the foundational principles of Modernity unappealing; he rejects a faith in constructivism and skepticism as foolish, and he rejects sterile academic debates that offer little in return. The cautious confidence of Cicero affords him a suitable model, a model of responsible modesty rather than the pride of narcissism or the pride of skepticism. Such pride shares a common ground in the pretense of knowing all the answers; it is a pretense indeed, one that neither narcissism nor skepticism can escape.

Both John of Salisbury and his predecessor Augustine of Hippo find all-inclusive metaphysical or physical systems of comprehending the world to be suspect. However, John of Salisbury is influenced by Aristotle's idea that we acquire knowledge by considering the resemblance of numerically different

individuals to obtain species; we also consider the resemblance of species to obtain genus. This Aristotelian approach to knowledge is essentially aesthetic. It dwells in the realm of fact, conceptualist reasoning, and identity. In contrast, in the realm of the divine and beauty John of Salisbury more closely follows Plato and Augustine. He avoids the pride of attempting to codify the nature of universals, and instead pursues Philology (words), Philosophy (wisdom), and *Philokalia* (beauty). As Etienne Gilson explains John of Salisbury's position:

> If the true God, is the true Wisdom, then the love of God is the true philosophy. The complete philosopher therefore is not he who is content with a theoretical knowledge, but he who lives the doctrine he preaches...*Philosophus amator Dei est.*[58]

John of Salisbury's avoidance of constructing comprehensive systems of interpretation may sound like just so much common sense to the Postmodern ear. As with Augustine, an avoidance of a prideful constructing of comprehensive systems of interpretation is an effective means by which to avoid their deconstruction. At the end of the twelfth century John of Salisbury condemned the striking sterility of those around him who attempted to make sense of life by depending on discursive logic, and also those who dwelt in the realm of emotion. He tenuously attempts to reconcile Aristotle with Plato—at the expense of the Augustinian approach.[59]. Those attempts continued via the rationalistic dominicans on the one hand and the emotional Franciscans on the other. That duality sets the template for the future.

Thomas Aquinas (1225-74) was dedicated to making sense of faith, to reconciling emotion and truth, the particular and the universal. He attempts to synthesize a wide variety of intellectual sources into a coherent whole. His brilliant system is dedicated to a grand synthesis [60] of Christian and Classical thought, of Augustine and Abelard, of Plato and Aristotle. He particularly relies upon the metaphysics of Aristotle, and those metaphysics directly influence his understanding of beauty. He accepts the Aristotelian notion of *being* having three modes: it is one, true, and good. Those transcendental qualities are manifested either univocally or equivocally. For example, every part of water is water, but no part of a house is a house; a man and a woman are both human, but a person and a picture of a person lack such a commonality. He holds that *being* is good, the good is what all things desire, and that which is desired is perfect. The fulfillment of this desire is pleasant, good, and beautiful.

Aquinas maintains that knowledge is not the result of the will, but rather consists in the occurrence of understanding. And he holds that such an occurrence results from two sources: sensory experience, and reasoning. Natural science permits us to reasonably attempt to comprehend the physical world, whereas philosophy and theology permit us to attempt to comprehend the meaning and purpose of that world. He thereby pursues an Aristotelian view by distinguishing reason stemming from natural science, philosophy and the-

ology. Similarly, he distinguishes theology from revelation; the former attempts to provide an understanding of all things, whereas Scripture studies divine things for their own sakes. Or to put it differently, he alters the Augustinian concept of Illumination; the singular pursuit of wisdom and beauty is now bifurcated into the categories of fact, philosophy, and theology; of aesthetic perfection, earthly wisdom, and that which is divine.

For example, the question of whether the universe is eternal or created is one with enormous cultural and ethical consequences. Aquinas maintains that philosophically it is equally plausible that the world is eternal, or that it is created. Aquinas chooses to believe the latter not as a conclusion of philosophy, but as a matter of theology— and therefore a matter of choice. In contrast, that choice makes no sense to Augustine. Augustine rejects the necessity— and the propriety—of distinguishing between philosophy and theology, and focuses rather on comprehending a purposeful world. Within that context philosophy and theology neither complement each other nor compete. A beatific vision is sought.

Aquinas maintains that people obtain knowledge of reality from sense data, and from them an intellectual understanding. That intellectual understanding results in memory which leads in turn to principle. He explains that process as part of human nature, where there are three kinds of activity (biological, sensory, cognitive), five special senses (sight, hearing, smell, taste, and touch), four kinds of internal activity, two kinds of appetition, eleven kinds of sensory passions, two kinds of volition, five ways of argument, etc.

What then of Beauty? Following the Book of Genesis as discussed above, and in reference to the position taken by Augustine, Jerome, and the writing of the Pseudo-Dionysius the Areopagite, goodness and beauty are understood to be one. Being is good and beautiful. But following Aristotelian thinking, he holds that there are two types of beauty: one that is spiritual, and another that is external consisting in a due ordering of the body. In the latter case beauty is actually a matter of aesthetics.

For Aquinas, as for Augustine, seeing is involved with more than the senses; seeing is both physical and cognitive. However, in place of Augustine's emphasis on aesthetics being but a moment on a qualitative ascent towards intelligible beauty and goodness, Aquinas adopts Aristotle's alternative: that in a purposeful world, a formal sensible aesthetics is both pleasurable and beautiful.

In response to the issue of whether something is beautiful because it is pleasurable or pleasurable because it is beautiful, Augustine unequivocally affirmed the latter. Things rightly give pleasure because they are beautiful. Aquinas offers that we can speak of beautiful sights and beautiful sounds, but we do not speak of beautiful tastes and beautiful odors:

> Thus it is evident that beauty adds to goodness a relation to the cognitive faculty: so that good means that which simply pleases the appetite; while the beautiful is something pleasant to apprehend.

...beautiful things are those which please when seen. Hence beauty consists in due proportion; for the senses delight in things duly proportioned, as in what is after their own kind—because even sense is a sort of reason, just as is every cognitive faculty...beauty properly belongs to the nature of a formal cause.

And of what does that formal cause consist? Aquinas provides an aesthetic response:

Three things are necessary for beauty: first, integrity or perfection, for things that are lacking in something are for this reason ugly; also due proportion or consonance; and again, clarity, for we call things beautiful when they are brightly colored.[61]

As noted above, Aristotle recognized four causes of perfection: the material cause (e.g. the bronze of a statue), the formal cause (the pattern or formula of the essence), the efficient cause (the sculptor and his activity), and the final cause (the end or purpose of a thing). But if the final cause is denied, then the formal cause looses its grounding in a meaningful reality. It becomes formalistic, that is a perfection of a kind, rather than perfection within a meaningful world. Does the Aquinian phrase "Man takes pleasure in the beauty of sensible things" lead to a denial of the final objectivity which permits beauty? Copleston argues that it does not:

St. Thomas recognizes, therefore, the objectivity of beauty and the fact that aesthetic appreciation or experience is something *sui generic*, that it cannot be identified simply with intellectual cognition and that it cannot be reduced to apprehension of the good.[62]

But Umberto Eco observes:

The phrase is visa placent (beautiful things please us when they are seen), and it is a disturbing intrusion into the whole question and its context. As we shall see, it introduces a subjective condition for beauty, and thus points to a denial of its transcendental status.[63]

If clarity of form is defined as beauty and beauty is associated not with goodness, but with pleasure, then a new possibility emerges: beauty without goodness, or pleasure without, and therefore in place of God. So within this paradigm, belief in God constitutes an aesthetic act of will, and it is circular to declare that such an act of will is Divine. It is a circularity that revolves not around Deity, but rather, a self-deification. That self-deification blossoms in the Modernist-Postmodernist mind.

Clearly, Aquinas' system makes a great deal of sense given the assumption that a benevolent God exists. However, it provides an intellectual structure to

make such belief unnecessary. Aristotelian Scholasticism takes for granted a distinction between aesthetics and reason, and between reason which is naturalistic or that which is theological. These distinctions bring into doubt the necessity of a transcendent God. In denying the notion of a continuum rising from the aesthetic to the beautiful, the qualitative distinction of beauty from aesthetics is reformulated. Now there is aesthetics, and moral beauty; one is formalistic, the other based on philosophy and theology. But the distinction between philosophy and theology again denies the necessity for both, particularly since within this scheme of things, theology cannot be less than willful. The question then becomes: whose will shall be done?

Recall that Abelard distinguished between Universals that are real and exist in the mind of God, and universals that are perceived in the mind. This position breaks ground for the Nominalists, who soon argue that the universals that are perceived in the mind are indeed just words. As Abelard marks a distinction between Truth (Universals in the mind of God) and truth (universals in our minds), so too is there a distinction between Beauty (harmony and clarity caused by God) and beauty (harmony and clarity in our minds). Beauty and truth separate from God are then either materially experienced or intellectually constructed.

This reduces Christian wisdom and beauty to an aesthetic matter of factual Biblical authority and emotional commitment. Neglected is Augustine's notion of illumination The prospect is that Aquinas, largely following Aristotle, attempts to strengthen theology by distinguishing it from philosophy, but perhaps the opposite occurs: beauty in reality and life are reduced to a subjective formalistic aesthetics alone. As later chapters will explain, the premises of Scholasticism lead inevitably to a Kantian—and Nietzschean conclusion.

This is evidenced in Aquinas' *Commentary on the Psalms*, where he states:

> Beauty, [pulchritude, aesthetics] health, and the like are defined in relation to something; for a certain mixture of the humors, which produces health in a boy, does not do the same in an old man...in the same way, beauty consists in a proportioning of limbs and coloring. *This is why one person's beauty is different from another's* [italics mine].[64]

There cannot be a single beauty common to all things, just as the beauty of a person is different than the beauty of a picture of a person. But this logical necessity of Aristotle's and Aquinas' system leads to the problem that beauty is everywhere different, and thus is simply a matter of emotional formalism. The subject seeking the object is transformed into a subjective-objectivity, and when that happens, *being* is transformed into an empty violence.

This clear possibility within Scholasticism is evidenced by the effort Jacques Maritain exerts in addressing it:

> By brilliance of form must be understood an ontological splendor which happens to be revealed to our minds, not a conceptual clarity...It is a Cartesian error to reduce abso-

lute brilliance to brilliance for us. Such an error produces academicism in art and condemns us to such a poor kind of beauty as can give only the meanest of pleasures to the soul.[65]

There is little reason to conclude that the intent of Aquinas was to bifurcate ontological form between the divine and that which is merely conceptual. Nor was it Descartes intent to secularize the Logos by advancing secular reason. Indeed, Descartes attempted to strengthen the faith by showing how reason is both human and Divine. But if both, then why need both? Just as with Abelard earlier (and Descartes, later) intentions can deviate into unanticipated conclusions. We will examine Descartes system shortly; whether the denial of the need for a transcendent God or purpose is an error of interpretation, or an inevitable consequence of Aristotelian and Abelardian thought, is the crux of the matter.

In summary, Abelard is a Conceptualist who states that truth exists in things, in the mind of humanity, and in the mind of God. If so, then why need the last? He also attempts to provide a comprehensive theory that explains divinity, morality and life. As Umberto Eco notes in *The Aesthetics of Thomas Aquinas* (1988, p. xi), that goal is similar to that of Modernist Structuralism where we construct comprehensive explanatory narratives. And it is useful to mention that Modernist physics is equally dedicated to the pursuit of TOE, the Theory of Everything. Whether cultural or scientific, the goal is to construct a comprehensive system of understanding the moral and physical universe. Eco comments upon those parallels:

> A system must have a contradiction to undermine it, for a system is a structural model which arrests reality for an instant and tries to make it intelligible…This is an insight which contemporary Structuralism, some of it at any rate, tends to reject. In this respect it resembles Scholasticism.

So the problem is one of the relationship of knowledge with reality, of *being* with time. The Incarnation and the Trinity reconcile *becoming* and *being* while neither skeptically denying nor combining them in an absolutist and nihilistic fashion. The result is that truth (*being*) remains ineffable, but some degree of knowledge is possible via the Incarnation, in which the unity but not just the identity of *being* and *becoming* occurs. It is when knowledge denies either *being* or *becoming* that skepticism results.. To put it differently, comprehensive systems assume *being* is *becoming*, and embrace a vision in which constructivism and deconstructivism violently alternate. History evidences just that conclusion, in the triumph during the nineteenth and twentieth centuries of Modernism and Postmodernism.

In *The Aesthetics of Thomas Aquinas* (1988) Eco discusses the relationship of beauty, goodness, and aesthetics. He affirms that for Aquinas beauty was still theoretically transcendental, but that there was no longer any need for it

to be so.[66] In contrast to the Augustinian perspective that beauty is the splendor of wisdom, beauty is now increasingly viewed as the splendor of ontological and formalistic form. A serious challenge thus occurs to the position that the universe is meaningful and beautiful: if form is immanent and experiential, then the universe need not be purposeful. Indeed it might well simply be existential, where neither goodness nor beauty can be understood. With both Aristotle and Aquinas, the assumption that the world is purposeful provides a meaningful context for a formalistic aesthetics. But lacking that context, then neither the Incarnation nor the splendor of ontological form can provide relief to tragedy. They simply are events lacking purpose and meaning.

Notes

1. In his text, *Fear and Trembling* (1843), as discussed below. This notion is defended by Wilfred Cantwell Smith, *Faith and Belief: The Difference Between Them* (Oxford: One World, 1998). In the 1998 edition he states (p.12): "…[faith] is an orientation of the personality…we use the term [belief] strictly for an activity of the mind. (It is possible, therefore, to believe without faith)." This emotivist and rationalistic understanding of Christianity is in stark contrast to the Augustinian position that faith, hope, and love lead to an understanding that cures fear. See: James Millar, translator, Adolph Harnack, *History of Dogma* (Oxford: Williams & Norgate, 1898), Vol. 5, 72.
2. There is Aristotelian logic, but then there is also a very different Buddhist logic. The nature and efficacy of logic is complex, and in the West that complexity has led to a contemporary choice: to pursue the Aristotelian-Scholastic-Kantian-Nietzschean approach, or to consider its alternative, the Platonic-Augustinian.
3. It should be remembered with humility that Ptolemy's astronomy agreed to a remarkable degree with empirical facts. Empirical science can be used to confirm what is later found to be false due to the limitations of its scope. The pseudo-sciences of eugenics and phrenology are other such examples.
4. The previous chapter discussed the difference between *kalos* and *aisthesis*, noting that Plato's use of the term is quite close to the Hebrew *towb* (*Strong's* 02896), equating beauty with goodness, whereas Aristotle confuses this terminology. He approaches the physical realm in terms of aesthetic perfection, not goodness. Aristotle thus attempts to aestheticize the notion of beauty just as, later, Kant did.
5. Wladyslaw Tatarkiewicz, *History of Aesthetics* (The Hague: Mouton, 1970), Vol. II, 7.
6. Tatarkiewicz, Ibid., Vol.2, 9.
7. Thomas Molnar discusses the association of the "God problem" with knowledge of reality. Thomas Molnar, *God and the Knowledge of Reality* (New Brunswick, NJ: Transaction Publishers, 1993). Those who consider knowledge of reality to be a personal or social construction engage in a self-deification.
8. Mary J. Gregor, *Immanuel Kant, The Conflict of the Faculties* (Lincoln: University of Nebraska Press, 1992).
9. As discussed below, the great painter of the French Revolution, Jacques Louis David, paints the assassinated terrorist Marat as a secular Christ.
10. Milton Steinberg, "Kierkegaard and Judaism," *Menorah Journal* (1949), 37:2, 176.
11. See: James Millar, translator, Adolph Harnack, *History of Dogma* (Oxford: Williams & Norgate, 1898), Vol. 5, 72.
12. So Boethius dies but not without redemption, for the temporal world (Kronos) is where good and evil conflict, but in the fullness of time and space (Kairos), goodness prevails.

13. For example, see Arthur Pontynen, "The Dual Nature of Laozi in Chinese History and Art," *Oriental Art* vol. 26, no.3 (Autumn, 1980), 308-13.

14. For example, Harry Elmer Barnes, *An Intellectual and Cultural History of the Western World* (New York: Dover Publications, 1965), Vol. 1, 277. Chesterton uses the same argument to come to the opposite conclusion: that the human assumption that an Incarnation is necessary, anticipates and buttresses rather than nullifies Christian belief.

15. Martha Nussbaum, *The Fragility of Goodness: Luck and Ethics in Greek Tragedy and Philosophy* (Cambridge: Cambridge University Press, 1986) 163: "...And it is striking that Nietzsche, anti-Platonist though he was, supports Plato's intuition here. His description of the so-called "last man" in Zarathustra predicts for the future of human morality in European bourgeois democracy the extinction of recognizable humanity, precisely through the extinction of the Platonic longing for self-transcendence."

16. To do so would be to embrace pantheism or monism, both of which deny the possibility of responsible individual acts.

17. J.R. Dummelow, editor, *A Commentary on the Holy Bible by Various Writers* (New York: The Macmillan Company, 1925), cxiii: "Perhaps the best way of gaining some faint glimpse of what it means, is to start with the idea of human sympathy, and to imagine it infinitely deepened and extended..."

18. As Thomas Molnar notes, Ernest Renan (1823-1892) attempted to discount the divinity of Christ while advocating a divinity emerging from humanity. The result is a totalitarian fiction. See: Thomas Molnar, *Utopia, the Perennial Heresy* (New York: Sherd and Walp, 1967), 122.

19. The issue of science and truth is now problematic. Thomas Kuhn presents the position that science is paradigmatic; Alan Sokol has exposed the foolishness of a Postmodern subjectification of physics. See: Alan Sokol, "Transgressing the Boundaries: Towards a Transformative Hermeneutics of Quantum Gravity," *Social Text* (Spring/Summer, 1996), nos. 46-47, 217-252. But as discussed below, the notion of *quanta* affects both physics and ethics; it can only perceive, and thus demands, an amoral universe. As such it is a deeply destructive provincialism.

20. The Postmodern attempt to identify purpose with self-expression and self-realization parallels its attempt to identify truth with power. This error will be discussed in detail below.

21. J.R. Dummelow, editor, *A Commentary on the Holy Bible by Various Writers* (New York: The Macmillan Company, 1925) cxiv: "...perfect love is only possible between equals. Just as a man cannot satisfy or realise his powers of love by loving the lower animals, so God cannot satisfy or realise His love by loving man or any creature. If God is truly Love, in the full sense of that term, He must have always possessed some equal object of His love, some alter ego, or, to use the language of Christian theology, a consubstantial, co-eternal, and co-equal Son...The Trinitarian, and the Trinitarian alone, is able to discern perfect love realized in his object of worship, and to recognize in the essential Nature of the Godhead, the perfect pattern of the Family, of the Church, and of the State."

22. For example, Charles Guignebert, *Ancient, Medieval and Modern Christianity. The Evolution of a Religion* (New York: University Books, 1961).

23. It is significant to recognize that to this view Christ's historical body was itself pneumatic from the moment of the Incarnation Adolph Harnack, *History of Dogma* (Oxford: Williams & Norgate,1898), vol. 5, 314.

24. Harnack anticipates the danger of faith descending into emotivism. Adolph Harnack, ibid., Vol. 7, 258: "But, finally, the idea of a 'more intimate, mystical' union of the Christian with Christ is, when viewed in the light of Luther's conception of faith,

altogether the worst kind of heresy; for it places in question the sovereign power and adequate efficacy of the Word of God for the sake of a vague feeling…"

25. WladyslawTatarkiewicz, *History of Aesthetics* (The Hague: Mouton, 1970), vol. 2, 65. In this book the term *pulchra* is translated as beauty. However, Augustine here uses pulchrum in reference to physical, external appearances or sensations disconnected from the transformative influence of the Incarnation.

26. For a contemporary application of this notion see: Thomas C. Oden, *Two Worlds* (Downers Grove: Intervarsity Press, 1992). It should be noted that his use of the term Postmodern in different than here.

27. Isaiah, 6:9-10. The association of seeing and hearing with understanding is also cited in Deuteronomy 29:4: "But to this day the Lord has not given you a mind that understands or eyes that see or ears that hear."

28. Wladyslaw Tatarkiewicz, *History of Aesthetics* (The Hague: Mouton, 1970), vol. 2, 64

29. Ibid., 62.

30. Anna S. Benjamin and L.H. Hackstaff, translators, *Saint Augustine. On Free Choice and the Will* (New York: Macmillan Publishing Company, 1964), 88ff.

31. Wladyslaw Tatarkiewicz, *History of Aesthetics* (The Hague: Mouton, 1970), vol. 2, 65.

32. Ibid., 37

33. Ibid., 23

34. Ibid., 23.

35. The lack of final system to this approach resists deconstruction since its structure lacks systematic rigidity. Discussed below is Umberto Eco's analysis of Scholasticism and Gödel's Theorem.

36. WladyslawTatarkiewicz, *History of Aesthetics* (The Hague: Mouton, 1970), vol. 2, 23.

37. Ibid., 25.

38. Ibid., 45-7.

39. Ibid., 47.

40. Irwin Edman, editor, *The Consolation of Philosophy* (New York: The Modern Library, 1943), 17.

41. Wladyslaw Tatarkiewicz, *History of Aesthetics* (The Hague: Mouton, 1970), vol.2, 86

42. Ibid., 79.

43. The association of grammar with beauty is clear, since both center on understanding reality. For a discussion of the demise of grammar see: David Mulroy, *The War Against Grammar* (Portsmouth: Heinemann, 2003).

44. John D. Jones, *Pseudo-Dionysius Areopagite. The Divine Names and Mystical Theology* (Milwaukee, WI: Marquette University Press, 1980), 4.

45. Hugh Bredin, translator, Umberto Eco, *The Aesthetics of Thomas Aquinas* (Cambridge, MA: Harvard University Press,1988), 231.

46. John D. Jones, *Pseudo-Dionysius Areopagite. The Divine Names and Mystical Theology* (Milwaukee, WI: Marquette University Press, 1980), 140ff. This will later be contrasted with Barnett Newman's proclamation that the purpose of Modernity is to destroy beauty.

47. Wladyslaw Tatarkiewicz, *History of Aesthetics* (The Hague: Mouton, 1970), 101,103.

48. Ibid., 104.

49. Ibid., 99.

50. Anthony Gythiel, translator, Leonid Ouspensky, *Theology of the Icon* (Crestwood, NY: St. Vladimir's Seminary Press, 1992), 142.

51. For an extensive discussion of Universals see Frederick Copleston, *A History of Philosophy, Mediaeval Philosophy* (Garden City, NY: Image Books, 1962), vol. 2 Part I, 157ff. In that discussion he addresses ontological, psychological, and conceptualist solutions, but not the symbolic solution offered by Augustine via his theory of illumination.

52. Kant's solution of the aesthetic transcendental will be critiqued below. In sum, his long questioned assumption of a naturalistic and universal structure of human rationality providing the foundation for moral thinking is no longer tenable with our new ability to alter basic genetic qualities. As discussed in the concluding chapters of this book, Noam Chomsky and Francis Fukuyama participate in the same presumptions, but conclude differently.

53. For a discussion see Hugh Bredin, translator, Umberto Eco, *The Aesthetics of Thomas Aquinas* (Cambridge, MA: Harvard University Press,1988), 43.

54. Wladyslaw Tatarkiewicz, *A History of Aesthetics* (The Hague: Mouton, 1970), II, 175-6

55. Following Etienne Gilson, *History of Christian Philosophy in the Middle Ages* (New York: Random House, 1955), 152 ff

56. Nominalism deeply informs the Modernist mind; for Kant the particular conforms to the universal that is found in the structure of our minds (as discussed below, this marks a dangerous self-deification).

57. For a discussion of the role of Scholastic conceptualism in the demise of grammar, see: David Mulroy, *The War Against Grammar* (2003), chapter 2.

58. Etienne Gilson, Ibid., 153.

59. Those who might defend the Aristotelian approach as essential to empirical science are faced by a contradiction: Postmodern science is questioning whether or not Aristotelian categories are essential (e.g., the writings of Thomas Kuhn).

60. His equivalent is found in the Chinese scholar and philosopher Chu Hsi. The descent from beauty to aesthetics is also found in Chinese Confucianism, a tradition that resonates with Aristotelian thought. See: Arthur Pontynen, "Confucianism," *Dictionary of Art* (London: McMillan Publishers Limited, 1996).

61. Hugh Bredin, translator, Umberto Eco, *The Aesthetics of Thomas Aquinas* (Cambridge, MA: Harvard University Press, 1988), 65.

62. Frederick Copleston, *A History of Philosophy* (Garden City, NY: Image Books, 1962), 143.

63. Ibid., 37.

64. Hugh Bredin, translator, Umberto Eco, *The Aesthetics of Thomas Aquinas* (Cambridge, MA: Harvard University Press, 1988), 97.

65. J. F. Scanlan, translator, Jacques Maritain, *Art and Scholasticism* (New York: Charles Scribner's Sons, 1947), 23.

66. Hugh Bredin, translator, Umberto Eco, *The Aesthetics of Thomas Aquinas* (Cambridge, MA: Harvard University Press, 1988), 47. Frederick Copleston, (*A History of Philosophy* (Garden City, NY: Image Books, 1962), Vol. 2, Pt. II, 142), convincingly argues that Aquinas does not deny the objectivity of beauty; that objectivity requires three elements: perfection, proportion, and clarity. But this requires the assumption of a purposeful world.

6

The Renaissance, Mannerism, and the Baroque: From a Qualitative to a Quantitative Universe

> *"I do not know what beauty is but I do know that it is to be found in the right, the correct, the useful, and naturally true."*—Galileo[1]

> *"What is beautiful is not always good."*
> —Leonardo Da Vinci[2]

The term Renaissance is a positive one, but it is a term that warrants critical attention. It literally refers to a rebirth or renewal of that either neglected or lost. During this period a renewed interest in certain long neglected ancient writers occurred; as did an interest in certain cultural and artistic themes. For example, in the fine arts the traditional theme of the nude makes a remarkable return. But it would be inaccurate to associate the Renaissance with the rebirth of responsible and sophisticated attempts to better understand the world and life. Such attempts have consistently been a part of cultural history. What then was the Renaissance? It was both a rebirth and a continuation. An interest in Classical culture continues, but there is also a renewed interest in Classical sociology. That renewed interest occurred not as a rejection of Medievalism, but rather, as a logical consequence of Scholastic and Conceptualist ideas.[3] That logical consequence marks the gradual decline of the notion of transcendent beauty in the face of an ascendant aesthetics.

During the Renaissance there remain Christian writers and artists (such as Raphael) who continue to believe that Plato, Aristotle, and Christianity could be synthesized via the Scholastic method. But there are also fervent advocates of beauty, whose understanding of beauty differs from Scholasticism and even from that of Augustine. Like Augustine, Marsilio Ficino (1433-1499) attempts to reconcile Neo-Platonism with Christianity; unlike Augustine, Ficino em-

phasizes that happiness is found in rather than via the inner life. It is more Plotinus than Augustine whom Ficino echoes in his *Commentarium*:

> "Beauty, finally, is the completed unfolding of the intelligible light and the intelligible species. Although Beauty is the last to proceed, as it were, in any god, it is the first to confront those ascending to that god.[4]

There also emerges a new cultural spirit, informed by a new type of humanism, empiricism, and mysticism. The unifying notion of this new period in cultural history is a gradual denial of the importance of transcendent universals and of our ability to intellectually comprehend them.

The crux of the matter centers on the problem of the nature of the universe and of its source of truth and purpose, God. Plato, Aristotle, and the Judeo-Christian tradition assert that the world is finite, whereas God is infinite. Creation is finite and involves limits, whereas God transcends the finite. But as explained by Aristotle, a finite world is one with a particular structure—a structure readily familiar to Dante—but not Delacroix or Nietzsche. The heavens are spherical (as discussed in his text, *On the Heavens*) and (as discussed in his *Metaphysics*) the world is comprised of both quantum and that which is qualitative. The latter indicates the realm where good and evil are discernible, particularly in living things that have purpose. But the relationship of the finite (creation) and the infinite (the Creator), indeed, the very structure of the cosmos, is now questioned. As explained by Alexandre Koyré:

> This scientific and philosophical revolution…can be described roughly as bringing forth the destruction of the Cosmos…of the conception of the world as a finite, closed, and hierarchically ordered whole…and its replacement by an indefinite and even infinite universe which is bound together by the identity of its fundamental components and laws, and in which all these components are placed on the same level of being. This, in turn, implies the discarding by scientific thought of all considerations based upon value-concepts, such as perfection, harmony, meaning, and aim, and finally the utter devalorization of being, the divorce of the world of value and the world of facts.[5]

The Platonic/Augustinian notion of a numinous reality occurs as a continuum from the particular and banal to the ideal that seeks the transcendent Divine; a transcendence ineffable but for degrees of illumination obtained via reason, Scripture, and the Incarnation. Aquinas attempts to reconcile this approach with that of Aristotle, where there is a distinction between material perfection and moral goodness. He concurs that reality is comprised of the Divine mind, earthly reason and material perfection. This is in contrast to Augustine who sought degrees of understanding; rather than seeking degrees of wisdom, Aquinas centers much of his system on the relationship of the universal and the particular. As discussed above, this results in the pursuit of wisdom being viewed as a product of formal logic. When truth is viewed this way science and humanism are formally separated from truth, from knowledge of reality. Instead the

world is viewed in terms of facts, feelings, and human logic. The secular minded celebrate natural science and the political, whereas the religious enthusiast identifies with the facts of scripture and emotional commitment.

Reality and life center then on facts, feelings, and a rationality that is increasingly aesthetic. This denial of pursuing transcendent wisdom and beauty[6] is important to the future development of Modernism and Postmodernism. The historical record evidences that the abandonment of beauty for aesthetics results in the abandonment of truth and love in life for a purposeless existentialism.

It is not surprising to find a new type of Classicism being pursued during the Renaissance—and later. It is a type of Classicism where increasingly those figures less concerned with the transcendent ideal come to the fore. The materialistic cosmology of Lucretius is newly championed by figures such as Nicholas of Cusa and Giordano Bruno. Whereas previously God was understood as a being of which the center is everywhere and the circumference nowhere, [7]now is the cosmos itself thus understood. The transcendent is immanentized, which is to say that the immanent is treated as if transcendent.

The transcendent aspects of Platonic and even those of Aristotelian thought are thus altered and those figures and their ideas are increasingly replaced by an interest in others; the immanent increasingly replaces the transcendent as the focus of our attention. One result is a Classicism that is more sociological than cultural in outlook. Another result is the transformation of Christian tradition into an empiricist, mystic, and rationalistic mode.

One of the major figures of the Renaissance is Galileo Galilei (1564-1642). We can recall that Galileo famously resisted the power of the Scholastic and Humanist establishment to declare that gravity is physical rather than metaphysical. Gravity is not, as Dante understood, the Divine force that moves the planets. Rather it is a naturalistic force within a naturalistic universe. Galileo advances a naturalistic vision in opposition to a metaphysical one, a vision where *what* is *why*. It might be argued that there need not be a conflict between the two visions: in Aristotelian fashion, naturalism is thus viewed as physical evidence of Divine purpose. But that would be a static analysis of a dynamic situation. As we shall see, naturalism can coexist with metaphysics, but without necessity, and therefore without endurance.

Galileo was not alone in his thinking. Copernicus and Kepler are disputing the ancient Aristotelian cosmology. But in contrast to them he does not admit that the world is finite. He thus is in harmony not with science, but with a particular philosophy. Not that of Plato and Aristotle, but rather of Lucretius. This is dangerous not because it involves questioning the existence of God; it is dangerous because it alters the very nature of God.

Since the Earth does indeed revolve around the Sun, it is commonly argued that Galileo was heroic in his defense of empirical fact. The Scholastic establishment can thereby be viewed as ignorant, reactionary, corrupt and—reli-

gious. But the historical situation was much more complex and the issues much more profound than to be reduced to such a simplistic dualism of Scholastic evil being contested by Galilean good. What was at stake was the possibility of recognizing in the world not only good and evil, but beauty as well.

Galileo proposed much more than merely replacing fiction with fact; he proposed transforming the Scholastic status quo. As discussed above, the Scholastic mind attempts to reconcile truth in things, in our minds, and in the mind of God, by separating them. No longer is Augustine's method of illumination at the fore. The Scholastic [8] worldview is increasingly affected and replaced by a Copernican view, which would newly reign. The Augustinian aspect of Scholasticism, where the world is moved by Divine Love, is undermined not only by the Aristotelian division of fact and faith. It is undermined by Galileo's altering an Aristotelian and Scholastic qualitative physics with a physics that is quantitative.

Galileo advances the perennial but then neglected naturalistic notion that *what* is *why*. Why was that notion neglected? Because Classical and Christian tradition rejects the naturalistic understanding of reality which lacks purpose when lacking the presence of divinity; and Scholasticism can offer no compelling need beyond emotion for that divinity to exist.[9] So equating what with why is to advance a naturalistic vision of reality and life where *why* does not matter—even if our consciousness and our emotions demand it. He thereby advances not a vision of beauty, but rather, an aesthetic—indeed mechanistic —vision of reality and life. It is to advance not only an aesthetic position, but an atheistic one as well. It is a vision that offers neither purpose nor meaning in reality, life, or art. The result is ethics grounded in physics, which provide a meaningless and violent metaphysics. Kepler acknowledged these difficulties. A devout Christian and Aristotelian, he resisted the notion of an infinite universe—a universe without a transcendent God, and without value.[10]

It can be contended that Galileo simply stood fast in advocating an obvious fact: the earth is not the center of the universe. But consider: the longstanding Ptolemaic assumption that the sun and stars revolve around the Earth was based upon mathematics and empirical observation as much as was Copernicus's alternative that the Earth revolves around the sun. It was not the neglect of observed fact that is at issue, but rather, the accuracy of observed *facts* and of our attempt to understand them. What is taken for fact may not be, and facts are subject to interpretation in our attempt to understand their significance. And more than facts are at stake, since (as Kant noted) facts without interpretation remain meaningless and silent.

We can recall that the issue of the meaning of Love (or Justice) has been a recurrent one in the history of culture. This is quite reasonable since so much of our lives are affected by how we understand love to be. It may at first appear odd to consider the notion of love in the context of physics. Nonetheless, a reconsideration of love in that context is precisely what occurs during the

Renaissance and the Enlightenment. Indeed, the Renaissance begins to sub-
stitute the notion that the universe makes sense because it is driven by truth
and love,[11] with the notion that the universe is either grounded in chance or in
mechanical or organic necessity. However, the premise that the universe lacks
purpose and makes no sense, that it is accidental, mechanical or naturalistic, is
intellectually no more compelling than the Augustinian (and to some degree,
Scholastic) alternative: that the world is informed with meaning and purpose,
and is driven by love. There is no inescapable necessity to privilege chance or
necessity over purpose. Nor need it be privileged over the wide variety of
cultural traditions around the world that affirm that reality and life do indeed
make sense, that is, that life is purposeful.

In his letter *On Theology as Queen of the Sciences* (1615) to the Grand
Duchess of Tuscany, Galileo makes the argument that physical science and
faith are two separate realms. This position is similar to the Averroist position
of previous centuries. It has roots in Aristotle and Scholasticism, and is central
to Modernism as well. But it is one that remains unpersuasive to the mind
dedicated to beauty. It is difficult for those imbued with a naturalistic vision to
identify with the mindset that understands physics to be inexorably connected
with, and inferior to, a purposeful metaphysics. But those who pretend to
reject metaphysical speculation display a naive ignorance that is neither en-
lightened nor benign. To embrace the notion of a purposeless or unknowable
universe is to advance that metaphysical vision of reality and life. So physics
is not a denial of metaphysics, rather it is an unacknowledged and inadequate
form of it. This is not to suggest that reality should conform to dogma, indeed
it was Kepler who was keenly concerned that:

> ...There is a sect of philosophers, who.....start their ratiocinations with sense-perception
> or accommodate the causes of the things to experience: but who immediately and as if
> inspired (by some kind of enthusiasm) conceive and develop in their heads a certain
> opinion about the constitution of the world; once they have embraced it, they stick to
> it; and they drag in by the hair [things] which occur and are experienced every day in
> order to accommodate them to their axioms.[12]

Dogma rarely appears dogmatic to the true believer. Major perennial op-
tions for understanding the world can be divided into aesthetic or beauty
seeking modes. The Aesthetic Axioms include materialist, empiricist, organic,
and purposeless modes; beauty-seeking traditions find those modes prelimi-
nary rather than conclusive. For example, the physical relativism of Einstein is
historically accompanied by the relativistic ethics of Bertrand Russell; both
can be viewed as epigones of Kant for whom it is axiomatic that our under-
standing of the world conforms to how we think. The biological vision of life
presented by Darwin is complemented by the Social Darwinism of Spencer;
the *Dialectics of Nature* by Engels is in harmony with the dialectics of history
and politics by Marx; the physics of Aristotle and Chu Hsi are consistent with

their ethical visions as well.[13] So historically the realms of fact and value, of what and why, are not culturally distinct. Those who philosophically—or scientifically—assert otherwise are naïve. That naiveté is encouraged by the incoherent position of the Aristotelian paradigm: that aesthetic perfection is separate from moral goodness and knowledge.[14] It is incoherent because aesthetics inescapably have a moral content —albeit a superficial and violent one. Aesthetics is not distinct from moral good; rather, it is an inadequate advocate of the good.

In the case of Galileo, to transform *what* into *why* is to aggressively take an initial step towards advancing a naturalistic or mechanistic metaphysics. This involves a sad irony, since in the name of objectivity a naturalistic, mechanistic, and indeterminate vision results. That vision can only see via a dogmatic scientism and emotivism that inescapably promotes its own metaphysics. It is a tragic metaphysics in that it promotes a meaningless metaphysics of facts, feelings, and power.

For many it is difficult indeed to grasp the possibility that the universe is not merely aesthetic (factual and subject to our emotional or rationalistic response) and meaningless. It is difficult for them to consider a different metaphysics, one of beauty. Nonetheless, in the last words of his great work, *The Divine Comedy*, Dante Alighieri (1265-1321) cites love as the cosmic force that drives the planets on their way. In that same work he describes the passage of life aspiring to rise from the ugly and corrupt to the beautiful and true, a passage informed by freedom and love. As noted in earlier chapters, if love is not a metaphysical reality, then our social, personal, and intimate lives are limited to entertainment, therapy, or power. Galileo could not read and pretend to understand Dante's great work without engaging in hypocrisy, deceit, or folly. To the contrary, it is held to be a matter of virtue to perceive a world without objective virtue.There are two strands of thought in Dante's work, one Augustinian, the other, Aquinian. Those two strands are also present in Scholasticism as a whole. The Augustinian tradition will later pursue its own path- peaking in odd form in the culture of the Victorians. But for the moment, it is useful to note that the Scholastic Dante failed to remain faithful to Augustinianism. On one hand, Augustine's position is that those who focus on literary style rather than substance are foolish. For example, one commentator on the *Divine Comedy* notes:

> Augustine's principles are nowhere better exemplified than in the case of the *Divina Commedia*, which we now persist in regarding as an example of "poetry" or *belles-lettres*, notwithstanding that Dante says of it himself that "the whole work was undertaken not for a speculative but a practical end...the purpose of the whole is to remove those who are living in this life from the state of wretchedness, and to lead them to the state of blessedness.[15]

But there is also the Aristotelian aspect of Scholasticism. Dante sums up this trend in Scholastic thought, holding that beauty is twofold: in the mind of

God and in the harmony and coherence of things. He offers that the purpose of poetry is twofold: one supernatural, the other natural, one attainable by grace, the other attainable by reason. Dante is confident that whereas Beauty can only be understood by the grace of God, the harmony of nature can be understood by secular reason. A worldly aesthetics, in science, ethics, and art, is to some degree possible to understand. Beyond that is the realm of subjective faith.

Dante defends yet separates Divine and natural truth, as do Aquinas, Kepler, and ostensibly Galileo. But there is a necessary and dreadful consequence to this Aristotelian separating of theology and philosophy, Divine and natural truth. It marks the reduction of beauty to aesthetics by reducing beauty to a matter of perfection *rather than* ontological profundity. It thereby advances the aesthetic notion that both truth and beauty are ultimately a matter of coherence, emotional response, and power. This results in beauty no longer being cognitive. And it no longer offers a profound understanding of the universe and life. It results in culture being aestheticized within a context that only tenuously relies upon the existence of ultimate and divine purpose being present in the world. It results in a Newtonian world that is but a way station to a perceived quantum universe and ethics.

That we can read works of literature such as Dante's for a beatific vision, an epiphany of beauty—is increasingly obscured—and not just by the enemies of Dante's viewpoint. Indeed, it is hard to reconcile the Augustinian Dante with the Aristotelian Dante. For Augustine beauty is the splendor of wisdom, which can be recognized to varying degrees; so too for the Pseudo-Dionysius Areopagite where the universe is a cascade of beauty resulting from the mind of God. For Aquinas physical beauty is increasingly viewed via an Aristotelian aesthetics pursued via the perfection of ontological form. Consequently, Aquinas associates Augustinian wisdom with harmony of form, and in his *Commentary on the Divine Names of Pseudo Dionysius*, in Aristotelian fashion he stresses that whereas goodness and beauty are indivisible in God, they are divisible in God's creation. In other words, there is a significant shift from the notion of beauty occurring as degrees of light and wisdom, to that of a separation of form and Divine content. A separation that includes the idea that beauty means different things for different people.

By stating in the *Convivio* that by its aesthetic appeal alone, a poem is able to be appreciated even by those who do not understand its meaning, Dante observes that aesthetics can be attractive even when content is unknown. This is in contradiction of Augustinian tradition; if things devoid of wisdom can attract—then how can that be good? If the purpose of art is to elevate the reader to a higher spiritual plane, but art can be appreciated by its formal characteristics alone, then what becomes of beauty and truth? Following Aquinas (and Aristotle), physical beauty has then but an aesthetic content. It is formalistic rather than substantive: it maintains that there can be, and is, beauty in poetry and art that is independent of substantive content. That aestheticized

beauty is recognizable by the measurable harmony and fittingness of things, but not its degree of wisdom. The superficiality of this position is clear, its consequence, dreadful.

Within the Christian context of Dante's culture, it is equivalent to superficially maintaining that the Incarnation is formally beautiful, the poetry of the Psalms is pleasant, and the meaning of either is secondary at best. Secularly, a corrupt person who is judged physically pleasing may therefore be deemed beautiful. Just as Aristotle takes for granted that only refined audiences who understand the world to make sense will pursue aesthetic pleasure, Aquinas assumes his audience will be Christian. But neither assumption is persuasive or inevitable.

So the intrinsic logic of Scholasticism leads to a non-Scholastic, indeed non-Christian, conclusion. The Scholastic attempt to reconcile Plato/Augustine with Aristotle contributes an intellectual means for the denial of the necessity of God. It offers an affirmation of a superficial and subjective metaphysics. A rationalistic empiricism is linked to a subjectivist mysticism, which may or may not be associated with Biblical principle. So just as Aristotle's doctrine of purgation inadequately faces the problem of tragedy, a Medieval Aristotelianism fails to defend wisdom and beauty via the formal aesthetics of Conceptualism. Even Dante observes that clarity of form can be attractive while content is not understood. As such, a formalistic aesthetics need not occur within a meaningful universe. As Kant would later say, it can be but a perfection of a kind.

So like frustrated love, aesthetics lacks an object that provides meaning. If that clarity of form occurs within a meaningless world, then not even clarity need be attractive. Formalism, be it Scholastic or, as we shall see, Modernist, is thus reduced to being empty, arbitrary, and meaningless.

To suggest that the Scholastic attempt to reconcile Augustine and Aristotle facilitates an intellectual path leading to an empty quantification of the world and life invites dispute. Defenders of Scholasticism such as Jacques Maritain take pains to suggest that the path to Modernism evidenced by Descartes (discussed below) is not its necessary consequence. But there are reasons to think otherwise.[16] Indeed, as discussed above, the pains taken to deny that the formalism of Aristotelian/Aquinian Scholasticism leads to the empty formalism of Modernism, gives credence to the suggestion that the possibility exists. And as discussed in subsequent chapters, the rise of Modernity with its reduction of thinking to rationalization and the true and good to that of fact, feeling, and the will, historically rose out of a Scholastic bosom.

It should be emphasized, however, that the rise of Modernity is not the only possibility, and to state such is not an indicator of being reactionary. Indeed, the very term Modernism has little to do with the contemporaneous. For example, Gothic art was in its time called modern; alternatively, in a Postmodern age Modern art is necessarily viewed as being of the past. The irony, however, is that Postmodernism is not really postmodern. It is rather the culmination of

the Modern – and of Scholasticism. Since the so-called Enlightenment what is shared is a Kantian starting point and a Nietzschean conclusion, although that conclusion can be manifest in a variety of modes.[17]

What other possibilities exist? The path of Western Culture since the Renaissance is at least twofold: that which leads from Scholasticism to the so-called Enlightenment, and that which does not, or rather, that which leads to aesthetics and that which leads to beauty. And in the West the primary and perennial vehicle by which we might pursue beauty is Augustinian. It is called Augustinian not as an ideology, not as a form of hero worship, nor as a static dogmatic tradition. Rather, it is Augustinianism as a living tradition that reveres reason without lapsing into rationalization or cult.

This will be discussed shortly. For the moment, note that there is a historical irony evident. Those so often depicted as antagonists, such as Galileo and the Scholastics, or Raphael and Leonardo Da Vinci, or later, Kant and Nietzsche, are actually protagonists within a cultural species or genera deeply influenced by Aristotelian and Scholastic thought. They share a common heritage and a common—and unfortunate—destiny.[18]

For example, an interest in reason is central to the Classical philosophy of Plato and Aristotle, as well as to Augustine, and the Scholastics of the Gothic period. The renewed interest in reason during the Renaissance differs from previous periods in that its understanding of reason develops within the context of late Scholasticism and Nominalism. That historical context centers on a paradoxical desire: to attempt to escape Scholasticism, but to do so by pursuing the necessary consequences resulting from the position of Abelard's Conceptualism and its companion, Nominalism. As we shall soon see, the attempt to escape Scholasticism while accepting its premises as a starting point is closely comparable to the contemporary Postmodern attempt to escape Modernism by beginning with Kant. It is not, however, an escape. Each marks the fulfillment of a set of basic principles.[19]

To the point, it would be an unfortunate oversimplification to suggest a break in the continuity of the ideas unfolding over the course of centuries. The culture of the Renaissance is part of a tradition, a cultural narrative, with historical roots and assumptions. It would also be foolish to assume that within the larger context of that narrative, that is, Western culture, there are no alternatives to consider and disputes to be sorted out. For example, for those who embrace the intellectual content of the Renaissance, the thirteenth century philosopher Bonaventura, or the fifteenth-century monk Savonarola, might well be viewed as the epitome of evil and ignorance; for those who embrace a different cultural tradition, they remain heroic, one no less than a martyr.

Reason, Beauty, and Aesthetics

The cultural context in which the Renaissance developed was Scholastic. The intellectual and theological problem of reconciling the universal with the

particular, the infinite with the finite, was increasingly applied to empirical studies as well.[20] In each case, the issue is how we might best understand the world and life. That involves the use of reason. Traditionally, reason marks the attempt to understand the world and life. It is therefore an essentially practical activity: reasoning facilitates our need to make the many decisions that confront us daily. Reason is also associated with beauty; by attempting to understand the world, it attempts to discern purpose; purpose known is beauty shown.

 Beauty is the realization of purpose, and in the West it is understood as that which is true and good. In this regard the pursuit of beauty is both reasonable and practical.

But to the aesthetic mind, reason and beauty are reduced to a matter of taste, formalism, or identity. They are grounded in fact or feeling, rationalization or authenticity. The separating of reason and beauty from understanding is aesthetic; this tendency gains cultural ascendancy during the Renaissance and has maintained that ascendancy until recently. It maintains that there is a distinction between mind and matter, body and soul, physics and metaphysics. To understand how and why this occurred, it is useful to consider the cultural context in which the shift from a qualitative to a quantitative universe occurred.

On the one hand, is the Platonic and Augustinian position that holds reason to be an intuitive grasping of the way things are, an intuition that is not merely subjective, but based upon an understanding of an object of knowledge. As represented by the Trinity, Humanity's self-consciousness arises when the self distinguishes itself from the not-self, when the conscious subject attempts to comprehend some object of thought distinct from itself. So the observation that two oranges plus two oranges equals four oranges is intuitive; it relies not on discursive reasoning or particular laws of logic, but rather on a grasp of objective reality as it is presented. Reason is then the gaze of the mind apprehending some degree of understanding of reality and life. However, some such intuitions go beyond the realm of mathematical or quantitative knowledge, and even when exposing wrong, those intuitions reveal something that is right. For example, as discussed earlier, is Augustine's axiom, *si fallor, sum*; that since we err, we exist. Augustine concurs with Socrates that a critical examination of belief often reveals error. So none can doubt that they think and live. As self-conscious beings we have both the necessity and the freedom to attempt to comprehend objective reality. We seek illumination via thought and art, and it is in this sense that beauty thrives

A person who walks into an art gallery might see all of the objects in it. But seeing does not understand. The same situation applies with a written text. We can look at works of art, or read books, in which we can recognize all that is depicted or printed, and appreciate how they affect us emotionally, but lacking an understanding that transcends the media or language, the object of our

interest and passion remains superficially understood. This essentially aesthetic approach leaves lacking the possibility of knowledge that is to any degree qualitative; we respond to the works without comprehending the meaning and value of the object or the text. The aesthetically minded, who assume that meaning is constructed, might appear to understand a work of art in a variety of ways. But to do so is to uniformly deny the possibility of any objective meaning. The work of art, or the work of literature, becomes then a matter of willful interpretation. It becomes a brute assertion that is essentially anti-cultural. However, if the meaning of the text or object is recognized to represent the true and good, then multiple attempts to understand reality and life result. This marks a genuinely pluralistic pursuit of truth and goodness. We seek to obtain some precious degree of wisdom via the light of reason. We hope to obtain a glimpse of beauty.

So in the pursuit of beauty factual knowledge is recognized as important, but wisdom is held to be more so.[21] Just as we rise from the realm of fact to that of understanding, we rise from the material to the spiritual in art and life. Factual knowledge is essential to obtaining understanding, but does not necessarily lead to understanding. The attainment of understanding is where factual knowledge and purpose combine; so there is no substantive difference between philosophy and theology. It is where as a matter of degree our love of beauty is consummated.

On the other hand is the Aristotelian and Scholastic position that sees reason as discursive and logical. It assumes that certain laws of logic are universal and inexorable and that such logic, rather than an informed intuition, is central to obtaining understanding. Within this tradition knowledge and belief (as well as reason and faith) are separate, but (except for Averroism) complementary. As a Scholastic, Thomas Aquinas attempts to reconcile reason and faith, while at the same time maintaining their distinctiveness. So too is the case with beauty. As just discussed, Aquinas holds physical beauty and goodness to be distinct, yet complementary. However, those who separate beauty and goodness, reason and belief, advance an advocacy not of beauty and love, but of aesthetics and power

To the point, within the Aristotelian tradition are found a variety of viewpoints united by reliance upon discursive logic. Included are Christian Scholastics such as Aquinas, and naturalistic Aristotelians such as Averroes, Avicenna, and Siger de Brabant. What divides these Aristotelians is that all but Aquinas directly contribute to the promotion of a militantly naturalistic and humanist thinking up to the present. It is a naturalism and an empiricist type of humanism that demands faith in the assumption that the world and life offer no objective purpose.

Within the Western tradition there are two distinct advocates of that type of science: one is reliant upon Aristotle's (and Scholasticism's) explication of categories such as species; the other is found in the Platonic and Christian

pursuit of the Divine, in which species can be associated with the divine. To the Scholastic mind, science (scientia) refers to any authoritative body of knowledge be it in physics, ethics, mathematics, or beauty; the Scholastics take for granted that science, ethics, and art are distinct yet complementary, as are knowing, doing, and making in daily life. In contrast is the Augustinian unity of physics, ethics, and metaphysics. So both Augustinians and Scholastics deny attempts to completely separate knowing, doing, and making in life. But once conceptually separated, there is little reason not to complete the task. So during the Renaissance the term science begins to be increasingly limited to empirical science rather than theology, philosophy, or fine art.

Empiricism differs from either the Platonic/Augustinian or the Scholastic/ Conceptualist traditions, in that it assumes that the universe is aesthetic, is purposeless, and therefore a matter of chance, or of mechanical or organic necessity. By the restrictions of its own descriptive methodology, it does not, and cannot properly address first principles, final causes, or ultimate purpose (eschatology); as such it remains blind to a purposeful reality and blind to beauty.

This is evidenced by Galileo in science and by Leonardo Da Vinci in art. It is worth noting that Galileo lectured in Averroist Padua from 1592 to 1610, where he advanced a quantitative physics.[22] It was also during this period that such naturalistic Aristotelians found an odd confluence of interests with the devout Franciscans. Instead of the Scholastic attempt to rise from the historic to the allegoric to the analogic, the focus now rested in the deemphasizing of such reasoning, in favor of fact, feeling and rationalization.

The Renaissance and Beauty: Petrarch and Giotto

One of the great poets of the fourteenth century was Francesco Petrarch (1304-1374). A scholar as well as a poet, Petrarch was repulsed by the Averroist notion that faith and reason were separate, but was also uncomfortable with the Scholastics. It is not surprising then that around 1342 Petrarch wrote *Secretum*, a dialogue between himself and St. Augustine. That work concerns both faith and reason in that it discusses the relationship of the physical with the metaphysical. But it steps back from Scholastic reasoning; Petrarch uses the symbolic and allegorical, which harkens back to Augustine. As a literary mode it presents experienced truth.

Petrarch's position on the relationship of beauty and aesthetics is concordant with his position on allegory. In another text, he presents a dialogue between Joy and Reason.[23] That dialogue addresses the conflict concerning beauty between two ancient writers, Virgil and Seneca. Both hold that virtue is a wonderful thing; Virgil holds that it is more charming when enhanced by a beautiful body, whereas for Seneca beauty cannot make virtue any greater. Petrarch concludes:

In short, although physical charm contains nothing lasting and desirable, if it is joined with virtue and if we do not err in our respective evaluations of these things, then I would agree to call beauty an embellishment of virtue which is indeed pleasing to the eye, but transient and fragile.[24]

Just as did Augustine, Petrarch makes a distinction between beauty that is associated with reason and that associated with feeling (more precisely, aesthetics). In his *Confessions* (of which Petrarch was an avid reader), Augustine laments that as a foolish young man he loved *pulchrum* [aesthetics] of a lower order and descended into the depths, and in his famous book, *The City of God*, Augustine distinguishes between the life dedicated to God, love, and beauty, and that of the self, cupidity and aesthetics. In his *Secretum* Petrarch notes his own unhappiness, and presents the following dialogue:

Augustine: Do you remember with what delight you used to wander in the depth of the country? Sometimes, laying yourself down on a bed of turf, you would listen to the water of a brook murmuring over the stones; at another time, seated on some open hill, you would let your eye wander freely over the plain stretched at your feet;...Never idle, in your soul you would ponder over some high meditation? ...Ever since you grew tired of your leafy trees, of your simple way of life, and society of country people, egged on by cupidity, you have plunged once more into the midst of the tumultuous life of cities. I read in your face and speech what a happy and peaceful life you lived; for what miseries have you not endured since then? Too rebellious against the teachings of experience, you still hesitate!

Petrarch: Do you mean to tell me my soul is still bound by two chains of which I am unconscious? What may these chains be of which you speak?

Augustine: Love and glory...You have admired the Divine Artificer as though in all His works He had made nothing fairer than the object of your love, although in truth the beauty of the body should be reckoned last of all.[25]

Here Petrarch rejects Aristotelian thought in favor of that of Augustine. He is consistent in that choice by differentiating intelligible beauty, which is perfect, from sensible aesthetics, which is charming yet dangerous. He transforms the analogic preoccupations of Scholasticism for a renewed emphasis on human experience; Petrarch's poetry uses the notion of allegory as a veiled referring to that known by human experience.

Discussed in the previous chapter were the ideas of Abbot Suger who held that fine art and architecture were analogic and anagogic: the material is used to obtain a glimpse of the spiritual—which remains ultimately ineffable. Another Gothic writer, William Durandus (c. 1220-96) wrote on the symbolism of churches and church ornaments:

Now, in Holy Scriptures there be divers senses: as historic, allegoric, tropologic, and anagogic...Allegory is when one thing is said and another meant: as when by one deed another is intended: which other thing, if it be visible, the whole is simply an allegory, if invisible and heavenly, an anagogue...The arrangement of a material church resembleth

that of the human body: the Chancel, or place where the Altar is, representeth the head; the Transepts, the hands and arms, and the remainder,—the rest of the body. The sacrifice of the Altar denoteth the vows of the heart....Represented in the Cradle, the artist commemorateth His Nativity: on the bosom of His Mother, His Childhood: the painting or carving His Cross signifieth His Passion: when depicted on a flight of steps, His Ascension is signified...[26]

But Petrarch's position differs. In contrast, for example, to the notion that Chartres Cathedral is an allegoric symbol of Christ and Mary, Petrarch advances the Augustinian idea that such allegoric symbolism is excessive. Mary and Christ were also living persons, not spiritual symbols lacking humanity.

This same idea is present in the frescoes painted by Giotto at the Basilica of St. Francis at Assisi and in the Arena Chapel in Padua. The Basilica was built in honor of St. Francis, a religious figure sharing many of the beliefs held by Petrarch. One of the frescoes in the Basilica depicts St. Francis' mystical marriage to Lady Poverty. That marriage is neither Scholastically symbolic nor

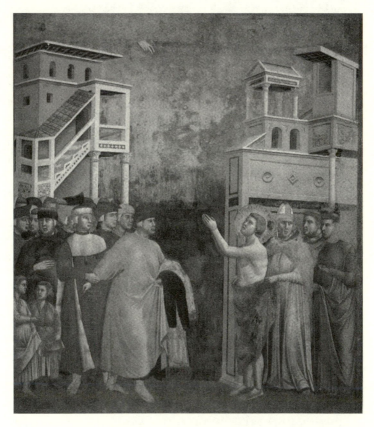

14. Giotto, *St. Francis' Mystic Marriage to Poverty*

fictitious, but one that conveys an experiential truth: power and glory are to be eschewed for a simple spiritual life among the common people.

The namesake of the Franciscan Order is Francis Bernardone, born in 1181 or 82 at Assisi. Born of a wealthy family, his early life was dissolute until a spell of illness and imprisonment caused him to see things anew. He then chose to disassociate himself from the perpetual commotion of the city and from false desires. He became a mendicant monk preaching piety and poverty, dedicated to the transformation of a fallen world by a life of unsullied service. His dedication lead to the formation of a religious order which stands as an alternative to Scholasticism; his opponent was pride, the pride of intellect being as dangerous as the pride of ignorance. St. Francis opposed what the historian Friedrich Heer explains:

> The new [Scholastic] theologians were imprisoning God within their philosophical system, bending divinity to their own wills and objects. The canon lawyers, the jurists of the Church, were endeavouring to transform the Roman household of the Pope into a stronghold of power. In the course of this struggle to assert the rights of the Curia and the Church the medieval Papacy fought its way up to its highest eminence and to its ruin.[27]

The Franciscan movement begins in Scholasticism and attempts to reform it. It grew at a fantastic rate, necessitating the formal organizing of an official Order. By 1282 it possessed 1,583 houses in Europe; soon after his death in 1226 the decision was made to construct a basilica and monastery in Assisi. Both at the Basilica in Assisi and the Arena Chapel, Padua, are a variety of frescoes attributed to Giotto, commemorating both St. Francis and the Christian faith. In the Arena Chapel two compositions are of particular interest, the *Flight into Egypt* and the *Pieta*.

The *Flight into Egypt* depicts Joseph, Mary, and the Christ child traveling to Egypt to escape Herod's decree that all first-born children are to be murdered; the *Pieta* depicts the realization that ultimately no parent or child can avoid the tragedies of life. But here we see in visual terms the intellectual and cultural ideals of a renewed Augustinianism. In place of Scholastic and Aristotelian allegory we see the figures presented as real people within a somewhat naturalistic landscape. But it is a naturalism that is informed with divine purpose. It is a fictional composition, but one grounded in experiential truth: it refers to a historical event that occurs within a divine drama. History as understood by Augustine represents not an endless cyclical repetition as held by Aristotle and Siger, nor is it a meaningless or mechanical sequence of events. Rather, history is understood to be part of a mystic drama in time, a drama in which virtue and beauty strive to overcome the pernicious assaults of evil. This understanding of history was articulated by Augustine in his early fifth-century book, *The City of God*; during this period an Augustinian message was proselytized by the Franciscans. But it is a new type of Augustinianism, one

that the Bishop of Hippo might not fully recognize. It is experiential and Biblical, but it no longer clearly operates in a universe where all of reality evidences degrees of transcendent wisdom and beauty.

For Augustine the symbol is not fiction, nor a rationalized Universal. As Communion is understood to indicate the real presence of the divine, history refers to a moral drama unfolding within a numinous world. The symbolic approach in Augustine indicates *experience operating within a purposeful context.* Whereas the symbolism of Late Scholasticism increasingly intellectualizes that experience into an abstract idea, the Augustinianism of Giotto returns to the symbol, but with a shift. It now indicates *the presence of the ideal within experience.* This may seem insignificant, but it marks a profound shift.

Both the traditional Augustinian notion of experience occurring within an Ideal context, and the Late Medieval notion of the Ideal occurring within experience, exhibit a superb and exquisite balance. As such, Giotto's paintings are a magnificent achievement. But Giotto's path diverts from Augustine nonetheless, and that diversion is aesthetic.

Skeptical of Aristotelian and Scholastic logic, and the Scholastic distinction between truth as the mind of God, in the mind of humanity, and in things, the Franciscans advocated a return to a less formalistic way of thinking and living. In place of the philosophy and logic of Scholasticism, and rather than an Augustinian/Pseudo-Dionysian world in which symbols refer to our experiencing degrees of the ideal, they start to emphasize a mystical imitation of the life of Christ. Mysticism relies upon the bond between empirical fact and feeling in that both emphasize the sensual rather than the intellectual. It is then a rejection of Aristotelian Scholasticism; but it is also a rejection of the Augustinian attempt to experience and understand that which occurs within a divinely ordered world. Indeed, it leads to a rejection of any attempt at all to understand the world and life. St. Francis begins his pious journey, but a mystic-empiricist mode contributes to a Nietzschean conclusion.

Just as Augustine would likely be surprised by these changes occurring to the Augustinian approach, so might be Aristotle. For Aristotle the natural world is teleological. Nature is understood to have a goal, a purpose, and a source: the unmoved mover. But a naturalistic Aristotelianism—as had been advocated by the Averroists—separates natural science from teleology and faith, resulting in the assumption that the laws of logic are grounded in an assumedly coherent nature, but not necessarily in a purpose-establishing and transcendent God. This accommodates a mechanistic or pantheistic vision that denies the possibility of free and responsible action. On the one hand, Franciscan mysticism remains in force, but the faith is emotional and scriptural, and to be experienced as such. On the other hand, a quantitative physics undermines a metaphysics of meaning, and thus mandates a meaningless metaphysics. In an increasingly quantitative world, Christian compassion begins to shift from the

sacramental to the emotional, from sympathy to empathy. The shared consequence is that reason is increasingly separated from reality, and therefore from beauty as well. We are now on the path to a meaningless aesthetics, where reason is but rationalization and power.

In summary, the mystical assumption that the world is purposeful due to the presence of the Divine is now incrementally replaced by a naturalistic vision of reality and life, a vision that attempts to assert that the world exists without the presence of objective purpose. As discussed in later chapters, we go from the rational and beauty seeking existentialism of Augustine to the a or irrational aesthetic existentialism of Postmodernity. Hegel, Kierkegaard, Marx, and Nietzsche might appear to be distinct, but they share an existentialist essence that is aesthetic and nihilistic in the end.

Giotto vs. Galileo and Leonardo: Beauty in Retreat

In contrast to the Augustinianism evident in the writings of Petrarch, and the altered Augustinianism evidenced by St. Francis and Giotto, is the naturalistic and aesthetic vision of Leonardo and Galileo. The aesthetic vision is a naturalistic and mystic one, and its adherents span the centuries from the Gothic to the Renaissance and then from the Modernist Enlightenment to Postmodernity. It is an ironic vision in that in its attempt to avoid a metaphysical vision it necessarily mandates a mechanical or random vision that is meaningless and desperate. To understand why a naturalistic and aesthetic worldview makes little sense, the historical context for the rise of that worldview warrants attention.

Leonardo

To compare Giotto's presentation of Mary with that of Leonardo is particularly poignant. In his painting of 1483, *Madonna of the Rocks,* Leonardo depicts Mary in the presence of Christ, John the Baptist, and an angel. It is clear that in place of an Augustinian vision we here are confronted by a very different way of viewing reality and life. The work is empiricist and mystic rather than illuminative in the Augustinian sense. Its empirical concern for a factual depiction of geology and flora is coupled with a mystical concern for feelings. Here that mysticism centers on the psychological more than the theological. Psychology shifts from an Aristotelian and Augustinian mode that centers on our response to a meaningful reality, to one more subjectivist. Its psychological ability to penetrate and depict the interior personal realm of those depicted contrasts with its mathematical structure, whereby the composition evidences a mathematical formalism.

The concern for a minute depiction of geology and flora would strike the Augustinian as a trivial and inappropriate intrusion into a historical *and* metaphysical story. Its concern for the psychological state of those depicted is one that would interest Augustine, but for him the psychological is linked to the historical and the spiritual. For Augustine history itself is psychological in the

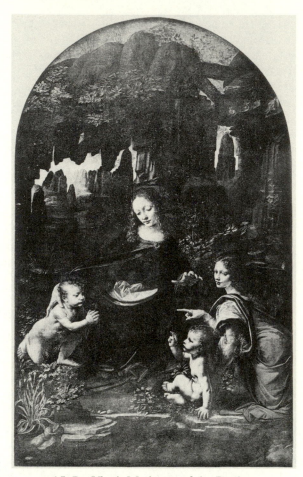

15. Da Vinci, Madonna of the Rocks

sense that the study of history is the study of the soul (lit., psychology) in its worldly struggles. It is the record of the spiritual and moral struggle of the soul, caught as it is between the *City of God* and the *City of Man*. And theologically, the symbolic quality of the worldly seeking to obtain a degree of wisdom and beauty is replaced by a split between the empiric and the mystic, in which we experience the world of facts and participate in the realm of faith.

Leonardo's work is decidedly naturalistic and mystic, linking psychology with a subjective response to a naturalistic and emotional environment. This reduces mysticism, where one traditionally acknowledges the presence of the Divine, to empiricism, where one feels an emotional response to the world and self. In contrast to Augustine's and the Pseudo-Dionysius' association of mysticism with beauty, we encounter a response where mysticism is aestheticized —and so too is love.

That Leonardo's work is both naturalistic and mystical makes sense given that mysticism and empiricism share a common foundation: feeling. But whereas the Augustinians would symbolically associate naturalism and mysticism with objective and intelligible meaning and beauty, there is no evidence that Leonardo shares such a concern. Indeed, as Frederick Hartt points out: in all of the documents produced by Leonardo, there is not one shred of evidence that he ever cared for another human being.

Finally, the implicit geometricizing of the composition indicates a mathematical view of the universe: that there is a harmony to the cosmos that is expressible numerically. But here the mathematics can be seen as naturalistic rather than ontological, formalistic rather than sacramental. Just as his painting of *The Last Supper* focuses on the mathematics of perspective and the subjective psychology of those depicted, here we find reference to a harmony and psychology that no longer suggest a metaphysical foundation.

Leonardo DaVinci's work emphasizes the dual aspects of naturalism: empiricism, and mysticism, a concern for fact and for feeling. In contrast to the Augustinian association of knowledge (scientia) with a superior wisdom (sapientia), aesthetics with a superior beauty, Leonardo views science via a naturalistic and aesthetic vision. He notes the importance of seeking knowledge, scientia, and recognizes the traditional understanding of science as any body of knowledge methodically obtained ("First study science (scientia), and then follow the practice born of that science"[28]); but he also states: "That painting is most praiseworthy which conforms most to the object portrayed," and that:

> The painter should see to it that in proportion and size, subject to perspective, nothing occurs in the work which is not considered, reasonable and in accordance with nature...The good painter has two principal things to paint: that is, man and the intention of his mind.[29]

For Leonardo the objective of art is the subjective cognition of the visible world;[30] in this regard he is close to the Classical notion that the purpose of art is imitative. Nonetheless, there are significant differences. For the Classicist, art is imitative of the natural world, but that natural world is purposeful. As Aristotle put it, nature is not merely the outward appearance of a visible world. Rather, it involves the creative force, the productive principle of the universe; in art and in nature there is a union of matter with constitutive form within a purposeful world.[31] And in contrast to Platonic and Christian tradition, Leonardo decrees: "What is beautiful is not always good." [32] It is a position with shocking implications.

In contrast to Classical and Christian tradition, Leonardo incrementally maintains that art is the product of the artist who is in essence a demigod:

> The divinity which is the science of painting transmutes the painter's mind into a resemblance of the divine mind. With free power it reasons concerning the generation of the diverse natures of the various animals, plants, fruits, landscapes, fields...

If the painter wishes to see beauties which will make him fall in love with them, he is a lord capable of creating them, and if he wishes to see monstrous things that frighten...he is their lord and their creator.[33]

So there are significant differences between Leonardo and his predecessors. Why those differences emerged, what those differences mean, and how they apply to how today we live our lives are important questions. They can now be addressed in reference to Galileo.

As introduced above, Galileo was a primary figure in the advancement of that worldview advocated by Leonardo. Born in 1564, he spent much of his life struggling with the notion of a qualitative physics. He considered the qualitative physics of Scholasticism to be based upon inaccurate and superficial observations, deceptive analogies, and logical formalism. Avoiding involvement in the study of gravity to avoid being associated with occultism, Galileo was aware of the historical association of empiricism with an often dubious mysticism. Nonetheless, he saw an inescapable conflict between the Scholastic worldview, and empirical fact. As a consequence, Galileo facilitated the rejection of the medieval notion of gravity being grounded in divine love (as expressed by Dante), to be replaced by a purposeless physics and metaphysics. In seeking *what* Galileo rejected an empirically impossible *why*.

Because this was recognized as a serious attack on a qualitative universe, the established institutions took action. In February 1615 Galileo was accused before the Holy Office; in 1616 Copernicus was also condemned as a heretic. In response Galileo cited Augustine in his defense of the pursuit of knowledge; however, it was an appeal with which Augustine could not have agreed. The significant issue is that the Scholastic reliance upon Aristotelian physics is associated with Aristotelian ethics; both unite to form a Scholastic worldview. So if the physics fall, then what of morality? The threat to the Scholastic status quo was clear: if ethics and nature have no objective and purposeful grounding, then neither can be qualitative. The believers in a qualitative world rightly worried that a shift to a quantitative physics would result in a shift towards an amoral nihilism.

It is a historical tragedy that those in power did not couple the defense of beauty, of a qualitative universe, with the free pursuit of truth. Unwilling to abandon Aristotelianism, it could not effectively face the intellectual challenge resulting from Conceptualism and Nominalism. The Scholastics and traditionalists choose to focus on a dispute over fact. This had been done previously, and successfully; but this time the facts were not on their side. And so, the notion of a qualitative universe suffered a ghastly blow. Had the comparative merits of a quantitative and qualitative physics been addressed, rather than the factual issue of whether the Earth circled or was circled by the Sun, then a very different cultural history might have resulted. The pursuit of beauty might not have been relegated for centuries to being a substratum of Western culture. As Frederich Heer puts it so concisely:

[There is a] basic law of intellectual history: whenever the thinking of a religious, political, or social group is forced into a corner by some specific historical circumstance, usually in a life and death struggle, the shock of this experience creates a psychological block which can prevent further thinking in a given traumatic area for centuries afterward. In other words, whole complexes of ideas and impressions are simply blotted out.

All human thought exists in a complex dialectical relationship with its given historical and social environment. This subtle interpenetration accounts for the bitterness of intellectual struggles...Something which the Church, the bearer of tradition and the guardian of the Christian inheritance, had found useful enough in its fight against some sect, philosophical tendency or political movement in the second century might be revealed in the fourth century as heresy....A heresy is no more than an attempt to solve all the intellectual and religious difficulties of a given time at once.[34]

What then is the heresy committed? Just as Classicism attempted and failed to adequately solve the problem of tragedy, the Scholastics attempted and failed to solve the problem of why the existence of God matters if truth can exist in nature as fact, and in our own minds as thought. This was compounded by the vexing non-Augustinian issues of the infinite vs. the finite, the universal vs. the particular. The pursuit of wisdom is thus viewed as a logical problem by Conceptualism, leading to an aestheticized rationality where only fact, feeling and ultimately power matter.

Galileo accurately noted that certain empirical facts differed from then current Scholastic tradition. The truth in our minds thus appeared to conflict with the truth of God and creation as understood by Scholasticism. But consider that the aesthetic Modernist alternative that we construct reality to conform to how we think is equally suspect. This suggests that history includes both tragedy and farce; it is tragedy when purpose is denied; it is farce when we are the cause of tragedy.

Particularly appropriate is how Sigmund Freud spoke of such issues in his essay on narcissism.[35] In that essay Freud addresses the relationship of cosmology and psychology; that how we understand the world is linked to how we live our lives. He refers to the broad shifts in worldviews that occurred through the ages, with particular emphasis on the relationship between those worldviews with narcissism, and the destructive propensity for self-love. He states clearly that a subjective-objectivity is violent, infantile, and sociopathic. He refers first to the Ptolemaic position, formulated by a great Alexandrian mathematician of the Second Century, a position that held sway for many centuries. Reliant both on mathematics and empiricist study, Ptolemy holds that the cosmos revolves around the Earth. Freud understood this worldview as both comforting and narcissistic. We exist in the center of the Universe. Freud cites the Copernican revolution where that worldview is shattered: rather than being in the center of the Universe, Copernicus argues that we are on an orb flying through space around the Sun. This Freud calls an initial, cosmological, blow against narcissism: we are no longer the center of the Universe. Freud

next posits the biological blow to narcissism: Darwin denies that reason and the soul distinguish human from animal. Consequently, the inherent narcissism of humanity suffers yet another blow. Finally, Freud cites the psychological blow to narcissism, where the ego is not master in its own house. He argues that Psychoanalytic analysis of humanity establishes that our reason is no longer viewed as the controller of our destiny. So he posits an assumedly progressive transformation from an ego-centric rationalism and physics to a perhaps more enlightened and empirical recognition that we are neither the center of the cosmological or biological universe, nor are we necessarily in rational control of our lives.

It is useful to recognize that Freud's analysis is aesthetic: at issue are facts, feelings, and rationalization. There is an irony present, however, in his aesthetic approach to culture. Although Freud laments the destructive influence of narcissism on culture, an emphasis on facts and feelings leads to a destructive narcissism. He laments the narcissistic assumption of the end of history, even though (as discussed later) the aesthetic worldview leads to that conclusion. If one considers the role of the Modernist tradition in the historical unfolding of culture, it is clear that the narcissism so troubling to Freud is ironically the necessary conclusion of Modernism and Postmodernism. .

A strong case can be made that we have come full circle from and to a narcissistic vision of reality and life. The world revolved around humanity for Ptolemy as well it does for the Modernist relativist. From the ego-centrism of Ptolemy we yet again follow the narcissistic steps taken by the culture of the Renaissance and the Enlightenment. This narcissistic shift is from truth-seeking to world-making, where *reality conforms to how we think and feel*; it will be discussed in detail in the next chapter. And since narcissism is destructive to the very possibility of culture, then our current situation warrants serious remedy.

Note, however, that just as not all ancient Greeks believed in Classical culture, not all figures that lived during the period of the Renaissance believed in and lived by the ideas and ideals of Renaissance empiricist belief. The empiricist culture of the Renaissance period is primarily grounded in a rejection of Scholasticism and an embracing of mysticism, empiricism, and various Pre-Scholastic traditions. It also involved a rejection of transcendence. But there were many who remained committed to a non-empiricist pursuit of culture, indeed of beauty, regardless of the difficulties involved.

Raphael and Scholasticism

"In sum this graceful and holy beauty is the highest adornment any thing can have, so that one can say that in a certain sense good and beauty are one and the same thing."
—*Balthasar Count Castiglione*[36]

In his great fresco, *The School of Athens* (1510-11) Raphael is not so much an innovator as a synthesizer. As discussed previously, the painting depicts in grand form a group of famous thinkers gathered about the two primary expositors of Western Classical thought: Plato and Aristotle.

The figures are depicted in a Leonardesque fashion: there is a clear, even mathematical precision to the composition coupled with a psychological intensity so common to Leonardo's art. But the point of the work is neither formal nor merely psychological. The perspective of the work is not that of an actual person standing before the work, but rather, is transcendent. It beckons us to gaze from a higher realm. Plato is depicted holding a copy of his cosmological book, *Timaeus*, while pointing to the heavens, while Aristotle holds a copy of his *Nichomachean Ethics* and points towards the ground. What is depicted here is an attempted philosophical reconciliation of the ideal with the empirical. That reconciliation lies at the heart of the philosophy of Scholasticism as developed particularly by Thomas Aquinas. Aquinas attempts to synthesize Plato's transcendent idealism with Aristotle's empirical realism; the ideal is God, and creation is the concrete and necessary gift of God's love.[37] As discussed previously, Aquinas, following both Abelard and Albert Magnus, holds that the ideal exists in the mind of God independent of things (ante rem), as intelligible forms in things (in re), and as concepts in the human mind formed by abstracting from things (post rem).

The *School of Athens* is not a singular work. Rather, it is part of a larger composition. Whereas the *School of Athens* represents philosophical truth, to its right is a fresco (*Justice*) depicting moral truth, to its left is the theme of artistic truth (*Parnassus*), and before it is divine truth (*Disputa*). According to Michael Greenhalgh:

> The Stanza della Segnatura, therefore, by the very juxtaposition of its scenes, displays a scheme for living. Rational Truth does not confront Divine Truth in the sense of wishing to oppose it, nor is Artistic Truth opposed to Moral Truth as divined by Justice. Rather, all four elements echo each other, and indeed are shown to be related...[38]

That they are here related is clear; what is not is whether the mind of God is necessary. If not, then thought has no purpose beyond power and pleasure, and lacking purpose, the School of Athens collapses. During the Renaissance three major cultural visions are then in contest: a lingering Scholasticism, an increasingly neglected or transformed Augustinianism, and an aesthetic view, be it Franciscan, or that of the proponents of Naturalism. Scholasticism had been the dominant cultural vision, but it found itself primarily in a struggle with mysticism and empiricism, particularly an empiricism that contradicted traditional cosmologies. The result is that the Scholastic House of Life was shaken to its foundations, resulting in the confusion of Mannerism, and a subsequent Baroque reevaluation of reason, emotion, and beauty.

Where then does this leave us? The essential point is that fine art attempts to explain reality and life; how we view reality affects how we treat other people, and how we view reality and how we treat each other is manifested in art. The Aristotelian aspect of Scholasticism is evidenced by the attempt to understand reason as discursive and logical, where reason complements matter, and exists in nature, in the mind of humanity, and/or in the mind of God. In contrast, the Platonic and Augustinian understanding of reason is that of an informed intuitive understanding of things. Reason is the apprehension of the nature of a thing, which is situated on a spectrum raising from the material and mundane to the spiritual and divine. The tension between these two ways of understanding the world is the same as that between aesthetics and beauty. The problem is that when beauty or truth can exist in the mind of God and/or in the mind of humanity, then the divine is unnecessary. It permits the transcendent to be ignored or denied, and in so doing it ignores or denies the essential aspect of the ideal. In its place rise empiricism and mysticism—or rather—aesthetics and power.

This is made manifest not only by a consideration of the writings of a principle philosopher of the period, Machiavelli, who advances the logic but consequently rejects the worldview of Aquinas and Dante; it is evidenced by the artistic results of the will to power evidenced by the notorious Sigismondo Malatesta. Notable for the distinction of having been publicly consigned to Hell while still alive, Sigismondo was simply a thug. In 1450 he commissioned the architect Alberti to continue the conversion of the monastic Church of San Francesco at Rimini into a temple dedicated to himself and his principal mistress—for whom he had his wife suffocated. Not only would it be a temple of fame and a mausoleum for he and his mistress, it would house the sarcophagi for the humanists (if they can so be named) of his court. Alberti spoke of beauty as: "...the harmony and concord of all of the parts, achieved in such a manner that nothing could be added, taken away or altered."[39] From patronage to completion, this project reeks then of hypocrisy. That Alberti pursued such a project speaks poorly of the state of culture at that time.[40]

Michelangelo and Mannerism: the Shift from Beauty to Aesthetics

"Whoever restricts beauty to the senses is most ill-advised."—Michelangelo[41]

Upon walking into the Sistine Chapel in Rome, we are undoubtedly impressed by the aesthetic spectacle hovering above: a grand composition of Biblical and Classical themes painted magnificently by Michelangelo (1475-1564). But is it ultimately beautiful, and if so, can we understand, that is, see, its beauty? Is the composition the presentation of truth, or is it merely a historical and aesthetic achievement of so-called personal genius?

It is clear from Michelangelo's own words ("Whoever restricts beauty to the senses is most ill-advised") that to appreciate this work of art merely aesthetically, merely sensually, is foolish. The alternative then is to examine its truth claims, and to see if those claims are substantial. The degree to which those claims are substantial will correspond with the degree to which we love the work, and see its beauty. Beauty is associated with understanding, and understanding is linked to reason that is connected with reality. The different understandings of reason as presented by Aristotle and Plato are evidenced in Michelangelo's art. His monumental task of painting the ceiling of the Sistine Chapel evidences a viewpoint that Giotto and Petrarch would largely appreciate. Painted in the period from 1508-12 it attempts to present in visual form a philosophical and theological explanation of reality and life. That explanation is essentially but not exclusively Platonic in that it evidences a hierarchy from the mundane to the divine, from the aesthetic to the beautiful. By free acts of will, the diligent soul can ascend from the trivial to the profound.

Looking up at the ceiling, the lowest level represents the world of matter, the next level represents the world of becoming and the highest portion of the ceiling represents the realm of *being*. Respectively, Michelangelo depicts figures driven by mere physical desire, those inspired by theology and philosophy, and ultimately, those informed by faith. Michelangelo accepts that beauty is objective, or rather, divine, but that it is experienced subjectively. The Sistine Chapel ceiling is an epiphany: it declares that there is truly cause for optimism, that the world is both meaningful and beautiful.

In Platonic and Augustinian fashion, Michelangelo holds that Nature is beautiful since God created it, but there is a Beauty that makes possible the beauty of nature: the intelligible beauty of Truth and Love. The freeing of the objective ideal from the material is given plastic form in his great sculpture, the *Boboli Captive* (c. 1530-34). It shows a human figure struggling to emerge from the stone. Unlike Laocoön who is depicted as the victim of arbitrary fate, Michelangelo shows the human soul attempting to rise above mere physical constraints and desires. But the optimism so evident in the *School of Athens* or the Sistine Chapel ceiling is lacking in the *Boboli Captive*. It is no longer self-evident that the desire to rise above the material and mundane is present or even plausible. The crux of the problem is that when Divine and moral beauty are separated from the physical and aesthetic (Aristotle), and the necessity of the divine mind is disputed by fact (Naturalism), or reduced to a concept (Conceptualism), then beauty, goodness, and divinity, become a matter of taste—and the will.

Michelangelo laments that "Good taste is now so rare, the world is blind," and that "The heart is slow to see beyond the eyes."[42] That lamentation indicates a decline from the Augustinian position that to see beauty one must understand wisdom, or the position of Pseudo-Dionysius that we ought to reach out for purposeful *being*. In science and art, the lack of universal prin-

ciples to guide one's taste results in good taste becoming problematic rather than an initial step towards beauty. Either it is the rare privilege of an alleged subjective genius, which cannot be taught, or it has no grounding beyond power. In either case it presents a worldview that is increasingly unintelligible. That worldview is Mannerism.

Mannerism

The triumph of nominalism and empiricism over Scholasticism (where the infinite universe prevails, and where universals are just words) results in the conclusion that the world is unintelligible, and facts and feelings are all that remain. That conclusion is central to Mannerism. What is Mannerism? A unifying factor of Mannerist art is the transformation and rejection of Classical and Christian traditions that maintained the significance of reason in providing a glimpse of beauty. Raphael's (and Aquinas') grand reconciliation of theology, philosophy, and science, is not so much under assault, as it is under a gradual dismissal. The empiricist position, advanced by Leonardo and Galileo that truth exists in the thing (in re) and is recognized in our minds (post rem) denies the necessity of Truth having a purposeful grounding in the mind of God (ante rem). The universe, therefore, no longer is or can be understood as purposeful or beautiful. Rather it is naturalistic, mystic (in an immanent fashion), and aesthetic. In each case, facts exist, but they conform to our varying perceptions, predilections, and our will. Indeed, the 16th century artist Pontormo presciently asserts in a letter to his contemporary and peer Vasari, that art changes nature; a variety of writers declare that poetry is beyond truth and falsehood, and not linked to historical reality.[43]

As we shall see in the next chapter, such assertions are close to those of Modernist and Postmodernist culture, and indeed it was during the time of Modernism and Postmodernism that Mannerist art received renewed scholarly interest. It is not surprising to find that Mannerist artists, long ignored as second rate, were gradually rediscovered by those whose values were so similar. Nor is it surprising that Mannerist art remains unappreciated by those who value beauty.

The two mainstreams of culture in the West, Platonic/Augustinianism and Aristotelian/Scholasticism experience a common transformation. The traditional Augustinian notion of experience occurring within the ideal shifts; Giotto's position that the ideal is present within experience comes to the fore. Giotto (and Petrarch) represents a later type of Augustinianism, a type which differs yet again from that of Michelangelo's. The seemingly small difference is that for Michelangelo the intuitive reasoning of Plato and Augustine is subjectively experienced more than intellectually comprehended. That is, for Plato and Augustine the world is understood to be intelligible whereas for Michelangelo the intelligible world is to be experienced. Intuitive reason shifts from the Augustinian notion of the objective light of understanding

which leads to wisdom, to the subjective experiencing of belief. This shift from the objective to the subjective is primary to the shift from ontology to epistemology, and from beauty to aesthetics. It is by such small changes that truly significant changes result.

Similarly, for Aristotle the world is teleological and cosmological, but via the perspective of empiricist and nominalist thought (such as embraced by Leonardo and Galileo) an immanent and naturalistic Aristotle now comes to the fore. The shift away from a cosmos that makes sense and can be understood to a cosmos that is immanent and a matter of descriptive fact and subjective feeling occurs. It contributes to a shift from intelligible (moral) beauty to emotivism, where all judgments of value are seen to be a matter of subjective opinion or feelings.

The Mannerists pursue this new naturalistic and emotive understanding of the Classical and Christian traditions. The result is a new type of Platonism and Aristotelianism distinct from the original Plato and Aristotle and distinct from Augustinianism and Scholasticism as well. Its unifying doctrine is an increasing shift from understanding to the realm of experience, a shift that advances the change from transcendentalism to immanentism. In sum, a rejection of Scholasticism is involved, where traditional Platonic and Aristotelian concepts are no longer used to understand the purpose of reality and life. Rather, they emphasize an experiencing of reality and life. That reinterpretation of the Classical tradition in particular leads to a radical transformation of that tradition, and to its eventual decline.

It is useful to recognize that the substance of Western culture has consistently focused on Classicism and Christianity. In each case the figures associated with those traditions have been re-evaluated. Just as the meaning of Jesus Christ has been understood differently through time, so has the meaning of the ideas of Aristotle and Plato. This is not to conclude that skepticism is inevitable; rather, it is to suggest that both wisdom and error are possible over time.

Aristotelianism has been interpreted in a variety of ways over the ages. During the late Medieval and early Renaissance periods, it was an Averroist Aristotle who was widely venerated, offering an understanding of Aristotle that he himself would scarcely have recognized. Then, during the Mannerist period yet another Aristotle emerges: one where a primary goal of art is pleasure. It accepts the traditional Aristotelian notion that the purpose of art is aesthetic, and that a lofty form of aesthetics is accessible—*to the refined*. However, the teleological source for that refinement, a rational contemplation which mirrors the divine mind, is now less convincingly inspirational. Rather, refinement and pleasure are grounded in an experiencing of a naturalistic universe. For example, Girolamo Cardano argues that it is by experiencing harmony in things that we experience beauty.[44] But to reduce beauty to experience is to subjectify and aestheticize it; for this to work, Aristotle assumes the need for a refined and elegant audience. But how can refinement and elegance

be more than a stylish facade in an aesthetic culture? Indeed, perhaps Nietzsche is right: better to be authentic than refined – or good.

Mannerist art is dedicated to an independence from accepted rules, a celebration of freedom and the psychological, although neither could affirm any glimpse of intelligible beauty. Giulio Cesare Scaliger (1484-1556) defines the Classical term *imitatio*, or imitation, as the representation of things according to the norms of nature,[45] but those norms are now problematic since he also regards the artist as a creator:

> It would seem that art not only tells us of things, as for example, the actor does, but also builds them, like some second God.[46]

To the point, Aristotle is now being discussed not in the context of a cosmos that is objectively purposeful, aspiring to a transcendent unmoved mover, but rather in a Galilean and Copernican cosmos that is naturalistic and no longer necessarily purposeful. It is a formalistic cosmos of fact, feeling, and the will. Scaliger evidences an immanentist advocacy in his definition of beauty:

> The beauty of the parts of the body depends on their pleasant appearance which results from their proper dimensions, shape, and colour. The body is beautiful when the parts are proportional. Therefore, the cause of beauty is self-consistency.[47]

This new naturalistic and experiential form of Aristotelianism is oddly compatible with Platonist/ Franciscan mysticism. The unifying notion is sensuality: that the cosmos, reality, and life are factual, naturalistic, and a matter of experiential fact and refined taste. It is worth recalling, however, Michelangelo's concern: "Good taste is now so rare, the world is blind." The difficulty is that in a world of experienced taste there is no objective way to discern *good* taste.

Good examples of Mannerism in art are found in the art of Pontormo. His *Joseph with Jacob in Egypt* (1518) contrasts with Raphael's *School of Athens;* it depicts a world that does not really make much sense.

The painting is disjointed in composition and irregular in scale: perspective is violated as is any sense of a unified space. In a single pictorial presentation three distinct occurrences in time are simultaneously depicted. In the upper right corner is shown the dream of the Pharaoh, Joseph's interpretation of which secured for him a high position. In the center of the painting is a staircase leading nowhere, overshadowing the story of Benjamin being found in possession of Joseph's silver cup, a deception by Joseph to force the return of his brothers to the city in Egypt where he lived. Last depicted is the reunion of Joseph with his father in Egypt.

The subject matter is part of a Biblical story (Genesis 42ff), a story that defies Scholastic Aristotelian logic while affirming a willful God and willful human manipulation. It presents the position that if at all, Divine purpose is

17. Pontormo, *Joseph in Egypt*

experiential rather than rationally understandable. Like Laocoön, the story makes little sense: Joseph's betrayal by his brothers, who sold him into slavery in Egypt, results in the salvation of the tribes of Israel; multiple deceptions result in a happy conclusion. The illogic of these events defies even the admonition in *Romans* that all things work towards the good for those who believe in God. God may work in mysterious ways, but standing alone, this passage presents a mystery beyond the possibility of human or even divine logos. It is not the mind of God that appears paramount, but rather, the will of God. A will that is aesthetic rather than beautiful; it is a will that is now a matter of divine taste. Similarly, his *Deposition* of 1526-28 depicts the moment of most uncertainty in the Christian saga. Christ has been crucified and died, but not yet resurrected. And this painting evidences little confidence that a resurrection will occur.

This is evidenced in the writings of Giordano Bruno (1548-1600). Disaffected with the anti-Scholastic Aristotelians, yet unsatisfied with the Augustinian concept of aesthetics leading via the Incarnation to intelligible and spiritual beauty, he embraces the notion of beauty being corporeal, or rather, aesthetic. Predictably, he holds that such beauty is relative and diverse:

Nothing is absolutely beautiful..., if it is beautiful, then it is beautiful in relation to something... Since beauty consists in a certain symmetry, and since the latter is diverse and incalculable, not simple, it follows that the impact of beauty is not simple and unqualified. Different species and different individuals are attracted by different things. One symmetry attracts Socrates, another attracts Plato, one attracts the mob, another exceptional people...[48]

And given his initial premises, logically concludes:

The essence of beauty, like the essence of pleasure or good, is indefinable and indescribable.[49]

The Reformation and the Baroque: Faith and Reason

During the Mannerist period there develops an increasingly aesthetic mode: in place of ontological reason, fact and emotional commitment prevail. In contrast to the universe being a continuum from the material to the Divine or *Being* (as understood by Augustine), there is a further developing of the Scholastic idea of the world being a perfection within a now tenuously purposeful universe. Since truth can exist in both the mind of God and the mind of humanity, the logical conclusion of naturalism is that the former is not all that necessary. If accepted nonetheless, then divine truth is to be understood not via reason, but by authoritative scripture and emotional commitment.

The trend then is towards a skeptical empiricism and a subjective mysticism. So the world is naturalistic, and purpose is either denied via a secular naturalism or affirmed by a faith in revealed truth as established by a reliance on authoritative Scripture. The Bible is accepted as an authority from which truth comes rather than the source of truth, which consequently is authoritative.

The role of theological reasoning is increasingly contested by those committed to fact and feeling. Moreover, traditional theology becomes suspect as newly discovered facts of natural science contest it; in its place an emotional response to the authority of Scripture comes to the fore. Naturalism succeeds in distinguishing physical fact from fiction, but it is a limited success in that it cannot provide any answer to the question why, and thereby assumes an individual or social determination of beauty, goodness, and justice. This involved a variety of spiritualist movements that threatened the very existence of civilization. A culture that cannot make objective value distinctions is no culture at all.

The Scholastic foundations of the West were shaken to its core, with two figures offering different solutions to the crisis: Luther and Descartes. Each was critical of the status quo, and each offered a distinct yet related solution. Those solutions are characterized by Luther's *Credo, ergo sum* (I exist by Faith), and Descartes' *Cogito, ergo sum* (I exist by Thought).

Martin Luther (1483-1546) was well versed in Scholastic philosophy but soon came under the influence of the nominalism of Occam. In May of 1505 he renounced the world and entered the monastery of the Augustinian Eremites at Erfurt. He became an ordained priest in 1507 and continued his theological studies with increasing influence from the teachings of Augustine. But it was an Augustinianism deeply influenced by the cultural battles of the time. Luther rejects the logic of Scholasticism, and embraces an Augustinianism within a time period in which empiricist and mystical influences abound. The facts of Scripture and the Grace of God are central aspects to his understanding of the Christian faith. That understanding involved a reevaluation of the need for liturgy, and of the meaning of Sacramentalism as well.

According to Augustine a *Sacrament* is an outward manifestation of inward grace: it is the physical representation of a divine presence. As noted in the previous chapter, in the study of beauty we find that how the Sacraments are understood correlates with how the fine arts are understood and valued. In contrast to Scholastic tradition, which recognizes seven sacraments,[50] it is generally agreed that Luther accepts but two: Baptism and Communion. In Scholasticism, Sacramentalism is closely associated with beauty; beauty is the splendor of ontological form, and the source of ontological form is God. By that is meant that objects of beauty embody that which is right within a purposeful world. So too with liturgy, which can be viewed as a kind of divinely inspired performance. But with the shift away from a sacramental universe, and towards a naturalistic universe perhaps presided over by God, the understanding of art and beauty pursues a new direction.

It makes perfectly good sense that—in the presence of a meaningful world —at some point facts become more than factual and they enter the realm of understanding. And the movement from fact to understanding is seen as a qualitative one. No doubt this occurs—who has not attempted to read a book in which all of the vocabulary is understood, but the meaning remains beyond comprehension? And who has looked at a work of art with perfect vision but no or little understanding? But explaining how occurs such a transition from fact to meaning, or from the material to the spiritual, is difficult beyond stating that such illumination occurs. For example, the Sacrament of Communion is Scholastically understood via the idea of transubstantiation. Transubstantiation is the term applied to make sense of how the bread and wine of communion becomes more than just matter. Just as fact and aesthetics miraculously become intelligible and beautiful in the pursuit of truth, the bread and the wine are transformed from the material to the spiritual in that same pursuit.

Augustine views the sacraments and art symbolically (not fictionally): as evidence of the presence of the divine; that presence is a matter of degree, its absence a matter of *omission*. The Pseudo-Dionysius views the sacramental and art in terms of conversion, with each witnessing a direct relationship of the material and the divine, a failure to embrace such a relationship is to do so as

a matter of *commission*. It indicates a deliberate failure to seek being. Those traditions that embrace conversion or transubstantiation are more iconic in their approach to art—and life.

Protestant traditions that reject transubstantiation view communion and worship as a symbolic act done in remembrance of Christ, and view art as reminders of important lessons and events. We find that within the Protestant tradition art is a skill, and fine art is commonly that which is naturalistic or that which reminds us of that which is historically important. Fine art does so by the literal depiction of significant events or persons, or it can do so by touching us emotionally with the aim of bringing our attention to that which is divine.

The Protestant Reformation

"Only God knows what Beauty is."
—Albrecht Dürer[51]

Albrecht Dürer (1471-1528) was considered by his friend Luther to be one of the best of men.[52] This is not surprising since the bond between these two figures is remarkable. As did Luther, Dürer lived first in a Scholastic culture, but later in a culture quite different. Like Luther's faith, Dürer's art is one that is both naturalistic and spiritual. He writes: "Never think that you will or could make anything better than God had enabled nature to do. For your power is as nothing compared to the work of God."[53] Dürer was committed to a naturalistic and faith-bound vision of reality and life. What then of Beauty? As Luther admonishes us to be humble before the presence of God, Dürer acknowledges that Beauty is equally mysterious and subject to divine explanation. But in this case that is not to suggest that Beauty is subjective. Dürer proposes a solution to the dilemma of recognizing beauty while holding that it cannot be defined:

> If we ask how we should make a beautiful figure, some will reply: in accordance with the opinion of people. Others, however, will not agree with that, nor do I agree...A judgement about a beautiful form is more credible coming from a painter who has a knowledge of art than from those who are guided by mere instinctive fancy.[54]

Within this view it is not surprising to see Dürer painting self-portraits; he is the expert whose knowledge of art permits his judgment to be authoritative, just as a pastor's knowledge of the Bible provides a coherent theology. What then is his judgement concerning beauty? Dürer relies upon long standing principles: that it is grounded in harmony, moderate, and proportioned. He recognizes that such notions of harmony, moderation, and proportion might vary ("Many are the forms and causes of Beauty"), and disquietingly wonders: if there are many such forms and causes, then in what does beauty consist? What Dürer is confronting in terms of beauty, Luther confronted in terms of faith: the priesthood of all believers, without guidance, will lead to chaos.

To escape that chaos, two sources are relied upon: the Bible and inspired historical leadership. Lutheran theology takes Scripture as its primary foundation, and formulates a limited creed based upon that foundation. Dürer presents both scripture and creed in his painting of *The Four Apostles* (1526). On the left panel St. Peter is in the background, not surprisingly since the Catholic position is that Peter is the rock upon which the Church is to be built. In the foreground is the Apostle Paul, whose theology (particularly that expressed in his Book of Romans) is so crucial to the Protestant Reformation. Those figures are painted over several quotations from Luther's German translation of the New Testament. They refer to the spiritual and political importance of not confusing the acts of humanity for the acts of God. An intense empirical and mystical vision, the figures are presented factually and psychologically in the presence of the Divine. For that reason they are presented as historical figures to be admired and emulated. Here a uniform approach to theology and painting is depicted: a naturalistic world in which the written Word permits, indeed necessitates, value judgments. Scripture places the ideal within the realm of experience.

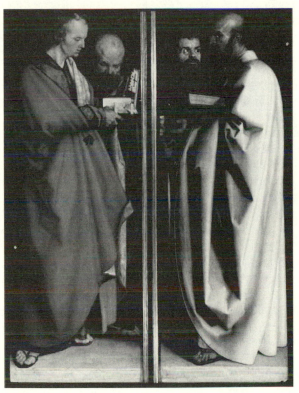

19. Dürer, *The Four Apostles*

For Augustine, the naturalistic world of fact is of but secondary importance; for late Scholasticism intelligible theology is more important than mystic experience and doctrine based upon scriptural authority. Now common to Lutheran and Franciscan alike, there is the will of God, and the will of humanity, with the devout holding that the latter is no gift but a burden, and the secularist holding that it is the most important gift—or trait—of all. In each case, what is crucial is the fusing of experience with belief. As Luther put it in a sermon on the 35th chapter of the Book of Moses:

> Therefore I have often given the admonition, that one must be far from separating from each other life and doctrine. The doctrine is that I believe in Christ, regard my work, suffering, and death as nothing, and serve my neighbor, and beyond this take no further account of what I ought to be. But the life is that I choose this or that course and act accordingly...thus there is not nearly so much dependent on life as on doctrine, so that, although the life is not so pure, yet the doctrine can nevertheless continue pure...Thus there is not nearly so much dependent on life as on doctrine...

Doctrine for Luther is primarily lived Biblical faith; art for Dürer is lived experience within a world in which the Ideal is present. But how are the choices that we make to be decided? And publicly who makes those value judgments? In the face of a growing cultural and theological anarchy (the Enthusiasts were eventually banned) Lutherans rely upon inspired historical leadership while composing their creeds.

The creeds of Lutheranism are of course theological. As such they represent the attempt to rationally understand the faith. Similar to Augustine's approach, the attempt is not discursive or Aristotelian. Rather, it aims to be grounded in Scriptural authority. But altered by Luther is Augustine's symbolic approach to art and the Sacramental. The world does not rise by degree towards an epiphany of meaning. There is the authority of Scripture, accompanied by naturalistic fact, and faith. So although rejecting Scholasticism, its influence remains: there is God and God's mind revealed via Scripture, there is inspired historical leadership, and there is a naturalistic world One result of this view is that the authority of Scripture determines truth. But what if that authority is not acknowledged? What if bad taste prevails?

Just as both Dürer and Michelangelo worried about the scarcity of good taste, Luther worried about corrupt leadership, and the acts of man being confused with the acts of God. The purpose of the Lutheran Creed is not to focus on explaining the relationship of the universal and the particular, nor pursue a comprehensive understanding of reality and life. The goal is to reconcile understanding with Scripture and both with personal and social existence. Neither Luther nor Dürer was comfortable with relegating judgments of faith and beauty to instinctive fancy or to the mob. Grace is supreme but antinomianism is denied. What then of art and the sacraments?

In his 1525 treatise, *Against the Heavenly Prophets in the Matter of Images and Sacraments*, the relationship of beauty and faith is clearly established. The treatise is a response to Andreas Bodenstein von Karlstadt (born ca. 1480). Karlstadt had first opposed Luther, but due to the influence of Augustine, later became Luther's advocate. However, he soon became a leader of a movement distinct from anything Luther (or Augustine) could condone. Karlstadt sought to destroy everything associated with traditional liturgy, including the use of vestments and works of art. It was in response to his efforts that caused Luther to preach against what he called the destructive mob.

Luther's position is that Scripture is to restrain the tendency towards a destructive mysticism, a mysticism that would lead to the destruction of the Christian faith and society. Indeed, he finds the very desire to destroy works of art and to deny the reality of the Sacrament of Holy Communion to be acts of evil pride. Luther argues that key to escaping idolatry is not the destruction of images, but rather the emancipation of the heart from the need for idolatry. In words reminiscent of the Iconoclastic Controversy of the Medieval past, he holds also that:

> ...[A]ccording to the law of Moses no other images are forbidden than an image of God which one worships. A crucifix, on the other hand, or any other holy image is not forbidden. Heigh now! You breakers of images, I defy you to prove the opposite![55]

Luther concludes with the observation:

> If it is not a sin but good to have the image of Christ in my heart, why should it be a sin to have it in my eyes? This is especially true since the heart is more important than the eyes, and should be less stained by sin because it is the true abode and dwelling place of God.[56]

Central to the dispute between Luther and Karlstadt is the issue of the role of reason and the nature of beauty. Luther finds Karlstadt's position to be dangerous. In the hands of those lacking a deep and profound knowledge of faith, Luther considers reason the handmaiden of violence. Indeed he associates the willful destruction of art with the destruction of people. To make his point Luther illustrates the danger of taking scripture literally but out of context. He points out that those who wish to destroy art by referring to Exodus 20:23, must reasonably also find solace in doing acts of violence to people by citing Deuteronomy 7:16. He concludes:

> If I were to destroy images in the same sense as they, I, too, would be compelled to follow through and command people to be murdered. For the commandment stands there pressing its claim. Dear lords, the devil does not care about image breaking. He only wants to get his foot in the door so that he can cause shedding of blood and murder in the world.[57]

So Luther rejects Scholasticism and advocates a Scripture based faith where the excesses of reason are limited by Scripture and lawful church and governmental authority. And as Dürer held that judgments about beautiful forms are more credible coming from a painter who has knowledge of art, Luther agreed that the same can be said of theology.

Indeed, Luther (prescient of the French Revolution) was concerned that unprincipled reason or exegesis will lead to rationalized murder and he is concerned that the doctrine of Grace will result in Antinomianism where sin no longer matters. The Christian life is to be lived, not minutely analyzed or reduced to obscurantism. That life is based upon an imitation of Christ. People and works of art are to serve as examples and reminders of that Divine life. But this position requires faith to be a given, and it relies upon the authority of inspired historical leadership; just as for Aristotle, a refined audience is expected of art—and politics. The crux of the matter remains: in the Protestant North, given Luther's *Credo, ergo sum*, that we exist by faith, what happens when that faith is not publicly agreed upon, or conversely, what happens when that faith is rooted merely in the willful authority of some, or of all?

The Baroque

Three trends continue to develop during the Baroque period: naturalism, mysticism, and a rationalism that is no longer intelligibly linked with God. These options remain with us to the present, within a variety of manifestations. The tradition of naturalism, with ancient sources in both West and East, and well advocated by Galileo and Leonardo now continues in the work of Vermeer (1632-75) in the North, and Caravaggio 1571–1610 in Italy.

Comparatively uninterested in theory, Caravaggio's art is dedicated to a naturalistic representation of subject matter. That dedication was not typically appreciated by his peers. In mixing naturalism with theological subject matter, he offended many by a vulgarization of religious belief in favor of a problematic religious experience. Caravaggio's art focuses on fact, feeling, and power; so does his life.

In his painting of *Mary with the Christ Child*, he depicts an impoverished young women standing in a tenement doorway, confronted by two visitors. Both Mary and her two visitors are dressed in rags. The visitors are kneeling before her and the Christ child, confronting the painting's viewer at eye level with the filthy soles of their feet. This tendency to present traditional themes naturalistically was ostensibly intended to establish a more immediate and emotional contact with the historical event and all that it represents. Mary and Christ are no longer associated with cosmic ideals, nor with royalty—such as with Blanche and St. Louis at Chartres Cathedral in France. But such familiarity might well be a sign of contempt. At some point humanizing Mary and Christ crosses the line and vulgarizes divinity, and a vulgarized divinity is no divinity at all.The figures in Caravaggio's art are often highlighted as if by a

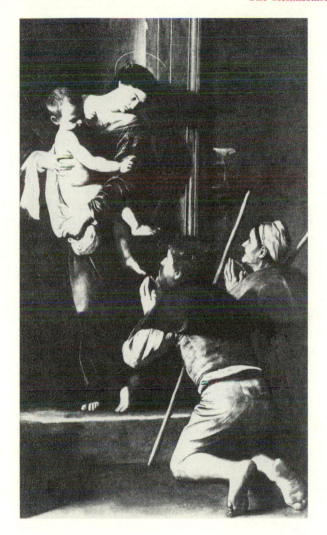

21. Caravaggio, *Mary and the Christ Child*

spotlight for dramatic effect. Augustine's Illumination Theory of Art under-
stands light to symbolize wisdom, rising from the physical to the intellectual,
from fact to meaning, within a numinous world. In contrast, Caravaggio's use
of light is naturalistic and emotional. The technique of *tenebrism* employs the
use of light for these purposes; it is employed to convey a naturalistic and
mystical content. But as Plato presciently argued, the combination of natural-
ism and mysticism is unstable; they share a foundation in feeling, and such
feeling shifts between and within the material and the emotional. In neither
case is reason and understanding primary.

The naturalism and mysticism of Caravaggio's painting of the *Calling of St Matthew* (1597-98) is subtly mocked by the inclusion of a foppish self-portrait of the artist; the groom in his *Conversion of St Paul* (1601-02) is anatomically bizarre. Bizarre as well is the odd mystical impact of many of his compositions. His paintings are emotion laden yet discordant. Just as dirty feet confront the viewer in his painting of Mary, a horse's rump dominates the composition of his painting, *Conversion of St. Paul*. Rationalizations are offered to justify these compositional choices: the placement of the canvas, the perspective of the viewer, the humanity and poverty of the historical Virgin Mary. But the result is a consistent yet subtle degradation of the transcendent. The emphasis on fact and feeling, so central to post- Scholastic culture manifests more than a whiff of skepticism. If a naturalistic drama to convey a profound mystical experience is intended, it is not achieved. It is worth noting that after long neglect by scholarship as unworthy of serious consideration, Caravaggio was rediscovered and deemed important at a time when the objectivity of transcendent ideals was once again questioned. His art, so aesthetic, was rediscovered as beauty was yet again historically denied.

In contrast to Caravaggio's suspect pietism stands the art of Gian Lorenzo Bernini (1598-1680). In the Cornaro Chapel, Santa Maria della Vittoria, Rome, Bernini produced his masterpiece. The *St. Teresa in Ecstasy* (1645-52) magnificently embodies the culture of the Catholic Baroque, as felt by the devout.

This sculpture represents neither the reasoning of Aristotle, or Augustine, nor the Scholasticism ranging from Abelard to Aquinas. Rather, it centers on a sort of Platonism, where reason is now associated with mystical religious experience. And that experience is now deeply physical as well. Teresa is depicted in the throes of mystical love, as described in her autobiography:

> In his hands I saw a great golden spear, and at the iron tip there appeared to be a point of fire. This he plunged into my heart several times so that it penetrated to my entrails. When he pulled it out, I felt he took them with it, and left me utterly consumed by the great love of God.[58]

Bernini centers his art on divine inspiration rather than intellectualization. The Saint has found a perfect artistic match. But is this a match found in heaven? The Baroque was so titled in the nineteenth century when the art historians Burckhardt and Lubke critically noted its distinct character from that of the Renaissance. Not the naturalistic and Machiavellian Renaissance, but rather the Renaissance of Raphael and Michelangelo. But as discussed above, whereas the reason and beauty of Scholasticism linger in Raphael, Michelangelo's late career makes clear its decline. So Bernini's mystic work is antagonistic to both Scholasticism with its faith in Divine and human reason, and to nineteenth-century scholarship with its faith in fact and secular reasoning. Indeed, to the eye of the naturalistic and rationalistic nineteenth century, the Baroque was viewed as a period of decadence. The reduction of understanding to passionate experience was viewed as foreboding by rationalist and naturaust alike.

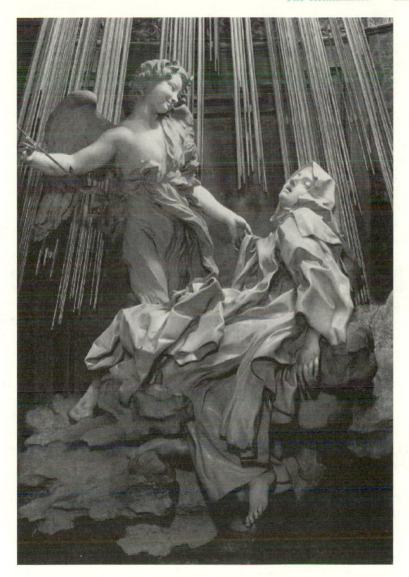

23. Bernini, *St. Theresa in Ecstasy*

In contrast is the art of Nicolas Poussin (1594-1665). Poussin was dedicated to returning an intellectual content to art - and consequently to life and ethics. Consistently he sought to base his art on general principles rather than mere experience, a pursuit in which he was largely alone. In seeking to base his art on general principles he was philosophically an essentialist. He wished to capture and depict the true character of things, not just their appearance. Significantly, he revives the Platonic concept of beauty being intelligible:

The idea of beauty does not infuse itself into matter which is not prepared to the utmost. This preparation consists of three things: order, mode, and form or species. Order means the spacing of the parts; mode has to do with quantity; species (form) consists in lines and colours....Painting...is more concerned with the idea of beauty than with any other idea.[59]

Poussin lauded ancient Greece as providing invaluable insight on the matter of beauty. He observes that they understood music (and law) to consist of modes: the severe and wise Dorian, the pleasant or intense Phrygian, the tragic Lydian, the joyful Hypolidian, and the festive Ionic. These modes are held to be essential in conveying meaning without relapse into exaggeration or foolishness. Poussin advocates the pursuit of the "Grand Manner" in art and life: nobility of thought and action, avoidance of sordidness, perfection without laboriousness, and the development of style that is true to nature and to self. That development of style is held to be a gift of nature and genius.

There are significant parallels to our understanding of genius, reason, and that of beauty. Indeed, as the notion of beauty changes through the ages (changes which result in significant cultural and political consequences) so changes the notion of genius and reason. During the classical period genius was understood to be an ego-less God-given gift, an undeserved capacity to achieve great things. Each artisan had a genius to do something, and as Plato said, a content society results when people do that which by their nature (and consequently by *Being* or God) they are meant to do. During the Renaissance the notion of genius is personalized and often secularized. People no longer have a genius for doing something; rather, they are a genius. Dürer advances this position, and as we shall see, during the Modernist period genius is further associated with personal superiority, be it reflective of a Kantian state of being, a Social Darwinist genetic and racial advantage, or a Nietzschean triumph of the individual will.

What then of Poussin? Poussin's notion of style consisting of being true to nature and to one's self is supported by an advocacy of genius; in anticipation of Kant, genius is understood as that which cannot be learned – but can be nurtured. In his listing on the principles of painting, he notes:

But first and foremost as to subject matter: It should be nobly conceived: not fashioned by man, in order to give the painter free scope for his genius and industry. The subject matter must be chosen so as to be capable to receive treatment of the most excellent form; one should consider first the disposition, then the ornament, the decoration, beauty, grace, vivacity, costume, verisimilitude, and above all, good judgment. These last things depend on the painter and cannot be learned. It is the Golden Bough of Virgil, which no one can find or pluck unless he be led to it by Fate.[60]

Poussin's *Et in Arcadia Ego* (1638-39) is an example of the Lydian mode of art and life. It depicts a meditative scene in which a thoughtful contemplation of the world starkly contrasts with the emotionalism of Caravaggio and Bernini.

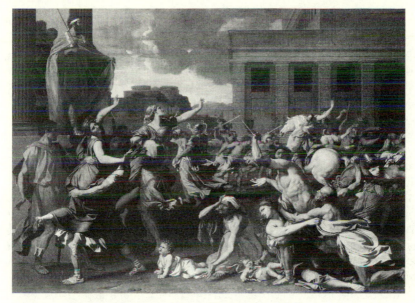

24. Poussin, *Rape of the Sabine Women*

It invites us to enter a world where contemplation provides the necessary distance for us to be free from the influence of the momentary, temporary, and fashionable. It thus moderates our passions without denying them, giving them direction and purpose so necessary to the realization of happiness.

In contrast to *Et in Arcadia Ego*, Poussin's *Rape of the Sabine Women* (1636-37) is in the Phrygian mode. It depicts a violent moment in the historical founding of Rome.

As described in a variety of historical accounts, Romulus, the founder of Rome faced a serious and practical problem. His new community consisted largely of unmarried men, and consequently, Rome could not long survive nor be civilized. Families provide the foundation for a stable and continuing society. Rome had few.

According to certain accounts, Romulus was rebuffed in peaceful attempts to solve this problem and consequently decided upon a strategy: during a great festival he gave a signal (folding and unfolding his mantle) and at that moment the men seized the Sabine women. These women were then forced to become the lawful wives of the Romans with all the rights associated with that status. When all of the known facts about the event are considered, one essential conclusion results: it was an act of violence, driven either by untamed passion or an act of necessity driven by a rational assessment of the circumstances. It is evident why Poussin chose to paint such a theme. As in the case of the Laocoön, it represents an historical event embodying the conflict between practicality and principle, emotion and reason. The event is abhorrent, but can

circumstances justify its need? Poussin's answer is that of Roman myth: that the event represents experiential reason employed out of necessity and directed towards a social good. If free from hypocrisy, the event this painting depicts arguably represents not the notion that the ends justify the means. Rather, rational principles can conflict and must often be reconciled, and that a lesser evil is sometimes necessary to avoid a greater evil. Whatever one's conclusion, this is not a Scholastic work. It is truly Baroque.

Strikingly similar in outlook to Poussin is the French philosopher René Descartes (1596-1650). He is perhaps best known for his axiom: "Cogito, ergo sum," I think, therefore I am. That axiom needs to be properly understood. It does not declare that none can doubt that they think and live—that was Augustine's position. In contrast, Descartes advocates the notion that none can doubt that we are self-conscious beings within a world of fact and feeling. The significance of this to the future development of Kantian Modernism is profound. In place of an Augustinian understanding of degrees of light and wisdom, Descartes continues the Scholastic and Conceptualist bifurcation of *being* and human thought.

Indeed, the significance of Descartes' axiom is found in his intentions in formulating it. In a fashion similar to Luther and Dürer, Descartes was faced with the chaos of irrational spiritualist movements on the one hand, and an empty empiricist nominalism on the other. Rather than offering a solution by appealing to the authority of Scripture, Descartes attempts to resuscitate the importance of reason, and by inference, the importance of Divine Reason. He is reported to have militarily fought against the Protestants in 1620, and in 1625 he disdainfully comments that he had never learned anything from the writings of Galileo. But there is a sad irony in this: Descartes mathematical rationalism ultimately undermines the traditions of the Church which he loved, and advances the mechanistic view of the universe advocated by Galileo, whom he found useless.

Descartes was dissatisfied not only with the conflicts of his age; he was also concerned with the logic and the traditionalism of Scholasticism. Noting that erudition is no guarantee of wisdom he criticizes those who believe that a firm knowledge of Plato and Aristotle will result in one being a philosopher, or that firm knowledge of mathematical proofs result in one being a mathematician. He rests his confidence not on the memorization of authoritative pronouncements, of proofs, or of empirical facts. His confidence relies upon human deduction and intuition as key to the obtaining of truth. In an Augustinian fashion intuition is understood as the undoubting conception of an unclouded and attentive mind that springs from the light of reason. It is such intuition that provides the foundational knowledge necessary for deductions to occur.

But contrary to Augustine, his philosophical work marks the culmination of cultural trends that developed with particular intensity during the Renaissance; it also points in the direction of those trends as they developed in the

future. Transcendence is increasingly replaced by fact, feeling, and a human rationality. The question of whether or not Descartes' system was progressive or destructive reflects how one understands the Enlightenment. Those who perceive the culture of the Enlightenment as truly progressive will laud Descartes as taking a decisive step towards Modernity; those who view the Enlightenment to be at best a tragic act of folly will regret those same efforts. This split between those who embrace the Enlightenment as the new faith from those who understand it to be a tragic mistake is confused by its very name. To be against the *Enlightenment* is to appear dedicated to be in favor of ignorance. But it is much more complicated than that. As explained below, the Enlightenment embraced a nihilistic conflict: it argues for truth while denying the possibility of knowledge of reality.[61] Consequently, it also denies beauty.

Descartes' work developed as part of a specific tradition of thought; that tradition can be directly linked to the Scholastics and the Nominalists of the Late Gothic era. As discussed in the previous chapter, Nominalism disputes the possibility of Universals (and ultimately, God) being more than just words. If universals are just words, then transcendental knowledge (as more than mental constructs) is impossible. If transcendental knowledge is impossible, then knowledge of reality (as opposed to facts) is impossible. For example, and as discussed in the next chapter, the twentieth century Cubist theoretician Andre Salmon stated that individual facts exist, but when those facts are put together to make an explanatory narrative of the world or life, then those facts simply refer to a mental tendency, a way of thinking, not a right way of *being*. Then what kind of knowledge is possible? As noted previously, the Scholastic Abelard initially attempted to address this problem by declaring that universals exist objectively in the mind of God, but occur only as a concept in the human mind and as a natural property in matter.

The distinction of metaphysical truth existing within the mind the of God, as opposed to truth that occurs only as a concept in the human mind or as a natural property in matter, leads to a significant and necessary possibility: the purpose-granting Truth in the mind of God can be ignored if it is present in our minds and in nature. If our understanding of the world is conceptual and empirical, then the world is no longer necessarily associated or imbued with objective meaning and purpose. It also facilitates a shift away from realism (where ideals such as Justice, Beauty, and Truth are objectively real) to materialism, deism, pantheism, and subjectivism. That shift has direct cultural consequences.

Descartes marks the high point of the Renaissance and Baroque traditions and the beginnings of Modernist culture as well. He accepts that two types of knowledge are possible: rational and material. There is knowledge which is purely rational and knowledge which results from direct experience. Descartes attempts to demonstrate that rightly cultivated reason could grasp the math-

ematical order of the natural world, and the mechanical order of nature both human and animal. So Descartes posits that the mind of God is mathematical, and nature reflects that mind. The result is that a rational/mathematical and mechanical explanation of the world and life becomes primary. As he wrote to a friend in 1630:

> All men to whom God has given the use of reason are obliged to know the latter and themselves. It was in this sense that I began my studies and I believe that one can prove metaphysical truth in a way which is even more enlightening than the proofs of geometry.[62]

Just as the axioms of geometry are beyond dispute, so too, Descartes holds, is his axiom: "Cogito, ergo sum," I think, therefore I am. This axiom is important for it marks an important step towards the assumption that secular reason can and does provide objective truth. The assumption that pure reason and empirical science can provide a solid foundation for ethics and culture is central to the later blossoming of what is called by its adherents the Enlightenment—and to the subsequent development of Modernism.

This focus on the rational and material is accompanied by a concern for the emotional. In contrast to the Augustinian symbol, the Scholastic analogic and anagogic, and the empiricist Renaissance notion that art is naturalistic, during the Baroque period culture is driven by the idea of sympathy,[63] but that idea gradually shifts to that of empathy. We are asked to admire St. Teresa's mysticism, but we are also invited to identify with her experience. Empathy rather than sympathy is the natural accompaniment to Descartes' approach to beauty. Nonetheless, Descartes the rationalist rejects taste, preferring a naturalistic *and* rationalistic view of intelligible beauty:

> As soon as a thing gives pleasure, it is boldly decided that it is beautiful. There could be, however, no more false principle. For there is nothing so bad as to be no one's taste, and nothing so perfect as to be everyone's taste...One of the main advantages of true beauty is that it is not mutable or ephemeral, but constant, certain and in keeping with the taste of all ages. False beauty has its admirers, but cannot keep them for long in defiance of nature.[64]

Descartes attempts to restore reason as a means of understanding reality, ethics, and art, but he does so at the cost of transcendent beauty. In contrast to Poussin's hope that intelligible beauty was obtainable, the rationalistic Descartes ultimately rejects an objective and rational approach to beauty. Instead he associates beauty with nature, and even with conditioned reflex:

> Your question as to how one can ascertain the reason why something is beautiful...But neither the beautiful nor the pleasant signifies anything other than the attitude of our judgment to the object in question. And since human judgments are various, it is impossible to find any definite measure for the beautiful or the pleasant...If one were to

thrash a dog five or six times to the sound of a violin, when he heard that sound again, he would surely whine and run away.[65]

According to Descartes, the philosopher can reduce the mysteries of the universe and God to a rationalistic and mathematical system and since that system is at its core mathematical, the universe can in turn be reduced to a naturalistic mechanism. Therefore, by reducing the universe to a rationalistic and naturalistic mechanism, no transcendent ground for value judgments remains. A secularized reason and beauty exist, but are relegated at best to the realm of rationalized pleasure. As Alexandre Koyré explains:

> The God of a philosopher and his world are correlated. Now Descartes' God, in contradiction to most previous Gods, is not symbolized by the things He created; He does not express Himself in them. There is no analogy between God and the world; no *imagines* and vestigial *Dei in mundo*; the only exception is our soul, that is, a pure mind, a being, a substance of which all essence consists in thought, a mind endowed with an intelligence able to grasp the idea of God, that is, of the infinite (which is even innate to it)...
>
> Teleological conceptions and explanations have no place and no value in physical science, just as they have no place and no meaning in mathematics, all the more so as the world created by the Cartesian God, that is, the world of Descartes, is by no means the colorful, multi-form and qualitatively determined world of the Aristotelian, the world of our daily life and experience —that world is only a subjective world of unstable and inconsistent opinion based upon the untruthful testimony of confused and erroneous sense-perception...there is nothing else in this world but matter and motion...[66]

So Poussin and Descartes share a commitment to return reason and general principles to prominence in art and life. On the one hand is the approach of Poussin, who by the study of ancient Greece, attempts to maintain an essentialist vision of the world being beautiful. On the other hand is the rationalism of Descartes who in Scholastic, Conceptualist fashion separates science and reason from teleology, wherein our existence is confirmed by our rationality, and yet the world is unintelligible.

In the development of Modernism it is Descartes rather than Poussin who prevails. In his denial of intelligible beauty he anticipates the continuing dissolution of beauty and truth in Western culture. It is not a dissolution embraced by all—and to paraphrase Alasdair McIntyre (who speaks of Western culture as now existing *after virtue*) we now live in a time *after beauty*. But if the tradition of the virtues—and beauty—survived the last dark ages, we are not entirely without grounds for hope.[67]

Notes

1. Jonathan Steinberg, translator, Frederick Heer, *An Intellectual History of Europe* (Cleveland: The World Publishing Company, 1966), 303.
2. Wladyslaw Tatarkiewicz, A History of Aesthetics (The Hague: Mouton, 1970), 127.
3. This is discussed in Hugh Bredin, translator, Umberto Eco, *The Aesthetics of Thomas Aquinas* (Cambridge, MA: Harvard University Press, 1988), Preface.
4. In his Commentarium Ficino states: "Beauty, finally, is the completed unfolding of the intelligible light and the intelligible species. Although beauty is the last to proceed, as it were, in any god, it is the first to confront those ascending to that god." Michael J.B. Allen, Introduction, texts, and translations, *Marsilio Ficino and the Phaedran Charioteer* (Berkeley: University of California Press, 1981), 108.
5. Alexandre Koyré, From the Closed World to the Infinite Universe (New York: Harper & Row, Publishers, 1957), 4.
6. Discussed by Richard Weaver, *Ideas Have Consequences* (Chicago: The University of Chicago Press, 1984).
7. Alexandre Koyre, From the Closed World to the Infinite Universe (New York: Harper & Row, Publishers, 1957), 18.
8. As discussed above, Umberto Eco argues that Aristotelian Scholasticism entails self-contradictions that necessarily lead to its own [Modernist/Postmodernist] decline. As he explains (Hugh Bredin, translator, Umberto Eco, *The Aesthetics of Thomas Aquinas* (Cambridge, MA: Harvard University Press, 1988), 202: "If we locate things in a certain system, which the system itself has not developed but which we can develop ourselves by following it internal logic, we may well arrive at conclusions which put the system into question."
9. Aquinas nonetheless provides intellectual arguments for the existence of God in terms of essence, or in reference to the Five Ways divinity is evident via causality. The latter are variations on the argument from design; but design can be cited in favor of either a naturalistic or a metaphysical vision, it can worship *ex deus machine* or *ex machine deus*. See: Armand Maurer, translator, *Thomas Aquinas., On Being and Essence* (Toronto: The Pontifical Institute of Medieval Studies, 1968).
10. How this consequence might be averted is presented in Alexandre Koyré, From the Closed World to the Infinite Universe (New York: Harper & Row, Publishers, 1957), 72: "Certainly we can, provided we abandon Kepler's empirical, that is, Aristotelian or semi-Aristotelian, epistemology which precludes this operation, and replace it by another: an a priori Platonic or at least semi-Platonic one." As discussed below, Kant attempts to do just this: in coming to the necessary consequences of Scholasticism, he attempts to pursue a synthetic a priori. The God-problem (as Thomas Molnar has phrased it) is solved, albeit via a self-deification.
11. As discussed in the Introduction, Dante closes his literary masterpiece with that observation.
12. Alexandre Koyre, *From the Closed World to the Infinite Universe* (New York: Harper & Row, Publishers, 1957), 59. Within a Postmodern context, Alan Sokol exposed the non-sense of Postmodern scientific thinking and jargon in his article "Transgressing the Boundaries: Toward a Transformative Hermeneutics of Quantum Gravity," *Social Text*, Spring/Summer (1996). The role of *quanta* in science, ethics, and art is discussed in the Conclusion.
13. As discussed below, Darwin's work was later used to justify a scientific foundation for racial superiority. Darwin can be quoted on both sides of the issue; the impact of his work is not limited to whatever his intent might have been.

14. Galileo makes the same disingenuous argument in his letter, On Theology as Queen of the Sciences, to the Grand Duchess Christina of Tuscany in 1615. His central *Aquinian and Modernist* point is that physical science and faith are two separate realms.

15. Ananda Coomaraswamy, *Christian and Oriental Philosophy of Art* (New York: Dover Publications, 1956), 107.

16. Alexandre Koyre, From the Closed World to the Infinite Universe (New York: Harper & Row, 1957), 138: "...Descartes, by his teaching, leads to materialism and, by his exclusion of God from the world, to atheism."

17. In his book, *The Twilight of the Idols*, in the section, "From the AntiChrist " (10) Nietzsche states: "Whence came all the rejoicing with which the appearance of Kant was greeted by the scholastic world of Germany, three-quarters of which consists of clergy-men's and schoolmaster's sons?" Geoffrey Clive, editor, *The Philosophy of Nietzsche* (New York: Meridian, 1996), 596.

18. Arthur Pontynen, Oedipus Wrecks: PC and Liberalism" *Measure* 113 (February, 1993): 1-4.

19. Alasdair MacIntyre, *Whose Justice? Which Rationality?* (Notre Dame, IN: University of Notre Dame Press, 1988), 10: "So the Aristotelian account of justice and of practical rationality emerges from the conflicts of the ancient polis, but is then developed by Aquinas in a way which escapes the limitation of the polis. So the Augustinian version of Christianity entered in the medieval period into complex relationships of antagonism, later of synthesis, and then of continuing antagonism to Aristotelianism. So in a quite different later cultural context Augustinian Christianity, now in a Calvinist form, and Aristotelianism, now in a Renaissance version, entered into a new symbiosis in the seventeenth-century Scotland, so engendering a tradition that at its climax of achievement was subverted from within by Hume. And so finally modern liberalism, born of antagonism to all tradition, has transformed itself gradually into what is now clearly recognizable even by some of its adherents as one more tradition."

20. The Modernist-Postmodernist distinction between natural science vs. theology and philosophy is a new development. Alexandre Koyré, *From the Closed World to the Infinite Universe* (New York: Harper & Row, 1957), 159: "...and though science, at that time, had not yet accomplished its disastrous divorce from philosophy, and though physics was still not only designated, but also thought of , as "natural philosophy," it is nevertheless true that [Newton's] primary interests are in the field of "science," not "philosophy." He deals, therefore, with metaphysics not *ex professo*, but only insofar as he needs it to establish the foundations of his intentionally empirical and allegedly positivistic mathematical investigation of nature."

21. Vernon J. Bourke, editor, *The Essential Augustine* (Indianapolis: Hackett Books, 1974), 20: "The distinction between knowledge (scientia) and wisdom (sapientia) is also fundamental in Augustinianism." It is a distinction, however, that denies dualism. Science is a step towards wisdom. Hence, the Augustinian viewpoint is not antagonistic to what is now known as natural science, so much as it is dissatisfied. It is not viewed as wrong, but as inadequate, and if left inadequate, it can do wrong. For example, the association of Darwinism with eugenics and racism reflects science lacking illumination.

22. In so doing he went beyond a naturalistic and rationalistic Aristotelianism to a naturalistic and empiricist philosophy where "man [is regarded] simply as an undistinguished fragment of nature marked by neither freedom, nor greatness." Wladyslaw Tatarkiewicz, *A History of Aesthetics* (The Hague: Mouton, 1970), vol. III, 44.

23. Ibid., 6.

24. Ibid., 11.
25. Franklin LeVan Baumer, editor, *Main Currents of Western Thought* (New Haven, CT: Yale University Press, 1978), 114.
26. Ibid., 44.
27. Jonathan Steinberg, translator, Friedrick Heer *The Medieval World. Europe 1100-1350* (Cleveland, OH: The World Publishing Company, 1962), 183.
28. Wladyslaw Tatarkiewicz, *A History of Aesthetics* (The Hague: Mouton, 1970), Vol. 3, 136.
29. Ibid., 139.
30. Ibid., 127.
31. S.H. Butcher, *Aristotle's Theory of Poetry and Fine Art* (New York: Dover Publications, 1951), 116.
32. Wladyslaw Tatarkiewicz, A History of Aesthetics (The Hague: Mouton, 1970), 127.
33. Wladyslaw Tatarkiewicz, *A History of Aesthetics* (The Hague: Mouton, 1970), Vol. 3, 136,138.
34. Jonathan Steinberg, translator, Frederick Heer, *An Intellectual History of Europe* (Cleveland, OH: The World Publishing Company, 1966), 8. This phenomenon refers also to the crisis faced more recently by Modernist Liberalism and Marxism.
35. Franklin LeVan Baumer, *Main Currents of Western Thought* (New Haven, CT: Yale University Press, 1978), 710ff.
36. Wladyslaw Tatarkiewicz, *History of Aesthetics* (The Hague: Mouton Press, 1970), Vol. 3, 122.
37. This is discussed in Richard Tarnas, *The Passion of the Western Mind* (New York: Ballantine Books, 1993), 184. This intellectual history is particularly useful as an example of a Postmodernist understanding of its subject.
38. Michael Greenhalgh, *The Classical Tradition in Art* (London: Duckworth, 1978), 15ff.
39. Frederick Hartt, *A History of Italian Renaissance Art* (Englewood Cliffs, NJ: Prentice-Hall, 1987), p. 223.
40. Similarly, a comparison of the Marcus Aurelius equestrian monument in Rome with those of Gattemalatta and Coleoni evidence two qualitatively distinct worldviews.
41. Wladyslaw Tatarkiewicz, *A History of Aesthetics* (The Hague: Mouton, 1970), Vol. 3, 144.
42. Ibid., vol.3, 144.
43. Ibid., vol. 3, 155; 186-7
44. Ibid., vol. 3, 160.
45. Ibid., vol.3, 179.
46. Ibid., vol. 3, 188.
47. Ibid., vol.3, 189.
48. Ibid., vol.3, 296.
49. Ibid., vol. 3, 295.
50. The traditional Sacraments are: Baptism, Confirmation, Communion, Penance, Extreme Unction, Orders and Marriage.
51. Wladyslaw Tatarkiewicz, *A History of Aesthetics* (The Hague: Mouton, 1970), Vol. 3, 246.
52. As Luther wrote in a letter to their mutual friend, Eoban Hesse shortly after Dürer's death in April 6, 1528.
53. Wladyslaw Tatarkiewicz, *A History of Aesthetics* (The Hague: Mouton, 1970), Vol. 3, 257.
54. Ibid., 246

55. Conrad Bergendoff, *Luther's Works* (Philadelphia: Muhlenberg Press, 1958), Vol. 40, 79ff.

56. Ibid.

57. Ibid., 105

58. J.M. Cohen, *Life of St. Theresa* (Baltimore, MD: Penguin Classics, 1957), 210.

59. Wladyslaw Tatarkiewicz, *A History of Aesthetics* (The Hague: Mouton, 1970), Vol. 3, 338-9.

60. Ibid., 340.

61. This is discussed by Thomas Molnar, *God and the Knowledge of Reality* (New Brunswick, NJ: Transaction Publishers, 1993). See also, Arthur Pontynen, "Beauty and the Enlightened Beast," *American Outlook* (2002).

62. Jonathan Steinberg, translator, Friedrick Heer, *The Intellectual History of Europe* (Cleveland, OH: The World Publishing Company, 1966), 341-2.

63. Jonathan Steinberg, translator, Friedrick Heer, *An Intellectual History of Europe* (Cleveland: The World Publishing Company, 1966), 304. The shift to empathy occurs as the notion of an objective God declines.

64. Wladyslaw Tatarkiewicz, *A History of Aesthetics* (The Hague: Mouton, 1970), Vol. 3, 375.

65. Ibid., 373.

66. Alexandre Koyré, *From the Closed World to the Infinite Universe* (New York: Harper & Row, 1957, 100.

67. Alasdair MacIntyre, *After Virtue* (Notre Dame, IN: University of Notre Dame Press, 1984), 263.

7

The Modernist-Postmodernist Tradition: The Subjective-Objectivity of the "Enlightenment" and the Decline of Beauty

In the eighteenth century, Western culture experiences increasing turmoil. Despite Poussin's earlier championing of the Classical and Christian foundations of the West, those foundations are crumbling. In France and Germany advocates of what is known as the Enlightenment are poised to overthrow the *ancien régime*. Meanwhile, the English turn to tradition as an alternative to both Scholasticism and anarchy, and its American offshoot experiments with a newly democratized Classicism and Christianity.

As it turns out, the task of overthrowing the *ancien régime* was not so difficult given the state of that regime. It was grounded in a vision of Beauty, but that vision was increasingly aestheticized. As discussed earlier, Scholasticism attempts to reconcile reason and faith via Abelard's Conceptualism. He maintains that truth exists in the mind of God, in the mind of Humanity (as a concept), and in things in themselves. God is the cause of harmony and clarity in all things, and as such is the author of beauty. But there is also the aesthetic pleasure that results from perfection. As Abelard marks a distinction between Truth as the Universal in the mind of God, and truth as the universal in our minds, so too is there a distinction between Beauty caused by God and an aestheticized beauty perceived in our minds.

The result is that within the Western tradition there are two distinct modes of thinking and understanding the world. On the one hand is that of Illumination, the Augustinian viewpoint that the world is purposeful, and that which most fulfills that purpose is most beautiful. So the world consists of a continuum from the material and aesthetic, to the spiritual and the beautiful. It is a continuum accommodative of the factual but not limited to it; it is not anti-science, but rather understands that science is more than just the descriptive. It

serves in the pursuit of wisdom. That pursuit centers on recognizing varying degrees of intelligible purpose, of goodness, which is comprehended via a passionate realization of the true and good.[1] Augustine recognizes that truth and goodness presuppose that the world makes sense—or conversely—that a world of aesthetics and fact presupposes that the world does not make sense. Should the world be purposeful, then one can rightly aspire to understand the world, and the inspiration to do so is found in love. Consequently understanding unites the intellectual and the willful, the philosophical and the theological. To comprehend the true and good, we must accept them, and to accept them is to love them. So fact, understanding and faith are united, as they must be since cognition involves passion. Beauty is the splendor of what is True and Good, which is comprehended via a passionate experiencing of the immediate light of reason. That experience is both intellectually objective and passionately subjective. It marks a love of intelligible beauty.

On the other hand is Conceptualism, where Truth exists in the mind of God, but can also exist in the mind of humanity, and in things themselves. This position, influenced by Aristotelian thought (and later developed by Kant), is one where perfection exists in the mind of God, but can also (or rather) exist in logic and things.[2] For Aristotle and Aquinas this position assumes that the world makes sense, and that audiences will be refined and cultured. They maintain that within that context, aesthetic objects evidence a perfection of form, of *being*, as do those who experience them. However, the assumption of a purposeful world, and that audiences will be refined, is not necessary—as Kant and Nietzsche later make clear. Rather than focusing on the love of truth and beauty, an interpretation of Scholasticism advances a dispassionate, formalistic reasoning in comprehending the natural world. It is the gift of Grace that affords us with an authoritatively beatific vision, but it is via an aesthetic formalism that we perceive the world and art. What then if that gift of Grace is replaced by skepticism, chance, and power?

The Scholastic interest in Aristotelian aesthetics advances the distinction of philosophy from theology, thought from passion. Rather than a passionate comprehension of Truth and Beauty, so central to Augustinian culture, Conceptualism sows the seeds of the separation of reason and passion, and an aestheticization of both. And it permits a separation of beauty and truth in the mind of humanity from that beauty and truth which reveals to varying degrees the mind of God.

This distancing makes inevitable the separation of truth and passion in the mind of the West, where on the one hand are the Intellectualists who emphasize the rational as the primal element of the mind (Descartes), whereas on the other hand are the Voluntarists who find the beginnings of mental life in the crude phenomena of the will, in appetites seeking gratification (Schopenhauer). Those such as Kant and Hegel, who attempt to reconcile these two positions without resort to traditional transcendentalism, are attempting to do the im-

possible because a willful rationalism is rationalism denied. Intellectualism and Voluntarism are both willful in the sense that they are grounded in an aesthetic vision, a vision that perceives no objective purpose. From such a point of view, the very assumption that Truth and Beauty exist in the mind of God becomes a merely willful proposition. We can willfully accept that truth and beauty has its source in Divinity, or not. So the Counter-Reformation is but a way station between Scholasticism and the Enlightenment. The content of the Enlightenment will be discussed in a moment, but for now it can be noted that the difference between it and Scholasticism hinges on how one feels about the universe: is it beautiful and purposeful, or is it not? The Enlightenment is not then so much a break with Scholasticism as the fulfillment of it. It makes respectable deism, and deism is but a momentary stop on the path to a meaningless universe. For the Deist, neither the existence of Divine purpose, nor beauty, matter much. What matters is fact, feeling, and rationalistic style.

Consider the differences between Descartes and Voltaire. The devout Descartes attempts to demonstrate that human reason can mirror the mind of God, and can grasp a mathematical and mechanical order in the world of nature and humanity. The irony is that in so doing he opens further the door cracked by Abelard: that a mechanical and mathematical explanation of the cosmos can be realized with or without a purpose granting God. But a mechanical vision of the universe voids the possibility that human existence can have any meaning at all. It is to deny that responsible freedom can exist. As a leading proponent of the French Enlightenment, the deist Voltaire faced that dilemma and chose to consider it a source of virtue. Indeed, he treats God more gently than he does Descartes. The former he ignored, the latter he ridiculed as worthless.

The *ancien régime* of continental Europe had largely (but not entirely) degenerated from within, intellectually, politically and artistically. The fruition of the Scholastic attempt to reconcile a worldly aesthetics and rationality with Divine providence is now realized in Descartes' rationalism, Voltaire's naturalism, and later by Schopenhauer and Nietzsche's focus on the will. With or without piety, this attempt at reconciliation results not in unity but separation, not in a passionate pursuit of the True and Beautiful, but rather in Intellectualism and Voluntarism.

As discussed in previous chapters, beauty is cognitive, whereas aesthetics refers literally to sensation and emotional response. The decline in the belief that beauty is intelligible and real is evidenced in the art of the eighteenth and subsequent centuries. Coinciding with the cultural phenomenon known as the Enlightenment, three distinct artistic movements occur: the Rococo, Neo-Classicism, and Romanticism. For all their differences, they share a common focus on aesthetics. Indeed, it was only in 1750 that the term *aesthetics* was first coined by the German philosopher Alexander Gottlieb Baumgarten. The

coining of this term is momentous. When beauty is understood to be a matter of aesthetics, reason is trivialized and brutalized. It is reduced to mere rationalization and willfulness, to intellectualism and voluntarism.

This is significant because of its reduction of art and life to aesthetics. As discussed in previous chapters, historically it was understood that attempts to comprehend the relationship of intelligible beauty and physical aesthetics were worthy of concern. Those concerns were often discussed via the meaning of the Incarnation, of the relationship of God and Christ, and in how the Sacraments are to be understood. Debates occurred as to their nature and character, but that debate made evident a varied pursuit of beauty. Those debates occurred not only in the context of the fine arts, but in philosophy and science, in theology and politics. They centered on the question of how we might make value judgments that evidence a purposeful life; rejected is the dogmatically aesthetic position that reduces meaning to fact, rationalization, and a willful voluntarism. To put it differently, what is revealed is the opposition of two possibilities that ultimately conflict: that the world and life ultimately make sense, or that they do not. These possibilities differ on the issue of whether ethics and beauty are to some degree objective and possible. But this possibility aesthetics cannot admit, for to do so is to reveal the inadequacy of aesthetics alone. Should we admit that two possibilities do exist, then aesthetics is recognized not only as inadequate but also as artificially limiting. Aesthetics is then denied its current privileged status, and the pursuit of truth and beauty is newly assumed. The aesthetic vision, which purports to tolerate diversity, denies the possibility of understanding, as well as the possibility of belief in anything other than a purposeless aesthetics. Its hypocrisy is revealed by the pursuit of beauty.

From an aesthetic viewpoint both Classicism and Christianity (or a wide variety of other traditions around the world) can no longer be entertained as offering the possibility that they present an understanding of the world and life. From an aesthetic viewpoint, an intellectual pursuit of the true, good, and beautiful makes no sense. The Incarnation becomes unintelligible as does the very idea of Classicism or Christianity as sets of defendable belief. In opposition to the notion that the Classical or the Christian traditions are recognizable as defendable sets of belief is the view that they are willful practices. The categories they represent are then merely aesthetic constructs. Classicism is thereby characterized as the various practices engaged in by persons living during the Classical period, including those holding skeptical and materialist points of view; Christianity is equally viewed as the shared subjective beliefs put into practice by groups of people at particular times. They are seen as intellectualist and voluntarist.

This sociologizing of Classicism and Christianity results in the proposition that not even *Classicism* or *Christianity* (or *Buddhism, Daoism,* etc.) are real objects of knowledge. Instead of consisting of a set of foundational onto-

logical beliefs, Classicism and Christianity are considered to be aesthetic constructs—as are their foundations. Each is a matter of taste, or subjective faith, and as such, is viewed as a source of subjective inspiration— or oppression. It also entails a narrative no longer informed by the pursuit of truth. Instead it is a narrative of tolerance - which devolves by default or intent to a narrative of power. The shift from beauty to aesthetics not only undermines the Classical and Christian foundations of the *ancien régime*, it undermines our ability to understand how it occurred and to discuss whether or not the results are good. We cannot understand the shift from beauty to aesthetics if we assume that all is power because power can offer no explanation beyond itself.

Beauty and the Enlightenment

In terms of the fine arts, the decline of the *ancien régime* is evidenced by a desiccated aristocratic pursuit of pleasure. As made manifest by the art of the Rococo period, François Boucher (1703-70) and Jean Honoré Fragonard (1732-1806) present art not as a means of understanding the world and human society as they ought to be in a meaningful universe, but rather, as they are fantasized to be.[3] As a counterpoint, a naturalistic pursuit of a sentimentalized piety is offered by the art of Jean Baptiste Simeon Chardin (1699-1779) and Jean Baptiste Greuze (1725-1805).

To compare the art produced by Fragonard, for example, with that of Poussin is to compare two distinct ways of viewing the world. It also marks an intellectual and spiritual decline. In conflict to the dramatic tension between reason and passion, principle and necessity, as evidenced by Poussin's *Rape of the Sabine Women* (1636-37), Fragonard's *The Swing* (c.1768-69) depicts the reduction of life to the mere pursuit of pleasure.

Here Cupid is reduced to the role of co-conspirator in a voyeuristic dalliance breathtaking in its sensual narcissism. Its self-indulgence is at the cost of any pretensions of seriousness. But there is not much of an alternative in the sentimentalized piety of Chardin or Greuze. In Greuze's *Village Bride* (1761) we are presented not with the sacramental notion of marriage, but rather with the notion of marriage being a moral duty; particularly when unsanctified parenthood is immanent. The art of Greuze is replete with such themes (*The Father's Curse; The Broken Pitcher*, etc.) equating morality with duty, often after the fact of immorality. The shift from the Sacramental to a dutiful morality marks a shift from responsible freedom to sentimentality and guilt, from beauty to mere aesthetics.

If Boucher or Fragonard, Chardin, or Greuze, had simply painted for their own pleasure, or that of the private predilections of their patrons then much of their art could be dismissed as merely trivial. But the fact is that these artists were commissioned by the court or by the growing bourgeoisie; this is not merely private art, but art that is public and therefore cultural and political. It represents a vision of life with cultural and political consequences. While the

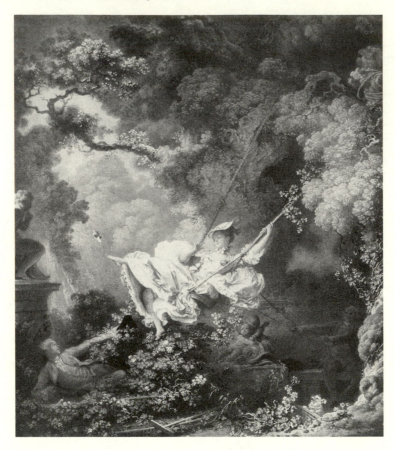

25. Fragonard, *The Swing*

traditional pursuit of beauty declines, the aesthetic pursuit of hedonistic or sanctimonious pleasure increases. And when public culture is reduced to the pursuit of pleasure, the results are not—pretty.

In contrast, consider the call to action present in the art of Jacques Louis David, the premier artist of the French Enlightenment. From the start of his long career he was associated with the French Enlightenment and the Revolution. In his work, *The Oath of the Horatii* (1784), he clearly advocates the ideas associated with those cultural movements. For the Augustinian *The Oath of the Horatii* is disquieting in that it exemplifies a conflict that rightly ought to be recognized as a moral struggle between goodness and evil, but is not.

The painting refers to an event in ancient Roman history, where duty called and was responded to at great personal cost. The Horatii and Curiatii were two sets of three brothers born on the same day of mothers who were twin sisters. One set of brothers was of Rome, the other of Alba Longa. It was agreed that

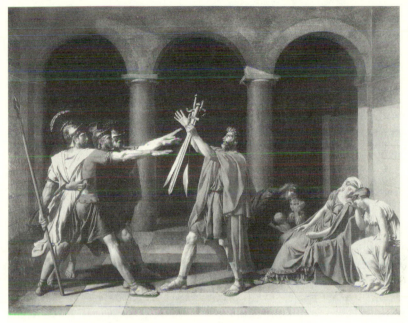

26, David, *The Oath of the Horatii*

combat between the two sets of brothers would resolve a war between the two cities. The result was that two of the Horatii were soon slain, but the third, hunted down by the Curiatii, managed nonetheless to kill them one by one. He then entered Rome triumphant, wearing the robe of a Curiatii that he killed. But that Curiatii was the beloved of his sister, who cursed him. He then killed his sister, and was condemned to death for the act. But he appealed to the people to be pardoned, and his life was spared.

The *Oath of the Horatii* is enough to make both the Aristocracy and Scholasticism shudder with apprehension. In place of the decadent hedonism of Fragonard's *The Swing*, the theme of David's painting accepts the importance of moral duty and service. But David's work admonishes us to pursue neither family devotion nor pleasure, but duty. Here David returns to the painting mode of Poussin (he said "I owe my picture to Poussin"), but not to Poussin's more traditional understanding of reason. David's painting evidences not a commitment to any of the traditional Seven Cardinal Virtues (faith, hope, love, justice, prudence, temperance, fortitude) as understood by Scholasticism, because their transcendental status was for many no longer intellectually plausible or politically palatable—remember they are associated with the foundations of the now decadent *ancien régime*. Rather the painting evidences a call to duty; in the pursuit of that duty the will of the people can condone even the murder of family members immediate or distant. The call to

duty is advocated not only by David, but by his contemporary, Immanuel Kant. It is a call that is today known as the Enlightenment.

Kant, Neo-Classicism and the Aesthetic Vision of Modernism[4]

Primarily associated with eighteenth-century German culture, with proponents in England and France as well, the Enlightenment was dedicated to advancing society beyond the constraints of superstition, tradition, and social habit. Immanuel Kant (1724-1804) praised the Enlightenment and provided its slogan:

> Enlightenment is humanity's departure from its self-imposed immaturity. This immaturity is self-imposed when its cause is not lack of intelligence but failure of courage to think without someone else's guidance. Dare to know! That is the slogan of the Enlightenment.[5]

Well versed in Scholasticism, Kant works from that foundation, and offers new conclusions of his own. Recognizing the importance of Newton's contribution toward perceiving a quantitative universe, and of Hume's empiricist skepticism, Kant is faced with a fundamental dilemma: how can such a mechanical vision of the world permit moral choice to occur? He faces the problem of reconciling the world of necessity (being) with the world of freedom (becoming), for without freedom and purpose there can be no morality and no human dignity. This he sees as the problem of reconciling natural science with Intellectualism and Voluntarism. Not willing to follow Voltaire by rejecting the notion of individual morality, he posits an ingenious -or sophist- solution.

Kant offers a solution to that question in two important texts of the Enlightenment, his *Critique of Pure Reason* (1781) and *Critique of Judgment* (1790). Kant agrees that facts (accurate descriptions of phenomena) can be obtained, but he also maintains that the world as it is, the *ding an sich*, cannot be understood, and that therefore truth—and purpose—cannot be known. Instead, he posits the pursuit of facts, feelings, and rationalistic style. Facts (phenomena) are objective, but how we put those facts into explanatory narratives is linked to how we think (noumena). He posits his own Copernican revolution holding that our knowledge of reality conforms to how we think. Thus, the process of making sense of the world via a rational arranging of facts is held to be both aesthetic and creative, and at its best, that process is the work of genius. Historically, genius is not what one is, but an ability that one possesses - as a gift of God. In contrast to previous understandings of the nature of genius Kant holds that it is a personal capacity that can be nurtured but cannot be taught. According to Kant's argument, although facts can with some confidence be recognized as objective, reality is subjective, that is, reality as it is (the *ding an sich*) is unknowable, but that which we do know conforms to how we think. Reality is then an aesthetic construct, a

conceptualization. Culturally, the most significant aesthetic constructs are those made by those who are geniuses. What then of morality? Kant declares that morality should be based upon a good will, which is the only thing that is good without qualification. A good will acts for the sake of duty, and that duty is to act out of reverence for the law. And what is the content of the law? Kant declares:

> Act only on that maxim through which you can at the same time *will that it should become* a universal law...Act as if the maxim of your action were *to become through your will* a Universal Law of Nature.[6]

Kant relies on a genius-based formalism as the key to an assumedly liberating aesthetic vision. He suggests that there are descriptive facts on the one hand, and formal, indeed aesthetic, structures on the other hand. There are facts, like bricks, and how one builds a House of Life with those bricks is a matter of personal taste. Personal taste, or rather, aesthetics, offers the possibility of a wide variety of fact-based narratives that are pluralistic, coherent, and free products of the imagination. Those lifestyles can be pursued as long as we do no harm.

In contrast to the traditional understanding of beauty as a means of comprehending a purposeful world, Kant proposes that art is non-cognitive (it does not attempt to explain the world), self-referential (is concerned with the intrinsic qualities of any activity), and a perfection of a kind. It does not reveal any transcendent truths about reality—and life. In contrast to the Scholastic prescription that reason and faith be complementary in the pursuit of beauty and love, the Modernist vision offers a willful aesthetics as a means of reconciling intellectualism and voluntarism. It thus replaces the role of the mind of God with the mind of humanity. Objective truth is subjectified and rationalized, and as we shall see, the political consequences center on a dreadful pursuit of the will to power.

Neo-Classicism reflects this shift from beauty to aesthetics. It celebrates antiquity, natural science, and reason as alternatives to Scholasticism, but in so doing redefines each. It views science not as systematic knowledge, but rather as a collection of empirical facts. In not choosing to accept Augustine's view that history is an on-going drama between good and evil, it reduces history to a nostalgic collection of facts telling a tale of perceived duty, tragedy, and power. It accepts natural science in place of superstition and falsehood, while rejecting the notion that science can be more than descriptive empirical fact or rational construct. Indeed, it posits a new type of rationality, one that does not refer to God, Being, or Truth. Reason reveals not the structure of the world, but the structure of the rational mind. Truth, reason, morality, and art are then for their own sake—that is—for our sake.

According to Kant, the structure of thought, or thinking, determines how we organize facts to obtain an understanding of reality and life. But that understanding is subjective not objective, or rather, it is a subjective-objectivity. The *ding an sich*, the thing in itself, cannot be known. Reason is thereby subsumed by feeling. Reason is now grounded in how we think and feel rather than how the world is understood, and morality is now grounded in duty rather than *Being*, or ontological principle. But this in turn presents various problems. First, it is self-contradictory to declare that the thing in itself cannot be known; belief in skepticism is belief in a thing, it is not a neutral intellectual stance. Second, it reduces the world and life to a matter of aesthetics and therefore demands that we believe that no beliefs can to some degree be true – except a belief in nothing. And third, it is meaningless to declare that morality is grounded in duty stemming from a rationalized good will because the notion of a good will is incoherent. Good is objective but the will is subjective. As discussed shortly, an attempt is made to bridge that gap by metaphysical claims of a benevolent human nature, or claims of a compelling structure of human thought, but neither is sufficient. Neither claim resolves how we can subjectively establish the reality of goodness. And if goodness does not exist then freedom and responsibility cannot exist. If we cannot freely choose to seek the good, we can only submit to calculations of power. To refer to such calculations as morality, is to aestheticize and brutalize human existence. So at the beginning of the nineteenth century there is a clear tension between the traditional notion of history as cosmic moral drama vs. the Modernist notion of history as merely an aesthetic construct, a concept, informed by human conflict; between the traditional notion of science as the pursuit of meaning vs. the Modernist idea of science as the pursuit of meaningless fact; the traditional notion of reason as the means of obtaining wisdom vs. reason as a means of constructing a particular perspective. As discussed in the prologue, a major artist of this period was Eugène Delacroix. Torn between tradition and revolution, beauty and aesthetics, in 1822 he painted *Dante and Virgil in Hell*. As previously discussed, the theme is literary, from Dante's great Fourteenth Century masterpiece, *The Divine Comedy*. The scene depicts Dante crossing the river Styx with Virgil, close to the beginning of his ascending journey towards Beatrice, or Divine Love.

In quick review, the story views history as a moral drama, with Dante facing many obstacles in the pursuit of truth and love. Delacroix is then selecting a traditional theme with a moral content. But an odd note is injected into the work: to the right is Phlegyas, the boatmen, attempting to steer the craft to the far shore. But his torso, to any person familiar with ancient art, is a duplication of the famous Belvedere Torso of the Hellenistic period. The use of the Belvedere Torso is clearly out of context. It thereby changes history from a record of a moral drama to an artificial construct. It historicizes the work. In terms of natural science, Delacroix famously altered this work by applying some dabs

of pure color on the torso of one of the damned. The application of primary pigment indicates a shift from the idea that a painting or literary work is scientific in the sense that it explains reality and life, to that of science being the pursuit of facts. As a matter of fact, this painting is not a vision of the *Divine Comedy*, but rather is paint on canvas. The non-illusionist application of pure paint emphasizes that idea.

In contrast to the harmony depicted between Plato and Aristotle in Raphael's *School of Athens*, here the two central figures are in uneasy tension: Virgil standing with Classical calm, with Dante in emotional turmoil. It is a tension that refers not only to the art of Delacroix, but to the substance of Western culture at this moment in time. Neo-Classicism is Intellectualist and Voluntarist, where the mind is viewed as the source of knowledge, but is willful nonetheless. It is aesthetic, subject to taste, and assumedly rational as well. Consequently, history, science, reason, and art, are trivialized as mental constructs (as opposed to a cautious, *doxatic*, pursuit of degrees of truth). Kant claims that in the pursuit of knowledge reality conforms to how we think; that it is our understanding that constructs nature in our minds but does not create it. But if reality conforms to how we think then it is semantics to claim that as a practical consequence we do not create it. In any case, the search for objective truth and love no longer makes sense. It reduces them to a matter of personal perspective, a matter of taste, and a matter of power. Therefore Truth and Love die, replaced by intellectualism and voluntarism, and aesthetics replaces beauty.

Whereas Plato and Aristotle are confident—yet humble—in their search for knowledge, Delacroix presents a Dante who could not possibly find Beatrice. And as we have seen, the *Oath of the Horatii* is a call to arms and to duty, but that ostensibly principled duty is grounded in the will. But when history is denied its moral drama, then that will evidences no purpose beyond its own triumph. That is the traditional view of hell; to claim that we do not create that hell is false, as is the claim that we are bound to do so.

Kant is then a major proponent of the Enlightenment; he associates morality with secular deontological reason (the Categorical Imperative), and both with duty. And he advances the cause of aesthetics by positing that reality conforms to how we think. Once again, the shift from beauty to aesthetics is accompanied by a shift from principle to duty, from intelligible virtue or sacrament to emotion, and from responsible freedom stemming from understanding, to that of rationalistic and willful manipulation. Consequently, the *Oath of the Horatii* is a fine example of a new, a *Neo*-Classicism, that differs from Classicism by its separation of reason from reality, its conflation of beauty with aesthetics, and of principle with duty.

The Neo-Classicism of the Enlightenment differs from the Classicism of Plato and Aristotle, and the Classical ideas used by Augustine and Aquinas. That Neo-Classicism centers on a pursuit of a new understanding of reason,

and therefore a new understanding of beauty and justice. That new under-standing of reason is pursued via the influence of figures such as Newton and Voltaire, but particularly pursues two distinct paths: Kantian and Hegelian. Those two paths are respectively Modernist and Postmodernist.[7] As the fol-lowing discussion will explain, with the former, there is a secularized or deontologized type of reason, in the later, reason is made immanent. In both cases reason is aestheticized—the foundational beliefs of Western culture are assaulted, and the reality of responsible freedom is diminished.

The grand hope of the French Revolution is that Liberty, Equality, and Fraternity can topple the *ancien régime* and usher in a new and more enlight-ened age. Hebert, the leader of the Paris Commune, proposed that the worship of secular reason should be substituted for the worship of God and even had an actress portray reason at the altar of Notre Dame Cathedral. This disassociation of reason from truth, from an understanding of the meaning and purpose of reality, *being*, God[8] would have surprised both Plato and Augustine. For the Platonic Classicist and pre-Reformation Christian, reason is the means by which a purposeful and qualitative universe is realized and understood. Rea-son is transcendent and associated with being rather than experiential and immanent. It is a goal, and a tool of our consciousness rather than its product. Whereas for Aristotle reason is at its core clear, logical, and discursive think-ing, assumedly untainted by the will, Augustine emphasizes that there are emotional, psychological and spiritual aspects to reasoning, that love and understanding go hand in hand, and that cognition requires a divine spark.

But with the Enlightenment, reason seeks not the transcendent ideal, but rather, the mathematical, the logical, and the sensual.[9] The Logos of the Apostle John is markedly different to that of Voltaire, Kant—or even Hegel. And in contrast to Augustine's and Luther's notion of the bondage of the perverse will, that free will is only free when it loves the good (for sinful acts by defini-tion fail to be in harmony with a beautiful reality), there is now a new and incoherent association of freedom with both mechanical and natural neces-sity, and sheer acts of the will. It is here that we witness the genesis of the debate of nature versus nurture in the attempt to understand human behavior, contested only by irrational choice. It is a debate that ignores the importance of responsible freedom, and results in a conundrum: the will is then not its own master, and yet the only master that can be. As we shall see, the net result is a Voluntarism which trumps Intellectualism and natural necessity because intel-lectualism exists only within the thinking subject.

The Enlightenment marks then a dominant shift from Beauty to aesthetics, and necessarily, a shift from the rational and often passionate pursuit of the Ideal to a rationalistic and/or naturalistic advancement of the will. With the reduction of beauty to the realm of aesthetics the pursuit of truth is denied. What then is in its place? The pursuit of facts, feelings, rationalistic style, and the will. As a practical consequence, it is no longer wisdom and beauty that

one seeks, but rather, sensitivity and taste. Or rather, it is one's sensibilities, feelings, indeed taste, that produces a new type of virtue. Voltaire (François-Marie Arouet, 1694-1778) a leading proponent of the Enlightenment in France, defines taste as follows:

> ...attaining a quick discernment, a sudden perception which, like the sensations of the palate, anticipates reflection; like the palate it relishes what is good with an exquisite and voluptuous sensibility, and rejects the contrary with loathing and disgust.[10]

The advocacy of taste necessarily involves a rejection of systematization. Voltaire rejects systematic thinking,[11] substituting reason based upon experience and facts. The dilemma then is just how does one discern good taste from bad, good reasoning from that which is faulty? One solution is to propose that human nature is intrinsically good. If we are well intentioned, then eventually all will be resolved.

In his essay, *On Evil and Free Will*, Voltaire argues for the intrinsic goodness of humanity, as a sentimentalist must, but he also rejects a belief in free will declaring that freedom is power grounded in natural necessity:

> Man, then is not born evil. Why then are some of them infected with this plague of malevolence? It's because those who are at their head have the malady and communicate it to the rest of mankind [like Syphilis]...What is meant by the expression to be free? It signifies power... Will is Will and liberty is power...
>
> You receive your ideas, and therefore you receive your will. You will then necessarily; consequently, the word liberty belongs not to will in any sense. Liberty, then, on which so many volumes have been written, reduced to its proper sense, is only the power of acting... We exclaim,—if it be thus, all things are machines merely...we are only wheels to the machine of the world.[12]

Voltaire argues then for a naturalistic vision of the world, where reason is an intuitive response to empirical facts and mechanical necessity. For him, freedom is acting in conformity with that which is natural— i.e., mechanical— that which interferes with such freedom is seen as malignant. This vision is at its core Newtonian, whom Voltaire called the greatest man who had ever lived. Within this vision, if there is a God, that God created the world as a complex mechanical system, composed of natural laws, and then disengaged from further participation in that creation. Divinity makes a world where there is no purpose beyond mechanical necessity.

David's painting can be considered via the perspective of Voltaire. The evidence suggests that Voltaire would consider the plight of the Horatii and Curiatii to involve people who though naturally good, are placed in a social situation that results in violence. But why must they pursue their dreadful fate? Voltaire resists the notion of responsible freedom declaring instead that freedom is simply a necessary existential act. For his contemporary, Immanuel Kant, a larger explanation is offered.

In place of traditional Platonic or Augustinian thought, Kant presents us with a new, aesthetic paradigm. That paradigm can be summed up as consisting of the Categorical Imperative and the Hypothetical Imperative. The Categorical Imperative provides the source for morality grounded in secular reason, whereas the Hypothetical Imperative provides us a means by which we subjectively perceive the world.

Why should we pursue the Categorical Imperative? Out of a sense of duty. Kant declares that the only thing recognizable as good in itself is a good will. The use of that good will is a duty accepted by the Horatii and Curiatii. To view *The Oath of the Horatii* from a Kantian perspective, is to see a call to civic responsibility and duty prevailing over personal comfort and pleasure. Duty calls and is answered. But duty is a willful rather than virtuous or sacramental notion. If duty is a willful notion, then there can be no clear boundaries to just what duty requires. This results in problems for Kant's association of moral goodness with duty. Duty is willful, but to will the good is to deny knowledge of goodness, because such willfulness cannot objectively define itself as good. It therefore manifests an incoherency at its core.[13]

Indeed, the French Revolution devolved into a terror difficult, if not impossible, to justify.[14] This is evidenced in the next phase of David's career, a phase that takes a remarkable turn. As noted above, in his essay *On Evil and Free Will* Voltaire cites a number of alleged facts in support of his generous sounding but essentially empty contention that human nature is good. To assume the natural goodness of humanity is evidence of a prideful arrogance. Both Schopenhauer and Nietzsche face this conclusion, and (following Kant) conclude that *good* comes ultimately from the will. Each has the integrity to admit that when good is equated with the will, then existence (*becoming*) comes before essence (*being*). The association of goodness with the will leads Schopenhauer to lament them both. That same association leads Nietzsche to celebrate not goodness, but instead the will alone. We can choose to lament or celebrate our will to power—but power is all that there is. And when human nature is associated with a will to power that produces the willfully good, then a self-divinization results. Duty is grace subjected.

The French Revolution soon descends into the grip of terror, but to declare that terror to be the result of evil socialization is to deny the individual responsibility of those who murdered with zeal for their cause. In a work titled *The Death of Marat*, David paints a portrait of just such a figure, one who murdered and was murdered for the cause.

Marat was an important participant in the French Revolution, who in the midst of a bath was murdered by Charlotte Corday. David paints Marat as a secular Christ, a martyr to the cause of liberty, equality, and fraternity, a victim of treachery and a tragic hero to the revolution. What is odd about the painting is its moral obtuseness. It offers the opportunity to contemplate two opposing moral visions: the Postmodernist notion that the ends justify the means, and the Christian and Kantian denial of that claim.

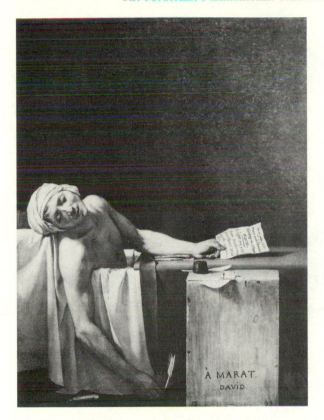

28. David, *The Death of Marat*

The question is whether Corday, or Marat, was an agent of goodness, or a delusional hypocrite. In looking at this painting the uninformed viewer might conclude that Marat was indeed a hero or tragic martyr. But the historical facts interfere with such an assessment. Without question, Marat was a ruthless demagogue matched only by the equally ruthless Robespierre. Each epitomized the essentially lawless notion that allegedly noble ends can justify even brutal means in their pursuit. Significantly, this Postmodern position is rejected both by Kant and by Biblical precept. To the informed viewer, looking upon Marat's visage is to be reminded that the transition from duty to fanaticism is slight. This painting makes clear the horror of the Terror as it unfolds, while giving it a noble appearance. And it confirms Augustine's opposition (in opposition to Dante) to the idea that appearance can be appreciated over meaning.

For the Spanish artist Francisco Goya (1746-1828), the deontological rationalistic spirit behind the Enlightenment and the *Oath of the Horatii* is revealed fully in the murder of Spanish civilians by the French. As depicted in

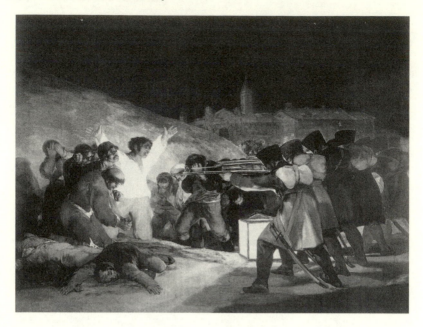

29. Goya, *The Third of May*

his painting, *The Third of May* (and by his print, *The Sleep of Reason Produces Monsters*) the Enlightenment has the appearance of civility, but not the substance.

In contrast to David's enthusiasm, the French Enlightenment led to lamentable consequences. Beyond the aesthetic, it resulted in qualitative and ontological horrors. Both David and Goya reveal that in the name of rationalistic duty revolutionists kill revolutionists and innocents alike, with both liberty and equality. As the blood flows, and as David and Goya paint, the Revolution seeks to violently construct an earthly Utopia[15] to replace the spurned heavenly one.

What is striking is that David, the great artist of the Enlightenment and Revolution, now becomes the great advocate, or rather, propagandist, of the dictator Napoleon. David paints *Napoleon Crossing the Alps*, (emulating Hannibal) his *Coronation (*emulating Charlemagne), and many other works. Does this shift in the art of David indicate the presence of cultural hypocrisy or political opportunism? The answer is more complex than either of these possibilities. How can David paint both for liberty and tyranny without embarrassment? Some might argue that the Napoleonic dictatorship was a practical response to a critical situation. But it is difficult to defend tyranny as a solution to tyranny, as it is difficult to pursue the good via evil means. Perhaps there exists a more plausible explanation for David's shifting stand and apparently shifting values. That answer is found in two distinct trends within the

Enlightenment: Kantian Modernism and Hegelian Postmodernism. The French Revolution begins as a Modernist movement but alternately becomes Postmodern. The Postmodern links between the philosophy of Hegel, the success of Napoleon, and the later art of David (and Beethoven) are clear; upon seeing Napoleon on horseback, Hegel famously remarked that he saw the Logos in the saddle.

How could David paint both for freedom and for tyranny? The Enlightenment advocated two distinct cultural viewpoints that for all their differences, are united by a shared commitment to aesthetics. On the one hand is taste dedicated to indifference to truth. It is the taste of the Hypothetical Imperative where morality is proposed via a deontological reason (Categorical Imperative). But on the other hand, is the taste dedicated to identity. That is the taste that insists upon its way—in the name of authenticity. So one is intellectualist, and the other is voluntarist. The result is a new and incoherent metaphysics that strives to replace the old.

On the one hand, is Kant celebrating with cautious enthusiasm the French and American Revolutions, on the other hand, is Hegel who sees Napoleon as embodying the unfolding of truth, or more precisely, of power. The incoherent dichotomy between Kant and Hegel, Neo-Classicism and Romanticism, indeed between Modernism and Postmodernism sets the stage for the next two hundred years. As explained shortly, with both Kant and Hegel, the practical idealism of Classical and Christian traditions is aestheticized and made intellectualist and voluntarist. A Conceptualism, operating in a meaningful context is now reduced to the exercising of rationalized or brute power. With the Enlightenment secularism is advanced, but in so doing, a deluded self-divinization emerges.

Examples of these developments will be discussed in detail shortly. For the moment, we can contrast Voltaire's and Kant's positions with that of Augustine, particularly since the Augustinian position survives through these periods, and up to the present, as a vital undercurrent. Both Augustine and Voltaire reject systematic and logical structures and facile notions of free will, both emphasize the active life over one merely contemplative or theoretical, both agree that knowledge is intuitive in the sense that it is an apprehension confirmed by experience and conceived with clarity. Where they differ is cosmological: Voltaire maintains that human nature is good, and driven by mechanical necessity in a purposeless world, while Augustine holds that the very assumption that human nature is good disproves itself by its prideful arrogance, an arrogance to be escaped by the grace of a God who provides purpose and meaning to existence. For Voltaire history is a record of contests between well-intentioned powers, and those victimized by evil are subject to the ill done by those socialized to do so. For Augustine history is the record of the struggle between those who attempt to seek beauty and those who embrace a violent aesthetics.

The French Revolutionists were hostile to transcendent thought such as that espoused by Augustine. As such the transcendent content of Platonic and Augustinian culture, and that of Christianity, were viewed as the unenlightened enemy. The Neo-Classical rejection of transcendent content is then a rejection of Classical culture; it is a *Neo*-Classicism in more ways than one. In its stead, non-transcendent Classical practices were assimilated. As the course of the French Revolution makes clear, those practices were markedly informed by a primal violence. In this light, Neo-Classicism is not a revival of Classical culture, but of the substitution of it with Classical sociology, and this suggests that at its foundations, the Enlightenment is a culture of violence. Such is the view of the founder of modern conservatism, Edmund Burke.

Conservatism, Liberalism, and the Enlightenment's Denial of Beauty

> *"Beauty is, for the greater part, some quality in bodies, acting mechanically upon the human mind by the intervention of the senses."*
> —*Edmund Burke*[16]

It is of historical significance that the denial of intelligible beauty is central to the work of Edmund Burke, a primary expositor of modern conservatism, and to that of Immanuel Kant, a primary source for modernist liberalism. That both contemporary conservatism and liberalism deny the significance of intelligible beauty is important in that it establishes that the denial of beauty is not simply a matter of the political and cultural Right versus the Left. Rather, it marks a fundamental and widespread—but not universal—decline in the cultural position of the West. It is a shift from the world having objective purpose to a world not having purpose. It is a shift from the notion of objective values to subjective ones; a shift from beauty and understanding to taste and feeling.

Burke was a skeptical viewer of the French Revolution of 1789. Nonetheless many of his positions echo those of Voltaire. In his book, *Reflections on the Revolution in France* (1790) Burke argues against grand intellectual schemes or radical innovation. He argues instead that tradition based upon Nature is key to securing both liberty and civility. Burke holds that among those natural rights are the right to justice, to the fruits of our labors, to inheritance from our parents, to the care and raising of our families, to instruction in life and consolation in death. We have equal rights in society, but not to equal things.[17]

For the Burkean conservative, tradition is the distilled wisdom of unlettered people, to be ignored at one's own peril. It is the accumulated wisdom of experience. That traditionalism is then naturalistic and social in realization, dependent neither on dogma nor ideology. It is not surprising then to find that Burke views beauty in like fashion.

Burke begins by critiquing three traditional approaches to beauty: that it is found in proportion, in fitness, and with goodness or perfection. Proportion, fitness, and goodness or perfection are critiqued as being empirically unjustified as criteria of beauty. He ignores the position concerning beauty associated with ontological goodness or perfection. Indeed, the idea of intelligible beauty associated with Plato, Augustine, is reintepreted in a deibtic neo-classical mode by Shaftesbury who said:

> ...what is BEAUTIFUL is Harmonious and Proportionable; what is Harmonious and Proportionable, is TRUE; and what is at once both Beautiful and True, is, of consequence, Agreeable and GOOD.[18]

In contrast to Augustine's admonition that taste and reason cannot be reconciled,[19] Burke adopts a generally empirical approach to beauty—or rather to aesthetics. In his work *A Philosophical Enquiry into the Origin of our Ideas of the Sublime and Beautiful* (1757) Burke argues that taste is based upon immutable natural laws discernible via knowledge, practiced judgment, and sensibility. In so doing, he agrees with Voltaire that beauty is now a synonym of aesthetics, but he distinguishes his position from that of Voltaire who held that taste is but a quick discernment, a sudden perception, like the sensations of the palette. Burke makes clear the folly of such an approach:

> [I]f Taste has no fixed principles, if the imagination is not affected according to some invariable and certain laws, our labour is like to be employed to very little purpose; as it must be judged an useless, if not an absurd undertaking, to lay down rules for caprice, and to set up for a legislator of whims and fancies. [20]

What then are those objects of knowledge so necessary to aesthetic judgment? Burke rejects the idea that Beauty is intelligible. Beauty is thought by him to depend on physical properties in objects, properties apprehended through sensation. Reason is not the determiner of beauty, but rather it is the means by which we come to understand the sensible experiences we encounter.

> Beauty is a thing much too affecting not to depend upon some positive qualities. And, since it is no creature of our reason, since it strikes us without any reference to use, and even where no use at all can be discerned, since the order and method of nature is generally very different from our measures and proportions, we must conclude that beauty is, for the greater part, some quality in bodies, acting mechanically upon the human mind by the intervention of the senses. We ought therefore to consider attentively in what manner those sensible qualities are disposed, in such things as by experience we find beautiful, or which excite in us the passion of love, or some correspondent affection.[21]

This is curious since there are echoes of the Platonic and Augustinian association of beauty with love and truth in his writings. But Burke, who also resonates with Aquinas when stating that beauty occurs via the senses, is a

sensationalist rather than a realist. It is not beauty of which he speaks, but rather, aesthetics, and ultimately, taste. In his *Introductory Discourse on Taste*, Burke discusses the allegedly naturalistic principles of good taste:

> ...It is probable that the standard of both reason and taste is the same in all human creatures. For if there were not some principles of judgment as well as of sentiment common to all mankind, no hold could possibly be taken either on their reason or their passions sufficient to maintain the ordinary correspondence of life[22]

He observes that taste occurs to the palette (where people agree that vinegar is sour),[23] to things of sight (where people agree that swans are more beautiful than geese), of the imagination (where the ability to imitate the natural object is supreme). The shoemaker can set right the painter in regard to mistakes made in depicting a shoe; the anatomist, critical of how the figure is painted may not even notice the shoe. For Burke, knowledge resulting from the experiencing of physical reality is the means to an acquisition of good taste.

The result is traditionalist aesthetics quite compatible with a traditionalist culture and politics. Both are combined in a painting from this period, Gainsborough's *Portrait of Mr. and Mrs. Andrews* (c.1750). It is a perfect exposition of the ideas articulated by Burkean conservatism.

Depicted is a successful couple enjoying with clear satisfaction the fruits of their labor. Rejected is any notion that their success is ill gotten. Property is not theft, as Proudhon proclaimed, but rather it is the record of virtue. It does not compete with human rights, but rather, secures those rights.[24] Or does it?

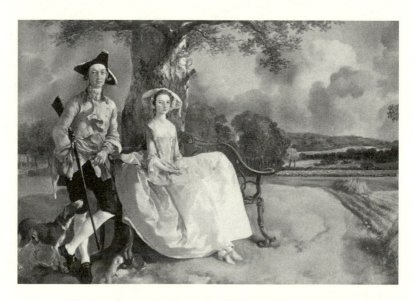

30. Gainsborough, *Portrait of Mr. And Mrs. Andrews*

There is an important undercurrent to this painting. That undercurrent is articulated by the Scottish philosopher David Hume (1711-1776). For Hume one's very identity is socially ascribed rather than found in any universal ideal; any belief in personal identity which purports to be grounded otherwise is seen as an unwarranted fiction. Pride and humility are deemed to be different, yet to have the same object: the self. Therefore, pride leads not to our loss of meaning, but rather, to a realization of meaning in our self. This association of pride with humility is as influential as Hegel's association of truth with power and Rousseiu's confusing thinking with feeling. There is an attempt at transforming the traditional vice of pride into virtue; there is also an attempt to aesthetically confuse love with power.

Alasdair MacIntyre explains Hume's position:

> ...So pride elicits, or at least seeks to elicit, what Hume calls love. And humility correspondingly elicits hatred. What we prize in ourselves is the object of our pride; what we prize in ourselves when presented as the same quality belonging to another is the object of our love.
>
> What according to Hume...moves us in others to either love or hatred is able to do so only because and insofar as it moves us to pride or humility regarding ourselves...[And as Hume states] "the relation, which is esteem'd the closest, and which of all others produces most commonly the passion of pride, is that of *property*.
>
> A system in which pride in houses and other such possessions, and in one's place within a hierarchy, is the keystone of a structure of reciprocity and mutuality, in which property determines rank, and in which law and justice have as their distinctive function the protection of the propertied, so that principles of justice provide no recognizable ground for appeals against the social order. ..What Hume presents as human nature as such turns out to be eighteenth-century English human nature, and indeed only one variant of that, even if the dominant one...Hume engages in practical reasoning qua member of a type of society in which rank, property, and pride structure social exchanges.[25]

As a matter of taste, it is a portrait that evokes in the Conservative mind admiration and inspiration. To the taste of the Revolutionary its respect for tradition, virtue, and property provokes hatred and envy. The irony is that in both cases, Hume's position is affirmed: in a culture of social identity, power is the determining narrative of life.

Kantian Aesthetics, the Hegelian Alternative, the Nietzschean Conclusion[26]

The issue of taste is central to the Enlightenment, and not only to Burke and Hume. It was of primary concern to Alexander Baumgarten, and to Immanuel Kant as well. When Kant wrote his important text, *The Critique of Pure Reason in* (1781) he was responding directly to the work of Hume; he was influenced by both Baumgarten and Burke in developing his arguments in *The Critique of Judgment* (1790). Kant acknowledged that the empirical

exposition of aesthetic judgments was central to the Enlightenment, and that Burke and Hume were important to its advancement.

The Enlightenment relied both on taste and a commitment to freedom of inquiry, of which we had a right and duty to engage. Primarily associated with 18th century German culture, with proponents in England and France as well, the Enlightenment was dedicated to advancing society beyond the constraints of superstition, mere tradition, and social habit. It offers instead an aesthetic worldview that centers on freedom and creativity. We should enjoy a freedom of inquiry; the fruits of that inquiry are to be manifest in a tolerant realm where we can aesthetically create different visions of reality. There are facts, and different ways of putting those facts together. As long as we pay attention to facts, and purport to do no harm, we confidently insist upon our right to believe and do as we wish. Consequently, it is easy today to be an advocate of freedom. To suggest that we ought to encourage freedom is safe indeed, but should we attempt to link that freedom to the pursuit of truth, then just watch the fireworks begin. The notion that freedom is reliant upon truth, upon knowledge that to some degree is objective and purposeful, seems somehow intolerant and even oppressive. It seems un-Enlightened, as well it is.

It is the aesthetic disassociation of freedom from truth that is the crux of the dilemma. To disassociate freedom from truth is to substantively deny both morality and beauty. Freedom is now commonly associated with creativity. In place of truth, of thought that corresponds with or informs reality, we now pursue facts: accurate descriptions of particular things; creativity involves arranging facts as we please. Our ability to arrange facts as we please allegedly marks not only creativity and freedom, but tolerance as well. A tolerant society is assumed to be one where there exists a shared commitment to freedom of conscience, where each can construct a unique vision of reality and life. In contrast, the notion of truth being to some degree a matter of objective knowledge of reality seems doctrinaire, oppressive, and intolerant. But given that the slogan of the Enlightenment is: "Dare to know," then lacking the notion of truth, we might reasonably wonder: *Just what is it that we are attempting to know, and why?* And lacking the notion of truth, we might reasonably wonder how we can have morality; lacking objective purpose, moral claims are necessarily reduced to unqualified calculations of pleasure and power. Morality and Beauty become aestheticized—and thus denied.

Immanuel Kant's publications attempt to establish just what kind of knowledge is to be sought, and how. In earlier discussions it was noted that *Being* or God was recognized to be ultimately ineffable but of which, none the less, some precious degree of knowledge was possible via reason and revelation. For example, with his theory of illumination Augustine found some degree of knowledge of reality to be rationally obtainable, and that rational knowledge was believed to be in harmony with Christian revelation. In contrast, in a conceptualist fashion Kant holds that the world as it is, the *ding an sich*,

cannot be known, so truth cannot be known. Instead, he posits that there are facts, feelings, and rationalistic style. Facts are objective, but how we put those facts into explanatory narratives is linked to how we think; facts conform to the structure of our minds, but now the structure of our minds need not refer to the mind of purposeful reality—God. The human logos need aspire neither to the mind of God nor even the structure of the cosmos.

The process of making sense of the world via a rational arranging of facts is held to be both aesthetic and creative; at its best, that process is the work of genius. The result is that facts are objective, but reality is subjective, it is an aesthetic construct. So the Enlightenment admonishes us to "Dare to know!" but if our worldviews and our lifestyles are constructed by us, then what is there to know? To reduce knowledge to facts, feelings, and rationalistic style is to reduce understanding to a willful existence. If freedom and creativity occur in a context without purpose or meaning, then what *good* can result? It is curious how creativity is lauded in the absence of truth, since in the absence of truth what can creativity be but trivial and violent? In the absence of truth we are reduced to aesthetic sentience. The challenge of escaping a life that is aesthetic and meaningless, and therefore tragic, is faced by Postmodernism. But as we shall see, it is a challenge accepted but not resolved; within the influence of the Aristotelian tradition the failure to solve tragedy reoccurs through history, with Postmodernist Existentialism but the most recent example. But this Nietzschean notion of eternal reoccurrence need not repeatedly occur; rather, the pursuit of beauty offers a perennial source of relief.

To the present point, there are many inherent difficulties with the Kantian and Neo-Classical vision. Those difficulties are products of a genius-based formalism that is key to a purportedly liberating and tolerant aesthetic vision. Kant claims that duty and a dutiful reasoning will allegedly provide individual and social morality. But a deontological rationality is conceptualist without a ground in *being*. Reality, life, and art are all reduced to a fact-based relativity (Hypothetical Imperative), where the necessary outcome is a cultural and moral relativism (a conceptualist Categorical Imperative). But as discussed in the opening chapters, cultural relativism demands a tolerance not easily granted, since there are cultures that do not believe in tolerance—or duty to rationalistic principle. Cultures dedicated to constitutional democracy, or universal human rights, are at odds with multiculturalism, and yet multiculturalism is the necessary conclusion of relativism. Cultural relativism is antinomian in that in the name of tolerance, belief in truth is denied, and even as truth is intolerantly denied, conflict remains as a consequence of taste. Intellectualism and voluntarism are thus incoherently deemed the principles of civilized behavior. In the name of freedom and creativity, we are condemned to a rationalistic willfulness in an aestheticized reality lacking purpose. The free pursuit of the good life is reduced to the willful constructing of lifestyles. Consequently, multiculturalism

reveals itself to be a violent monoculture, where a rationalistic willfulness masks a will to power and despair.

With its Intellectualism and Voluntarism, Kantian relativism provides neither meaning nor intelligible purpose to life. The attempt to define the good via a willful duty has ominous implications—as will shortly be shown. What is denied is the possibility of beauty—or love—in our lives. Kant presents an aesthetic vision of Enlightenment, one which Plato and Augustine would condemn as lacking illumination. And three fatal flaws of Modernism are soon recognized by the Postmodernists and others: First, the assumption that a tolerant aestheticism will lead to civility makes no sense. Lifestyles do in fact come into bitter conflict. Second, the admonition that we ought to do as we will, as long as we do no harm to others, offers us not a clue as to what is worth doing. Finally, the aestheticization of reality and life intolerantly trivializes the world in the name of tolerance. It is in response to that trivialization, that Hegel, Marx, and Nietzsche come to the fore.

Transcendental vs. Immanent Aesthetics: the Cultural Contradictions of Modern-Postmodern Relativism

A tragic conflict between knowledge and experience plagues the Classical mind. Fate or chance appear unreconciled with virtue and freedom. A similar conflict between knowledge and experience afflicts Scholastic Conceptualism. There is no necessity in believing that truth exists *both* in the mind of God *and* the mind of humanity. Therefore, there is no necessity for transcendent beauty to be recognized as important in the world we experience, but without such beauty, all meaning is denied.

Both the Aristotelian and the Scholastic face a similar question: Can acts of volition have meaning, or rather, can responsible freedom lead to beauty and justice? The Aristotelian offers no solution beyond purgation; the Scholastic offers a solution, but one with a tragic flaw: the assumption that philosophy and theology are separate advances a purposeless philosophy. Notwithstanding its intention, it thereby lays the foundation for a purposeless world and the nihilistic self-deification—and self-hatred—of Postmodernist Existentialism.

In facing the question of how to solve the conflict between knowledge and experience, the Modernist-Postmodernist tradition uniformly emphasizes the notion of a subjective-objectivity. It advocates an alleged *transcendental aesthetics*. But a transcendental aesthetics leads to a violent metaphysics. Aesthetics equates *being* with *becoming*. It thus denies *being* as purpose. The denial of the objectivity of *being*, of reality, results in an existential void where *becoming* is *being* and we are divine. But since there is and can be no purpose to life, then such subjctive claims or divinity become tradegy—and farce.

Truth is no longer transcendent and associated with intelligible beauty. It is no longer ontologically objective; rather, it is grounded in subjectivism. That

subjectivism may variously purport to be objective, by being grounded in immanent reality, but immanent truth alone results in an empty confusing of power for truth. The result is that truth is associated with the will. Consequently, this paradigm requires the recognition of an unresolved conflict, or dialectic, between experience and our will, and between aesthetics and beauty. But more than a conflict, or dialectic, it is a gulf, a void, a chasm, which makes manifest a fundamental, existential, anxiety. Our will should be done, but it is ineffective in its demands, and has no purpose.

Specifically, the Modernist-Postmodernist mind comes to an existential conclusion. Beyond the rationalizations of race, economic class, gender, or individual preference, there is an existential void. It is a void where self-expression and self-realization are celebrated as meaningless yet beautiful. That solution has been offered to span the gap between experience and understanding, between a life of subjectivist aesthetics and one of beauty. The foundational assumption of such a solution offered by Immanuel Kant is his proposed *transcendent aesthetic*.

In Kant's *Critique of Pure Reason* he offers two circular and even conflicting first principles. Working from the Scholastic and Aquinian doctrine that all knowledge stems from sense experience, Kant declares that knowledge begins with empirical experience, but in Conceptualist fashion he separates the mind of humanity and the mind of God by stating that reality conforms to how we think. Kant explains:

> That all our knowledge begins with experience there can be no doubt…But though all our knowledge begins with experience, it does not follow that it all arises out of experience.
>
> Hitherto it has been assumed that all our knowledge must conform to objects. But all attempts to ascertain anything about them a priori by concepts, and thus to extend our knowledge, came to nothing on this assumption. Let us try, then whether we may not make better progress in the task of metaphysics if we assume that objects must conform to our knowledge. [27]

For example, empirically the sun travels across the sky from east to west; whether we conceptually understand that movement via a Ptolemaic, or Copernican perspective, observed reality remains the same. Copleston explains,

> "Kant's 'Copernican revolution' does not imply the view that reality can be reduced to the human mind and its ideas…What he is suggesting is that we cannot know things…except in so far as they are subjected to certain a priori conditions of knowledge on the part of the subject." [28]

So reality is not reduced to idealism. Rather, reality conforms to how our minds naturally organize data. The goal of obtaining genuine knowledge of the world (metaphysics) without succumbing to preexisting (a priori) assumptions is deemed impossible; but a constructed or *synthetic a priori* knowledge

is deemed possible by the interactions between experience and reason. That *synthetic a priori* is referred to as the *transcendental aesthetic*.

And just what is meant by such terms? We can begin by this example: knowledge that a flame can burn your finger is obtained experientially; but that experience provides an a priori knowledge for future use. We can know in advance that we should not touch a flame. Kant would call this an example of a synthetic a priori knowledge. However, Kant seeks a more profound sort of a priori knowledge via experience. He seeks one that is necessary and universal. Just as he embraces a subjective-objectivity in regards to truth, Kant seeks a transcendental aesthetics to displace the pursuit of beauty.

Aesthetics refers to fact and feeling, whereas transcendence refers to meaning and purpose. If not substantively incoherent, postulating a transcendent aesthetic is at the very least consistent with equating truth with power and goodness with the will. The concepts informing the *transcendental aesthetic* are central to Kant's system and to Modernist Liberalism as well. What is a *transcendental aesthetic* and does it make any sense? We can begin with Copleston's explanation of Kant's position:

> The only way, says Kant at the beginning of the *Transcendental Aesthetic*, in which our knowledge can relate immediately to objects is by means of an intuition…The Divine intellect is said to be both intuitive and archetypal. That is to say, the divine intuition creates its objects. But this is not the case with human intuition, which presupposes an object…
>
> Human knowledge arises from two chief sources in the mind. The first is the faculty or power of receiving impressions…Sense intuition provides us with data…The second main source of human knowledge is the power of thinking the data by concepts…The receptivity of the mind for impressions is called sensibility (Sinnlichkeit). The faculty of spontaneously producing representations is called understanding (Verstand). And the cooperation of both faculties is required for knowledge of objects.[29]

In a Neo-Classical fashion Kant tweaks the Classical notion of an external world being in an undifferentiated state awaiting an objective and rational arrangement by which cosmos can emerge out of chaos. But just as Neo-Classicism rejects the ontological realism of Plato, Kant rejects reason as being connected with an understanding of a beautiful reality. Rather, we are to reduce all operations of the understanding to judgments, so that the understanding can be represented as the power of judging. And what does it mean to exercise the power to judge? Copleston states Kant's position:

> The understanding does not intuit; it judges. And to judge is to synthesize. Now, there are certain fundamental ways of synthesizing (functions of unity in judgment, as Kant puts it), exhibited in the possible logical types or forms of judgment. And these exhibit the *a priori* structures of the understanding
>
> To judge, which is the same as to think, is to unify different representations to form one cognition *by means of concepts*.[30]

To view Kant as the fulfillment of Conceptualism is obviously justified. For Kant those concepts are found not in a Divine mind, but rather in the very structure of our minds. They are not found in a purposeful nature, but in the mode of Voltaire it is assumed that they are natural to the cognitive processes of the human mind. Just as Aristotle pursued a formalistic categorization of thinking, so does Kant. But Kant declares that in contrast to Aristotle's haphazard categories, his list is based upon principle. That principle is the synthesizing power of understanding. Understanding relies upon those categories or modes of thinking we use to make sense of the world. Echoing Aristotle and Scholasticism, Kant postulates that there are twelve such categories of understanding which are *a priori* conditions for knowledge.

It is important to recognize that just as the Platonic/Augustinian tradition resisted Conceptualism, it today resists Kantianism. It is also important to recognize that until recently the majority of the population of the West lived by choice or habit in accordance with transcendent values—be they Classical or Judeo-Christian. The majority pursued their lives affected by the Conceptualist thrust of Scholasticism, and its later proponents such as Kant, while managing to cling to transcendent values and the ideal of responsible freedom. But antagonistic to the tradition of beauty within the Western community is the aesthetic Modern-Postmodern House of Life. It is a different sort of house of life, in which Empiricism, Intellectualism, and Voluntarism dominate. It is a house constructed by the combination of facts, feelings, rational consistency, and the will. Those combinations can vary in particulars, but they conform to each other by their essentially aesthetic vision of reality and life. Modernism aestheticizes reality and life by its conviction that facts are objective, reality is subjective, and that both conform to how we think and feel. We construct an understanding of reality and life. This notion of constructivism, so central to contemporary relativism, has been defended as scientifically sound. The physics of relativism is seen as hard scientific proof of the soundness of a culture of relativism. But it is important to note that it was not the physics of relativism that led to the culture of relativism. Rather, it was just the opposite. Kant's philosophical position that reality conforms to how we think is *a priori* to Einstein's scientific position. It can rightly be argued that the scientific vision of relativism—conforms to—how *Kant* thinks.

But it is not just how Kant, or we, think. It is also a matter of experience. As noted above, Kant maintains that knowledge is a matter of both rationality and experience. He concludes that reality conforms to the categories of our minds. But this Modernist relativism results in a formalism that offers no prize and elicits no meaningful passion. In place of the pursuit of the good life, Kant substitutes the notion of a variety of aesthetic lifestyles, an advocacy of lifestyles that mandates tolerance but denies meaning. Kant speaks of duty and rational restraint, but whereas human dignity is linked by beauty with human rights and self-control, by aesthetics it is reduced to human appetites

demanding to be satisfied. It reduces human freedom to mere license. Whether or not this was Kant's intention is beside the point. His viewpoint is intolerant of belief—or at least of belief other than the shallow aesthetics offered by facts and feelings, and it is thus intolerant of responsible freedom. Despite its title, Kant's transcendental aesthetics denies transcendence—and therefore beauty and freedom as well. This substitution of the human mind as the *a priori* determiner of knowledge and reality (as anticipated by Descartes) is to substitute the human mind for the mind of God. Even from the perspective of atheism, it is a substitution with dangerous social and political implications.

But rather than accept Kant's conclusion, where meaning is reduced to aesthetic taste, why not pursue existential certainty? Postmodernism accepts Kant's premises but rejects his conclusions. As noted above, in his *Critique of Pure Reason* Kant states that there can be no doubt that all our knowledge begins with experience. There remains then the option of experienced reality. In place of Kant's (aesthetic) Constructivist relativism Postmodernity focuses on an (aesthetic) Existentialist relativism. By Existentialist is meant that the foundations of culture are immanent. They refer to fact, feeling, and our direct empirical experiences. They are a matter of identity.

Hegel and Romanticism

Hegel is often portrayed as the antithesis of Kantian Modernism. In many ways that is true and he therefore warrants the designation of being the first Postmodernist. But in his attempt to refute the aesthetic liberalism of Kant, he nonetheless remains aesthetically oriented. He attempts to escape aesthetic relativism, but does so by adopting a new type of relativism: that of an immanentist identity. By that is meant that he conflates reason with feeling and power, and thereby conflates beauty with aesthetics, and purpose with self-expression and self-realization. Hegel rejects Kantian Liberalism as intellectually and morally lacking, and with it the Kantian notion that culture and history are the records of our ever futile striving for a self- defined perfection. He rejects the idea that culture and history are ultimately matters of fact and rationalization. Similarly, he rejects the Augustinian view of history as a moral struggle between goodness and evil, where in the fullness of history, responsible freedom ultimately prevails.

In their place he posits a different vision of reality and life, one that on the face of it would appear to favor beauty over aesthetics. He views culture and history as the identity of Reason with material reality. The unfolding of culture presents the inevitable unfolding of cosmic truth and purpose. That identity of Reason and reality, he holds, liberates us from the Kantian trivialization of culture and from a purely mechanical understanding of the world. But by associating truth with power, Hegel aestheticizes the traditional meaning of beauty, truth, and goodness.

The vitality of Western Culture has long relied upon the acceptance of the existence of objective Truth, *and* of the personal and social difficulty in rationally understanding that Truth. As Hegel affirms, the pursuit of Truth is directly connected with the cultural heritage of the Christian West, a heritage resulting in both intellectual and political freedom. But Kantian aesthetics reduces that pursuit to a mere shadow of itself. Since reality (the *ding an sich*) cannot be known, then the pursuit of Truth has lost its grounding. In its place is a rationalistic ethics (the Categorical Imperative) combined with a practical relativism: facts are objective, but reality is subjective (the Hypothetical Imperative), and as long as we are tolerant then all should go well.

Hegel rejects the Kantian and Modernist notion that reality is merely "reality," is merely an aesthetic construct. What then does Hegel offer? He attempts to understand reality, or better yet, to consciously participate in reality. In contrast to the traditional Augustinian notion of reason seeking to illuminate and contribute to a difficult to discern Divine purpose, Hegel posits that history, nature, and the political state are all manifestations of an immanent reason or Absolute Spirit. That reason, or Logos, manifests itself in the whole of reality, and therefore, is identical with Nature, Culture, and Civilization.[31] By ignoring transcendentalism, he immanentizes and aestheticizes both the Platonic-Augustinian tradition and the Aristotelian-Conceptualist tradition as well.

Hegel argues for an immanent vision of the world, where nature, culture, and civilization are knowable because they participate in the Absolute Spirit which informs reality with purpose. The political State is the unfolding of Truth, and as such, evidences the unfolding of freedom. It is an unfolding that is Beautiful, because Beauty is the sensuous semblance of the Idea. So truth and beauty appear to once again be associated. Not only truth and matter, but subjectivity and objectivity as well, are synthesized. But that synthesis is now felt rather than understood. As Hegel puts it: "Art has the task of presenting the Idea to immediate intuition in sensuous form, and not in the form of thought or pure spirituality." [32] Copleston explains:

> Both the artist and the beholder may feel that the product is, so to speak, just right or perfect...But it by no means follows that either of them can state the metaphysical significance of the work of art, whether to himself or to anyone else.

According to Hegel, culture and history are comprised of four stages in the development of Spirit as manifested in the State. They are defined as the Oriental, the Greek, the Roman, and the German. The Oriental consciousness had not attained knowledge of freedom; that knowledge first occurred among the Greeks, and they and the Romans assumed that only some humans ought to be free; finally, the German Nations, under the influence of Christianity, first fully understood that humanity as humanity—is free.

Hegel advocates a return to intelligible beauty, but continues with the now centuries-old tendency to associate intelligible beauty not with a largely ineffable mind and substance of God, but rather, with willful aesthetic experience. That will is neither divine nor human - rather it is both. Hegel considers the history of the world as an unfolding of Spirit, but the Spirit is no longer the transcendental God of Christianity. Arguing that it was Christianity that first offered the self-awareness of that Absolute Spirit essential to freedom, Hegel sees world history as the process whereby that Spirit comes to actual consciousness of itself as freedom. This consciousness is attained via the mind of humanity. In what Hegel calls the Absolute Spirit, humanity's knowledge of the Absolute and the Absolute's knowledge of itself are two aspects of the same reality.[33]

According to Hegel there is an ascending order of art and culture. The most material and least free is the art and culture which is Symbolic. The term Symbolic is not understood in the Augustinian sense as a physical indication of the presence of the divine, but rather, as an object. Classical art balances matter and idea, whereas the highest form of art and culture is Romantic, where the material object cannot adequately contain the spiritual content present. It is Romantic art that represents the German consciousness, most true and free, where the previous conflict between the secular German mode of life has with the Christian mode been synthesized into a single order of rational freedom. That rational freedom, Hegel maintains, is found in the singularity of the Romantic State. The secular State embodies the will of God, and *freedom is to be found in obedience to the State.*

In his manuscript notes for his lectures at the University of Berlin Hegel rightly notes the difference between aesthetics and beauty:

> ...*Aesthetic* denotes more accurately the science of the senses or emotion. It came by its origins as a science, or philosophy, during the period...when works of art were generally regarded in Germany with reference to the feelings they were calculated to evoke...we are [now] justified in maintaining categorically that the beauty of art stands higher than Nature. For the beauty of art is a beauty begotten, a new birth of mind; and to the extent that Spirit and its creations stand higher than Nature and its phenomena, to that extent the beauty of art is more exalted than the beauty of Nature.[34]

This is not to say, however, that the beauty of Nature is separate from the beauty of the Spirit. Hegel views the world as an organic process. In discussing pantheism Hegel said:

> The ancient philosophers have described God under the image of a round ball. But if that be His nature, God has unfolded it; and in the actual world He has opened the closed shell of truth into a system of Nature, into a State-system, a system of Law and Morality, into the system of the world's History.[35]

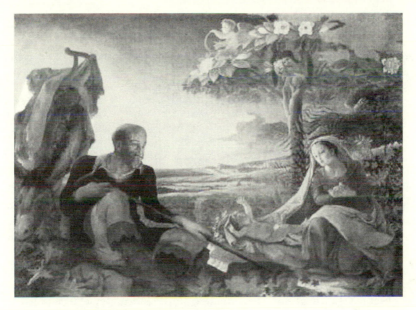

31. Runge, *Flight to Egypt*

Later disciples such as F. Theodore Vischer (1807-1887) did not hesitate to develop Hegel's ideas to the conclusion that only pantheism does justice to Beauty. Those pantheistic tendencies within the Hegelian scheme have both political and artistic consequences.

For example, Phillip Otto Runge's painting, *The Flight to Egypt* evidences this incoherent Germanic-Christian pantheism. At first glance the work appears to simply represent a standard depiction of Mary, Joseph, and the Christ Child, as painted so many times in the past. However, a discordant note is present. In the crown of the tree is depicted a nature deity. The presence of a nature deity injects a pantheistic content into a non-pantheistic theme. One cannot be a pantheistic-Christian, or a Christian-pantheist. Why not? For this reason: there is an incontrovertible difference between pantheism and the transcendent monotheism of the Judeo-Christian tradition. That difference is profoundly significant. Pantheism denies that personalities can be unique. The absorption of all things in an immanent God reduces human personality to zero. Martineau describes pantheism as:

> ...reason that does no thinking for itself, a conscience that flings aside no temptation and springs to no duty, affection that toils in no chosen service of love, a religious senti- ment that waits for such faith as may come into it, simply negative their own functions and disappear.[36]

In his book, *The Phenomenology of the Spirit,* Hegel attempts the reconcil- ing of the human and the divine via the unity of synthesized consciousnesses.

The result is that the State embodies the unfolding of the logos, and freedom consists of obedience to the State. On 13 October 1806, when Napoleon entered Jena at the head of the French occupying forces, the thirty-six-year-old Hegel wrote in a letter,

> I saw the Emperor, that soul of worldwide significance, riding on parade through the city. It is indeed a wonderful sensation to see such an individual who here, concentrated in one point, sitting on a horse, encompasses the world and dominates it.

As Hegel notes, it is Napoleon who embodies the Logos, the unfolding of cultural necessity. Alexandre Kojève comments on Hegel's text, *The Phenomenology of the Spirit*, by asking if Hegel, the prophet to the God- Napoleon, was not actually expecting to be invited by the emperor to Paris to become the court-sage of the universal state. We can ask the same question of latter day Postmodernists, such as Heidegger (discussed below), who saw in Hitler what Hegel saw in Napoleon, and who similarly curried favor.[37]

As discussed previously, David, the great painter of the Enlightenment and Neo-Classicism, first painted in the name of liberty, equality and fraternity, but later becomes the great advocate, or rather, propagandist, of the dictator Napoleon. David paints *Napoleon Crossing the Alps*, his *Coronation*, and many other works. The drawing, *The Coronation of Napoleon* marks the political moment where transcendentalist philosophy is replaced by immanentism.

As part of his coronation, Napoleon had invited to Paris the Pope. The historical associations resonate: Charlemagne had gone to Rome where he was crowned by Pope Leo; now a millennium later, a later Pope would come to Paris. And to do what? Not to confer legitimacy, but rather, to witness it. Napoleon as the embodiment of historical necessity, crowns himself, in self-conscious contrast to his predecessor Charlemagne. Lest the accusation be made of overstating the case, David's later portraits of an imperial Napoleon (or those by Ingres) suffice to make the point. Napoleon was declared Consul for Life on August 2, 1802. Although he crowns his wife Josephine empress of his empire in David's famous painting depicting the event, he later abandons her out of political opportunism, or the historical necessity of the moment in which the unfolding logos demands that he yield to the interests of France. As with Louis XIV, the state is again identified with a personality, but this time there are no pretenses of divine sanction—at least to divine sanction beyond that claimed by and in the personality of Napoleon.

To return to an earlier question: In first painting for the Revolution, and then painting for a dictator, does the art of David indicate the presence of cultural hypocrisy or political opportunism? The evidence suggests not. It evidences rather a person torn by the logical consequences of illogical belief. David struggled with the two distinct trends within the Enlightenment: Kantian Modernism and Hegelian Postmodernism. The French Revolution begins as a Modernist movement but the Postmodern alternative soon debuts. The Mod-

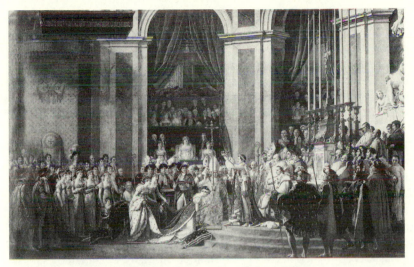

32. David, *Coronation of Josephine*

ernist relativism of Kant facilitates the Postmodern relativism of Hegel, that is, a Postmodernist relativism that relies upon an identity with a pantheistic view of reality and life. The Postmodern links between the philosophy of Hegel, the success of Napoleon, and the later art of David (and Beethoven)[38] are indisputable. So too are their violent, banal and totalitarian consequences.

So rather than knowledge being processed by the Scholastic sounding alleged twelve rational structures of the human mind, as postulated by Kant, it can be processed existentially. It can be grounded in the Spirit of Nature (Hegel), of the Economic Class (Marx), of Race or Gender (Darwin, Comte, Spencer), or of the unfettered Individual (Nietzsche). The foundations of each are an identity based aesthetics rather than a pursuit of beauty.

David's celebration of Napoleon parallels Hegel's belief that Napoleon was the World Spirit in the saddle. Runge's interpretation of a Christian theme parallels Hegel's transformation of Christian culture (which is both Transcendent and Immanent) into a Germanic and Postmodernist Immanentism. Those on the Right attempted to reconcile Hegel's system with a nationalistic and incoherent version of Protestant theology; those on the Left used it to advance pantheism, naturalism, and atheism. In either case, obedience to the State is freedom, and the acts of Napoleon, and logically, of Hitler and Stalin, are necessarily instruments of the Absolute Spirit differently made manifest.[39] To the point, Hegelianism is an *alternative in kind* to Kantianism, and it is not the only alternative. There is also the materialism of Marx.

The Postmodernism of Marx

"Beauty is in nature, and in reality is encoun-
tered under the most diverse forms.

The beauty based on nature is superior to all artistic conventions." —Gustave Courbet

In contrast to Kant, Karl Marx accepts that material reality exists outside of the human mind and can be understood. In contrast to Hegel, Marx maintains that it is not the Idea that determines how the world is, but rather, it is material reality that determines how we think. Early in his career, Karl Marx (1818-1883) was a member of a radical Hegelian group, convinced that Hegel provided a philosophical means by which to understand reality and life. Marx was also influenced by Ludwig Feuerbach, who declared in his text, *The Essence of Christianity*, that it is man not God who is the basic reality (for the Augustinian this pronouncement states simply that man is God).[40] Hegel's structure of thought remained viable to Marx, but his fundamental premises did not. Reality is not the unfolding of the willful consciousness of the Absolute Spirit, or immanent God; rather, it is the unfolding of the willful consciousness of man. That will is grounded in dialectical materialism and economic class. Therefore, the purpose of culture is not to understand the world, nor to interpret it, but to change it.

In 1848 Marx wrote *The Manifesto of the Communist Party*, where the primary principles of his vision are presented: history is the story of struggle, that struggle is based upon economic class. It was in the very next year that Gustave Courbet (1819-77) painted *The Stonebreakers*.

The painting depicts a young boy and an old man engaging in heavy manual labor alongside of a road. It is not a Neo-Classical call to principled duty. Nor is it meant to be an example of Kantian art for art's sake: an aesthetic composition that is non-cognitive, self referential, and a perfection of a kind.

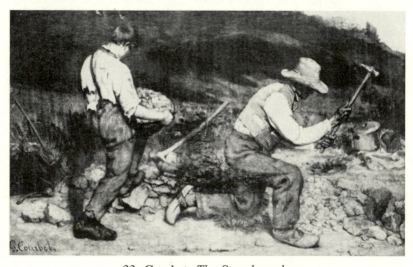

33. Courbet, *The Stonebreaakers*

There is no suggestion that it invites us to celebrate the Divine, be it Theist or Pantheist. Instead, the message of this painting is clear: the young boy and old man are victims of an unjust society. Neither should be doing such work. The painting hopes to provide an objective understanding of injustice, and a provocation to change the world.

A friend of Courbet's, Max Buchon, described the work as the depiction of a life of drudgery and a wish for action:

> Yet this man, who in no way is the product of the artist's imagination, this man flesh and bones who is really living in Ornans, just as you see him there, this man, with his years, with his hard labour, with his misery...this man is not yet the last word in human distress. Just think what would happen if he would take it into his head to side with the Reds: He could be resented, accused, exiled, and dismissed. Just ask the prefect.[41]

The issue of class-consciousness is clearly present in the writings of Courbet. In a letter dated December 25, 1861, Courbet responds to a request by a group of students that he be their director:

> GENTLEMEN and dear friends; You want to open a painting studio in which you can freely continue your artistic education and you have been kind enough to offer to place it under my direction...I do not have, and I can not have, students. I who believe that every artist should be his own master, can not think of making myself into a professor. I can not teach art...because I deny that art can be taught...I say that art or talent to an artist can only be (in my opinion) the means of applying his personal faculties to the ideas and the objects of the time in which he lives...I also believe that painting is an essentially CONCRETE art and can only consist in the representation of REAL AND EXISTING objects.
> Beauty is in nature, and in reality is encountered under the most diverse forms. The beauty based on nature is superior to all artistic conventions.[42]

So Courbet concurs with Kant that art can be nurtured but cannot be taught; but he differs from Kant in affirming that we can indeed talk about reality. And what is the nature of reality? Just as the term *realism* once referred to the transcendent ideal, but now commonly refers to the material, so too is the case with beauty. When the Postmodernist uses the term beauty, it now refers to the aesthetic by another name. The assumption that such "beauty" exists in nature is central to Postmodern thought; when Postmodernist thought is not materialistic or sociological, it is pantheistic. When Hegel states that: "For the beauty of art is a beauty begotten, a new birth of mind," that mind is not transcendent. It is immanent. Hegel and particularly his epigones associate beauty with a pantheistic ideal. But whereas for Hegel that mind is manifested via nature and culture, for Marx (and Voltaire), it is nature and nurture that determine mind. "Beauty" is grounded in the material world, and the material world is ever changing via a dialectical process. Notions of "Beauty" change as culture changes; Shakespeare may be literature in one era, but not another.

It is interesting to note that in a famous manuscript, *Grundrisse* (1857-8) Marx admirably admits to what is for him problematic: the perennial appeal of Greek Classical art. This appeal is in contradiction to his understanding of culture being grounded in a historical process informed by conflict:

> But the difficulty lies not in understanding that the Greek arts and epic are bound up with certain forms of social development. The difficulty is that they still afford us artistic pleasure and that in a certain respect they count as a norm and as an unattainable model.[43]

Western culture during the nineteenth and twentieth centuries is dominated by an essentially incoherent approach to aesthetic taste by Modernist and Postmodernist thought. Both traditions deny the possibility of transcendent truth and beauty, arguing instead for an aesthetic vision of reality and life. The Modernist tradition argues for the relativistic notion that reality is comprised of facts, but how those facts are understood is essentially a matter of taste, of an assumedly coherent and experiential rationality. For Kant, reality and art conform or refer to the structure of our minds. In contrast is the Postmodern attempt to escape that trivializing relativism, via taste as a matter of identity, differently pursued by Hegel, Marx, and Nietzsche.

Particularly representative of the Modernist cultural strand is the art of Manet, Monet, and Picasso. We have already discussed Edouard Manet's *Olympia*, a work depicting a young girl in a traditional Classical pose, but presented in a non-Classical way. He similarly transforms traditional Christian themes into a new materialistic vision: *The Dead Christ* is but one example, where the crucified Christ, the Incarnation of Transcendent Truth is now depicted as a dead coal miner flanked by people pretending to be *"Angels."* The intellectual content of the Incarnation is reduced to an aestheticized historical and sociological fact. For those who choose to believe yet, and thus find this painting repugnant, their belief is reduced to a puerile form of hero worship, a Postmodern vision or faith based upon feeling and identity rather than truth sought and to a degree understood and loved.

Less confrontational than Manet is the art of Claude Monet (1835-1926). As an Impressionist, his art appears to be radically unconcerned with ideas, content, or meaning. It appears to be a celebration of the factual and emotional aspects of life. Those appearances are accurate but incomplete. Just as Manet is consciously working towards a redefinition of realism, so too is Monet. For example, he painted Rouen Cathedral, haystacks, and a train station at various times of the day to capture the fleeting effects of natural phenomena: the changing light, and one's emotional response to those changes. In none of these paintings does Monet pay much attention to the notion that the world is purposeful and can be known as such.

Rouen Cathedral is of course a Gothic edifice, and as such subscribes to the view that light is symbolic of wisdom, and its entering the church is symbolic

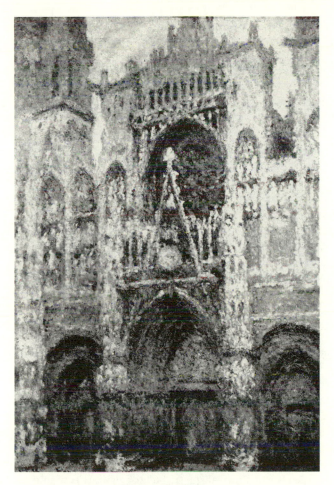

34. Monet, *Rouen Cathedral*

of wisdom entering the world. It is realistic in the traditional sense of the term. In Monet's treatment, an Augustinian metaphysics of light where light entering a cathedral is analogic of wisdom entering into the human mind and community is replaced by a physics of light. In this quantified vision of the natural world, forcefully advanced by Galileo and others, light is reduced to a trivialized series of physical and emotional events. It is a painting that evinces a joyful hedonism albeit neither joy nor pleasure can be objectively measured. In 1877 Fréderic Chevalier, a contemporary of Monet wrote:

> The disturbing ensemble of contradictory qualities...which distinguish...the Impressionists...the crude application of paint, the down to earth subjects...the appearance of spontaneity...the conscious incoherence, the bold colors, the contempt for

form, the childish naiveté that they mix heedlessly with exquisite refinements, ...all of this is not without analogy to the chaos of contradictory forces that trouble our era.[44]

What are those troubling contradictory forces? The contradictions inherent to the Modernist viewpoint: attempting to find enlightenment while denying knowledge of reality, associating truth with power, finding joy in a purpose-less world, and attempting to reconcile individuality with community in a world lacking Universals. In both the Modernist and Postmodernist cases, contradictions result from substituting or confusing the pursuit of beauty with the pursuit of aesthetics. Although the Hegelian Postmodernists attempt to escape the relativistic aestheticism of Kantian Modernism by renewing the pursuit of the ideal, they do so by specifically rejecting all ideals that are transcendent. They reject all ideals that hold reality to be objectively purpose-ful. Consequently, they necessarily pursue an immanent idealism – or none at all. In either case that pursuit is aesthetic rather than beautiful, narcissistic rather than ennobling. They embrace an aesthetic worldview even as they attempt to transcend aesthetics.

Postmodern Idealism

"[The Realist's] art was nothing but the direct representation of material forms; ...they prided themselves upon presenting us *beautiful* objects - that means *beautiful as objects*—they have painted conventional objectivity..."—G. Albert Aurier[45]

Whereas the Impressionists advocated a joyful materialism the Postimpressionists rejected their approach as dreadfully superficial. Instead, they sought to connect with a meaningful reality; they sought an ontological understanding of reality and life. As discussed above, some sought meaning via the aesthetics of Hegel, whereas others sought meaning via the aesthetics of Marx. And some fluctuate between the two. In common, they sought mean-ing in life, which is a spiritual quest; but for them it is a spirituality that is immanent rather than transcendent, aesthetic rather than beautiful. And an aesthetic spirituality is no spirituality at all; it is but the will to power.

An advance, so to speak, of Postmodern thought now comes to the fore: the beliefs of Arthur Schopenhauer (1788-1860) and Friedrich Nietzsche (1844-1900). Schopenhauer accepts that the attempt to make sense of reality and life is too embedded in the human mind to be ignored. In contrast to the later Friedrich Nietzsche, who celebrates the will, Schopenhauer pessimistically views the will to be comprised of a blind and purposeless striving. He wrote *The World as Will and Representation* (1818; 1844), a tract advocating the importance of aesthetic experience. He in effect posits a mysticism without a transcendent object; a mysticism not seeking God, but self- not seeking cel-ebration, but negation. The human will, by extinguishing itself, can become the will of nature; the will of nature is purposeless and meaningless. It is

existential. In the realization of such a meaningless mysticism of self, beauty is replaced by aesthetics, and the self is destroyed—and thus liberated.

Schopenhauer notes that the Aristotelian method is at odds with the Platonic. He finds the former to be like a mighty storm bending, agitating and carrying everything with it; the latter is seen as a silent sunbeam cutting through the chaos. One is like an agitated waterfall; the other is like the rainbow floating serenely above. But instead of identifying with the intelligible Platonic Ideal, instead he sees the Platonic Ideas as an objectification of the will. Instead of Augustine's identification of happiness resulting from our loving and embracing the True and Good, Schopenhauer adopts a quasi-Buddhistic framework, stating that an endless cycle of desire and suffering can be escaped only by a denial of the human will which obscures the Platonic will. That denial of the personal will is achieved via aesthetic experience. Aesthetic experience is how the human will can cease to obstruct the identification of humanity with the Will that lurks behind the realm of appearances. In place of the Augustinian notion of love as a blessed consummation of desire by an embracing of the True and Good, it is the absence of the will that leads to an identification of subject and object. That empathetic union of subject and object is achieved when the perceiver and perceived become one. The self is then destroyed.

The art of Vincent Van Gogh (1853-90) can be understood within the context of these ideas. His faith, art, and life, evidence an anxious conflict between the material and the spiritual, between Marxism and Hegelianism; and clear reference is made to the idea of an empathic union with experience. His career is a record of this journey. As we will see, his family background is orthodox Calvinist, his theological training is imbued with an incoherent Christian communism, and he eventually comes to embrace a mystic and ultimately nihilistic pantheism. It is a path that leads from beauty to aesthetics, and that path culminates in suicide.

In 1877, Van Gogh studied theology in Amsterdam, but it was not an orthodox form of Christian theology. Filled with the aestheticized ideals of a Christian communism, he went to work living among poor Belgian miners. Subsequent to that experience, he painted an important first work, titled *The Potato Eaters* (1885). It depicts the faithful miners eating a miserable dinner, in the presence of the promise of redemption. That promise is offered by the Christian faith, and made present via a painted Crucifixion on the wall of the miner's hovel. The painting raises the perennial challenge of reconciling knowledge with experience. The Christian tradition maintains that happiness centers on our loving what is true and good (Augustine), and embracing a divinely mandated state of *being* (Pseudo-Dionysius Areopagite). For the Calvinist, that mandate is made clear by the Scriptures, whose writers were sure and authentic recorders of the Holy Spirit. Scripture permits us to obtain a glimpse of the infinite and transcendent sovereignty of God, and thus is to know the

purpose of life. Evil results from the failure to do so, and that failure is predes-
tined by God. It is through faith that the believer receives justification, that
sins are forgiven and is held to be righteous by God. But that faith is contin-
gent upon the will of the Holy Spirit; some are divinely pre-destined to eternal
life, and some to eternal death.

Rather than as part of a cosmic drama, a primary concern for Van Gogh in
painting *The Potato Eaters* is to be authentic. Authentic to what? Aesthetic
experience. It is the immediate life and experiences of a peasant's existence
that is paramount. As Van Gogh puts it:

> Painting peasant life is a serious thing, and I for one would reproach myself it I did not
> try to make paintings in such a way that they could rouse serious thoughts in those
> who think seriously of art and of life…one must paint peasants as if one of them, feeling
> and thinking as they do. As not being able to be other than one is.[46]

What then of religious themes? In his paintings he depicts a variety of
religious subjects, but as was the case with Manet, those themes are treated
unconventionally. In one work he depicts himself as Lazarus, in another, as
Christ. In neither is there evidence of justification—on the part of Van Gogh or
others. Rather, he finds hope not in the orthodox Calvinism of his heritage, nor
ultimately in a socialist vision. Rather, his art and life conclude in tragic
pursuit of a mystic, indeed Hegelian faith in a creative force animating all of
reality and life.

Wheat Field and Cypress Trees (1889) presents an image of the natural and
spiritual world combined, an immanent spirituality where a Calvinistic justi-
fication by the will of a transcendent God is replaced by a messianic panthe-
ism—and eventual madness. In an essay on the art of Van Gogh, G. Albert
Aurier, a contemporary critic praises Van Gogh::

> Beneath skies, now carved from dazzling sapphire or turquoise, now encrusted with
> some unknown, infernal, hot, noxious and blinding sulphur; or beneath skies dripping
> like a liquid fusion of metal and crystal,; there a universal, blinding, mindless coruscation
> of matter; and this matter is the whole of nature strangled in a frantic paroxysm, exacer-
> bated beyond belief; where form itself becomes nightmare, nightmare turns into flames,
> lava and precious stones, light becomes fire, and life becomes burning fear.
>
> Such is, without exaggeration, whatever you may think, the impression left on the
> retina by a first glance at the extraordinary and intense works of Vincent van Gogh…
> [He] is an inspired enemy of all bourgeois sobriety and scruple, a man whose mind is
> constantly erupting, pouring its lava down through every channel of art, an irresistible,
> terrifying, crazed genius, often sublime, sometimes grotesque, always on the brink of
> the pathological. Finally and above all, he displays clear symptoms of
> *hyperaesthesia*…And that is why his realism, sincerity and truth, born of neurosis, are
> so different from the realism, sincerity and truth of those great but essentially petty-
> bourgeois Dutchmen, so healthy and balanced in mind and body, who were his
> ancestors and his masters.
>
> Indeed if we refuse to admit that behind this naturalist art lie idealist tendencies, a
> considerable part of the work would remain impenetrable to our understanding. …[U]nless

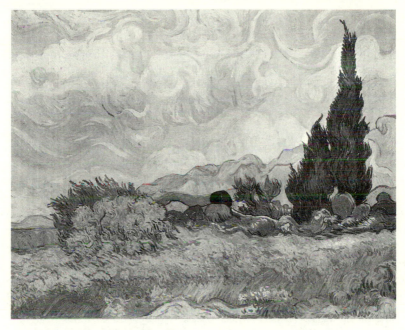

35. Van Gogh, *Wheat Field and Cypress Trees*

we are prepared to admit that his mind was haunted by an 'idee fixe', that is, the urgent need for there to come a man, a Messiah, a sower of truth, in order to regenerate our decrepit art and, perhaps, our mindless, industrialized society?[47]

A hyper-aesthesia has replaced the pursuit of beauty, one where the material refers to the spiritual, but the spiritual no longer refers to transcendent and purposeful being. Calvinist purpose is then replaced by a Marxist/Hegelian *becoming*, but to combine *being* and *becoming* without the possibility of transcendence[48] is to deny a meaningful *being*, and as Schopenhauer recognizes, when *becoming* alone remains, it must intrinsically be purposeless.

Similar developments are evidenced in the art of Paul Gauguin. Born in Paris in 1848, raised in Peru, he became a successful financier in Paris. He decided to pursue his hobby of painting full time. Leaving his wife and family in Denmark, he went to live among the peasants of Brittany. The goal: to escape a materialistic superficiality by an attempted empathetic union with those more primitive and thus more closely authentic. There is a touch of the Rousseauean in his attempt to identify with their traditional spirituality; but also a touch of despair. The Christian faith of his provincial subjects centers on imitating—not becoming—Christ. In contrast, Gauguin attempts to empathize with the Divine by painting himself as Adam and the crucified Christ. In so doing he attempts to be divine while remaining a voyeur in the presence of the lived Christian faith of those who worship God. The result is a deep anxi-

ety as he continues his search for "a new myth for a new age," a search that was multicultural and aesthetic rather than cosmopolitan and transcendent. Abandoning his wife and family yet again, in 1891 he went to Tahiti in the attempt to embrace a new spiritual mode free from the assumedly corrupting influence of civilization. He seeks to depict via his artistic genius a glimpse of the spiritual that is transcendent only in the limited sense that it denies rational conscious thought and effort.[49]

Gauguin's career evidences the interactions between Modernist Relativism and the Existentialism of Postmodernism. On the one hand he seeks the spiritual by pursuing a Tahitian paganism as an alternative to contemporary Western culture (more specifically, the traditional Classicism and Christianity of France); on the other hand he embodies an attempt to establish himself as a messiah figure; thus a sympathetic imitation of Christ (viz Thomas à Kempis) is replaced by an empathetic unity in which the perceiver and perceived become one. This shift results in the presentation of a new morality—as well as a new art.[50] In a letter written to Paul Gauguin, G. Albert Aurier wrote:

> [I]n the eyes of the artist—that is, the one who must be the *Expresser of Absolute Beings*—objects are only relative beings, which are nothing but a translation proportionate to the relativity of our intellects, of Ideas, of absolute and essential beings…the artist always has the right to exaggerate those directly significant qualities…according to the needs of the Idea to be expressed…
>
> [The Artist] needs, to be really worthy of this fine title of nobility—so stained in our industrialized world of today—, to add another gift even more sublime to this ability of comprehension. I mean the gift of *emotivity*.. Thanks to this gift, art which is complete, perfect, absolute, exists at last.[51]

Kandinsky and Postmodern Spirituality[52]

This emotive and messianic tendency is found in a variety of artists and philosophers during this period. For example, Helena Petrovna Blavatsky and Rudolf Steiner promoted a cultural movement called Theosophy. The primary task of this movement is to combat both Christianity and Science.[53] Blavatsky's association of Christianity with Science, and her critique of both, is significant; she accurately recognizes the association of Christian moral truth with natural science as central to traditional Western culture. And she wants to all destroy them.

This association of science with Christianity is, however, confusing to the aesthetic mind. As discussed in the opening chapters of this book, the aesthetic mind focuses on two things: sensation and emotional response, the realms of fact and of feeling. The two are rationally combined, but rationality is no longer the means by which reality is to be understood. Rather, it is the means by which it is constructed—by us. The result is a *scientism* and *emotivism* which challenges the association of what is historically indisputable: that science and Christianity are primary, complementary, and rational facets of

Western culture. The superficial assumption of the aesthetic mind, particularly since the Renaissance, is that neither Christianity nor science is rational, nor are they complementary. Consequently, Galileo and Savonarola cannot both be right, nor can be Darwin and the Book of Genesis. But science and Christianity necessarily conflict only if we presume—as an act of faith—that the world lacks intelligible purpose. That presumption is an aesthetic one, and it leads to an aesthetic conclusion. It requires a separation of science and faith just as it demands a distinction of philosophy from theology. Reason is then no longer a means of understanding reality. Instead, it becomes rationalistic or emotive

Blavatsky criticizes scientism, the presumption that only facts can and will advance human understanding. And she rejects the Christian tradition's recognition that fact and emotion within a purposeful world are rationally elevated to a numinous unity. Instead, she seeks an empathetic contact with reality. In place of science and Christianity she advocates a form of speculative mysticism. As she writes in her book *Isis Unveiled:*

> It is nineteen centuries since, as we are told, the night of Heathenism and Paganism was first dispelled by the divine light of Christianity; and two-and-a-half centuries since the bright lamp of Modern Science began to shine on the darkness of the ignorance of the ages. Within these respective epochs, we are required to believe, the true moral and intellectual progress of the race has occurred...
>
> This is the assumption; what are the facts? On the one hand an unspiritual, dogmatic, too often debauched clergy.....On the other hand, scientific hypotheses built on sand...
>
> It is the Platonic philosophy, the most elaborate compend of the abstruse systems of old India, that can alone afford us [a] middle ground. [54]

That middle ground is allegedly Platonic—but it is a Platonism that Plato would not likely recognize. Blavatsky proposes a mystic synthesis of Ancient and Oriental philosophies, whereby a new and assumedly progressive idealism is obtained. This idealistic and multi-cultural approach echoes Schopenhauer's interest in Buddhist and Hindu thought, but Blavatsky's conclusions differ from Schopenhauer's.

Theosophy accepts that the world ultimately makes sense. It therefore attempts to reconcile the existence of evil with the existence of an all powerful and omnipresent Being. In a Neo-Platonic and Gnostic mode, the popular message of Theosophy is that the material world is debased wicked and corrupt, and those conditions result from a privation of the Divine essence in them. The goal of creation is to be one with the Divine. The spiritual does not center on self-negation, but rather, on an emotive and empathetic self-divinization. As she states:

> Basing all his doctrines upon the presence of the Supreme Mind, Plato taught that the nous, spirit, or rational soul of man, being 'generated' by the Divine Father,' pos-

sessed a nature kindred, or even *homogeneous* [italics mine], with the Divinity, and was capable of beholding the eternal realities.[55]

Theosophy holds that karma is the operative dynamic of the universe. Why do bad things happen to good people? Due to the multi-generational consequences of good or bad acts. What is a bad act? An act that separates us from the Godhead. To rise above those actions and consequences we must seek an emotive unity with the Godhead. It is not a matter of the secular vs. the sacred; emotivism requires empathetically becoming one with the One.

Madame Blavatsky considers the Platonic tradition as a pan-cultural means of doing so; or rather, the Platonic tradition is seen as a manifestation of the same truth revealed in Indian tradition.[56] But it is a Platonism distinct from that celebrated by Augustine. For the Neo-Platonism of Plotinus the goal is to become one with the Divine; so too with later figures such as Meister Eckhart. As Thomas Molnar states:

> Eckhart's disciples and successors, Henry Suso and John Tauler, also taught that "internal man" is purged of the vices of "external man." Tauler, who acknowledged his debt to the fifth century Neoplatonist, Proclus, expressed the view that when we enter in contact with our inner self, we recognize God there at once, more clearly than the eye can see the sun. [57]

Not only does Eckhart want to fuse with the Godhead; he assumes that the Godhead is superior to the personal God of Christianity. And whereas the personal God of Christianity is associated with light, Eckhart's presumed Godhead is associated with a dark and formless essence.

This attempt to be one with the One is in contrast to the aspirations of Augustine and the Pseudo-Dionysius Areopagite; they seek to embrace, not become, Beauty and Truth. For Augustine the goal is for the subject to seek the meaningful object. For the Pseudo-Dionysius Areopagite we attempt to embrace rather than resist *being*. Divinity is recognized here as a *being* that is neither just a *being* nor a *non-being*. Rather, Divinity is a super-essential entity with an intelligible yet ineffable quality. It is a Deity knowable by degree or by negation, but not knowable in completion. For to completely know God is to play God; to completely deny God is to play God as well.

In essence, Theosophy is a Postmodernist form of speculative mysticism, with strong pantheistic tendencies. Theosophy maintains a Modernist, relativistic notion that the wide variety of spiritual experiences around the world is in fact merely facets of the same religious impulse. At the same time, the Hegelian notion that the world is the unfolding of the Divine Mind is deeply resonant with basic Theosophical principles. Theosophy centers then on a personal, messianic identity with the immanent divine. However, its assumption that all religions seek the same divinity is demonstrably false; the assumption that the divine is realized via a personal messianic identification

with the Absolute Spirit (to use Hegelian terms) is dangerous. It is dangerous because it involves a self-deification—and an intoxication.

This may seem as just so much metaphysical speculation, merely theoretic rather than practical. But whereas theory is often cold and abstract, biography, by its very nature, is concerned with the human condition. Biography goes beyond the theoretical by inviting a contemplation of the practical consequences of a worldview or a set of beliefs. The cultural occurs where theory and life meet—and the often poignant results can be for better or for worse.

In the early twentieth century many prominent artists were associated with Theosophy. Piet Mondrian (1872-1944) and Wassily Kandinsky (1866-1944) are two such examples. They joined the Theosophical Society and advocated its ideals. It is typical to encounter vague accounts of their involvement with Theosophy. But it is useful to compare their pursuits with their non-Theosophical contemporaries. One contemporary of Kandinsky's is Pavel Florensky; in comparing their beliefs and lives, the danger of an emotivist self-deification becomes clear.

They share much: both were Russian, and were contemporaries; both were concerned with fine art and the spiritual as well. Pavel Florensky was a Russian Orthodox priest involved in aesthetic theory and traditional theology; Wassily Kandinsky was an artist involved in Theosophy, in a "New Age" theology. Both were embraced by Postmodernism. In comparing the ideas of Pavel Florensky with those of Wassily Kandinsky, and by comparing their lives, new and even chilling light is shed on Postmodernism and beauty. Florensky and Kandinsky were concerned with form, color, and light; both were concerned with the spiritual significance of art. But one was Postmodernist, the other was not.[58]

Kandinsky manifests a Postmodernist, New Age mysticism. Kandinsky's New Age mysticism—with its subjective-objectivity, its denial of reason being a means of understanding an objective and purposeful reality—is all too obviously part and parcel of Postmodernist culture. What then is the goal of that New Age mysticism and its art? Kandinsky repeatedly refers to the realm of spiritual volition, yearning for a mystic union with the noumenal realm. But what is the nature of that noumenal realm? Its core is inner necessity. And like the other Postmodernists, inner necessity is but a discrete way of advocating the will to power.

For example, in 1911 Kandinsky painted *Composition IV;* what does the work mean? We are presented with a mystical image of the spiritual, as understood in the context of Madame Blavatsky and Theosophy. The painting reflects Kandinsky's rejection of materialism and rational intellectual discourse. It reflects a shift from beauty to a mystical aesthetics.

We can compare Kandinsky's position on color, form, and composition with those of Florensky. Both Kandinsky and Florensky reject the Modernist notion of art for art's sake. But what is particularly interesting is how Kandinsky

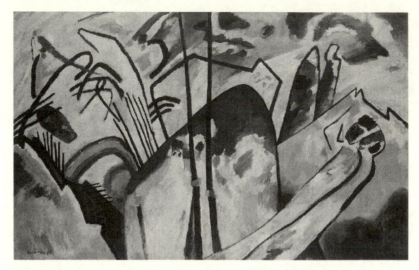

36. Kanoinsky, Composition IV

transforms his cultural heritage into a Postmodernist vision. To the point, Kandinsky takes the notions of beauty and art as understood within a Russian Orthodox culture, a culture defended by Florensky, and debases them into a Postmodernist New Age mysticism. A mysticism where the spiritual is (de)contextualized and reduced to the will to power.

What do Kandinsky and Florensky say about color, line, composition, and the spiritual in art? We can compare their positions. In his book, *On the Spiritual in Art* (1946 edition), Wassily Kandinsky follows Blavatsky's interest in cosmic geometry by equating the spiritual in art with a triangle, the lower reaches of which are common, but the apex of which is populated by those few with the unique vision of inner necessity:

> "When religion, science, and morals...are shaken and when the outer supports threaten to fall, man turns his gaze from the external to the deeper essence within him..." "[The artist] strives to create his inner life..." "...on the road to inner necessity, [the artist] has discovered already treasures of new beauty." [59]

Concerning color Kandinsky declares that it resonates with spiritual necessity amongst those capable of such spirituality: "Color harmony can rest only on the principle of the corresponding vibration of the human soul. This basis can be considered as the principle of innermost necessity." Similarly Kandinsky states that "...it is evident that forms of harmony reflect in a corresponding vibration on the human soul. This principle has been designated here as the principle of the innermost need."[60]

We could continue in excruciating detail, but Kandinsky's theories about color and form lead to one central concern: what is the object of that inner

necessity? Kandinsky provides his answer: "All means are sacred when called upon by innermost necessity… All means are a sin and lacking virtue, if they do not come from this source."[61]

For Kandinsky, inner necessity is a subjective objectivity; it justifies itself without reference to anything other than itself. It provides the foundation for art, ethics, and culture. But for those driven by inner necessity, they become indistinguishable from a will to power. The one becomes the One. And this is dangerous because it involves both a self-deification and intoxication.

In contrast are the ideals expressed by Florensky. He rejects the notions that all means are sacred, that the artist strives to create his inner life - that inner necessity, alone, is the ultimate criteria. For Florensky, inner necessity, just as with color and form, are means to an end and initially that end is love. Florensky states that understanding is an act of love. Love requires an object, something to be desired, and that the realization of love is beauty.[62]

Art, for Florensky, is not scientific, naturalistically psychological, or merely driven by a willful inner necessity. Rather, it is ontological. It offers a glimpse of what is true and good and beautiful. It offers, to some precious degree, an explanation of *why*. In his advocacy of an ontological vision he rejects naturalism for realism. In his advocacy of a metaphysical content he advocates non-Renaissance perspective and a cognitive symbolism of color and light.

In contrast to Dostoevsky's Grand Inquisitor who declares that since God is dead, therefore man becomes God and everything is possible—except—freedom and love, Florensky notes that "Everything is beautiful in a person when he turns toward God, and everything is ugly when he is turned away from God." He states that "The artist does not himself invent the image, but only removes the covering from an image that already exists...he does not put paint on canvas, but, as it were, clears away the alien patina, the `over painting' of spiritual reality."[63]

So we have two competing and irreconcilably antagonistic visions of color, form, composition, art,—and ethics. One is aesthetic. The Postmodernist tradition reduces art and its foundations to the realm of physics, psychology, sociology, and the will to power. The other is dedicated to beauty, where aesthetics is understood as the face of being, an initial appearance of truth and goodness. This tradition views art as ontological, as attempting to offer a glimpse of a purposeful and benevolent reality, and of an ethical life.

On the one hand is Kandinsky's Postmodernist vision where color form and composition are coherent manifestations of inner necessity, an inner necessity that centers on an amorphous New Age mysticism that ultimately relies on seeking the god within us. And what is the nature of the god within us? The will to power. On the other hand is Florensky's Orthodox vision where color, form, and composition are aesthetic gateways to a spiritual realm of bliss. That realm centers on love being the desire to embrace beauty, with beauty being the splendor of what is true and good.

As noted earlier, both Kandinsky and Florensky were embraced by Postmodernism. But the differences in that embrace are telling. For example, Kandinsky's fate is to be revered in our books and our cultural institutions - institutions that have long been in the hands of adherents to the Modernist-Postmodernist tradition. Shortly after Wasilly Kandinsky's peaceful death in France in 1944, a museum in New York was dedicated to his work, and in 1946 his book, *On the Spiritual in Art*, was republished.

Pavel Florensky is commonly unknown within "progressive" circles, a Russian Orthodox priest and aesthetician who actually believed in truth, good, and beauty. Pavel Florensky's fate was also in the hands of the Postmodernists who controlled the cultural institutions of the twentieth-century West. And what are the ethical consequences of inner necessity, of the one becoming the One? For Pavel Florensky the consequences are indisputable: in 1937 he died by firing squad execution at the Solovki Gulag. And that is why the choice between aesthetics and beauty is more than merely a matter of taste.

Empathy, Beauty and Authenticity:
Schopenhauer, Nietzsche, and Heidegger

The association of aesthetics with a narcissistic self-divinization are celebrated by the important work of Wilhelm Worringer. As introduced earlier, his book, *Abstraction and Empathy* (1912) uses as a starting point the work of Theodore Lipps. Worringer presents a fundamental premise of Postmodern aesthetic theory, a theory inapplicable, he observes, to wide tracts of art history:

> Modern Aesthetics, which has taken the decisive step from aesthetic objectivism [i.e., Intelligible Beauty] to aesthetic subjectivism, i.e. which no longer takes the aesthetic as the starting point of its investigations, but proceeds from the behaviour of the contemplating subject, culminates in a doctrine that may be characterized by the broad general name of the theory of empathy.
>
> Every sensuous object, in so far as it exists for me, is always the product of two components, of that which is sensuously given and of my apperceptive activity... It is fundamental fact of all psychology, and most certainly of all aesthetics, that a 'sensuously given object', precisely understood, is an unreality, something that does not, cannot, exist. In that it exists for me—and such objects alone come into question—is permeated by my activity, by my inner life.
>
> The simplest formula that expresses this kind of aesthetic experience runs: Aesthetic enjoyment is objectified self-enjoyment. To enjoy aesthetically means to enjoy myself in a sensuous object diverse from myself, to empathise myself into it...By its nature, this activity is an activity of the will.[64]

Worringer observes that this emphasis on empathy results in a self-destructiveness:

> In empathizing this will to activity into another object, however, we are in the other object...In this [aesthetic] self-objectivation lies a self-alienation.[65]

It is acknowledged that such a self-alienation is associated with polytheism, pantheism, and monism; what is missed is that each of these denies the significance of responsible freedom and the individual personality:

> [The] principle of immanence...wearing the various colours of polytheism, pantheism or monism, regard the divine as being contained in the world and identical with it. At bottom, indeed, this conception of divine immanence is nothing other than a total anthropomorphisation of the world...The process of anthropomorphisation here becomes a process of empathy, i.e. a transference of man's own organic vitality onto all objects of the phenomenal world.[66]

Worringer notes that the alternative to empathy is abstraction,[67] which in contrast to the immanence of empathy, is transcendental in nature. Worringer laments that Western culture had become part and parcel to the viewpoint of Aristotelian Classical and Renaissance culture, and had therefore embraced an immanent rather than transcendent stance. What is curious, however, is that for Worringer transcendence refers not to an intelligible reality, where, for example, beauty and justice are immaterial and real. Rather, Worringer views transcendence (as does Kant, and Soren Kierkegaard) as a purely personal experience, an objectified self-enjoyment. So beauty, for Worringer (as God for Kierkegaard, and transcendence for Kant) becomes aesthetic: not that which one to some degree understands, but rather, that which one experiences. And an experiential transcendence, like a subjective-objectivity, is not transcendent at all.

Once again, what may seem abstruse philosophical and theological doctrine is actually central to how we live our lives. This idea of aesthetic experience as an ethical foundation has a variety of expressions. We have seen it in the art and lives of Van Gogh, Gauguin,[68] and Kandinsky, and in the lives of its victims, such as Pavel Florensky. Historically, the attempt to reconcile faith, reason, and science, is central to the narrative of Western culture. That reconciliation was often sought via the means of rationally harmonizing Plato and Aristotle within the context of Christian doctrine. That is the grand project of Scholasticism. But as we have seen, what Aquinas and Raphael assumed accomplished was soon subject to unforeseen developments. Those developments aim to deny the Scholastic reconciliation of transcendentalism and immanentism. As the traditional transcendentalism of Classical and Christian culture was battered, there emerged the perennial immanentist alternatives: materialism, pantheism, and monism. It is from a materialist and mystic perspective that Kandinsky reevaluates the orthodox Christianity of figures such as Florensky; similarly, Arthur Schopenhauer (1788-1860) reevaluates Plato and Aristotle. The result is a Classicism that would scarcely be recognizable to Aquinas or Raphael. It is a Classicism that leads to the important work of Friedrich Nietzsche.

Arthur Schopenhauer rejects both Kantian relativism and Hegelian-Marxist dialecticism. Instead he posits that the primary instinct of life is the will to exist. Humans can recognize facts, and cause and effect, on a practical level, but beneath that realm is an irrational urge simply to exist. It is that Will to Live, that desire, which is the source both of goodness and evil, with evil prevailing. In a Quasi-Buddhistic, or ascetic mode, Schopenhauer views happiness as obtainable only by a cessation of the will to live.

The ability to recognize that we simply exist involves getting beyond the practical but superficial level of facts. For Schopenhauer that ability is available only to those who have a facility for obtaining a glimpse of things independent of reason. That facility is associated both with genius and the fine arts. Science provides facts, but artistic genius provides a type of understanding. It is the artist who can pierce the superficial realm of facts and obtain a glimpse of reality. It is the artist who is authentic.

Schopenhauer advocates a pursuit of beauty, but beauty is no longer associated with cognition, with an intellectual attempt to understand an objective and purposeful reality. He is influenced by David Hume, who stated that beauty is no quality in things themselves; it exists merely in the mind which contemplates them. Schopenhauer concludes that beauty is not to be understood, but experienced. It is then associated with an immanent mysticism. We experience phenomena, and in so doing, a variety of sense perceptions exist in our minds as ideas. Consequently, each of us can say that the world is our Idea. His definition of beauty is expressed in Section 41 of his text, *The World as Will and Idea* (1818):

> When we say that a thing is beautiful, we thereby assert that it is an object of our aesthetic contemplation, and this has a double meaning; on the one hand it means that the sight of the thing makes us objective, that is to say, that in contemplating it we are no longer conscious of ourselves as individuals, but as pure will-less subjects of knowledge; and on the other hand it means that we recognize in the object, not the particular thing, but an Idea.[69]

In aesthetic experience, perceiver and perceived become an empathetic One. Beauty is associated with the abstract Idea, but the Idea is not cognitive in a discursive way. Rather, it is the result of a conscious experience. It is an intuition, but one lacking an intellectual illumination of an objective and purposeful reality. Empathy and abstraction thus reduce reality to an immediate personal experience rather than an intelligible ontological whole. Exercised instinct results in experience, and the ideation of experience results in a type of understanding—and an alleged type of beauty. The assumption that authenticity is key to both knowledge and beauty results in a cultural viewpoint that reduces the importance of rationality as a means by which we might understand the world. It also denies the objectivity of judgments of quality. What then does culture consist of? The will to exist, a subjective-objectivity.

This results in at least three positions: that the will to exist be lamented, ridiculed, or celebrated. Schopenhauer embraces the first, Friedrich Nietzsche embraces the last.

Schopenhauer's work deeply influenced Frederick Nietzsche (1844-1900), who epitomizes the necessary Postmodernist conclusion to the Modernist aesthetic vision. Nietzsche agrees with Schopenhauer that human life is often affliction and pain, and that the primary law of human existence is self-preservation. He chooses, however, to admire not the ascetic but rather those who would strive to prevail over the difficulties of life. His first major work, *The Birth of Tragedy* (1872), posits that Greek culture consists of a battle between two fundamental positions: the Apollonian and the Dionysian. Apollo is associated with the intellectual, whereas Dionysius represents the will to life, to pleasure. Nietzsche concludes that Dionysius represents the true reality of life as it is experienced, but concedes that without the Apollonian it leads to violence and chaos. Those who would deny the vitality of the Dionysian are those such as Jews and Christians who advocate a universal transcendent morality. Such morality is merely a sham to hinder the actions of the Dionysians. Christianity is a slave morality oppressing the natural instincts of those who aspire to being masters of their own fate. Indeed, the traditional culture of the West has exalted the mediocre values of the herd. Beauty and ethics are intertwined, as they must be, but for Nietzsche their character relies upon experience and the will to power rather than notions of truth or goodness. We define ourselves by what we do rather than by what we ought to do:

> Man mirrors himself in things. He counts everything beautiful which reflects his likeness...His sense of power, his will to power, his feeling of pride and efficiency—all sink with the ugly and rise with the beautiful...Therefore art is the great stimulus to life. We cannot conceive it as being purposeless or aimless. "Art for art's sake" is a phrase without meaning.[70]

As later realized by Kandinsky and others, in a world without purpose it is inner necessity which provides meaning in life. But what provides meaning to inner necessity? For Nietzsche becoming is being, the one is the One. We are free to make choices, even though there are no rational criteria for those choices. Ethics is comprised of what we want. It is by making meaningless choices that we purportedly obtain meaning and beauty in life. However, when the one becomes the One, loves no longer has an object. This vision of beauty denies love by its narcissism, and that narcissism is deeply violent.

The Nietzschean Endgame

Friedrich Nietzsche (1844-1900) brilliantly articulates the necessary conclusions of Kantian Modernism. He rejects the "weight of European culture" (as does the American Existentialist, Barnett Newman [1905-70], as discussed below) in favor of an existentialist aestheticization of reality and life. As did

Blavatsky, Nietzsche treats with contempt the twin foundations of Western culture, Classicism and Christianity. Both are viewed via an aesthetic perspective; their common pursuit of beauty is denied.

Nietzsche's aesthetic analysis begins with the observation that within Classical culture there was a fundamental contradiction—or rather—tragedy. Classicism takes as a foundational principle that the world ultimately makes sense. It is rightly a cosmos rather than a chaos. Given that the world ultimately makes sense, then the attempt to comprehend the world via reason makes sense as well. The problem then is the occurrence of tragedy: in a word that makes sense, how do we respond to nonsense—why do bad things happen to good people. Nietzsche's conclusion is that there is no genuine solution to tragedy—and therefore—there can be no purpose to life beyond existence. As he states in his book, *The Birth of Tragedy* (1870-71), tragedy is an Apollonian embrace of Dionysiac insights and powers. That is, rather than Apollo representing the light of reason, offering knowledge of a purposeful cosmos, Nietzsche sees Apollo as a mask for Dionysius—the god of pleasure.

Within the Modernist-Postmodernist tradition there are repeated contradictions. We have been presented with notions of a subjective-objectivity, a willful-morality, a material-culture, a transcendent-aesthetic, and a tolerance which is intolerant of belief. We are now confronted by a Dionysian-wisdom where tragedy is to be resolved not by understanding, but by an act of the will.

The Socratic tradition rejects tragedy and affirms rationality; Apollo is real. However, Socrates argues that the writing of books denies an active rationality where the free pursuit of meaning flourishes. Books, like the tragic theatre, mandate a passive response, a rejection of the Apollonian, and as such deaden the mind and soul. But Plato argues that rational dialogues in philosophy and in the theatre can indeed facilitate an active pursuit of the true, good, and beautiful. Consequently, the dialogue offers a response to tragedy – in art and life. The chorus of the Greek tragedy is no longer limited to the role of the initiate, or the recipient of divine wisdom, or of omniscience. Instead, the chorus now joins the spectator in reflecting on the meaning of the play and life; but the result is that the tragic chorus thus loses its reason for existence. As explained by Martha Nussbaum:

> [T]he dialogue sets up, in its open-endedness, a similarly dialectical relation with the reader, who is invited to enter critically and actively into the give—and—take, much as a spectator of tragedy is invited to reflect (often along with the chorus) about the meaning of the events for his own system of values…although sometimes one position emerges as clearly superior, this outcome is not forced upon the spectator/reader by any claim to authority made by a voice inside the text…
>
> Dialogues, then, unlike all the books criticized by Socrates, might fairly claim that they awaken and enliven the soul, arousing it to rational activity rather than lulling it into drugged passivity. They owe this to their kinship with theatre.[71]

This rejection of the Dionysian tragedy by Apollonian dialogue is indeed a rejection of aesthetic taste. It makes real a discursive pursuit of the true, good, and beautiful. As such it is viewed contemptuously by Nietzsche:

> Consider the consequences of the Socratic maxims: "Virtue is knowledge; all sins arise from ignorance; only the virtuous are happy"—these three basic formulations of optimism spell the death of tragedy…What is the view taken of the chorus in this new Socratic-optimistic stage world, and of the entire musical and Dionysiac foundation of tragedy? They are seen as accidental features, as reminders of the origin of tragedy, which can well be dispensed with—while we have in fact come to understand that the chorus is the cause of tragedy and the tragic spirit.
>
> Already in Sophocles we find some embarrassment with regard to the chorus, which suggests that the Dionysiac floor of tragedy is beginning to give way. Sophocles no longer dares to give the chorus the major role in the tragedy but treats it as almost on the same footing as the actors, as though it had been raised from the orchestra onto the scene. By so doing he necessarily destroyed its meaning, despite Aristotle's endorsement of this conception of the chorus. This shift in attitude…entirely destroyed the meaning of tragedy…[72]

The tragic chorus puts into doubt the possibility of understanding the world; the Socratic view makes suspect the need for such a chorus. But for Nietzsche, attempts to comprehend a purposeful world are but a farce. Apollo is simply Dionysius in disguise; the tragic chorus cannot be, indeed ought not to be denied.

Among his attributes, Dionysius is the god of tragic and comic poetry; the opponents of the Socratic and Apollonian pursuit of love and beauty hope for the restoration of Dionysius, and along with him a restoration of tragedy, comedy, and as they see it, freedom.[73] This indicates two different perceptions of freedom, one aesthetic, and the other beautiful. Plato is associated with a distrust of democracy—that is—of rule by the emotive mob. As Nussbaum notes:

> It is not accidental, however, that it was in fifth-century Athens that this dialectical debate-filled sort of theater got its hold. These aspects of tragedy are thoroughly continuous with the nature of Athenian political discourse, where public debate is everywhere, and each citizen is encouraged to be either a participant or at least an actively critical judge…These practices were subject to abuse and manipulation; but at their best they had the characteristics that Plato seeks. Thus Plato's debt to tragic theater is not a debt to some arbitrary aesthetic invention—it is at the same time a debt to the social institutions of his culture. In the same way, his repudiations of tragedy and of Athenian democracy are closely linked.[74]

But it is equally important to consider the political consequences of the Dionysian view, how freedom is understood by Postmodernity, and the consequences of the Nietzschean revival of a Dionysian politics.

Nietzsche's interpretation of Classicism, Christianity, indeed of a purposeful *Being*, or reality, is fundamentally aesthetic (as was Kierkegaard's). As he notes in his introduction to *The Birth of Tragedy:*

As a matter of fact, throughout the book I attributed a purely esthetic meaning—whether implied or overt- to all process: a kind of divinity if you like, God as the supreme artist, amoral, recklessly creating and destroying, realizing himself indifferently in whatever he does or undoes…

That whole esthetic metaphysics might be rejected out of hand as so much rattle or rant. Yet in its essential traits it already prefigured that spirit of deep distrust and defiance which, later on, was to resist to the bitter end any moral interpretation of existence whatsoever...

The depth of this anti-moral bias may best be gauged by noting the wary and hostile silence I observed on the subject of Christianity—Christianity being the most extravagant set of variations ever produced on the theme of ethics. No doubt, the purely esthetic interpretation and justification of the world I was propounding in those pages placed them at the opposite pole from Christian doctrine, a doctrine entirely moral in purport using absolute standards…

I had always sensed strongly the furious, vindictive hatred of life implicit in that system of idea and values; and sense, too, that in order to be consistent with its premises a system of this sort was forced to abominate art…Thus it happened that in those days, with this problem book, my vital instincts turned against ethics and founded a radical counter doctrine, slanted esthetically, to oppose the Christian libel on life. But it still wanted a name. Being a philologist, that is to say a man of words, I christened it rather arbitrarily—for who can tell the real name of the Antichrist?—with the name of a Greek god, Dionysos.[75]

Nietzsche evidences the courage to face the necessary conclusions of the Kantian foundations of Modernist thought. He also acknowledges the affect of Scholastic and Modernist thought on both Classicism and Christianity. In his text, *The Twilight of the Idols* (1888) he states that philosophy is ruined by the blood of theologians. He declares that Protestantism marks the partial paralysis of Christianity and of reason, whereas the Scholastic world of German Catholicism foolishly rejoiced in the appearance of Kant. Kant is recognized as continuing the Scholastic project of finding truth in the mind of God, in the mind of man, and in nature. But for Nietzsche such truth- claims are bogus; as he puts it:

"Virtue," "Duty," "Goodness in itself," goodness stamped with the character of impersonality and universal validity—these things are mere metal hallucinations, in which decline the final devitalization of life and Koenigsbergian Chinadom find expression. The most fundamental laws of preservation and growth demand precisely the reverse, namely, that each should discover his own virtue, his own Categorical Imperative…German decadence made into philosophy—that is Kant!

But Kant and Nietzsche participate in a single conversation. They both reject Beauty as understood and pursued by Socrates, Plato, and Augustine; they detest the Platonic dialogue, ignore the Augustinian position, and develop to its necessary conclusion the Scholastic dialectic when viewed via a purposeless aesthetic vision. They take as fundamental the principle that the world is purposeless (or that purpose cannot be known), and Nietzsche rightly concludes that attempts by a secular rationality to provide meaning in a pur-

poseless world are masks for power. In the name of honesty, he posits that superior individuals should will their own values into being. As noted above, we are the Anti-Christ; we are Dionysian worldmakers. But as we shall see, the self-awareness of this assertion leads us not only back to tragedy (Abstract Expressionism), but forward to comedy (Pop Art).

For Nietzsche, the meaning of the Incarnation and beauty must be a rationalization masking a will to power. Both the Classical and Christian logos is to be replaced by a Dionysian wisdom, a will to power. But that will to power denies dialogue, and results in an aesthetic self-deification. It is a self-deification which offers a dubious—indeed dangerous—alternative. It is dangerous on a personal level as being delusional, and it is also dangerous on a social and political level. Self-deification is intrinsically violent to others—be they recognizable as competing deities or not. The world is thus reduced to an aesthetic of the will without hope of meaning or beauty. It thus affirms (Nietzsche) and denies (Schopenhauer) the importance of *becoming* without or as *being*. It leads to a nihilistic void.

It is useful to keep in mind that the Kantan-Nietzschean *world-weltbaumeister or maker* (and *world-making*) here discussed have been in the ascendancy for a long time; attempts to make reality conform to the will is a commonplace in the twentieth century. Today, in Universities across the nation, *worldmakers* have taught us, and they teach our children. They influence the formulation of our laws and our public policies. Within the mainstream of the culture of the Enlightenment, the philosopher, scientist, artist, and citizen are all demiurgic, we all claim to possess the special facility and right to be *worldmakers*. We are sublime. This transformation of culture is legitimatized as a progressive pursuit of creativity and tolerance. That claim to legitimacy is illusory. At first it discounts meaningful dialogue; then it produces a culture of violence; it later reduces that violence to parody. It is an anti-art poised as art, a public repudiation of the public realm.

To discuss the merits of public art is to engage in a discussion of public values. It is a discussion that has long been abandoned by Modernist and Postmodernist Liberalism. Following the conclusions of Kant and Nietzsche, the public square is now devoid not only of traditional Classical and Christian art. It is also devoid of positive ideals that indicate a purposeful world. The discussion of public values has been subjectified and thus made inhospitable to reasonable discussion and to beauty. Perhaps that discussion has been increasingly abandoned by provincialism rather than malevolence. The result remains: a solipsistic vision that holds all visions of life to be a matter of aesthetic taste and ultimately a matter of power. A vision held by those lost in the fantasy that their power is benevolent but the other's is not. But beyond the issue of such prejudice and fantasy is that of quality, the quality of artistic content and the quality of our public life. We have long been told that such a conversation about quality need not or cannot occur. That we are trapped in a

dogmatic relativism; a relativism where ideals have no place and an empty tolerance or a balance of power is the last redoubt of civility. No wonder the fine arts—and the public realm—have been reduced to entertainment, therapy, or propaganda. It is time for a renewed dialogue about the values that ought to inform our public life and art. That conversation has in fact already begun.

Implicit to Nietzsche's vision of reality and life is a commitment to authenticity. The pursuit of authenticity is central to Existentialist Postmodern thought, and central to the work of Martin Heidegger. Following in the tradition of Kierkegaard,[76] Jaspers, Schopenhauer, and Nietzsche, Heidegger argues that humanity's essential condition is that of existence, lacking original essence or objective purpose. As Heidegger puts it: human *being* involves facticity, existentiality, and forfeiture; we exist in the world, but as part of a process of shaping the world, and in so doing we are lost to the world. This self-negating and therefore anxious process culminates in a conscious awareness of death—which marks the ultimate authenticity of human *being*. Virtue occurs within an anxious authenticity; it is conscious decision making in the face of an incomprehensible yet experienced universe. Indeed, since *Being* is grounded in time—*being* is actually *becoming*—but for human *beings*, *becoming* eventually leads to death. So the most authentic experience of human *being* is realized in the negation of *being* and *becoming*—via death.

For Heidegger truth is not found, rather it is something experienced and unconcealed; so too with beauty and ethics. But unlike Florensky, for whom enduring Divine purpose lies concealed by the patina of aesthetics and the world, Heidegger concludes that when being is unconcealed, there is no purpose, only existence. Being is existence; truth is a subjective-objectivity.

In his essay, *The Origin of the Work of Art* (1935-6) Heidegger defines beauty as:

> Beauty is one way in which truth occurs as unconcealedness...Truth is the unconcealedness of that which is as something that is. Truth is the truth of Being. Beauty does not occur alongside and apart from this truth. When truth sets itself into the work, it appears.[77]

The association of beauty and truth with authenticity that is experienced rather than understood marks an aestheticization of beauty and truth – and ethics. And to aestheticize ethics is to deny its existence. One can cite Heidegger or equally so Jean-Paul Sartre, who declares that our aspiration to become as a god gives meaning to life:

> ...[I]f God does not exist, there is at least one being in whom existence precedes essence, a being who exists before he can be defined by any concept, and that this being is man...What is meant here by saying that existence precedes essence? It means that, first of all, man exists, turns up, appears on the scene, and, only afterwards, defines himself.

If existence really does precede essence, there is no explaining things away by reference to a fixed and given human nature. In other words, there is no determinism, man is free, man is freedom. On the other hand, if God does not exist, we find no values or commands to turn to which legitimize our conduct. So, in the bright realm of values, we have no excuse behind us, nor justification before us. We are alone, with no excuses.

When Descartes said, "Conquer yourself rather than the world," he meant essentially the same thing...Hence, let us at once announce the discovery of a world which we shall call inter-subjectivity; *this is the world in which man decides what he is and what others are [italics added].*[78]

The desire to decide what others are should make us pause. As discussed shortly, the desire to make reality and others conform to our will is infantile, sociopathic, and violent.

The association of these intellectual concerns with the development of culture is clearly evidenced by a wide variety of Nineteenth and particularly Twentieth Century works of art. Heidegger talks about a painting by Vincent Van Gogh depicting a pair of peasant shoes.

For the superficial viewer, it is merely a still life; for the sentimentalist, it is an evocation of the joys of unsophisticated virtue, for the economically minded, it is an elevation of the poor to the realm of high culture. But to Heidegger, Van Gogh's painting is significant because it is authentic:

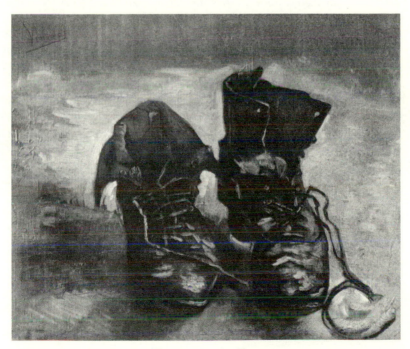

37. Van Gogh, *Shoes*

> In them there vibrates the silent call of the earth, its quiet gift of ripening corn and its enigmatic self-refusal in the fallow desolation of the wintry field. This equipment belongs to the earth and it is protected in the world of the peasant woman...Van Gogh's painting is the disclosure of what the equipment, the pair of peasant shoes, is in truth...This entity emerges into the unconcealment of its being.[79]

That such immanent authenticity marks an advance from a superficial aestheticism (e.g., Impressionism) is clear; it is difficult to defend the importance of the trivial. But it is not much of an advance. For example, Edvard Munch (1863-1944) was influenced both by Schopenhauer and by Nietzsche, whose portrait he painted. And within his cultural milieu the influence of Kierkegaard is clear. His art is then emphatically aesthetic. Within that aesthetic context, an existentialist authenticity is deemed laudable. His attempt to be authentic centers on an attempt to unconceal the true nature of *being*. But for the Existentialist, *being* is meaningless *becoming*,[80] so the search for authenticity via a meaningless becoming results in a tragic anxiety. It defies the dignity sought by Schopenhauer and defies the heroism that is sought by Nietzsche. But this tragedy is self-imposed, and thus its anxiety shifts (as tragedy can) into comedy, where anxiety becomes hysterical—and thus becomes a parody of itself. [81]

Munch's painting *The Scream* (1893) is the antithesis of the Modernist notion of art for art's sake; and it does not do very well as a Postmodern work of art.[82] It simultaneously manifests authenticity and anxiety, but by definition anxiety depends on inauthenticity. Aesthetically speaking, anxiety results when there is a conflict between the self and the world. It results when there is a failure of the inner world to be in harmony with reality. Granted, as Heidegger notes, that such conflicts can result due to personal or social obstacles to authenticity. But within the subjective-objectivity of the Modernist-Postmodernist tradition, reality itself is constructed or meaningless, and therefore, such anxiety can only be a parody of deep anxiety. Consequently, to consider Munch's painting (or even the previously discussed *Laocoön*) as a statement of the human condition makes no sense, since there is no human condition that is normative. So to state that authenticity and anxiety are complementary is intrinsically and extrinsically incoherent; to state that we should become anxious about such incoherence is incoherent as well.

In contrast to Classicism and Christianity which face the anxiety resulting from the conflict between what is and what ought to be, between aesthetics and beauty, the Existentialist assumes a conflict between what is becoming - and—what is becoming. But such a conflict makes little sense. The denial of transcendence makes anxiety impossible—except as farce. For the Existentialist there are no grounds for anxiety except subjectivity—but whereas subjectivity—like taste—differs, it cannot differ in any meaningful way. They can differ according to experience and preference, but they cannot substantively conflict because substance is not recognized as having meaning.

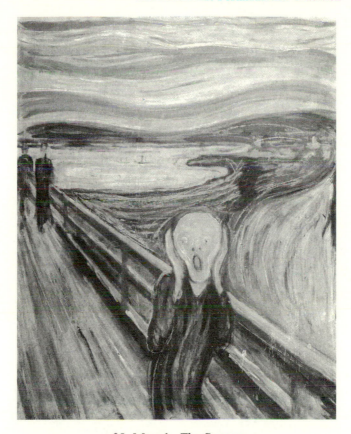

38. Munch, *The Scream*

As Frederic Jameson puts it:

...Edvard Munch's painting *The Scream* is of course a canonical expression of the great modernist thematics of alienation, anomie, solitude and social fragmentation and iso-lation, a virtually programmatic emblem of what used to be called the age of anxiety...

...it seems evident that *The Scream* subtly but elaborately deconstructs its own aesthetic of expression, all the while remaining imprisoned within it....concepts such as anxiety and alienation...are no longer appropriate in the world of the postmodern...

...when you constitute your individual subjectivity as a self-sufficient field and a closed realm in its own right, you thereby also shut yourself off from everything else and condemn yourself to the windless solitude of the monad, buried alive and con-demned to a prison-cell without egress.

[Liberation]...from the older *anomie* of the centered subject may also mean, not merely a liberation from anxiety, but a liberation from every other kind of feeling as well, since there is no longer a self present to do the feeling.[83]

By reducing the pursuit of truth and beauty to the realm of subjective experience, not only do truth and beauty dissolve, the subject dissolves as

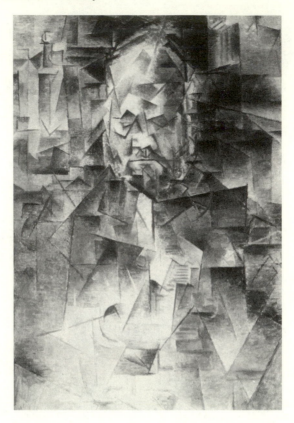

39. Picasso, *Portrait of Ambroise Vollard*

well. The subject can only exist as an act of will, but now, that act of will can only be by an existing subject. The Existentialist "I exist therefore become" is then an immanentizing of the Judeo-Christian understanding of the transcendent God as expressed in *Exodus*: "I am that I am." But whereas the Judeo-Christian goal of the individual is to sympathize and imitate the transcendent Divine (and thereby maintain the uniqueness of the individual), the Existentialist requires an act of empathy with oneself—which marks a self-destructive narcissism. In that case there is no actual anxiety because there is no conflict between internal and external, nor is there any meaningful substance to either.

In commenting on the transition from Modernism to Postmodernism, Frederic Jameson also observes that:

> This shift in the dynamics of cultural pathology can be characterized as one in which the alienation of the subject is displaced by the fragmentation of the subject.[84]

This fragmentation of reality and life is evidenced by the art of Cubism. To give just one example, in Cubism, Picasso's *Portrait of Ambroise Vollard* (1910) evidences a subject dissolving into a fragmented visage, where the ego perilously clings to itself in an indeterminate world that is a manifestation of the ego.

In speaking of the intellectual content of Cubism, Andre Salmon declared:

> There is nothing real outside ourselves; there is nothing real except the coincidence of a sensation and an individual mental tendency. Be it far from us to throw any doubts upon the existence of the objects which impress our senses; but, rationally speaking, we can only experience certitude in respect to the images which the produce in the mind...We seek the essential, but we seek it in our personality and not in a sort of eternity, laboriously divided by mathematicians and philosophers.[85]

Notes

1. Robert J. O'connell, S.J. , *Art and the Christian Intelligence in St. Augustine* (Cambridge: Harvard University Press, 1978), 68ff.

2. Concerning Augustine and Kant, O'Connor (Ibid, 166ff), writes: "Is it an illusion to think that being holds out to man not only the promise of intelligibility, but the promise of ultimate satisfaction as well?....But is the insistence that the world make moral sense exclusively a belief in being as good? Or has another face of being subtly asserted its claims, one that Kant came to contemplate in his Third Critique, being's face as beauty, beauty, that elicits the judgment that the picture is "right," in the profoundest sense, "decorous" just as it *decet,* "ought to be"? 'The aesthetic face of being, here associated with Kant, needs to be carefully distinguished from the aesthetic face of being cited by orthodox Christians such as Florensky (discussed below); to grant substance to an empty formalism via a self-deification is anathema to the Augustinian view.

3. Granted some of those fantasies were lived by an aristocracy wealthy enough to do so. But it cannot be argued that having the money to purchase a ticket to Disneyworld makes Disneyworld real in any meaningful sense.

4. Many of the ideas presented in this section have been published in "Art, Science, and Postmodern Society" *American Outlook (*November-December 2000), 37-39.

5. As discussed by Jacques Barzun, *From Dawn to Decadence* (New York: HarperCollins, 2000), 441.

6. Frederick Copleston, *A History of Philosophy* (Garden City, NY: Image Books, 1966), Vol..VI, 324.

7. Modernism is here associated with Kant, and Postmodernists are those who start from Kant's position, but reject it. A less restrictive alternative exists for all those who do not assume that Kant is the starting point. Rousseau's Postmoderism is critiqued by Irving Babbitt, *Roussen and Romanticism* (1919).

8. See Thomas Molnar, *God and the knowledge of Reality* (New Brunswick, NJ: Transaction Publishers, 1993).

9. As Kant puts it, "There is a great difference between something given to my reason as an object absolutely, or merely as an object in the idea...in the latter case there is in fact only a scheme for which there is no object, not even a hypothetical one." Samuel Stumpf, *Philosophy. History and Problems* (New York:McGraw-Hill,1971), 316. This is in contrast to Augustine's emphasis on mathematics, logic, and a sensuality that is ontological and even sacramental.

10. William Fleming, *Arts and Ideas* (New York: Holt, Rinehart and Winston, 1994), 461.
11. As stated in the *Encyclopédie* (1745-80). See: Franklin LeVan Baumer, *Main Currents of Western Thought* (New Haven, CT: Yale University Press, 1978), 378. Augustine also rejects ideology, but does not embrace mere taste.
12. Ibid., 414ff.
13. As Umberto Eco notes, citing Gödel's theorem, comprehensive systems always contain a self-destructive contradiction.
14. Edmund Burke's Reflections on the French Revolution will be discussed shortly.
15. For a superb analysis of utopianism see: As Thomas Molnar, *Utopia, the Perennial Heresy* (New York: Sherd and Walp, 1967).
16. James T. Boulton, editor, *Edmund Burke, A Philosophical Enquiry into the Origins of our Ideas of the Sublime and the Beautiful* (Notre Dame, IN: University of Notre Dame Press, 1968), 112.
17. Franklin LeVan Baumer, *Main Currents of Western Thought* (New Haven, CT: Yale University Press, 1978), 492.
18. Boulton, lxiii
19. De Ordine, trans. Russell, 133-35
20. James T. Boulton, editor, Edmund Burke, *A Philosophical Enquiry into the Origin of our Ideas of the Sublime and Beautiful* (Notre Dame, IN: University of Notre Dame Press, 1968), xxx.
21. Ibid, 112
22. Ibid., 11ff.
23. Ibid. In contrast is the East Asian parable of the three vinegar tasters, Lao-tzu, Sakyamuni, and Confucius who respectively declare that vinegar is sweet, bitter, and sour. Those differences in understanding the nature of vinegar are grounded in differences in understanding reality and life.
24. Richard Weaver discusses the metaphysics of property in his text, *Ideas Have Consequences* (Chicago: University of Chicago Press, 1984).
25. Alasdair MacIntyre, *Whose Reason? Which Justice?* (Notre Dame, IN: University of Notre Dame Press, 1988), 292ff.
26. Many of the ideas here discussed were introduced in "Beauty and the Enlightened Beast," *American Outlook Magazine*, 2002.
27. Frederick Copleston *A History of Philosophy* (Garden City, NY: Image Books, 1966), 217, 224. This makes suspect the dogmatic authority of science. See: E.A. Burtt, *The Metaphysical Foundations of Modern Science* (Garden City, NY: Doubleday Books, 1954).
28. Ibid., 225.
29. Ibid, 236, 247.
30. Ibid, 249.
31. The pantheistic impulse in Hegel is clear: "… although Hegel rejects any deification of existing Nature, the fact remains that if Nature is real it must be a moment in the life of the Absolute." (Frederick Copleston, *A History of Philosophy* (Garden City, NY: Image Books, 1966) , Vol. 3, 200.
32. Ibid., 231.
33. Ibid, 169.
34. Albert Hofstadter, Richard Kuhns, *Philosophies of Art and Beauty* (Chicago: Chicago University Press, 1976) 382ff.
35. John Hibben, *The Problems of Philosophy* (New York: Charles Scribner's Sons, 1908), 72.
36. John Hibben, *The Problems of Philosophy* (New York: Charles Scribner's Sons, 1908), 76.

37. See: Allan Blunden, translator, *Hugo Ott, Martin Heidegger. A Political Life* (New York: Basic Books, 1993).
38. As mentioned above, Aldous Huxley associates Beethoven with the reduction of music to mere emotionalism. The political implications of such music correspond.
39. Frederick Copleston, *A History of Philosophy* (Garden City, NY: Image Books, 1966), 223.
40. As Thomas Molnar notes, Ernest Renan (1823-1892) attempted to discount the divinity of Christ while advocating a divinity emerging from humanity. The result is a totalitarian and violent fiction. See: Thomas Molnar, *Utopia, the Perennial Heresy* (New York: Sherd and Walp, 1967), 122
41. Charles Harrison and Paul Wood with Jason Gaiger, *Art in Theory. 1815-1900* (Oxford: Blackwell Publishers, 1998), 1, 364
42. Franklin LeVan Baumer, *Main Currents of Western Thought* (New Haven, CT: Yale University Press, 1978), 557ff.
43. Charles Harrison and Paul Wood with Jason Gaiger, *Art in Theory. 1815-1900* (Oxford: Blackwell Publishers, 1998), 1, 343.
44. Sam Hunter, John Jacobus, *Modern Art* (Englewood Cliffs, NJ: Prentice-Hall, Inc, 1985), 19.
45. Charles Harrison and Paul Wood with Jason Gaiger, *Art in Theory. 1815-1900* (Oxford: Blackwell Publishers, 1998), 1, 1025.
46. Charles Harrison and Paul Wood with Jason Gaiger, *Art in Theory. 1815-1900* (Oxford: Blackwell Publishers, 1998), 1, 898.
47. Ibid., 951.
48. The intellectual meaning of Trinitarianism provides a solution to this problem, and thus reconciles being with becoming, purpose with time, *Kairos* with *Kronos*.
49. Ibid.,18.
50. Sam Hunter, John Jacobus, Modern Art (Englewood Cliffs: Prentice-Hall, Inc., 1985), 42.
51. Charles Harrison and Paul Wood with Jason Gaiger, *Art in Theory. 1815-1900* (Oxford: Blackwell Publishers, 1998), 1, 1026ff.
52. Parts of this section were published in "Facts, Feelings, and (In)coherence vs. The Pursuit of Beauty, Kandinsky and Florenshy," *St. Vladimir's Theological Quarterly* (1996), vol. 40, no.3, 173-180.
53. Charles Harrison and Paul Wood with Jason Gaiger, *Art in Theory. 1815-1900* (Oxford: Blackwell Publishers, 1998), 1, 746.
54. Charles Harrison and Paul Wood with Jason Gaiger, *Art in Theory. 1815-1900* (Oxford: Blackwell Publishers, 1998), 1, 746 ff.
55. Ibid., 750.
56. This viewpoint is echoed by that of Ananda Coomaraswamy who for many years was curator at the Museum of Fine Arts, Boston. See: Coomaraswamy, *Christian and Oriental Philosophy of Art* (New York: Dover Publicatons, 1956).
57. Thomas Molnar, *God and the Knowledge of Reality* (New Brunswick: Transaction Publishers, 1993), xi, 19.
58. The ideas in this section were introduced in Arthur Pontynen, "Facts, Feelings, and (In)coherence vs. The pursuit of Beauty (Kandinsky and Florensky)," *St. Vladimir's Theological Quarterly* (1996), vol. 40, no. 3, 173-180.
59. Hilla Rebay, editor, *Wassily Kandinsky, On the Spiritual in Art* (New York: Solomon Guggenheim Foundation, 1946), 26,35,30.
60. Ibid., 43,47.
61. Ibid., 58.

62. Victor Bychkov, *The Aesthetic Face of Being* (Scarsdale, NY: St. Vladimir's Seminary Press, 1993), 28.
63. Ibid., 26,44.
64. Wilhelm Worringer, trans by Michael Bullock, *Abstraction and Empathy* (Cleveland, OH: Meridian Books, 1967), 4-7.
65. Ibid, 24
66. Ibid., 128
67. This dichotomy of empathy and abstraction will later be explained by Friedrich Nietzsche as a matter of the Dionysian and the Apollonian.
68. Charles Harrison and Paul Wood , *Art in Theory. 1900-1990* (Oxford: Blackwell Publishers, 1997), 2 , 15.
69. Albert Hofstadter and Richard Kuhns, *Philosophies of Art & Beauty* (Chicago: University of Chicago Press, 1976), 467.
70. *Götzendammerung*, IX, sections 19, 24.
71. Martha Nussbaum, *The Fragility of Goodness. Luck and ethics in Greek tragedy and philosophy* (Cambridge: Cambridge University Press, 1986), 126 ff.
72. Francis Golffing, trans., *Friedrich Nietzsche, The Birth of Tragedy and The Genealogy of Morals* (Garden City: Doubleday & Company, 1956), 88ff.
73. Martha Nussbaum, *The Fragility of Goodness. Luck and ethics in Greek tragedy and philosophy* (Cambridge: Cambridge University Press, 1986), 170.
74. Ibid. 127.
75. Golffing, Ibid., 10ff.
76. The Existentialist mode is found in secular and religious contexts. Kierkegaard promotes an aestheticized a-rational Christianity. As such, it is radically unorthodox and incoherent.
77. Albert Hofstadter and Richard Kuhns, *Philosophies of Art & Beauty* (Chicago: University of Chicago Press, 1976), 682,702.
78. Franklin LeVan Baumer, *Main Currents of Western Thought* (New Haven, CT: Yale University Press, 1978), 680-1.
79. As discussed by Frederic Jameson, "The Deconstruction of Expression," in Charles Harrison and Paul Wood, *Art in Theory 1900-1990* (Oxford: Blackwell, 1992), 1076. See also: Albert Hofstadter, Martin Heidegger, *Poetry, Language, Thought* (New York: Harper & Row, 1975).
80. This central idea of existentialism is discussed in Martin Heidegger, *Being and Time* (1927).
81. This will be discussed below in reference to Pop Art. As Fredric Jameson puts it (Charles Harrison and Paul Wood, *Art in Theory. 1900-1990* [Oxford: Blackwell Publishers, 1997]), 1079: "…concepts such as anxiety and alienation (and the experiences to which they correspond, as in *The Scream*) are no longer appropriate in the world of the postmodern…The great Warhol figures…would seem to have little enough in common anymore, either with the hysterics and neurotics of Freud's own day, or with those canonical experiences of radical isolation and solitude…which dominated the period of high modernism [e.g. van Gogh]."
82. In his essay, "Post-Modernism: or the Cultural Logic of Late Capitalism," Frederic Jameson argues that four contemporary means of analyzing culture and art are now untenable: the dialectical one of essence and appearance, the Freudian model of latent and manifest, the existential model of authenticity and inauthenticity, and the semiotic opposition between signifier and signified. See: Charles Harrison and Paul Wood , *Art in Theory. 1900-1990* (Oxford: Blackwell Publishers, 1997), 1078-9. What remains vital is that advocated by Augustine: an existential analysis within a purposeful reality.

83. Ibid. 1079.
84. Ibid.
85. Herschell B. Chipp, *Theories of Modern Art* (Berkeley: University of California Press, 1984), 214.

8

Ways of Worldmaking:
Nietzsche's Rebirth of Tragedy

"The impulse of modern art was [the] desire to destroy beauty"— Barnett Newman

"No god searches for Wisdom."
 —Plato, Symposium *204A*

In his essay, "Modernism Mummified," Daniel Bell speaks of the notion that somehow things fundamentally changed during the twentieth century. He notes the oft-cited remark of Virginia Woolf, that "on or about December 1910 human nature changed." With the correction that the exact quote is that human *character* changed, nonetheless his point remains: for many, Modernism and Postmodernism altered how culture and life are understood in the West. Bell refers to Lionel Trilling, who was persuaded by reading the classics that human nature does not change and that moral life remains unified. But Bell continues:

> [Trilling did note that] in the late Sixteenth and early Seventeenth centuries something like a mutation in human nature took place, and that a new concern with the *self*, and being at one with one's self, became a salient, perhaps definitive, characteristic of Western culture for some four hundred years.[1]

The point that something changed in the twentieth century is clear, and so too is the idea that it was the result of a long development reaching back four hundred years. What changed for many was the choice to pursue aesthetics rather than beauty. So there is substantial evidence that as Western culture increasingly abandoned the pursuit of transcendent beauty (at least since Descartes), there has been an increasing shift towards aestheticism and narcissism.[2] The association of aesthetics with self, or rather, with narcissism, is not complimentary. Until relatively recently, narcissism was understood as an anti-cultural affliction rather than a human right. It was understood to indicate a malady of character rather than a sign of virtue. If it is true that the trajectory of aesthetics heads inevitably towards narcissism, then the attempt to obtain an

aesthetic culture both lofty and free is doomed to failure. It is doomed to failure because a narcissistic culture is no culture at all. This conclusion is obnoxious to the majority of public figures who today advocate an aesthetic vision as key to freedom, creativity, and justice. It is obnoxious to those who view transcendentalism as religious nonsense, while they remain oblivious to the religious content of their own aesthetic vision. It is a content that presumes, advocates, and demands belief in a purposeless world. So either we seek transcendence or embrace immanentism and nihilism; we either seek God or play God, and to play God is to embrace an empty violence.

Nonetheless, there are ample grounds to make that suggestion. We have already cited previous examples of the self-deification associated with aesthetics: from Kant to Hegel Feuerbach and Renan Marx; from Manet to Courbet and Gauguin and Kandinsky, to name but a few. The association of aesthetics with narcissism and self-deification reveals the folly of the empiricist assumption that the existence of God is a self-projection; rather, *the assumed non-existence of God* (of cosmic purpose, be it called Jahweh, Logos, Dharma, or the Dao, to name but a few) *requires a divine self-projection.* The options are to seek beauty or aesthetics, purpose or nihilism, to seek a Worldmaker, or to assume we are worldmakers, or to use Nietzsche's term, we constitute a constellation of worldmakers. The problem is that such a presumed constellation, lacking objective purpose, makes no sense and devolves into violence.

The World as Found Beauty or Made Aesthetics

It is easy today to be an advocate of freedom. As long as we pay attention to facts, and purport to do no harm, we insist upon our right to believe and do as we wish. To suggest that we ought to encourage freedom is safe indeed, but link that freedom to the pursuit of truth, and just watch the fireworks begin. The notion that freedom is reliant upon truth, upon knowledge that to some degree is objective and purposeful, seems somehow intolerant and even oppressive. It seems un-Enlightened, as well it is.

As discussed earlier, the Enlightenment was dedicated to advancing society beyond the constraints of superstition, mere tradition, and social habit. Primarily associated with eighteenth-century German culture, with proponents in England and France as well, Immanuel Kant considered the Enlightenment to be a progressive inevitability; he praised the Enlightenment and provided its slogan:

> Enlightenment is humanity's departure from its self-imposed immaturity. This immaturity is self-imposed when its cause is not lack of intelligence, but failure of courage to think without someone else's guidance. Dare to know! That is the slogan of the Enlightenment.[3]

An important text of the Enlightenment is Immanuel Kant's *Critique of Judgment* (1790). A primary text of Modernism, it attempts to establish just

what kind of knowledge is to be sought, and how. As introduced above, Kant holds that the world as it is, the *ding an sich*, cannot be known, so truth cannot be known. Instead, he posits that there are facts, feelings, and style. Facts are objective, but how we put those facts into explanatory narratives is said to be linked to how we think; facts conform to the alleged structure of our minds.[4] The process of making sense of the world via a rational arranging of facts is held to be both aesthetic and creative; at its best, that process is the work of genius. The result is that facts are objective, but reality is subjective; the result is a subjective-objectivity, which is an aesthetic construct.

The notion that creativity is both sacred and distinct from truth claims is discussed by Nelson Goodman in his book *Ways of Worldmaking* (1978). Its foreword (x) states that the book belongs in that mainstream of modern philosophy that began when Kant "exchanged the structure of the world for the structure of the mind, continued when C.I. Lewis exchanged the structure of the mind for the structure of concepts," resulting in, "The movement...from unique truth and a world fixed and found to a diversity of right and even conflicting versions or worlds in the making." Goodman offers some thoughts on the notion of truth (19):

> "The truth, the whole truth, and nothing but the truth" would thus be a perverse and paralyzing policy for any world-maker...The truth alone would be too little, for some right versions are not true—being either false or neither true nor false—and even for true versions rightness may matter more.

The idea that some "right versions are not true," and that "even for true versions, rightness might matter more," echoes Nietzsche's admonition that truth cannot compete with willfulness, that we must rise above alleged principle in our daily lives. Nietzsche's critique of transcendent beauty and morality, and particularly his critique of Classicism and Christianity will be the focus of the concluding chapter. But presently it is useful to point out that as a Postmodernist, Nietzsche denies claims of both genius and a rational, secular morality (the Categorical Imperative). Instead, he posits the triumph of the will, an intrinsic individual right to self-expression and self-realization. Other Postmodernists share this advocacy of self-expression and self-realization, but associate that right with empirical groups. With Marxists, that will is associated with economic class, with Nazis that will is associated with racial class, with gender feminists that will is associated with sexual class. Whether we speak of race, gender, economic class, or the individual, whether we speak of the majority or a minority, the unifying dogma of Postmodernist thought is the will to power.

So the Enlightenment admonishes us to "Dare to know!" But if our worldviews and our lifestyles are constructed—and deconstructed—by us, then what is there to know? How, also, do we determine what we ought to do? The answer is not pretty; it is, however, aesthetic. According to Goodman (18):

> Truth, far from being a solemn and severe master, is a docile and obedient servant. The scientist who supposes that he is single-mindedly dedicated to the search for truth deceives himself....He seeks system, simplicity, and scope; and when satisfied on these scores he tailors truth to fit. He as much decrees as discovers the laws he sets forth, as much designs as discerns the patterns he delineates.

The Enlightenment's duty to know has come to its necessary Postmodern conclusion. That conclusion is that given facts, feelings, and rationalistic style, the duty to know is actually the duty to create. We are *worldmakers*. This assumed duty to create reality and life posits an aesthetic vision of reality and life. It takes for granted that we can aesthetically construct the world and our lifestyles according to our will. From a Kantian perspective this does not present us with problems—since the assumption is that the only thing that is good is a good will. But as discussed previously, the idea of a good will makes no greater sense than good taste, or a subjective-objectivity. Even if one accepts the dubious proposition that duty results in our summoning the will to do good (via the Categorical Imperative), the Kantian vision offers no insight as to what is worth doing and no sanction for ignoring our alleged duty to do it. This aestheticization of reality and life has personal and social consequences. We have already considered the political consequences suffered by Florensky. We can also examine those consequences from psychological, philosophical, and theological perspectives.

In *Creativity and Perversion* (1984), Janine Chasseguet-Smirgel explains the psychological association of aestheticism, creativity, and perversion. She finds the driving cultural force behind each to be the unwillingness of the child to acknowledge reality, particularly the differences between things that exist. Following Freud, she centers on the importance of recognizing differences between the sexes and the generations. Denial of those differences is understood as neither enlightened nor tolerant. It results in a psychology that is fundamentally sadistic. It is grounded in an immature attempt to obtain a single goal: the violent elimination of all distinctions to a common banality. In illustration, Chasseguet-Smirgel refers to another figure of the Enlightenment, the Marquis [Comte] de Sade:

> The materialistic reasoning of Sade when he speaks of the equality of man with an oyster, the equality of all human beings, the equality of Good and Evil, the equality of death and life...reveals but one basic intention: to reduce the universe to faeces...The Sadean hero actually becomes the grinding machine, the cauldron in which the universe will be dissolved.[5]

She likens the unwillingness to come to terms with reality to an act of pride, and consequently as an act of violence. That violence has a sexual component: it is grounded in a denial of reality, and a wish to make others conform to one's own will—or pleasure. In his 1911 essay, "The Two Principles of Mental Functioning," Freud discusses the necessary substitution of the reality prin-

ciple for the pleasure principle. When pleasure attempts to replace reality, our pleasure is grounded in the perverse. By reducing our relationships to a matter of subjective rightness, rather than truth, we thereby gain our pleasure from those whom we willfully manipulate.

In the context of science, Freud studied the substitution of the reality principle by the pleasure principle, concluding that the aim of the scientist suffering from pride [i.e., *worldmaking*] is not to reach truth (the reality principle), but rather to place science in the service of perverse pleasure. So too with art. Chasseguet-Smirgel takes three examples of "Luciferian" characters: a historical one, Caligula, a fictional one, the scientist Doctor Moreau, and an artist, Hans Bellmer. In each case a will to construct reality according to one's pleasure is evidenced, coupled with a sexually sadistic tendency.

Bellmer is known for creating dolls with a disturbing sexual violence. The artist is quoted (in 1965):

> The body can be compared to a sentence inviting one to disarticulate it for its true elements to be recombined in a series of endless anagrams...leib (body), lieb (love), Beil (axe).

This sadism evinces a substituting of perverse pleasure for reality. Bellmer is not alone in this regard. There are numerous examples of a sadistic content in the culture of the Enlightenment, from the Marquis de Sade, to Edward Munch (whose paintings and prints entitled *Madonna* link sex with violence) to Marcel Duchamp.

Duchamp assumed male and female persona; in his art he presents his alter ego, Rose Selavy, which suggests in French: "Eros, such is life." Chasseguet-Smirgel uses that name to discuss a patient who exhibits classic symptoms of perversion. Duchamp took a reproduction of the Mona Lisa, altering both art and life by applying a goatee and moustache on her/him, and writing beneath the transformed object/subject *L.H.O.O.Q.,* an anagram which phonetically conveys in French an erotic notion: She has a hot bottom.

Thus, the original work is violently altered in several ways—particularly in reference to the notion of eroticism. The name Rose Selavy declares that eros is life. But what is eros? As discussed above, Plato associates the erotic with the pursuit of truth; both are directed at objects in the world, and seek completion. Eroticism differs from mere sensuality in that there is a subjective and self-conscious element to it, it is a subject that consciously seeks an object. That search must be sympathetic rather than empathetic since empathy would destroy the object that is loved. It aims for a completion of desire, but a completion that does not deconstruct the object of desire. But if we embrace a subjective-objectivity, where we construct the object sought via truth and love, then an empathetic nihilism is unavoidable.

In contrast to the blatant violence in the art of Bellmer, or the ironically masked violence of Duchamp, in which the human body is reduced to a fetish-

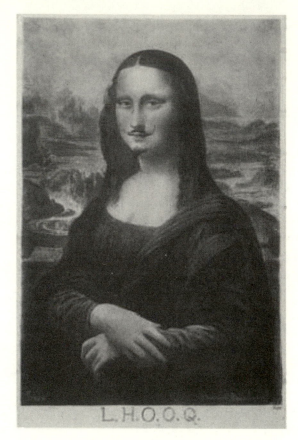

40. Duchamp, *L.H.O.O.Q.*

istic object, eroticism is historically associated not merely with a willful and subjectivist sensuality, but rather with the self-conscious desire of one person to physically, emotionally, and spiritually connect with another self-conscious person. It centers on a self-conscious connection between two distinctly self-conscious beings,[6] by which self-consciousness is transcended to a higher unity, a supra-consciousness. The transcendent unity of two self-conscious beings constitutes genuine love. Lacking a shared spiritual unity, a spiritual disunity of two self-conscious beings (even if physically joined) reveals an exploitative violence; an empathetic union by definition results in a violent destruction of the object of love. Eroticism can either ascend to the realm of love and beauty, or fester in a narcissistic aestheticism of power and brutality.

What then of Duchamp? The transcendent beauty of an erotic embracing of subject and object is parodied and thus denied by an aesthetic act of violence. In place of a beatific union of lovers there is an objectified self-enjoyment. It is a physical and empathetic union that narcissistically denies the possibility

of love by its denial of a subject-object relationship. If she does indeed have a hot bottom, then emotively the only recourse is onanism – which is no intercourse at all. Other works by Duchamp are onanistic and scatological as well. His last major piece, *The Bride Stripped Bare by the Bachelors*, posits the violent futility of love. It is an eros without love, and life without beauty. Within a world where objectivity is denied, the conclusion of eros is not life, but death.

More recent examples of these tendencies include Serrano's *Piss Christ* and Olfili's *Madonna*, a painting included in a controversial Brooklyn Museum show, and which was painted with feces. In each case, images advocating a reality principle are used to provide perverse pleasure by associating *being* with, and therefore violated by, human waste. Psychoanalysis maintains that the will to create the world in our own image, in science, ethics, or art, evidences a childish and perversely violent psychology and sexuality. *Worldmakers* stand in contradiction to the Modernist Enlightenment's stated goal: Dare to know. Yet, *worldmaking* is the necessary conclusion of the Enlightenment.

Regrettably, unqualified pleasure, and an attempted equalizing of differences, is nothing new in human experience. It is central to the work of the Marquis de Sade, who merely updated the *worldmaking* aspirations of the Roman Emperor worldmaker Caligula. Rather than go into a detailed historical account of the sordid activities of *worldmakers* through the ages, the reader can refer to the histories of Suetonius, Procopius, and more currently, to the *Black Book*, a compendium of atrocities committed in the name of Communism.

The Enlightenment's goal of escaping superstition, which widely was understood to include escaping religious dogma, has been shown to be terribly flawed. Be it in the political, the sexual, or the scientific realm, the Sadean hero puts himself in the position of God, and through a process of destruction, attempts to become the creator of a new kind of reality. [7] That creative act of *worldmaking* is aesthetic and violent: it centers on pleasure qualified only by the will—and therefore not qualified at all.

In his book, *God and the Knowledge of Reality*, Thomas Molnar brings our attention to Kant's private notes, not published until 1920:

> God must be represented not as a substance outside me, but as the highest moral principle in me...The Idea of that which human reason itself makes out of the World-All is the active representation of God. Not as a special personality, substance outside of me, but as a thought in me.[8]

As Kant's private notes verify, and as Hegel blatantly asserts,[9] in a realm of *worldmakers* the philosopher becomes God, the scientist becomes an alchemist, the citizen is encouraged to think and do as one pleases—without objective qualitative meaning. But lacking the possibility of an objective reality,

then a narcissistic existentialism is dogmatic. The choice then is clear: it is not one of religious dogma versus secular enlightenment. Rather, it is one of seeking objective truth or making the world, of seeking beauty, or making willful aesthetic constructs.

Molnar presents a historical account of *worldmaking,* or to use his terms, hermetism and alchemy. In his chapter, "The Philosopher's Magic Quest," Molnar notes that hermetism and alchemy have long been present in history, from the ancient Greeks to the Neo-Platonists, Origen, Tertullian, Erigena, and Ficino; in the East it played a central role in Daoism as well. *Worldmaking* is neither new nor progressive. It is a perennial point of foolishness. Molnar explains:

> The most notable thing about this comparison between Hermetic speculation and modern philosophy is the fact that all the operations of the philosopher are *mental* operations. They take place in the *subject* -not in the sense in which cognitive processes are, of course, mental ones, but in the sense that the subject regards his ideas as *agents* shaping the real world...
>
> The subjectivist philosopher is convinced...he modifies the constitution of being. His increased "true knowledge" signifies a general increase of mankind's and the world's maturity...it brings about an absolute change, a transmutation in man's morality, intellectual powers, and political insights; it brings about a change of being...[but] the models he constructs are impotent to influence the real world.[10]

The epitome of this development is evidenced by the art and life of Jackson Pollock. In the 1950s he painted a number of works representative of his mature stage, including *Alchemy*, and *Lucifer*. As a major figure of Abstract Expressionism, Pollock advocates the unity of experience and art. A physics of time and life is evident, and that physics is associated with violence. Pollock's art evidences a variety of Postmodern influences. He works from a historicist and existentialist perspective. The general theme of his art is a rejection of the attempt to comprehend an objective world. Rather, the goal of art is to participate—as a demiurge—in the realization of experience. He states, for example,[11]

> Modern art to me is nothing more than the expression of contemporary aims of the age that we're living in. ...The thing that interests me is that today painters do not have to go to a subject matter outside of themselves. Most modern painters work from a different source. They work from within... [they are] expressing an inner world—in other words—expressing the energy, the motion, and other inner forces.

Pollock's art is both a record of his existence and a creation of his existence. But it is a creation and existence that lacks purpose or beauty. It therefore offers no intelligible purpose to reality or life. But this is seen as virtue, not vice. Barnett Newman was Pollock's colleague within the artistic movement known as Abstract Expressionism. His work makes clear a concern for the spiritual in art and life, but it is a spiritual vision distinct from tradition. He

ignores the claims of beauty found in the Old Testament, and dismisses in general the pursuit of beauty. Instead he advocates the pursuit of an existential sublime, a notion whose primary articulator was Soren Kierkegaard (1813-1855). As discussed above, Kierkegaard's primary notion was grounded in a particular understanding of the Old Testament story Abraham and Isaac; he maintained that in the presence of an infinite and ineffable God, we can only exist in a state of fear and trembling. We must rise above a hedonistic aestheticism, and above a rational ethics, to that religious stage where Truth is but a subjective experience. Truth is existential. But if Truth is a subjective experience, then the prospect arises yet again of an empty self-deification.

For example, Newman chose to paint a traditional theme in his painting, *The First Station of the Cross* (1965-66), but does so in an obviously untraditional manner. What does the painting mean? Newman wrote an important essay in 1948 titled, "The Sublime is Now."[12] He offers an analysis of reality and beauty which the Pseudo-Dionysius could not comprehend:

> The invention of beauty by the Greeks, that is, their postulate of beauty as an ideal, has been the bugbear of European art and European aesthetic philosophies…the European artist has been continually involved in the moral struggle between notions of beauty and the desire for sublimity…
>
> The impulse of modern art was this desire to destroy beauty…modern art, caught without a sublime content, was incapable of creating a new sublime image…
>
> I believe that here in America, some of us, free from the weight of European culture, are finding the answer, by completely denying that art has any concern with the problem of beauty and where to find it. The question that now arises is how, if we are living in a time without a legend or mythos that can be called sublime, if we refuse to admit any exaltation in pure relations, if we refuse to live in the abstract, how can we be creating sublime art?
>
> We are reasserting man's natural desire for the exalted, for a concern with our relationship to the absolute emotions…Instead of making *cathedrals* out of Christ, man, or 'life,' we are making it out of ourselves, out of our own feelings.. .

For those who are philosophically and historically aware, these sentiments are deeply Nietzschean in content. Nietzsche focuses on tragedy, but accompanying tragedy is comedy, since both deny the efficacy of reason in comprehending the world. But comedy can also be used to mock irrationality and pride. It can be used in the attempt to mock the pretensions of reason, or the pretensions of the unreasonable. Nietzsche disapproves of the way in which the Socratic Euripides mocks the unreasonable, whereas Aristophanes makes light of the pretensions of some attempts at being reasonable. Again, as Nussbaum puts it:

> The comedy comes in the sudden perception of ourselves from another vantage point, the sudden turning round of our heads and eyes to look at [ourselves anew]…It is like those moments in Aristophanes actual plays, when we are shown some absurd or even base behavior and then, all at once, are made to see that it is our own.[13]

A self-conscious awareness of folly is then a perennial source of comedy; its association with the tragic is clear. Tragedy and comedy are linked by the failure of self-conscious choices making sense. In mocking the irrational yet self-conscious choices of Existentialism we cross the line from tragedy to comedy. Being absurd is not as good as being aware of one's absurdity; but being aware of one's own absurdity is painful yet. The irrational pretensions of a Postmodernist Existentialism, and its Nietzschean, Dionysian-wisdom is soon mocked by Pop Art—but not resolved.

In the concluding line of his book *The Genealogy of Morals: an Attack* (1887) Nietzsche self-consciously concludes that "man would sooner have the void for his purpose than be void of a purpose." [14] And in his book, *From the Twilight of the Idols*, section 20, he writes: "Nothing is beautiful; man alone is beautiful: all aesthetic rests on this piece of ingenuousness, it is the first axiom of this science." The self-conscious seriousness of Abstract Expressionism is where the work of art marks *becoming* as the very *being* of existence. It is the heroic will in a meaningless world, but to view that will as sublime is pretentiously incoherent. It invites a tragic and comedic response. That response is found in the detached irony of the Pop Art movement. It is an elitist movement that mocks the elitism of Existentialism. It democratizes art —and ethics—while mocking such democratization. It is a subjective-objectivity where art and meaning are subjectified and aestheticized.

Roy Lichtenstein (b. 1923) produced numerous works of art where the ontological claims of previous works of art are reduced to superficial design executed via a comic book technique. In particular, his works depicting the existential brushwork of Abstract Expressionism are devoid of passion, devoid of an ontological ground, devoid of heroism. And that emptiness is not simply empty—it is mockingly so.

Lichtenstein's painting *Brushstroke* (1965) mocks the pretension of the existentialist position that by sheer force of will we can establish meaning within the context of a meaningless or ineffable universe. He paints a painting of an Abstract Expressionists brushstroke, using a mechanical graphic arts mode. By reproducing the brushstroke of the Abstract Expressionist, which is allegedly the physical representation of the existential authenticity and angst of the hero artist standing in defiance of meaninglessness, Lichtenstein mocks the very pretentiousness of it all.

Indeed, *being* within an aesthetic world of fact and feeling, of scientism and emotivism, is recognized not by its heroism, but rather by its banality—even while it is ironically and aesthetically celebrated. Lichtenstein produces paintings about paintings. This results in an ironic detachment that is devastating not only to the existentialist solution to Modernist alienation; it is (presumably) unintentionally devastating to Pop Art as well. Aesthetics leads to an existentialist emphasizing of being, but existentialist being is reduced to parody by aesthetics. The aestheticization of beauty by existentialism is

mocked for being aesthetic, but then that mockery can only be aesthetic it-self.[15]

Roy Lichtenstein notes:[16]

Pop may be seen as a product of two twentieth-century tendencies: one the outside—the subject matter; and the other from within—an esthetic sensibility…The esthetic sensibility to which I refer is anti-sensibility—an apparent anti-sensibility…Although the anti-sensibilities stance appears as mindless, mechanical, gross and abrupt or as directed by prior or non-art decisions, its real meaning, I feel, lies in the artist's personal sensation of performing a difficult feat of bravado while really respecting all of the sensibilities…

The content of aesthetic relativism is evidenced by the Pop Art of Lichtenstein and Warhol, as well as by Minimalism and Conceptualism.[17] As relativists they all deny the possibility of lofty purpose in art and life, and they deny the possibility of obtaining wisdom or beauty. Therefore, attempts to explain and evaluate the meaning of such art are either pointless or subject to sterile dispute. To evaluate the merits of these works of art it is necessary to examine the quality of their content. The dilemma is that from a Modernist Liberal position the quality of the content of the object cannot objectively be judged. Why not? Because the root belief of that viewpoint is grounded in a dogmatic subjective-objectivity where relativism asserts there is no objective purpose and there are no objective ideals in politics and life. For them all values and meanings are a matter of perspective and ultimately a matter of power. As such, judgments of value are based upon subjective claims of genius or authority, on an act of will that can incoherently be viewed as either be-nevolent or malevolent. The conclusion is that a critique of relativist art can-not be objective. It must then be grounded in a skeptical subjectivity. Pop prefers an apparently benevolent skepticism, but is actually deeply malevo-lent. Skepticism mocks belief and sincerity and thus cannot distinguish com-edy from tragedy. The selection and critique of aesthetic works of art must therefore be grounded in skepticism as well; those who select works assume they are benevolent, whereas the *other* must be malevolent. This emotive game of gauging the nature of other's intentions is now commonplace—and destructive.

Rather than engage in such aesthetic disputes concerning the subjective meaning of art, one can equally consider if it is beautiful; whether is offers a glimpse of wisdom. This can be facilitated by observing what art says or does not say. And what it does not say can truly be informative. What it does not say is exactly what its alternatives offer: that somehow, ultimately, life does have meaning and purpose. Life is not just a process, not just a mechanistic[18] or random series of events. Rather, life is formed and informed with meaning, however difficult to perceive or to live by. It is driven by a passionate erotic love which aspires to beauty. From such a point of view Pop Art, Minimalism,

and Conceptualism offer little. In each case is seen a cultural and political void, a void without hope and without merit, a void that the public rightfully should resist.

Nietzsche's critique of Classicism leads to an existentialist conclusion. That conclusion accepts both tragedy and comedy as prevailing, with an empty nihilism the necessary consequence. Nietzsche's treatment of Classicism is paralleled by his rejection of Christianity. His father, a Lutheran pastor, died when Nietzsche was but five years old; during the time of his studies at the University of Bonn, he replaced the faith of his father and the father of his faith, with the atheism of Schopenhauer. With the publication of his book, *The Joyful Wisdom* (1882), Nietzsche argues that Christianity is hostile to life; in *Beyond Good and Evil* (1886) and *A Genealogy of Moral: An Attack* (1887) he argues for relativistic and pragmatic view of truth, in which the criterion of truth lies in the intensification of the feeling of power.[19] As mentioned above, the concluding comment in that text is: "man would sooner have the void for his purpose than be void of purpose."

In his book, *Theology and Social Theory* (1990) John Milbank discusses the various arguments in favor of the Modernist-Postmodernist notion of *worldmaking*. In his chapter, "Ontological Violence or the Postmodern Problematic" he notes that contemporary culture stemming from the Enlightenment constitutes a lamentable culture of violence. The Enlightenment leads to the Nietzschean conclusion that freedom is power, but a culture of power denies freedom—and love. He offers this conclusion (279):

> Kantian liberalism is merely the "great delayer"...For once it has been conceded, as by Kant, that ethics is to be grounded in the fact of the will and of human freedom, then quite quickly it is realized that freedom is not an ahistorical fact about an essential human subject, but is constantly distilled from the complex strategies of power within which subjects are interpellated as unequal, mutually dependent persons. The protection of an equality of freedom therefore collapses into the promotion of the inequality of power.

The Enlightenment advocates freedom and pleasure, but delivers violence; its program of attempting to achieve freedom by democratizing power leads to a society where we must live our lives as beasts. Milbank is influenced by Augustinian thought. In addressing the issue of human happiness Augustine observes:

> We all certainly desire to live happily; and there is no human being but assents to this statement almost before it is made. But the title happy cannot, in my opinion, belong either to him who has not what he loves, whatever it may be, or to him who has what he loves if it is hurtful, or to him who does not love what he has, although it is good in perfection. For the one who seeks what he cannot obtain suffers torture, and one who has got what is not desirable is cheated, and the one who does not seek for what is worth seeking for is diseased...

I find, then, a fourth case, where the happy life exists-when that which is man's chief good is both loved and possessed. For what do we call enjoyment but having at hand the objects of love?[20]

In attempting to understand Postmodernism, the twentieth century philosopher Hannah Arendt studied Augustine's thought,[21] especially his comment: "To will and to be able are not the same." In her essay "What is Freedom?" she wrote: "Only where the I-will and the I-can coincide does freedom come to pass." Both freedom and love need objects as well as subjects; neither abstraction nor empathy will do. And as Freud and Augustine note, lacking recognition of both an objective reality, and of difference, superstition and a destructive narcissism result. It is not *worldmaking* that indicates a mature freedom, but rather, the pursuit of beauty. Postmodern *worldmakers* confuse myth for reality, so let us conclude by using a myth to return to reality. Beauty and the Beast is a well-known tale representing not a Sadean world of equality and violence, but rather an epiphany. It is the failure to recognize and love the other that condemns the Prince to be reduced to the level of a Beast. The solution was not for Beauty and the Beast to be one. Rather, it was the love of Beauty that restored the Prince to what he was meant to be.

Notes

1. Daniel Bell, "Modernism Mummified," Editor Daniel Joseph Singal, *Modernist Culture in America* (Belmont: Wadsworth Publishing Company, 1991), 159.
2. See: Christopher Lasch, *The Culture of Narcissism* (New York: Warner Books, 1979).
3. Immanuel Kant, « Reponse a la question:Qu'est-ce que "les lumieres? " In Kant, *La Philosophie de l'histoire*, ed. Montaigne, 1947, p.46. The passage quoted is found in Jacques Barzun, *From Dawn to Decadence* (New York: Harper Collins, 2000), 441.
4. In his linguistic studies, Noam Chomsky follows the lead of this Kantian principle.
5. Janine Chasseguet-Smirgel, *Creativity and Perversion* (New York: W.W. Norton & Company, 1985), 4ff.
6. As discussed earlier, this is the intellectual meaning of the Christian Trinity within the context of a cosmos driven by truth and love.
7. Chasseguet-Smirgel, 4
8. Thomas Molnar, *God and the Knowledge of Reality*, (New Brunswick, NJ: Transac9. Ibid., 110.
10. Ibid., 98ff.
11. Charles Harrison and Paul Wood , *Art in Theory. 1900-1990* (Oxford: Blackwell Publishers, 1997), 575ff.
12. Ibid., 572ff.
13. Ibid., 173.
14. Francis Golffing, translator, *Friedrich Nietzsche, The Birth of Tragedy and The Genealogy of Morals* (1956), 299.
15. See Frederic Jameson's comments above.
16. Charles Harrison and Paul Wood , *Art in Theory. 1900-1990* (Oxford: Blackwell Publishers, 1997), 734.

17. For a discussion of the intellectual and spiritual content of such a proposed public work of art see: Arthur Pontynen, "Public Art and Public Values: The Blue Shirt," *WI: Wisconsin Interest*, 2003.

18. As Andy Warhol puts it: "The reason I'm painting this way is that I want to be a machine, and I feel that whatever I do and do machine-like is what I want to do." Charles Harrison and Paul Wood , *Art in Theory. 1900-1990* (Oxford: Blackwell Publishers, 1997),. 732.

19. Frederick Copleston, *A History of Philosophy* (Garden City, NY: Image Books, 1985), Vol. 7, 395.

20. Vernon J. Bourke, *The Essential Augustine* (Cleveland, OH: Hackett Publishers, 1974), 153ff. Pseudo-Dionysius Areopagite holds that sin is the failure to embrace *being*; alternatively is Milbank's conclusion that "...neither ignorance nor sin make mistakes; instead they somehow do not do enough."

21. Joanna Vecchiarelli Scott and Judith Chelius Stark, editors, *Love and St. Augustine. Hannah Arendt* (Chicago: The University of Chicago Press, 1996).

9

Western Culture at the Crossroads:
The History of Art and the
Postmodern Eschaton

It is obvious that a history of art is concerned with art, history, and time; what may not be obvious is that our understanding of art, history, and time is central to how we understand - and conduct- our lives. We have seen that there exist within art the option of pursuing beauty, and also the option of pursuing aesthetics. For those who pursue aesthetics, beauty is but a fiction; for those pursuing beauty, aesthetics alone are shallow and violent. The same holds true for history—and time—as well.

Those who approach history and time aesthetically, approach time within the context of physics. At first glance it seems natural enough to associate history with time and time with physics. Time is thus understood to be the measure of motion in the physical world. But that measuring differs. For Newton time is an independent, absolute, continuum, for Kant it is a mental category; for Einstein it exists within a space-time continuum, for Heisenberg it is comprised of momentary events or *quanta*. In each case, this understanding of time bifurcates into the physical and the mental, or as Kant put it: between the phenomenal and the noumenal. It centers on the idea of motion as a perceived event, or sequence of events, in the context of the physical world. Shared is a notion of historicism, be it absolute, relative, or based on chance.

As Newton puts it:

I do not define time, space, place, and motion as being well know to all. Only I must observe that the vulgar conceive those quantities under no other notions but from the relations they bear to sensible objects. And thence arise certain prejudices, for the removing of which, it will be convenient to distinguish them into absolute and relative, true and apparent, mathematical and common.[1]

Newton conceives of time, space, place, and motion as quantities (rather than qualities); or as he puts it elsewhere:

> The qualities of bodies, which *admit neither intensification nor remission of degrees,* and which are found to belong to all bodies within the reach of our experiments, are to be esteemed the universal qualities of all bodies whatsoever.[2]

Newton thereby posits a quantitive-quality just as Kant later posits an aesthetic-beauty. Both language and thought thereby become blind to objective purpose. What these different measurings of time share is that each is existential; it is *kronos*, or time, without *kairos*, purpose or quality. Time is merely *becoming,* gravity is understood as power, and it rather than love, drives the world. Newton makes clear his deist position without exposing himself to condemnation:

> Gravity must be caused by an agent acting constantly according to certain laws, but whether this agent be material or immaterial I have left to the consideration of my readers.[3]

From this quantitive perspective history marks the perceived passage of physical time, and the history of art and culture is the record of objects or events experienced. Not only are works of art seen to be time and place specific, their meaning is time and place specific as well. That specificity is linked to worldviews, or, worldmaking. For Newton time is absolute, and historicist, in which purposeless natural agents drive a meaningless world; for Kant time is a mental category and the world as understood is contingent to our perceptions; for Heisenberg the conflicts between the two, so vexing to Einstein, are resolved by a world comprised of indeterminate momentary events. For each of these worldviews an ethical position is mandated.

Within this context, our attempts to historically understand art center on an effort to recognize the relationship of the phenomenon of art with its noumenon. But this approach is clearly Aristotelian and Conceptualist, resulting in an aesthetic vision which *a priori* historicizes history and which permits no purpose or beauty to *be.* It denies meaningful time or *kairos.* It denies a purposeful context.

The association of time and history with aesthetics, with fact, feeling, and rationalization, is so commonplace today as to seem inevitable. But close inspection reveals a fundamental confusion. That inspection makes clear that the association of time and history with physics makes little sense and is culturally and politically devastating.

Consider this: those who associate time with physics differ in how they understand history. The nature of history cannot be absolute for Newton, a mental construct Kant, determinate for Marx, and indeterminate for Heisenberg—without requiring that our understanding of both history and reality be radically incoherent. Indeed, if such a requirement of conceptual incoherence be granted (and such a concession could be nothing more than willful), the result is a denial of the possibility of taking seriously any attempt

to understand time— or history. This assumed inability to understand time or history presents then an existential understanding of history and time. Since existentialism denies meaning or purpose, we go from tragedy to farce—where as Nietzsche put it, we become so empty that we cannot even manage to have contempt for ourselves.

Since our attempt to understand history depends on our understanding of time, when time is associated with physics—when it is aestheticized—it can be understood differently. Since time then lacks purpose, those differences cannot be understood at all. This is not an esoteric issue with little impact on our lives. Within an aestheticized physics of time, neither time nor history makes much sense. When history makes little sense, our lives make little sense.

History is naturally associated with time, but for those who pursue beauty, it is also associated with purpose; history is reconciled with that which some-how transcends time. When time (or *kronos*) strives for transcendent purpose, when *becoming* seeks *being*, it is associated with beautiful time (or *kairos*) where time and life are filled with meaning. Those who seek beauty view history as the pursuit of wisdom, and life as the practical application of that wisdom. They might differ on whether the *being* sought exists beyond the realm of time (Plato), or whether *being* can be reconciled with *becoming*, (Augustine); and they might differ as to whether that reconciliation is to be pursued via an illuminating fulfillment of *being* (Plato and Augustine) or a willful adherence to *being* (Pseudo-Dionysius Areopagite—or in the East, Lao-tzu). But they remain committed to a subjective pursuit of objective *be-ing* via time, and hence, to a timely realization of timeless beauty and ethics.

What they commonly reject, however, is that *being* is *becoming*. In the pursuit of beauty they reject the aesthetic vision of Postmodernism in which the goal is to assume a subjective-objectivity. That Postmodernist vision is historicist, and as such views history just as it views aesthetics—and ethics. As previously discussed, the term *gustibus non disputandum* (that there is no disputing taste), can be viewed in two distinct ways. Either aesthetic taste is indifferent, or aesthetic taste is a matter of non-negotiable identity. As Newton introduced the idea of time both historicist and absolute, these two options equally apply to our understanding of culture. Historicism can refer to a Kantian trivialization of history or a reduction of history to a Hegelian/Marxist abso-lutist determinism.

We have already discussed Plato's understanding of history as the moving image of eternity, and Augustine's understanding of history as a progressive record of those seeking goodness and the sad failure of those who choose not to do so. And we have differentiated Plato's and Augustine's illuminating fulfillment of *being* from the Pseudo Dionysius Areopagite's focus on a willful choice to embrace *being,* or not. They stand in contrast to Kant's reduction of *being* as that which cannot be known, and to Heidegger's brutalization of

being as *becoming* made manifest as an act of the quantum will. For those who feel fatigued by a consideration of such seemingly abstruse matters, a reminder is useful: the record of the practical results of the various Postmodernist movements in the twentieth century is one of bloody violence on an unprecedented scale. The choice between aesthetics and beauty is profoundly consequential.

So where the pursuit of transcendent beauty occurs, history is the record of life aspiring to meaning, to purpose, and therefore to responsible freedom. Freedom is manifest in the attempt to embrace a meaningful reality, and within the specific parameters established by the Classical and Judeo-Christian core of Western culture, that attempt permits free and responsible conversation in the analysis of evidence. Time is elevated to *kairos*, and filled with meaning. Lacking that end and those means, we are condemned to a brutal aesthetic meaninglessness where time is *kronos*, a purposeless realm be it a matter of chance, an aesthetic construct, or power.

Beauty and understanding are realized as we strive to rise above the factual, as metaphysics is glimpsed as we rise above the physical. When denied the prospect of beautiful time (*kairos*), aesthetics (*kronos*) does not avoid metaphysics, rather it brutalizes it. That brutality can be transcended by a timely pursuit of benevolent *being* existing beyond time. *Becoming* makes real the attempt to embrace *being* as an act of love.

But those who view history as a subjective-objectivity, as an aesthetic construct and experience, combine *being* and *becoming*. They thereby view history as the pursuit of self-expression and self-realization. In this context, Kant considers history to be a construct of the mind; Hegel, Marx, and Nietzsche see history as the product of existential power. Once again there is the distinction between those who do not believe that some knowledge of reality can occur (Kant) and those who do by equating reality with existential experience —and power (Hegel, Marx, Nietzsche). In the pursuit of aesthetics, all agree that the goal of life is to construct meaning and in so doing to obtain an assumed existentialist freedom of self-expression and self-realization. Freedom is then associated with creativity, with *becoming*, with a realization of our ability to be world-makers. It is an aesthetic vision where history is defined by physics rather than metaphysics, facts and feelings rather than purpose. To this view the world and life are not qualitative, but quantitative. The Postmodern *quanta* apply to both physics and ethics: it is the will to power that is supreme. In a quantum universe both physics and ethics lack beauty; it is to assume an amoral and violent society and universe—as an act of faith. As Frederick Copleston explains:

> If Nietzsche is prepared to apply his view of truth to alleged eternal truths, he must obviously apply it *a fortiori* to scientific hypotheses. The atomic theory, for example, is fictional in character; that is to say, it is a schema imposed on phenomena by the

scientist with a view to mastery...the atom, considered as an entity, a seat of force, is a symbol invented by the scientist, a mental projection.

However, if we presuppose the fictional character of the atomic theory, we can go on to say that *every atom is a quantum of energy or, better, of the Will to Power.* (Italics added) [4]

A God of Love is replaced by a God of Power, whose will (ovrs) shall be done. That will to power is then viewed in terms of empirical fact and rationalized feeling, reflecting race, gender, and economic class, or the unfettered will of the individual. It might be tempered by legality, custom, or claims of social contract, but the will to power remains the essence of *being*. *Being* is then *becoming*, and thus purpose and ethics are denied. We are then masters of a random universe; the immanent wills of humanity replace the transcendent *Will* and *Being* of God. But the singular or collective immanent will is not really free, and it is not that deity is avoided, but rather, that a self-deification has occurred. It is not that sectarian violence has been averted, but rather, that a pseudo-secular violence is mandated. It is mandated because within a quantum universe of competing wills there is no possibility of justice, love, or beauty.

This results in a violent confusion. That both time and history are in a state of confusion is problematic enough, but beyond that confusion lurks a far greater problem. Differences can be analyzed but self-contradictions defy analysis. They can indicate confusion or worse. The contradiction to which I am referring is that those who associate time with physics attempt to kill time. They have come to nihilistically posit the end of time, of history, art, science, and of meaning.

As noted above, the Postmodernist Martin Heidegger argues that human *being* involves facticity, existentiality, and forfeiture; we exist in the world, but as part of a process of shaping the world, and in so doing we are lost to the world. This self-negating and therefore anxious process culminates in a conscious awareness of death—which marks the ultimate authenticity of human *being*. Since for Heidegger *being* is grounded in time—and thus *being* is actually *becoming*—then the most authentic experience of human being is realized in the unity of both being and time—via death.

This vision is echoed by Francis Fukuyama in his book, The *End of History and the Last Man* (2002). He makes the argument that contemporary Western culture, Liberal and Capitalist, is the final endgame of history. History, and by extension time and culture, have ended. As he states his position:

> I argued that liberal democracy may constitute the "end point of mankind's ideological evolution" and the "final form of human government," and as such constituted the "end of history."...
> ...what I suggested had come to an end was not the occurrence of events, even large and grave events, but History: that is, history understood as a single, coherent, evolutionary process, when taking into account the experience of all peoples in all times.
> ...I arrive at [this conclusion] for two separate reasons. One has to do with economics, and the other has to do with what is termed the "struggle for recognition."[5]

This premise is much more than idle intellectual speculation. It is in fact religious advocacy. It is religious in that it is part and parcel to the notion of the *Eschaton*, the study of the end of things. In positing the end of history Fukuyama posits a specific eschatology—and ethics. The ethical position is one appalling to both Augustine and Dante: it is posited that self-realization and self-expression, coupled with the fulfillment of our appetites, have lead to our alleged current political and cultural utopia. The tragedy is that any earthly utopianism is totalitarian; the farce is that the symbols of this utopianism, where the transcendent is now immanent—is manifested by us. We are *being* and *becoming* joined. We are divine without hope of resurrection—therefore we celebrate both narcissism and death.

For those aware of the implications of an aesthetic vision of reality and life the shift from a physics of time to a metaphysics marking the end of time reveals a dreadful nihilism. It is a nihilism that is informed by a narcissistic yet empty self-deification. Rather than a blossoming of the aesthetic paradigm of self-expression and self-realization, central to the entire Modernist-Postmodernist tradition, the end of history indicates the failure and folly of the aesthetic project of the Enlightenment. Nietzsche's and Heidegger's position is affirmed; aesthetic self-expression and self-realization is completed in a self-deification, but that self-deification results in a nihilistic farce. It culminates in a celebration of what Derrida called the gift of death. By sacrificing ourselves to *becoming*, we become authentic. But such sacrifice negates authenticity, and is thus *un-becoming*. Nihilism is thus neither ethical nor unethical—but if that is the case, then ethics, like life, is denied.

The association of the end of history with the end of the world is addressed in traditional Christian thought. The conclusion is that by embracing—but not becoming—benevolent *Being*, both time and death are denied. In his essay *On Narcissism*, Sigmund Freud also discusses the end of the world, but he sees a connection between it, what is here referred to as constructivism, and narcissism:

> The question arises: What is the fate of the libido when withdrawn from external objects in schizophrenia? ...The libido withdrawn from the outer world has been directed on to the ego, giving rise to a state which we may call *narcissism*...
> [In narcissism] we find characteristics which, if they occurred singly, might be put down to megalomania: an over-estimation of the power of wishes and mental processes, the *omnipotence of thoughts*, a belief in the magical virtue of words, and a method of dealing with the outer world—the art of *magic*—which appears to be a logical application of these grandiose premises...
> The highest form of development of which object-libido is capable is seen in the state of being in love, when the subject seems to yield up his whole personality in favor of object-cathexis; while we have the opposite condition in the paranoiac's phantasy (or self-perception) of the *end of the world*.[6]

The theme of a nihilistic death of history is repeated in the history of Modernist and Postmodernist art. For example, the American Abstract Expressionist artist Ad Reinhardt (1913-1967) believed that painting had reached an end of its own history. In an essay entitled "Art as Art" (1962) he wrote:

> The one thing to say about art is that it is one thing. Art is art-as-art and everything else is everything else. Art-as-art is nothing but art. Art is not what is not art...
>
> The one subject of a hundred years of modern art is that awareness of art of itself, of art preoccupied with its own process and means, with its own identity and distinction, art concerned with its own unique statement, art conscious of its own evolution and history and destiny, toward its own freedom, its own dignity, its own essence, its own reason, its own morality and its own conscience...
>
> The one intention of the word 'aesthetics' of the eighteenth century is to isolate the art experience from other things...The one meaning in art-as-art, past or present, is art meaning. When an art object is separated from its original time and place and use and is moved into the art museum, it gets emptied and purified of all its meanings except one...No one in his right mind goes to an art museum to worship anything but art, or to learn about anything else.
>
> The one history of painting progresses from the painting of a variety of ideas with a variety of subjects and objects, to one idea with a variety of subjects and objects, to one subject with a variety of objects, to one object with a variety of subjects, then to one object with one subject, to one object with no subject, and to one subject with no object, then to the idea of no object and no subject and no variety at all.[7]

In reading this essay it is useful to simply substitute variations of the word *myself* for *art,* and the word *culture* for *painting.* It resonates with the nihilistic eschaton of Postmodernity. Art, history, and life are meaningless *quanta.*

It is worth repeating that it was not until 1750 that Alexander Baumgarten coined the term aesthetic in his book *Aesthetica.* The coining of the new term aesthetic coincided with the birth of a new Enlightenment and indeed of a new metaphysics. But it was an attempt at murder as well. Not murder as a violent physical act, but murder as an attempt to destroy. What was marked for destruction by the introduction of Aesthetics? As noted above, Barnett Newman states that the goal of Modernity is to destroy Beauty. And with the attempted destruction of beauty comes the attempted destruction of memory, of understanding, of purposeful history, and of the self.

The theme of the book *The End of History and the Last Man* is a concise *summa* of the Modernist-Postmodernist tradition. As such it is comfortable for the aesthetic minded. It posits a self-satisfied eschatology where paradise is found and is manifest in—us. A subjective-objectivity is deemed the final solution; we have *become being.* But when we immanentize the transcendent[8] a fetish results since that is what an immanentized symbol of transcendence must be. However self-satisfying it might appear, the subjectivist, the immanentist, cannot escape the consequences of pride. The End of History may indeed be an endgame, but not in the positive sense presumed. It marks the endgame of Modernism and Postmodernism, and of its aesthetic vision of

time and life. It marks the endgame of an immanentized eschatology that is essentially narcissistic and nihilistic. It is the endgame of aesthetics, but beauty remains the remedy.

For culture to exist, a struggle for recognition and economic success is not enough. To transform egoism into virtue and appetite into goodness is to descend into barbarism, however aesthetically seductive it might appear. How might we avoid the dreadful consequences of attempting to satisfy purpose-less pleasures and appetites, a violent and narcissistic consumerism devolved into an empty hedonism? By having a worthy object of love. As Augustine puts it in his book, *The City of God* (19: 24):

> "A people is an assemblage of reasonable beings bound together by a common agreement as to the objects of their love."

Augustine notes that happiness is not found in loving what is bad, nor in loving but lacking what is good; rather, he speaks of happiness as consisting in loving and having what is good. Determining what that good is necessitates conversation, but it is a conversation of which the aesthetic view cannot speak. It is beyond its ken.

So the choice is clear: the association of history with beauty depends upon a transcendent and objective metaphysics, upon the assumption that there is an objective yet difficult to discern purpose to reality and life that should be sought. In contrast, an aesthetics of history is limited by physics, where if purpose exists at all, then it is limited to a mandated purposeless self-expression and self-realization. The shift from a qualitative to a quantitative world concludes in a physics of time where the *quanta*, the will to power, prevails in science, ethics, and art.

To put it differently, time is now commonly associated with physics and physics permits but an aesthetic vision of reality and life. But history is purposeful in its pursuit of understanding and beauty. Physics may provide positivistic facts, but the attempt to understand those facts is beyond physics, or rather, is metaphysical. Attempts to make sense of the world and life go beyond aesthetics and by varying degree enter into the realm of beauty.

For the sake of clarity it is worth emphasizing what even Immanuel Kant noted: that the most jejune collection of facts constitutes a deliberate attempt to understand the world. The attempt to understand any set of phenomena is an attempt to accurately understand how and why those phenomena occur or fit together. Such an understanding is more than a matter of physical fact. It requires a pursuit and advocacy of metaphysics.

To present as fact that the apple falls because of gravity or that Monet was an Impressionist, is not to provide an explanation of gravity or of Impressionism. It provides a factual account of what has happened, but neither a narrative nor an explanation, of what has happened. Physical properties such as gravity

may exist because the universe is an accident, a machine, an organism, or as Dante noted in his *Divine Comedy*, as a manifestation of Divine Love. Dante and Monet differ as to which of these explanations is plausible. So too is the case with history. To the point, Dante and Monet can agree neither on the meaning of art, nor the meaning of history, ethics, or time. Therefore, Monet and Dante cannot both be right about the meaning of reality, art, or history. A choice must be made to avoid total confusion. What then can we believe?

That type of question confuses those who view time as the measure of motion in the physical world. For them the facts of Dante occur in one time, the facts of Impressionism occur in another. Time and history are mental constructs, and the facts used in such quantum constructions have no meaningful and shared context. But nonetheless, both Dante and Monet attempt to explain reality and life. Both attempt to provide an audience with a metaphysical reckoning of reality and life. Which (if either) of those explanations we accept concerning the nature of reality and life will affect our acceptance of which works of art and historical narratives are worthy of belief. They will fundamentally affect how we choose to live our lives.

The determination of whether we find Monet or Dante more compelling concerning the nature of gravity, time, and life, marks a value judgment, a determination of which metaphysical claim is better. To deny that Impressionism makes a metaphysical claim is to claim that such paintings have no meaning and that we engage in no conscious evaluation process when viewing them. To do so is to embrace an apostasy of the intellect; if in fact such an empty embrace is all that Impressionism offers, then what is established is the superficiality rather than the absence of Impressionist metaphysics.

This affirms conscious decision making as a fundamental characteristic of human nature. It affirms the importance of our making daily value judgments in art, culture, and life. Whether one refers to Augustine or Descartes, none can effectively deny that they think and live. Therefore the metaphysical attempt to discern meaning in art and life is inescapably a human freedom and a human responsibility. Since aesthetics attempts to deny the possibility of such value judgments, it should therefore be recognized as fallacious and inhumane.

The attempt to understand any set of facts is an attempt to accurately understand how and why those phenomena fit together. Such an understanding is more than a matter of physical fact. It requires the pursuit of metaphysics, and it entails taking a religious position as well. To say that an apple falls because of gravity does not really tell us much, since the fact that it falls does not explain why it falls. Similarly, the association of memory and time with physics does not so much deny metaphysics; rather it requires that we settle for a superficial metaphysics—and religion.

So the attempt to understand physics necessarily involves entering into the realm of metaphysics, and once metaphysics is pursued then its conclusions are religious. Metaphysics is the pursuit of meaning, and religion consists of

our conclusions about the existence of such meaning. The issues of memory and time in culture, art history, and indeed life, are essentially religious issues. Both Monet and Dante are religious proponents —it is just the substance and depth of their religiosity that differ. Those differences occur in but two general ways.

Approaches to religion can be divided into two broad categories: the pursuit of aesthetics or the pursuit of beauty. Which approaches can be called aesthetic and which beautiful? It is helpful first to remember how the meaning of those terms. Aesthetics refers to sensation and emotional response whereas beauty refers to perfection in a purposeful world, and the splendor of wisdom. Aesthetics is non-cognitive, whereas the pursuit of beauty aspires to some significant degree of cognition, of understanding being, of ontology. Aesthetics refers to physics, to the realm of fact and feeling. Beauty refers to metaphysics, to the attempt to understand reality and life. The difference between aesthetics and beauty was once widely recognized, just as was the distinction between fact and truth. Today that distinction is blurred, and when blurred, a shallow aesthetics prevails.

Distinct Historical Lineages: Beauty or Aesthetics

We can mark the beginning of what was until recently known as Western Culture as the point at which two distinct traditions begin to join hands: the Judeo-Christian and the Classicism of Plato. Shared by each is the centrality of the self-conscious attempt to comprehend an object; of a self-conscious humanity attempting to understand reality and life, and the need and ability to do so conversationally. In this regard neither is unique; numerous cultures around the world attempt to do the same. What is noteworthy, however, is the optimistic realism of the Western tradition. Within that tradition it is historically accepted that the world (*being*) is rightly beautiful and to some precious degree intelligible. Consequently responsible freedom, as manifested by freedom of conscience, and the pursuit of the True, Good, and Beautiful is prized.

The reasons for why that optimistic realism is accepted provide the narrative of Western culture. The recognized gap between the self-conscious inquirer and the meaningful object denies the poverty of obscurantism and the arrogance of self-deification; and the prospect of bridging that gap makes real the possibility of responsible freedom and makes practical the pursuit of wisdom and beauty.

Both the Classicism of Plato, and the Judeo-Christian tradition, are committed to seeking knowledge of that which is true and good; they both believe that reality is beautiful and is infused with meaning. As discussed above, and as recognized by Aquinas and Kant alike, the assumption that the world is purposeful is as intellectually plausible as the assumption that the world lacks purpose. Beauty offers then as plausible a cosmology as does aesthetics. Since they are equally plausible to the human mind, then the choice offered by the

Platonic and Judeo-Christian traditions is at least as plausible as that offered by the Modernist- Postmodernist tradition. The hope for a meaningful and beautiful universe is at least as plausible as the despair that the universe is meaningless—and aesthetic.

Equal plausibility does not by necessity conclude in equal validity or desirability; and the choice between a meaningful, or a meaningless, cosmology can neither be reconciled nor avoided. It is between beauty and aesthetics that ultimately we must choose, but it is only beauty that permits culture, fine art, and scholarship to warrant a positive public voice. The pursuit of beauty is indeed a pursuit of wisdom, and that pursuit relishes the freedom that flourishes in the gap between the thinker and object. But whereas beauty assumes that beyond the thinking subject and its object there exists a higher objective purpose that provides comprehensive meaning, for the aesthetic mind there is no purpose beyond fact and feeling, self-expression and self-realization. And therein lies an antimony: the aesthetic mind rejects the correspondence theory of truth and beauty because it is assumedly results in willful mental constructs, but it advocates a cultural vision where all meaning is aesthetic and (de)constructivist. The aesthetic vision attempts to justify itself on the same grounds by which it rejects beauty. As such, it is a justification that is incoherently solipsistic, and thus, no justification at all.

To declare that since all cultures are aesthetic, claims to beauty must be aesthetic as well is not much of an argument. Nonetheless, it is a common argument today. What is ignored is that beauty offers a fundamentally different way of approaching culture, art, and life. Beauty centers on the pursuit of meaning whereas aesthetics centers on the pursuit of epistemology; we either discuss reality, life, and art, or we discuss theories of knowledge of reality, life, and art. We either pursue beauty or aesthetics, ontology or epistemology.

The aesthetic mind presumes that the notion of an intellectually bridgeable gap between knower and object makes no sense—the two are (con)fused by an empathetic subjective-objectivity. It denies the possibility of discerning glimpses of Truth, Goodness and Beauty, even while *Being* remains ineffable. Instead, we dwell upon a subjective-objectivity comprised of facts, emotions, and (de)constructivism. We ought then to focus on epistemology rather than wisdom, aesthetic theories and facts rather than beauty. We focus not on Art or Life or Truth, but rather on theories of art, life, and truth, or power. When the primary question is epistemological, then our primary concern is: "How can we know what we think we know?"

In contrast, Plato and Augustine attempt to talk about reality, and accept that the gap between subject and object can to some degree consciously be bridged; the conscious attempt to comprehend the world is clearly possible since the self-conscious mind recognizes the objective existence of reality. None can doubt that they think and live. In this pursuit of knowledge the focus is on degrees of wisdom rather than epistemological certainty; we focus on

reality rather than theory. Instead of merely distinguishing fact from fiction, or attempting to rise from doubt to Dogma, we accept the pursuit of truth and wisdom confident in our task and humble in our conclusions. As Copleston puts it, Augustine advises that we:

> ...reach out to an object greater than [ourselves], an object which can bring peace and happiness, and knowledge of that object is an essential condition of its attainment; but he sees knowledge in function of an end, beatitude...
>
> It would be a mistake to think that Augustine was preoccupied with the question, 'Can we attain certainty?' As we shall see shortly, he did answer this question, but the question that occupied his attention in the mature period of his thought was rather this, 'How is it that we can attain certainty?'[9]

It is the confident pursuit of the ideal that affirms the unity of philosophy and theology, and of fact and value. In the passionate pursuit of wisdom and beauty, philosophy and theology are not separate. They are united by the common quest for Truth, and they are united by the pursuit of *being* and how *being* refers to *becoming*. Therefore, in a meaningful world no meaningful distinction between philosophy and theology truly exists: each is seeking knowledge of reality, and as such, each is complementary of the other. We noted above that the aesthetic mind rejects the correspondence theory of truth and beauty because it is assumedly a mental construct, but then advocates a cultural vision where all meaning is aesthetic and constructivist. There is yet another irony: the aesthetic mind purportedly separates philosophy and theology—but then merges them via a subjective aestheticism. The theology of the aesthetic mind is relativism. Both truth and reality becomes the product of the human mind or experience, but it is not a product of a secular vision. It is one of self-deification.

Historically, the interaction between Platonic analysis and Biblical exegesis is pursued by both Jewish and Christian thinkers; it is an exegesis that attempts to explain reality and life via a rational attempt to comprehend the world, life, and Scripture. But it is a rationality that is neither formalistic nor deontological. Augustine avoids pursuing a formal system of rationality, which would be subject to deconstruction. As Copleston explains,

> ...the Augustinian tradition is not faced by a complete system to be accepted, rejected or mutilated: he is faced by an approach, an inspiration, certain basic ideas which are capable of considerable development. [10]

Those basic ideas include the following primary principles: (1) that the universe is purposeful, (2) that Truth is ineffable, but that (3) some degree of insight is possible and achieved via serious and active dialogue. These basic principles are found in both the Judeo-Christian tradition and in Classicism. To those first principles, the following existential principles are included: (1) none can doubt that they live and think and aspire to understand, (2) that the

object of our understanding is the source of purpose in the universe, and that some degree of knowledge of that purpose is necessary for happiness, (3) that in the pursuit of wisdom one attempts to rise from fact to understanding, from the material and mundane to wisdom. Augustine declares that we exist between sense below and benevolent *Being*, and from the realm of aesthetics one should strive to rise to obtain a beatific vision, a glimpse of the intelligible beauty of the Divine.

So Augustine accepts the pursuit of beauty, of that which is true and good, as the inescapable privilege of self-conscious beings. He accepts foundational principles that are rationally and experientially irrefutable (e.g., *Si fallor sum*) not as the result of conceptualist logic, but rather as a result of intellectual illumination. The mathematical proof that 2 plus 2 is 4 requires no logical proof. It is a matter of intuition and intellectual illumination for which there is obvious corroborating evidence. There is then no necessary conflict between reason and faith; given that the world is purposeful (which is rationally and experientially defendable), then knowledge of that purpose is the supreme goal. Sense knowledge is important but most superficial; understanding is rational and most supreme; there is no dichotomy between the two.

This Platonic and Augustinian lineage continues into the fifth century AD with the work of the Pseudo Dionysius Areopagite. As discussed above, the writer of the text *The Divine Names and Mystical Theology* explains that to claim to understand Truth is to play God since the finite cannot comprehend the infinite; but to claim to deny Truth is to play God yet again by assuming that purpose is subjective. However, since reality is perfection, we can cautiously associate via a positive manner Goodness and Wisdom as Divine attributes which occur to varying degrees in creation; God is then both Goodness and Beauty. Via a negative manner, we must recognize, however, that Divine attributes such as Goodness, Wisdom and Beauty cannot be fully comprehended by limited human intelligence. It is our inability to do so perfectly which distinguishes us from God. It is our ability to partially do so which nonetheless unites us with God, and makes real the notion of responsible freedom. So we attempt to imitate that which is beyond imitation, not as a puerile effort, but rather, as an effort to increasingly embrace a numinous *being*, to rise from aesthetics to beauty, from error to a numinous realism.

Up to this point the mainstream of Western Culture agrees that there is no distinction between philosophy and theology, since both pursue Truth. The pursuit of Truth makes possible responsible freedom, love, and beauty. But a distinction between philosophy and theology had indeed been earlier introduced by Aristotle. A separating of philosophy and theology occurs when aesthetics is seen as distinct from beauty.

As discussed earlier, the Aristotelian assumption that matter and the ideal are complementary requires that the archetypal ideal must be rationally reconciled with matter. It is no longer a matter of determining to what degree we

have risen from aesthetics to beauty; rather, it is the matter of physical perfection and moral beauty that marks a distinction found in the conceptualism of Abelard's Scholasticism, where truth exists in the mind of God and/or in the mind of humanity, to Descartes, and to Kant, where there has been a gradual decline from beauty towards a meaningless aesthetics.[11]

In contrast is the alternative tradition, long neglected or abused. Plato's attempt to comprehend a meaningful world caused him to distrust aesthetics but to value beauty. Although he was suspicious of *doxa* as a viable alternative to ignorance and skepticism, he nonetheless recognized its importance as a middle step in the practical pursuit of wisdom. Similarly, Augustine accepted that the pursuit of wisdom is one of illumination. The human mind is moved to comprehend to some degree the purpose of a purposeful reality and life. And Augustine affirms aesthetics, but only as a step on the rise towards beauty. So it is not that aesthetics is denied, but rather that it is recognized as being elementary and base. It occurs at the lowest level of comprehension and the lowest level of reality and life. The shift from fact to understanding, from power to culture, is one from mere aesthetics, to beauty. For Augustine the gap between base aesthetics and transcendent Divine truth is bridged by the Incarnation where aesthetics is made numinous.

The Aristotelian penchant for aesthetics, and for distinguishing philosophy from theology and art from ethics, was criticized by those of the Platonist and Augustinian tradition; but in attacking the Aristotelian logic employed by the Scholastics, the Augustinian tradition aided the empiricists and mystics who would later turn on them as well.

As discussed above, the paradox is that the aestheticization of the Augustinian tradition itself was advanced by its rejection of Scholastic rationalism. Both Reformation and Counter-reformation cultures increasingly turn their backs on the traditional notions of a qualitative or numinous world and life discernable via an experiential rationalism. Both contributed to a turn from seeking intelligible Beauty, to an aesthetic dichotomy where natural fact and Scripture, coexist with feeling. That remnant dedicated to the pursuit of beauty made a noble stand in the Victorianism of the nineteenth century and includes today Evangelical Christians and some Jewish and Catholic communities of faith as well. But that stand can be undermined by its own aestheticism. When feeling begins as piety there is little to prevent it concluding in existentialism.

The consequence is a shallow and violent aesthetics that does not acknowledge a distinction between the subject and the object, between knowledge and power. It attempts to end meaningful conversation in search of knowledge of *being* as heroically established by Socrates within Classicism, and by the Book of Genesis' account of eating the fruit of knowledge in the Garden of Eden. It is now found in the contemporary aestheticization of many traditionally transcendental cultures. As previously discussed, Kierkegaard, Schopenhauer, Nietzsche, and Blavatsky reinterpret the religious and philo-

sophical traditions of the West—and East. But they are not unique. There are now Modernist-Postmodernist forms of most traditions around the world. But its aesthetic gaze not only encroaches upon those traditions. By degree it destroys their optimism and our ability to believe in that optimism. It has withered Classicism and the Judeo-Christian tradition in the West, and Buddhism and Daoism in the East. That aestheticization goes beyond the fine arts and ethics, to our very understanding of space and time, and consequently of our memory and history. And it has resulted in confusion about the very notion of what the term Enlightenment means.

The pursuit of Enlightenment is now commonly associated with that cultural phenomenon which occurred in Western Europe in the early eighteenth century. But in contrast, say, to the Enlightenment sought by Augustinianism in the West, or by traditional Buddhism, the Enlightenment of eighteenth-century Europe is aesthetic, dedicated to the pursuit of fact, feelings, and power. As such, it is not very enlightening after all. From a Buddhist viewpoint Edward Conze explains:

> All the meaning that life may have derives from contact with the…spiritual world, and without such contact it ceases to be worth while, fruitful and invested with beauty….
>
> People at present can understand the difference between facts which exist and 'non-facts' which do not exist. But they believe that fact, if real, are all equally real, and that qualitative distinctions between them give no sense…
>
> At the time when Buddhism flourished, this would have seemed the height of absurdity. Also the leading European systems of that time, like those of Aristotle and Plotinus, took the hierarchy of levels of reality quite for granted, and were indeed entirely based upon it…contact with the higher degrees of reality entails a life which is qualitatively superior to one based on contact with the lower degrees.
>
> About this time [AD 1450] there began in Europe that estrangement from reality which is the starting point of most modern European philosophy. Epistemology took the place of ontology. In consequence, thinkers seek for 'successful fictions' and 'reality' has become a mere word.[12]

That aesthetic Enlightenment embraces nihilistic contradictions: in the Modernist pursuit of knowledge of reality such knowledge of reality is denied, in the denial of transcendence a self-deification occurs; in place of a crucified Christ [or objective Dharma] we crucify ourselves by obtaining authenticity without hope of redemption. We embrace death as the ultimate act of an authentic life. Being and time unite in nihilism.

Kant claims the nature of time to be an aesthetic construct grounded in the alleged structure of our minds. Correspondingly, so too is the case with history. Fine art and culture are then relegated to the realm of aesthetic experience, the work is to be aesthetically experienced and the meaning of the work of art is perspectival and subjective. The understanding of fine art is relative to our mind, and of that mind's organizing of time and place. But even if such mental structures exist, then saying that such structures provide a foundation

for evaluating our claims of knowledge and ethics fails. It is analogous to stating that the hardware and software of our computers determine the truthfulness of data and the meaning of *Being;* that epistemology determines ontology. That stands as an incoherent assertion. It states what it cannot claim to know: that a subjective-objectivity is objectively true.

Postmodernists such as Hegel, Marx, and Nietzsche agree that a work of art is to be aesthetically experienced, and such experience results in a type of knowledge that results from experience. They posit an existential knowledge based on an empathetic union of subject and object. But if what we know is the result of a subjective-objectivity then we are forced to embrace an alchemical and empty metaphysics. What is the content of that alchemical metaphysics of meaninglessness? In such an existential world we can only believe in a self-destructive empathy—be it fundamentalist, individualist, or based on race, gender, or economic class. A self-destructive empathy that leads to a nihilistic end of beauty—and meaning—in the world; with it, there is a denial of responsible freedom.

The contradictions inherent to the European Enlightenment are worth reflecting on. Dedicated to the elimination of superstition, ignorance, and religion, the Enlightenment comes to a nihilistic and ironic religious conclusion: reality is conceptualized as an aesthetic construction or experience. A major proponent of the Enlightenment, Immanuel Kant, declares that the *ding an sich*, the thing in itself, cannot be known. If reality cannot be known, then what of art, science, and civilization? In place of the traditional denial of pride in the pursuit of truth, here a prideful skepticism denies the possibility of seeking truth, and purports to be humble. Culture becomes an aesthetic phenomenon where understanding is reduced to a rationalized aesthetic taste, and remember—*gustibus non disputandum*—there is no disputing taste. That can be taken two ways: the Modernist trivialization of taste, or the Postmodernist demand that particular tastes be realized—and thus denied objective value.

To the point: the association of time, history, science, and culture with physics (or aesthetics) results in an empathetic fusion of the immanent and the transcendent. That fusion destroys *being-as-such*, and consequently, *being* is nowhere. It is not surprising then to find this development associated with the pursuit of an aestheticized heaven: Sir Thomas More coined the new term *utopia* to refer to a non-existent paradise. The search for utopia is now associated with the nothingness of meaningless *being*; however logically consistent, the result is dreadful.

But an eschatology that centers on self-expression and self-realization, and leads us to an immanent utopianism, provides no purpose via its eschatology. And since it confuses truth with power, then the content of that utopianism must be fundamentally narcissistic and violent. The empathetic unity of *being* and *becoming* denies *being* as an object of love; it makes real *kronos* rather than *kairos*, and thus *being = becoming = the gift of death.*[13]

The current End of History argument is part and parcel to that aesthetic tradition that runs from Abelard to Nietzsche via Kant, Hegel, and Marx. We construct a subjective-objective reality and life, and such constructs, such utopias, be they Liberal-Capitalist, Hegelian/Marxist Statist, or Nietzschean-Nihilist, conclude in an existentialist endgame. Each associates physics with time, and each posits a violently purposeless eschatology which denies beauty and lofty purpose.

As evidenced by Nietzsche, or later epigones such as Heidegger and Reinhardt, the Modernist-Postmodernist eschatology espoused is now orthodox. Wilhelm Worringer reveals this cultural paradigm in stating the primacy of an identity-based style in the pursuit of happiness, and declares it normative:

> Every style represented the maximum bestowal of happiness for the humanity that created it. This must become the supreme dogma of all objective [sic] consideration of the history of art.[14]

That aesthetic dogma is then an endgame of the foundational ideas of the Modernist-Postmodernist tradition. It is in fact locked into one very particular and peculiar historical viewpoint. In this way it serves a useful if unintended purpose. In exposing the multiple contradictions in the aesthetic vision we obtain a glimpse of the incoherence of the aesthetic Enlightenment of the West. In starting to understand that incoherence we start to rise above a physics of time and history to the realm of beauty.

The end of history, indeed of responsible inquiry and freedom includes the lamentation that science, fine art, and culture become mere caretaking tasks. Like the Scholasticism of the past, this new aesthetic Scholasticism now obtains. The tragedy is that culture and fine art are now viewed by many as entertainment, therapy, or propaganda. The comedy is that proponents of aesthetic scholasticism have fought for their own demise.

Lacking a hope for truth, goodness, and beauty, the alternative to irrelevancy is sociopathy. The caretakers of aesthetic culture are thereby anti-cultural. In a new book, *Our Posthuman Future*, Fukuyama now posits that time and history have recommenced due to a Nietzschean biotechnological manipulation of human genes. This presents him with a telling problem. Via Kantianism, Fukuyama notes that genetics provides the key to civilization: it provides the rational structures of the human mind that permit morality to exist. But what happens to that rational structure when genetics are manipulated by biotechnology? The objectivity of genetics and morality thus dissolve in a Nietzschean will to power. So history indeed continues, but still without purpose. It is an aestheticized history which leads to a Nietzschean conclusion where a re-occurring violence becomes the narrative of a Nietzschean and Darwinian universe. The *quanta* are expressions of the will to

power, but now those quanta operate within a biological context. The goal of a peaceable kingdom, depicted so often in art, is now judged a quaint triviality. Rather, truth is power, reality is the will, and the sociopath is the defender of culture.

But it is not so much that time and history have ended, or have seemed to have ended and then restarted. They have been foundationally and consistently viewed as Nietzschean constructs of the human will to power. For those who study history in the pursuit of wisdom the associations of the term will to power (particularly when associated with Darwinian eugenics) are obvious and evil.[15] The repeated utopian attempt to reconstruct and perfect humanity is foundational to the atrocities resulting from the aesthetic Enlightenment.

What then is the alternative? Culturally, the alternative begins with a pluralistic pursuit of beauty. The aesthetic assumption of a purposeless world is inadequate as an option for culture and civilization, since it privileges, and mandates, an existentialist void that is nihilistic. As such, aesthetics destroys the possibility of meaning, of knowledge, and of tolerance. The alternative is a free and diverse pursuit of beauty, where most differences of conclusion are tolerated. But tolerance does not require agreement in politics or culture. To aesthetically equate tolerance with agreement is totalitarian and therefore inhumane. To tolerate those who would destroy you is absurd.

The pursuit of beauty is not restricted to the provincial and incoherent efforts of the Modernist-Postmodernist tradition of eighteenth- to twentieth-century Europe. Indeed, those efforts unsuccessfully attempt to deny the very possibility of beauty. The pursuit of beauty is central to Western civilization, and remains as a viable universal cultural option to this day. In the pursuit of beauty, tolerance centers on the free pursuit of meaning and understanding of the world, it thus accepts a genuine diversity of belief. But the tolerance associated with the pursuit of beauty cannot tolerate nihilism or totalitarianism.

The attempt to comprehend our existence is now commonly limited by, and to, a reductionistic Existentialism; that viewpoint is the necessary result of an aesthetic worldview. That reductionistic aesthetics is one where the only objects of our self-consciousness are the individual self, or an extension of the self as it exists as a matter of empirical identity. Be it of the political Left or the Right, it is now often agreed that meaning is grounded in an existentialist vision limited to the individual or group will.

The seemingly wide array of contemporary Postmodern art is in fact uniformly contained within that dogmatically narrow aesthetic vision. An aesthetic of the will, of empirical identity, of utility, be it pursued singularly or in combination, results merely in variations on the same limited theme. As such, contemporary Postmodernists are but epigones of the major figures of the past such as Burke and Kant, Hegel and Marx, Kierkegaard and Nietzsche.

That theme is a world of fact and feeling, where reason is deontological or confused with tradition or power, and meaning is limited to mere existence. As in the case of Pollock and Newman that meaning evokes a self-conscious cry; as in the case with Lichtenstein and Warhol that cry becomes a parody, a cry of self-conscious mockery. In neither case do life and art inspire thought, knowledge, and love. The existentialism of Abstract Expressionism reduces meaning to silence, whereas the existentialism of Pop Art reduces that silence to parody. Neither can escape the self-consciousness of an aesthetic existentialism, nor can any other aesthetic vision, be it mechanistic, pantheist, or reduced to *quanta*.

In the pursuit of culture both scholarship and the fine arts have traditionally been dedicated to discerning what is true and good in reality and life. In Western culture, Classicism and the Judeo-Christian are the two traditions historically relied upon to provide such knowledge; in other cultures a wide variety of traditions have similar aspirations. However imperfectly, historically each has been dedicated to the pursuit of universal wisdom and beauty. Each has been cosmopolitan rather than multi-cultural and provincial in its goal. But more recently, each has been increasingly redefined, first by the aesthetic vision of Modernism, and later, via a Postmodern aesthetic. The Modernist-Postmodernist gaze withers all attempts to see beauty—and incoherently does so in the name of empathetic tolerance and identity. As such, intellectual attempts to comprehend the meaning and purpose of life are *a priori* denied, replaced by an assumed expression of personal or group - preference or identity. Beauty seeking traditions around the world have brutally been reduced to a matter of aesthetic taste, even by Modernist and Postmodernist proponents of traditions devoted to beauty.

The shortcomings of approaching meaning via aesthetic taste have been discussed throughout this text. The nexus is that aesthetic taste can variously be pursued but for no vital purpose. Scientism and emotivism, subjectivism and empirical identity, hedonism and utility, nostalgic or deterministic historicism, all evidence what appears to be a wide variety of choices but in fact offers but one: aesthetic taste. And that dogma of seeking meaning via an aesthetic vision cannot succeed. It cannot because a subjective-objectivity concludes in the death of history, science, art, and love. The aesthetic vision can see no objective meaning to reality and life.[16] It offers no object of which knowledge and love can be realized. It offers no hope.

The assumption that there cannot be any degree of objective insight concerning a purposeful universe is a perversely self-fulfilling prophecy. In the cultural realm of meaning, we tend not to seek that which we do not believe could exist. So the aesthetic mind lacks a self-conscious awareness of the possibility of beauty, and thereby lacks a desire to comprehend the cosmos. It is then a daunting task to get the aesthetic mind to escape its own limitations —it is asking the narcissist to become aware of and to love *the other*. By

definition, the narcissist must lack awareness that such a possibility exists, much less that it is desirable.

The aesthetic mind is trapped in what I have called elsewhere, an Empirical Scholasticism[17]; a Scholasticism that dogmatically denies the possibility of viewing the world and life via any other than an aesthetic perspective. It is the fulfillment of an Aristotelian based Scholasticism that has unfolded for centuries. It is not that proponents of Scholasticism intended this result. But ideas have consequences.

The attempt to understand reality and life is intrinsic to self-conscious beings, and it is a pursuit that is essential in establishing culture and fine art. Those who manage to doubt the aesthetic mind of contemporary Modernist-Postmodernist culture will be drawn to consider if any of the non-Modernist-Postmodernist cultural traditions of the world are compelling. In the West, the two historically primary traditions are Classical and Judeo-Christian.

However, those today who are willing to consider Classicism as a meaningful means by which to attempt to comprehend the world face significant obstacles. They must first overcome the Modernist/Postmodernist assumption that it is a sociological rather than cultural phenomenon; next they must overcome the assumptions of Neo-Classicism where a purposeful reality is no longer assumed; and finally they must come to terms with a Nietzschean Postmodern Classicism that neither Plato nor Aristotle would comprehend.

Alternatively, those Christians (or Jews) who embrace an aestheticized Christianity (or Judaism), have remained a vital culture influence. They have significantly advanced the continuing influence of Classical and Judeo-Christian belief, of the pursuit of beauty as advocated by Platonic and Augustinian thought. But they face distinct challenges. First, since they must interact with those who do not share their commitment to the authority of Christian tradition, and the factual accuracy of Scripture, they therefore face the problem of being considered a cult—and just one amongst an assumed many. Second, basing their faith upon scriptural authority or emotional commitment, they turn the authority of Scripture into a fetish, and they lack the means by which to proselytize or defend their beliefs from those who are indifferent or hostile.[18] Third, they face the secular Modernist-postmodernist challenge that the writing and the meaning of Scripture offers no authoritative object to be understood and loved, but rather are matters of personal or sociological taste and power. And lastly, they must face the Postmodernist existential challenge affirmed via Kierkegaard: if one identifies with a faith that is beyond comprehension, then even those who accept Scripture as authoritative cannot escape their faith slipping into a solipsistic self-consciousness, and therefore a self-deifying, mysticism.[19]

Both the Modernist aesthetics of tolerance and the Postmodernist aesthetics of identity are facets of a tradition that resists the possibility that any other traditions can be taken seriously. The Modernists claim that to privilege Clas-

sicism or Christianity (or Buddhism, or Confucianism...) is to commit an act of intolerance against other traditions. This ignores the fact that Modernism exclusively privileges relativism and a suspension of meaningful belief. Alternatively, Postmodernist relativism variously declares that the proponents of identity-based culture have the intrinsic right to embrace that identity—be they of a minority or a majority. But if our identity is based upon empirical categories such as race, gender, economic class, or the authority of tradition or Scripture, then our self-conscious freedom to comprehend the world no longer matters and is denied. To equate culture with empirical identity is to embrace a totalitarian mind. Tolerance was once understood as a subject accepting the presence of that object with which we disagree. But if identity is paramount, then tolerance requires agreement—the subject and object must be one. When tolerance requires agreement, it is no longer tolerant. Sympathy is replaced by empathy, and the tolerant self is destroyed.

As a product of self-conscious thought, culture is grounded in but not limited by human nature. It is human nature to think and choose, but it is a cultural responsibility to make choices that are meaningful. The historical norm has been that culture marks the attempt to comprehend the world and life – and as such is a matter of intellectual history and the pursuit of beauty, of the pursuit of knowledge of that which is true and good. In tracing the historical development of the foundations of Western culture, we find that one trend has been one from beauty to aesthetics, and it is a trend that concludes in a narcissistic violence relieved only by the banalities of pleasure and power. That trend is one resulting in a Postmodern conclusion which is likely to have been rejected entirely by the persons who contributed to its gradual dominance. It is inconceivable that Aristotle or Aquinas, Luther or Kant, would find acceptable the cultural conclusions of Postmodernism. Nonetheless, Postmodern ideas are the conclusion of a long historical lineage. It is not, however, the only possible lineage—or conclusion. There remains the possibility of beauty.

Notes

1. Alexandre Koyré, *From the Closed World to the Infinite Universe* (New York: Harper & Row, 1957),162.
2. Ibid., 173.
3. Ibid., 179.
4. Frederick Copleston *A History of Philosophy* (Garden City, NY: Image Books, 1985), Book Three, 411.
5. Francis Fukuyama, *The End of History and the Last Man* (New York: The Free Press, 1992), xii, ff. See also: John Horgan, the End of Science (Reading, MA: Addison-Wesley, 1996).
6. Mortimer Adler, Editor, *Great Books of the Western World. Freud* (Chicago: Encyclopedia Britannica, Inc., 1978), 399–400.
7. Charles Harrison and Paul Wood , *Art in Theory. 1900-1990* (Oxford: Blackwell Publishers, 1997), 806ff. This echoes not only Heidegger, but also Nelson Goodman's (Ways of Worldmaking) comments concerning philosophy shifting from the struc-

ture of reality, to the structure of thinking, to a diversity of right and even conflicting versions or worlds in the making.

8.　As discussed by Russell Kirk, *The Conservative Mind* (Chicago: Regnery Books, 1986), iv.

9.　Frederick Copleston, *A History of Philosophy, Medieval Philosophy* (Garden City, NY: Image Books, 1962), Vol. 2, 66ff.

10.　Ibid., 65.

11.　Frederick Copleston, *A History of Philosophy, Medieval Philosophy* (Garden City, NY: Image Books, 1962), Vol. 2, 21: "I have tried to make intelligible the general development of mediaeval philosophy from its early struggles, through its splendid maturity, to its eventual decline…The last phase was an inevitable phase and, in the long run, may be of benefit, as stimulating Scholastic philosophers to develop and establish their principles more firmly in face of criticism."

12.　Edward Conze, *Buddhist Thought in India* (Ann Arbor: University of Michigan Press, 1973), 24-5.

13.　Concerning the last, see: David Wills, translator, *Jacques Derrida, The Gift of Death* (Chicago: The University of Chicago Press, 1995).

14.　Michael Bullock, translator, *Wilhelm Worringer, Abstraction and Empathy* (Cleveland, OH: Meridian Books, 1967), 13.

15.　Peter Singer, discussed above, combines a hedonistic utilitarianism with a Nietzschean and Darwinian perspective which concludes in an advocacy of animal rights, euthanasia of the handicapped, and even bestiality. It is useful to note that the full original title of Darwin's famous text on evolution is now often left unmentioned: *On the Origin of Species by Means of Natural Selection, or the Preservation of Favoured Races in the Struggle for Life.* Both Darwin and Singer have been critiqued by me in a series of articles published in *American Outlook* magazine, previously cited. See also: Richard Weikart, *From Darwin to Hitler: Evolutionary Ethics, Eugenics, and Racism in Germany* (Palgrave Macmillan, 2005). For a critique of utopianism see Thomas Molnar, *Utopia: The Penennial Heresy* (New York: Rowman and Littlefield Publishers, Inc, 1990).

16.　The U.S. Supreme Court decision in Planned Parenthood of Southeastern Pa. v. Casey (1992) states: "At the heart of liberty is the right to define one's own concept of existence, of meaning, of the universe, and the mystery of human life…" Dissenters hold that this defines not liberty, but license; if mystery is controlling, then no rational justification for any values are possible—including those of the mystery decision.

17.　Arthur Pontynen, "A Winter Landscape: Reflections on the Theory and Practice of Art History." *Art Bulletin*, 1986.

18.　Copleston, *A History of Philosophy* (Garden City, NY, Image Books), Vol. 2, 27ff: "…as Christianity made fast its roots and grew, it aroused the suspicion and hostility, not merely of the Jews and the political authorities, but also of pagan intellectuals and writers…Some of the attacks leveled against Christianity…were delivered on the theoretical plane, on philosophical grounds, and these attacks had to be met…Thus while in Tertullian's eyes pagan philosophy was little more than the foolishness of this world, Clement of Alexandria regarded philosophy as a gift of God, a means of educating the pagan world…"

19.　As discussed previously, the Pseudo-Dionysius Areopagite affirmed negative theology to limit the arrogance of human reason, and he relied upon positive theology to deny personal egoism.

10

Conclusion: Subject, Object and Responsible Freedom in the Pursuit of Beauty

Beauty is central to the notion of culture, and the free pursuit of beauty is that which offers us the key to escaping the brutal limitations of the aesthetic mind. Within Western culture there are two primary and perennial approaches to the pursuit of beauty: the Platonic/Augustinian and the Aristotelian/Aquinian. As discussed in detail above, beauty is reduced to aesthetics via the Aristotelian distinction of perfection from moral goodness, a distinction later developed under Conceptualism and then advanced by an interpretation of Scholasticism. That interpretation of Scholasticism is consummated in the work of the empirical and emotivist Scholasticism of Kant and his epigones, particularly Nietzsche and Heidegger. There is a wide variety of tactics by which to advance an aesthetic worldview, but they all share a single and common aesthetic strategy. That strategy foundationally relies upon the purposeless metaphysics of existentialism. It centers on a subjective-objectivity where reason is reduced to a matter of taste and ultimately the will. Consequently reasonable conversation is replaced by sheer assertion or denial—be it ironic and detached or violently engaged.

It is not so much that the pursuit of objective truth and beauty had early been declared abandoned, and by decree replaced by a sheer subjectivism. That would be recognized and rejected as destructive and nihilistic. Rather they have gradually been aestheticized by positing an allegedly tolerant subjective-objectivity, and by its gradualism made to appear progressive and benevolent. It is the common idea of a subjective-objectivity that informs the Modernist and Postmodernist shift from beauty to aesthetics, but a subjective-objectivity makes no sense. It replaces humility and caution with an arrogant skepticism; its attempt to deny dogmatism simply masks a new - but nihilistic - dogmatism. The shift to aesthetics involves a shift to a subjective-objectivity that denies the objectivity of *Being*. As discussed above, if *Being* is denied as the touchstone of Scholasticism, then a purposeless truth exists in things and

in our minds. Newton advances the former idea, and Kant the later, by maintaining that the world as we understand it is an aesthetic product of our minds, and so too are ethics. The world is abstraction and a rationalized empathy. What Kant proposes, Nietzsche develops to its necessary conclusion: the world and ethics are existential, where empirical experience is truth. The world shifts then from a qualitative to a *quanta*-tative realm. Nietzsche recognizes that a subjective-objectivity in a purposeless world denies the reality of beauty, love, knowledge, and sympathy. Indeed, Nietzsche despises sympathy as an element of a slave mentality. What remains in a world of abstraction and empathy is a nihilistic will to power.

But historically, major cultural traditions around the world reject this notion of a subjective-objectivity. In the West traditional Classicism and the Judeo-Christian tradition do not accept this notion; each posits that there is an intellectual gap between subject and object, a gap that makes possible knowledge and responsible freedom. The goal is to obtain some degree of insight that sympathetically spans that gap. It is a goal that is not ideological, but cultural, in the sense that it is not the product of a culture but the means by which culture is to be sought. When we lose the distinction between subject and object, between empathy and sympathy, then the worldmakers appear. And the desire to make the world—and other people—conform to our will is intrinsically perverse and violently sadistic. It is then only the appearance of beauty, love and knowledge that remains, and the aesthetic face of such utopianism masks a brutalization of humanity. With the subtle shift from a subject seeking knowledge of the object (as an act of love), to a subjective-objectivity (as an act of human will), it is not only purpose or transcendence that are denied. It is objectivity itself, and with it freedom, reason, and love.

Self-consciousness is central to the human condition. The self-conscious subject seeking knowledge of the objective world is a rational endeavor. *Modernist rationality* aspires not to knowledge of reality and what purpose it contains. Rather, it asserts that reality conforms to the structures of our minds —and our wills. But if the structures of our minds, and our wills, determine meaning, then we engage in an empty and violent self-deification. Similarly, *Postmodernist rationality* seeks knowledge not of a purposeful reality, but of authentic existence. But when *being* is found in *becoming*, then *being and purpose,* no longer exist. And to be authentic without *being* consummates in a nihilistic death. The result of the aesthetic vision is authentic yet empty. Reason becomes contingent on the authority of the subject, of power, not the subject's ability to understand the object—a beautiful world and life. It thereby becomes a fetish and meaning fades away.

Nietzsche's contempt for Classicism and the Judeo-Christian tradition, and his view of reason as a mask for pleasure, are oddly affirmed by his contemporary Victorian (and aesthetic)[1] Christian apologist, Matthew Arnold. And there

is a touch of the tragic yet again. The Victorians valiantly attempted to continue the tradition of seeking beauty, but nonetheless were deeply affected by aestheticism. In his poem *Dover Beach* (1867) Arnold speaks of a melancholic sadness resulting from the declining influence of Classical and Christian belief in a materialistic age. As the lines of his poem make clear, he accepts the premise that Classicism and Christian faith are no longer in accord with human understanding and experience:

> The sea is calm to-night.
> The tide is full, the moon lies fair
> Upon the straits; -on the French coast the light
> Gleams and is gone; the cliffs of England stand,
> Glimmering and vast, out in the tranquil bay.
> Come to the window, sweet is the night air!
> Only, from the long line of spray
> Where the sea meets the moon-blanch'd land,
> Listen! you hear the grating roar
> Of pebbles which the waves draw back, and fling,
> At their return, up the high strand,
> Begin, and cease, and then again begin,
> With tremulous cadence slow, and bring
> The eternal note of sadness in.
>
> Sophocles long ago
> Heard it on the Aegean, and it brought
> Into his mind the turbid ebb and flow
> Of human misery; we
> Find also in the sound a thought,
> Hearing it by this distant northern sea.
>
> The Sea of Faith
> Was once, too, at the full, and round earth's shore
> Lay like the folds of a bright girdle furl'd.
> But now I only hear
> Its melancholy, long, withdrawing roar,
> Retreating, to the breath
> Of the night-wind, down the vast edges drear
> And naked shingles of the world.
>
> Ah, love, let us be true
> To one another! for the world, which seems
> To lie before us like a land of dreams,
> So various, so beautiful, so new,
> Hath really neither joy, nor love, nor light,
>
> Nor certitude, nor peace, nor help for pain;
> And we are here as on a darkling plain
> Swept with confused alarms of struggle and flight,
> Where ignorant armies clash by night

The Postmodernist poet Anthony Hecht mocks Arnold in his 1967 poem *Dover Bitch,* in which a materialistic and existentialist hedonism is presented as a response to the specter and reality of death:

> So there stood Matthew Arnold and this girl
> With the cliffs of England crumbling away behind them,
> And he said to her, 'Try to be true to me,
> And I'll do the same for you, for things are bad
> All over, etc., etc.'
> Well now, I knew this girl. It's true she had read
> Sophocles in a fairly good translation
> And caught that bitter allusion to the sea,
> But all the time he was talking she had in mind
> The notion of what his whiskers would feel like
> On the back of her neck. She told me later on
> That after a while she got to looking out
> At the lights across the channel, and really felt sad,
> Thinking of all the wine and enormous beds
> And blandishments in French and the perfumes.
> And then she got really angry. To have been brought
> All the way down from London, and then be addressed
> As a sort of mournful cosmic last resort
> Is really tough on a girl, and she was pretty.
> Anyway, she watched him pace the room
> And finger his watch-chain and seem to sweat a bit,
> And then she said one or two unprintable things.
> But you mustn't judge her by that. What I mean to say is,
> She's really all right. I still see her once in a while
> And she always treats me right. We have a drink
> And I give her a good time, and perhaps it's a year
> Before I see her again, but there she is,
> Running to fat, but dependable as they come.
> And sometimes I bring her a bottle of Nuit d' Amour.

Hecht attempts to mock what Arnold found tragic, but in doing so he mocks himself—and us. Both Arnold and Hecht share an aesthetic worldview, one nostalgic of beauty, the other showing a hostile indifference. Neither Arnold nor Hecht sought to understand beauty, so it was left unknown. The tragic remains, and as we shift from contemplations on the Dover Beach to (the subjective-objective) ruminations by and of the Dover Bitch, we slip into an existentialist coarseness and an unctuousl patronizing, one without genuine hope, or love, or even sympathy. None is granted by or to the Dover Bitch, but unlike Laocoön, none is warranted. This rebirth of tragedy is then trivialized, and in its trivialization an attempt is made at comedy. But it is a dark comedy of which the joke is still on us.

The idea of a subjective-objectivity is an aesthetic one. As such it indirectly denies beauty and knowledge by substituting skepticism for a cautious pursuit of truth, mere assertion for informed opinion (*doxa*). Denied is the path

which leads to what Augustine calls illumination, to increasing degrees of insight, however imperfect. A variety of writers have been cited above who address the results of a subjective-objectivity. The post-modern art historian Wilhelm Worringer represents the Nietzschean position and praises it in his book *Abstraction and Empathy*. But there are those who dissent by holding that a subjective-objectivity is destructive. As discussed above, it marks a sociopathic narcissism which is alchemical (Molnar), sadistic (Freud, Chasseguet-Smirgel) and indicates a primordial violence (Milbank). In immanentizing the religious symbols of transcendence (Voegelin) the aesthetic vision embraces a self-divinization which is coercive, destructive, and politically fascist (Walter Benjamin) or totalitarian. And although we now live in a culture *after beauty* (to paraphrase Alasdair MacIntyre), beauty nonetheless beckons —as does virtue.

Although the Modernist-Postmodernist aestheticization of art, culture, and knowledge appears to be progressive and irreversible, it is actually quite brittle. As evidenced by Scholasticism—be it that of Abelard, Aquinas, or Kant, ideological systems cannot avoid contradictions. As discussed in detail above, the subjective-objectivity of the Modernist-Postmodernist tradition is replete in contradictions, for example, the Kantian intolerance of belief in the name of tolerance; the Heideggerian belief in an authentic life found via an identity of *being* with *becoming*—and therefore with death; of the irreconcilability of Modernist tolerance with Postmodernist identity.

If all ideologies deconstruct, then it is tempting to conclude that since beauty is associated with understanding, and no system of understanding can avoid deconstruction, then the quest for beauty is indeed an illusion, a fetish. But it is aesthetics rather than beauty that is a fetish because it cannot be grounded in meaningful reality. It does not avoid reason, but reduces it to a matter of taste, and when reason is a matter of taste, of pleasure, it is a meaningless willful preference. So the reduction of reason to the will to power is itself a fetish. Indeed, it is not just the systematization of optimistic ideologies that is subject to deconstruction; those who would universalize the will to power deconstruct as well. The aesthetic vision mandates two very different yet related approaches to reality and life. As discussed above, *gustibus non disputandum* (there is no disputing taste) is to be taken as an advocacy of tolerance, and as an advocacy of identity. To use Kant's terminology, a belief in aesthetic taste presents us with an antinomy between an alleged politics of tolerance and the politics of identity.

A subjective-objectivity not only deconstructs, but does so dramatically. It presents itself as an alternative to dogma or religion. As such it offers a substitution of transcendence by immanence, of purpose by existentialism. But instead of seeking truth or God, we are truth or God—and the tragic becomes a violent farce, because that which we will does not necessarily become, nor should it.

Beyond being incoherent, neither an aesthetics of tolerance nor the aesthetics of identity suffice. The millennial shift from beauty to aesthetics marks a gradual development from an ontological to an empiricist scholasticism. In each case an aesthetic fetishization of reason—and the self—results. It is a result that denies the possibility of responsible freedom where as a self-conscious act humanity engages in the pursuit of truth, of knowledge of a meaningful reality.

The pursuit of beauty remains an alternative. It is an alternative that resists both a dogmatic of belief—and of disbelief. It denies the reduction of art and reason to the status of fetish. Whereas to the aesthetic relativist all is opinion or power, beauty seeking traditions around the world differ markedly in how they understand the world and life. For example, Buddhism is foundationally distinct from either Classicism or Christianity. So a pluralistic pursuit of beauty offers a substantively varied alternative to a uniformly aesthetic vision. It is the pursuit of beauty that offers a genuine diversity. What is significant about a cosmopolitan pursuit of beauty is its dedication to the attempt to comprehend a purposeful world without recourse to dogmatism or skepticism.

In the West the pursuit of beauty is historically associated with the Socratic/ Platonic/Augustinian tradition. What is that tradition? As Copleston explains, "[T]he Augustinian attitude contemplates always man *as he is*, man in the concrete, for *de facto* man has only one final end, a supernatural end." [2] And he continues:

> [K]nowledge of truth is to be sought, not for purely academic purposes, but as bringing true happiness, true beatitude. Man feels his insufficiency, he reaches out to an object greater than himself, an object which can bring peace and happiness, and knowledge of that object is an essential condition of its attainment; but he sees knowledge in function of an end, beatitude. Only the wise man can be happy and wisdom postulates knowledge of the truth....

So humanity exists within a purposeful reality. Within that existence some certain knowledge is possible, for example, *si fallor sum*, we err and therefore we exist. And the goal of our self-conscious existence is to be in harmony with meaningful *being*, with reality. The pursuit of beauty is culturally realized by focusing on what knowledge is possible. The pursuit of beauty is the pursuit of some degree of knowledge about the meaning of reality and life. As such it addresses what natural science and emotion cannot. We live not in a state of arrogant ideology, or of arrogant skepticism, but in one of practical hope. The hope is that within a purposeful world a sympathetic approach to the world and life makes sense. In so doing, we can reject the Modernist/Postmodernist metaphysical assumption of a primordial ontological and violent void.

So assertions that the pursuit of beauty would be intellectually invalid, or totalitarian, are false. Nor is the pursuit of beauty, as advanced by Augustine, subject to Augustine's will to power, his religious feelings, or to his errors. It is

neither an ideology nor a cult, but a methodology with broad parameters. In the pursuit of beauty it is not a matter of who says it, but rather, whether what being said to some degree makes sense. It focuses on the issues of the relationship of *being* and *becoming* (and what might be beyond either), of object and subject, and the nature of history and time. It recognizes the self-conscious subject (be it Heidegger, Augustine, Christ, Lao-tzu, or others)[3] seeking knowledge of a purposeful object; it makes real that search by recognizing that Heidegger's reduction of *being* to *becoming*, and his assertion that this reduction results in meaningful time, is unnecessary and nihilistic.

In the West the relationship of *being* and *becoming* is historically understood via the doctrines of the Platonic Ideal, and of the Incarnation and Trinity. That understanding offers a solution that ensures responsible freedom. One may or may not accept as a unique ontological reality the existential success of that reconciliation of *being* and *becoming*, the subject seeking to be successfully in accord with a meaningful object, of the realization of purposeful time. But either the hope for, or the reality of, that reconciliation denies the claim of a subjective-objectivity in which all are *purposeless incarnate being*. Denied is the despair of no meaning or the violence resulting from multiple claims of those who would declare themselves to be the transcendent immanentized. It thus condemns the constellation of demigods and demagogues who declare themselves to be worldmakers, and whom in the name of an aesthetic identity commit atrocities. [4] It denies a constellation of aspiring worldmakers from declaring truth to be willful, and thereby destroying responsible freedom and beauty. And it denies the resultant (often hedonistic) nihilism that aspires not just to the end of history, science, and art, but to the end—as tragedy or farce—of culture and civilization.

Instead, the pursuit of beauty seeks knowledge of the True and Good. It seeks timely knowledge of purposeful *being*, the attainment of which is via love. It is then an untenable aesthetic assertion that there is a distinction between faith and knowledge, theology and philosophy, wisdom and science. The pursuit of beauty recognizes unity rather than constructs confusion, and that pursuit mandates freedom of conscience and purpose.

What then of the political realm? Does the pursuit of beauty lead to political tyranny and atrocity no better than aesthetic nihilism in its cultural effect? It depends upon the nature of our knowledge and belief, and of *being*. For example, the history of the West is marred by the record of anti-Semitism. The record of brutalities inflicted is disheartening. But there are also accounts of brutalities upon the martyrs of Christianity. So we can rightly construct two factual narratives: that of atrocities committed on innocent Jews, and that of atrocities committed on innocent Christians. So what do we do with these and many other such narratives of violence? The aesthetic Modernist-Postmodernist mind offers no solution, and no peace. The incoherent aesthetics of tolerance *and* identity devolve into a subjective-objectivity, where *being* is *becoming*,

made manifest in a will to power and devolving into nihilism. But beauty offers a means by which we can transcend such brutal narratives.

An identity-based will to power can be celebrated (Nietzsche), lamented (Schopenhauer), —or mocked. As Ludwig Wittgenstein argues in section 84e of his *Philosophical Investigations*:

> 215. But isn't the same at least the same? We seem to have an infallible paradigm of identity in the identity of a thing with itself. I feel like saying: "Here at any rate there can't be a variety of interpretations. If you are seeing a thing you are seeing identity too."
>
> Then are two things the same when they are what one thing is? And how am I to apply what the one thing shews me to the case of two things?
>
> 216. "A thing is identical with itself."—There is no finer example of a useless proposition...

But a mockery of the politics of identity is naïve; atrocities done in the name of identity-based science and faith, are too numerous and sad to ignore. How then can we enjoy a fullness of belief and tolerance? Identity requires that tolerance be grounded in agreement, but that requirement is both totalitarian and intolerant. As previously noted, Voegelin observes that a politics where the symbols of the transcendent are immanentized is totalitarian; and as Igor Golomstock puts it:

> In one conversation from the year 1920 Lenin expressed an idea that was to become a cornerstone of totalitarian aesthetics:
> "What matters is not what art gives to several hundred or even several thousand members of a population of millions. Art belongs to the people. It must penetrate with its deepest roots into the very heart of the broad working masses. It must be understandable to the masses and loved by them. It must unite the feeling, thoughts, and will of these masses, it must elevate them."

And Golomstock concludes:

> ...the concept which constitutes the very kernel and foundation of all totalitarian aesthetics: the principle of the identity of the artistic ideal in art and life...[5]

As made clear by the history of the rise of totalitarianism in the West, from the Inquisition to the concentration camps and the Gulags of the twentieth century, belief necessarily leads to tyranny only if it is aestheticized. Belief is simply another word for knowledge of that which we hold to be true; to aestheticize belief is to restrict belief to scientism and emotivism, where reason or understanding no longer matter, and where conversation is denied by sheer assertion.

The pursuit of beauty is a sympathetic pursuit of *being*, and as described above, for traditional Classicism and Christianity, *being,* that is, *reality*, is

positive, and largely but not totally ineffable. It is judged to be more realistic to be an optimist than a pessimist. In the pursuit of beauty an intellectual and spiritual illumination, a purposeful enlightenment, seeks our assent. In contrast, the pursuit of aesthetics is an empathetic pursuit of *being;* for Kant *being* is unknowable yet a product or our minds, and for Nietzsche and Heidegger *being* is *becoming*, and thus a *quanta*, a will to power. Being is thus destroyed, as are reason, understanding, and purpose. There is no illumination, only a brutal coercion. A *quali*-tative world is reduced to a *quanta*-tative world without wisdom, ethics, or beauty.

The choice between a positive understanding of *being*, or a negative one, is inescapable. It matters not whether that choice occurs as a result of commission or omission. It is a choice in which to varying degrees we are self-consciously involved. As subjects we must act on a presumption of the nature of the object, and of *being* itself. It necessarily involves some degree of rational assessment. Is it then politically prejudiced to privilege optimism over pessimism? The aesthetic vision so declares, but incoherently since in either case privilege is granted; the irony (and farce) of the aesthetic view is that any such granting of privilege makes no sense—since *being* assumedly lacks purpose.

So in the public realm a subjective-objectivity is intolerant of the subject seeking knowledge of an object, of *being*; but in denying knowledge of *being*, the subject asserts itself as *being*, and collapses within an empty self. To demand an empty public square is hypocritical and nihilistic. Just as (for example) Buddhists, Christians, and Classicists attempt to universalize their beliefs, so do Relativists. However, relativists attempt to universalize their belief in a purposeless aesthetics, or rather, they attempt to universalize their contempt for beauty. But the choice between beauty and aesthetics remains for those who aspire to rise from despair to hope.

An absence of beauty in the public square is then not possible; when the square appears empty it is simply trivialized, and a trivialized public square is one that is banal and violent at the same time. But how can beauty be sought without becoming politically oppressive? By recognizing a difference between subject and object, the personal and the political. Empathy assumes a unity of subject and object, where politics are a matter of identity. When politics are a matter of identity then they become devoid of and antagonistic to meaningful discussion. Demagogues become politicians and scholars. Beauty presents an alternative: that politics and scholarship are a matter of belief rather than identity and those beliefs are subject to rational personal and public analysis. Within the beauty-seeking traditions of the West a distinction is recognized separating the subject from the object in the pursuit of beauty; correspondingly there is a traditional separation of Church and State.

Aesthetically, the separation of Church and State is understood as a matter of taste: faith ought not to be imposed on others, unless it is a matter of identity (yet another contradiction). But then the will of the state (or the mob) becomes

divine. Historically, in the West the Church (a term used broadly here) represents the realm of conscience and belief, whereas the State represents the arena of practicality. For Augustine these elements exist in the presence of benevolent *being* rather than in a willfully purposeless world. The State is not a Hegelian/Marxist manifestation of the transcendent immanentized—*and destined to wither.* That would at the very least deny moral freedom; nor should the State be ignored. As Copleston explains:

> ...[A]lthough Augustine deprived the State of its aura of divinity, he at the same time insisted on the value of the free human personality and of moral responsibility, even against the State, so that in this way he 'made possible' the ideal of a social order resting upon the free personality and a common effort towards moral ends.[6]

Consequently, the aesthetic State is subject to our cultural yearning for beauty.

Whereas civilization, or even authoritarianism, demands that we obey laws even if we do not like them, totalitarianism demands that we not only obey the law, but that we must love it as well. We must accept an identity with a particular political object, and in that act of empathy we lose our freedom—and identity. So totalitarianism is coercive in terms of action and conscience, and destructive of *being* as well. Since freedom of conscience is essential to human *being* (and human rights), such coercion is unconscionable. To demand an individual human being to empathetically become one with the other, is to destroy the individual human and objective *being* as well. To substantively and empathetically unite the two is to embrace an aesthetic and totalitarian view. The subject seeking knowledge of *being* is aesthetically brutalized into a subjective-objectivity where as a matter of identity, one's identity is brutally denied.

What then is the solution? It is offered by the traditional Western understanding of a sympathetic separation of Church and State, by which the gap between subject and object remains, and is denied absolute power. To each coerce a unity of conscience or belief with practicality is totalitarian; to deny either is nihilism. As discussed above, when David painted the emperor Napoleon crowning himself in Notre Dame Cathedral, he not only dismisses the Church; he ushers in Modernist-Postmodernist totalitarianism where his will becomes divine, and that divine will is now immanent and codified. A subjective-objectivity is allegedly realized via his personal and immanent manifestation of the Hegelian Logos.

In contrast, beauty acknowledges a separation of subject and object, a separation that grants the individual freedom to come to conclusions of conscience. Within the context of informed and free debate decisions are made; those decisions result in both culture and public policy. So if a Modernist majority wishes to declare the meaning of existence and life to be a mystery, and that we live in a subjective-objectivity, then even though such a position makes little sense, it can nonetheless obtain force of law via an impartial

constitutional process. However, a constitution enabling responsible freedom can only resist an aestheticized culture for a while. Such a constitutional mechanism will initially resist aesthetic totalitarianism, but once a subjective-objectivity is culturally established, beauty and justice are aestheticized, and made totalitarian. Then both culture and constitutional law are eroded by the will of those who judge—or the mob. The judicial and the prejudicial empathetically become one—and Justice, which ought to be Beautiful, dies.

To the point: aesthetic taste alone cannot be judged or debated, so a culture grounded in responsible freedom cannot exist merely as a matter of taste. To accept aesthetic preferences in the public square is to impose the tyranny of a relativist public square that is hostile to belief other than those relativist. And it is hostile to freedom of conscience and debate, the rule of law, and of beauty.

So what then is a solution that is meaningful yet not dogmatic? Let us conclude this book not with a contradiction, nor a paradox. Nietzsche worries that with the end of history humanity will become so dull and complacent that our spiritual life will atrophy into Nietzsche's "last man" who is so despicable that he is no longer able to despise himself. We needn't worry; we need not travel from the *Dover Beach* to the *Dover Bitch*.

A culture that associates history with a physics of time, where there is *kronos* but no *kairos* (or in Heidegger's case, where *kairos* is found in *kronos* and death) does not deny metaphysics; it merely brutalizes it. The association of physics with a pointless aesthetics will remain an article of faith for those committed to the will to power. Dante called it the realm of the damned. But Dante offers a different option, in which it is time to seek that which eternally inspires; it is time to obtain some degree of knowledge of a meaningful reality. In contrast is the beatific vision where time is both physical and transcendent, *kronos* and *kairos*, where that which is transcendent and largely ineffable makes possible the temporal pursuit of ethics and beauty. Dante does not offer his own end of history, a final solution to our quest for meaning. That end is established by *being*. But he does evidence a methodology by which we might seek it, as do Socrates, Plato, and Augustine (and Sakyamuni for that matter). Each worked within an existential age but rose above it. Each did so not by rejecting the contingent and the temporal but by refusing to be limited by them. Each escaped the limitations of an imperfect world by pursuing beauty. In his text, *The City of God*, Augustine posits that the narrative of history is not meaningless, contingent, or based upon power. Rather it is a narrative where responsible freedom is indeed primary. Dante quotes Augustine in his book (Paradiso iii, [85]): "Too late I came to love Thee, O Thou Beauty both so ancient and so fresh...in Thy good pleasure lies our peace."

Neither an aesthetic tolerance nor identity will suffice; the aesthetic fetish, with its violent and hedonistic calculus, falls short of beauty. It is time to go beyond the physics of purposeless *quanta* of the will to a conscious and free pursuit of that which is metaphysically purposeful and therefore beautiful.

The historical pursuit of beauty is then an optimistic one, antithetical to the pessimism and nihilism of aesthetics. It is a search informed not by the will to power in a meaningless world, but rather by a conversation aimed at achieving a beatific vision. A vision where freedom, history, and beauty are reconciled via a passionate pursuit of truth. The history of art has come to this timely choice. And so have we.

The history of art studies fine art; fine art attempts to provide us with knowledge of reality, of *Being*. That knowledge constitutes culture. Augustine suggested that rather than a nihilistic aesthetics of identity, culture is better understood in terms of beauty and love. To return to a quote previously cited:

> "A people is an assemblage of reasonable beings bound together by a common agreement as to the objects of their love." Augustine, City of God, xix, 24.

Culture is a self-conscious phenomenon, but one which is achieved by obtaining knowledge of that which is beyond self-consciousness. The subject seeks knowledge of a meaningful object. It results from humanity's need to comprehend the meaning inherent in the world and life. As Plato noted, both truth and love seek completion. As Augustine put it so long ago, none can doubt that they think and live and seek to understand. As self-conscious beings we enjoy the freedom and necessity of attempting to understand our existence; that in turn involves the freedom and responsibility of making meaningful choices in life. This need is historically addressed by the fine arts and humanities; indeed it is this role by which fine art and the humanities are distinguished from entertainment, therapy, or propaganda.

The topic of this book is the history of art, but that in turn leads to a consideration of the relationship of aesthetics and beauty. It is a relationship which touches upon every aspect of our lives. The currently dominant mode of art history denies the pursuit of beauty, even when that denial contradicts the intrinsic meaning of the art studied. The objects of art history are thus aestheticized and fetishized, even those of the many cultures around the world that commonly center on the pursuit of beauty. In both East and West that pursuit has been largely supplanted by a shallow and violent aestheticism; it is time to renew culture by renewing the pursuit of beauty.

A call for renewal has implications for the past, the present, and the future. It is a criticism in looking back, an irritant for many at the present, and an admonition to all in looking towards the future. Such an admonition is practical in terms of culture; the past and present are linked whereas the future is by us unknown. As a matter of responsibility, the future lies significantly within our hands. The conclusion of this text is that the past and present are currently dominated by a dogmatic and malevolent aestheticism, that aestheticism marks a global cultural decline, and that the future of culture and the humanities lies in a renewal of the pursuit of beauty.

This call for renewal is irritating or worse to those who by habit or by personal identity embrace the long dominant trend within global contemporary culture. That dominant trend has been the aesthetic vision of Modernism and Postmodernism; they both approach reality and life aesthetically. As such, it is not that they are necessarily wrong, but that they fail to do enough. They fail to admit the possibility of a purposeful world and life. They arbitrarily privilege a denial of the validity of beauty— and of *kairos*. The very idea that the shift to aesthetics from beauty marks a decline rather than progress is rightly seen by Modernists and Postmodernists as subversive. It is subversive of the dominance of the aesthetics of Modernism-Postmodernism, and of its status as somehow being progressive, tolerant, and benevolent.

To undermine the unique authority of Modernism and Postmodernism is not only to be subversive of the dominance of aesthetics; it is to be subversive of the mainstream of academic discourse today. The contemporary academy is dominantly aesthetic in outlook, and for the humanities and fine arts this is particularly tragic. Within an aesthetic worldview the humanities and our lives have no purpose beyond, at best, stylish pleas for tolerance which are but masks for a violent and hedonistic substance.

The subjective-objectivity of the aesthetic vision results in both science and culture being reduced to *quanta,* to expressions of the will to power. The result is scientism and emotivism. A consequence of scientism and emotivism is the current cultural model where the natural and the social sciences are judged to be empirically justified *quanta* and the humanities are reduced to a matter of personally or socially justified *quanta.* Those *quanta* operate within a purposeless metaphysics and physics, in which a subjective-objectivity asserts that beauty and ethics conform to our will. But Hannah Arendt reminds us of the words of Augustine:

> To will and to be able is not the same.[7]

For Augustine the will neither triumphs nor should it be condemned. It cannot occur as a Kantian thing-in-itself, a good will without purpose; to embrace a good will without purpose is to embrace nihilism. Rather, the will needs to be united via knowledge with a benevolent object. It seeks a beatific vision of *being.* As Harnack puts it:

> ...[I]t is only true of a good will that it is free: freedom of will and moral goodness coincide...
> But it follows from this that the will truly free possesses its liberty not in caprice, but in being bound to the motive which impels to goodness ("beata necessitas boni")... and realizes *the destiny and design of man to possess himself of true being and life.*
> ...[W]hen the mind has been imbued with the commencement of faith which works by love, it aspires by a good life to reach the manifestation in which holy and perfect hearts perceive *the ineffable beauty whose complete vision is the highest felicity.*[8]

We will to do evil, and we will to do good, but in neither case do our desires necessarily become real. But the will is more true, good, and beautiful when it freely and cautiously aspires to benevolent *being*; the will is bondage when by commission or omission it does not seek that *being*. We can futilely choose not to seek *being*, or we can futilely attempt to become *being* by a subjective-objectivity. In either case the result is a will that annuls itself into *non-being*.

The aesthetic vision dogmatically assumes and demands as a foundational principle that the universe and life cannot have any objective meaning. Consequently, reason is not associated with the attempt to comprehend the meaning of reality and life. Rather, reason is a fetish, reduced to a formalistic rationalization or to a calculating of pleasure, equity, or advantage. Beauty, ethics, and justice thereby wither. The net result is a culture that scarcely rises above barbarism by the stylistic constraints of legality and a hedonistic utility.

In contrast is the notion of beauty. Beauty is associated with the attempt to comprehend to some precious degree reality and life, to attempt to comprehend to some precious degree what is objectively true and good. The pursuit of beauty is the pursuit of benevolent *being*. As such it takes for granted that the universe is purposeful, however difficult or obscure that purpose might be to comprehend. In Western culture beauty was pursued via the attempt to comprehend the Logos; it is associated with reason which marks the attempt by the human mind to comprehend some degree of the purpose of the universe. In the East this is pursued via a search for the Dao, Dharma, or more. Whether we refer, for example, to Classicism or Christianity, to Buddhism, Confucianism, or Daoism, those who seek beauty are united by their conviction that ultimately reality and life are purposeful and that it is part of the human condition to freely attempt to comprehend such purpose. The attempt to seek knowledge of that purpose is both practical and good.

To the point, from the perspective of aesthetics, beauty is fiction, be it viewed as exotic or banal, benevolent or malevolent. To the aesthetic mind beauty cannot possibly *be*—true. In contrast, from the perspective of beauty, aesthetics is shallow and violent. It sees aesthetics as superficial and trivial. Facts and feelings exist, as do self-expression and self-realization. But it is dehumanizing to limit self-consciousness to the level of mere sentience. To view culture, the humanities, and the fine arts via an aesthetic vision is to reduce thought to feeling and culture to brutality. And that reductionism is anti-cultural, which is to say it is barbaric.

The pursuit of beauty is one that evidences a joyful optimism. It posits a world and life that are filled with meaning. It sees a continuum from the factual to the realm of understanding, from the sentient to that of self-consciousness, and consciousness of the other. It is a continuum that is as realistic as it is qualitative. As such it recognizes the influence passion has on reason but accepts that in a meaningful world love and truth are one. The pursuit of beauty offers respite from the destruction caused by a purposeless aesthetics. It

offers the promise of meaning in our personal, social, and political lives. As such it establishes the primacy of conversation over sheer assertion, humility over absolutist or nihilistic arrogance, of love and truth over violence. Beauty and wisdom deny closure, deny the alleged end of history, science, and art, because such claims mark death. The pursuit of truth, goodness, and beauty offers the vital possibility of engaging in a perennial conversation that offers temporal substantive benefits, without ideological closure.

It is a cosmopolitan viewpoint that sees not only fine art, but history itself as the realm of responsible freedom, where without insisting upon its way, there is entertained the continuing possibility of a glimpse of wisdom—and beauty. It is time to once again renew that conversation. And so we have.

Notes

1. The Victorians, defenders of tradition, did so aesthetically, and thereby advanced the agenda of the Modernist-Postmodernists whom they wished to reject. For a discussion of the Victorian aesthetic vision see: John Steegman, *Victorian Taste. A study of the Arts and Architecture from 1830 to 1870* (Cambridge, MA: MIT Press, 1970).

2. Frederick Copleston, *A History of Philosophy* (Garden City, NY: Image Books, 1962), 64 ff.

3. So intellectually both Heidegger and Christ address the relationship of *becoming* and *being*. The former assumes a meaningless world, where *being* is *becoming*, and which concludes in an authenticity of death, whereas the latter assumes a purposeful world, where there *is becoming* and *being*, by which life is affirmed (or death is denied) via a love of *being*. *Becoming* and *being* are united and yet distinct via the doctrines of the Incarnation and Trinity. Love and truth are thus reconciled. For a different discussion of the positive cultural benefits of this perspective see: Rodney Stark, *For the Glory of God: How Monotheism Led to Reformations, Science, Witch-hunts, and the End of Slavery* (Princeton, NJ: Princeton University Press, 2003).

4. Those atrocities have occurred on the political Right and Left. The evil of the Holocaust needs no citation to be evident; see also Jonathan Murphy, Mark Kramer, translators, Stephane Courtois et al., *The Black Book of Communism* (Cambridge, MA: Harvard University Press, 2000).

5. Igor Golomstock, Totalitarian Art (New York: IconEditions, 1990) 174ff

6. Frederick Copleston, *A History of Philosophy* (Garden City, NY: Image Books, 1962), Vol. 2. pt. 1, 105.

7. Joanna Vecchiarelli Scott and Judith Chelius Stark, *Love and Saint Augustine. Hannah Arendt* (Chicago: The University of Chicago Press, 1996).

8. James Millar, translator, *Adolph Harnack, History of Dogma* (Oxford: Williams & Norgate, 1898), Vol. 5, 113, 123,

Bibliography

Aquinas, Thomas, *On Being and Essence*. Armand Maurer, translator. Toronto: The Pontifical Institute of Medieval Studies, 1968.

Arendt, Hannah, *Love and St. Augustine*. Joanna Vecchiarelli Scott and Judith Chelius Stark, editors. Chicago: The University of Chicago Press, 1996.

Artz, Frederick, *The Mind of the Middle Ages*. Chicago: University of Chicago Press, 1980.

Baker, Robert S. and James Sexton, *The Complete Essays of Aldous Huxley*. Chicago: Ivan Dee Publishers, 2002.

Barnes, Henry Elmer, *An Intellectual and Cultural History of the Western World*. New York: Dover Publications, 1967.

Barzun, Jacques, *From Dawn to Decadence*. New York: Harper Collins, 2000.

Bauerlein, Mark, "Social Constructionism: Philosophy for the Academic Workplace, "*Partisan Review*, LXVIII, 2 2001.

Baumer, Franklin LeVan, *Main Currents of Western Thought*. New Haven, CT: Yale University Press, 1978.

Beabout, Gregory R., "Liberty is a Lady, " *First Things*, 46, October, 1994.

Benjamin, Andrew and Peter Osborne, *Walter Benjamin's Philosophy. Destruction and Experience*. London: Routledge, 1994.

Bergendoff, Conrad, *Luther's Works*. Philadelphia: Muhlenberg Press, 1958.

Black, Hugh, *Culture and Restraint*. New York: Fleming H. Revell Company, 1901.

Boulton, James T, editor, Edmund Burke, *A Philosophical Enquiry into the Origins of our Ideas of the Sublime and Beautiful*. Notre Dame, IN: University of Notre Dame Press, 1968.

Bourke, Vernon J,. editor, *The Essential Augustine*. Indianapolis, IN: Hackett Books, 1974.

Burtt, Edwin, *The Metaphysical Foundations of Modern Physical Science*. Garden City, NY: Doubleday Books, 1954.

———. *Types of Religious Philosophy*. New York: Harper and Brothers Publishers, 1939.

Butcher, S.H. *Aristotle's Theory of Poetry and Fine Art*. New York: Dover Publications, 1951.

Bychkov, Viktor, *The Aesthetic Face of Being*. Scarsdale, NY: St. Vladimir's Seminary Press, 1993.

Cassirer, Ernst, *An Essay on Man*. New Haven, CT: Yale University Press, 1944.

Chasseguet-Smirgel, Janine, *Creativity and Perversion*. New York: W.W. Norton & Company, 1984.

Chipp, Herschell B., *Theories of Modern Art*. Berkeley: University of California Press, 1984.

Clark, Kenneth, *The Nude. A Study in Ideal Form*. Garden City, NY: Doubleday Anchor, 1956.

Clive, Geoffrey, editor, *The Philosophy of Nietzsche*. New York: Meridian, 1996.

Cohen, J.M., *Life of St. Theresa*. Baltimore, MD: Penguin Classics, 1957.

Conze, Edward, *Buddhist Thought in India*. Ann Arbor: University of Michigan Press, 1973.

Coomaraswamy, Ananda, *Christian and Oriental Philosophy of Art*. New York: Dover Publications, 1956.

Copleston, Frederick, *A History of Philosophy*. Garden City, New York: Image Books, 1962.

Courtois, Stephane et al., *The Black Book of Communism*, Jonathan Murphy, Mark Kramer, translators. Cambridge, MA: Harvard University Press, 2000.

Derrida, Jacques, *The Gift of Death*, David Wills, translator. Chicago: University of Chicago Press, 1995.

Dummelow, J., editor, *A Commentary on the Holy Bible by Various Writers*. New York: The Macmillan Company, 1925.

Eagleton, Terry, *Literary Theory*. Minneapolis: Minnesota University Press, 1996.

Eco, Umberto, *The Aesthetics of Thomas Aquinas*. Hugh Bredin, translator. Cambridge, MA: Harvard University Press, 1988.

Fisher, Helen, *Why We Love*. New York: Henry Holt Publishers, 2004.

Fleming, William, *Art and Ideas*. New York: Holt, Rinehart and Winston, 1994.

Fukuyama, Francis, *The End of History and the Last Man*. New York: The Free Press, 1992.

Gardner, Helen, *A History of Art*. New York: Harcourt Brace Jovanovich, 1975.

Gilson, Etienne, *History of Christian Philosophy in the Middle Ages*. New York: Random House, 1955.

Goodman, Nelson, *Ways of Worldmaking*, Indianapolis, IN: Hackett Publishing Company, 1988.

Golomstock, Igor, *Totalitarian Art*. New York: Icon Editions, 1990.

Greenhalgh, Michael, *The Classical Tradition in Art*. London: Duckworth, 1978.

Gregor, Mary J., *Immanuel Kant, The Conflict of the Faculties*. Lincoln: University of Nebraska Press, 1992.

Guignebert, Charles, *Ancient, Medieval and Modern Christianity. The Evolution of a Religion*. New Hyde Park, NY: University Books, 1961.

Hamilton, Gerald Heard, *Manet and his Critics*. New York: W.W. Norton & Company, 1969.

Harnack, Adolf, *History of Dogma*, James Millar, translator. Oxford: Williams & Norgate, 1898.

Harrison, Ccharles, and Paul Wood, with Jason Gaiger, editors, *Art in Theory 1815-1900. An Anthology of Changing Ideas*. Oxford: Blackwell Publishers, 1998.

——. *Art in Theory 1900-1990. An Anthology of Changing Ideas*. Oxford: Blackwell Publishers, 1992.

Hartt, Frederick, *Italian Renaissance Art*. Englewood Cliffs, NJ: Prentice Hall, 1987.

Heidegger, Martin, *Poetry, Language, Thought*. New York: Harper & Row, 1975.

Heer, Friedrich, *An Intellectual History of Europe*, Jonathan Steinberg, translator. Cleveland, OH: The World Publishing Company, 1953.

Hibben, John, *The Problems of Philosophy*. New York: Charles Scribner's Sons, 1908.

Hofstadter, Albert and Richard Kuhns, *Philosophies of Art and Beauty*. Chicago: Chicago University Press, 1976.

Horgan, John, *The End of Science*. Reading, MA: Addison-Wesley, 1996.

Hornblower, Simon and Antony Spawforth, *Oxford Classical Dictionary*. Oxford: Oxford University Press, 1996.

Hunter, Sam and John Jacobus, *Modern Art*. Englewood Cliffs, NJ: Prentice-Hall, Inc., 1985.

Huntington, Samuel, *The Clash of Civilizations and the Remaking of World Order*. New York: Touchstone, 1996.

Jameson, Frederic, "The Deconstruction of Expression, " in Charles Harrison and Paul Wood, *Art in Theory 1900-1990*. Oxford: Blackwell, 1992.

Jones, John D., *Pseudo-Dionysius Areopagite. The Divine Names and Mystical Theology*. Milwaukee, MN: Marquette University Press, 1980.

Kandinsky, Wassily, *On the Spiritual in Art,* Hilla Rebay, editor. New York: Solomon Guggenheim Foundation, 1946.

Kierkegaard, Soren, *Fear and Trembling*. Alastair Hannay, translator. London: Penguin Books, Ltd., 1985.

Kirk, Russell, *The Conservative Mind*. Chicago: Washington, DC: Regnery Books, 1986.

Koyré, Alexandre, *From the Closed World to the Infinite Universe*. New York: Harper & Row, Publishers, 1957.

Kuhn, Thomas, *The Structure of Scientific Revolutions*. Chicago: University of Chicago Press, 1970.

Kurtz, Stanley, "The Future of History, " *Policy Review*, no. 113, June-July 2002.

Kvanvig, Jonathan, *The Intellectual Virtues and the Life of the Mind: the Place of Virtues in Contemporary Epistemology*. Maryland: Savage, 1992.

Lasch, Christopher, *The Culture of Narcissism*. New York: Warner Books, 1979.

Maritain, Jacques, *Art and Scholasticism*, J.F. Scanlan, translator. New York: Charles Scribner's Sons, 1947.

McIntyre, Alasdair, *After Virtue*. Notre Dame, In: University of Notre Dame Press, 1981.

——. *Whose Justice? Which Rationality?* Notre Dame, IN: University of Notre Dame Press, 1988.

Milbank, John , *Theology and Social Theory. Beyond Secular Reason*. Oxford: Blackwell Publishers, 1995.

Molnar, Thomas, *God and the Knowledge of Reality*. New Brunswick, NJ: Transaction Publishers, 1993.

——. *Utopia, the Perennial Heresy*. New York: Sherd and Walp, 1967.

Nussbaum, Martha, *The Fragility of Goodness. Luck and Ethics in Greek Tragedy and Philosophy*. Cambridge: Cambridge University Press, 1986.

Neuhaus, Richard John, *The Naked Public Square. Religion and Democracy in America*. Grand Rapids, MI: W.B. Eerdmans Publishing Co. 1984.

Nietzsche, Friedrich, *The Birth of Tragedy and the Genealogy of Morals*. Francis Golffing, translator. New York: Doubleday Anchor Book, 1956.

Nochlin, Linda, *Realism*. Baltimore, MD: Penguin Books, 1972.

O'Connell, S.J., Robert J., *Art and the Christian Intelligence in St. Augustine*. Cambridge, MA: Harvard University Press, 1978.

Ott, Hugo, *Martin Heidegger. A Political Life,* .Allan Blunden, translator. New York: Basic Books, 1993.

Ouspensky, Leonid, *Theology of the Icon*. Anthony Gythiel, translator. Crestwood, NY: St. Vladimir's Seminary Press, 1992.

Pelikan, Jaroslav, *Jesus Through the Centuries. His Place in the History of Culture*. New York: Harper and Row, 1985.

Pollitt, J.H., *Art and Experience in Classical Greece*. Cambridge: Cambridge University Press, 1972.

Pontynen, Arthur, "A Winter Landscape: Reflections on the Theory and Practice of Art History, "*Art Bulletin*, LXVIII, no. 3, September, 1986, 467-79.

——. "Art, Science, and Postmodern Culture, "*American Outlook*, November-December, 2000, 37-39.

——. "Beauty and the Enlightened Beast, "*American Outlook* Magazine, 2002, 37-40

——. "Beauty vs. Aesthetics: Ethics in the Fine Arts Curriculum". In Robert Ashmore and Richard Starr, editors, *Ethics Across the Curriculum*. Milwaukee, MI: Marquette University Press, 1994.

——. "Daoism." "Confucianism, " *A Dictionary of Art*. London: Macmillan Press, 1996.

——. "Facts, Feelings, and (In)coherence vs. The Pursuit of Beauty (Kandinsky and Florensky)." *St.Vladimir's Theological Quarterly*, 1996, vol. 40 no. 3.

——. "Oedipus Wrecks: PC and Liberalism, " *Measure* 113, February, 1993, 1-4.

——. "Public Art and Public Values: The Blue Shirt." WI: *Wisconsin Interest*, 2003.

——. "The Aesthetics of Race, the Beauty of Humanity, " *American Outlook* Magazine, 2002, 37-40.

——."The Dual Nature of Laozi in Chinese History and Art." *Oriental Art* Magazine, vol. 26, no. 3, Autumn, 1980.

——. "The National Endowment for the Arts." *Ready Reference: Censorship*. Pasadena: Salem Press Publishers, 1996.

Singal, Daniel Joseph, *Modernist Culture in America*. Belmont: Wadsworth Publishing Company, 1991.

Sokol, Alan, "Transgressing the Boundaries: Towards a Transformative Hermeneutics of Quantum Gravity." *Social Text*, Spring/Summer, 1996, # 46-47.

Stark, Rodney, *For the Glory of God: How Monotheism Led to Reformations, Science, Witch-hunts, and the End of Slavery*. Princeton, NJ: Princeton University Press, 2003

Steegman, John, *Victorian Taste. A Study of the Arts and Architecture from 1830-1870.* Cambridge, MA: MIT Press, 1970.

Steinberg, Milton, "Kierkegaard and Judaism, " *Menorah Journal.* 1949, 37:2.

Stern, Raphael, and Esther Robison, editors, *Changing Concepts of Art.* New York: Haven Publishers, 1983.

Stumpf, Samuel, *Philosophy. History and Problems.* New York: McGraw-Hill, 1971.

Tarnas, Richard, *The Passion of the Western Mind.* New York: Ballantine Books, 1993.

Tatarkiewicz, Wladyslaw, *History of Aesthetics.* The Hague: Mouton, 1970.

Weaver, Richard, *Ideas Have Consequences.* Chicago: The University of Chicago Press, 1984.

Weikart, Richard, *From Darwin to Hitler: Evolutionary Ethics, Eugenics, and Racism in Germany.* Palgrave Macmillan, 2005.

Winterer, Caroline, *The Culture of Classicism.* Baltimore, MD: John Hopkins Press, 2002.

Worringer, Wilhelm, *Abstraction and Empathy.* Michael Bullock, translator. Cleveland, OH: Meridian Books, 1967.

Index